Prais The Women J

"Scharff's approach to Jefferson .

man who was passionate, vulnerable, and charming but also hypocritical, difficult, and demanding. *The Women Jefferson Loved* adds to our understanding of one of the most fascinating personalities of the American Revolution."

-Andrea Wulf, New York Times Book Review

"What if the women who shared Jefferson's life actually mattered—not just as appendages to him or objects of his attention, thoughts, and actions, but as human beings in their own right? In this luminous and long overdue addition to Jefferson scholarship, Virginia Scharff considers the mother, sisters, wife, sisters-in-law, daughters, mistress, and granddaughters who shared Jefferson's existence and helped make him the man he was. This book is a tour de force, a must-read for all who are interested in early America, Jefferson, and Monticello."

> -Annette Gordon-Reed, author of The Hemingses of Monticello: An American Family

"[A] fascinating study.... Scharff doesn't shy from controversy.... Writing with precision, control, and a delicate lyricism, Scharff unearths not only five important figures but also a society facing epic shifts." —Publishers Weekly

"Engaging.... A story of Revolution-era America and its many divides—slave and free, male and female, revolutionaries and loyalists." —Randy Dotinga, *Christian Science Monitor* "With dazzling imagination and careful attention to the facts hidden in plain sight, Virginia Scharff helps us see Thomas Jefferson in an entirely new light. Who knew there could be anything fresh to say about Jefferson? But with wit and verve, Scharff introduces us to a new side of the Founding Father, unraveling the intricate ties between his public and private lives and creating an unforgettable portrait of a man bound up in the struggle between head and heart." —Martha A. Sandweiss, author of *Passing Strange: A Gilded Age*

Tale of Love and Deception Across the Color Line

"This fascinating and highly readable account deepens our understanding of how Jefferson's emotional life with women, including his mother, wife, concubine, daughters, and slaves, influenced his thinking and greatest public acts.... Scharff has created an entertaining and insightful portrait of Jefferson, the women in his life, and what women endured in the pursuit of happiness." —American History

"By studying these women, Scharff not only opens a window to the heart and soul of one of our nation's founders but also resurrects their own contributions to our nation's history." —Booklist

"It is not often that I spend a day reading a single book, but *The Women Jefferson Loved* is that gripping. Moving, brilliantly written, and deeply sympathetic to everyone concerned—it is a wonder." —Richard White, author of *The Middle Ground*

"The author brings out each of the women's importance in Jefferson's life and, along the way, looks at what life was like in America for women of their various social stations.... Scharff illuminates her impressive research, and she effectively contextualizes each of these women's stories, using them to illustrate the times and traditions in which they lived. A focused, fresh spin on Jeffersonian biography." —*Kirkus Reviews* "The Women Jefferson Loved will change your view of Thomas Jefferson and his once-believed misogynist's attitude and behavior toward women. This is not a book about his secret trysts, but a true account, based on newly released historical documentation. . . . Scharff takes the reader on a journey into Jefferson's life . . . telling the story without pretense or common assumptions. . . . paints a colorful, mosaic work of art of a man laden with values, morals, and a heart for love. . . . An enlightening and touching read."

-M. Chris Johnson, Sacramento Book Review

"The book rests on a brilliant concept, which is then skillfully realized: We've *all* heard about the influence of the women 'behind' great men. Virginia Scharff actually shows this by examining all the women in Jefferson's life—his mother, white wife, black commonlaw wife, daughters, and granddaughters. A grand, lively read."

-Linda Gordon, author of Dorothea Lange: A Life Beyond Limits

"[Scharff's] copious research is complemented by her ability to imbue her historical writing with dramatic tension and draw characters that are compelling regardless of their stature." —Santa Fe New Mexican

"Virginia Scharff's *The Women Jefferson Loved* is a smart, eyeopening, vividly written saga of Monticello. It's an indispensable portrait of Thomas Jefferson like none other. Highly recommended!" —Douglas Brinkley, author of *The Wilderness Warrior*

"Scharff weaves a fascinating tale, enriched by the insights of the best contemporary scholarship, and seamlessly constructed from family lore, letters, garden and account books, and Martha Jefferson's housekeeping journal. This is a terrific read!"

> -Barbara Oberg, General Editor, The Papers of Thomas Jefferson, Princeton University

"If you think there's nothing new to learn about Thomas Jefferson, think again—and read this original, shrewd, and above all compassionate book. Virginia Scharff introduces us to the remarkable women who, as much as Jefferson himself, illuminate their time through their lives and their strength of character."

-Elliott West, author of The Last Indian War: The Nez Perce Story

"A fascinating and intimate account that will attract American history buffs and students of Jefferson." —*Library Journal*

"Setting each woman firmly within her own milieu, [Scharff] makes excellent use of available documentation . . . capably distills what information there is, and focuses clearly on each figure and her place in Jefferson's life. She skillfully navigates the entangled relationship within their Virginia family network and fleshes out her narrative with a wealth of historical details concerning the era in which her subjects lived. In the process of profiling each of these women, the author presents the reader with a fuller picture of Jefferson's life." *—Historical Novels Review*

"The rich contexts Scharff supplies for her subjects help to bring into clearer focus women who have remained in the shadows, particularly Jane Randolph and Martha Jefferson."

-Virginia Magazine of History and Biography

"Based on sources that include family letters, and written with empathy and great insight, *The Women Jefferson Loved* is a welcome new look at this legendary American and offers a fresh twist on American history itself." —*American Towns*

THE WOMEN JEFFERSON LOVED

VIRGINIA SCHARFF

NEW YORK . LONDON . TORONTO . SYDNEY . NEW DELHI . AUCKLAND

HARPER PERENNIAL

A hardcover edition of this book was published in 2010 by Harper, an imprint of HarperCollins Publishers.

THE WOMEN JEFFERSON LOVED. Copyright © 2010 by Virginia Scharff. All rights reserved. Printed in the United States of America. No part of this book may be used or reproduced in any manner whatsoever without written permission except in the case of brief quotations embodied in critical articles and reviews. For information address HarperCollins Publishers, 195 Broadway, New York, NY 10007.

> HarperCollins books may be purchased for educational, business, or sales promotional use. For information please e-mail the Special Markets Department at SPsales@harpercollins.com.

> Page 451 constitutes an extension of this copyright page.

FIRST HARPER PERENNIAL EDITION PUBLISHED 2011.

The Library of Congress has catalogued the hardcover edition as follows:

Scharff, Virginia.

The women Jefferson loved / Virginia Scharff.-1st ed.

p. cm.

Includes bibliographical references and index.

ISBN 978-0-06-122707-3

1. Jefferson, Thomas, 1743–1826—Relations with women. 2. Jefferson, Thomas, 1743–1826—Family. 3. Jefferson family. 4. Presidents—United States—Biography. I. Title.

E332.2. S33 2010

973.4'6092-dc22

2010005717

ISBN 978-0-06-122708-0 (pbk.)

17 18 19 20 OV/RDD 10 9 8 7 6 5 4 3 2

то

CHRIS

who understands the claims of the head and the heart

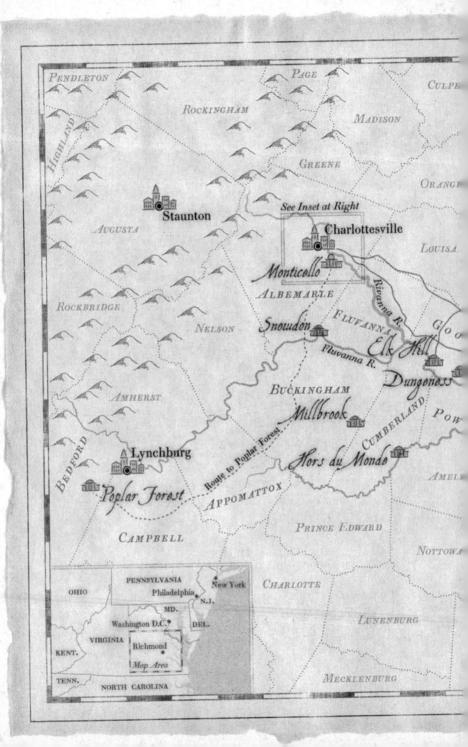

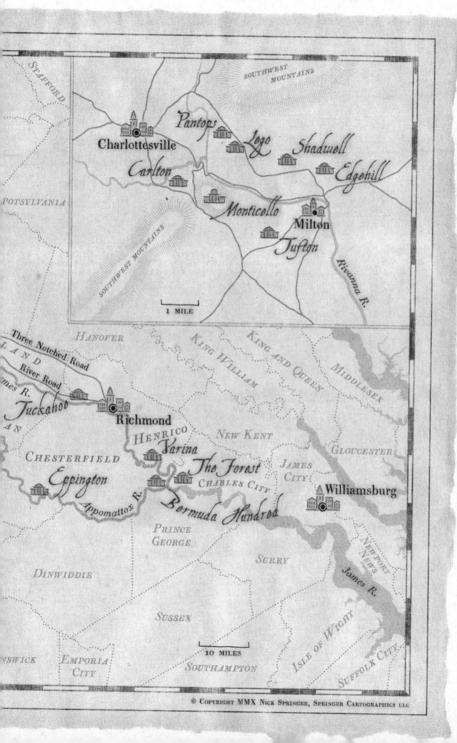

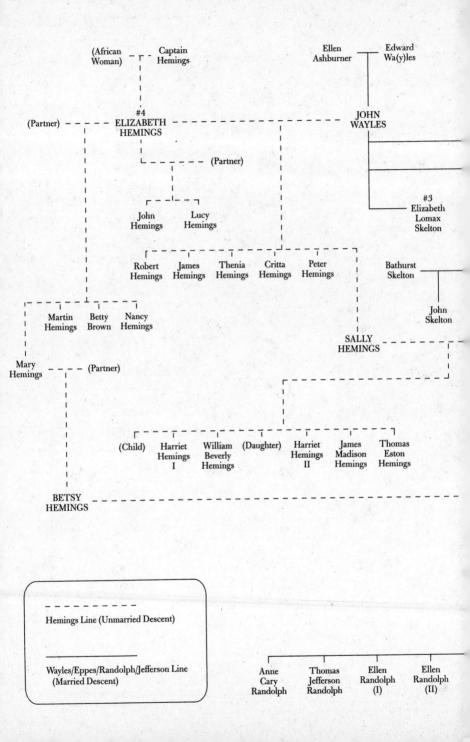

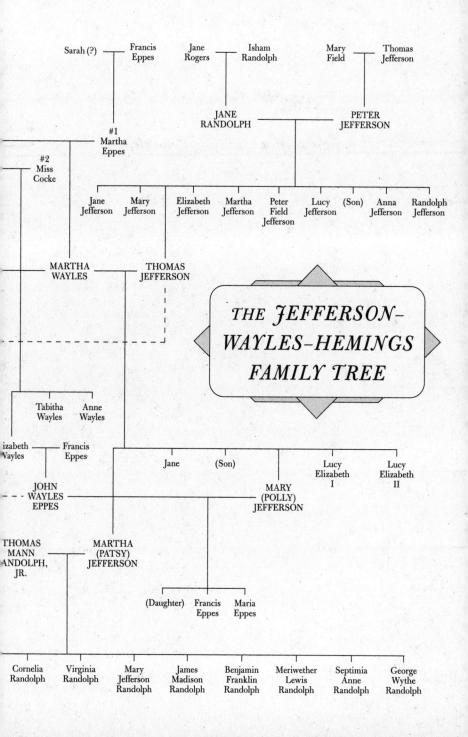

Nobody cares for him who cares for nobody. — THOMAS JEFFERSON, 1786

Contents

FAMILY TREE	x
A FEW WORDS ON NOMENCLATURE AND GENEALOGY	xv
INTRODUCTION	vvii

I. JANE

1	The Planter's Daughter	3
2	The Planter's Wife	16
3	The Widow Jefferson	28
4	The Revolutionary's Mother	38

II. MARTHA

5	The Debt Collector's Daughter	61
6	Bride and Widow	73
7	Mr. and Mrs. Jefferson	86
8	Martha's Property	100
9	His World and Hers	110
10	Domestic Tranquility	121
11	The War Comes Home	132
12	The Butcher's Bill	144

III. SALLY

13	Stories and Shadow Families	159
14	Summoned and Sent	172
15	Paris	188
16	Amazons versus Angels	198
17	Sally's Choice	214
18	Coming Home	226

IV. PATSY AND POLLY

19	Patsy and Polly	239
20	Trouble in the Neighborhood	253
21	Domestic Tranquility, Revisited	270
22	Danger	280
23	Scandal	291
94	Motherhood and Mortality	306

V. A HOUSE DIVIDED

25	Domestic Diversification	315
26	The Pursuit of Happiness	331
27	The Perils of Matrimony	342
28	The Capriciousness of Fortune	356
29	When We Think How We Liv'd	
	but to Love Them	368
		1

ACKNOWLEDGMENTS	385
DRAMATIS PERSONAE	393
NOTES	403
BIBLIOGRAPHY	443
ILLUSTRATION CREDITS	451
INDEX	453

A Few Words on Nomenclature and Genealogy

IN THIS BOOK, at the risk of appearing to lack respect for my subjects, I will often refer to people by their first names and even by nicknames, rather than by their full names or last names. I do so to avoid confusion among relatives with names so bewilderingly similar that even the most dogged reader would be flattened by the effort of trying to make sense of all the Janes and Marthas and Marys, Jeffersons and Randolphs, Johns and Thomases. I hope that by referring to Sarah Hemings as Sally and to Martha Jefferson Randolph as Patsy, I enable my readers to keep these women in plain sight. I refer to Martha Wayles Skelton Jefferson, Thomas Jefferson's wife, by her formal first name, and not her nickname (which was Patty), in order to avoid confusion between her and her long-lived daughter, Patsy Jefferson Randolph. For consistency, I also use the spelling "Hemings" for all members of the Hemings family, though some members (notably, John Hemings and Betsy Hemings) spelled their surname with two *m*'s.

Anyone who enters the world of Thomas Jefferson must also grapple with the problem of genealogy. Americans' current enthusiasm for the subject reflects our history as a nation of immigrants, a fascination with finding out from whom, and from where, we came. That passion

xvi 💥 NOMENCLATURE AND GENEALOGY

is particularly deep-rooted in Virginia, where a cult of founding families has produced the acronym FFV, shorthand for First Families of Virginia, a three-letter soubriquet that packs a gigantic load of meaning. But genealogies, which seem to mark the orderly procession of births and marriages, the cementing of harmonious ties, hide as much complexity and conflict as they reveal. The Randolph family, for example, one of the most storied of the FFVs, has a genealogy that one wag said resembled "a tangle of fish hooks." Thomas Jefferson knew from decades of experience that genealogy was no guarantee of virtue, wisdom, loyalty, or even sanity.

Genealogies also tend to be stultifyingly repetitive and confusing, none more so than those of the Virginia families who appear here. But they are also indispensable to histories of people related by blood. I want to show the ways in which the Wayles, Hemings, Jefferson, and Eppes families came together and shadowed one another through three generations. So that readers may know the players, I offer a program, a family tree in the front, and a Dramatis Personae at the back of this book. Unlike most genealogical charts, this one includes lines that cross, which some readers may find puzzling, or even troubling. That is probably as it should be.

Introduction

CORNELIA JEFFERSON RANDOLPH, a spinster at twenty-seven, contemplated her family's ruin with more optimism than she had any right to feel. Her dear grandfather, Thomas Jefferson, had died five months before, on the fiftieth anniversary of his Declaration of Independence. His passing had left Cornelia's mother, Martha Jefferson Randolph, homeless, destitute, depressed, and exhausted. The family was making do as best it could, crowded together in makeshift households, scrimping on coffee and sugar and firewood, depending mostly on Cornelia's harried brother, Thomas Jefferson Randolph, to house them and feed them and fend off the creditors and the scavengers.

On that dreary December day of the hardest Virginia winter she had ever known, Cornelia wrote to her sister Ellen, who had escaped the worst by marrying a Yankee and moving to Boston. Cornelia confided that she hated "dependance particularly dependance on brother Jeff." Noble as he was, Jeff annoyed his sisters Cornelia, Mary, and Virginia with his nagging and penny-pinching, his second-guessing of their housekeeping, his aversion to music. Cornelia was determined to find her way to independence, inspired by her grandfather's example. "We are his children," she declared, "and the energy he has shewn in public affairs, is in our blood & we will shew it in our

xviii 🧏 INTRODUCTION

private affairs. we will never despair, we will never be cast down by difficulties, we will bear ourselves bravely & be cheerful in the midst of misfortunes, & if we are thrown upon our own resources we will find them in ourselves." Cornelia had seen her grandfather's perseverance. When his crippled right hand hurt too much to go on, he picked up the pen and wrote with the left.

At that very trying moment, Cornelia Randolph felt particularly close to Thomas Jefferson. She was immersed in copying his papers, perhaps the most precious thing he had left behind. Priceless as they were to his family, they were also a badly needed financial asset, soon to be sold to the Library of Congress, that great institution her grandfather had founded. Jeff Randolph served as official executor of the papers, but his sisters had the job of making legible copies of the manuscripts. As they scratched away with frozen fingers, huddled close to a meager fire, they may also have carried on another family tradition: feeding the flames with anything that felt too private or caused too much pain, anything that could not be comfortably explained or ignored.

Nearly all his adult life, Thomas Jefferson had methodically filed the letters he received, and made his own copies of the ones he wrote. But many of those letters have never been found. Like the twinned black inkblots in a Rorschach test, the missing letters sometimes form meaningful patterns, hinting at a suggestive shadow literature of their own, a record of the things Jefferson and his descendants did not care to pass down to posterity. Jefferson himself, and his daughters and granddaughters as well, sometimes ended personal letters by urging the recipient to "throw this in the fire." The burning was as creative as it was destructive. Just as Thomas Jefferson's slaves "burned" bricks to construct the walls of his magnificent house, he and his descendants burned letters to construct an imaginary but seemingly impenetrable wall between his public legacy and his private life. As much "pulling down and putting up" went into fashioning Thomas Jefferson's correspondence for public consumption as there was in the many makings of Monticello. The voluminous corpus that remains for public perusal seems a complete collection, just as the mansion we see today appears a timeless masterpiece. But both were products of changing times and close editing, artifacts of careful storytelling, history handmade by Thomas Jefferson, his loving family, his preservers and defenders.

THOMAS JEFFERSON MEANT to make his own history. But he could not do so just as he pleased. Even as he worked to preserve the wall between his public and private lives, he insisted that everything he did and said and worked for in public, all the remarkable achievements that have made him the most beloved and vexing of the Founding Fathers, he did out of love for his family and home. His love for those closest to him, and the sacred bonds of affection, inspired his immortal embrace of life, liberty, and the pursuit of happiness. No wonder the American public has been fascinated with his private life. We agree with James Parton, the Jefferson biographer who wrote in 1874, "If Jefferson was wrong, America is wrong." We see in him America's greatness and meanness, its generosity and arrogant possessiveness, its good intentions and bad habits, its magnificent achievements and tragic shortcomings. We want to know what made him tick, to see the beating heart of him.

What Jefferson tried hardest to hide, we suspect holds the key. As it turns out, his most closely guarded secrets, most fiercely maintained silences, nearly all had to do with the women he loved. This book is about those women, about what love meant to him and to them, and about what it cost them all. Their ways of loving were different from ours, but love was a powerful force in their lives, nonetheless. We see proof of the power of love in scores of carefully preserved, fascinating letters, exchanged among Jefferson and his daughters and granddaughters. But some of the women Jefferson loved most are hardest to know.

There may, of course, be remnants of these mysterious women hidden in private collections, keepsakes of a family history deemed too precious or too potentially embarrassing to share with the public. But as far as we know, not a scrap of paper between Jefferson and his mother survives. He, or someone else, burned every last exchange with his wife, and nearly every letter that might have mentioned his slave and concubine, Sally Hemings. After he died, his grandchildren charged themselves with keeping his secrets and preserving his legacy. They suppressed some stories and told others. They did a fine job, but they did not always tell the truth. Now we have new tools to restore what flame destroyed, what careful forgetting tried to wipe out, new ways to approach the stories passed down and repeated, denied and bitterly contested.

For decades—centuries, even—those who told the official story of Thomas Jefferson's life concealed what Jefferson wanted hidden. They tended to be white Victorian women and southern gentlemen who defended Jefferson's honor according to the code of white supremacy and racial segregation. They believed, as is written in stone at the Library of Congress, that THE HISTORY OF THE WORLD IS THE BIOGRAPHY OF GREAT MEN. Writing about the heroic Jefferson, they worked to preserve a way of life that excluded or at least diminished the importance of those people not deemed great—black people and women of any color, for example—suggesting that perhaps they were not worthwhile subjects for history at all.

But Thomas Jefferson lived out his long life embedded in a multigenerational web of biological, social, and emotional connections between his cherished white family and the family of his slave, Sally Hemings. His father-in-law, John Wayles, was father not only to Jefferson's wife, Martha Wayles Skelton Jefferson, but also to Sally Hemings and five of her sisters and brothers, making Martha and Sally half-sisters. Martha grew up with the Hemingses, brought them with her to Monticello, gathered them around her as she lay dying. Jefferson, in turn, was father to Martha's six children, and also to Sally's seven children. The Hemingses were half-cousins to Martha's daughters; they were also half-sisters and half-brothers. Jefferson's son-in-law, John Wayles Eppes, would carry on the family tradition with Sally Hemings's niece, Betsy. The two families were linked, intimately and genetically, for three generations. They have shadowed one another through history.

To this day, many who revere Thomas Jefferson see it as their duty to erase, ignore, obscure, dismiss, and angrily dispute the fact that Jefferson inhabited a house divided, one half of his family designated as white and free, the other half denigrated as black and enslaved. When Fawn M. Brodie acknowledged and investigated that kinship in her bestselling 1974 biography of Jefferson, the "Jefferson Establishment," including Julian Boyd, the editor of the definitive (and ongoing) edition of Jefferson's papers, Dumas Malone, author of the magisterial multivolume biography, and Merrill Peterson, distinguished historian of Jefferson's legacy, could no longer ignore the story. So they determined to ruin Brodie professionally, accusing her of sloppy research, falsification of data, and not least, of womanly weakness.

Much has changed since Brodie's time. Over the past dozen years or so, historians at Monticello, led by Lucia Stanton, the Shannon Senior Historian, have begun the monumental task of reuniting what had been so painstakingly kept apart, and restoring Thomas Jefferson to the complicated world in which he lived. The pathbreaking 1997 study of the evidence for Jefferson's paternity of Sally Hemings's children, by law professor and historian Annette Gordon-Reed, revealed the racism at the heart of the argument for denial and made a powerful case that Jefferson had indeed fathered Sally Hemings's children. A year later, a DNA study by Dr. Eugene Foster and others established that a Jefferson male had fathered Eston Hemings, the youngest of those children. Fraser D. Neiman, director of archaeology at Monticello, added the weight of a rigorous statistical analysis and the application of Occam's famous razor: of all Jefferson males, Thomas was far and away the likeliest father not only of Sally Hemings's youngest son, but of all her children. Gordon-Reed's highly acclaimed family history, *The Hemingses of Monticello*, stands as triumphant proof of the past it is possible to know when we stop acting as if some people never lived, or if they did, never mattered.

It is time to stop pretending that history never happened. Once we see Jefferson in his own world, the shell of the sphinx cracks, crumbles, falls away. Beneath the veneer, we find a man vulnerable and knowable, a man who makes sense, a man who belongs to all of us. In this book, I enter the world that Brodie and Stanton and Gordon-Reed and others have illuminated, to see in one place the divided family that lived so intimately together, people whose histories have been wrenched apart by the habits of intellectual apartheid. They shared a physical intimacy lasting three generations—several lifetimes of trust and betrayal, hope and disappointment, caring and resentment, obligation and desire. They were not simply Jeffersons and Hemingses; their veins also ran with the blood of Randolphs and Wayleses and Eppeses. They were linked by the power of paternity, and the blood and the pain and the love of women.

Some will object that these stories do not belong together. American slavery divided the Jeffersons and Wayleses and Eppeses and Randolphs from the Hemingses, the white families from the black, erecting a wall of tyranny that no amount of intimacy could breach. Likewise, many will point out that the habit of thinking in black and white was so deeply ingrained in all the people I write about here, that to imagine intimacy across the color line misses the larger matter of violent oppression.

The fissures of race and caste cut so deep that they wound our nation to this day. Those chasms have been kept open by force and hatred and physical brutality, including sexual violence. But it is time to relinquish the burden of segregationist histories and to imagine the possibility of reconciliation. In this book, readers will see not only the divisions, but the connections; not just the estrangements, but the (always troubled) intimacies, and not simply the prurient aspects of those intimacies, but the everyday bonds of tension and affection. Masters and slaves, men and women, did not have equal access to power or property or fame, or even to control over their own bodies. But they depended upon one another, from one generation to the next, to the point of life and death.

MY TITLE, *The Women Jefferson Loved*, invites the winking observation, "Oh, I bet there were *lots* of them!" Everybody wants to know about Jefferson's sex life. Everybody always has, ever since the days in which he had one. But I have not written this book as an inquiry into the history of Thomas Jefferson's progenerative body parts. I will disappoint some readers when they discover that I am more interested in what he did with his head and his heart. I want to know how he loved women, how he thought about and practiced his deep love of women his mother, Jane Randolph Jefferson; his wife, Martha Wayles Skelton Jefferson; his enslaved mistress, Sally Hemings; his diverse daughters, Martha Jefferson Randolph, Mary Jefferson Eppes, and Harriet Hemings; and his Randolph granddaughters, Anne, Ellen, Cornelia, Mary, Virginia, and Septimia.

I contend that he loved them all—a controversial enough claim in its own right. Fawn Brodie and others suggested that he hated his mother. Many historians deny that he had any real feelings for Sally

xxiv 💥 INTRODUCTION

Hemings. And some have seen in him a sexist reactionary pure and simple, a notable misogynist even for his own time. I see Jefferson as a possessive patriarch, as sure of his right to rule his domain as any of the kings he despised, but also as a man who loved women. Love is not a simple or predictable or necessarily helpful thing, and it is certainly not in any sense "pure." Love hurts as much as it heals, and even when love is trying its hardest to be a force for good, it makes people do small, sometimes benighted things that have great consequences. Please see the works of Shakespeare or Faulkner for examples.

AND WHAT OF the women themselves, the women Jefferson loved? Why have I chosen to focus on the women of his family? Jefferson had a number of close female friends, including, for a time, Abigail Adams, one of the great figures in American history. He formed a deep attachment to the Anglo-Italian artist Maria Cosway during their time together in Paris, and corresponded with her for the rest of his life. We have letters, quite a few letters, that attest to his regard for those formidable persons.

Abigail Adams and Maria Cosway played important parts in Jefferson's life, and readers will meet them in this book. And for a time, of course, Thomas Jefferson was *in love* with Maria Cosway. But real love between men and women was, for him, something deeper, a sacred bond that imposed on both parties a lifetime of reciprocal duties and obligations. His connections to the women in this book showed him that love was more than infatuation or companionship or a stroll through a lovely garden. Remarkable as Adams and Cosway were, they learned, to their frustration, that Thomas Jefferson sailed through his life on his own terms, and his great regard for them had no bearing on his course. The women of his family, by contrast, were the stars by which he plotted the voyage. His love for them shaped his vision for the nation, his most monumental achievements, his ongoing legacy. It is time we got to know them better.

STILL, YOU MAY say: books about Thomas Jefferson are about as rare as Tuesdays. Why this one?

The time is ripe. We have newly available materials, from the brilliantly annotated editions of Jefferson's memorandum books, to the online collections of his papers and his family's letters, to the archaeological excavations at Shadwell and Monticello. These sources make it possible to know a great deal about women who have long been considered ciphers, particularly his mother, Jane, his wife, Martha, and his slave mistress, Sally Hemings. His daughters' and granddaughters' letters are now available to anyone with an Internet connection.

Some of these women were pampered children of privilege, commanding fine houses, riding blooded horses, setting their tables with imported linen and china and silver. Some were condemned to be bondservants to their relatives, under the constant threat of sale. All of them lived in a harsh and volatile world. They were scarred by fire and flood, by slavery and war and motherhood. They had friends and relatives and acquaintances who had committed murder, and others who died by violence. Some of them were fragile, but they were not innocent. They knew kidnapping and domestic abuse and the organized viciousness of the slave trade. If nothing else, the toll of childbearing taught them about life and death.

The women Jefferson loved knew how to give orders and take them, how to make soap and bottle cider, how to make over a madeover dress. Some loved flowers and some drank beer. Some hated housekeeping, but they knew what it took to slaughter a hog, mix up a pudding, or prepare a body for burial. Some sailed across the ocean. Some could speak French, or even Spanish and Italian, and some could read the classics in the original Latin. One could render architectural drawings with a fine hand. One saw to it that her children would go free. Not one of them could hope to attend college or cast a vote in an election.

For the most part, they relied on the weapons of the weak: indirection and manipulation. We should not look to them as perfect role models for our daughters. They were flawed humans with fascinating stories, and they mattered. Their lives, their Revolutions, their vulnerabilities shaped the choices Jefferson made, from the selection of words and ideas in his Declaration, to the endless building of his mountaintop mansion, to the vision of a great agrarian nation that powered his Louisiana Purchase. So far, the histories of these women have appeared to us as fragments of separate stories, divided by generation and, more drastically, by race. But that was not how they lived. Their fortunes and their honor were bound up with, and often at odds with, one another.

Thomas Jefferson did not live his whole life according to the things he read in the books in his library. He learned about love between men and women from his parents, and grew into a curious and exuberant young man, dreaming and planning, in a family full of sisters, in his mother's plantation house. He adored his wife and never got over the anguish of believing that he had killed her not only with his desire, but with his ambition. He cherished his daughters and tried to mold them into paragons of womanhood, looking forward to the day he could retire to Monticello and revel in the happiness of his extended family. When he entered into a liaison with the enslaved halfsister of his late wife, he vowed to do right by Sally Hemings and their children.

His notion of domestic utopia was his most tenacious and most foolish fantasy. In an ideal world, he would preside over an extended household, where they all lived together in harmony and plenty. No one will be surprised to learn that everyday difficulties and lifechanging tragedies got in the way of his dream. But setbacks and crises seemed always to take him by surprise. Asking each of the women he loved to honor his commitment to the others, to suppress their warring interests, jealousies, and anger, he imposed upon them a regime of silence and tension we can barely fathom.

Jefferson struggled all his life to fulfill the promises he made to the women of his family, to honor the love they bore him, each in her own fashion, which he returned, in his. He pledged his devotion in the midst of political upheaval, invasion, and war, at heady moments of liberation and amid the mundane cruelties of slavery, in the fertile exuberance of a Monticello spring and the crushing torment of a new mother's deathbed. His promises differed just as much as there are different ways a son loves his exasperating mother, a husband his mortal wife, a father his devoted daughters, a master his solicitous mistress and slave, a grandfather his adoring granddaughters.

Jefferson talked about love all the time, but we have either not listened very carefully to what he was saying, or have refused to take him at his word. In the heat of his greatest political challenges—writing the Declaration, dealing with Cornwallis's invading army, fomenting revolution in France, awaiting the outcome of the election of 1800—he longed to be home, surrounded by peace and harmony and attentive women and charming children. He never gave up that romantic vision, and he never stopped trying to make it a reality. For Jefferson, love was indestructible and lifelong, a self-evident truth and a sacred obligation. Love was loyal and generous beyond limit. But it was not equal.

As strongly as he argued that men must have individual liberty, he believed just as deeply that women were fitted by nature to depend on men. He embraced that natural order as a fundamental condition for

xxviii 🎇 INTRODUCTION

happiness, in large matters as well as small: the personal was the political. Jefferson thought men should protect and provide for the women they loved. He labored his whole life to fulfill that sacred trust. But he was also idealistic and nostalgic, sentimental and self-justifying. He could be nearly delusional in his optimism, insisting that he would take care of everyone and everything, that things would turn out all right. And when he failed, it broke his heart.

THE WOMEN JEFFERSON LOVED

Part I

JANE

The Planter's Daughter

1

BEFORE SHE REACHED the age of six, Jane Randolph took the most momentous step of her life. She walked up the gangplank of a ship bound from England, across the ocean to the Chesapeake. Jane, of course, had no choice in the matter. Her father, Captain Isham Randolph, had decided to return to the land of his birth. The Randolph clan was fast becoming one of the richest and most influential families in Virginia, and Isham's parents had bequeathed substantial colonial estates to all their sons. It was time to take up planting in earnest.

Isham had called London home for years. He had gone to sea as a young man and in 1710, at the age of twenty-five, had assumed command of his first vessel, the *Henrietta*. He took up residence in England, and seven years later married an Englishwoman, Jane Lilburne Rogers, who hailed from the parish of Shadwell, a precinct at the edge of London that was just beginning to attract the chaotic custom of seafaring men. Captain and Mrs. Randolph entertained visitors from near and far. One such guest, a young Virginia gentleman by the name of John Carter, found Isham lively company and described his young bride as "a pretty sort of woman."

Isham Randolph prospered, commanding ships and selling tobacco

4 🎽 THE WOMEN JEFFERSON LOVED

for his fellow Virginians, buying and shipping British goods. But the tobacco trade was shifting from London to Glasgow, Liverpool, and Bristol. He had a choice to make. His brother, Edward, moved to Bristol with his English wife, who was said to despise slavery so much that she flatly refused to consider living in Virginia. Isham charted a different course and wagered his prospects on Virginia and tobacco and slavery. His first two children had been born in England, but his future offspring would be native to the New World. He would raise them all to take their places as plantation masters and mistresses.

THE RANDOLPH FAMILY sailed to America sometime between August 1724 and October 1725. As a small child, Jane could not have understood the perils she faced. Passengers heading westward in those days typically bade their farewells with no small measure of fear. Some were literally bound for the New World, forced to go as indentured servants, or under the lash of enslavement. Many were lost at sea, and those who survived might never again see the loved ones they had left behind.

In times of war, ships traveled in immense convoys extending into the hundreds of vessels. Captains like Isham Randolph hated the delays, the discipline, and the perils of knocking into other boats, or the equally daunting danger of lagging behind or blowing off course and into the hands of the enemy, or the clutches of pirates. But happily, England was at peace, and Isham Randolph was no neophyte. Mrs. Randolph and her daughter and small son could feel confident on the voyage.

Of course, a transatlantic voyage was no easy thing. They would be on the water at least six weeks with fair winds, and longer in bad weather. Even if they made good time, they had to endure the close and crowded quarters, the pitching and rolling of small wooden vessels, the perils of wind and choppy seas, the foul drinking water. Little water could be spared for washing. Many ships had problems with rats and worm-infested, spoiled, or scarce provisions. Passengers who did not suffer from seasickness could not escape from those who did, and ships were ideal and infamous containers for deadly contagions including smallpox.

Even on voyages where stores were abundant, passengers and crew ate mostly ship's biscuit, salted meat, peas, and cheese. If they wanted anything further, fresh meat, for example, someone would have to slaughter a sheep or a pig on deck. Passengers ate what and where they could, often balancing their dinners on their laps, sometimes sharing one bowl among several people, passing a spoon from hand to hand. It was enough to drive people to drink even more than they did on land. The combination of poor sanitation and rolling waves made the crossings interludes of nastiness, misery, and even death, for too many travelers. Captain Randolph's English wife knew the dangers all too well. The year before their journey, an acquaintance of her husband's, a twenty-three-year-old Virginian named Thomas Jefferson, had died aboard Isham Randolph's ship, the *Williamsburg*.

But whether the journey was long and difficult, or blessedly short and calm, or something in between, both Mrs. Randolph and little Jane and her baby brother proved equal to the crossing. They were pampered passengers, assuredly not among those obliged to slit an animal's throat and clean up the blood and entrails, or even to cook the bacon. Captain Randolph's wife and children were accustomed to being waited on by servants, some of them perhaps Africans the Randolphs held in slavery. Isham's business interests included trafficking in slaves, a hideous commerce England had opened to private merchants in 1712. Scarcely sixty years earlier, the Virginia legislature had passed a law declaring that such people taken from Africa would be obliged to serve their masters all their lives, and that their slavery would be hereditary. Some or all of those servants would have

6 🎇 THE WOMEN JEFFERSON LOVED

accompanied the family on board, to ease the discomforts of passage for the white man and woman and their children. They would not have been left behind, because slaves were valuable property. From the moment they disembarked in Virginia, the Randolphs' African servants and all their progeny would be considered not people, but chattel.

Before Captain Randolph's family ever sailed, little Jane had already assumed some of the privileges she would enjoy as the eldest daughter of a slaveholding Virginia family. But Jane could not have begun to imagine what she would find upon her arrival in a new world of amazing possibility and massive brutality.

AS THE SHIP sailed into Chesapeake Bay, into the mouth of the James River, the heavily wooded shoreline, broken here and there by plantation landings and small settlements, was a wondrous, daunting sight to English eyes accustomed to the tamed and cutover aspect of their native land. But there was family aplenty to welcome them. While their own home was being readied, the Randolphs found shelter in Williamsburg, and with Isham's father, William, at Turkey Island plantation, at the juncture of the Appomattox and the James. By 1730, young Jane Randolph and her parents, brother, and two small sisters found their way to their new home; they ferried up and across the rivers and creeks of water-scored country to Dungeness plantation in Goochland County, on the north bank of the James.

Isham Randolph traded the ocean for the land, planted vast fields of tobacco, and took his place in local politics. As he did his duty with the colonial militia, stood for the House of Burgesses, and exchanged the title of "captain" for "colonel," he built a fortune on high tobacco prices and erected a house said to be among the most lavish in the colony.

Which was, let it be said, pretty lavish. In a world of Virginia tobacco gentry dedicated to keeping up with English fashions in learning, living, and consuming, Isham and Jane Randolph set the bar high. A portrait of Isham, painted not long before he left England, reveals a stout fellow in a curled white wig, frock coat, vest, and spotless linen cravat, gazing calmly at the viewer, a portfolio under his arm. His Dungeness estate was a stunning place, with a coach house, mill house, henhouse, horses and chariot for riding, and vast gardens sequestered behind brick walls. The household was stocked with the very latest in European furnishings, food, and drink, and was tended by a hundred enslaved people. Family portraits hung on the walls. In London, Isham had kept company with wealthy merchants like Peter Collinson, a devotee of the science of botany, and members of the Royal Society, including Hans Sloane, founder of the British Museum. In Virginia, he maintained his reputation as a stylish, generous host and a cultivated man. When Pennsylvania botanist William Bartram, son of Collinson's friend and protégé, John Bartram, began to make plans for a tour of Virginia, Collinson urged Bartram to seek out Isham Randolph. "No one," Collinson told Bartram, "will make thee more welcome."

Randolph's hospitality came with expectations. Virginia tobacco lords and ladies dressed in satins and lace in the latest style. They wore elaborate wigs and hats and elegant shoes and silk stockings (although, truth be told, bathing was not generally among their daily habits). Bartram, a farmer by trade and a Quaker by faith, affected plain speech and modest clothing. Peter Collinson urged his protégé to dress to impress, or at least not to embarrass. "One thing I must desire of thee," Collinson wrote Bartram: do "not appear to disgrace thyself or me; for though I should not esteem thee less to come to me in what dress thou will, yet these Virginians are a very gentle,

8 🎇 THE WOMEN JEFFERSON LOVED

well-dressed people, and look, perhaps, more at a man's outside than his inside. For these and other reasons, pray go very clean, neat, and handsomely dressed, in Virginia."

An opulent establishment like Dungeness required a mistress who knew how to manage legions of people and immense quantities of food, drink, and furnishings. Jane's mother had to entertain guests with witty conversation and amusing activities, planning each day as if a horde of unexpected visitors might arrive at any minute. The mistress needed to perform her duties, and compel others to do theirs, in sickness and in health, a tall order. Disease, infection, accident, and, not least, the manifold dangers of pregnancy and childbirth killed Virginia women early and often. In fact, in colonial Virginia, as in many other places and times in the world's history, there were two kinds of women: those lucky enough to be fitted for carrying and bearing children, and those for whom maternity was deadly. Isham Randolph had made a fortunate choice in his wife. Jane Rogers Randolph would be the first of her line in Virginia to prove a great breeder.

Daughter Jane was the eldest of the nine of Jane Rogers Randolph's children who survived to adulthood, six of them female, five born at Dungeness. Such a brood must have rattled the walls of even a very large mansion, and a growing girl in a crowded house knew something about the rigors of pregnancy and childbirth, as her mother loomed heavy and large, again and again, as each labor began and as the pains wore on. Someone would be called to help, a relative, a slave "auntie," a neighborhood midwife, entrusted to oversee the proceedings. Everyone might treat the lying-in times as matters of course, going mostly about their business, but surely sometimes the household grew hushed and fearful, listening anxiously to groans or screams until the crisis was past, the newest Randolph suckling or sleeping. Was young Jane allowed into the room, to hold a hand, or fetch water, or just be a comfortingly healthy sight? Perhaps she was

9

curious and eager to learn about women's duties and destinies. Or maybe she was querulous or timid or fretful or angry, best kept out of the way?

Whether or not she was deliberately brought to witness her mother's trials, Jane doubtless acquired some knowledge of the mysteries of childbirth, just as surely as she learned to inventory the hams hanging in the smokehouse, count up the silver spoons, and keep track of the wine goblets. She also watched her elders demonstrate how to give orders, and learned to practice that art at a very early age. Planters' daughters like Jane had slave girls near their own age as maids to iron their linens and carry their slops. Jane was raised to be a lady. She was taught to read and write, by her mother or perhaps by a tutor hired primarily to give lessons to her brothers. She learned to dance and play and sing from the dancing masters and music teachers who came to Dungeness to instruct the master's children. She was being prepared for the marriage market.

AT THE AGE of nineteen, Jane was more than old enough to marry, and she needed to do so. Dungeness, and Isham Randolph's other holdings, did not belong to Jane. Her three brothers would inherit the lands, furnishings, and people that her father left behind. The six Randolph daughters were promised so-called marriage portions of two hundred pounds each, but Jane and her sisters had to find their own fortunes in husbands, preferably reliable men with good prospects.

Jane may well have welcomed the chance to get married and have a house of her own, away from a mother hardened by duty. According to family tradition, recalled decades later by Jane's great-granddaughter, Jane's mother was "a stern, strict lady of the old school, much feared and little loved by her children." Jane had accepted the commands of her father, the disciplines imposed by her mother, and now

10 💥 THE WOMEN JEFFERSON LOVED

she would have the duty to obey her husband. She would keep a tidy, comfortable, orderly house, instruct her children, and submit to her husband's will and wishes. If the man she married lived up to expectations, he in turn would provide financial security and protect her, as far as he could, from physical harm. But even as a husband should be lord and master, a planter's wife had privileges and responsibilities of her own.

Jane Randolph was something of a pioneer, the first among a new generation of women in her family raised from childhood to run plantations and command slaves. Her mother had come to Virginia as an adult and a foreigner. When she arrived in the Chesapeake, this Englishwoman from the outskirts of London had to learn new tasks and habits, how to use or avoid the unfamiliar plants and animals that surrounded her, how to instill obedience in people whose loyalty could not be assured. Simply to get from one place to another in Virginia, Isham Randolph's wife had to navigate a watery landscape of far-flung households linked by creeks and rivers. Spring "freshets," the Virginian term for floods, occurred with regularity. In 1724, one famous freshet wrecked houses and destroyed most of the tobacco along the James River, and even drove boats ashore. When Jane grew up and had her own place on the Rivanna, recurring freshets carried off boats and outbuildings and destroyed a painstakingly built mill dam.

Jane Randolph's mother had to learn the lay of the land and the movements of water, and she had to master the peculiarities of slaveholding, to find her place among the people of Virginia. The rigors of such a life transformed Isham Randolph's wife from the "pretty sort of woman" of London into the "stern, strict lady . . . much feared and little loved" of Virginia. Mrs. Randolph, like her daughter Jane, learned how to live in Virginia from a man who had made his living commanding ships and growing and trading tobacco and slaves. Neither sea captains nor plantation masters were renowned for their tender mercies.

IF HIS TREATMENT of other people's human property offers any clue to how he ruled his own slaves, Isham Randolph was a harsh master. Like most elite Virginia men, he served his time as a justice of the peace and commander of militia, and rose to the rank of adjutant general of the colony. And like most planters and magistrates, Randolph dealt harshly with any sign of unrest among the enslaved. When he was judge in the trial of "some Negroes charged with murder," Randolph saw no reason for clemency, even toward three of the accused who were his own brother's slaves. According to Randolph family chronicler Jonathan Daniels, Isham Randolph

... approved the sometimes savage punishments which prevailed. As a justice he joined several other such officials in the trial of some Negroes charged with murder. Since three of the slaves on trial belonged to his brother William he might have excused himself. Still he agreed in the judgment that two convicted slaves not only be hanged but that their bodies be dismembered and that the heads and quarters be displayed on poles in various parts of the county. The decorative society in which Isham lived could be a harsh one too ... well described by [William] Byrd who had slaves whipped and then gave them a bottle of rum: "they had a fiddle and danced while I walked in the garden."

Dismemberments and gardens, whippings and fiddles and rum. Young Jane Randolph grew up in a world of savage contradictions, where gayety and cruelty, fear and privilege sat uneasily side by side. She learned to be a woman amid a hundred enslaved people hoeing

12 💥 THE WOMEN JEFFERSON LOVED

tobacco and holding horses, gathering eggs and butchering pigs, hauling water and carrying dishes to table. Slaves waited on the denizens and guests of Dungeness plantation and did the everyday work of farming and feeding and clothing and cleaning. They coped with itinerant botanists and mounted banquets and balls and weddings and funerals. They labored out of fatalism or loyalty, out of habit or an inability to envision alternatives, and always under the threat of punishment. Their work might bring some pleasure, some joy even, but in the end they were compelled, at the snap of the lash, to do what their masters wanted them to do.

For all their power, the masters feared their slaves. Rumors of slave conspiracies, and the actuality of punishments for rebellion, swirled like a poisonous fog around Jane Randolph's early days and brought swift retribution upon discovery. A 1722 plot had landed seven enslaved men in the Williamsburg jail, awaiting a trial in which three of the leaders would be sentenced to be sold and transported out of the colony for "conspiring among themselves and with the said other slaves to kill murder & destroy very many." These conspirators, like seven men convicted not long after in a similar scheme, were sold and exiled rather than executed, since judges did not want to have to reimburse masters out of the public treasury. But exile, for the enslaved, likely meant a trip to the sugar plantations, tantamount to a sentence of death.

Insurrection scares and real plots led the Virginia legislature in 1723 to clamp down on enslaved people in a series of harsh measures. Slaves' ability to travel, assemble, attend church or go to funerals, or possess weapons was severely curtailed. The law also made it hard for masters to free their slaves. In young Jane's world, owners who had misgivings about the institution of slavery kept their thoughts to themselves. They worked hard to maintain control, suspecting that some slaves would turn to violence to escape their chains, if they could. In 1730, when Jane was ten, a larger plot was uncovered. A rumor had spread that the king had issued an order freeing all Christian slaves, but that Virginia's Governor William Gooch had suppressed the king's proclamation. Slaves fired with the holy spirit of Christian evangelism determined that their salvation in the next world should entitle them to their freedom in this one. The rebellion spread to as many as five Virginia counties. Four ringleaders were executed, and the rest were severely punished. Governor Gooch called up white militias to patrol two or three nights a week to prevent secret meetings, and even required militiamen to bring their guns to church on Sundays.

What did such alarms mean for the Randolphs of Dungeness, the home of so many enslaved Africans and their American-born descendants? Our glimpses of Isham Randolph's draconian judicial record suggest that the genial, gracious master of Dungeness, "a Gentleman well known and universally loved" according to the terms of his appointment as adjutant general of Virginia, ran his realm with a belief in the efficacy of terror.

A YOUNG VIRGINIA gentlewoman of the 1730s might have looked uneasily to her future, anxious for a husband who could provide for her needs and, with any luck, treat her with at least a little respect and affection as he increased the family's fortunes. For Jane Randolph, Peter Jefferson appeared a solid bet. He was thirteen years older than Jane, a giant, some said, big and powerful enough to tip up a thousand-pound hogshead of tobacco with each hand. When he went off on long surveying trips in the wilderness, they said, Peter "could tire out his assistants, and tire out his mules; then eat his mules, and still press on, sleeping alone by night in a hollow tree, to the howling of the wolves."

This early American Paul Bunyan must have towered over his future wife. As for her temperament, her great-great-granddaughter

14 🧏 THE WOMEN JEFFERSON LOVED

avowed that Jane Randolph was "a woman of a clear and strong understanding, and, in every respect, worthy of the love of such a man as Peter Jefferson." She was said to possess that "cheerful and hopeful temper and disposition" so characteristic of her eldest son, Thomas. Henry Randall, the man Thomas Jefferson's grandchildren chose to write the first grand Jefferson biography, deemed Jane

an agreeable, intelligent woman, as well educated as the other Virginia ladies of the day, . . . but that by no means implying any very profound acquirements—and like most of the daughters of the Ancient Dominion, of every rank, in the olden time, she was a notable housekeeper. She possessed a most amiable and affectionate disposition, a lively, cheerful temper, and a great fund of humor. She was fond of writing, particularly letters, and wrote readily and well.

Unaccountably, some later Jefferson biographers took a dimmer view of the great man's mother. Randolph family chronicler H. J. Eckenrode offered an unflattering portrait based solely on her age at the time of her marriage to Peter Jefferson:

Possibly the Dungeness family was glad to get such a levelheaded young chap as a husband for the girl. It is even probable that she was not good-looking and, consequently, was not much pursued by the young gentlemen of the vicinity. She was nineteen years old when married, a ripe age for marriage in a period when, because of the urge for population, girls married at sixteen, fifteen, or even earlier.

In fact, white women of Jane's time and place typically married in their late teens or early twenties, so she was hardly "on the shelf" when she wed Peter Jefferson. Her father promised her husband a dowry of two hundred pounds sterling, no more than he offered for his other daughters. Such an amount, while substantial, was well within the means of a man engaged in the big business of the day: tobacco and slaves. The year that Jane married Peter Jefferson, Isham Randolph shared a consignment of 380 persons, captured from Africa to be brought to Virginia and sold into slavery. Isham might even have offered Jane a marriage portion including slaves, as many slaveholding fathers did. But if there were human beings among Jane Randolph's wedding presents, no marriage settlement recorded the gifts. Whatever Isham Randolph's intentions, the dowry pledge was eventually paid out of his estate. Isham Randolph died four years after Jane and Peter Jefferson's marriage. By that time the couple had headed west, to grow up with the country.

The Planter's Wife

2

PETER JEFFERSON WAS a man of substance, with complicated and farflung affairs to tend. As an expert surveyor and mapmaker, he trekked off to remote corners of Virginia for weeks and months at a time. He sought and won public office, as justice of the peace, then sheriff of the county, and like his father-in-law, he was commissioned colonel in the colonial militia. He had dozens of slaves and hundreds of acres of real estate. He wanted more land and would acquire more human property. When Peter was absent, Jane had to see to the farm and deal with anyone who came to buy or sell, to collect debts, to make demands. There must have been days she dreaded, times when she wondered and worried.

Peter did what he could to give his family comfort and prosperity. Men who meant to rise by planting tobacco looked for land on the water so they could ship their crop to market. He had inherited from his father a place on Fine Creek, some fifteen miles distant from Dungeness on the other side of the James. But he wanted to move west. He had some land up on the Rivanna River, just east of the Blue Ridge Mountains, where he hoped to build a permanent home. The best place for a house, however, was on an adjoining tract owned by Jane's cousin William Randolph, a rich and almost too convivial young man. William and Peter were great friends, and a Jefferson family story related the casual way in which Peter Jefferson came to possess his Albemarle County plantation. When he let William Randolph know he wanted the land for his house, Randolph offered to trade the land for a bowl of arrack punch. Peter called the new place Shadwell, in homage to Jane's birthplace, a gesture designed to help her imagine this farm in the forest as a new home, however removed from her family and friends. Peter may have moved to Shadwell as early as 1737, and when they married in 1739, Jane joined him there. The first child born to Jane at Shadwell, in 1740, was a daughter, named Jane after her mother and grandmother.

In eighteenth-century Virginia, having babies was the most dangerous thing a person could do, more lethal than hunting or going to battle or drinking a bowl of arrack punch and then getting on a horse to ride home. We may wonder how Jane Jefferson prepared for what was then called her "confinement" in a country where white settlers were still few and houses were far apart. Her sister, Mary Lewis, lived nearby, and they probably summoned a neighborhood midwife, as they did for slave women at Shadwell. And what of Peter? Was he at home when the babies were born, or would it have taken some time, even been impossible, merely to get word to him, off in the fields or forests or tending to remote business, that Jane's time had come? Whatever the company or the circumstances, Jane Jefferson was fitted for childbearing. She had a second daughter, Mary, in 1741, and was pregnant with her third child when her father, Isham Randolph, died in 1742. Thomas Jefferson, born at Shadwell in 1743, never knew the grandfather who had planted his family in Virginia, nor did his sister Elizabeth, born a year and a half after her brother.

At the moment Thomas Jefferson was introduced to the world, Shadwell was a work in progress. It took a long time to cut down trees

18 🧏 THE WOMEN JEFFERSON LOVED

and pull up stumps, to frame and roof and finish even a modest house, in that era of hand-hewn joints and hand-forged nails. Peter probably did some of the building himself, but he also hired free workers and used slave labor. Shadwell was a place still being torn out of a country of densely wooded steep hillsides, cut by rivers that could swell and rage, miles from the cluster of plantations along the James that Jane Randolph Jefferson knew best. But Shadwell was also the beautiful place where she would live out her life. Maybe Jane loved it from the first, when it was still wild, and loved it still more as work and time brought order and prosperity. The Jeffersons would ultimately have a fine house there, a center of hospitality fully equipped with everything a prominent Virginia family might need or want.

In the early years, with four children and an enterprising, fast-moving husband, Jane had plenty to do to make Shadwell feel like home. We may wonder how she managed the trick. Did she sing as she stewed apples or beat a carpet? Did she have a guitar or a fiddle, was she partial to hymns or country tunes or lullabies, did she read music, as so many well-born Virginia girls did? Surely bearing four children in less than five years took a toll on her spirits as well as her body. Doubtless she longed for company and comfort. Amid her tangle of kin and friends at Dungeness, Peter Jefferson had been an up-andcomer in a well-established community. Out at the edge of settlement, he was a leading man in a new world. As his wife, Jane had to deal with visitors as well as children and servants. The planter's wife had dozens of daily duties: clothes to be made and mended, meals planned and prepared, a cow to feed and milk, chickens and eggs, a garden to tend, beer to be brewed. Pigs were useful-fat to render into lard for cooking or mix with ashes and lye for soap, meat to be butchered and smoked, bristles for brushes. Jane left the heaviest and dirtiest jobs to others-to slaves, by and large, but also to hired help. As mistress of an increasingly grand establishment, Jane delegated to others many of those things that humbler housewives did themselves. For one thing, it seems that she did not nurse her babies. She probably handed that task over to a slave mother who cared for the little Jeffersons along with her own children.

Now Jane had a place of her own after growing up amid the hubbub of so many sisters and brothers and cousins and friends. But if she was sometimes overworked and homesick, fate provided a tragic cure for the malady. William Randolph, the cousin who had deeded Shadwell to Peter Jefferson for a bowl of punch, died in 1745. Randolph had been a widower, and he left three young children and a fine plantation house at Tuckahoe, scarcely ten miles from Dungeness. Facing his death, Randolph had asked Peter to move to Tuckahoe and take care of his orphaned children. Peter and Jane, their four children, and some of their slaves packed up and headed back to Goochland County, where they would remain for nearly eight years.

Most people have a hard time remembering events of their lives before the age of three, but in the quality of his memory, as in so many other things, Thomas Jefferson proved a prodigy. His earliest recollection was of the journey to Tuckahoe, when he was scarcely two years old, being carried on a pillow by a slave on horseback. We do not know whether Jane rode a horse or traveled in a carriage, but she may have been pregnant, again, when she made the trip.

Whatever Jane's reservations about leaving her home, there were advantages to moving to Tuckahoe. The house, an H-shaped brick and frame structure with two tall chimneys, was grander than the Jeffersons' Shadwell place, and Tuckahoe was much nearer to her family and friends. There Jane would bear four more children, a daughter, Martha, in 1746; Peter Field, born in 1748, who survived only a month; an unnamed son, born in 1750, who lived but a day; and Lucy, born in 1752.

At Tuckahoe, Peter Jefferson took on the management of a large

20 🧏 THE WOMEN JEFFERSON LOVED

house, enormous landholdings, and scores of enslaved people in addition to his own properties. At least seven Tuckahoe overseers supervised the growing of far more tobacco than Peter grew at Shadwell and his other Albemarle County plantations. This was also the time in their marriage when Peter launched his greatest adventures as a surveyor. In 1746 and again in 1749, he led ambitious mapmaking expeditions commissioned by crown and colony. He headed off into the dense forests and rough terrain, to face rotten weather, wild animals, unruly crews, and hunger bordering sometimes on starvation. On these dangerous excursions he was far out of touch. He left the management of the land and field workers to overseers while Jane looked after her six surviving children and the three young Randolphs, in a household larger than any she had commanded before.

Tuckahoe was not precisely hers to command. She was the wife rather than the husband, and she was not fully the lady of the house. The Jeffersons and their Randolph charges could live in the double-winged mansion almost as two families, with the Jeffersons as resident plantation stewards and caretakers of the Randolph heir-inwaiting and his sisters. Jane had to impose her will on the enslaved people who carried out her commands, some of them brought from Shadwell, others destined to become the property of young master Thomas Mann Randolph, still others newly hired or purchased. Keeping order, preventing or dealing with open defiance, could not have been easy. Or pretty.

BACK HOME AT Shadwell, slaves and hired managers saw to things while the Jeffersons were gone. They moved back permanently to Shadwell in the summer of 1753. The Jeffersons' newly expanded story-and-a-half house had four large rooms and a hall passage on the ground floor, with two bedrooms upstairs, encompassing some 1,600 square feet of living space, along with a large brick cellar below. The house faced the Rivanna on the south, and the "Three-Notched Road," the county's main east-west thoroughfare, to the north. There was a kitchen outbuilding and a house for an enslaved cook and her family, along with quarters for thirty or more slaves. There were fences and gates and vegetable and flower gardens laid out in numbered beds, each row designated by a letter. Peter erected a sundial to track the hours of the day. Shadwell was a busy, orderly, beautiful place. Jane and her children planted hyacinths and narcissus, carnations and marigolds, lilacs and Spanish broom. In the woods, violets and dwarf irises and wild honeysuckle bloomed.

Jane had grown up in a family that owned the latest imported luxuries—French silk and English china and dainty glassware, walnut and cherry furniture and silver flatware, spices for cooking, wine and leather-bound books. The Jeffersons too had such things, entertaining their guests with coffee and tea, punch and wine, rum, Madeira, and cider, and eating their meals on well-set tables spread with damask cloths. Jane's son Thomas would, in later years, become famous for his love of gourmet cuisine and fine wine, of fragrant flowers and fresh vegetables. He learned early and well the delights of the first peas and asparagus and cucumbers of the season, served in refined style at his mother's table.

The Jeffersons sated their appetites with fancy imported goods, but they raised and made and processed all kinds of things on the plantation. The people at Shadwell consumed massive amounts of beef, corn, pork, and wheat, and needed light as well as heat, clothing as well as food. Jane, or her daughters and slaves, brewed beer, and someone at Shadwell made candles, a process that began with the slaughtering of animals and the rendering of fat. There were sheep at Shadwell, and both there and later at Monticello, slave women spun and wove. When Thomas Jefferson moved to Monticello, he sent his mother unwashed wool and picked cotton, so somebody in her household must have been washing and carding and spinning before the time came for knitting stockings or weaving cloth or cutting out clothes.

Jane's daughters took on some of that work. Jane Jr. and Mary were thirteen and twelve when they moved back to Shadwell, easily old enough to work a spinning wheel and handle a pair of knitting needles, and both girls eventually owned wheels of their own. Elizabeth, at eight, would already have shown signs of the mental retardation that kept her a child the rest of her life. Martha, at six, was just beginning to help her mother around the house, though Lucy, still a baby, would have been years away from taking on even small tasks. There would be extra work for the girls in 1755, when their mother gave birth to twins, Anna Scott and Randolph, both of whom may also have suffered brain damage at birth. But Jane also paid small sums to neighbor women for "knitting stockings for the children" and making "negroes clothes." Jane spent her own time on other pursuits.

As the Jefferson children were growing up, Shadwell was on a main east-west route through Virginia. Friends and family lived close enough to visit, but often too far away to go home at night. Entertaining visitors meant feeding and sheltering not only the human guests and the slaves who attended them, but also the horses that brought them and drew their carriages. Thomas Jefferson, later celebrated for his lavish generosity, learned about hospitality from watching his mother welcome people to Shadwell. Generation after generation of Randolph and Jefferson women taught their daughters the occupations of plantation housekeeping and entertaining, and they were not always happy housewives. In fact, Jane's great-granddaughters vocally detested the job, even as they accepted their duty.

Running a plantation house was not simply a matter of making sure the soup was salted and the bed linens aired. Jane, like Randolph and Jefferson women before and after, also showed her daughters how to see themselves as mistresses of enslaved people. She modeled for them the deep habits of distance, haughtiness, and taken-for-granted contempt that made it possible for them to command people they knew intimately—knew, in some cases, all their lives, people whose parents and children they also knew well. To Randolph and Jefferson daughters, the power to command slaves had to seem as natural as the duty to obey their fathers, to defer to their brothers, and ultimately, to rely on their sons.

Jane Jefferson's daughters also learned to read and write, and some of them learned to sing and play instruments, and all of them learned to dance. Thomas and his sister Jane were particularly fond of music, and they played together, he on the violin, she on a spinet. Much later, Jefferson recalled that "I suppose that during at least a dozen years of my life, I played no less than three hours a day." Their literate mother likely took it upon herself to show her children their ABCs, and she and Peter plainly expected that their children would be educated. At Tuckahoe young Thomas Jefferson, and perhaps the girls, had lessons in a one-room house close to the main residence. After the move back to Shadwell, Jane hired a tutor named Benjamin Snead to teach her daughters as well as her younger son, Randolph, though neither he nor his twin sister, Anna, ever progressed much beyond basic literacy. Her elder son, Thomas, of course was another story. Surely he was a curious, quick, remarkably focused little boy. That famously passionate learner was sent out to board with clergymen schoolmasters, starting when he was nine years old. Both Thomas and Randolph had more formal schooling than their sisters, but the Jefferson women were unusually well educated for their time.

Peter and Jane Jefferson were married for eighteen years. While no one can ever really know the inside of a marriage except the two parties to the relation, it seems that they shared a sense of duty, respect for learning, and enjoyment of the fine things of life. Peter's "tastes approached to the elegant, in his own household," wrote Jefferson biographer Henry Randall. "After the wearisome and often stirring events of a day of border life were passed, he spent the evening in reading historians, essayists, and even poets. Addison, Swift and Pope were prime favorites with him—but Shakespeare was his great favorite!"

Together they brought the trappings of gentility to a frontier town, raised a family, commanded slaves and ran a plantation, and established their place as Virginia gentry. Peter might be often absent but Jane could be confident he would do all he could to provide for her and the children. She, in turn, tried to make Peter's home a welcoming place, where children knew their duty and their manners and the wife did all she could to please him.

PETER WAS FIFTY years old, and Jane was thirty-seven, when he died on August 17, 1757, of some unknown illness. He had written his will a month earlier, and appointed a high-powered team of executors. He was buried at Shadwell; preaching the funeral sermon was the Reverend James Maury, who was an Episcopal clergyman and Thomas Jefferson's tutor. Peter had been a pillar of his community, a vestryman and public officeholder, planter and surveyor, slaveholder and family man. His death was an event not only for his family, but for all the people who worked for and with him, for myriad friends and acquaintances and allies, people who owed him money and some sixty people whom he himself owned. But the person most affected was the woman with whom he also shared the blessing of affection. Peter's will referred to Jane as his "Dear & Well beloved Wife," and he did everything he could to provide for her after his death.

We can only begin to imagine the distress and confusion that beset Jane Jefferson when her husband died. During their years of marriage, Peter kept the books and ran the farms and managed their business dealings, from transactions with neighbors to transatlantic commerce. Jane took care of the household and children. While he and Jane were certainly partners in running a successful plantation and raising a family, neither of them expected Jane to deal with financial matters. Peter chose his friends and neighbors, Dr. Thomas Walker and John Harvie, as his executors. They assumed the management of his estate for seven years, until Thomas, his firstborn son and principal heir, turned twenty-one.

Some widows of Jane's time and place welcomed the challenge of running their own affairs and flourished as they took control over people, land, and intricate questions of business. Jane's own father, Isham Randolph, had trusted his widow enough to make her the executor of his estate. But Jane Jefferson had never had much to do with her husband's business. There is not one scratch of her handwriting in her husband's account book, not a line penned to her son Thomas about business affairs when he finally took over, assuming responsibility for his younger siblings as well as his mother. Instead, with eight children between the ages of two and seventeen and a complicated household to run, Jane left the management of thousands of acres and dozens of people to her late husband's executors. She assumed that they would be honest and competent, manage her lands and slaves, and pay the bills she ran up with local merchants. Eventually she would apply not to John Harvie or Thomas Walker for her pocket money, but would instead rely on her eldest son to make sure that her credit with shopkeepers was good.

In many regards, she was a lucky woman. Peter Jefferson had left her with a prosperous and beautiful place to live, without the worry of pressing debt, and with children mature and loving enough to offer her some support. But losing her husband left her brokenhearted. We can hear a whisper of Jane's grief in a letter written nearly fifty years after the death of Peter Jefferson, by Thomas Jefferson. His volatile son-in-law, Thomas Mann Randolph, Jr., was quarreling with his even more unstable cousin, John Randolph of Roanoke, and Jefferson feared that a duel was imminent. Terrified that his daughter Patsy might be left a widow, the aging Thomas Jefferson tried to talk some sense into her hotheaded husband. Jefferson's letter to Tom Randolph echoed Jane's deep sorrow and helplessness, and Thomas Jefferson's own earliest pain. The son had revered his father's strength, his regard for learning, his devotion to his farm and family. He too was crushed by the loss, but his words, so many years later, carried loving echoes of his mother's devastation, and of the effect of her loss on her children, as he compared his son-in-law's situation to that of the bachelor John Randolph:

How different is the stake which you two would bring into the field! On his side, unentangled in the affections of the world, a single life, of no value to himself or others, on yours, yourself, a wife, and a family of children, all depending for their happiness and protection in this world on you alone. Should they lose you, my care for them, a poor substitute at my time, could continue, by the course of nature, but for a short time. Seven children, all under the age of discretion and down to infancy could then be left without guide or guardian but a poor brokenhearted woman, doomed herself to misery the rest of her life. And should her frail frame sink under it, what is then to become of them? Is it possible that your duties to these dear objects can weigh more lightly than those to a gladiator?

If Jane Jefferson was "a poor broken-hearted woman, doomed herself to misery the rest of her life," she was fortunate that Peter had left his affairs in good order. At the time of his death, he was one of the wealthiest men in Albemarle County, the second-largest slaveholder

in the county. Unlike many Virginia planters, he left no debt. Thus Jane was spared the fate of so many widows who were plunged into poverty by their husbands' unpaid obligations, or cheated by unscrupulous trustees, or left destitute by their sons' profligate ways. There was money enough to see to her sons' education, boarding with schoolmasters and then at the College of William and Mary. There were funds for furniture and household supplies, gloves and jewelry and silk corsets for the girls, dancing lessons for all the children. The widow Jefferson's life of hosting kin and friends, commanding her servants, looking after her children, shopping and paying visits of her own, continued amid joy and pain. This woman who had crossed an ocean and lived in half a dozen houses, borne ten children, buried two of her babies, cared for a mentally disabled daughter, and managed two households and dozens of people had remarkable power to endure. But in the years to come it must have seemed to Jane Jefferson that for every life that came into her world, someone she loved was torn away.

The Widow Jefferson

3

THE DEATH OF a father can shatter a family. Under the best of circumstances, the survivors, like planets searching for a new sun, shift in their orbits, exerting the pull of gravity on one another, searching for a new solar center. In the wake of Peter's death, Jane had to maintain stability at Shadwell without actually taking command. As a new widow she was entitled to inherit one-third of the people her husband had owned. She had hard and fateful choices to make. Even if she wanted to keep enslaved parents and children together, Peter Jefferson's will bequeathed certain slave children to the Jefferson children. Jane's family was entwined with the families of the slaves she chose.

Jane owned a woman named Sall, whose children served the Jefferson children. Ever since Thomas had been a small child, he had been attended by Sall's son, Jupiter, a boy his own age. One of Sall's daughters was assigned to wait on Thomas's older sister, Mary. Jane decided to claim thirty-five-year-old Sall herself, along with her son, Caesar, and two of her other daughters, Lucinda and "Little Salley," who would look after Jane's mentally challenged daughter, Elizabeth Jefferson. Jane also claimed a number of other people, including a baby named Fanny, though she did not claim Fanny's mother, a twenty-five-year-old woman named Myrtilla, who took care of the younger Jefferson children. Myrtilla would be inherited by Thomas Jefferson when he came of age, and she may have been the first person Thomas Jefferson ever sold.

HOWEVER SHE GRIEVED, the widowed Jane Jefferson ran a household bursting with daughters and sons and relatives and guests. In time the place was once again alive with music and warm with the aromas of good food. Jane and her children enjoyed a quality of life impossible without the work of enslaved people who did everything from cultivating tobacco to churning butter, from scrubbing out chamber pots to dressing her daughters' hair. Jane likewise visited family and friends on other plantations, traveling in a carriage or by horseback, enjoying the hospitality that the Virginia gentry took for granted. She did what she could to re-create the comfort in which she had grown up at Dungeness, even if on a less grandiose scale.

On April 13, 1764, when Thomas Jefferson turned twenty-one, he assumed command of everything at Shadwell and Peter Jefferson's other properties. Thomas was then studying the law in Williamsburg, where he had spent much of his time since he'd enrolled at William and Mary in 1760. He would be frequently at the colonial capital, or on the road, practicing his profession. But busy as he was, he began to take over the family accounts from trustee John Harvie, to manage his mother's and sisters' spending, and to pay attention to goings-on at Shadwell. He made a point of being home often enough to notice when the flowers in the woods began to bloom. He took time to plant his garden and enjoy its bounty.

Thomas Jefferson recorded his delight in his mother's home in the earliest jottings in the "garden book" that he would keep for more than half a century. He wrote the famously exuberant first line of that book, "Purple hyacinth begins to bloom," not at Monticello, but at Shadwell, in 1766. He and his sisters helped out in their mother's garden, as slaves like young Caesar no doubt also did, and there they grew a wondrous variety of vegetables and fruits for the table: peas and asparagus, celery and onions, radishes, lettuce, broccoli and cauliflower, cucumbers, gooseberries, and tiny luscious strawberries (Thomas noted, "100 fill half a pint"). The Shadwell garden produced a profusion of fragrant and showy flowers: narcissus and various "flags" (irises), carnations, Indian pinks, marigolds, globe amaranth, Dutch violets, lunaria, sweet William, hollyhocks, larkspurs, snapdragons, poppies, lychnis, and "a flower like the Prince's feather, Lathyrus."

As Jane tended her garden and rebuilt her life among her children and in the midst of her families of slaves, the Jefferson children began hiving off. They would be lucky to have as good a marriage as their parents had, solid as oak, respectable as a family portrait, and with enough warmth to produce children who danced and sang. Judging from the few of his early letters that remain, Thomas Jefferson, as a boy and a young man, was as high-spirited as he was scholarly, as sociable as he was brilliant, thrilled by the fascinating variety of the world. Sorrow and betrayal would layer reserve and caution over that youthful buoyancy, but nearly to the end of his life he never lost the capacity for delight. That gift sustained him through setbacks and heartbreaks, and no one has it late in life if it is not nurtured early.

Jane's children learned to look to marriage as a source of happiness. But not all were destined to enjoy wedded bliss. Three years after Peter's death, Jane's second daughter, eighteen-year-old Mary, wed John Bolling, a planter and gentleman and a very likely prospect. The Bolling family, long-standing friends of Jane's parents, had lands near Dungeness in Goochland County, and Mary and her husband set up housekeeping at Fairfields, halfway between Richmond and Charlottesville. Peter Jefferson bequeathed Mary a marriage "fortune" of two hundred pounds and an enslaved woman named Nan. In 1766, Jane would separate Myrtilla from her daughter Fanny, a girl of perhaps six years of age, giving the child to Mary Bolling "In & of consideration of the Natural love & affection which I have and so bear unto my Daughter." Mary Jefferson Bolling kept in close touch with her mother and sisters. She returned when she could to Shadwell to visit. She and her husband buried a child there and planted cedars by the grave. After Jane's death, Mary's little sister, Anna Scott Jefferson (nicknamed Nancy), went to live with the Bollings in the years before her own marriage.

The Bollings' forty years of marriage yielded nine children, but also considerable misery for Mary. She endured the deaths of children, and John sank ever deeper into alcoholism. For a time they were separated, and in her increasing unhappiness, Mary relied on her family and friends, her brothers and sisters and their children, and took a keen interest in their lives.

By contrast, Martha, the second of Jane's daughters to marry, did indeed find harmony with her husband, making a match that delighted her family. On July 20, 1765, nineteen-year-old Martha married Dabney Carr, Thomas Jefferson's best friend, a promising lawyer soon to be elected to the Virginia House of Burgesses. Biographer Henry Randall offered a highly sentimental portrait of the attachment between the two young men, "inseparable companions, [who] read, studied, took their exercise, practiced their music, and formed their plans together. They daily repaired to an oak near the summit of the Monticello . . . where they had constructed themselves a rustic seat, and here, in the deep woods, far away from the sight and hearing of man, they together pored over Bracton, Coke, and Matthew Bacon; read their miscellaneous reading; discussed the present, and painted the glowing visions of the future."

Dabney and Martha Carr moved to a modest house at Spring

Forest in Goochland County, where Martha followed in the footsteps of her prodigious mother and grandmother, bearing six children in eight years. When Thomas Jefferson visited the Carrs in 1770, he found them in humble but cheerful circumstances, writing to his friend John Page, "This friend of ours, Page, in a very small house, with a table, half a dozen chairs, and one or two servants, is the happiest man in the universe."

With the household at Shadwell now reduced by two daughters, tragedy soon took a third. Thomas's older sister Jane, age twenty-five, died on October 1, 1765. We know nothing of the circumstances of her death. This young woman, revered in family lore as "the pride and ornament of her house," was remembered as "her brother's constant companion when at home, and the confidant of all his youthful feelings." She lived long in Thomas Jefferson's memory. He told his grandchildren that he had regarded his sister Jane as "fully his own equal in understanding, and there was a depth, earnestness, purity and simplicity in her high nature which made an impression on his mind which was never effaced." According to Randall:

More than half a century afterwards he continued to occasionally speak of her to his grand-daughters in terms of as warm admiration and love as if the grave had just closed on her. It was listening to church music that oftenest struck the chord of these memories. She had been a singer of uncommon skill and sweetness, and both were particularly fond of the solemn music used by the Church of England in the Psalms. . . . His sister Jane excelled in this description of music, to the execution of which she brought the fervor of a deep religious devotion; and many a winter evening, round the family fireside, and many a soft summer twilight, on the wooded banks of the Rivanna, heard their voices, accompanied by the notes of his violin, thus ascending together.

Young Jane Jefferson left behind an impressive estate for a woman, including three slaves, furniture and bedding, a saddle and riding chair, trunks, a spinning wheel, a fashionable wardrobe, jewelry, and books. Still unmarried at the time of her death, she remained forever a daughter and a sister, never a wife. Her family missed her. In December 1771, Thomas made plans for the picturesque cemetery he envisioned at Monticello, a landscape "among antient and venerable oaks, intersperse some gloomy evergreens," with a small Gothic temple at the center of a spiral path, and "in the middle of the temple an altar, the sides of turf, the top a plain stone. Very little light, perhaps none at all save only the feeble ray of an half extinguished lamp." He was considering having her body disinterred from the burial ground at his mother's home and moved to a new resting place, and he wrote an epitaph for her tombstone: "Jane Jefferson. Ah, Joanna, best of girls. Ah, torn away from the bloom of vigorous age. May the earth be light upon you. Farewell, forever and ever."

A fourth Jefferson daughter left the household in 1769. Lucy, then sixteen, married her first cousin, Charles Lilburn Lewis, son of Jane's sister Mary and her husband, Charles Lewis. The couple moved to Buck Island, Lewis's plantation a few miles from Shadwell. While Jane surely approved of her new son-in-law's breeding, Charles Lewis proved a bad businessman. When he fell deep into debt, the Lewises moved to Kentucky in search of better luck.

Young Virginia gentlemen, like their English counterparts, commonly left home early to go to school, and Thomas Jefferson had been sent away to board with his tutor at the age of nine. The experience put him at some emotional as well as physical distance from Shadwell, but the boy who loved the deep woods and the sight and smell of his mother's gardens, who revered his father and sang with his sister, was surely sometimes lonely and homesick. Jane too must have missed her absent children. The only Jeffersons remaining at

34 🎽 THE WOMEN JEFFERSON LOVED

Shadwell by the beginning of 1770 were Jane herself, her twenty-fiveyear-old, developmentally disabled daughter, Elizabeth, and fifteenyear-old twins Randolph and Anna Scott. Still, the other children returned often, for days or weeks at a time. On one of Thomas's visits home, the world Jane had so painstakingly nurtured at Shadwell went up in smoke.

NO ONE KNOWS how the fire started. Thomas Jefferson and his mother were away from home, "on a visit to a neighbor," Thomas wrote. It was February, and there would have been need for many fires, islands of warmth against winter's deep chill. Cooking fires, heating fires, the fires of everyday life could burst, in a flash, into fires of tragedy. Such things were common in those days—a stray spark from a neglected hearth, a chimney not cleaned, carelessness, or happenstance.

Or malice. Every master or mistress knew the lurking danger. Even those slaveholders who tried to avoid violence, who hoped to manage their houses and fields with humanity and persuasion, relied in the end on the whip. The weak had their weapons, from sulking to sabotage, spoiled porridge to poison, costly accident to careful destruction. Jane Jefferson had grown up with the ever-present fear of conspiracies and revolts. Every planter prayed the day would never come when smoldering resentment would burst into flaming rebellion.

Nobody suggested that the fire that destroyed Jane Jefferson's house at Shadwell plantation on February 1, 1770, was set deliberately. Those who left the written records were not there to witness the first flames. One account, set down many years later, blamed "the alarm and confusion of the slaves" for the great destruction. Some of the slaves did what they could to save a bed here, a few books there. An enslaved man rescued Thomas Jefferson's violin and presented the instrument with poignant pride to the young master. The house and nearly everything in it was burned, so whatever was salvaged must have held special significance, then and thereafter. Perhaps saving the violin came with a reward, and that was why, on that day, twenty-sixyear-old Thomas paid three shillings and sixpence to a man named "old Toby," a member of the Shadwell household since before the death of Peter Jefferson, Thomas's father, in 1757.

One other longtime member of the household at Shadwell made an appearance in Thomas Jefferson's accounts for that terrible week, but not to claim a reward. Myrtilla had been a Jefferson slave since his father's time. Four days after the fire, on February 5, Thomas Jefferson quietly sold Myrtilla to Benjamin Moore, a man who appeared in Jefferson's voluminous financial memoranda only this once, in connection with the purchase of this woman. We know nothing else about Benjamin Moore: who he was, where he lived, why he wanted to buy Myrtilla, why Thomas Jefferson saw fit to sell her. As far as the records tell us, no other person serving in the house at Shadwell had ever been sold by Thomas Jefferson.

Thomas mourned the loss of his papers and his precious law books. He had plans to build his own place, three miles distant, across the river, on a mountaintop, and now he wanted to get a house built as soon as possible. He left no hint of his feelings toward the crushing loss borne by his mother, or the fate or emotions of the siblings still at home under Jane's care. The Shadwell fire was the crucible of Thomas Jefferson's passage into manhood, the disaster that gave his Monticello project an urgency beyond hopes and dreams. That same event was a catastrophe for those who remained to sort through the ashes.

Jane lost the gracious home she'd created with her husband, Peter, the house in which she'd raised her children and welcomed family, neighbors, friends, and connections, the center and the compass of her life and world for nearly twenty years. There she had journeyed

36 🎇 THE WOMEN JEFFERSON LOVED

as a bride, birthed babies, commanded dozens of servants, fed and sheltered multitudes of guests and relations. A week before her fiftieth birthday, she was homeless, with three of her ten children still to care for and dozens of slaves still under her supervision.

The fire also threatened the security of Shadwell slaves. Peter Jefferson, and later his executors and heir, had run Peter's plantations on a sound financial basis. But the institution of slavery guaranteed neither ease nor safety for those in its thrall. After the fire, or perhaps shortly before, a slave woman named Hannah left the Shadwell household. Like Myrtilla, Hannah had a daughter named Fan. They had all belonged to Peter Jefferson at the time of his death, and they may have been related by blood. Hannah and her daughter were sent from Shadwell to Snowdon, a plantation on the Fluvanna River set aside as an inheritance for Randolph Jefferson, only fourteen years old at the time and far from ready to take control of his legacy.

Sometime in 1770, a man named Isaac Bates was hired as overseer at Snowdon, and early in his tenure there he beat a slave named Hannah to death. We can't be certain whether the Hannah who left Shadwell for Snowdon and the woman murdered by Isaac Bates were one and the same, but everyone on the Jefferson holdings, slave and free, would have known about this terrible event.

All we have are the cold traces of business that followed this murder, in Thomas Jefferson's words, "by a cruel whipping." Thomas, acting on behalf of his minor brother, sought Bates's arrest and sued the murderer for compensation for Randolph's financial loss. Jane Jefferson also did what she could to make up for Hannah's death. In the wake of the murder, Jane gave Randolph a two-year-old girl named Rachel, daughter of the woman who took care of Elizabeth Jefferson. Jane showed her affection for her own children by separating the mothers and children who worked as her slaves.

*

WHILE THE SITE of the Shadwell house was cleared of charred debris and prepared for the building of a new, smaller dwelling for Jane and her children, the mistress made do. Randolph could be sent off to live with relatives until he left for the College of William and Mary in October 1771. Jane and Elizabeth and Anna, and the slave women who attended them, took refuge in an overseer's house. They could visit cousins or go to stay with Jane's married daughters at their homes not far away. Her son Thomas, closest at hand of all her children, was just a couple of miles away and across the river, building his house, planting his gardens, and courting a widow while also assuming command of the family's farms and business affairs.

*

Jane no longer needed as many slaves to see to the needs of her children, and just as the fire destroyed walls and timbers, furniture and linens and books and countless letters and cherished keepsakes, so it may have gutted her desire to keep house in the grand manner. To re-create the capacious Shadwell household would take an enormous effort on her part, not to mention the help of children who were busy with plantations and families of their own. Perhaps that was why she began to send off the women who had served in her house, why little Fanny, Myrtilla's child, was sent to the Bollings at Fairfields, why Thomas removed Hannah and Fan to the horror at Snowdon, why Myrtilla was sold while the embers of Shadwell still smoldered. With Thomas moving up onto the mountain, Jane remained responsible for Elizabeth, still a child at age twenty-six, and the twins, still minors. But her life at the center of a social universe was slipping into the mist of memory.

The Revolutionary's Mother

4

ON A SEPTEMBER day in 1772, Jane Randolph Jefferson took up a handsome Bible, probably a replacement for a cherished book lost in the great fire, and began to set down her family history. On the page facing the title page, she wrote "Jane Jefferson Her Booke" and the date. Then she noted the dates and locations of the births of each of her children with Peter Jefferson, the deaths of two of those children, along with the date of Peter's death, "Wednesday 17th Aug: 1757." In this careful, spare inscription, the only known vestige of her handwriting apart from her will, Jane rebuilt her world; she ordered and memorialized the family that was her life.

Jane had spent more than thirty years making a home for her family. But now the center of that family was shifting across the river and up the mountain, to a place only just cleared and planted, only just becoming the site of a small brick house, the seat of a plantation grandly and romantically called Monticello. Thomas had courted a young widow, Martha Wayles Skelton, daughter of a rich lawyer-planter in Charles City County and already the mother of a young son. Thomas and Martha had married on New Year's Day, 1772, at Martha's father's house. Now she would occupy Thomas Jefferson's heart and his home, even as his public life, and momentous events of the day, began to claim more and more of his time, his talent, and his genius. Martha would soon inherit a fortune in land and slaves, along with a mountain of debt, and she and Thomas would begin to build their own family. Perhaps it was the impending birth of their first child, daughter Martha, born on September 27, 1772, that inspired Jane to write down her own family's history.

But if Jane Jefferson began to feel marginal in her children's lives, they still returned home to visit and continued to rely on her in their own times of need. In May 1773, Jane's daughter Martha Jefferson Carr came back to Shadwell to give birth to her sixth child in the small house built for Jane on the site of the home she had lost. Martha's husband, Dabney, had been elected to the Virginia House of Burgesses, and since he was expected back in Williamsburg, it seemed best that his wife go to her mother's place to have her baby. Only a month before, Dabney Carr had launched his career in Virginia politics with a triumphant speech in the House of Burgesses, introducing resolutions that established Virginia's Committee of Correspondence. At a time when Virginia politicians were joining their Massachusetts brethren in stirring up the growing unrest in the colonies, it looked as if Dabney Carr, not yet thirty years old, would take a leading role.

Martha had her baby, a son named Dabney Jr. The baby's father stayed at Shadwell for the birth, then set out on horseback to return to Williamsburg. Not far from Shadwell, Carr was suddenly stricken with "a bilious fever," possibly typhoid. He was brought back to Shadwell, where Dr. George Gilmer, favorite physician of the family at Shadwell, did what he could to save him. But to no avail. On May 16, after a short, violent illness, Dabney Carr, Sr., died.

In her later years, as a cherished aunt to Thomas Jefferson's children and grandchildren, Martha Jefferson Carr impressed at least one young relative as "a woman of vigorous understanding and earnest warmth of heart." But weak and sick after giving birth, and now newly widowed, Martha Carr, family legend had it, nearly went crazy. According to Henry Randall,

Carr's sudden death fell with stunning force on his wife. She was ill, from recent confinement, when her husband set out on his last journey, and her mind was perhaps therefore filled with the most gloomy presentiments concerning him. After her last farewell, she again raised herself on her sick couch, to catch a parting glimpse of him as he rode past her window; but she saw merely his moving hat. This object took strong hold of an imagination rendered morbid by disease, and soon to be fearfully excited by an almost despairing grief. For weeks and months, whether in the blaze of noon-day or in the darkness of night, the moving, phantomy hat was ever passing before her eye. For a period, reason tottered on its throne.

With Thomas away in Williamsburg, dividing his time between the legislature and his own mortally ill father-in-law, Jane Jefferson was left to cope with birth, death, her daughter's wild bereavement, her own loss, and not least, her six Carr grandchildren. The steamy heat of a Virginia summer was already coming on; as Thomas Jefferson noted, a week later in his Garden Book, "this spring is remarkably forward." Given the weather and the virulence of Carr's final illness, Jane had good reason to worry that whatever had killed him might spread like fire among the people at Shadwell. And so those who mourned him settled on a quick funeral. Dabney Carr was laid to rest in the Shadwell burying ground.

Thomas's return to Albemarle County brought a fresh round of frantic grief as he claimed the power and the status of the family patriarch, possessor of the right to determine not only the fate of the living, but also the disposition of the dead. Thomas insisted that his brother-in-law's body be dug up and moved, to be reburied up on the mountain, under the oaks where he and Dabney had so often read and talked. Jefferson distanced himself from his sorrow, and that of his mother and widowed sister, in a way that would become a hallmark of his character. He turned an emotional event into a mathematics problem: "2 hands grubbed the Grave yard 80 f. sq. = 1/7 of an acre in 3 ½ hours, so that one would have done it in 7. hours, and would grub an acre in 49 hours = 4 days." Thomas made his notes as he watched two enslaved men laboring in the spring heat to clear his Monticello cemetery. Neither he nor anyone else left a record of his mother's or his sister's reaction to his appropriation of Dabney Carr's body, or for that matter, any hint of the thoughts or feelings of the men who dug Carr's second grave. This was the first burial in the new Monticello cemetery.

Thomas Jefferson composed an epitaph for his brother-in-law that reflected Dabney Carr's immersion in the Shadwell family as much as it recorded Thomas's own desolation:

HERE LIE THE REMAINS OF

DABNEY CARR

Son of John and Jane Carr, of Louisa County,

Who was born-, 1744.

Intermarried with Martha Jefferson, daughter of Peter

And Jane Jefferson, 1765; And died at Charlottesville, May 16, 1773, Leaving six small children.

To his Virtue, Good Sense, Learning and Friendship This stone is dedicated by Thomas Jefferson, who, of all men living, loved him most.

42 🧚 THE WOMEN JEFFERSON LOVED

Perhaps the death of Dabney Carr precipitated Jane's fears about her own mortality. Or maybe those thoughts were merely the product of an aging body and the health problems that pile up as time passes. Sometime in 1772 or 1773, Jane wrote her will, making bequests to her unmarried children: slaves for Anna and Randolph, and for Elizabeth a bed and some of Jane's clothes. By this time Jane had come to rely utterly on Thomas's stewardship of her affairs. Dr. Gilmer paid dozens of visits to Shadwell, and Jefferson paid the doctor's fees and settled her accounts of all kinds. Local storekeepers applied to him when she charged things, and he handled matters when she wanted to buy or sell animals. Thomas kept careful track of his expenses on her behalf, and as the years passed, it became clearer and clearer that she had no way to repay him. So in September 1773, in return for his assumption of all her debts, she handed over to him her only property of value, the deeds to her remaining slaves.

The Reverend Charles Clay, Episcopal minister, ardent patriot, and lifelong friend of Thomas Jefferson, had preached Dabney Carr's funeral service, and was paid forty shillings (two pounds) for his efforts. The following year, the Reverend Clay would perform another sad office for Jane Jefferson's family. On February 21, 1774, at 2:11 in the afternoon, the first recorded earthquake in Virginia history "shook the houses so sensibly that every body run out of doors." Two aftershocks followed. Sometime shortly after the tremors, Elizabeth Jefferson and her maid, Little Sall, who was sister to Thomas's slave Jupiter, attempted to cross the Rivanna in a skiff, trying to get to Thomas's place on the other shore. The river was running high; by March 6, the Rivanna would be in flood, eighteen inches "higher than the one which carried N. Lewis's bridge away . . . the highest ever known except the great fresh in May 1771."

On March 1, Thomas wrote sorrowfully, "My sister Elizabeth was

found last Thursday being Feb. 24." Elizabeth and Little Sall had drowned in the Rivanna. Thomas made no mention of the death of the enslaved woman he had known for most of his life, sister of the man who attended to his daily needs and cared for his horses and drove his carriage, the woman who looked after the Jefferson sister who could not take care of herself. Neither Elizabeth nor Sall was buried at Monticello, so we may assume that their bodies were taken back to Shadwell, to be buried by their grieving mothers and remaining brothers and sisters. Jane Jefferson had now outlived her husband and four of her children.

THE FINAL YEARS of Jane's life were anything but peaceful. As she coped with the changes and losses in her family, a larger revolution gathered. Her son eagerly joined and then led the insurgency in Virginia, on his way up the ladder of risk and fame and notoriety and greatness. When Thomas Jefferson and Dabney Carr had plotted to establish Virginia's Committee of Correspondence in 1773, the royal governor, John Murray, Fourth Earl of Dunmore, responded by proroguing the House of Burgesses—in essence, suspending the assembly, which did not meet again until May 1774. By that time some Bostonians had made their famous protest against the tea tax, and the British had declared the port of Boston closed. Thirty-one-year-old Thomas Jefferson wasn't much for making speeches, but he labored behind the scenes and began to establish himself as a clear, bold, and inspiring writer on behalf of the patriot cause.

Amid rising political tensions, life at Shadwell and Monticello went on pretty much as usual. Thomas continued to manage his family's affairs, now including his sisters' estates and his wife's inheritance. But he was becoming ever more involved in political controversy. Lord Dunmore refused to permit the House of Burgesses to

43

44 🧩 THE WOMEN JEFFERSON LOVED

meet, but the rebellious Virginians determined to assemble anyway. Thomas Jefferson headed off to Williamsburg to attend that meeting, but on the way suffered an attack of dysentery and was forced to turn back. He nonetheless sent to Williamsburg, probably in the hands of Jupiter, his draft of resolutions he hoped the Virginia delegates would present in Philadelphia. That document would shortly be published as a pamphlet, *A Summary View of the Rights of British America*, setting out some of the ideas he would present in the Declaration of Independence and catapulting Thomas Jefferson to the forefront of philosophers and propagandists of the revolutionary cause.

What was a mother to think, as her son and his compatriots tacked toward treason? Jane Randolph Jefferson had been born in England and reared among British gentry in Virginia. She valued the fine things connected with the mother country. She still had family in England, and even those who agitated for change in the colonies' status considered themselves, as the title of Thomas's pamphlet suggested, British Americans. Jane was long accustomed to the men of her family taking leading roles in public life; her father and husband, her son and sonsin-law all sat in the House of Burgesses. In ordinary times her men might hold any number of bold ideas or unconventional philosophical leanings, but such notions would have fewer real consequences.

These were extraordinary times. British colonies that had once dealt with one another chiefly through the mother country had begun to communicate, and to plot their responses to British policies. Now Thomas Jefferson was elected a delegate from Virginia to a Second Continental Congress. As he set out for Philadelphia in June 1775, to take up an office that kept him far distant from his family for months on end in a fetid and unhealthy city, he courted the fury of an empire.

Jane Jefferson may never have sensed greatness in her elder son. She knew, early on, that Thomas was uncommonly bright, devoted to his books and his music with a rare discipline. She saw his passionate curiosity, his ardor for planning and calculating, planting and building. Certainly she could see the vast differences between Thomas and her younger son, Randolph, who had scraped by at William and Mary for a year and a half before returning to Albemarle, to take up life as a Piedmont planter, a man of humble accomplishments, rudimentary learning, and little ambition. In the course of his life Randolph would be a man who stayed close to home, tending his tobacco, hunting with his dogs, living down a road he could never get around to repairing, failing even to make it to his sister's funeral at Monticello, twenty miles away. Even during Jane's lifetime, Thomas was a different story. She knew well her eldest son's devotion to family duty, the daily responsibilities he recorded in meticulously detailed memorandum books. But Jane's father, Isham Randolph, and her husband, Peter Jefferson, had likewise been learned, civic-minded, family men and community leaders, eminent Virginians in their time.

There was something different about Thomas Jefferson. He and his colleagues, propelled by the greatest political crisis in the history of the British colonies in North America, were committing sedition and contemplating revolution. If Jane was proud of Thomas's achievements, surely she was also terrified at the thought of seeing her son with a noose around his neck.

The wrath of the English authorities was not the only force to be feared. All over Virginia, people wondered whether so much talk of liberty would incite the enslaved to rise up and seize their own freedom. Now, as white Virginians began to gather up arms and organize militias, Lord Dunmore considered encouraging slaves to rebel against their masters. In November 1775, Dunmore issued a proclamation declaring the colony to be in a state of rebellion. He instituted martial law and offered freedom to all slaves willing to take up arms and fight for the British.

Thomas Jefferson, then in Philadelphia, heard of Dunmore's

46 🎇 THE WOMEN JEFFERSON LOVED

actions from Robert Carter Nicholas, who had written a letter to Virginia's delegates in Congress. Nicholas captured the terror that Dunmore's order struck in the hearts of slaveholding Virginians:

A few Days since was handed to us from Norfolk Ld. D's [Dunmore's] infamous Proclamation, declaring the Law martial in force throughout this Colony and offering Freedom to such of our Slaves, as would join him . . . great Number's have flocked to L.D's Standard. The Tories of Norfolk are said to be the Ringleaders; many of our Natives it is said have been intimidated and compeld to join them and great Numbers of Slaves from different Quarters have graced their Corps. The Tenders are plying up the Rivers, plundering Plantations and using every art to seduce the Negroes. The Person of no Man in the Colony is safe, when marked out as an Object of their Vengeance; unless he is immediately under the Protection of our little Army. They have many Prisoners of different Classes; . . . No Country ever required greater Exertions of Wisdom than ours does at present. . . .

The Jefferson family endeavored to make at least some effort to keep slave families together, to provide decent food and clothing and medical treatment. But the murder of Hannah at Snowdon unmasked the bloody force underlying domestic tranquility on the Jeffersons' lands. Slaves and slaveholders alike knew that not far beneath the surface of plantation life lurked resentment at enforced labor, the dull and menacing hum of simmering violence. Across the South, severe slave codes testified to the planters' fears. The widow Jane Jefferson had grown up, come of age, and grown old amid the brutalities of slavery: the petty indignities, mundane mortifications, and extreme cruelties, from her father's execution of her uncle's slaves to her son's overseer's vicious killing of a slave woman. Jane would not live to see a crime even more horrendous. In 1811, Jane's grandsons, Isham and Lilburne Lewis, "literally chopped a Negro slave to pieces."

How loyal were the Jefferson family slaves to their owners? We will never know for certain why Myrtilla, a longtime member of Jane's household, was sold so soon after the Shadwell fire. Two years earlier, Thomas Jefferson had trusted Myrtilla enough to have given her and a farm laborer named Harry, possibly Myrtilla's husband, an "order on R. Harvie for goods to 16/6." Six years later, in 1781, the year in which Governor Thomas Jefferson would see British soldiers rampaging across Virginia and occupying his very home, more than thirty of the people he owned left to join the British. Among them would be Harry, who had been a Jefferson slave for at least twentyfour years.

JANE JEFFERSON LIVED out her last months amid the building fear and carnage of war, though she would not survive to see the creation of a new nation. She died on March 31, 1776. She may have been in failing health for some time, since Thomas made many payments to doctors on her behalf, and he and Martha may have brought his aging mother up to Monticello for nursing. Still, the end came more suddenly than anyone expected. As Thomas wrote to his mother's brother, William Randolph, Jane had died "after an illness of not more than an hour," after what Jefferson called an apoplexy-a stroke. According to the inscription on her tombstone, she died at Monticello and was buried there. Jane was survived by four daughters and two sons, numerous grandchildren, dozens of enslaved people, and a wide community of family, friends, and acquaintances in Albemarle County, across Virginia, across the ocean in England. Once again the Reverend Charles Clay preached a funeral service for the Jefferson family, the third in three years. Following her death, Thomas Jefferson suffered a migraine headache that lasted some six weeks.

48 🧏 THE WOMEN JEFFERSON LOVED

Relationships between parents and children are never simple, and the warmest attachments have their chilly moments. Even among those who remain in intimate circumstances, grown children's feelings toward their parents are seldom easy. From all we can tell, Jane Jefferson had stayed close to her children, though she had sent her precocious oldest boy away for his schooling at an early age. We should certainly assume that as in all families, there were edgy times. Whatever the conflicts, Jane's children relied on her, just as she depended upon them. Mary buried a child at Shadwell; Martha returned there to bear a son and mourn a husband; Lucy married Jane's sister's son, and Randolph would eventually marry a daughter of that same sister. If Thomas was often away from Shadwell, he nonetheless lived in his mother's house longer than any of his siblings except the afflicted Elizabeth. He built his dream estate on lands that adjoined his mother's place, though he could have chosen more distant properties he had inherited, or for that matter, could have moved to one of the lovely and productive plantations his wife had inherited from her father. Duty bound the Jefferson family together, and the love between Jane Jefferson and her children was deeply rooted in their mutual pledges, of parental care and filial loyalty. There was as much affection as obligation in the mix, as the family's memory of her, preserved by her great-granddaughter Ellen Randolph Coolidge, and her great-greatgranddaughter, Sarah Nicholas Randolph, suggest.

We have no letters between Jane and her children to help us understand what passed between mother and children, how they felt about her or she about them. The Shadwell fire of 1770 consumed nearly everything that might give us a glimpse inside those relationships. If family lore that she was a great letter writer holds any truth at all, we may assume that she wrote to her daughters when they were away, sometimes only a few miles away at their own houses, or slightly farther, visiting friends and relations. Jane likely sent letters to her son while he was in Williamsburg and possibly in Philadelphia, and if Thomas's later performance as a letter writer for the ages is any indication, he wrote back. In the years after 1770, their letters may have been less frequent, partly because they lived in proximity much of the time, but also because Thomas Jefferson would marry and focus more on his wife than his mother.

One way or another, no trace of correspondence between them remains, lost through careless or deliberate destruction by one or the other party, perhaps in the throes of grief. Or maybe, at least in the 1770s, there was just not much there in the first place.

Some historians have made a leap of logic from the absence of documents to insist that the most famous of Jane Jefferson's children did not write to her, or chose to destroy his letters, out of a desire to obliterate her influence on his life. They have concluded that the everscribbling Thomas Jefferson disliked his mother. Vaulting beyond Sherlock Holmes, who deduced the solution to the mystery by noticing the dog that didn't bark, these scholars presume that the lack of surviving letters implies a want of affection between Jane and her celebrated son. If that were true, we ought to have dozens and dozens of letters between Jefferson and his adored wife, Martha Wayles Skelton Jefferson. But we don't. Neither, for that matter, do we have letters between Thomas Jefferson and his closest male friend, Dabney Carr.

Historians have ignored the absence of letters between Jefferson and Carr, and have assumed that Jefferson burned his correspondence with his mother, as well as his wife, reducing those precious documents to ash as cold and silent as the remains of his childhood home. But why identify the lack of letters to or from Jane as proof that she and Thomas were on strained terms? The similar absence of correspondence in the cases of Dabney Carr and Martha Jefferson has been held as either insignificant (in Carr's case) or as a token of Jefferson's undying love and devotion (in Martha's). Why assume that documentary silence means one thing in the case of the mother, precisely the opposite in the case of the wife, and nothing at all in the matter of his bosom friend?

Perhaps some of Thomas Jefferson's biographers have let their own sentiments color their readings of Thomas Jefferson's feelings about Jane Randolph Jefferson. As the historian Susan Kern has pointed out, "Jane suffered greatly during the twentieth century at the hands of the Momists, psychohistorians, psychosexual historians, and worshipers of the patriarchy . . . [she] stands as the often-maligned mother with whom her son Thomas could just not relate. . . . Yet the family remembrances of Jane and the nineteenth-century biographers of Thomas Jefferson who relied on those remembrances present Jane in glowing terms, suggesting that in her own time, she was revered."

Why the about-face? Those who argue that Thomas Jefferson disliked his mother have pointed to the seven years between the death of Peter Jefferson and Thomas's attainment of his majority, a time when the son was purportedly chafing under the control of a domineering mother. They also point to the vicious misogyny evident in Thomas Jefferson's commonplace book, a collection of literary quotations he copied out as a young man. But the traces of Jane Jefferson in the Shadwell accounts and in archaeological remains offer no evidence that the widow stepped up to manage her husband's estate while her son seethed at having to wait his turn. Instead, it seems, Jane was content to let the trustees handle business, having plenty to do just caring for her children, running her household, pursuing her social duties, and dealing with the enslaved people whose work and attentions made the Jeffersons' comfortable life possible.

As for the anti-woman quotes in Thomas's commonplace book, it seems too great a stretch to insist that those generic words were aimed directly at his mother. We should recall that Thomas Jefferson came of age in an era in which open misogyny was as common as dirt, and that he grew up in a house full of sisters, two of them older than himself. Commonplace books of the sort kept by the young Thomas Jefferson functioned in somewhat the same way that teenagers' diaries do, as places to vent the loves and hates and wishes and rages that beset us at our stormiest point in life. What is so notable about the boy who is furious with his mother, or his sisters, or for that matter, the girls who fail to return his ardor? And what more likely place for that anger to surface than in the private book reserved for outbursts not fit for public expression?

Those who have dismissed Jane Jefferson as a cipher or a despised burden in her son's life rest their case even more heavily on the fact that he seldom mentioned her (a fact Dumas Malone reasonably attributed to "his characteristic reticence about the women of his family"). Apart from that silence, they cite only two fragments of evidence: the letter written to Jane's brother, William Randolph, nine years younger than Jane, sometime in the late spring or early summer of 1776, and a passing reference in the autobiography Thomas Jefferson began to write at the age of sixty-six, upon retirement from the presidency, but never finished. In the latter, the aging Jefferson remarked archly that his mother "was the daughter of Isham Randolph, one of the seven sons of that name and family settled in Dungeness, in Goochland. They trace their pedigree far back in England and Scotland, to which let every one ascribe the faith and merit he chooses." Jefferson had, by 1809, pursued a long political course largely in opposition to the British, studded with achievements as stellar as the Declaration of Independence and as ill-conceived as the Embargo of 1807. He had also lived for more than six decades among the many descendants of Isham Randolph and his six brothers, from his unstable, hard-pressed son-in-law, Thomas Mann Randolph, Jr., to his

52 🧏 THE WOMEN JEFFERSON LOVED

explosive cousin, John Randolph of Roanoke, to the many cousins, nephews, nieces, and other relatives who went broke, stole, cheated, betrayed their kin, went crazy, and even committed murder.

When Jane Jefferson wrote her family history in her Bible, she transcribed not the names of her ancestors, but those of her children. It was her husband, Peter, who had written down a fragment of Jane's own Randolph family history, the birthplaces and dates of Jane and her brothers and sisters. For all we know, Jane may have taken pride in her Randolph pedigree; we have no strong evidence either way on that question. Jefferson's daughters and granddaughters had a habit of referring to eccentric, touchy, or stubborn behavior in any family member as a showing of "the Randolph." Jefferson, at sixty-six, had many more reasons other than particular shortcomings evinced by his mother to question his English heritage and mock Randolph family claims to inherited superiority.

So what of the letter written to his uncle, William Randolph, so soon after his mother's death? Some observers have found Thomas Jefferson's language cold to the point of antipathy: "The death of my mother you have probably not heard of. This happened on the last day of March after an illness of not more than an hour. We suppose it to have been apoplectic. Be pleased to tender my affectionate wishes to Mrs. Randolph and my unknown cousins...."

Once again we need to put these words in context. William Randolph was the heir to Dungeness plantation, Jane's childhood home. But he had moved to England, joining other Randolphs there, not simply on the other side of the ocean from his property, but on the opposite side of the cause that would very shortly rip Virginia away from the mother country to join the new nation. William had written to his sister's son to ask if he would collect the rent due on William's Virginia properties, complaining about the inconveniences he was experiencing due to the boycott of British trade by the rebellious colonies.

Thomas's reply invoked the ties of familial affection, but it also carried clear undertones of his anger at a relative who had abandoned his farm and home in search of wealth, a relative who had chosen the wrong side of the cause to which Thomas Jefferson had decided to pledge his life, his fortune, and his sacred honor. This same relative had deserted a sister he would never see again. Thomas Jefferson was capable of anger toward his mother and sisters, and forgiveness toward an estranged relative. But Jefferson was, more importantly, a man whose whole life testified to a deep belief in the duty of sons and brothers to protect and provide for mothers and sisters who had no husbands to take care of them. Jefferson was no egalitarian when it came to the sexes. He believed that men and women were essentially different, in strengths and weaknesses, in temperament, talent, and possibilities. They owed one another not equal duty, but reciprocal responsibility. Throughout his life he felt a sense of obligation toward women who depended upon him, a trust that lay at the heart of his way of loving women. Women, in turn, owed men their unquestioning obedience and loyalty and nurturance, and even their silent submission. That kind of love was, for Jefferson, rooted in the laws of nature. It was sacred and absolutely essential to a just and good society.

Jefferson began his letter to William Randolph disingenuously, by assuring his uncle that "I am extremely concerned at the difficulties under which you are thrown by the stoppage of trade," but also pointing out that "I heartily join with you in wishing you had chosen a residence among us." In his earlier letter, William Randolph had expressed concern about the safety of Virginia, and Jefferson responded with assurances that carried a note of sneering fury, contrasting the virtuous lot of the farmer (himself) with the insecure greed of the merchant (William Randolph):

Our interior situation is to me most agreeable, as withdrawing me in great measure from the noise and busle of the world. It's remoteness from the seat of war, which you mention as conferring security, we do not however consider in that point of view. Our idea is that every place is secure except those which lie immediately on the water edge; and these we are prepared to give up. But I can easily conceive the situation of a farmer, depending on none but the soil and seasons, preferable to the precarious tho' more enlarged prospects of trade.

He followed immediately with the news of his mother's death, as if to say, "And oh. By the way. If you care at all, my mother—your sister is dead." He finished with a testimonial to family ties that could not have sounded more wounded, or have concluded more equivocally:

I hope no dissentions between the bodies politic of which we happen to be members will ever interfere with the ties of relation. Tho' most heartily engaged in the quarrel on my part from a sense of the most unprovoked injuries, I retain the same affection for individuals which nature or knowledge of their merit calls for.

We have long known that Thomas Jefferson's opposition to the British in 1776 involved both economic interest and high principle. But what this letter reveals is the intensely personal dimension of that rebellion, the connection, in his heart, with the loss of his mother, her abandonment by a Tory brother, his own determination to redress "unprovoked injuries" at the hands of England, if not specifically of William Randolph. This letter, indeed, goes far toward explaining a strikingly passionate section of Thomas Jefferson's Declaration of Independence written not long after the letter, later excised by Congress. In this passage, Jefferson reflected on the willingness of "our British brethren" to permit their king to usurp American rights, and to send foreign mercenaries to prey on their American kin:

These facts have given the last stab to agonizing affection, and manly spirit bids us to renounce for ever these unfeeling brethren. We must endeavor to forget our former love for them, and to hold them as we hold the rest of mankind enemies in war, in peace friends. We might have been a free and a great people together; but a communication of grandeur and of freedom it seems is below their dignity. Be it so, since they will have it. The road to happiness and to glory is open to us too. We will tread it apart from them.

Historian Joseph Ellis has observed, "What strikes the modern reader is not the timidity of the Continental Congress for excising the passage so much as the melodramatic sentimentalism of Jefferson in composing it." But when we realize that at the time Thomas Jefferson wrote those words, he was deep in mourning for the mother he had lost, the woman whose death he had flung in the face of just such an unfeeling English brother, the language seems not so much melodramatic or sentimental as shockingly personal; too personal, indeed, for such public declaration.

JANE RANDOLPH JEFFERSON was not the target of Thomas Jefferson's sarcasm in either his autobiography or his letter to his uncle. But those historians who insist that he never wrote about her anywhere else, and by inference, never gave her another warm thought, are wrong about that, too. On October 7, 1791, a day Thomas Jefferson was at home at Monticello, cleaning up old business, he responded to a letter from a Mr. James Lyle, written nearly a year before. Lyle had written as an agent of the merchant firm of Kippen and Company, requesting payment from Jane Jefferson's estate of a debt to a local merchant amounting to £126.9.5 from "before the beginning of the war." Sixteen years after Jane's death, Jefferson described his perpetual attention to his mother's debts, but also his efforts to ensure that she did not worry about money while she was alive. He told Lyle, "I have greatly overpaid the assets of that estate which have come to my hands, even counting at their full value negroes on which the testatrice had only a life estate. Yet as I paid all demands against her during her life, and believe that on view of that she had credit & quiet from the merchants with whom she dealt, I am willing to assume this debt also to be paid with interest." This was the voice of an exasperated son, dealing with a mother who seems to have had so little gift for keeping track of her expenses. But here we also find the tenderness of a man who hoped to lift her burden of worry, even as Jane Jefferson's debts added to the crushing weight that bore ever more heavily down upon her son over the course of his life.

Duty and devotion spurred his actions, but Jefferson made his choices as a slaveholder. In this effort to finish paying off debts including those of his mother, he wrote to his brother-in-law, John Bolling, "I find myself obliged this winter to make a very considerable sale of negroes in addition to the sale of land I have already made and shall further make." Though he did not, in that instance, actually sell people, he, like Jane, showed his devotion to his white family by his willingness to break up the families of his slaves.

And then, of course, there was her Bible. This most bookish of Jane Jefferson's children was the person who had the means and the persistence to find a replacement for a cherished Bible lost to the flames in 1770, a gift of tender kindness. After her death, Thomas Jefferson preserved that relic with more than usual care. The book would be passed down to his daughter, Martha, and in turn to her youngest daughter, Septimia. Sometime in the late eighteenth century, he had Jane's Bible rebound into a volume that also included Thomas's own Book of Common Prayer, a London concordance, and the page on which Peter Jefferson had recorded the birth dates and places of Jane and her Randolph siblings. Thomas added his own notations in that volume, as did his daughter Martha and granddaughter Septimia.

Thomas Jefferson cared for his mother no less than he attempted to protect and provide for all the people who depended on him, and upon whom he would find himself dependent—his wife, his daughters, his grandchildren, and his slaves. What had started as the filial attachment of the son became obligation to stand in for his father in protecting his mother. That patriarchal responsibility was more than a duty, more than a promise; it was, for him, a sacred trust, his part of a bargain grounded in nature and sealed in mutual affection, nurturing, loyalty, and comfort. He had learned to believe in that fundamental exchange early, and with fervor, in the home of his parents, Peter and Jane Jefferson. He lived up to his part of the bargain where his mother was concerned, and we have no reason to doubt that she in turn lived up to hers. His devotion and duty to the women he loved would guide him in matters great and small for the rest of his life.

Part II

MARTHA

The Debt Collector's Daughter

JOHN WAYLES OF Virginia, a planter and a lawyer, was a man of business and charm. Born in Lancaster, England, in 1715, he grew up poor, but with talent and ambition. Sometime in the 1730s, he crossed the Atlantic as a "Servant Boy," and within ten years he had acquired a thriving law practice and thousands of acres of land. He dealt in real estate and tobacco and in human beings by the hundreds. As slavery thrust millions into misery, it lifted John Wayles higher.

Wayles moved among the lordly ladies and gentlemen of Virginia's famous families, cultivating fine manners and a winning personality. Yet he perpetually walked the line between coldhearted commerce and the customs of the country, between the English merchants he often represented and the Virginia gentlemen who were his friends, and soon to be his relations. He stood just a little outside their ranks, not simply because he was a self-made man, but also because he'd chosen one path to fortune that put him at odds with those he sought to please. John Wayles was a debt collector.

The most opulent plantation mansions, the finest horses and coaches, the most elegant gardens and verdant fields of Virginia were built not simply on the brute foundation of forced labor, but also on

5

the slithering silt of ever-mounting debt. Wayles's future son-in-law, Thomas Jefferson, once observed that Virginia planters were "a species of property annexed to certain mercantile houses in London." When John Wayles came to visit, he might expect a gentleman's welcome, but all too often the host greeted him with dread. Some found reason to be absent when they learned he intended to call.

As the agent for Farell and Jones, the Bristol, England, tobacco merchants who shipped so much of Virginia's signature crop, Wayles had to squeeze his neighbors on behalf of their distant creditors, to figure out who was likely to pay, and how much, and when. The debtors were a wily bunch, and they tried every stratagem to put him off. Some offered bonds given them by friends and family, basically secondhand IOUs. "When I came to inquire after the people [who had first signed the bonds]," Wayles discovered, "they mostly lived on the Borders of Carolina. It would probably take 7 Years to Collect them." Others used their family connections to evade payment. Of one Nathaniel Harrison, Wayles observed, "I have wrote more Letters, & made more Personal Applications for so small a Sum, then I ever did to any other Gentlemen. This family is somehow or other so connected with your other Friends, that, where the debt is not in danger, indulgencies are unavoidable." In Virginia, of course, family connections were the coin of the realm. A Mr. Syme, said Wayles, "cannot be worth less than 15 or 20 thousand pounds." Syme had "married an heiress possessed of the Lands about New Castle where he lives & other Estate to a considerable Value."

For all the awkward moments demanded by his position, Wayles still managed to ingratiate himself with the prominent and the powerful. He was, according to Thomas Jefferson, "a lawyer of much practice, to which he was introduced more by his great industry, punctuality and practical readiness, than to eminence in the science of his profession. He was a most agreeable companion, full of pleasantry and good humor, and welcomed in every society." John Wayles studied the habits of the Virginia aristocracy, and he knew how to succeed among them. Like the solvent Mr. Symes, John Wayles married an heiress. In fact he would marry three daughters of Virginia's first families, two of them heiresses of no small means.

The first was the widow Martha Eppes Eppes, a real catch. She was born in 1721 at Bermuda Hundred, her father's plantation at the confluence of the James and Appomattox rivers in Chesterfield County, not far from Wayles's place, "the Forest," in Charles City County near Williamsburg. The Eppeses loved hunting and horse racing and high living. When she married John Wayles in May 1746, Martha Eppes had property inherited from her late husband (an Eppes cousin), as well as a substantial legacy from her father and from a deceased older brother. She owned 1,200 acres of land, feather beds and silver spoons, a horse, a saddle, furniture, and nine enslaved people.

According to the English law of coverture, a woman's property passed to her husband upon marriage. The law assumed that husbands would protect and provide for the wives and children who depended upon them. But Martha Eppes, a second-time bride, shared a pragmatic outlook with her prospective husband. She made a somewhat different arrangement with John Wayles. According to the couple's marriage indenture, a contract signed a few days before the wedding, John Wayles would be entitled only to the use of his wife's property during his lifetime. If he died before she did, Martha would resume control over her estate, "notwithstanding her Coverture." Her property was not his to dispose of as he saw fit. If Martha died before her husband, according to their contract, her assets would pass to her own children, and not to any children Wayles might have with anyone else.

64 🧏 THE WOMEN JEFFERSON LOVED

There certainly was reason for Martha Eppes to be concerned. In colonial Virginia, "'til death do us part" could be a near-term proposition. She had already lost one husband, and even among the most privileged Virginians, wives had a tendency to die young, leaving their children at the mercy of future stepmothers. Childbirth was then, as now, a bloody business, but in Virginia in the middle of the eighteenth century, having a baby was far too often a lethal experience for the mother, the child, or both.

Seven and a half months after they married, Martha Eppes Wayles gave birth, prematurely, to twins, a boy and a girl. Her daughter was born dead. Her son lived only a few hours. A year later, she was again pregnant, and this time the baby survived, but the ordeal killed the mother. She delivered a daughter on October 31, 1748, lay dying for five days, and then she was gone, dead at the age of twenty-seven. The baby, named Martha after her mother and called Patty by her family, never knew the woman who gave her life at the cost of her own. The father quickly sought a new wife to raise his small daughter and run his household. John Wayles married a woman of the Cocke family, yet another prominent Virginia planter clan. The second Mrs. Wayles gave him four more daughters, three of whom—Elizabeth, Tabitha, and Anne—lived to adulthood. But Wayles's second wife died, leaving him a widower yet again.

By January 1760, Wayles had found himself a third wife, yet another stepmother for his daughters. This time he chose the widow Elizabeth Lomax Skelton, who had inherited property from her late husband, Reuben Skelton. Scarcely more than a year after the wedding, she too was dead. Wedding, bedding, and burying a third wife was enough for John Wayles. He never married again.

WE KNOW ALL these things about the Wayles family from a single document: a memorandum written by Thomas Jefferson, who had a wellknown penchant for recording statistics, vital and otherwise, and for cataloging the names of things. The man who eventually married Martha Wayles took care to mark the births, marriages, and deaths of his wife's immediate family members, information he must have learned from Martha herself. But Jefferson entered no given names for either of Martha's stepmothers. Martha, it seems, did not speak of those women often enough for their names to lodge in the mind of a devoted husband with a legendary memory. Given her later desperate terror of stepmothers, Martha's silence may have been a way to quell the bad memories of a motherless child. Those things we actively refuse to speak about echo in the mind and scorch the heart.

John Wayles, thrice wifeless, did not live out his days alone; he took a concubine. He turned to a woman who had lived in his household longer than any of his wives. Elizabeth "Betty" Hemings was the daughter of an English sea captain and an enslaved African woman. She had come to the Forest at about the age of thirteen, as Martha Eppes's slave. Over eleven years, Betty Hemings bore twelve children. John Wayles was the father of six of them, three boys and three girls: Robert, James, Thenia, Critta, Peter, and Sally. Their half-sisters, Martha, Elizabeth, Tabitha, and Anne, bore their father's last name of Wayles, but Betty's six children would bear the surname Hemings and be held as slaves by their father. Their half-sister, Martha Wayles, would inherit them all, according to the terms of her mother's marriage contract.

John Wayles, wrote Annette Gordon-Reed, "grew rich himself off of Africans. He used them as items of trade, held them in bondage, and mixed his blood with theirs."

The Wayles sisters surely knew that six of the Hemingses were their half-siblings. Betty Hemings had known the Wayles girls from birth—knew them as Patty, Betsy, Tibby, and Nancy. She may have assisted in bringing them into the world, and she had outlasted all their mothers as the most constant fixture in their household. She would have had a hand in raising all four, and Martha, the daughter of her late mistress, most of all.

When Betty Hemings began her liaison with John Wayles, she already had four children. By the time she gave birth to Robert, known in the neighborhood to have been John Wayles's child, Martha Wayles was thirteen years old, old enough, according to Virginia law, to marry in her own right. If her sisters were at that moment too young to suspect what had arisen between their father and his slave, the arrival of five more mixed-race babies, the last born in 1773, must have made the case plain.

We cannot know how the Wayles girls talked about the matter among themselves, whether their father ever said anything to them, whether they ever asked. Perhaps there was no need. The Forest was a substantial house, but it was not a great mansion, not a place where the comings and goings of some inhabitants would escape the notice of others. Children see more than their parents think they do, even when they learn not to talk about what they know. White people might pretend to know nothing of interracial sex, but public silence was no bar to private action. Indeed, where sex across the color line was commonplace, maintaining public silence required family acquiescence.

Martha Wayles learned her place in a world of open secrets. As a well-to-do white woman, she was born to direct, but also to obey. In order to command her kin as servants, she had to master distance, to learn not to see what was in front of her eyes, to play a deadly serious game of genealogical make-believe. Some of John Wayles's children took his name and claimed his race. Others would be known as black or negro or colored, and go by the name of Hemings. Hemingses would be enslaved for life, made to serve their Wayles relatives, hidden in plain sight, in houses where women skated along the bloody bodily edge of race and bondage. THE WAYLES HALF-SISTERS grew up privileged, though not strictly secure. Their father made a fortune but in the process fell into the debt he deplored in his neighbors. Risk, after all, was inherent to the kind of business he did. Still, there were huge profits to be made from high prices for tobacco and slaves bought and sold on credit. Martha and her sisters moved in the most elevated circles, visiting and hosting friends and relations, Eppeses and Skeltons, Bollings and Harrises and Cockes. They took along slaves to light their fires and carry their water, iron their linens, fetch their tea, rub down their horses. They had fancy goods as well as skilled attendants: pattern books and fine fabrics, stays and stockings and slippers and boots, hair powder and cloaks and jewels.

Familiar as he was with the avalanche of debt that threatened to bury some of his friends and relations, their father was leery of extravagance for its own sake. Wayles had seen planters borrow more and more from British merchants. He observed in 1766 that in his younger years, a planter's debt of one thousand English pounds "due to a Merchant was looked upon as a Sum imense and never to be got over." But times had changed.

Ten times that sum is now spoke of with Indifference & thought no great burthen on some Estates. . . . Luxury & expensive living have gone hand in hand with the increase of wealth. In 1740 I don't remember to have seen such a thing as a turkey Carpet in the Country except a small thing in a bed chamber. Now nothing are so common as Turkey or Wilton Carpets, the whole Furniture of the Roomes Elegant & every appearance of Opulence. All this is in great measure owing to the Credit which the Planters have had from England . . . tho many are ignorant of the true Cause.

68 🎽 THE WOMEN JEFFERSON LOVED

Martha Wayles was taught from an early age to prize thrift and beware reckless spending, as she prepared to take on the myriad tasks of an industrious plantation wife. At barely the age of fourteen, motherless again, she assumed the duties of woman of the house. While her slaves performed the hardest and worst jobs, she learned the ways of butchering hogs, cattle, and fowl, rendering lard to mix with lye and ashes for soap, brewing beer, counting out the linens and spoons, and dispensing clothing and food to slaves. She saw to these duties at the Forest and took part in running John Wayles's other plantations. As Martha stood in for her mother and stepmothers, she completed her training in housewifery under the eyes of Elizabeth Hemings.

Whatever Betty Hemings could teach Martha Wayles about housekeeping, she could not train Martha in everything she needed to know. Other women, female relations and friends, initiated Martha into the niceties and treacheries of white plantation society, the arts of mingling politeness and poison in genteel conversation, or setting tiny stitches in fancy sewing. Her father likely taught her to keep household accounts, and someone showed her how to sit a horse. Teachers and tutors came to the Forest to instruct the young ladies in music and dancing and drawing. Martha was known for her musical gifts, her skill on the spinet and harpsichord and her sweet singing voice.

By the age of seventeen, Martha began to look for a husband among the young men she met in plantation drawing rooms, in the ballrooms and parlors of Richmond and Williamsburg. She would have been as good a match as her mother had been, or even better: her rich father, having no male heir, would settle his property on his daughters. But Martha possessed attractions of her own. According to family tradition, which doubtless painted her in the rosiest tones, Martha was a beautiful young woman, auburn-haired and hazel-eyed, "with a lithe and exquisitely formed figure, . . . a model of graceful and queenlike carriage." While Isaac Jefferson, who spent most of his life as a slave at Monticello, described Martha as "small" and "low," others recalled that she had been somewhat above medium height for a woman.

She had, it seems, a sparkle about her. Her sister Tabitha's husband, Robert Skipwith, knew her well and praised Martha as possessor of "the greatest fund of good nature [and] sprightliness and sensibility." Her granddaughter, Ellen Randolph Coolidge, celebrated "her wit, her vivacity and her agreeable person and manners," while her greatgranddaughter, Sarah Nicholas Randolph, added that Martha was "a person of great intelligence and strength of character," with "a mind of no ordinary caliber. She was well-educated for her day, and a constant reader; she inherited from her father his method and industry."

This paragon of white southern womanhood was not, however, all sweetness, as even her most devoted descendants admitted. "My grandmother Jefferson," wrote Ellen Randolph Coolidge, drawing on her own mother's memories, "had a vivacity of temper which might sometimes border on tartness." We should not be surprised that John Wayles's daughter sometimes expressed herself in blunt, even acid terms.

Tart-tongued or not, Martha had her share of suitors, even though she entered the marriage market at a time of family turmoil. In the summer of 1766, her father had taken the case of a man named John Chiswell, a heavily indebted planter accused of murdering a merchant named Robert Routledge in a Williamsburg tavern. The murder happened amid conflict between Virginia planters and the English merchants they owed, a tension that contributed mightily to the coming confrontation with the British government. John Wayles found himself to be a man in the middle. When he agreed to serve as Chiswell's lawyer, he surprised his merchant allies. And when he managed to get his client released on bail, Routledge's friends were furious, charging that the court had given the accused special deference due to his rank in society. If John Wayles had not seen the nasty side of courtliness

70 🏋 THE WOMEN JEFFERSON LOVED

before that point, the Chiswell affair gave him a lesson in the spectacle of the Virginia gentleman in full snarling attack. William Rind, publisher of the *Virginia Gazette*, made John Wayles the target of written tirades. That he was attacked as a "Judas" suggests that some of his critics saw him as a traitor to his own interests.

Martha and her sisters may have chosen not to read the scurrilous stuff in Rind's paper, the bad satiric poetry ridiculing their father's good manners and calling him "ill-bred," the essays accusing him of lying and claiming that he'd long had a bad reputation, although Rind demurred from specifying the nature of Wayles's offenses. But the Wayles girls could not have been unaware of the attacks, or the fact that their father was representing the very sort of debtor that he usually pursued. Wayles tried to refute what had been said and written, but simply by engaging his assailants publicly he fed the fire of controversy. The outcry died down when John Chiswell, Wayles's client, committed suicide while awaiting trial. Before that ugly denouement, and surely after, the Wayles girls must have heard whispers, perhaps even open slights, when they went out into society, a hard thing for young women in any age. The gossip seemingly strayed into the territory of John Wayles's peculiar domestic arrangements, and bad blood between Martha's kin and the Rind family would, as it turned out, be passed on for another generation.

If the Chiswell matter caused discomfort in the Wayles household, far worse lay in store. In the same summer, Martha's first cousin, Richard Henry Eppes, was murdered at Bermuda Hundred, the plantation where her own mother had grown up. According to a story published in the *New-York Mercury* and datelined "Williamsburg, in Virginia, June 20":

On Thursday last Week, the following melancholy Affair happened in Chesterfield County: A Negro Girl carried Mrs. Epps's

THE DEBT COLLECTOR'S DAUGHTER 💥

71

Son to the River Side with a Pretence to divert him, but when he got there, she struck him several Times on the Head with a Stave, until he was stunn'd, and then flung him into the Water; but recovering a little, he made shift to get out; upon which, with the Help of a Negro Boy, she again beat him until he appeared to be dead, and flung him into the River, and then made off; but a Boat coming by immediately after, discover'd him, and carried him home, where he had not been long before he recovered so far as to give the above Account, but died soon after.

The teenage Richard Henry Eppes had lived with his mother and his older half-brother, Francis, at Bermuda Hundred. Local authorities wasted no time bringing his attackers to justice. On June 21, the day after the dateline of the story in the *New-York Mercury* and nine days after the incident, two enslaved people belonging to Mrs. Eppes, Sukey and Will, were tried for the murder. Will, the alleged accomplice, was found not guilty. According to family history, Sukey was convicted and hanged.

This story, which traveled like lightning all the way to New York, gives us an inkling of the terror the event occasioned in Virginia, let alone in the neighborhood, not to mention among the family. A young slave woman had planned with care a brutal assault on a planter's son and had involved an accomplice. For slave owners, the fear of violence against masters might be repressed, but it never ceased to bubble beneath the surface of everyday life. Sukey's (and Will's) fury tapped the slaveholders' deepest anxiety, like a dentist's drill hitting a nerve.

Why would a slave girl, a person with no rights of any kind, risk everything to kill the young master? She must have been either crazy or desperately provoked. Masters, after all, enjoyed the legal right to starve, to beat, to sexually assault and exploit, to use in any way, even to kill those they enslaved, for any reason, or no reason at all. Richard Henry Eppes was not legally Sukey's owner (she belonged to the boy's mother), but as a son of the house, who stood to inherit Sukey and the rest of his mother's property, he was, for all purposes, her master.

The killing of Richard Henry Eppes was not some distant event for people at the Forest, Wayleses and Hemingses alike. The Wayles sisters were very much at home at Bermuda Hundred, a neighboring plantation. The victim's father had signed John Wayles and Martha Eppes's marriage indenture. Elizabeth Hemings had been raised at Bermuda Hundred and knew the Eppes family well. Three years later, Elizabeth Wayles, the sister closest to Martha, married the murdered boy's older brother, Francis Eppes. In the Wayles household, where the wall between master and slave had been so repeatedly breached, the news of murder so close at hand set off screaming alarms.

Bride and Widow

6

IN THE SHADOW of suicide and scandal and murder, eighteen-yearold Martha Wayles became a bride. She married twenty-two-year-old Bathurst Skelton on November 20, 1766. They had known one another for years. In the convoluted manner of Virginia planter families, Martha's new husband was by way of being her step-uncle: the youngest brother of her stepmother's first husband, Reuben Skelton. Martha had property of her own, but no marriage indenture was recorded for Martha and Bathurst Skelton. Instead John Wayles relied on the contract he had made with Martha's mother twenty years earlier, reinforced in his own will, which guaranteed that his eldest daughter would inherit money and land and people, including Betty Hemings and her children. One way or another, the law would transfer her property to her young husband, who would promise to protect and provide for her, as she in turn would pledge to honor and obey him, so long as they both lived.

Bathurst Skelton was just two years out of the College of William and Mary when he married Martha Wayles. The small library he would leave behind offers an inkling of his aptitudes, or at least of the

74 🧏 THE WOMEN JEFFERSON LOVED

college curriculum, including volumes on mathematics and algebra, mechanics, astronomy, French, and geography. He owned two translations of Virgil, Addison and Steele's *Spectator*, and a good smattering of the essentials in English literature: Milton's *Paradise Lost*, eight volumes of Swift and ten of Pope, Smollett's *Roderick Random*, and Dr. Johnson's Dictionary. Young Skelton may or may not have read these books with any care, or at all, and his wife may or may not have ever given them a glance. But Martha did marry two men who possessed books, one of them a passionate reader and collector, and on her deathbed, she would struggle to trace out beloved lines from Laurence Sterne.

The Skeltons set up housekeeping at Elk Hill, a Goochland County plantation that John Wayles had purchased in 1746, a beautiful place both of them knew well. They occupied a bluff-top brick house overlooking Byrd Creek at the confluence of the James. The newlyweds could gaze out over the lush bottomland of Elk Island, where Bathurst Skelton owned a thousand-acre plantation and John Wayles leased land and grew tobacco. Elk Hill must have seemed an obvious place for the young couple to make their home. Here they had a comfortable house with a gorgeous view, offering an abundance of game and access to the Elk Island plantation. They hosted hunting parties and family gatherings as the warm and vivacious Martha began her life as Mrs. Bathurst Skelton.

Of course, a Virginia plantation wife's principal duty was to provide her husband with an heir. Martha fulfilled that expectation without delay. On November 7, 1767, not quite a year after their wedding, Martha gave birth to their first and only child, a boy they named John, after his grandfather Wayles.

Whatever joy they felt at the birth of their son would be cut short. Ten months later, on September 30, 1768, Bathurst Skelton died suddenly. He made his will on his deathbed, too weak to sign the document himself. In extremis, Skelton was aware of his wife's legacy from her mother, the foundation of her fortune, currently in his hands. But knowing that Martha was likely to remarry, he made sure to provide for his son in the chief form of wealth he possessed: enslaved people. "Whereas my wife Martha will be entitled to sundry slaves at the death of her father, by virtue of a marriage settlement made betwixt him and her mother, all which slaves I give to her and her heirs forever in case my son dies under age, or unmarried," his will read. "But if he attains to lawful age or marriage, then the said slaves to be equally divided betwixt them, my wife and son." Skelton named Martha and John Wayles as guardians for little John, and as his own executors, and added a note bequeathing his phaeton, a light, doorless, twowheeled carriage with a seat for two, and horses to Martha.

Thus Martha, at the age of nineteen, found herself a widow and the mother of a child who had not yet reached his first birthday. She left Elk Hill behind, though years later she found a way to reclaim her first bridal home. She went home to the Forest, where her father—and Elizabeth Hemings—could care for her and her son.

Not yet twenty, Martha Wayles Skelton had endured loss after loss. How did she cope? Many people seek solace in faith, but whether religion provided some comfort, we cannot say. Her father was a churchgoing man after the fashion of elite Virginians of the time, more given to the social than spiritual aspects of their observances. He was an active member of his Episcopal church, but not precisely a pious pillar of devotion. Maria Byrd, wife of William Byrd III, had written to her husband that Wayles was working to recruit speakers for the congregation, including one "Parson Duglish, he says to make us laugh."

Perhaps that capacity to laugh sustained his daughter, too. Despite so many blows, she somehow managed to retain the spark that those who knew her best remarked on so often. Her ability to move forward with grace and purpose, to seek and find joy, bespeaks an impressive inner strength. That strength would be more than tested in the years to come.

WHEN MARTHA RETURNED to the Forest, late in 1768, she found a household full of Hemingses. Elizabeth Hemings had borne John Wayles two sons and a daughter: Robert (born 1762), James (born 1765), and Thenia, born the same year as their half-nephew, little John Skelton. Hemings's four eldest children—Mary (fifteen), Martin (thirteen), Betty (nine), and Nancy (seven)—were old enough to take on household duties. Martha's enslaved half-brothers and half-sisters were still too young to work, though Robert, now six, might have been enlisted, alongside the older children, to carry water and make fires, to help mind his little brothers and sisters and John Skelton. While Martha lived as a widow in her father's house, Betty Hemings gave birth to two more half-siblings, Critta, in 1769, and Peter, in 1770.

John Wayles and Elizabeth Hemings had the kind of relationship that everyone knew about and many denied. But their connection endured more than a decade, lasted until his death, and stubbornly survived in the memory of their descendants and neighbors. Whatever Martha felt about her father's liaison, about her slave brothers and sisters, about their mother, the enslaved matriarch of the Hemings clan and the young widow Skelton were raising little children in the same household, even as they regarded one another across the abyss of race and caste. What Annette Gordon-Reed has called "the catechism of white supremacy-one of those things people live by, even though they know they're not true"-kept that chasm from closing. It corroded Martha's vision of their kinship as surely as a bottle of vitriol thrown in the eyes. And it forced the Hemingses to pretend ignorance of what they knew to be true. The law gave Martha Wayles Skelton a right to own property, though like all women, she ceded that right to any man she married. The law viewed Elizabeth Hemings as property. She had no authority over her own children, no right even to her own body.

The shock and pain of Bathurst Skelton's death inevitably ebbed, and Martha looked ahead. She began to enjoy society again, and it seems, to entertain suitors. One such admirer arrived at the Forest for a brief visit in early October 1770. Twenty-seven-year-old Thomas Jefferson—lawyer, planter, and member of the Virginia House of Burgesses—came on horseback, or perhaps in his phaeton, accompanied by Jupiter, his body servant. He was so determined to get there that he persisted through some mishap—a thrown horseshoe, a broken spring. Martha encouraged his attentions, and she must have been much on his mind, since he soon returned.

Thomas Jefferson was a busy man, shuttling back and forth between Williamsburg and Charlottesville in the wake of the terrible Shadwell fire, occupied too with a law practice that obliged him to ride around to plantations and county courthouses and the General Court in Williamsburg. As a member of the House of Burgesses, he was increasingly consumed by the growing conflict between the British government and the colonial legislatures. And he was working frantically to get a house built at Monticello. But he still managed to find the time to go to see Martha.

At some point Jefferson emerged as the leading contender among Martha's numerous suitors. Some five years her senior, six feet two inches tall, brilliant and agreeable, he had charms of his own. Biographer Henry Randall offered an appealing picture of the young man:

Mr Jefferson was generally . . . rather a favorite with the other sex, and not without reason. His appearance was engaging. His face, though angular, and far from beautiful, beamed with intelligence, with benevolence, and with the cheerful vivacity of a happy, hopeful spirit. . . . He was an expert musician, a fine dancer, a dashing rider.... There was a frankness, earnestness, and cordiality in his tone—a deep sympathy with humanity—a confidence in man, and a sanguine hopefulness in his destiny.

Martha Skelton and Thomas Jefferson shared the gift of music. He was devoted to his violin, she to her spinet, and they both loved to sing. They rejoiced in playing together. For many years after, their descendants preserved a favorite story of their courtship. It seems that two of Martha's other suitors, still holding out hope, arrived at the Forest one day and met accidentally in the hall. Just as they prepared to enter the drawing room, they heard Thomas and Martha singing together. They exchanged a knowing look, put on their hats, and left.

What, apart from music, drew Thomas Jefferson and Martha Wayles Skelton together? They were of similar rank in society, both related to important families through their mothers, with fathers who had succeeded in business by working hard, by cultivating friendships with powerful people, and by marrying well. Each was left with only one parent. They were both products of plantation life, had both been raised to take for granted their right to command and own slaves. They were accustomed to wealth, to fine imported goods, even as the House of Burgesses was struggling with the British government over taxes on luxury items.

But they also had similar ideas about the pursuit of happiness. Both were devoted to the novels of Laurence Sterne, a writer who celebrated sentiment. They also discussed the poetry of Ossian (a supposedly ancient Scottish poet, purportedly translated by the eighteenth-century writer James Macpherson). Martha had an eminently pragmatic father, but she embraced the sentimentalism then popular in the cultured classes of Europe and the colonies. Thomas Jefferson, for all that he would soon emerge as the most famous disciple of reason in American history, never underestimated the claims of the heart. One of his early biographers, James Parton, hyperbolically observed that "the mightiest capacity which this man possessed was the capacity to love. In every other quality and grace of human nature he has been often equalled, sometimes excelled; but where has there ever been a *lover* so tender, so warm, so constant, as he?"

We cannot estimate with any precision the rank of Thomas Jefferson among the great lovers in history, but throughout his life he proved to be a man who loved deeply, and whose actions and ideas were shaped by that love. His passion for the woman who would become his only wife was fervent, lifelong, and consequential.

By the beginning of 1771, Thomas Jefferson had made his intentions clear, though Martha Skelton had not quite accepted his proposal. He wrote to his friend James Ogilvie on February 20 with news of a mutual friend who "is wishing to take himself a wife; and nothing obstructs it but the unfeeling temper of a parent who delays, perhaps refuses to approve her daughter's choice." Like the friend, Jefferson hoped to marry soon. But he was forced to wait, he insisted, not because of parental disapproval, but due to the fire that had destroyed Shadwell a year earlier, robbing him of a proper house to which to bring a bride:

I too am in that way [of hoping to marry]; and have still greater difficulties to encounter not from the forwardness [*sic*] of parents, nor perhaps want of feeling in the fair one, but from other causes as unpliable to my wishes as these. Since you left us I was unlucky enough to lose the house in which we lived, and in which all its contents were consumed. A very few books, two or three beds &c. were with difficulty saved from the flames. I have lately removed to the mountain from whence this is dated, and with which you are not unacquainted. I have here but one room, which, like the cobler's, serves me for parlour for kitchen and hall. I may add, for bed chamber and study too. My friends sometimes take a temperate dinner with me and then retire to look for beds elsewhere. I have hopes however of getting more elbow room this summer.

Jefferson envisioned a summer wedding, though he still had to convince Martha to marry him. They did manage to see each other, sometimes in the capital, and their friends hoped he would succeed. A Quaker woman he knew from Williamsburg urged him, "persever thou, good Young Man, persevere.—She has good Sence, and good Nature, and I hope will not refuse (the Blessing shal' I say) why not as I think it,—of Yr. Hand, if her Hearts, not ingaged already. . . . And belive me, that I most sincearly wish You, the full completion, of all Yr. Wishes, both as to the Lady and every thing else."

Why did Martha hesitate? Perhaps she thought it was seemly to do so. Maybe she was considering other offers. Possibly she was afraid to commit herself again, having lost one husband so young. And while Jefferson's letter to James Ogilvie suggested that neither his mother nor her father opposed the match, Jefferson had supported the Virginia Burgesses' nonimportation agreements in response to the Townshend Acts, and John Wayles was the agent for British merchants; in 1766, Wayles had declared the uproar over the Stamp Act a "great Licentiousness." Still, Wayles was a friend to the Randolph clan and doubtless knew Jane Jefferson as well as her son. He must have seen pleasing prospects in the match.

By the beginning of June, Thomas Jefferson had won over his prospective bride. And why did Martha say yes? She had reason enough to choose a husband carefully. As Henry Randall observed, "With rank and wealth (if the last can be supposed to have had any influence on the men of the olden time!) it is not wonderful that Mrs. Skelton was a favorite with the other sex—that her hand was sought by wooers far and near." She stood to inherit more than Jefferson possessed, so she was not marrying for money. As a daughter of the Eppes line, she did not need to marry for social advantage. She might have remained an unmarried widow, as her future sister-in-law, Martha Carr, would do, under the far more difficult circumstance of raising six children, and as another future sister-in-law, the childless Anna Jefferson Marks, would do much later. Jefferson's two sisters, left vulnerable by their husbands' deaths, fell back on their brother as provider and protector, and Martha had no brother. But she did have a fortune of her own, and if she needed a man to administer her affairs, her father could certainly arrange with his friends to serve as trustees. So, why?

Martha Skelton accepted Thomas Jefferson's proposal, it would seem, not out of necessity, but on account of desire. She wanted more children, but she could have had those with a richer, more important man. She chose Jefferson because she wanted him. In 1771 no one could have predicted where the course of life would take him. He was a Virginia planter with good prospects to be a leading man in the colony, but who could have imagined more? That, assuredly, was enough for Martha at the time she agreed to become his wife. And it was almost surely not his greatest asset, in her eyes. We have to conclude, in the end, that she decided to marry Thomas Jefferson because of a mutual attraction, an emotional and physical chemistry between them that meant a great deal to both of them. Many people they knew married without such connections or expectations, seeing sustenance, security, and status as good enough causes to make a match. Many were content with less, but Martha wanted more. As we would say now, she loved him, and accepted his proposal because of that, and because he loved her.

AS JEFFERSON LOOKED forward to setting up housekeeping with Martha at Monticello, he indulged in one of his favorite pastimes: he shopped. And in doing so, he failed, or at least skirted, a political test. As American resistance to England spread, colonial legislatures passed laws against the importing of British goods. Jefferson wanted to honor the boycott but he nonetheless wrote to London merchant Thomas Adams requesting a large order of expensive goods, as soon as possible. He was an exacting customer. In a previous letter he had ordered a clavichord, but now he allowed as how "I have since seen a Forte-piano and am charmed with it. Send me this instrument then instead of the Clavichord. Let the case be of fine mahogany, solid, not vineered. The compass from Double G. To F. In alt. A plenty of spare strings; and the workmanship of the whole very handsome, and worthy the acceptance of a lady for whom I intend it." He was, indeed, "very impatient" to have the pianoforte and urged Adams to send it forthwith.

Music, love, luxury, and indebtedness suffused the marriage between Martha Wayles Skelton and Thomas Jefferson. "By this change of the Clavichord into a Forte-piano and addition of the other things," Jefferson acknowledged to his merchant correspondent, "I shall be brought in debt to you." But that did not bother him, and indeed, he asked Thomas Adams to send him not just goods, but also "an architect... as soon as you can." To pay what he owed, he proposed an arrangement familiar to all Virginia planters and all English merchants: "To discharge [the debt] I will ship you of the first tobaccos I get to the warehouse in the fall."

Martha too had high hopes as the snows of winter melted and the trees budded, as the crocuses and wood violets of spring gave way to flowering dogwood and lilac and honeysuckle. She looked forward to life with a scintillating and adoring husband, brothers and sisters for John, and the promise of a beautiful house on a mountaintop. Jefferson, for his part, prepared to take on a wife and stepson, setting up an account for little John Skelton in his fee book. But that spring brought new suffering and sorrow. On May 26, a terrible flood on the James— "the greatest flood ever known in Virginia," as Jefferson wrote in his Garden Book—washed away the Jefferson mill at Shadwell and wrecked John Wayles's tobacco crop at Elk Island. Martha's own dower lands on the island were doubtless inundated, though we have no record of those losses. Leaving the cleanup at Shadwell in others' hands, Jefferson made his way to the Forest, where tragedy awaited. We don't know if little John Skelton was a sickly child from the first, or whether some childhood disease or tragic accident took him. But in June 1771 he died at the age of three and a half.

Coping with devastation both emotional and physical, they postponed the wedding. Thomas had to parcel out his days between Williamsburg and Monticello, Shadwell and the Forest, spending as much time as he could with Martha. He was determined to get Monticello ready for his bride, but the place was a construction site on which one brick outbuilding, twenty by twenty feet, had served as Jefferson's bachelor quarters. The grand house to come was then nothing more than a Palladian dream, years of commotion and chaos away. Still, Martha and Thomas were both optimists. How else, amid a landscape littered with the wreckage the raging James River had left behind, in the wake of a child's death, can we explain a famous exchange of letters between Jefferson and his prospective brother-in-law, Robert Skipwith, who was soon to marry Martha's sister Tabitha?

Robert Skipwith had written to Jefferson to ask for advice about books. Jefferson, who had quickly refurnished his own library after the Shadwell fire, was only too glad to comply. In a gesture that would prove characteristic in him over the years, he imagined convincing his friend and soon to be brother-in-law to move to Albemarle and

84 🧏 THE WOMEN JEFFERSON LOVED

become his neighbor. Sitting in his one-room house at Monticello, amid the din and smoke as enslaved men and boys moulded bricks and hauled them to the kiln to be "burned," Jefferson shared with Skipwith an effusive fantasy of a life together, married to Wayles sisters:

Come to the new Rowanty, from which you may reach your hand to a library formed on a more extensive plan. Separated from each other but a few paces, the possessions of each would be open to the other. A spring, centrally situated, might be the scene of every evening's joy. There we should talk over the lessons of the day, or lose them in Musick, Chess, or the merriments of our family companions. The heart thus lightened, our pillows would be soft, and health and long life would attend the happy scene. Come then and bring our dear Tibby with you; the first in your affections, and second in mine. Offer prayers for me too at that shrine to which, tho' absent, I pay continual devotion. In every scheme of happiness she is placed in the foreground of the picture, as the principal figure. Take that away, and it is no picture for me.

Skipwith's delighted reply gives us a hint that by September, despite her mourning, Martha was finding her way back to imagining future happiness with Thomas Jefferson:

Your invitation to the New Rowanty with the pleasing plan for a happy life but above all the affectionate manner in which you speak of my dearest Tibby are so flattering that were it not ruinous to my small fortune I would at all events be neighbours to a couple so well calculated and disposed to communicate knowledge and pleasure. My sister Skelton, Jefferson I wish it were, with the greatest fund of good nature has all that sprightliness and sensibility which promises to ensure you the greatest happiness mortals are capable of enjoying. May business and play musick and the merriments of your family companions lighten your hearts, soften your pillows and procure you health long life and every human felicity! Adieu!

The pretty vision they shared would never come to pass. Sometime between this letter and February 1773, Tabitha Wayles Skipwith died. We know nothing of the cause of that untimely death, but if Jefferson's reference to "our dear Tibby" reflected his bride-to-be's affection for her younger sister, here was another crushing loss. Martha could not get past one source of grief before another swooped down.

Mr. and Mrs. Jefferson

7

THROUGHOUT THE FALL of 1771, Thomas Jefferson worked at his law practice and pushed ahead at Monticello, directing free and enslaved workers as they made thousands of bricks, cleared stumps, and dug out and graded the first of his roundabout roads and a turnaround for carriages. In a sweet moment amid all the heavy work, he noted the small delight of harvesting his first peaches on the mountaintop, at the late date of October 8.

Finally, after all the delays, the wedding between Jefferson and Martha Skelton was set for January 1, 1772, at the Forest. Francis Eppes, who was married to Martha's sister Elizabeth, signed the marriage bond, and Jefferson paid forty shillings for the license. The guest list included the bride's father and the Eppeses, who were then building their house at Eppington in Chesterfield County. Her other sisters, Anne and Tabitha, and the men who would be their husbands, brothers Henry and Robert Skipwith, probably also attended. Jane Jefferson, if her health permitted, would have wanted to be present at the wedding of her eldest son and to bring along her daughters Elizabeth and Anna and son Randolph. Jefferson's sister Mary and brother-in-law John Bolling, friends of the Wayles family, would also be invited. We cannot say whether Martha and Dabney Carr would have been in attendance, given their fast-growing family. But their house at Spring Forest was in Goochland County, and Martha had lived nearby during her marriage to Bathurst Skelton. Surely Jefferson wanted his brother-in-law and best friend, and the sister who had become his closest sibling, to see his joy. There was music and feasting, judging by the liberal tips Jefferson gave to "a fidler" and various enslaved people at the Forest (including Betty Hemings and her son, Martin) for tending to the guests, their slaves, and their horses. The Reverend William Coutts officiated, although the minister for the parish, William Davis, was also present, and Jefferson paid each man five pounds, five times what the law demanded.

MARTHA WAYLES SKELTON and Thomas Jefferson made their vows according to the rites of the Church of England, as embodied in "The Form of Solemnization of Matrimony" in the Book of Common Prayer. The ceremony began with the three "causes for which matrimony is ordained," the first being for "the procreation of children, to be brought up in the fear and nurture of the Lord, and to the praise of His holy name"; the second, as "a remedy against sin, and to avoid fornication"; and the third, "for the mutual society, help and comfort, that the one ought to have of the other, both in prosperity and adversity." Thomas Jefferson promised to "love her, honor her, comfort her and keep her in sickness and in health." Martha Skelton swore to "obey him, serve him, love, honor and keep him in sickness and in health." John Wayles stepped forward to give his daughter to Jefferson, as he had done once before to Bathurst Skelton. Both vowed to love and cherish one another, and Martha again promised to obey her husband. Prayers followed: that the couple be blessed with children, and live long enough to give those children a Christian upbringing; that in the marriage, representing "the spiritual marriage and unity

between Christ and his church," Thomas would love his wife, and Martha would "be loving and amiable, faithful and obedient to her husband, and in all quietness, sobriety and peace, be a follower of holy and godly matrons." Reverend Coutts reminded the couple of Saints Paul and Peter's advice on the duties of husbands and wives, enjoining Jefferson to love his wife even as himself, weaker vessel that she was; and reminding Martha to "submit to your husband as unto the Lord, for the husband is the head of the wife, even as Christ is the head of the church," to be in subjection and obey with a meek and quiet spirit, "as Sarah obeyed Abraham, calling him Lord."

Thomas and Martha Jefferson loved one another deeply. For them love was not what many of us today think it should be. It was not a bond between equals. But neither was marriage what it had been for their parents' generation, when there had been no question about who was in charge, and not much sentiment about arrangements made primarily as alliances of family and property. By the time Martha and Thomas came together, elite Virginians had begun to believe that husbands and wives should share "mutual affections." These feelings were different for each; they were reciprocal obligations and emotions. Thomas and Martha both embraced what the age called "sensibility," a "development of sensitivity toward others, particularly one's inferiors—the poor and the weak, including females and children." They still expected different things from one another.

Thomas Jefferson was a devoted partisan of "domestic tranquility," an ideal that depended on a wife's willingness to put the goal of pleasing her husband above every other need or desire. He took pride in keeping his own temper in check, in presenting a mild face to the world, though he intended to be in charge. He assumed that Martha would play her part as a sweet and sunny helpmeet who would defer to his wishes and judgments. "Gentle and sympathetic people always attracted him most, and clearly she was that sort," wrote Dumas Malone, Jefferson's great biographer, conceding that "she may have had her fiery moments before childbearing wore her out."

How would they maintain such tranquility? Thomas Jefferson believed that men must control themselves, reining in their anger and ruling their households with a firm but loving hand. Women, he thought, had a sacred duty to please their husbands in all regards, to make themselves attractive and keep a clean, welcoming, and abundant home. They should never object to their husbands' decisions, and should repress even the urge to quibble or complain. The historian Kathleen Brown has written that men like Jefferson may have embraced the notion of domestic tranquility in their effort "to maintain the upper hand against women who often brought significant economic resources to the marriage." Martha, as her friends and family knew her, was a spirited, popular, sometimes sharp-tongued woman, a widow who had lost a son. She was no longer a girl, and she brought the power of her future inheritance to their union.

Martha pledged to obey as well as love and honor her new husband, to tailor her wishes to his desires and determinations. But she worked to manipulate what she could not control. Thomas had promised, for his part, to provide for and protect her, a taller order than either of them could know. As before, she made no prenuptial agreement in this marriage, left no trace of writing to signify her claims. She preferred to get what she wanted using other means.

THE NEWLYWEDS STAYED for a time at the Forest and made a visit to Tuckahoe before heading off to Monticello. The trip would become the stuff of family legend, and a favorite tale of Jefferson biographers. Their daughter Martha Jefferson Randolph recounted her father's story of a honeymoon journey in a snowstorm. Thomas and Martha Jefferson set out in the phaeton, but as the snow piled higher and higher, they left the vehicle at a neighbor's house, continuing up the mountain on horseback through snow growing ever deeper. By the time they arrived, it was long past dark. Since they had not sent word that they were coming, no one on the mountain had prepared for their arrival. Who, after all, would travel in such weather? As Jefferson would record in his Garden Book, "the deepest snow we have ever seen. In Albemarle it was 3. f. deep."

The place was dark, the hearth cold, and Martha, her daughter would attest, "shivered at the horrible dreariness of such a house." The slaves who lived on the mountain were asleep in their own cabins. According to Henry Randall, "Part of a bottle of wine, found on a shelf behind some books, had to serve the new-married couple both for fire and supper. Tempers too sunny to be ruffled by many ten times as serious annoyances in after life, now found sources of diversion in these ludicrous *contre-temps*, and the 'horrible dreariness' was lit up with song, and merriment, and laughter!" James Parton found even more romance in the scene. "Who could wish a better place for a honeymoon than a snug brick cottage, lifted five hundred and eighty feet above the world, with half a dozen counties in sight, and three feet of snow blocking out all intruders? What readings of Ossian there must have been! I hope she enjoyed them as well as he."

Linger here a moment, at the very instant in which Jefferson biographers have led us to imagine the first flowering of a Monticello idyll, of what Thomas Jefferson would depict as "ten years in unchequered happiness" with Martha Wayles Skelton Jefferson, his beloved and only wife. Here is a picture of them lighting up the dark in a frigid brick cottage, singing and sipping and sporting to the rhythms of a fraudulent Celtic poet, a poet Dr. Samuel Johnson believed so bad, indeed, that when someone asked Johnson whether he believed that any man could have written the poems of Ossian, he was said to have replied, "Yes. Many men, many women, and many children." JOHNSON, OF COURSE, may have been too hard on Ossian, as he was on any number of people. But if the poetry was of debatable provenance, what of the idyll? Consider the cold comfort of Martha's first encounter with Monticello, a place, we are told, she and the deliriously happy Jefferson soon warmed with their joy in each other, in a bed he had recently bought for the substantial sum of nearly eight pounds. Martha Jefferson, gentlewoman, slaveholder, and daughter of a slave trader, expected to be cared for and catered to. Both she and Thomas generally traveled with servants, in Martha's case probably fourteen-year-old Betty Brown, Betty Hemings's daughter, while Thomas usually rode with Jupiter. When the newlyweds set out in the phaeton, they likely sent their baggage in a wagon, and if the story of their arrival alone at the mountaintop is true, at some point in the snowy journey they must have left their slaves and the luggage behind. Otherwise Jefferson surely would have sent Jupiter ahead to announce their arrival and begin to make preparations, as he did on many other occasions. Possibly there were four, not two people slogging their way up the mountain that night, and Jefferson's reminiscences merely reflect the slaveholder's habitual erasure of the presence of the enslaved.

But perhaps the couple decided they cared more about privacy than comfort at Jefferson's little house. Maybe they preferred not to share the one room, or to spend time making sleeping arrangements for two other people. One way or another, Martha proved a confident horsewoman, riding sidesaddle in wet skirts, to put herself through such a trip.

As the miles wore on and the snow drifted and blew, deeper and deeper, Thomas and Martha surely hoped that someone at Monticello had prepared to make them comfortable. The story, told so often and meant to inspire laughter, still bespeaks their disappointment at finding the place dark and cold. No one had laid a fire or even left dry wood, prepared a hot meal, or just set out cold bread and cheese. But why should things have been otherwise? The master had only moved into the house in a provisional way. Since first taking up residence, Thomas Jefferson had been absent more than he'd been home—off to Williamsburg, riding around tending his law practice, visiting his bride-to-be. He'd been gone for weeks, since long before the wedding and nearly a month after. This epic winter journey was not, as Jefferson scholars have suggested, the freezing but merry beginning of Martha and Thomas Jefferson's housekeeping at their legendary home. It was, instead, a brief, memorable episode in a journey that would take Thomas back to his work in Williamsburg, and Martha back to her own home places.

Martha might reasonably have felt dismay, disappointment, or anger at finding herself cold and hungry after such a hard trip, in a place doubtless oversold by her enthusiastic and romantic husband. Here was a first, excellent lesson in how to create domestic tranquility: by looking on the bright side. No doubt she was relieved to get off the horse, and in any case she adored her new husband. He believed it was a woman's duty to shrug off minor inconveniences and even major disappointments, and nothing she could do would change his mind. So Martha cheered up as best she could, and as she would do again and again over ten years scored with trauma after trauma. After her death, Jefferson would remember her as the embodiment of gentleness, warmth, and forbearance. Putting a good face on things, whenever possible, helped Martha get what she wanted, though at a cost she would later find hard to pay.

The diversions of rustic seclusion had a short shelf life. And the snow began to melt. By February 2, they had relinquished the rough pleasures of Monticello for the comfort of Elk Hill, the house Martha had shared with Bathurst Skelton. Martha determined to claim that residence as her own, and returned there again and again. Meanwhile, because of business obligations, Thomas spent much of their first year of marriage living in rented rooms in Williamsburg. Martha was not with him. She went not to Monticello, but back to her family.

MARTHA AND THOMAS Jefferson returned to Monticello at the end of June. She had once again proven herself a fertile bride, with the baby due in the fall. She may have had some trouble with the pregnancy, or perhaps she was simply acting on a previous problem with breastfeeding, since Thomas purchased breast pipes, blown glass instruments used to elongate inverted nipples, in Williamsburg. To use those pipes, someone had to suck through a glass tube attached to a bowl. The fact that Thomas Jefferson bought such devices for his wife suggests he was intimately involved in seeking to relieve the uncomfortable aspects of her pregnancy.

Martha set about her housekeeping with energy as soon as they returned to Monticello. She borrowed an account book in which Thomas was keeping some legal notations, and began keeping track of her household activities. That journal of daily endeavor at Monticello, one of the few surviving documents in Martha's hand, offers a kind of counterpoint to Thomas Jefferson's famous garden and farm books. Historians have delighted in the entry that opened the Garden Book in 1766—"Purple hyacinth begins to bloom"—just as they have contemplated the coldly dispassionate way Jefferson tallied his human property in the Farm Book. Martha's book—or part of a book, a sheaf of borrowed pages—began in a homelier and more pragmatic way, echoing Thomas's Garden Book through a misspelling. On February 10, 1772, she wrote, "opened a barrel of col. Harrisons flower."

Many of the entries for that year dealt with slaughter: "a mutton killed" on February 13 and again on March 20; turkeys and pullets

94 🧏 THE WOMEN JEFFERSON LOVED

and ducks and geese, shoats and pigs slaughtered. She wrote down when she broke open loaves of sugar, and recorded the hard and soft soap she made from the rendered fat of the butchered sheep. She bought eighty pounds of butter and no small quantity of beef. She was downright devoted to the brewing of beer, mainly "small beer" with low alcohol content. Over the course of the year, Martha brewed no less than fourteen casks of beer at Monticello.

As hard as they worked for their masters, enslaved people sometimes managed to raise a little cash by gardening, gathering, raising poultry, and trapping small game. In the summer of 1772, Martha paid slaves for eggs, peas, ducks, watermelons, and nearly a hundred chickens! Thomas saw to the ongoing house construction and road building and paid a man for cleaning the well. The Monticello well was unreliable and even dried up from time to time. Jefferson had chosen to build his dream house at the top of a mountain, a site calculated more to provide a view than to ensure a steady supply of fresh water. In drought years, slave wagoners hauled barrels of water up the mountain from springs below. In 1773 and again in 1777, the well was completely dry, and Martha had to manage a large and complex household, not to mention having babies and keeping them healthy, without ready access to clean water.

Their daughter Martha, nicknamed Patsy, was born September 27, 1772, just shy of nine months after the wedding (the Jeffersons, it seems, had answered the first of the Episcopalian causes for holy matrimony, if not necessarily the second). For all the trouble Martha would later have with pregnancy and childbirth, she was brewing beer the week before she gave birth. Still, her father was concerned about her, and hoping to see Thomas in Williamsburg once John Wayles cleared up the matter of a business deal that was not working out.

Wayles and his partner, Richard Randolph, were acting as selling agents for a consignment of 490 people, captured in Africa and brought over on a slave ship called the *Prince of Wales*. As fate would have it, the ship might more aptly have been named the *Price of Wayles*. The two partners financed the deal with a loan from the British merchant house Farell and Jones, intending to hold a slave auction at Bermuda Hundred, pay off the loan, and keep the profit. But trading in captive people, potentially enormously lucrative, was also incredibly risky. By the time the ship arrived, ninety of the miserable passengers had died, a horrifying but by no means unusual incidence of mortality for a slave ship. Those who lived were in terrible condition. The purchasers at the auction bought these people on—what else?—credit, pledging to pay in tobacco. Wayles would die with those debts uncollected, leaving Richard Randolph and Wayles's own heirs holding the bag.

John Wayles was worried about his daughter, his slave ship, and the rising fervor of opposition to Britain. He expressed his concern to Thomas Jefferson, who was then in Williamsburg aligning himself with the resistance: "I have heard nothing about our dear Patty since you left this place. . . . Our sale of Slaves go[es] on Slowly so 'tis uncertain when we shall be down but I suppose before the Rebel party leaves town."

WE DO NOT know how Martha felt about her father's ventures in human beings. She may have been ignorant of the financial and legal aspects, and though she was certainly steeped in the daily regimes of slavery, she may never have attended a slave auction herself. But even if Martha did not personally witness the buying and selling of people, she took for granted her right to exploit that terrible commerce to solve her intimate problems. In January 1773, at Martha's behest, Thomas attended a slave sale. He went to a plantation called Maiden's Adventure, where he spent £210 (on twelve months' credit) to purchase three people: Ursula Granger, her fourteen-year-old son, George, and her five-year-old son, Bagwell. Martha wanted him to buy Ursula, a large and formidable person who could do everything from laundry and ironing to caring for children, from smoking hams and making pastry to "switching" miscreants. To get Ursula, who would become a "favorite housewoman," Martha was willing to also take the children. Martha and Thomas agreed that enslaved families should be kept together, the owners' finances permitting. Jefferson would shortly buy Ursula's husband, George Granger, from another planter, and the Grangers were soon central members of the Jefferson household. Isaac Jefferson, Ursula's youngest son, recalled the way that "Mrs. Jefferson would come out there with a cookery book in her hand and read out of it to Isaac's mother how to make cakes, tarts, and so on." But the relationship between the mistress and her slave woman was more intimate than cakes and tarts. Martha did have trouble nursing, as she had anticipated, and Patsy continued to be small and sickly. The Jeffersons asked Ursula to wet-nurse Patsy, providing what Thomas Jefferson called "a good breast of milk." Patsy rapidly began to thrive, although Ursula's own baby, Archy, died in 1774.

AS BABY PATSY began to bloom, the Jeffersons left the mountain. Thomas attended the legislature, while Martha had family business. Her sister Elizabeth Eppes, like Martha, had already lost a son, but was pregnant again. She gave birth to her second child, John Wayles Eppes (to be known as Jack) at Eppington, on April 7, 1773. Martha had worries as well as joy: her father was seriously ill. She stayed at or near the Forest at least through the spring, perhaps through the early summer.

Consequently, the Jeffersons were absent when another new cousin arrived at Shadwell, when Thomas's sister, Martha Carr, gave birth to her sixth child. As we have seen, Dabney Carr could not linger with his namesake baby boy. He headed off to Williamsburg for that fateful session of the legislature, when the Burgesses voted to establish the first colonial Committee of Correspondence, and the royal governor, Lord Dunmore, in retaliation dissolved the assembly.

This time of political upheaval was another season of tragedy for Martha and Thomas, as each lost the most important man in her and his life. Dabney Carr went to Shadwell after the history-making legislative session, intending to return to politics in the capital. Carr was feeling poorly while at Shadwell, and felt so ill on his attempt to ride back to Williamsburg that he returned to his mother-in-law's house and took to his bed. Whatever was wrong with him, the Jeffersons' doctor, George Gilmer, diagnosed the ailment as "a bilious fever." Following the practices common to the so-called heroic medicine of the day, Gilmer treated Carr with ipecacahuana (to induce sweating and vomiting) and a cathartic that caused severe diarrhea. Doctors believed that if such dosing did not kill the patient, it would provoke a cathartic cure. On May 16, 1773, Dabney Carr died.

As we have seen, Dabney Carr's body was buried not once, but yet again when the grief-stricken Jefferson returned and insisted on having the corpse moved to Monticello. Carr's widow, Jefferson's sister, had already returned with her children to her house at Spring Forest in Goochland County. Thomas Jefferson's terrible grief at his friend's death was compounded by his own wife's absence. Jefferson had left his father-in-law "in so low a situation that his life could not be depended on, which makes me extremely anxious to return." Carr's second grave had scarcely been dug and filled when John Wayles died, on May 28, at the age of fifty-eight. Martha had spent most of that spring at the Forest, taking care of her dying father.

Historian Rhys Isaac pointed out that when Thomas Jefferson

brought Martha to his mountaintop, "he marked Monticello strongly as an example of the novel setting that was becoming increasingly prevalent in the North Atlantic world at this time—a household sentimentalized by the married couple at its center as the secluded domestic sphere of 'home.'" The death and reburial of Dabney Carr, the first person interred in Thomas Jefferson's Monticello cemetery, was similarly a sacred origin tale for Monticello. "With Carr," wrote Isaac, "the mythologizing of the mountaintop as a place of destiny, the place of their shared last rest, had begun."

But these were Thomas's visions and dreams, reiterated and embroidered and treasured by daughters and grandchildren as mementos of the founding mother most of them had never known. Those visions foundered on the rocks of reality and mortality. Martha's experiences of Monticello were starkly different from those of her husband. In the case of the tragic demise of Dabney Carr, that mythic moment in the Monticello graveyard, she wasn't even there.

JOHN WAYLES DIED when Martha was not yet twenty-five years old. Her world would never be the same. Her father had been her source of security her entire life, as a motherless child, a bereaved widow, the heartbroken mother of a dead son. He was still looking out for her when he amended his will in February 1773. His health failing, he worried about the debt he owed Farell and Jones, growing larger on account of his last, immense foray into the slave trade. Wayles stipulated that all the tobacco he was growing on his various lands be shipped to pay that debt, "unless my children should find it to their interest to pay and satisfie the same in a manner that may be agreeable to the said Farrel and Jones."

John Wayles had always taken care of Martha. He had written a first will long before, in April 1760, soon after his third marriage. Martha was then twelve years old, a tough age for a girl faced with yet another stepmother. Many fathers, either through neglect or to please the new wife, disinherited children from their previous marriages. Wayles, however, made it clear that Martha must inherit the legacy spelled out in her mother's marriage settlement, and he went even further. He worried that Martha would feel that she had been treated unfairly when he left the rest of his estate—"all & singular my Lands Tenements & Hereditaments, and also all my slaves and all my other Estate both real and personal"—to his other daughters, Elizabeth, Tabitha, and Anne. Thus he declared, "It is my desire that, if my Daughter Martha thinks her portion not Equal to her Sisters, that her Portion may be thrown into Hotchpotch with her three sisters above and the same Equally Divided among them."

Martha chose not to intermingle her inheritance in "hotchpotch" with her sisters' legacies. Her share already encompassed some eleven thousand acres of land and 135 human beings. With Martha's inheritance, Thomas Jefferson became, for the first time, a truly rich man, more than doubling his own fortune. But he also inherited the debt that so worried John Wayles, an obligation that did not seem onerous at the time but would bedevil Jefferson for all the years to come.

Martha's Property

8

IN THE SUMMER of 1773, Thomas Jefferson began the journey to his ringing embrace of life, liberty, and the pursuit of happiness. Martha Jefferson contemplated death, duty, and the fate of her slaves. The three surviving Wayles sisters—Martha, Elizabeth Eppes, and Anne Skipwith—now had to come to grips with the consequences of their father's death. They had land to partition, people to divide up and move around. Martha had already begun to assemble her household, beginning with her maid, Betty Brown, and the redoubtable Ursula and her family. Thomas too was attending to his human property, claiming his mother's slaves in return for assuming Jane Jefferson's debts. Digging and hammering and brick burning at Monticello continued.

Now Martha had to make some decisions about the Hemings family, from thirty-eight-year-old Betty Hemings on down to Martha's youngest half-sister, the infant Sally Hemings. Since Martha had inherited Betty and her descendants, the Hemingses were now Thomas Jefferson's property. As long as John Wayles lived, they had been part of the household at the Forest. But what would happen to them now?

Martha's sister Elizabeth and the latter's husband, Francis, had

temporarily given up their new house at Eppington and moved to the Forest, to manage John Wayles's estate. The oldest Hemings sons, Martin and Robert, would stay there to serve the Eppeses, but Betty and her younger children would leave. Anne and Henry Skipwith, recently married, were moving to the Appomattox River plantation John Wayles had named Guinea but that the Skipwiths gave a more high-toned name, Hors du Monde. Betty Hemings and her children went there with the Skipwiths, far from Williamsburg.

Packing their late father's concubine and their youngest half-sisters and half-brothers off to Hors du Monde was a good way for the Wayles sisters to keep the Hemingses out of sight. Anne Skipwith, like Martha Jefferson, had inherited thousands of acres of land and scores of slaves of her own. Presumably Henry Skipwith also came to the marriage with human property. Surely there were others who could help with the housekeeping for a newlywed couple.

If Betty Hemings had stayed at the Forest, there would have been two babies around the house, Jack Eppes and Sally Hemings, nephew and aunt, respectively. There might be family resemblances that everyone would have to ignore or deny. John Wayles may have taken his mixed-race household for granted, but as the attacks on his character following the Chiswell case suggest, some of his neighbors may have taken a dimmer view. Given the murder of Francis Eppes's brother by Sukey, the slave girl, seven years before, how did Eppes feel about the light-skinned Hemings children, who provided such indisputable evidence of master-slave intimacy?

Whatever the emotions of their white relatives and owners, Betty Hemings and her children had no claim to a home, or, really, to anything at all after the death of their master and father. The person who had the power to determine their fate was Thomas Jefferson. This newly wealthy man had immense plans for his domestic establishment. He was in love, and eager to please his wife. And he was certainly aware of the risks that slaves faced on plantations remote from the home quarters. It was only three years since the murder of Hannah at Snowdon, an incident likely known to the Hemingses and to Martha as well. The Jeffersons preferred to act as if such things did not happen, but that kind of news traveled far and fast in colonial Virginia, and left deep scars in its path.

Thomas Jefferson had the legal right to decide what happened to the Hemingses, right up to putting them on the auction block. Such a course may have occurred to him. His brothers-in-law, Francis Eppes and Henry Skipwith, were preparing to sell 150 of the slaves their wives had inherited from John Wayles. Jefferson already owned whole families of people who had staffed the household at Shadwell.

But it seems Jefferson never thought about selling the Hemingses. Instead he began to bring them to Monticello, installing them in the foremost positions of responsibility, supplanting some of the people who had served his mother and father before him. He was clearly doing what Martha wished. Still, the Hemingses had to earn his trust. Martin Hemings left the Eppeses at the Forest and came to Monticello, and so did nearly five dozen bottles of Jamaican rum. Jefferson noted his intent to "keep a tally of these as we use them by making a mark in the margin in order to try the fidelity of Martin."

Elizabeth Hemings had known Martha all her life, and Martha had grown up with the Hemings children. She knew what had transpired between her father and his concubine, and Martha had just spent months with the pregnant Betty Hemings, nursing John Wayles through his last illness. She saw to it that the Hemings family came to live with her. But we should not romanticize the relationship between Martha the mistress and her enslaved kin. Whatever affection existed between them was shot through with the stubborn fiction of white supremacy and the inescapable fact of human bondage. Love, as we have seen in the case of the Jeffersons, did not imply equal power or responsibility between people—far from it. Instead, a man's love for a woman, or a master's affection toward a slave, expressed a belief that the superior person must protect the loved (and in some measure, despised or pitied) inferior. Thomas Jefferson loved his wife but would never have imagined her to be his peer. Martha may have loved Elizabeth Hemings and her children but she would not have seen them as her equals. If their skin color and family ties made them, in her eyes, a caste apart from other enslaved people, they were also a caste apart from her.

Trying to wrap our twenty-first-century minds around the entanglements of the Wayles-Eppes-Hemings-Jefferson family is a little like trying to eat spaghetti with a knife. Annette Gordon-Reed has rightly called such a confusion of cross-caste, cross-race kinship "bizarre." The white members of this extended family practiced a denial so deep that it became second nature. The black members had to pretend that they saw and knew only what whites wanted them to see and know, while among themselves they kept alive the larger story. The strangeness and silencing of southern interracial kinship was so pervasive, and so weighty a legacy, that six children and their mother could disappear inside it, not just for days or years, but for decades and centuries. In 1948, Dumas Malone would write blithely that John Wayles's death was "less tragic" than that of Dabney Carr, "for he was a widower of fifty-eight and his children were all grown or nearly so." That cavalier pronouncement would have come as bitter but not surprising news to Elizabeth Hemings, nursing little Sally and wondering about her future.

Love never occurs in a vacuum, and love is never, ever simple. Love can be exploitative and terribly cruel. Even in today's small nuclear families there is plenty of room for warmth and rage, for gratitude and resentment, for soothing and laughing and fighting, for lies, secrets, and silences. How much more volatile and confusing was the world of Martha Jefferson's family! For one thing, Betty Hemings's older children—Mary, Martin, Nancy, and Betty Brown—had reason to feel differently about their new owners than the younger ones would. The older Hemingses had grown up under the control of John Wayles, a man who bought and sold human beings by the hundreds, right up to his last days, and who had taken their mother as his concubine. The younger ones would come of age as possessions of Thomas Jefferson. As a young lawyer, Jefferson had represented a slave suing for his freedom. He lived well off the labor of the enslaved but he hated the institution. He resented the debt John Wayles had left as a result of the voyage of the slave ship *Prince of Wales* and did what he could to keep from paying his part of that debt. And, of course, Thomas Jefferson would become the most celebrated lover of liberty in American history.

For her part, Martha Wayles Skelton Jefferson depended upon and took for granted the right to own slaves. She may have cared for them, may have loved some of them. She might even have considered the possibility of freedom for some of those closest to her. But she would not have imagined that it was within her power to do anything at all about the larger institution. More, even, than most women of her time, place, and class, she was willing to leave public matters entirely to men, trusting them to do the right thing. Unlike her mother and her daughters, she never signed a marriage contract, asserting her legal rights over her own property. Her father had always taken care of such matters, and her husband believed women were happiest when they confined themselves strictly to matters of hearth and home. She could not, and perhaps did not want to change the law, or even men's minds. Her way, instead, was to focus on what she could do personally, and that was no simple matter. Every day she faced dozens of choices about how to treat people she was related to but could not openly recognize, people she needed and owned, people who were skilled and knowledgeable and emotionally invested and conflicted in their own right.

Martha's family-the nucleus of what Jefferson would come to refer to, in the slaveholder's patriarchal language, by the same word-was tailor-made for ambivalence and pettiness, generosity and anger. If she harbored any jealousy of Elizabeth Hemings, if she resented the Hemings children, she had the right to express any or all of those feelings toward the Hemingses, while they could not respond in kind. If she felt like hitting any one of them, at any time, law and custom gave her complete license to do so. Few of her contemporaries questioned the necessity of using the rod to keep order and to teach moral lessons. Even Thomas Jefferson, no advocate of violent punishment, on occasion resorted to the whip. We have no way of knowing what kind of discipline John Wayles, the poor boy turned slave trader, used on the people he owned, or for that matter, on his legitimate daughters. We do know that on at least one occasion Thomas Jefferson admonished Martha for being too hard on little Patsy, who would recall to her own daughter, Ellen Randolph Coolidge, Martha's "vivacity of temper," a "little asperity [that] sometimes shewed itself to her children, and of course more to my mother, her oldest child, than the others who were much younger."

Martha Jefferson was a charming woman. She had a gentle, amiable, cheerful way about her. But she expected to give orders and to see her commands obeyed. Her father had held hundreds of slaves, and through her inheritance, her husband would do likewise. While she may have known the names of some who sweated out their lives in the tobacco fields, she had little personal contact with most of those people. From her point of view, it was enough that they kept the crops growing and selling, kept her father's or husband's line of credit flowing. She took her own job, as manager of the household, seriously, and kept her accounts not out of some childlike desire to emulate her document-loving husband, but at least in part as a hedge against theft by those she supervised. She watched closely over the slaughtering of hogs to make sure that nobody made off with a hunk of her meat.

The enslaved people Martha saw and lived with every day had to please her. If they did not, she could use the whip to compel obedience, or order an overseer to administer punishment. She may have disagreed with her husband about matters of discipline. Jefferson hated violence; as Marie and Edmund Morgan write, "It was as natural as breathing for Jefferson to prefer wheedling to whipping." If he stayed her hand with Patsy, perhaps he did likewise with those bound to obey Martha's will. But it seems just as likely that Martha used familiar feminine tools—gentle persuasion, indirection, manipulation—to get her way with those who served, as well as those who ruled.

THE HEMINGSES DID not go all at once to Monticello. There was at least one good reason not to move more people to the mountain in the summer of 1773: the well was dry. But the Jeffersons began to bring them closer. In 1774, Martin, Robert, James, and Mary Hemings joined their sister, Betty Brown (and their half-sister, Martha Jefferson), on the mountain, raising the number of enslaved people there to forty-five. Betty Hemings went with her older daughter Nancy and the younger children, Thenia, Critta, Peter, and Sally, to Elk Hill, bringing the slave population at that establishment to seventy-four.

Martha sent the Hemingses to Elk Hill as a way of claiming the place. Even though she had not insisted on a prenuptial agreement, she was determined to shape the future of her property, in real estate as well as people. Thomas needed to find some way to pay his third of John Wayles's debts, and in July 1773 he began to think about which of his newly inherited lands to put up for sale. He planned to keep Poplar Forest, the Wayles plantation in Bedford County that would eventually become his home away from home. But he thought he might sell Martha's lands at Elk Island. Though Martha had lived at Elk Hill, John Wayles had left the place not to her, but instead to Anne and Henry Skipwith. In the months after Wayles's death, Jefferson thought it might be a good idea to get rid of all his Goochland County properties.

Instead, in January 1774, as he sold more than half the land Martha had inherited, he decided to buy Elk Hill from the Skipwiths. The deed for the property reflected Martha's reticence about public matters; both her sister and brother-in-law signed as sellers, but only Thomas Jefferson was listed as purchaser. The same held true later, when Jefferson bought two more tracts of land adjoining the original Elk Hill property, more than doubling the size of that estate to a total of 669 acres.

Why would Jefferson keep Elk Island and seek not simply to own but also to expand the plantation where his wife had lived with her first husband? Judging from their visit so soon after their wedding, and the fact that she returned there again and again, the place meant something to her. She had an established, peaceful house at Elk Hill; at the unfinished and half-habitable Monticello, a shifting cast of white workmen and enslaved laborers was still blasting roadbeds and firing bricks. Elk Hill had particular charms-a great view of the river, an abundance of game. Thomas Jefferson had learned to shoot from his father, and was known to hunt small game from time to time, in part as a means of getting off in the countryside by himself. Isaac Jefferson, Ursula's son, recalled that "Mr. Jefferson used to hunt squirrels and partridges; kept five or six guns. Oftentimes carred Isaac wid him. Old Master wouldn't shoot partridges settin'. Said 'he wouldn't take advantage of 'em'-would give 'em a chance for thar life. Wouldn't shoot a hare settin' nuther; skeer him up fust." But Thomas Jefferson never showed any particular interest in the kind of hunting so adored

by the Virginia gentry, with foxes and hounds and grand, bibulous breakfasts. The opportunity to host hunting parties was one of Elk Hill's attractions, more Martha's idea of fun than her husband's.

Thomas had reasons of his own for deciding to make Elk Hill a second residence. It was near his widowed sister's place at Spring Forest, and on the way to Tuckahoe as well as Williamsburg. Elk Hill was also closer than Monticello to Martha's sisters at the Forest and Hors du Monde. It was convenient and comfortable, and being there pleased Martha. They could afford two houses. If Monticello was then and would always be his creation and his passion, it was not necessarily the center, and certainly not the compass, of Martha's world. For her, Elk Hill was a beloved place.

IN THE WAKE of John Wayles's death, the Jeffersons spent most of their time with Martha's family, at Williamsburg, the Forest, Bermuda Hundred, and Elk Hill. But they were, after all, building a home of their own. They returned to Monticello in January 1774. With another baby expected in the spring, Martha pursued her housekeeping. She saw to the hog slaughtering, borrowed ten pounds of sugar from her mother-in-law, and used the sugar to brew fifteen gallons of beer. She churned butter and paid back those ten pounds of Jane Jefferson's sugar. She played cards (and lost a shilling and threepence), a pursuit of which her husband was said to disapprove, though he played a little backgammon himself. The closer she came to giving birth, the more beer she brewed. If this musical woman ever conceived of keeping house as being a little like playing a song, her steady work at brewing was a refrain in merry measure. But the tune would falter. As far as we know, this was the last beer she ever brewed.

February brought the frightening earthquake and the drowning of Thomas's sister Elizabeth. As he recovered from that tragedy, Thomas turned to gardening at Monticello with a passion, laying out a vast new garden bed, seeing to the planting of radicchio, salsify, cippolinis, lentils, all sorts of plain and exotic vegetables; hills of nasturtiums and cresses; apples, cherries, and almonds from seed and seedlings. Their second daughter was born on April 3, 1774. In homage to a mother-in-law coping with her own daughter's death, they named the baby Jane Randolph Jefferson.

His World and Hers

AS THE PEACH trees bloomed and the shoots of early peas poked up through the soil, events conspired to pull Thomas Jefferson more and more away from home. He returned to Williamsburg shortly after his daughter Jane was born, in May 1774. The assembly met again, in the wake of the Boston Tea Party and closure of the port of Boston. Martha stayed behind at Monticello and tried to notice things Thomas would want to know when he returned. She duly recorded eating the first ripe cherries from the trees he had planted, and noted those first peas of the season. When Thomas got back, he would look over her journal and record her observations in his Garden Book.

Much as he treasured the small pleasures of home, the torrent of public life was sweeping Thomas away. Down in Williamsburg, when Jefferson and his allies proposed a day of fasting and prayer in solidarity with their "sister colony" of Massachusetts, the governor, Lord Dunmore, responded by dissolving the assembly. Jefferson, by now a leader of the radicals in the legislature, joined the unofficial meetings at the Raleigh Tavern. As he looked back later, he would describe his younger self as "bold in the pursuit of knowledge, never fearing

9

to follow truth and reason to whatever results they led, and bearding every authority which stood in the way."

The stalking of truth and reason was about to become a very dangerous hunt, and we may wonder how a mother of two little girls felt about her young husband's willingness to take such risks. Thomas was embroiled in controversy and formulating his first great statement of political philosophy, an incendiary pamphlet that would be printed, without his knowledge or consent, though not without pride in his authorship, as *A Summary View of the Rights of British America*. Martha, back at Monticello, was suffering from a painful and worrisome breast abscess. Dr. Gilmer came to treat her, though she could not take time away from her growing household. At the end of June, she distributed clothing to the household slaves, counted up her china and pewter ware, made soap and candles, and bought and butchered beef and mutton and shoats.

This was the season in which Thomas Jefferson, planter, lawyer, and provincial aristocrat, became a revolutionary. In *A Summary View*, he rejected the authority of Parliament in America, arguing that though the colonies owed allegiance to the king, they elected their own representatives to local legislatures. The Continental Congress, then meeting in Philadelphia, would not tread that far, not yet. As historian Fawn Brodie pointed out, "Jefferson must have known that his *Summary View* invited hanging."

He was on perilous political ground, but Jefferson situated his argument deeply and firmly in the terrain of his real life, as an Albemarle County planter and lawyer, clearing his lands, traversing the breadth of Virginia, leaving his family at home for days and weeks on end. Should such a man's fate be tied to a distant, negligent, sometimes abusive government? As he saw it, the original British colonists, like their Saxon ancestors, had left "the country in which chance, not choice, had placed them." They had conquered and settled their new lands as individuals: "For themselves they fought, for themselves they conquered, and for themselves alone they have the right to hold." Railing against the colonists' lack of representation in Parliament, Jefferson pointed out the immensity and remoteness of Virginia, a colony that had "as yet affixed no boundary to the westward. Their western counties"—such as Bedford, where Martha had so recently inherited the Poplar Forest lands from her father—"are, therefore, of indefinite extent. Some of them are actually seated many hundreds of miles from their eastern limits." The inhabitants of such far-flung places, he insisted, had a right to govern themselves in a way that suited their lives and livelihoods.

The free man depicted in the *Summary View* sounded very much like the master of Monticello, king in his own vast domain, though a man who ruled uneasily. Jefferson insisted that "the abolition of slavery is the great object of desire in those colonies where it was, unhappily, introduced in their infant state," just as he was coming to grips with his life as holder of hundreds of enslaved people, some of them his wife's kin. But if nature abhorred slavery, nothing in nature prevented certain forms of dominance, certain habits of deference. On any given day, he could sit and write thrilling words about liberty and democracy while his wife and enslaved workers slaughtered a sheep and rendered the fat. Martha might stir the vat of lye and ashes, making soap to wash the ink off Thomas's stained fingers, taking a moment to offer him a refreshing drink. Ursula might wipe her dripping knife, take off a blood-soaked apron, rinse off her hands and face, and take a Jefferson baby to her breast.

MAKING REVOLUTION DID, of course, entail sacrifices. Most of those were ahead of him in the summer of 1774, but even then Thomas Jefferson had his hands full, with his legal work, his enlarged estate, and

his house project. He gave up practicing law (the British had closed the Virginia courts, in any case), but he was having problems making progress on the house, by any measure an ambitious project. Jefferson had ordered fourteen—fourteen!—pairs of sash windows from Britain for Monticello; he expected that they would be seized when they reached Virginia (he would eventually buy them back at auction). The want of those windows added one more incentive to the Jeffersons' decision to move the family to Elk Hill for the winter. Work on the house continued, with the arrival of carpenters Joseph Neilson and William Fossett, and the family would return to the mountain from time to time, of necessity. Thomas had been elected to the Albemarle County committee charged with enforcing the Continental Congress's trade ban with England. Martha had to supervise the winter slaughtering in January, when twenty-five hogs and a goose met their maker at Monticello.

While Thomas attended the Virginia Convention in Richmond, Martha and the girls stayed nearby, at Elk Hill. Patrick Henry called for liberty or death and the Virginia delegates voted to organize and arm militias. Amid the rising preparation for violence, Thomas was chosen to go to the Continental Congress. By now her husband had been a member of what her father called "the rebel party" for years, and Martha must have known what an important part he played in that bold faction. As much as they had been apart before, they had managed to not be far from one another. Now he would go to Philadelphia, more than three hundred miles and seven days' travel away.

As Thomas sallied forth into the bright light of history, Martha retreated into invisibility. He left from Williamsburg on June 11, 1775, arriving in Philadelphia on June 20. For the next five weeks, an abundance of public and private records tells us in vivid detail where Thomas Jefferson was, and what he was doing—paying for punch at City Tavern, buying books and boots and buckles, getting a whip repaired and a key mended, purchasing pickled oysters, corn salve, violin strings, and a tomahawk.

During that same time, we have no idea where Martha was, or who was with her, or what she was doing. She had seldom stayed at Monticello when he was not there. We do not know whether they exchanged letters. He was a devoted husband and a great correspondent, but given the unreliable post and Thomas's plan to return as soon as possible, they may not have done so. In any case, no letters between them have been found. But the fact that he expected to return by way of Virginia's convention at Richmond suggests that Martha may have been at Elk Hill. They would soon head for Monticello. Going to the mountaintop, whatever its allures, had been something less than an exercise in domestic tranquility before. It would be anything but that this time.

During the first three years of their marriage, Thomas Jefferson had been a prominent man in his colony, a man whose wealth and influence were increasing. Martha had married him expecting as much, and knowing that her own inheritance would add to his stature. Now he had taken a perilous road to a distant place, leaving her behind with her fears for him, for her own safety, for her children. One of those terrors became a reality in September, when little Jane, only a year and a half old, died at Monticello. No stone was laid in the graveyard to mark the child's passing.

Thomas could not stay to mourn with Martha. He set out again for Philadelphia on September 25, and this time he would be gone for more than three months. Instead of going with him, Martha went to the Forest to be with her sister, Elizabeth Eppes. Both women had recently borne children who died. For a person as private as Martha, the intimacy of home and the sympathy of family appealed more than the noise, cold, and dirt of a city full of strangers.

But privacy did not ensure safety. That fall of 1775, being in Vir-

ginia, so near to Williamsburg, was riskier than going to Philadelphia. There was fighting along the coast and a rising threat of invasion. Lord Dunmore tried to burn the town of Hampton, and issued his proclamation offering to free any slave who took up arms against rebel masters. The Eppeses knew firsthand how even a weaponless girl could find a way to kill her erstwhile master, and the prospect of armed rebellion could not have been reassuring.

Back in Philadelphia, with matters in Congress increasingly critical, Jefferson wrote regularly to Martha, telling her the political news and worrying about events back home. Historians have presumed that he destroyed all their letters to one another, but we know that he wrote long letters to her and shared with her his views about politics, because he said so in letters to Francis Eppes. "I wrote to Patty on my arrival here," he said on October 10, "and there being then nothing new in the political way I include her letter under a blank cover to you. Since that we have received from England news of much importance," he added, offering a summary of military developments. But instead of repeating what he'd written to his wife, Jefferson advised Eppes that for a more detailed account of developments in the war, "I must refer you to Patty."

Even in Philadelphia, family tragedy seemed to follow Thomas Jefferson. On October 22, he went to dine with his relative and mentor, Peyton Randolph, speaker of the Virginia assembly, at the country house of a Philadelphia wine merchant. That night Randolph suffered a stroke and died. Jefferson wrote the sad news to Martha almost immediately, adding to Francis Eppes, "Our good old Speaker died the night before last. For the particulars of that melancholy event I must refer you to Patty."

While Jefferson could set aside only one day a week to write letters, he wrote to his wife at least every two weeks, and followed up with letters to his brother-in-law. He heard nothing in return. Maybe

116 🧏 THE WOMEN JEFFERSON LOVED

Martha and Eppes did write back, and their letters fell victim to unreliable postal service. Or perhaps they were worried that anything they wrote to him could put them or him in greater danger. Or possibly they were too busy or distraught to write. By the beginning of November, as the Congress boiled with rumors of invasion and insurrection in Virginia, Jefferson was frantic. "I have never received the scrip of a pen from any mortal in Virginia since I left it, nor been able by any enquiries I could make to hear of my family," he wrote to Francis Eppes. "I had hoped that when Mrs. Byrd came I should have heard something of them, but she could tell me nothing about them. The suspense under which I am is too terrible to be endured. If any thing has happened, for god's sake let me know it."

Two weeks later, a terrified Jefferson urged Martha and the Eppeses to flee the Forest and head for a safer place, probably Monticello. "I have written to Patty a proposition to keep yourselves at a distance from the alarms of Ld. Dunmore. To her therefore for want of time I must refer you and shall hope to meet you as proposed." Within days, Robert Carter Nicholas would send his dire warning to the Virginia delegates, conjuring a vision of a country in flames, open to the depredations of Tory militias and the vengeance of rebellious slaves: "The Person of no Man in the Colony is safe, when marked out as an Object of their Vengeance."

Still, Jefferson could not go to Virginia until December 28. For her part, Martha was back at Monticello on December 14, butchering hogs for the smokehouse and killing cattle "for the workmen," making candles and breaking a loaf of sugar. She must have been a very brave woman to journey across Virginia, from the Forest to Monticello, in that fearful time, traveling with a three-year-old. In all likelihood, Martha's trip also required the assistance of enslaved people she felt she could trust, despite Dunmore's proclamation of freedom. All of them would have been safer in Philadelphia. AS THOMAS JEFFERSON made his way home, Lord Dunmore rang in 1776 by bombarding Norfolk. Martha was stocking up. Someone at Monticello was making clothes—Martha had paid a weaver to make twenty-five yards of cloth and purchased stays and scissors and she slaughtered hogs on a larger scale than ever. Ursula presided over most of the work of killing animals and cutting them up, salting and applying saltpeter and hanging the meat in the smokehouse. But Martha was deeply involved as well, if only to stand nearby and make sure that no one stole away with any of her hams. Amid such bloody abundance, the Jeffersons counted themselves well provisioned and safely removed from the war, far enough from the coast to escape the British navy. Work went on at the house, still not fully habitable but rising faster now with the efforts of the white carpenter Joseph Neilson and his apprentice, William Fossett. Life seemed to go on normally enough.

*

So did death. Thomas Jefferson's mother died on March 31 at Monticello. Whether Martha was at her side, we do not know. There was, of course, contact and commerce between Monticello and Shadwell, visits back and forth. Martha sometimes referred to Jane as "my mother," just as Robert Skipwith had referred to Martha as "my sister" rather than sister-in-law. But in the four years Martha had been married to Thomas Jefferson, she had spent relatively little time in Albemarle County. When her husband was away, Martha generally left, too. Having never had a mother of her own, she relied on her sisters, especially Elizabeth Eppes, for support. Jane Jefferson died at the age of fifty-seven, one year younger than John Wayles, and older at the time of her death than many of the women Martha had known. We do not know how Martha felt about her mother-in-law, whether they were close, how she felt the loss. She may have had her hands full caring for the living, in any case, including her husband, who was home at this point suffering with a six-week-long migraine headache.

Jefferson was due back in Philadelphia, and his friend Thomas Nelson, Jr., wrote from there in February, saying that he'd brought his own wife, and Jefferson should bring Martha along when he returned. Martha would have to be inoculated against smallpox if she came, but Nelson insisted, "You must certainly bring Mrs. Jefferson with you. Mrs. Nelson shall nurse her in the small pox and take all possible care of her."

Whether or not Martha wanted to go with her husband to Philadelphia, circumstances conspired to prevent her from taking the trip. Sometime during their months together at Monticello, Martha once more became pregnant. This pregnancy, Martha's fourth as far as we know (she may also have miscarried in 1775), nearly killed her. Historians have wondered about Martha's health problems, which accelerated in the years of the Revolution. Fawn Brodie speculated that Martha may have suffered from "debilitating monthly hemorrhaging, or from a tendency to miscarry when pregnant, or from dangerous anemia after childbirth, or from all three." Whether those hypotheses were correct or not, Brodie was surely on target in asserting that "one would understand why Jefferson could not bring himself to explain even in a private letter the nature of any of these problems. Such was the commonplace taboo."

THOMAS JEFFERSON WAS finally ready to depart for the Congress on May 7, and was clearly worried about Martha. Before he left, he gave her ten pounds (presumably in Virginia currency), more money than he'd ever given her before. Though he would try to get back as soon as he could, he expected to be gone for a while. She would spend the months of April and May at Monticello, but in June she decided to risk going to the Forest. However much she wanted the company of her sister during her pregnancy, both she and Jefferson knew that by moving close to Williamsburg, Martha and three-year-old Patsy would be in greater danger from the British than they were at Monticello. Jefferson's friend John Page, then president of the Virginia Council of State (the provisional government), had sent an alarming letter from Williamsburg to Philadelphia obliterating any imagined distinction between the battlefront and the home front in Virginia, where wartime shortages and instability were eroding morale and stirring up anger at the rebels. "I have snatched a few Moments to scribble you a few loose Thoughts on our present critical Situation," Page wrote.

I think our Countrymen have exhibited an uncommon Degree of Virtue, not only in submiting to all the hard Restrictions and exposing themselves to all the Dangers which are the Consequence of the Disputes they are involved in with Great Britain, but in behaving so peaceably and honestly as they have when they were free from the Restraint of Laws. But how long this may be the Case who can tell? When to their Want of Salt there shall be added a Want of Clothes and Blankets and when to this there may be added the Terrors of a desolating War raging unchecked for Want of Arms and Ammunition, who can say what the People might not do in such a Situation, and tempted with the Prospect of Peace Security and a Trade equal to their wishes? Might they not be induced to give up the Authors of their Misfortunes, their Leaders, who had lead them into such a Scrape, and be willing to sacrifice them to a Reconciliation?

With the fear of social upheaval added to his concern about Martha's health, Jefferson attended the Congress, where there was more bad news about the Continental Army's attempts in Canada. The time

120 🎽 THE WOMEN JEFFERSON LOVED

for independence was at hand; Virginia itself was already functioning as an independent entity, if not a fully governed state. As spring gave way to summer, and Thomas Jefferson took up the perilous, sometimes terrifying, sometimes tedious, eventually exhilarating work of separating from England, he was a man torn in two, dedicated to the liberty of his country but frightened half to death about the state of his family, especially the woman he loved above all other human beings. He had begged Martha and the Eppeses to write to him weekly, and waited anxiously for the arrival of their letters even as the business of the Congress became more and more urgent and absorbing.

Domestic Tranquility

10

WHILE THOMAS JEFFERSON assisted at the birth of his country in Philadelphia, Martha Jefferson fought for her life in Virginia. This pregnancy had gone horribly wrong. She was never far from his mind, even as he drafted his immortal Declaration of Independence, squirmed through the Congress's revisions, and readied himself for the step that put his head irrevocably on the imperial block and inscribed his name in the history books. His original draft of the Declaration reflected his state of mind. As is well known, in one passage deleted by the Congress he passionately condemned King George III for "waging cruel war against human nature itself," by capturing "a distant people who never offended him" and selling them into slavery in America. But in a far less celebrated passage, he also excoriated the king for "exciting those very people to rise in arms among us, and to purchase that liberty of which he has deprived them, by murdering the people on whom he also obtruded them." Philadelphia might be a dangerous place, but he was desperately worried about his ailing wife back home, surrounded by enslaved people, any of whom might take Dunmore's proclamation as a signal to rise against their masters.

* :

ON JUNE 30, he wrote to Edmund Pendleton, President of the Virginia Committee of Safety, to ask that he be replaced in the Congress, for reasons he expressed euphemistically but with force:

I am sorry the situation of my domestic affairs renders it indispensably necessary that I should sollicit the substitution of some other person here in my room. The delicacy of the house will not require me to enter minutely into the private causes which render this necessary.

Concerned as he was, Jefferson held on to hope with tenacity and tenderness. On July 4, 1776, he made time to go shopping, purchasing seven pairs of women's gloves for twenty-seven shillings, acting like a man who meant to spend a good long time hand in hand with his wife. But Martha's condition worsened. Jefferson was frantic. "I have received no letter this week, which lays me under great anxiety," he wrote to Francis Eppes on July 23. "I shall leave this place about the 11th of next month. Give my love to Mrs. Eppes, and tell her that when both you and Patty fail to write to me, I think it shall not be unreasonable in insisting she shall." Letters soon arrived that did nothing but feed his anxiety. He was desperate to leave Congress and get home. To Richard Henry Lee, the replacement delegate who had not yet arrived in Philadelphia, he wrote, "For god's sake, for your country's sake, and for my sake, come. I receive by every post such accounts of the state of Mrs. Jefferson's health, that it will be impossible for me to disappoint her expectation of seeing me at the time I have promised. ... I am under a sacred obligation to go home." He told John Page, "Every letter brings me such an account of the state of her health that it is with great pain that I can stay here."

We do not know how far Martha's pregnancy had advanced when

she miscarried sometime in late June. That sad event saved Martha's life. On the day before independence was declared, Francis Eppes wrote to Jefferson to say that she was recuperating at Elk Hill. "We return'd last Sunday from Elk-Hill whare we had been for a week on a visit to your good Lady; she is perfectly recover'd from her late indisposition and except being a little weak, is as well as ever she was. She is in great expectation of seeing you in August, if your appointment to serve in Congress the insuing year don't prevent." By the end of that month, Edmund Pendleton was writing to wish Jefferson a pleasant journey home and to say that he hoped "you'll find Mrs. Jefferson recovered, as I had the pleasure of hearing in Goochland that she was better." Martha was eager to join her husband, who was heading to Williamsburg to attend the assembly, but Jefferson wrote to Elizabeth Eppes hoping "to stay Patty with her awhile longer."

It took Jefferson only six days to get from Philadelphia to Monticello, and we do not know whether Martha was there to greet him. He had been gone long enough that his wine cellar had run low; someone went down to Shadwell to fetch the bottle he credited to his mother's estate. Martha and Thomas were together by October 4, when he gave her money to tip two slave women at the Forest. Now they would make their way to Williamsburg, where Jefferson's friend George Wythe, then attending the Congress in Philadelphia, had offered the use of his house.

Despite the perils of war, the Jeffersons lived in the capital in comfort and style. Robert Hemings had replaced Jupiter as Jefferson's valet, and he and his older brother Martin attended them. Presumably Martha also had a maid of her own and someone to help with the children. While there were wartime shortages of some goods, the Jeffersons nonetheless managed to buy coffee and tea, bread and cake, oysters and mutton, and shoats and fowl. There was ribbon and gauze and lace to be had, and Patsy even got a new doll. That fall Martha

124 🎽 THE WOMEN JEFFERSON LOVED

became pregnant for the fifth time. Once again she was ill, or at least uneasy; a doctor visited her in early December.

For the moment, they believed, Virginia was secure from the British. Dunmore had sailed away in May, taking with him the "shattered remains" of the "Ethiopian Regiment" of fugitives from slavery, with smallpox on board the ship. In December, Martha and Thomas took a meandering course homeward, visiting their sisters along the way. Jefferson's friend John Page had worried that the shortage of salt was the first step to hardships that would turn the common people away from their revolutionary leaders, but Thomas Jefferson overcame that problem for himself. On the way home, he bought five bushels of salt, a good thing with all the hogs awaiting slaughter at Monticello.

WHEN MARTHA RETURNED to the mountaintop this time, after all the drama and difficulty and danger, Monticello seemed like home. In the best situations there is some tension between mothers-in-law and daughters-in-law, especially when they live as neighbors. We will never know how Martha and Jane Jefferson felt about one another, but one thing is certain: Martha was now indisputably in charge of her household, and at the center of her family's social life. She had another baby coming to replace the children she had lost. As the house at Monticello grew more complete and more majestic, her husband was near at hand, full of high ideals and great plans. In January, she and Ursula killed sixty-eight hogs. Life was good.

Thomas Jefferson treasured the distance between his Albemarle County sanctuary and the war theater. His friend Thomas Nelson, Jr., wrote from Baltimore, describing the horror of the scene of British invasion and the particular dangers to American women:

Could we but get a good Regular Army we should soon clear the Continent of these dan'd Invaders. They play the very Devil with the Girls and even old Women to satisfy their libidinous appetites. There is Scarcely a Virgin to be found in the part of the Country they have passed thro' and yet the Jersies will not turn out. Rapes, Rapine, and Murder are not sufficient to rouse the resentments of these People.

But at Monticello, peace reigned. Amid the usual routine of slaughtering and curing and storing, of candle- and soap-making, Martha inventoried her bedding and linens, made a list of the family's clothes, and generally acted like an expectant mother in the throes of a nesting frenzy. Martha's version of cleaning closets was to make eight dozen candles and sixty-eight pounds of soft soap when she was eight months pregnant. At the end of April, Thomas went off to the legislature in Williamsburg, and as her lying-in time approached in May, she recorded the planting of beans and peas and made still more candles. Finally, on May 28, her son was born, with the assistance of a midwife. Thomas made it back to the mountain just in time.

The baby lived little more than two weeks, not even long enough to acquire a name. Martha resumed her housekeeping, trading with enslaved people, buying their chickens with her bacon. But she lost track of time. She was usually meticulous about dating her household activities in her account book, but in the months of June and July, no dates appeared for her transactions. In August, she determined to get control over her affairs. That month, nearly day by day, she carefully listed every duck or goose or lamb killed, and made a point of mentioning which hams and sides of bacon and pork shoulders and legs they took out of the smokehouse to pack into bags "for our own eating," and which "for workmen." As August flowed into September, she dreamed over her accounts and drew a winsome sketch of two birds on a leafy branch.

In the wake of their son's death, Thomas stayed close, neglecting

his public duties. His colleagues noticed, and some were critical. "It will not perhaps be disagreeable to you in your retirement, sometimes to hear the events of war, and how in other respects we proceed in the arduous business we are engaged in," wrote a sarcastic Richard Henry Lee, in a letter Jefferson did not answer.

Martha's health, and her state of mind, were sometimes too fragile for outdoor work. So she kept busy in the house, making inventories of every bed, blanket, and sheet at Monticello and Elk Hill and Poplar Forest, enumerating Patsy's frocks and pockets and kerchiefs, counting her own nightcaps and aprons and "suits of brussels lace" and Thomas's breeches and coats, his ruffled shirts and white silk stockings. In November, six months after losing her last child, she was pregnant yet again, and as another new year dawned, was back at her slaughtering—forty-two hogs from Bedford, twenty-two from Monticello, another twenty-eight from Elk Hill. On March 17, she echoed the first entry in her housekeeping journal: "opened a barrel of flower." But now she would be thrown into the maelstrom of politics and warfare. Her journal fell silent, not to resume for years.

IN THE SPRING of 1778, the war grew wider. The British had shifted their strategy after the American victory at the Battle of Saratoga and were now putting more redcoats in the South. Thomas Jefferson crisscrossed the state, between Charlottesville and Williamsburg. Sometimes he was at Elk Hill and whenever possible, he was at Monticello. He planted his vegetable garden and tended a tree nursery he hoped would one day yield quinces, apricots, almonds, plums, peaches, nectarines, and a profusion of apples. But Jefferson's memorandum books made no mention of his wife.

Their third daughter, Mary Jefferson, was born on August 1, 1778. Jefferson paid Mrs. Gaines, the midwife, twenty pounds for attending Martha, along with another twenty shillings for assisting Nell, an enslaved woman, who gave birth to a daughter named Scilla. Dr. Gilmer, who had made multiple visits during the preceding months, was there as well. After bearing five children and suffering at least one miscarriage, the repeated ordeal of pregnancy and childbirth had begun to take a serious toll on Martha's body. But she had reason for hope, and for joy. This time, the baby lived. Little Mary, to be called Polly by those who knew her, would be one of only two of Martha's children to live to adulthood. When Polly herself set out on the road to marriage and motherhood, Thomas Jefferson would present his daughter and her new husband with gifts including Scilla, the child born on the same day, at the same place, as the woman who would own her.

Jefferson had lingered at Monticello with Martha, but eventually he was compelled to go to Williamsburg to attend the legislature. He went reluctantly. The House of Delegates went into session on October 5, but when he finally made an appearance on November 30, he was in the custody of the sergeant at arms. As often as he expressed his desire to remove himself from public office and political life, this heavy-handed compulsion of duty did nothing to change his mind. He paid a fine for nonattendance, then hastened to join his family at the Forest before going home to Monticello to greet the new year.

THE WAR FOR Independence came to Albemarle County in a deceptively bloodless way. Following the defeat of British and Hessian troops at Saratoga, four thousand prisoners of war were marched from New York to Charlottesville, to be quartered until they could be exchanged or deported. Among those prisoners were the British general William Phillips and a number of German noblemen who shared Jefferson's love of music, gardening, and the finer things in life. Jefferson offered a nearby property to the German general, Baron Friedrich Adolf von Riedesel, along with his wife and three daughters. As the German prisoners planted gardens, and their aristocratic officers

128 🎽 THE WOMEN JEFFERSON LOVED

joined in musical evenings at Monticello, the Jeffersons and the Riedesels struck up a friendship that included their children.

Frederika Charlotte Louise von Massow, Baroness von Riedesel, was three years younger than Martha, but she had seen far more of the world. The baroness had lived through the hardship of crossing an ocean to join her husband, only to find herself swept up in the war at Saratoga, nursing the wounded in battle and suffering the devastation of defeat. She had journeyed to Albemarle amid deprivation and terror; she and her little girls had nearly starved on the passage through Virginia. "Often our lives were in danger when we passed over breakneck roads, and we suffered terribly from the cold and, what was even worse, from lack of food," she wrote in her vivid memoir of her time in America. To make matters worse, the locals were anything but friendly to the captured woman:

When we arrived in Virginia and had only another day to go before reaching our destination, we had nothing left but tea and some bread and butter, nor could we get anything else. One of the natives gave me a handful of dried fruit. At noon we arrived at a house where I asked for some food, but it was refused harshly with the remark that the people had nothing to give to the royalist dogs. I saw some Turkish flour [Indian meal] and begged for a couple handfuls so that I could mix it with water and make some bread. The woman replied, "No, that is for our Negroes who work for us; you, however, wanted to kill us." Captain Edmonstone offered her a guinea or two for it because my children were so hungry, but she replied, "Not for a hundred would I give it to you; and if you die of hunger, so much the better."

The Riedesels must have been grateful indeed to be in the hands of the generous Jeffersons. Frederika von Massow von Riedesel was likely the first, and probably the only baroness whom Martha ever met, but the two women had much in common. The baroness prided herself on her good cheer and resilience, as did Martha. She too had a passionately devoted husband. And like Martha, she had lost children, a son and a daughter, and was caring for a baby girl. Her title notwithstanding, the baroness was in some regards amazingly downto-earth. Her husband, like Jefferson, loved gardening, though the baron was foolish enough to refuse to wear a hat, and as a result suffered severe sunstroke. The baroness nursed him while she too traded with entrepreneurial slaves for poultry and vegetables, and took her turn in slaughtering oxen and pigs.

For all their earthy activities, however, Martha and the baroness were both accustomed to certain privileges and amenities. Martha had slaves to command; the baroness found soldiers to do her bidding. For her part, the baroness was appalled at the way most Virginians treated their enslaved workers:

Many of them let the slaves walk about stark naked until they are between fifteen and sixteen years old, and the clothes which they give them afterward are not worth wearing. The slaves are in the charge of an overseer who leads them out into the fields at daybreak, where they have to work like cattle or suffer a beating; and when they come home completely tired out and sunburnt they are given some Indian meal called hominy, which they make into baked stuff. Often, however, they are too exhausted to eat and prefer sleeping a couple of hours, because they must go back to work. They look upon it as a misfortune to have children, because these, in turn, will also be slaves and unhappy men. As they have no time to cultivate their own bit of land that is given to them, they have no money whatever, except what they can get from the sale of poultry, with which to buy their clothes.

130 🏋 THE WOMEN JEFFERSON LOVED

She nonetheless admitted, "There are, of course, good masters too. One can recognize them immediately, because their slaves are well dressed and housed. These Negroes are very good servants, very faithful to their master, and very much attached to him."

Whether the baroness had Thomas Jefferson in mind when she pointed to the exceptional "good master," we cannot be sure. The families did spend time together, judging by letters the baron later wrote to Thomas Jefferson, presenting "my respects and Madame de Riedesels best Compliments to Mrs. Jefferson, whose very amiable Character and the many proofs which we have experienced of Her Friendship can never be effaced from out of our Memory, and she will ever possess a high rank among Madame de R's particular Friends." They shared a love of music and attended evenings at the now-completed and impressive Monticello, "an elegant building, projected according to [Jefferson's] own fancy." A Hessian officer whose painting Jefferson admired remarked, "As all Virginians are fond of Music, he is particularly so. You will find in his House an elegant Harpsichord, Pianoforte, & some Violins. The latter he performs very well upon himself, the former his Lady touches very skillfully & who is in all respects a very agreeable, sensible & accomplished lady." Even after the troops were sent off to New York, and war thundered across Virginia, the Baron and Jefferson sent one another affectionate letters, always appending their greetings and good wishes for each other's wives.

For all their friendliness, when the baroness wrote her memoirs she said nothing of the Jeffersons. By the time Frederika von Riedesel looked back, Martha Jefferson had died. Perhaps the baroness shared Thomas Jefferson's belief that silence was the best remedy for grief. Or perhaps their congenial moments had come only intermittently. The entire time the Jeffersons and Riedesels were together in Albemarle, and indeed, for the first nine months of 1779, Martha Jefferson appeared nowhere in Thomas's accounts. He gave money to Martin Hemings on a regular basis, and Martha may have been too ill to manage her household, leaving daily duties to the Monticello majordomo. Whatever the state of her health, Martha had managed to rally for social occasions and to present a gracious and cultured welcome to the noble prisoners.

This interlude of comity between enemies did not last long. Thomas Jefferson sold the pianoforte he'd bought for Martha in 1772 to General Riedesel, who pledged to pay a hundred pounds. At the beginning of May, Jefferson set out for the legislature at Williamsburg, by way of Elk Hill and the Forest. Martha, Patsy, and Polly remained with the Eppeses at the Forest, where they learned that Jefferson had been elected governor of Virginia. He had rather narrowly defeated his friend John Page, who hastened to offer congratulations and assured Jefferson, "As soon as Mrs. Jefferson comes to town Mrs. Page will wait on her." But Jefferson replied that Martha did not intend to come to Williamsburg any time soon. He himself was to depart immediately for a weekend at the Forest. When Martha did decide to join her husband at the capital, Jefferson assured Page, "She has too much [value] for [Mrs.] Page not to consider her acquaintance as a principal among those circumstances which are to reconcile her to her situation." Martha was not eager to take her place as the governor's lady, and her own reservations surely weighed upon a husband always ambivalent about his duty to the public, always longing to return to the peaceful shelter of his home and family.

The War Comes Home

DURING HIS FIRST year and a half as governor, Thomas Jefferson presided over a state that had not yet felt the lash of invasion. But the British were coming. Jefferson struggled to secure money, supplies, and soldiers, and kept an uneasy eye on reports from the northern front, while coping with urgent requests for help from the Continental Army. At least Martha was with him in Williamsburg, sharing something of his public life. For the first time, instead of trading bacon for eggs and chickens and cabbages, she dealt extensively in cash. She started out asking for small sums for her household expenses, but soon found she needed much more of the fast-inflating Virginia currency. In February 1780, she paid almost £120 for an apron.

Martha was more at home in the country than the town, but keeping house anywhere required familiar skills and familiar faces. Ursula and George and their children were there, along with Jupiter, acting as driver and chief groom, Suck (Jupiter's wife and the cook), Martin, Robert, James and Mary Hemings, and Betty Brown. Ursula and George's son, Isaac (later known as Isaac Jefferson), was only five years old at the time, old enough to make fires and carry water. For

11

him the move to town was a momentous event. He recalled much later the impressive procession of the Jefferson entourage, "coming down to Williamsburg... at the time Mr. Jefferson was Governor. He came down in the phaeton, his family with him in a coach and four. Bob Hemings drove the phaeton; Jim Hemings was a body servant; Martin Hemings the butler.... Mary Hemings rode in the wagon." The state capital was relocated to Richmond in April 1780, a move Jefferson promoted over the objections of Tidewater leaders, arguing that getting away from the coast would make the capital both more secure and more convenient to upcountry citizens. "It was cold weather when they moved up," remembered Isaac Jefferson. "Mr. Jefferson lived in a wooden house near where the palace stands now. Richmond was a small place then, no more than two brick houses in the town—all wooden houses what there was."

Being governor did not assure luxury, but at least the horror of war still seemed far away. Thomas and Martha Jefferson received a letter from their friend and putative enemy, General Riedesel, then in New York, announcing "the happy recovery of Madame de Riedesel after having presented me a fourth Daughter, near three weeks ago . . . we both beg leave to reiterate our assurances that it will ever give us much pleasure, not merely from gratitude but our real personal attachment, to hear of your and Mrs. Jeffersons uninterrupted Happiness." Jefferson wrote back quickly, offering facetious congratulations and his own assurances of friendship:

I sincerely condole with Madame de Riedesel on the birth of a *daughter*, but receive great pleasure from the information of her recovery, as every circumstance of felicity to her, yourself or family is interesting to us. The little attentions you are pleased to magnify so much never deserved a mention or thought....

opposed as we happen to be in our sentiments of duty and honor, and anxious for contrary events, I shall nevertheless sincerely rejoice in every circumstance of happiness or safety which may attend you personally, and when a termination of the present contest shall put it in my power to declare to you more unreservedly how sincere are the sentiments of esteem & respect (wherein Mrs. Jefferson joins me) which I entertain for Madme. Riedesel & yourself.

Jefferson's teasing tone belied his own concerns. By this time, it was clear that Martha was enduring her seventh (or perhaps eighth) pregnancy. Only seven-year-old Patsy and two-year-old Polly had survived. Jefferson, like the baroness, clearly hoped for a son.

While Martha remained devoted to her family and household, she dipped a toe into the fast-moving stream of public affairs. At the behest of Martha Washington, she joined in a campaign to make clothes and raise money for the army. She wrote what until recently most historians have assumed was her only surviving letter, to Eleanor Madison, wife of the Reverend James Madison, endorsing the plan. Her letter echoed her pride in her husband's high ideals and his work in founding the new nation:

Richmond, August 8, 1780

MADAM

Mrs. Washington has done me the honor of communicating the inclosed proposition of our sisters of Pennsylvania and of informing me that the same grateful sentiments are displaying themselves in Maryland. Justified by the sanction of her letter in handing forward the scheme I undertake with chearfulness the duty of furnishing to my country women an opportunity of proving that they also participate of those virtuous feelings which gave birth to it. I cannot do more for its promotion than by inclosing to you some of the papers to be disposed of as you think proper. I am with the greatest respect Madam Your most humble servant, MARTHA 7EFFERSON

Martha could not "do more for its promotion" than to send on pertinent papers, because she was once again in poor health. But there is no reason to assume that Martha opposed the war or failed as a patriot. If the letter said nothing else, it plainly stated that she counted herself among those women of her country who "participate in those virtuous feelings which gave birth to it."

We should not be surprised to find Martha using the words virtue and birth in the same sentence. Other women of her time may have tried to control their fertility by using herbal concoctions, the rhythm method, or abortion, the only birth control methods known at the time. But though she struggled with her fragile body, Martha Jefferson staked her life on perpetual pregnancy. Her husband worried about her, and wrote friends that he hoped to retire "at the close of the present campaign." That autumn brought rumors of an imminent British invasion. General Alexander Leslie sailed up the James and skirmished with militias at Portsmouth, but withdrew, much to the relief of the denizens of the capital. On November 3, Martha gave birth to Lucy Elizabeth, who came into the world weighing ten and a half pounds. Such birth weights have become more common in the twenty-first century, but in the eighteenth, babies this large were a serious hazard to the mother, and perhaps an indication of a more serious health problem, gestational diabetes. If Martha suffered from diabetes, she would surely have had difficulties with the Monticello diet, so heavily laden with ham and sugar, butter and flour. With a wife who may have needed lighter fare, Thomas Jefferson's devotion to his gardens, to those first peas of spring and the peaches of high

summer, appears less a matter of caprice than a carefully considered labor of devotion.

Within the month, Martha was well enough to resume her housekeeping, while Jefferson worried about the fighting both north and south of Virginia. He worked to raise and supply the state militia, unable to rely on Congress or the hard-pressed Continental Army for help. He struggled with declining civilian morale, untested and unreliable recruits, prisoners of war now a menace rather than guests of his house. Things went from bad to worse: no food, no arms, no horses or boats, spectacularly inflated paper currency, general fear and instability. Now word came from General Washington that a British fleet had left New York, sailing south. Scouts sighted twenty-seven sails off the Virginia coast. Jefferson hesitated before calling up the militia, and paid the price for his tardiness. The winds proved good for the British fleet heading up the James, and disastrous for the Virginians. British troops under the command of Benedict Arnold, the turncoat American general whose name had already become synonymous with treason, reached Richmond on January 5.

The day before Arnold's troops arrived to burn and pillage in Richmond, Martha, Patsy, Polly, and baby Lucy Elizabeth fled in the carriage, with Robert and James Hemings (and, presumably, Betty Brown), heading for Tuckahoe. Governor Jefferson stayed behind, feverishly mustering his forces and sounding the alarm. Isaac Jefferson was among the slaves left behind as every white person who could get away did so and the British marched into town, formed their lines, and fired their cannons. Isaac never forgot the experience: "In ten minutes not a white man was to be seen in Richmond; they ran hard as they could . . . Isaac was out in the yard; his mother ran out and cotch him up by the hand and carried him into the kitchen hollering. Mary Hemings, she jerked up her daughter the same way. Isaac run out again in a minute and his mother too; she was so skeered, she didn't know whether to stay indoors or out." When the British fired again, Jefferson had his horse fetched and rode away. The British troops told the slaves that they were disappointed not to find Jefferson, since they had a "nice pair of silver handcuffs" they wanted to put on him. He spent the next days on horseback, riding frantically in pursuit of General von Steuben, then in command of the Virginia militia. But to the small slave boy left behind, Thomas Jefferson had simply run away: "Isaac never see his Old Master arter dat for six months."

The British moved on to blow up the powder magazine at Westham, only to return to Richmond the next day to round up the abandoned slaves and march them to the encampment near Yorktown. Jupiter and Suck, Ursula and George, Mary Hemings, and four children (Mary's daughter and sons: Molly, Daniel, the infant Joe, and Isaac himself) were taken. "All of 'em had to walk," Isaac recalled, "except Daniel and Molly . . . and Isaac." There was smallpox in the British camp, and many died, though none of "Mr. Jefferson's folks." Amid such frightening misery, Isaac's memory bespoke the concerns of a slave child: "The British treated them mighty well; give 'em plenty of fresh meat and wheat bread."

What went through Martha's mind as she abandoned her beloved husband and the people she knew so well, driving off in a panic with her half-brothers, clutching her daughters about her? What were Robert and James Hemings and Betty Brown (pregnant herself, just then) thinking as they left behind their sister and her children? And what did those who were taken think about the Jeffersons' willingness to leave them in the hands of the enemy? During all the time that Isaac and his family and friends remained with the British, nobody who had escaped could know who among the captives starved or suffered, who lived and who died. They did know that wherever the British army went, smallpox followed.

138 🎇 THE WOMEN JEFFERSON LOVED

The Jefferson slaves remained with the British into the siege of Yorktown, where little Isaac saw and heard "tremendous fire and smoke—seemed like heaven and earth was come together. . . . Heard the wounded men hollerin'. When the smoke blow off, you see the dead men laying on the ground." Washington gathered together the surviving slaves and took them back to Richmond, notifying their owners. "Old Master sent down two wagons right away, and all of 'em that was carred away went up back to Monticello. Old Master was mightily pleased to see his people come back safe and sound." George had even saved the family silver by hiding it in a mattress ticking, and told the British they'd already sent the silver up to the mountain.

BENEDICT ARNOLD'S FURIOUS forces wrought havoc along the James, then fell back to Portsmouth. Governor Jefferson did what he could to manage the situation, but he was no military leader. He had waited two critical days before calling upon the militia. His enemies deemed his behavior during the invasion erratic and cowardly. They launched an inquiry into his conduct, which wounded him to the bone and compounded his own feelings of failure. Though George Washington assured Jefferson that he had done all he could, the widespread criticism rankled. He was determined to clear his name and retire once more from public office.

Jefferson joined Martha and the children, then moved them to his father's plantation at Fine Creek before they returned to Richmond. Amid so much turmoil, Martha understood the dire situation her husband faced. The militia needed wagons and horses and guns and food and men, and so did the Continental Army. He was struggling to keep the populace from turning on his government and joining with the British. Jefferson hoped that reinforcements would come sailing in, but instead, in March, the British returned to Chesapeake Bay, to join Arnold and await General Charles Cornwallis, coming up from the south. The newly arrived British troops were commanded by General William Phillips, who had dined at Monticello only a few months earlier.

In this most turbulent time in the lives of Thomas and Martha Jefferson, there fell another devastating blow. On April 15, baby Lucy Elizabeth Jefferson, not yet six months old, died. The Governor's Council was to meet the next day, in miserable weather, but Jefferson wrote to say he could not bear to take part: "The day is so very bad that I hardly expect a council, and there being nothing that I know of very pressing, and Mrs. Jefferson in a situation in which I would not wish to leave her, I shall not attend to-day."

Martha had now lost four children. The way the war was going, she had reason to fear she might lose everything else. Little more than a week after the baby's death, the British massed for another push up the James. Martha, Patsy, and Polly fled Richmond again, with Jupiter driving the carriage, headed this time for Elk Hill. She and the children remained there through the terrifying weeks that followed. A guest at John and Mary Bolling's place in Goochland County gave Jefferson an account of the worry and confusion in the neighborhood:

We receive every day vague reports of the conduct of our cruel foe, but can't tell what degree of credit to give thereto. If you can spare so much time, I should be extremely obliged in receiving from Your Excellency by the return of the bearer an account of the present situation of both armies, the strength of each, the probable designs of the Enemy, our loss in the action on Appomattox, the particular depredations and injury done *at* and in the vicinity of Petersburg and at Osbornes, and in short every other interesting circumstance, for I had rather know the worst that can have happened than continue any Longer in a state of suspense and uncertainty.

140 🧏 THE WOMEN JEFFERSON LOVED

The anxiety could not have been easier to bear at Elk Hill, though Martha could draw comfort from familiar surroundings in that awful spring. Patsy, at the age of eight, was old enough to have developed an attachment to this place her mother cherished. This particular interlude at Elk Hill made a powerful impression on that bright child, who had been hauled back and forth across Virginia in the terror and turbulence of war. It was, after all, springtime, with greening grass, flowers beginning to bloom, a time of rebirth. A young girl and her mother might walk out to see cows licking their newborn calves, and spindly-legged foals frolicking in the fields. But even at Elk Hill, the war pressed in. Cornwallis's troops were ready to move up the river. Jefferson was working to have the capital moved to Charlottesville, prior to his anticipated retirement on June 2. Martha would have to leave Elk Hill and travel to Albemarle County, a more difficult proposition than ever before. She had to cross the James to get home, and boats were in short supply. "Mrs. Jefferson and your little family were very well yesterday at Elk-hill," a friend assured the governor, "and were endeavouring to procure a vessel to cross over the river to Mr. C: Harrisons, but I doubt they would find it difficult, for the Q:Master had the day before collected all the canoes in the neighbourhood and sent them down the river loaded with grain for the use of the army."

Cornwallis arrived in mid-May, launching a campaign up the James and into the very heart of Virginia. He knew Jefferson was at Monticello, and sent Colonel Banastre Tarleton, the notoriously ruthless cavalry commander, in pursuit of the rebel governor and assembly. Once again the Jefferson family took flight, with Thomas sending Martha and the children as far away as he could, off to Poplar Forest, far to the west in Bedford County. He promised to join them as soon as he could.

Tarleton arrived on June 4, only hours after Jefferson himself fled the mountaintop, once again leaving enslaved people behind and at the mercy of the invading army. Where "Great George" Granger had been the man to save the family silver in Richmond, that fabled task now fell to twenty-six-year-old Martin Hemings. According to one of the most famous stories in Monticello lore, Tarleton's troops were pounding up the mountain while Martin and another slave hid the silver beneath the planks of the steps of one of the front porticos. The British arrived just as they finished, with Martin slamming the planks down on the other man, who was trapped below. That man would be stuck in the tight, dark hole until the next day; meanwhile Martin faced down soldiers armed with loaded guns and bayonets. They threatened to shoot him if he did not reveal the whereabouts of the master and his treasures. "Fire away, then," Martin reportedly told them, a cocked pistol pointed at his chest. This display of bravery was not simply a selfless gesture of loyalty to the master, but was also a defiant assertion of Martin's manhood. As Annette Gordon-Reed has written, "Martin Hemings was as much his own man at that moment as he could ever have been in his life to date."

TARLETON'S CAVALRY LEFT Monticello intact, for reasons passing understanding. But Cornwallis, in Jefferson's words "the most active, enterprising and vindictive Officer who has ever appeared in Arms against us," inflicted a cruel blow. He aimed at Jefferson but struck the lives of Martha and many enslaved people the hardest. Cornwallis took his army to Elk Hill and occupied the place for ten days. There he wrought his vengeance on the fugitive governor "in a spirit of total extermination." Seven years later, the memory of Cornwallis's depredations at Elk Hill still burned bitterly for Thomas Jefferson. He recalled that the British general

destroyed all my growing crops of corn and tobacco, he burned all my barns containing the same articles of the last year, having first taken what he wanted; he used, as was to be expected, all my stocks of cattle, sheep and hogs for the sustenance of his army, and carried off all the horses capable of service: of those too young for service he cut the throats, and he burned all the fences on the plantation, so as to leave it an absolute waste.

There was also a heavy human cost. Some thirty slaves left with Cornwallis, either as captives or, as Jefferson put it in his Farm Book in 1781, "fled to the enemy," "joined enemy," or simply "run away." In his later recollection, Jefferson blamed Cornwallis for "carrying off" those enslaved people, and commented, "Had this been to give them freedom he would have done right, but it was to consign them to inevitable death from the small pox and putrid fever then raging in his camp." Most died in enemy hands. Some made it back to Elk Hill and Monticello, bringing smallpox with them.

Jefferson scholars have, until recently, taken an oddly sanguine view of the losses the Jefferson household endured at the hands of the British. Dumas Malone acknowledged the devastation at Elk Hill, but commented blithely, "His supply of slaves was not seriously depleted, for he still had more than two hundred," including "his very special 'people,'" Jupiter and Suck, George and Ursula, "and the superior Heming [*sic*] family of 'bright' mulattoes.'" Life at Monticello, said Malone, "resumed its normal character and tempo."

One wonders what Martha Jefferson would have made of such an assessment by her husband's most distinguished biographer. True, the "normal character and tempo" of Martha Wayles Skelton Jefferson's life throbbed with death and loss, but nothing had ever come close to this: A husband in disgrace and despair. Ursula and her family, Mary Hemings and her children taken prisoners by the British, and dozens of people seized by, or running to, the enemy. Her most intimate domain had been invaded. If she had any letters there from her beloved husband, Cornwallis would have found them, and done with them what he pleased. Her lovely place had been laid waste, the new colts lying blood-soaked, their throats slashed, bellies bloated to bursting and swarming with flies, amid ruined fields and the smokeblackened remnants of fences.

Her own thirty-three-year-old body was itself a war zone, torn by the ravages of eight pregnancies, perhaps more. She had flown from place to place in terror. She must have been exhausted. Still, some of her ramparts had held. Thomas was alive and well; so were Patsy and Polly. Monticello was unharmed. The Hemings family, along with Jupiter, had stood by the Jeffersons: from Robert and James, bravely transporting Martha and the girls across frightful terrain, to Elizabeth and the other children, looking after things at Monticello, to Martin, legendary savior of the family silver. With what she had been through, and what was yet to come, tea services and cruet sets were the least of her problems.

The Butcher's Bill

WHILE CORNWALLIS RAGED at Elk Hill, the Jeffersons took refuge at Poplar Forest, some ninety miles to the south and west of Monticello. There, Thomas, an expert, hard-riding horseman, was thrown from Caractacus, his favorite mount, and "disabled from riding on horseback for some months." Such accidents could be fatal, as Martha well knew. But Jefferson was a resilient man, and Martha, who had suffered so much, had that in common with her husband. He seized his enforced immobility as an opportunity to write his *Notes on the State* of Virginia. This remarkable document, the product of those months together at Poplar Forest and then, finally, back at Monticello, bespoke his continuing love for Virginia, for places they had shared, people they knew, illuminated by a mind as searching and scintillating as any in the history of their country. Jefferson's *Notes* also revealed some of the less admirable dimensions of his mind, including the depth and breadth and scientific oddities of his faith in white supremacy.

When they got back to Monticello, they settled in with purpose, ramping up their household, keeping the careful accounts that proved their worth as industrious and well-schooled plantation owners. While Thomas inventoried his homeland, Martha counted

12

out her sheets and blankets, bolsters and pillows, napkins and tablecloths, duly noting her tallies in her long-neglected housekeeping journal. Martha ran a patriotic household, eschewing imported cloth for the homespun and homemade. They hired a man to weave the cotton, hemp, and woolen and flaxen threads spun by slave women at Shadwell, Monticello, and Elk Hill. Martha kept track of all aspects of their textile production, from the raw fibers to the cloth that the family and slaves used and wore: fine cotton for her children and her counterpanes, fine linen for Mr. Jefferson's shirts, coarse linen and "yarne cloth" for "our negroes," good linen for "house servants." In November she sent bolsters, blankets, and sheets for two beds from Monticello to Elk Hill. Thomas was surveying his world while Martha rebuilt hers, and it seems she looked forward to making the place that Cornwallis had savaged into a home once again.

Every battlefield is something else, the site of a farm or a church, a pasture, a pond. Some places recover. Others never do. Martha's body was scarred and weakened by pregnancy and fear and war. On August 15, 1781, Thomas Jefferson "Left with Mrs. Jefferson £165." On September 25, she returned £120. This was the last time money ever changed hands between them. Fawn Brodie observed that Martha's disappearance from her husband's accounts was a signal that she was sick. That September, she was certainly pregnant again. She kept up her record of the spinning and weaving, but during the months Martha carried her last child, she did not record any spending or slaughtering, no soap, no candles. On April 30, she wrote down "5 lb. picked cotton from Elk-hill," and on May 1 she made the final entry in her housekeeping journal, noting the weaving of "5 yds. Of fine mixt cloth for a coat, mr. Jefferson." As far as we know, with one famous exception, these were the last words she ever wrote.

A week later, on May 8, she gave birth to her fifth daughter. Thomas recorded the birth of "Lucy Elizabeth (second of that name)."

HISTORIANS HAVE PORTRAYED Martha Jefferson as slight and delicate, gentle and submissive, cheerful despite her frail body and withdrawing temperament. But these are retrospective judgments, rendered alongside the regret that we can never know Thomas Jefferson's wife, since he, or someone else, destroyed every letter between the two of them. "Because of this impenetrable silence on his part, probably we shall never know much about Martha Wayles Jefferson and her life with him," wrote Dumas Malone.

But Jefferson's act of possessive vandalism did not obliterate all traces of this ordinary and remarkable woman. Those who say we have too little left of Martha to know her, speak only in relative terms. Compared to what we know about her husband, we do not know much about Martha. Compared to what we are able to learn about most of the people historians have written about, let alone most of the people who have lived on this earth, Martha left an immensity of information about her life, enough, indeed, to say a very great deal about how she lived, who she was, what and whom she loved.

Martha Wayles Skelton Jefferson survived a life of perpetual loss with amazing vivacity and resilience. She liked beer and cards and hunting parties. If she cultivated sensibility and delicate feeling, she was also a landed, slaveholding plantation woman, a woman who could ride a horse through a mountain blizzard, give orders to scores of people, run several households at once, preside over the slaughter of a herd of hogs. She loved her family and nurtured them faithfully, though it appears she was capable of sharp speech and of using manipulation to get what she wanted. She persuaded her smitten husband to buy the place where she had lived with another man, a place where she had borne her only son who lived beyond his first days. She took herself to that place again and again. But Thomas Jefferson had no reason to doubt Martha's devotion to him. Their passion for each other would prove fatal to her, and devastating to him.

Martha was a strong woman to endure what she did. By the summer of 1782, only three of the eight children she had carried still lived. She had sustained recurrent physical traumas amid the horror and destruction of a war that tore right through her household, a campaign of kidnapping and burning, of panic-stricken flight, of destruction of her livestock, barns, and fences, of the disgrace and depression of her idealistic husband. From the first, she had suffered in pregnancy and childbirth. She had survived potentially lethal breast infections, and borne at least one baby weighing over ten pounds. Any one of her pregnancies carried risks that could have killed her. Repeated childbearing and the ravages of revolution sucked away her strength and ripped her body to pieces.

On May 20, with a very sick wife and a tiny infant in a room nearby, Thomas Jefferson wrote from Monticello to his friend James Monroe, refusing absolutely Monroe's entreaties that Jefferson return to public life. He had been elected to the Virginia House but had refused to attend. He risked being arrested and compelled to go to Richmond.

Jefferson's letter to Monroe drew on his personal anguish and anxiety about Martha to make a strong political argument about citizens' right to privacy. The state, he insisted, had no "*perpetual* right to the service of all it's members." Such a claim "would be to annihilate the blessing of existence; to contradict the giver of life who gave it for happiness and not for wretchedness, and certainly to such it was better that they had never been born. . . . I may think public service and private misery inseparably linked together." While Jefferson invoked divine authority to justify his determination to stay home with his desperately ailing wife, when he referred to "the giver of life who gave it for happiness and not for wretchedness" he had Martha in mind.

148 🧏 THE WOMEN JEFFERSON LOVED

When he spoke of wishing that someone had never been born, the infant Lucy Elizabeth lay close at hand. "Mrs. Jefferson has added another daughter to our family," he wrote Monroe, in closing. "She has been ever since and still continues very dangerously ill."

Some of Jefferson's other friends and acquaintances questioned his motives and his judgment in not answering the call of service. Fawn Brodie observed, "The callousness of Jefferson's admirers and friends in refusing to heed the impending tragedy seems now almost incomprehensible." But Monroe was deeply sympathetic. "I have been much distress'd upon the subject of Mrs. Jefferson and have fear'd, as well from what you suggested yourself as what I have heard from others, that the report of each succeeding day would inform me she was no more. . . . It may please heaven to restore our amiable friend to health and thereby to you a friend whose loss you would always lament, and to your children a parent which no change of circumstance would ever compensate for. . . . Nothing will give me so much pleasure as to hear of Mrs. Jefferson's recovery, and to be informed of it from yourself."

There would be no letter from Thomas Jefferson to James Monroe, or for that matter, to anyone else. While Martha lived, Thomas stayed close. According to their daughter Patsy, "For four months that she lingered he was never out of calling. When not at her bed side he was writing in a small room which opened immediately at the head of her bed" and took his turn "administering her medicines and drink to the last." Sometime near the end, Martha began to copy out poignant lines from Laurence Sterne's *Tristram Shandy*:

> Time wastes too fast: every letter I trace tells me with what rapidity life follows my pen. The days and hours Of it are flying over our heads like

Clouds of windy day never to return— More every thing presses on—

But she was too weak to continue. And so Thomas, in anguish, took up a pen and went on:

> and every time I kiss thy hand to bid adieu, every absence which follows it, are preludes to that eternal separation which we are shortly to make!

He would wrap this scrap of verse around a lock of her hair, and keep it with him, all his days.

AT THE END Martha had gathered those closest to her around her deathbed. Elizabeth Eppes and Anne Skipwith and her daughters, Patsy and Polly, were there. But they were not alone. Edmund Bacon, a later Jefferson overseer, told a story preserved by the enslaved people at Monticello, a story in which certain details were wrong or muddled, but which featured the shadow family Martha Jefferson had kept with her throughout her life. "The House servants," said Bacon, "were Betty Brown, Sally, Critta, and Betty Hemings, Nance and Ursula. They were old family servants and great favorites. They were in the room when Mrs. Jefferson died."

They have often told my wife that when Mrs. Jefferson died they stood around the bed. Mr. Jefferson sat by her, and she gave him directions about a good many things that she wanted done. When she came to the children, she wept and could not speak for some time. Finally she held up her hand, and spreading out her four fingers, she told him she could not die happy if she thought her four children were ever to have a stepmother brought in over them. Holding her other hand in his, Mr. Jefferson promised her solemnly that he would never marry again. And he never did. He was then quite a young man and very handsome, and I suppose he could have married well; but he always kept that promise.

Martha Jefferson had only three remaining children when she died, not four. But no one stepped forward to challenge the other details of Bacon's secondhand account.

On September 6, 1782, Thomas Jefferson wrote down a sadness he could scarcely speak: "My dear wife died this day at 11:45 a.m." Many years later, Patsy Jefferson, by this time an aging wife and mother with many sorrows of her own, recalled her father's reaction to her mother's death. "A moment before the closing scene he was led from the room almost in a state of insensibility by his sister mrs. Carr who with great difficulty got him into his library where he fainted and remained so long insensible that they feared he would never revive. The scene that followed I did not witness but the violence of his emotion, of his grief when almost by stealth I entered his room at night to this day I dare not trust myself to describe."

For weeks after Martha's death, Thomas Jefferson was prisoner to his unquenchable grief. "He kept his room for three weeks and I was never for a moment from his side," Patsy recalled. "He walked almost incessantly night and day only lying down occasionally when nature was completely exhausted on a pallet that had been brought in during his long fainting fit. My Aunts remained constantly with him for some weeks, I do not remember how many."

JEFFERSON'S FRIENDS WORRIED about his sanity. Edmund Randolph, then serving in the Continental Congress, wrote to James Madison that "Mrs. Jefferson has at last shaken off her tormenting pains, by yielding to them, and has left our friend inconsolable. I ever thought him to rank domestic happiness in the first class of the chief good; but scarcely supposed that his grief would be so violent as to justify the circulating report of his swooning away whenever he sees his children."

And what of those children? Like her own mother, Martha Jefferson had left a motherless baby, little Lucy Elizabeth, too young to have any memory of the woman who had borne her. Daughter Polly, at four, would be left with a terror of abandonment, and would struggle to come to terms with her father for the rest of her own life. Patsy, at age ten, reacted differently, appointing herself her father's life companion in their mother's stead. "When at last he left his room," she remembered, "he rode out and from that time he was incessantly on horseback rambling about the mountain in the least frequented roads and just as often through the woods; in those melancholy rambles I was his constant companion, a solitary witness to many a violent burst of grief, the remembrance of which has consecrated particular scenes of that lost home beyond the power of time to obliterate."

Martha Wayles Skelton Jefferson was buried at Monticello, her grave marked with a tombstone inscribed in Greek: "Nay, if even in the House of Hades the dead forget their dead / yet will I even there be mindful of my dear comrade." Below that message is the inscription: "To the memory of Martha Jefferson, Daughter of John Wayles; Born October 19th, 1748, O.S. Intermarried with Thomas Jefferson January 1st, 1772; Torn from him by death September 6th, 1782: This monument of his love is inscribed."

IT TOOK JEFFERSON a month or more to pull himself together enough to write a letter. When he sat down to write to his sister-in-law, Elizabeth Eppes, he said he did so on behalf of his daughters. He was still shattered, obsessed with mortality, including his own. He showed Elizabeth Eppes his feelings without restraint. "This miserable kind of existence is really too burthensome to be borne," he wrote, "and were it not for the infidelity of deserting the sacred charge left me, I could not wish it's continuance a moment. For what could it be wished? All my plans of comfort and happiness reversed by a single event and nothing answering in prospect before me but a gloom unbrightened with one cheerful expectation." He was longing to flee his sorrows, to the grave or elsewhere. But he had to hang on, for the children's sake, and because Martha would want him to look after their girls. "The care and instruction of our children indeed affords some temporary abstractions from wretchedness," he said, "and nourishes a soothing reflection that if there be beyond the grave any concern for the things of this world there is one angel at least who views these attentions with pleasure and wishes continuance of them while she must pity the miseries to which they confine me."

Even in this private letter to Martha's sister, he could not bring himself to utter Martha's name. He assured Elizabeth Eppes that the children "are in perfect health," but he seemed both dazed and offended at the fact that the girls were "as happy as if they had no part in the unmeasurable loss we have sustained." But he hinted at one reason for their seeming happiness, an injunction on the part of their aunt, and possibly a plea from their own mother, not to lose themselves in sadness. Elizabeth Eppes had told Jefferson not to mourn forever, to seek happiness at the first opportunity. He was finding that task impossible:

I forget that I began this correspondence on behalf of the children and am afflicting you at the distance of 70 or 80 miles with sorrows which you had a right to think yourself out of the reach of. I will endeavor to correct myself and keep what I feel to myself that I may not dispirit you from a communication with us... I say nothing of coming to Eppington because I promised you this should not be till I could support such a countenance as might not cast a damp on the chearfulness of others.

Jefferson's letter to Elizabeth Eppes was the cry of a man in the grip of an emotional riptide, in the anguish of simultaneously remembering and trying to forget the woman he loved so well. It was the literary version of his tortured rides across the countryside, his young, worried, faithful daughter by his side, and he invoked those rambles in the letter: "Patsy rides with me 5 or 6. Miles a day," he wrote, "and presses for permission to accompany me on horseback to Elkhill whenever I shall go there. When that may be however I cannot tell; finding myself absolutely unable to attend to any thing like business."

Some historians have seen Jefferson's wild grief as a sign of his guilt about his own part in Martha's death, about his relentless claim to her body, a passion and a possession that led to the pregnancies that wore her down and finally killed her. Martha had surely suffered from the physical ordeal of carrying and bearing children. But her husband believed that her death had been hastened not just by childbirth, but also by the repeated traumas of invasion and war, by the Revolution that he himself had helped to birth. If Thomas Jefferson held any truth to be self-evident, it was the notion that happiness lay in preserving a high, impregnable wall between the turbulent public world of politics and strife, a realm assigned to men, and the peaceful sphere of domestic tranquility, a place associated with women. The Revolution had breached that wall, and violence had flowed into his home, his wife's sheltering domain, with the force of a spring freshet tearing away a mill dam, with the smell of smoke and the taste of blood and a sound as horrible as the shriek of a dying horse. War, he thought, had

killed Martha Jefferson as surely as the babies she relentlessly bore, and this war, like those babies, was his fault.

Thomas Jefferson loved his wife with all his heart. The only way he knew to grieve was to draw a shroud of silence over her, to obliterate all trace of her, to ruthlessly suppress memory of her presence. In the shadow of her death, at a moment when he was hardly able to function rationally, he determined to sell Elk Hill, the place Martha cherished and had tried to reclaim despite Cornwallis's horrible violation. But Patsy's feelings about that place, like her thoughts about her mother, differed from those of her father. She begged to go with him to Elk Hill whenever he could bring himself to ride there. The daughter's plea bespoke her longing for the place where she could best sense the presence of the mother she had lost, a place she identified with happier times, and not a desire to erase grief.

Isaac Jefferson, Ursula's son, remembered Elk Hill well. "Old Master had a small brick house there where he used to stay, about a mile from Elk Island on the north side of the James River. The river forks there: one half runs one side of the island, tother the other side. When Mr. Jefferson was Governor, he used to stay thar a month or sich a matter; and when he was at the mountain, he would come and stay a month or so and then go back again." Jefferson scholar James A. Bear, Jr., editor of Isaac's memoir, pointed out that Jefferson's memorandum books, "which chronicled his whereabouts, do not support Isaac's report of the visits to Elk Hill," though Bear acknowledges that some Farm Book entries do suggest that the Jeffersons visited there. But Isaac Jefferson, who must have been taken to Elk Hill by his mother, was not wrong about family visits to Martha's beloved private retreat. Martha and the children went there often, and Thomas Jefferson visited them at Elk Hill whenever he could get away from the work of creating a new nation.

Like so many transactions in Thomas Jefferson's life, the plan to

sell Elk Hill dragged on for years. The deeds for the second and third parcels he purchased there were not recorded until 1782 and 1783 after the sacking by Cornwallis, even after Martha's death. Much as he labored to reduce that beloved, tragic place to a business proposition, he could never fully wipe away the memory of his life there with Martha. When he advertised Elk Hill for sale in 1790, he had not been there for some time. Yet he could describe the place with precision: the rich red loam of the highlands and dark, rich loam of the low grounds, the "good dwelling house, of 4. Rooms below, and two above; with convenient out houses, on a very high and beautiful position, commanding a fine view of the Blue mountains, of James river for several miles, and of Elk Island." He could draw a fine map, too, boundaries not quite as precise as in the maps he drew from survey notations, but by his own lights reflecting "a General idea of the lands, drawn from memory, yet not far from the truth."

Thomas Jefferson could not forget Elk Hill. How much harder it was for him to suppress his yearning for the woman who had given him so much happiness despite the difficulties of their days together. He would come to terms with her death by rebuilding and defending the wall between the private world he shared with the women he loved, and the contentious realm of his public life. He—or someone close to him—burned his private letters, systematically destroying those documents, just as meticulously as he cataloged and copied his public correspondence. Dumas Malone wrote that Jefferson "carefully preserved and deeply cherished small souvenirs of his dead wife, but eventually he also saw to it that none of their letters should ever be open to prying eyes. . . . He was determined that the sacred intimacies of a lover and husband should remain inviolate. His wife did not belong to posterity; she belonged to him."

But Martha did not belong entirely to him. She also belonged to others who knew her, who loved her, who had raised her and been

raised with her and raised by her, commanded by her, even owned by her, worked and played and laughed and cried alongside her. Thomas Jefferson could not wipe out their memories, however he might try. They too would have to come to grips with Martha's influence on their lives.

Thomas Jefferson himself assuredly belonged to her. His promise never to wed again bound him to her, far beyond the grave. Somewhere over the course of her own life, Martha Wayles Skelton Jefferson had acquired a horror of stepmothers, but not, it seems, of half-siblings, or Hemingses. The tension between remembering and forgetting the tangled, sometimes warmly joyous, too often tragic life of Martha Wayles Skelton Jefferson would shape the relationships between Thomas Jefferson and the women he would love for the rest of his life.

Part III

SALLY

Stories and Shadow Families

13

JOHN WAYLES'S YOUNGEST daughter, like all children, had four biological grandparents. Three of those grandparents were English. Her mother's mother was African. In other places or times—a hundred years earlier in Virginia, or sixteen hundred miles distant in Nuevo Mexico, or four thousand miles across an ocean, in Spain or France— Sally Hemings's maternal heritage would not have sealed her destiny. But because of where and when Sally was born—in Virginia, in 1773 the accident of birth determined her race—black, or negro—and her legal status—slave.

Sally Hemings's foremothers also gave her another legacy. They bequeathed to her a set of stories to be used as weapons against enslavement, and against the lacerations of race. Sally, in turn, passed those stories on to her children, and we know them because her son, James Madison Hemings, preserved them through slavery and freedom, through secession, war, and reunion, and told them to a newspaperman named S. F. Wetmore, the editor of the *Pike County* (Ohio) *Republican*, in 1873. "I never knew of but one white man who bore the name of Hemings," Madison affirmed. "He was an Englishman and my great grandfather. He was captain of an English whaling vessel

which sailed between England and Williamsburg, Va., then quite a port." His great-grandmother, he explained, "was a fullblooded African, and possibly a native of that country. She was the property of John Wales [Wayles], a Welchman."

Madison Hemings's family story began with a tale of attempted rescue, in which his great-grandfather, discovering that the woman he had sold had borne his child, played the role of hero, and his grandfather, John Wayles, took the part of villain. "Capt. Hemings happened to be in the port of Williamsburg at the time my grandmother was born," he told the journalist, "and acknowledging her fatherhood he tried to purchase her of Mr. Wales who would not part with the child, though he was offered an extraordinarily large price for her. She was named Elizabeth Hemings." The captain, said Madison, was "determined to own his own flesh and blood." But he would be thwarted, not just by John Wayles, but more treacherously, by informers in Wayles's household. Captain Hemings "resolved to take the child by force or stealth, but the knowledge of his intention coming to John Wales' ears, through leaky fellow servants of the mother, she and the child were taken into the 'great house' under the master's immediate care."

According to Madison Hemings, his grandfather Wayles was not acting out of simple greed. He was also curious about how this new creature, half-English and half-African and neither black nor white, but something else, might turn out. "I have been informed that it was not the extra value of that child over other slave children that induced Mr. Wales to refuse to sell it, for slave masters then, as in later days, had no compunctions of conscience which restrained them from parting mother and child of however tender age," Hemings told S. F. Wetmore, "but he was restrained by the fact that just about that time amalgamation began, and the child was so great a curiosity that its owner desired to raise it himself that he might see its outcome." His heroic attempt at redemption thwarted, "Capt. Hemings soon afterwards sailed from Williamsburg, never to return. Such is the story that comes down to me."

In Madison Hemings's telling, John Wayles's first motive in claiming Betty Hemings as his slave had been curiosity. Wayles's later actions bespoke more carnal impulses. "Elizabeth Hemings grew to womanhood in the family of John Wales," Madison Hemings continued, "whose wife dying she (Elizabeth) was taken by the widower Wales as his concubine, by whom she had six children—three sons and three daughters, viz: Robert, James, Peter, Critty, Sally and Thena. These children went by the name of Hemings."

GENEALOGIES ARE FAMILY stories with a purpose. They are intended as much to exclude as to include, and as they emphasize some details, they omit or mistake others. There is another way to tell the story of Sally Hemings's family, not simply as an unfriendly transaction between men, but as a tale of wedding gifts and women's legacies. At the time of Betty Hemings's birth, about 1735, when Captain Hemings was supposed to have made his offer, Betty's mother did not belong to John Wayles. She was the property of Francis and Sarah Eppes, Martha Jefferson's grandparents. In 1746, they gave Betty and her mother to their daughter Martha, who was marrying John Wayles. The bride's property passed instantly to her new husband, and in turn, to Martha and her own husband, Thomas Jefferson.

Such details would not have mattered to Madison Hemings, but other things did. He was careful to note that his great-grandfather commanded a whaling boat, not a slave ship. Madison Hemings distanced his heroic progenitor from that unholy traffic. He likewise never referred to his great-grandmother, grandmother, and mother as "slaves," though he took pains to explain that Elizabeth Hemings was different from "other slave children" and had been betrayed by "leaky fellow servants," in other words, by tattling slaves. The Hemingses embraced a genealogy that linked them by blood to white men and slave masters—the whaling captain, the planter-lawyer, the author of the Declaration—and set them apart from other enslaved people. Generations of Hemingses stubbornly preserved the story of their British progenitor and their kinship with Wayleses and Eppeses, Jeffersons and Randolphs. Most importantly, they linked themselves to Thomas Jefferson. The linchpin of this celestial connection was Sally Hemings, one of the most famous, least known women in American history. She was not the first, or the last, Hemings woman to have a long relationship and children with a white man. She was the middle woman in a multigenerational dual lineage, granddaughter, daughter, mother, aunt, sister, and niece to women who lived as partners of white men.

SALLY HEMINGS WOULD not have remembered her father, since she was born in 1773, possibly after his death. Surely she heard stories about him from her mother and siblings, from other enslaved people, from the white half-sisters who inherited their father's property, and perhaps from their husbands. Monticello would be the first home she remembered. In that not-yet-famous place, Sally Hemings came to consciousness in the heat of the American Revolution.

Sally's world was full of Hemingses, her mother and five brothers and six sisters all close at hand. The eldest, Mary, was twenty years older than Sally. She worked as a seamstress and took care of her own children. The youngest, a little brother and sister, were John, whose father was the carpenter Joseph Neilson, and baby Lucy. As war came up the river and into the neighborhood, the Hemings family would be pulled apart. Sally was five years old when British and German prisoners came to Albemarle County, a time, it seems, of relative tranquility and plenty, but a harbinger of things to come. If she did not hear firsthand, from the voluble Baroness Riedesel or the baroness's little daughters, the story of their ordeals in battle and as prisoners of war, surely such a colorful, horrible tale spread through the Monticello grapevine.

When Sally was six, Thomas Jefferson became governor of Virginia. Her sisters, Mary and Betty, and her brothers, Martin, Robert, and James, moved away, first to Williamsburg, and then to Richmond. Sally remained with her mother, her older sister, Nance, and the other youngest Hemingses—Thenia, Critta, Peter, John, and Lucy—at Monticello. Though she was too young to understand the maneuverings of politicians or the movements of armies, she was old enough to recognize that many of the people she knew best were gone. Now came the rumors of British invasion, and the redcoat army itself, under the traitor Arnold, making its way toward the state capital, toward so many in her family.

Sally would have been at Monticello when the Jefferson carriage rolled up, driven by her brothers, Robert and James, carrying the frightened mistress and her three small girls, bearing tales of the terror in Richmond. Sally's mother would learn that her daughter Mary and grandchildren had been left behind to be seized by the British. And what did the Hemingses know of those who were not taken captive, but who had voluntarily gone with the British, in the hope of claiming their freedom? Some died. Some returned, carrying smallpox. Sally, fortunately, did not contract that hideous and deadly disease. Not all scars are physical.

When Sally was eight, the Revolution swept through the door. The master fled the majestic house he had spent so many years building. Once more Thomas Jefferson left his slaves to fend for themselves, assuming they would defend his home and property. Sally was at Monticello when Banastre Tarleton's cavalry arrived. If she did not personally witness her brother Martin's fierce resistance to the British, the story of his heroism would be told again and again. In the

months of transience and uncertainty that followed, the Hemingses were dispersed over the landscape of Virginia, from the British encampment at Yorktown to the western outpost of Poplar Forest. Some of them went with Martha Jefferson as she made her last visits to the Forest and Elk Hill. Elizabeth and the youngest children, it seems, remained at Monticello through this time of instability and anxiety.

WHEN MARTHA JEFFERSON came home to Monticello for the last time, Sally Hemings was among those who cared for her. As Annette Gordon-Reed explained, "Just as Elizabeth Hemings and her daughters had seen Martha in her weakest and most vulnerable moments, they had seen her husband at his lowest point as well, and they shared memories of this defining time at Monticello." They would learn too that Thomas Jefferson "was not the master of everything." Martha's death set off shock waves that scattered the Hemingses like shrapnel from a hand grenade.

In October 1782, Thomas Jefferson left his home, convinced he could never be happy at Monticello again. He took along his three daughters and Martin, Robert, and James Hemings. He planned to stop at Eppington, the long-neglected plantation on the Appomattox to which Martha's sister, Elizabeth Eppes, and her husband, Francis, had lately returned. Jefferson had only rarely visited Eppington. In fact, he had to hire a guide to show him the way, so that he might leave his tiny baby daughter, Lucy Elizabeth, in the care of her aunt. He was making plans to leave the country.

Jefferson had spent the final years of his wife's life fending off the claims of public service, even turning down an enticing appointment as a peace commissioner in Paris. He had not yet emerged from the torture of fresh grief when the Congress, at James Madison's urging, renewed the appointment. The news came to Jefferson in December, at a friend's plantation, where he had taken his older daughters, Patsy

STORIES AND SHADOW FAMILIES 💥 165

and Polly, to be inoculated against smallpox. He saw in the opportunity a chance to flee his sorrow, to travel to a country he ardently longed to see. He hurried to arrange his departure, sending four-yearold Polly to join her baby sister at Eppington, while he planned to take Patsy with him to France.

And now came months of uncertainty and wandering. Jefferson traveled from Virginia to Boston in search of a boat that might take him safely to Europe, in the dead of winter and with the risk of capture by British warships. Amid many delays, the peace treaty was signed without him. He returned to Monticello for the summer, gathering his family about him again, when Virginia reelected him to the Continental Congress. Over the course of the next year, he followed the Congress from Philadelphia to Princeton and then to Annapolis. He traveled with Robert or sometimes James Hemings. He installed Patsy in Philadelphia, while the two younger girls stayed at Eppington. He would never see his youngest daughter again.

JEFFERSON WAS APPOINTED minister plenipotentiary to European nations in May 1784. He was to join John Adams and Benjamin Franklin in negotiating treaties of amity and commerce. Before leaving he shuttered and shut down his remarkable house at Monticello. Jefferson left the management of his business affairs in the hands of his friend and neighbor, Nicholas Lewis, and gave his power of attorney to his brother-in-law, Francis Eppes. Enslaved people would still tend the master's tobacco fields, under the eyes of hired overseers, rather than under the governance of a man who hated the brutalities of slavery. Elizabeth Hemings and her daughters, now with no household duties to perform, would retreat to their cabins. Jefferson left instructions that the Hemings women not be forced to do field work, or as he phrased it, be "put into the ground."

Jefferson also made provision for Betty's older sons. James Hemings

accompanied him to France, first in the role of body servant, but ultimately, to be trained in the art of French cuisine. Martin and Robert Hemings found employment away from Monticello, with their master's explicit approval. Mary Hemings was hired out to Charlottesville merchant Thomas Bell. And Sally Hemings, at nine or ten years old, about the age Thomas Jefferson had been when his mother and father sent him off to be tutored by a stern and narrow minister, would be separated from her mother and sent to Eppington to serve as maid to Polly Jefferson, her half-niece, now six years old.

THE EPPESES AND Wayleses and Jeffersons and Hemingses were united by generations of blood. Francis Eppes was Martha's first cousin as well as her brother-in-law. Their grandfather had owned Sally Hemings's grandmother and had refused to sell Elizabeth Hemings back to her English father. Martha and her half-sister, Elizabeth Eppes, were so close that Elizabeth took in Martha's two youngest daughters after Martha's death. Thomas Jefferson and Francis Eppes were also intimate friends, and Jefferson would in time make his nephew, Jack Eppes, one of his protégés.

Martha Jefferson had made a point of keeping the Hemingses close, dancing a minuet of intimacy and denial with her father's shadow family. Elizabeth Eppes was also half-sister to six of the Hemings siblings, but her relation to them differed from Martha's in one important regard: she did not own them. Still, she was familiar to the enslaved members of the Monticello household; Isaac Jefferson, Ursula's son, recalled that "Mrs. Eppes was a sister of Mrs. Jefferson—mightily like her sister." Elizabeth Eppes remained close to Martha, nursing her through her last illness. But if either Mrs. Eppes or her husband felt any obligation to the Hemingses, any impulse to see to their welfare after Martha's death, they did not make use of their labor or their talents, with one exception: they permitted Sally Hemings to come into their household, to give comfort to little Polly Jefferson.

Elizabeth Eppes's life had followed a course similar to Martha's. She married a man devoted to science with a passion for gardening, a landowner and slaveholder who hoped to build a big house on property he had inherited from his father. She bore eight children, two of whom died young. She inherited her share of her father's wealth and his debt, and her husband struggled with that legacy his whole life.

Francis Eppes, like Thomas Jefferson, had grand plans for his home, a two-story house, white stucco with a red-shingled hipped roof, with a commanding view of the Appomattox River from the rear, where he planned and planted extensive gardens. Guests who arrived by road traveled down a long drive through the woods, the view opening up to a sweep of lawn and the vista of the imposing house. Eppington was impressive, though nothing on the extravagant scale of the Monticello house where Thomas and Martha Jefferson lived together. Eppes had begun to build in about 1770, but his project was stalled by the death of his father-in-law, John Wayles. The management of the Wayles estate, wartime disruption, and perhaps even the needs of Martha Jefferson kept the Eppeses at the Forest through the Revolution. When they returned to Eppington in 1783, Francis Eppes undertook to expand the house, adding two wings and a porch. They had to tear down chimneys and cut doors, no easy process for the people living there. Like Monticello, Eppington would be a dwelling designed by the master to suit his wants and needs, a place long under construction. The west wing, not accessible from the main house, served as Francis Eppes's office and study, his sanctuary.

Hemingses had lived at various Wayles, Eppes, and Jefferson holdings, from Bermuda Hundred and the Forest to Hors du Monde and Elk Hill. But Sally Hemings had spent most if not all of her life at

Monticello. When she left her mother and brothers and sisters for the first time, she was heading nearly eighty long miles away, into unknown territory. Polly Jefferson, taken to Eppington to join Lucy Elizabeth, was too young to understand what such a journey meant, and in any case, she had traveled a great deal in the first turbulent years of her life. Over the next few years, Polly developed a fierce attachment to her loving aunt and uncle, and to the place that seemed to her more home than anywhere else she had known. But for Sally Hemings, Eppington was a place of exile from and abandonment by nearly everyone she had loved. She bid good-bye to her mother at Monticello, and went to a strange place, probably taken there by her brother, Robert, in July 1784. When Robert left, Sally was pretty much on her own.

VIRGINIA WAS A dangerous place to be a child in the waning years of the eighteenth century. Surviving the ordeal of birth was the first challenge. And then there were the recurring epidemics of childhood diseases, from measles and mumps to scarlet fever and pertussis, or whooping cough. Sickness came to Eppington in the autumn of 1784, less than two months after Thomas Jefferson left for Paris and deposited his daughters and their slave maid at the plantation on the Appomattox. People began to suffer the symptoms of pertussis-the runny nose, sneezing and fever, the cough that becomes increasingly sharp and wracking. Sufferers struggle for air through an excruciating cough that has a distinctive barking or whooping sound. Some victims cough so terribly that they vomit. Some cough so incessantly that they cannot retain food or water, and die of malnutrition or dehydration. Some develop pneumonia and other acute infections that can prove deadly. The disease is spread through contact with airborne discharges from the mucous membranes-in other words, by spending time in proximity to coughing or sneezing people. The old and the very young are at greatest risk of dying from whooping cough, though anyone can catch it.

People at Eppington got very ill, and some died. Francis Eppes was plainly worried when he wrote to Thomas Jefferson in September, in a letter that warned of financial as well as physical dangers to Jefferson's family. Crops were bad at Monticello, Poplar Forest, and Elk Hill. Creditors clamored to be paid, and Eppes was expecting lawsuits. John Wayles's heirs—Francis Eppes, Thomas Jefferson, and Henry Skipwith—would have to sell property to pay the debts from Wayles's estate. And the children were terribly sick. "I wish it was in my power to inform you that your children were well," Eppes wrote. "They as well as our own are laid up with the hooping cough. Your little Lucy and our youngest and Bolling are I think very ill. Polly has it badly but she sleeps well and eats hartily."

Enslaved people at Eppington, living in crowded, drafty quarters and in far from sanitary conditions, would have been extremely vulnerable to infection and to complications. Sally Hemings, as maid to Polly Jefferson, may have slept in her young mistress's room, or perhaps in a dwelling with other slaves, but she undoubtedly shared her sleeping place with other people. Sally was repeatedly exposed to the whooping cough virus, since Polly and Lucy Elizabeth, and their cousins, Martha (called "Bolling") and Lucy Eppes, all came down with the disease. Polly and Bolling Eppes suffered, but survived. The two Lucys did not. The grief-stricken Elizabeth Eppes wrote the news in a heartbreaking letter to Thomas Jefferson:

It is impossible to paint the anguish of my heart on this melancholy occasion. A most unfortunate Hooping cough has deprived you, and us of two sweet Lucys, within a week. Ours was the first that fell a sacrifice. She was thrown into violent convulsions linger'd out a week and then expired. Your dear angel was confined a week to her bed, her sufferings were great though nothing like a fit. She retain'd her senses perfectly, calld me a few moments before she died, and asked distinctly for water. Dear Polly has had it most violently, though always kept about, and is now quite recovered. My heart shudders for my poor Bolling, who is reduced to a skeleton, and the cough still very obstinate. Life is scarcely supportable under such severe afflictions.

It took nearly seven months for this letter, and a similar one from Francis Eppes, to reach Thomas Jefferson. Their letters arrived at precisely the moment Jefferson learned that he would be staying in Paris, to succeed Benjamin Franklin as minister to the French court. He had, however, found out about his daughter's death earlier, in a letter sent by James Currie, the doctor who had treated the children at Eppington. Currie wrote that Lucy Jefferson "fell a Martyr to the Complicated evils of teething, Worms, and Hopping Cough which last was carried there by the Virus of their friends without their knowing it was in their train."

If Lucy Jefferson had intestinal parasites as well as whooping cough, chances were good that others at Eppington suffered from the same malady, which would have made people there miserable long after the whooping cough had passed. Sally Hemings may have suffered from any of these afflictions, but she was far from people who loved her, who might have offered particular care and comfort.

Thomas Jefferson, grieving anew, made the decision that would change Sally's life forever. From the moment Jefferson received the Eppes's letters informing him about one daughter's death, he was absolutely determined that the other must leave Eppington and come to France. He wrote to Francis Eppes to say that his new appointment would keep him in Europe longer, so "I must have Polly." He knew that his letter would take months to reach Virginia, so he could not expect her to come for another year at the least. He hoped that would allow time to make proper arrangements, to find a woman in Virginia who might be hired to accompany his daughter on a long and daunting ocean voyage.

Summoned and Sent

14

NEARLY THREE YEARS passed between the death of Lucy Jefferson and the moment when Polly Jefferson and Sally Hemings were put on a ship bound not for Paris, but for London. The delay in their departure was not simply a matter of slow mail service. Three other things kept Polly in Virginia: the fact that she was dead set against leaving, the problem of finding the right ship to transport her, and the challenge of finding the right person to take a terrified little girl across the Atlantic.

Since her father's and sister's departures, Polly had learned to think of Eppington as her home. For Polly, family now meant aunts and uncles and cousins. The Eppeses doted on her, and she was deeply attached to them. Her father, on the other hand, had left her, newly motherless, when she was only four years old. However much he wanted her with him, and however many letters he wrote to other people about his concern for her and his plans to bring her to him, Jefferson never wrote a single letter *to her* during all the years that an ocean lay between them. While he told Francis Eppes that "dear Poll . . . hangs on my mind night and day," those words were not addressed to Polly herself. Polly, for her part, was learning to read and write. By the time she was seven, she wrote well enough to send her father a letter of her own, notable for its firmness and its brevity: "Dear Papa, I want to see you and sister Patsy, but you must come to Uncle Eppes's house. Polly Jefferson."

Thomas Jefferson felt sure that Polly would grow accustomed to the idea of leaving Eppington. She never did. She clung to her resistance with a steadfastness that grew into desperation and flashed into frenzy, as her father relentlessly demanded that she come to him. In the end he had to force her to leave the home she had come to love, to embark on a hazardous voyage across the sea to join a father she barely remembered. The dangers were very real, from deadly weather to the precarious seaworthiness of vessels too new to be tested, or too old and battered to be watertight. Jefferson acknowledged the problems when he wrote to Francis Eppes in August 1785, affirming that "I must now repeat my wish to have Polly sent to me next summer":

This, however, must depend on the circumstance of a good vessel sailing from Virginia in the months of April, May, June, or July. I would not have her set out sooner or later on account of the equinoxes. The vessel should have performed one voyage at least, but not be more than four or five years old. We do not attend to this circumstance till we have been to sea, but there the consequence of it is felt. I think it would be found that all the vessels which are lost are either on their first voyage or after they are five years old; at least there are few exceptions to this... I will only add that I would rather live a year longer without her than have her trusted to any but a good ship and a summer passage.

No one knew better than Thomas Jefferson, United States minister to France, that these were not the only perils. Algerian pirates had been a problem in the Mediterranean and the Atlantic for centuries. Even as he wrote to Francis Eppes, pirate corsairs were attacking American ships. "The Algerines this fall took two vessels from us, and now have 22. of our citizens in slavery," Jefferson told Francis Eppes. "Their dispositions are . . . hostile, and they very possibly will demand a higher tribute than America will pay. In this event they will commit depredations on our trade next summer. . . . My mind revolts at the possibility of a capture; so that unless you hear from myself (not trusting the information of any other person on earth) that peace is made with the *Algerines*, do not send her but in a vessel of French or English property: for these vessels alone are safe from prize by the barbarians."

Jefferson was so worried about pirates that he repeated his warning to Eppes in January, adding one detail: "I write the present chiefly to repeat a prayer I urged... that you would confide my daughter only to a French or English vessel having a Mediterranean pass. This attention, tho' of little consequence in matters of merchandize, is weight in the mind of a parent which sees even possibilities of capture beyond the reach of any estimate. If a peace be concluded with the Algerines ... I pray you to believe it from nobody else."

Such warnings did nothing to reassure the Eppeses that they ought to bow to Jefferson's wishes and send a stubbornly resistant little girl across the ocean to join her equally obdurate father. Finding the right ship, sailing at the right time and with the right captain and credentials, was enough of a problem. How much more complicated was the task of recruiting someone to take care of Polly on the trip. Jefferson had begun by proposing the idea of hiring a woman to serve as a nanny on the voyage, and asked the Eppeses for their advice about such a person. By August 1785, he had given the matter further thought. "With respect to the person to whose care she should be trusted," he wrote to Francis Eppes, "I must leave it to yourself and Mrs. Eppes altogether." But he had some suggestions. Some good lady passing from America to France, or even England, would be most eligible; but a careful gentleman who would be so kind as to superintend her would do. In this case some woman who has had the small-pox must attend her. A careful negro woman, as Isabel, for instance, if she has had the small-pox, would suffice under the patronage of a gentleman. The woman need not come farther than Havre, l'Orient, Nantes, or whatever port she should land at, because I could go there for the child myself, and the person could return to Virginia directly.

As months went by, Jefferson and Francis Eppes worked to recruit a chaperone for Polly. At first Jefferson hoped Polly might accompany Thomas Barclay, the American consul in Paris, who was expecting to travel to Philadelphia and then return to France. "She would be in the best hands possible; and should the time of his return become well ascertained, I will write you on the subject." But he did not want the Eppeses to wait for Barclay if they had already located the right ship and the right escort. "In the mean time it need not prevent your embracing any opportunity which occurs of a sound French or English ship, neither new nor old, sailing in the months of April, May, June or July under the care of a trusty person." And he added, in a teasing tone, "You see how much trouble I give you till you get this little charge out of your hands."

Elizabeth Eppes hated Jefferson's scheme from the beginning. Jefferson tried to overcome his sister-in-law's resistance with a combination of flattery and patriarchal firmness, working through his brother-in-law. "I know that Mrs. Eppes's goodness will make her feel her separation from an infant who has experienced so much of her tenderness," he wrote to Francis Eppes. "My unlimited confidence in her has been the greatest solace possible under my own separation from Polly. Mrs. Eppes's goodness will suggest to her many considerations which render it of importance to the future happiness of the child that she should neither forget, nor be forgotten by her sister and myself."

In the end, Francis Eppes decided that a father's insistent claim outweighed a child's frantic resistance, and looked for a ship and an escort. Overruling his worried wife and his terrified niece, Eppes told Jefferson in April 1787, only two weeks before the vessel was to set sail, that he had found an appropriate ship. The Robert was scheduled to depart for England on May 1, commanded by Captain Andrew Ramsay, "a man of very good temper." "She is a fine ship and has every accommodation to make [Polly] cumfortable except a Female attendant," Eppes wrote. He had hoped to be able to send Polly with the French consul and his wife, but that eventuality had fallen through. Thus Polly's chaperone was to be "a Mr. John Amonit a young man of caracter who promises to do every thing in his power to make her happy . . . recommended to you by our Governor and some others of your particular Friends." As to the question of the female attendant, Eppes reported that "Isabel or Sally will come with her either of whome will answer under the direction of Mr. Am[onit]." Some of the letters between Eppes and Jefferson have not been found. Perhaps they were destroyed, by Thomas Jefferson or his protective descendants, because they discussed the possibility that Sally Hemings would be going to Europe with Polly Jefferson.

THE LAUDED MR. AMONIT did not sail on the *Robert* as chaperone to Polly Jefferson. Instead, the nine-year-old girl crossed the ocean under the direct protection of the captain of the ship, Andrew Ramsay. Her sole traveling companion was fourteen-year-old Sally Hemings, who had come instead of Isabel Hern, a twenty-seven-year-old enslaved woman from Monticello whom Jefferson had mentioned. The Eppeses had fully intended to send Isabel, who was taken from Monticello to Eppington, leaving behind her husband and four children, in the spring of 1786. Francis Eppes set about pursuing "the necessary ceremony of enoculating" Isabel, as Jefferson had directed. All that took time, delaying Polly's departure another year. In the meantime, Isabel returned to Monticello and became pregnant again. She had a difficult birth with her fifth child, and was too sick to make the trip. Two weeks before the ship sailed, Francis Eppes was still holding out hope that Isabel would recover. But by that time he had settled on Sally as a suitable replacement.

Why? Sally Hemings hardly answered Jefferson's description of the person he required to accompany his daughter. She might have been a careful girl, but Sally was no mature woman. She had not been inoculated against smallpox. She was to be supervised by John Amonit, but he did not make the trip. And yet the Eppeses saw fit to go through with the plan, with Captain Ramsay's assurances that he would look after Polly. That would be no minor responsibility. The child was so distraught at the thought of leaving that the Eppeses had to trick her into boarding the ship. They brought their own children on board at Bermuda Hundred to play with Polly for a day or two, hoping to "reconcile her to" the voyage. The children played until Polly fell asleep, and then the Eppes family slipped away, leaving Polly and Sally on board. When Polly awoke, the ship had sailed.

If the Eppeses were concerned about Polly's safety under Sally's care, they could have simply canceled the plan and written to Jefferson that the situation had become impossible. They decided to push ahead. Surely they could have found some other slave woman to make the trip, including Elizabeth Hemings, who was then doing light duty at the shuttered Monticello. So why send a fourteen-year-old slave girl across the ocean, on a dangerous voyage with a child who burst into wild hysterics at even the thought of leaving her Virginia home?

The Eppeses clearly considered Sally Hemings to be healthy, trustworthy, intelligent, and diligent enough to see the journey through, and to deliver Polly safely to her father. Nobody had a closer acquaintance with Polly Jefferson's desires and tantrums than Sally Hemings. Sally had known Polly since she was born. At Eppington, Sally had been charged with Polly's personal care, which included far more than washing out her linen, mending her stockings, and emptying her chamber pot. The Eppeses knew that Polly would not make it easy on whoever was with her when she woke up aboard the *Robert*, anchors aweigh. Sally, as Polly's slave, had no choice but to deal with Polly's fury, and she surely knew what would or would not work when the storm broke. When nothing could be done to calm Polly down, Sally perforce must wait for the fit to play itself out, tolerating tears or even blows, ready to fetch a drink of water or to tuck an exhausted little girl into bed.

For Francis Eppes, that may have been enough. But for Elizabeth Eppes, there may have been something more, something complicated. As Abigail Adams would later observe, Sally was fond of Polly, and it appears that Polly liked to have Sally nearby. Whatever affection lay between these two girls was both a product of, and in defiance of, biological heritage. Family resemblances are quirky things, even in shadow families. Especially in growing children, we see fleeting glimpses of the father one day, the mother another, and sometimes even of ourselves. As much as Elizabeth Eppes ignored or rejected their kinship, and as much as Sally played her part in the approved family drama, surely there were times when, unwittingly and unwillingly, Elizabeth Eppes noticed an expression or a gesture, a look about the eyes or angle of the head, the shape of hands or feet or a way of laughing, that reminded her of her father, or one of her Wayles sisters (two of them now dead), or of her own children, or of herself. Sally Hemings was Polly Jefferson's flesh and blood, her aunt, to no

less a degree than Elizabeth Eppes. Disconcerting as those resemblances were, they also offered some whisper of consolation.

And if Sally remained at Eppington once Polly was gone, what would they do with her? No matter how much they needed hands to do the backbreaking job of growing tobacco, Sally could not be sent into the fields, since Jefferson preferred that Hemings women not do heavy farmwork. If they kept her on as a maid in the Eppes household, Sally posed a particular kind of risk. She was, according to the few descriptions we have of her, very light-skinned and beautiful, "mighty near white . . . very handsome, long straight hair down her back" according to Isaac Jefferson, and "light colored and decidedly good-looking" in the words of Thomas Jefferson's grandson, Jefferson Randolph.

Jack Eppes, Elizabeth and Francis's son, was then fourteen, just the age when young masters began to assert their authority. Some boys also began to trumpet their budding sexuality by exploiting slave girls. Francis Eppes's brother, Richard Henry Eppes, had been around Jack's age when Richard Henry was murdered by a desperate slave girl. Did the master of Eppington worry about his own son? All this would be pure speculation, if we did not know more about Jack Eppes. He had a tendency, as his father would later say, to "fall in love." He would eventually marry his first cousin, Polly Jefferson, and years later, after Polly's death, Jack would follow in his grandfather's and father-in-law's footsteps, keeping his own shadow family with Betsy Hemings—Sally Hemings's niece.

For her part, Elizabeth Eppes had grown up in a household where her father had a sexual relationship with his slave, Betty Hemings, and maintained a slave family right alongside his free family. Sally Hemings, Elizabeth Eppes's half-sister, was biologically Jack's half-aunt. Did it occur to Elizabeth Eppes that if Jack determined to set his sights on Sally, he would be pressing a sexual relationship on her own sister?

The Eppeses thus may have had ample reasons to see Sally on her way—back to Monticello, preferably, but in the jumble of events, to England with Polly. Sally, of course, had no choice in the matter. If life at Eppington had been hard in many ways, there must also have been good moments, times when Polly was in a good mood, charming and wanting to play; warm spring days when Sally could steal a few minutes to walk through Francis Eppes's blooming gardens, maybe even visits back to Monticello. Sally may well have wanted to return to Monticello, which was, after all, her home, a lovely place where she was a member of a special family. But at Monticello, the kind master had been replaced by an overseer. Her brothers, Martin, Robert, and James, and sister Mary, were away, working on their own.

It is also possible that Sally wanted to go to France with Polly. Her brother James was in Paris, as was the master she doubtless remembered better than Polly did. Having seen Thomas Jefferson in the depths of his grief, knowing Polly's resistance to him, and separated from her own family, Sally might have felt sympathy for his longing for his children. Surely she sympathized with little Polly, who was to be cruelly forced away from the people she had come to love, at the very age when Sally herself had been sent away from her own Hemings kin. Sally knew that making the trip would require some bravery. Her brother Martin had demonstrated his courage when the British came to Monticello. Simply to board the ship and head off into the utterly unknown, Sally Hemings had to be brave, too.

IF POLLY JEFFERSON had dreaded the voyage with a vengeance, how much more perilous it was for Sally to take that trip! For one thing, Polly had been inoculated against smallpox, and Sally had not. But just as important, the two girls were miles apart socially. Polly quickly became the pet of the captain and crew. She was the daughter of the American ambassador, traveling under Captain Ramsay's protection. She would cling to Andrew Ramsay like a human barnacle, and he became attached to her in turn. For all her terror, little Polly was in a considerably more secure position than the pretty, very vulnerable Sally Hemings. Even if Ramsay tried to offer Sally some measure of protection, he clearly could not watch over her every second of the five-week journey. She would have to venture off on her own to fetch water or food, to get help if Polly was sick or disgruntled, to dispose of slops. Seagoing men were not known for their fine manners, even where genteel women were concerned. What might the sailors have had to say to a comely slave girl? What unsolicited contact could occur in the close passages of the ship? And what did Sally Hemings know of Algerian pirates who captured people and sold them into slavery, what did she hear either from her rough and ready shipmates, or from Virginia slaves who had their own memories of Arab slave catchers and traders?

The depredations of the Algerian pirates were, after all, common knowledge on both sides of the Atlantic. They even worried Patsy Jefferson, in school at the fashionable Abbaye de Panthémont in Paris, awaiting word of her little sister's voyage. Patsy wrote to her father, who was on tour in the south of France, to remind him to hurry back, "as you must be here for the arrival of my sister." Being in a convent school assuredly did not prevent Patsy from hearing or discussing the latest news. She related vivid details of a skirmish between an American ship and an Algerian corsair. "A Virginia ship coming to spain met with a corser of the same strength," she wrote. "They fought and the battle lasted an hour and a quarter. The Americans gained and boarded the corser where they found chains that had been prepared for them. They took them and made use of them for the algerians themselves."

Some who heard the story doubtless believed turnabout was fair play, but Patsy saw the event as a story of the iniquity of slavery.

"They returned to virginia from whence they are to go back to algers to change the prisoners to which if the algerines will not consent the poor creatures will be sold as slaves. Good god have we not enough? I wish with all my soul that the poor negroes were freed."

The *Robert* had the proper credentials to keep pirates away, and as long as she was with Polly, Sally would be relatively safe. But Sally must have been told that she would likely have to return across the ocean alone. She would have to cope, on her own, with the sea and the sailors and maybe even with slave-trading pirates. Sometimes even the brave have excellent reason to be afraid.

SMALL WONDER, THEN, that when they arrived in London on June 26, 1787, to be delivered to Abigail Adams by Captain Ramsay, Sally Hemings was not a very impressive figure. Jefferson had developed close relationships with both John Adams, now American minister to England, and his wife, Abigail, when the couple were still in Paris. He had written in December to let Abigail Adams know that Polly would be sailing to London, and that he hoped that she would "take her under your wing till I can have notice to send for her, which I shall do express in the moment of my knowing she is arrived. She is about 8. years old, and will be in the care of her nurse, a black woman, to whom she is confided with safety."

Adams had a terrible time prying Polly loose from the captain, and she was appalled, from the first, at Polly's resistance to her father. She was also aghast that "the old Nurse whom you expected to have attended her, was sick and unable to come. She has a Girl about 15 or 16 with her, the Sister of the Servant you have with you." Sally was only fourteen. Perhaps Abigail Adams overestimated her age because she looked older than she was. Or perhaps Adams simply could not believe that Jefferson's relatives would send his daughter across the ocean with someone that young. By the next day, Adams had managed to calm Polly down; Polly rapidly transferred her attachment from the captain to her new protector. Adams, who had found Polly in such ragged condition that she had taken her shopping for "a few articles which she could not well do without," remained shocked at the idea of such a child being sent across the ocean with a young slave: "The Girl who is with her is quite a child, and Captain Ramsey is of the opinion will be of so little Service that he had better carry her back with him." Adams was understandably reluctant to give her approval to that plan without explicit instructions from Jefferson. "But of this you will be the judge. She seems fond of the child and appears good naturd."

Abigail Adams had considerable knowledge of the culture and character of men who made their living on the sea. Her husband had famously defended the British soldiers charged in the Boston Massacre by arguing that the mob that had taunted the redcoats into firing was nothing more than a rabble of "saucy boys, negroes and mullatoes, and outlandish jack tars." Abigail expressed no personal attachment to Sally Hemings, but she did see fit to purchase clothing for her, as she had for Polly, "as I should have done had they been my own," since both girls arrived with "cloaths only proper for the sea." If she had any thought of simply sending Sally back with Andrew Ramsay, she would likely not have put herself to that expense and trouble.

INSTEAD OF COMING to get Polly himself, Thomas Jefferson sent his French mâitre d'hotel, Adrien Petit. Polly, disappointed and betrayed once again by her father, fell into a fresh round of fits, which Abigail Adams sought in vain to relieve. Still, she believed that Polly would come around. When the child had first arrived, after five weeks at sea "with men only . . . she was rough as a little sailor, and then she had been decoyed from the ship, which made her very angry, and no one having any Authority over her; I was apprehensive I should meet with some trouble." But Abigail Adams was captivated by Jefferson's younger daughter, "a child of the quickest sensibility, and the maturest understanding . . . the favourite of every creature in the House." What a shame, Adams offered, that Jefferson must lose the pleasure of Polly's company by "committing her to a convent. Yet situated as you are," she agreed, "you cannot keep her with you. The Girl she has with her, wants more care than the child, and is wholly incapable of looking properly after her, without some superiour to direct her."

Dumas Malone took from Adams's remark a general lesson about Sally Hemings's role as Polly Jefferson's escort across the sea: "This girl proved to be of little help." Malone, one of the people who most vehemently denied Thomas Jefferson's later relationship with Sally Hemings, had reasons of his own for dismissing Sally Hemings as a nameless, useless nobody. But rather than following Malone's lead, we must put Abigail Adams's words in context. Polly Jefferson might be enchanting, but she was quite a handful, liable to pitch a shrieking fit at the thought of separation from whatever person served as her protector of the moment. She had been repeatedly deceived and manipulated, in ways that strike a modern parent as singularly cruel. Polly had learned to get her way by alternately charming and raging. One minute an "amiable lovely Child" who "reads to me by the hour with great distinctness, and comments on what she reads with much propriety," she was at the next moment "almost in a Frenzy."

Sally Hemings had no standing to take Polly in hand and make her behave. Her job was to do as Polly commanded. No one should have expected Sally to take on the job of correcting Polly, and Abigail Adams was not suggesting that she do so. In Adams's mind, Sally simply did not merit that much thought. Instead, Adams rather acidly pointed out that apart from arranging for Polly to go to a Catholic boarding school, something of which Adams clearly disapproved, Thomas Jefferson had not taken any steps to see that she was properly supervised, including during her five weeks at sea "with only men." Under the circumstances, he could hardly expect Sally to provide all the care and direction Polly needed.

And what did Abigail Adams mean when she wrote that Sally Hemings "wants more care than the child"? Adams obviously found Sally immature and seems to have regarded the enslaved girl with a mixture of pity and contempt. Sally had come to her poorly clothed and, to her eyes, too young, ignorant, and soft to govern the tempestuous and scintillating Polly Jefferson. The two girls were, to Adams's eyes, a study in contrasts. Polly Jefferson was educated: at nine, already a great reader and a writer of letters. Francis Eppes, like Thomas Jefferson, believed in schooling for girls and had written to Jefferson to ask him to find a tutor, "a man or Woman not younger than forty capable of teaching our girls French English erethmatick and musick." Polly was also a hearty eater, who had once said she was unable to write to her father because she had a rash on her arms, a malady her aunt Elizabeth chalked up to "eating too freely of butter'd muffins."

No one would have taken pains to procure an education for Sally Hemings, or have expected Sally to court the approval of a strange white woman by reading to her. If Sally could read at all, she would have had to persuade someone to teach her. She would have spent her years at Eppington dining not on butter'd muffins, but on slave rations, typically corn and fatty pork, and whatever vegetables, eggs, or meat she might get from an enslaved person who kept a garden or chickens. Sally probably had to work for those treats. On board the ship, Polly Jefferson would have been fed the choicest tidbits from the captain's table, while Sally Hemings ate whatever the cook saw fit to give her.

If the two girls arrived in London in torn and dirty dresses, desperately needing decent clothing, the quality of even their shabby garments marked the difference in their ranks. Abigail Adams would

soon outfit Polly with fine Irish Holland frocks and muslin trimmed with lace, stockings and nightcaps and a brown beaver hat with a feather, leather gloves, and a blue satin sash and a comb and brush and a toothbrush. Adams bought for Sally Hemings enough calico to make two short gowns and coats, and Irish linen for aprons, stockings, and a handkerchief shawl. She paid six shillings and eight pence "for washing," presumably for the clothes in which Sally had arrived. Adams had also paid to have Polly's trunks delivered; we may assume that Sally's baggage was modest at best.

Though Abigail Adams was silent on the matter, Sally Hemings was very light-skinned, and may have borne some obvious physical resemblance to her niece. Such things are sometimes more apparent to strangers than to those who have schooled themselves not to see. That would have made the contrasts between the two girls all the more painfully plain.

While Polly Jefferson was emotionally unhinged when Abigail Adams knew her, she was evidently in good health. We cannot be sure of the same for Sally Hemings, although if she had been very sick, Adams would have mentioned the fact. But if Polly was distraught at the thought of being taken to her distant but loving father, with what emotions must Sally have faced the wild uncertainty of her own fate?

Sally too had been separated from all she knew and thrust on board a ship, subjected to five weeks with a volatile little mistress and a boatload of strange men. She was facing the prospect of staying in London, a dirty, noisy, scary place, the likes of which she had never seen, awaiting a long and frightening voyage back, alone, in worsening weather. Andrew Ramsay may have offered to "carry her back with him" but he said nothing at all about Sally Hemings in the letter he wrote to Thomas Jefferson on July 6, 1787, offering to take Polly all the way to Paris if necessary. Ramsay might have been, as Annette Gordon-Reed has written, "just a bit too eager" to take Sally Hemings away; Gordon-Reed reminds us that "sexual exploitation—either the potential for it or the actual experience of it—was a constant threat" in the lives of enslaved girls. But even if Ramsay had only noble motives for wanting to take Sally back to Virginia, members of the Hemings family knew that the best intentions of white sea captains were easily thwarted. Sally's brother James was in Paris. She may have wanted badly to accompany Polly, when the little girl was at last persuaded or compelled to go.

In the end, Sally Hemings found her way to Paris not because of her own wishes, but because Polly Jefferson wanted her to go. More importantly, she boarded a boat bound for France and not America because Thomas Jefferson was willing to have her come. Paris

15

THE FOURTEEN-YEAR-OLD GIRL who traveled to France in the summer of 1787 was unsophisticated, but not innocent. Sally Hemings had grown up with revolution and invasion. Members of her family had been taken captive, and a place she knew had been pillaged. She had seen the British cavalry come riding up to the great house at Monticello. People close to her had died: her mistress and half-sister, two Lucys at Eppington (both her half-nieces), and her own nine-year-old sister, another Lucy. She knew people who had been bought and sold. Her master at Eppington had seen a slave girl hanged for the murder of his brother.

Sally had lived on Virginia farms her whole life, but the remoteness of such places did not keep out violence or sin or sorrow in the lives of the free or the enslaved. She had felt cold and heat and sickness and sadness. But she had known peaceful times, too, when Monticello and Eppington were quiet, green places ruled by the seasons and the habits of slavery, which were orderly and familiar.

Thomas Jefferson, awaiting the arrival of his daughter and her maid, surely believed he was waiting for two young girls, though he must have wondered how the years had changed his daughter and this slave who was also a blood relation, his beloved Martha's halfsister. Then again, he may not have given the matter a lot of thought. He had plenty to occupy his mind. He had only just returned from a mostly idyllic tour of southern France and Italy, and like many people who have been on vacation, he had a lot of catching up to do. In addition to his mundane duties—processing passports, negotiating for Americans who had business in France, seeking economic and political ties—he was contending with an international crisis. War between Turkey and Russia threatened to inflame all of Europe, with unclear but troubling consequences for the newborn United States.

Adrien Petit, Polly Jefferson, and Sally Hemings arrived in Paris on July 15, 1787. Polly "had totally forgotten her sister," Jefferson reported to Abigail Adams, "but thought, on seeing me, that she recollected something of me." Her reaction was understandable, as was Jefferson's similar response: "She neither knew us nor should we have known her had we met with her unexpectedly." Of all the Virginians present at the reunion in Paris, Thomas Jefferson had surely changed the least, in physical terms. True, he was dressing far more fashionably than he had three years earlier, but the three girls would have been absolutely transformed, the two eldest now heading into womanhood.

Madison Hemings, Sally's second son, would tell an interviewer that his mother had come to Paris as nearly a "young woman grown." Sally may have chosen to portray herself as more or less mature, for reasons we will soon explore, when she told her children about her time in Paris. Abigail Adams, on the other hand, had deemed Sally "quite a child" but "fond" and "good naturd" when she hosted the two girls in London. One way or another, Sally Hemings's time in Paris would change her forever.

PARIS MUST HAVE struck Sally and Polly as another planet. The dark and teeming streets, the fabulous boulevards, cacophonous with

oxcarts and wagons groaning with stones or meat, driven by cursing teamsters; gilded carriages ferrying women with coiffeurs a foot high, gowned in silk and dripping with jewels, and men in satin and lace and silvery wigs; the harsh cries of street vendors hawking everything from cherries and chestnuts to live birds, old hats, snuffboxes, and soap; the plaintive wails of the unemployed, selling the rags they had picked from garbage heaps; the emaciated young girls, selling themselves. How marvelous, the magnificent colonnaded buildings, immense lush gardens, imposing statues of men on horseback. And how intimidating, the hulking women carrying heavy loads and brawling with one another at the top of their lungs. Strange men leered and hurled incomprehensible, threatening suggestions. And then there were the pitiful tattered figures of begging children and starving mothers, crying for bread. What did not assault the girls' eyes or ears would have attacked their noses, the outdoor privies of plantation life having nothing on the infamous open sewers of the French capital. Especially in July. If they were not feeling faint by the time they reached the Hôtel de Langeac, they must have had strong stomachs indeed.

As the hired coach turned off the Champs-Elysées and onto the Rue de Berri, into the courtyard, they beheld the two-story neoclassical façade of Thomas Jefferson's rented home, the Hôtel de Langeac. Sally Hemings and Polly Jefferson had known some grand houses, on the Virginia scale. Eppington, while no architectural novelty, was stately and imposing, with its white façade and red roof, its high ceilings and sweeping views. Monticello, though not yet the domed landmark it would become, was a fine brick building in command of a mountaintop, equipped with the columned porticos and grand salon that bespoke the importance and vision of the owner. But neither Sally nor Polly had ever seen anything like the great houses of Paris. The Hôtel de Langeac was located at what was then the western edge of Paris. It was built in the shape of a trapezoid, squeezed into the place where the streets met at a sharp angle. The front doors opened into a great elliptical entrance hall, illuminated from above and leading to a circular salon with a skylight that inspired Jefferson in his later design of the dome room at Monticello. His private suite, upstairs, included an oval study overlooking the garden. The place was a refuge from the clamor of the city, with its bright, airy rooms, its extensive gardens, its gilded mirrors and gleaming floors, pianoforte and paintings and clocks, the kitchen hung with its immense battery of shiny copper pots and pans. Jefferson's house was also equipped with an indoor privy, a convenience that must have seemed a wonder to girls from the Virginia countryside.

THOMAS JEFFERSON WAS a creature of order and routine, in matters ranging from the laying of fires and winding of clocks, to the settling of girls who depended upon him. Within a week of her arrival, Polly had been dispatched to the Abbaye de Panthémont, the elite Catholic girls' boarding school that Patsy had attended since coming to France. Polly would live and study with her sister, with the promise of seeing her father once or twice a week.

Sally had a reunion of her own, with her brother James. He was just finishing up his apprenticeship in cooking and was about to be promoted to chef de cuisine in Jefferson's household. James was eight years older than Sally, and even before the journey to Paris, he had traveled more broadly than Sally ever had or would again, once she returned to America. How formidable he must have seemed, in his chef's toque and work uniform, speaking French and, very soon, earning regular wages.

Sally too would develop new skills during her time in France, but first there was some unfinished business. Jefferson would have to make a place for this young female slave in his decidedly masculine, French-speaking household. In addition to Petit, Jefferson employed a valet de chambre, a coachman, a frotteur (who polished the parquet floors by skating around on brushes), and a gardener, all Frenchmen. He had previously hired a woman to cook, but now James Hemings was making the transition from personal servant to chef de cuisine. However trustworthy Sally had proven herself by getting Polly safely across the ocean, she could not be sent out on errands, since she spoke no French and did not know the city. As soon as he could, Jefferson sent her off to the outskirts of town. She was to be inoculated against smallpox, a weeks-long ordeal of risk and recovery brilliantly reconstructed by historian Annette Gordon-Reed. Both Jefferson and Francis Eppes had made so much of the need for immunization that Sally must have been relieved that she would finally be protected from the dreaded disease. Jefferson entrusted her to the care of Dr. Robert Sutton and his sons, the foremost "inoculationists" not only in Paris, but in the world at the time. Sally would be isolated and carefully nursed while she suffered whatever symptoms she endured, and she evidently survived the experience without lasting effects. But what a painful, bizarre, and confusing way to be introduced to life in a foreign country, among complete strangers, most of whom spoke no English.

For more than two years, Sally Hemings lived in Paris. According to her son, Madison Hemings, she learned to speak French with some facility. She had to communicate with the other servants in the Jefferson household, and James had hired a tutor to help him learn the language. Polly and Patsy were also studying and speaking French at school, and Patsy was already beginning to forget her first language, and to resort to French sentence constructions even when she wrote in English. "I begin to have really great difficulty to write in English," she told her father in one letter, asking about the wrist he had broken earlier by writing, "Pray, how does your arm go?" By the time Sally Hemings returned to America, she was thinking in French, too, at least sometimes. Like many people who have treasured their time abroad, Sally would sprinkle French words into her sentences for years after.

In that summer of 1787, Thomas Jefferson gave Sally Hemings the attention due one more person for whom he was responsible, and probably not much more than that. It was his duty to take care of the people who depended upon him, especially females, even when he was occupied with a thousand other things, from matters of war and peace to the pursuit of his own happiness. Just as he made certain that Sally was secure against smallpox, he also needed to see that she had a place to stay, food to eat, clothing to wear. She may have lived in his house, or in the nearby servants' quarters. She ate what the other servants did, although her brother the chef likely introduced her to special treats, like his delicate "Snow Eggs," a custard and poached meringue confection known to later gourmet cooks as "Floating Island."

Sally had new words to wrap her mouth around, and new food to tempt her palate, and new clothes to make her presentable in the eyes of those who would identify her with her distinguished master. Patsy began to go out more in society, requiring her own elaborate dresses and accessories, including a maid to accompany her on social visits and to evening events. So Jefferson spent money on clothing for Sally. Just as he began to pay James Hemings for serving as his chef, Jefferson also began, on New Year's Day of 1788, to pay wages to Sally. It is not clear what kind of work she did to earn her pay. Now that Polly was at school, Sally was no longer serving as her maid on a daily basis, though she would likely have assisted both Patsy and Polly when they came home on weekends and for more extended visits, carrying their water and their waste, sewing up their ripped hems, tending their hair, scrubbing stains out of their gloves. She learned to care for the fine fabrics the Jefferson girls began to wear, and to do fancy sewing, a skill at which her eldest sister, Mary, excelled, and which Thomas Jefferson believed all women should master. With so little to do much of the time, Sally likely began her lifelong job as Thomas Jefferson's chambermaid, or *femme de chambre*.

A Virginia slave girl with money in her pocket may have found Paris a magical place full of wonderful things to see and do, to hear and taste, to inspect and buy. But if the city offered delights, it was also a place of unspeakable poverty, seething with the resentment of the many who labored for little, in the shadow of the glittering excesses of the few. The working women of Paris might roam the streets to ply their trades, to flirt and bargain and brawl, but the pretty young servant of a luminary like Thomas Jefferson, raised in relative isolation in Virginia and with an imperfect knowledge of French, must have found the clamor and bustle of the streets daunting, and sometimes dangerous.

There were other reasons that Sally might not have embraced all that Paris offered. Her brother James needed to be out in the city, elbowing his way through the markets and haggling for the things he required to prepare meals for an exacting master and numerous guests. But Sally's work would not often have taken her away from the house. The men who watched over her would not have given her a lot of room to roam on her own. James, a Virginian, after all, might well have felt that it was his duty to keep an eye on his beautiful little sister, amid so many perils and temptations. And the master, for all his own fascination with "the vaunted scene of Europe," was a man who believed, to the depth of his soul, that women needed to be protected, and men's duty was to provide that protection. Jefferson was absolutely appalled at the way European women of all ranks flaunted themselves in public.

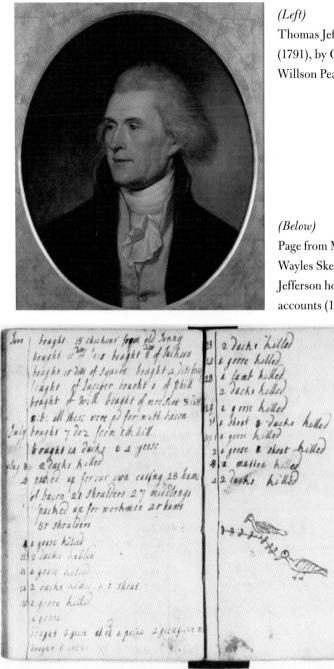

Thomas Jefferson (1791), by Charles Willson Peale.

Page from Martha Wayles Skelton Jefferson household accounts (1777).

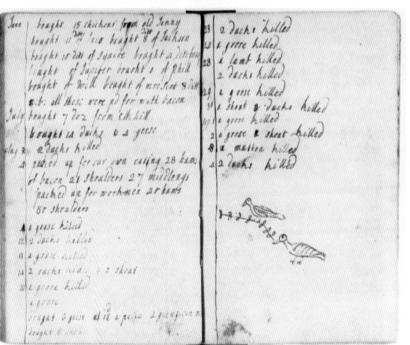

For sale in Virginia The lands called Elk hill on Jam HH. Bu 1. 826 1.060 a Com the 24 3 H. 30

(Left) Map of Elk Hill property, drawn from memory by Thomas Jefferson (1793).

(Below) The house at Eppington.

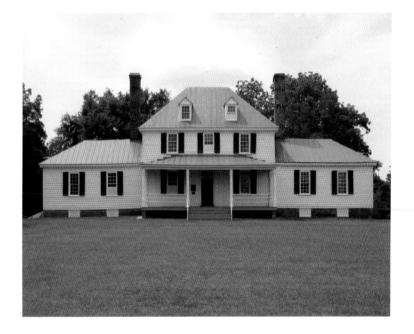

(Right) Maria Cosway selfportrait, mezzotint by Valentine Green.

(Below) The Monticello mansion.

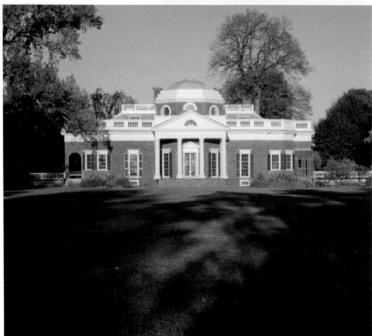

(Above) Thomas Jefferson's bedroom and study.

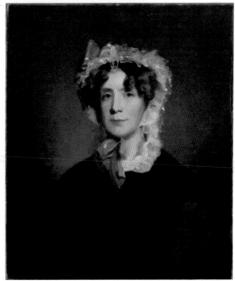

(Right) Martha Jefferson Randolph, portrait by Thomas Sully.

(Above) Martha Jefferson Randolph's sitting room (south square room) at Monticello.

(Left) The Monticello staircase.

(Above) Cook's Room in the south dependency, similar to the room in which Sally Hemings may have lived for a time.

> *(Right)* Ann Cary Randolph Bankhead, portrait by James Ford.

Ellen Wayles Randolph Coolidge, portrait by unknown artist.

Cornelia Jefferson Randolph, bust by William Coffee.

	College 2 gener lande van die helensen 1 destaar heer gest Japane 2 destaar of Handbar 2 destaar of Handbar 2 destaar of Handbar 2 destaar of Handbar	An all a second transmission of the second s
A long for the second of the	Andread and an an and a second of the second	A desta dance de la desta desta de la desta dest

(Above) Floor plan of Monticello, with estate inventory, by Cornelia Jefferson Randolph.

(Below) Photograph of Virginia Randolph Trist and Ellen Randolph Coolidge (ca. 1850s).

(Above) Bell used by Martha Jefferson, given to Sally Hemings. THOMAS JEFFERSON HAD long believed in a natural law of gender, a separation of the roles and responsibilities of women and men that, ideally, confined women to the protected sphere of domesticity while giving men both the freedoms and the burdens of public life. The American Revolution had breached that divide, with mortal consequences for his beloved wife, and perhaps even some of his children. In Paris, experiencing wondrous sights, sounds, and sensations, amid heady talk of liberty and progress and even perfectibility, in the company of scintillating friends, including some notably intelligent, assertive, and ambitious women, Jefferson had begun to recover from Martha's death, to enjoy life, and to reimagine his own future.

But much as Jefferson relished the companionship of women in Paris, much as he learned to practice the gallantries and flirtations that made French society so effervescent, his time in Europe deepened and solidified his belief that nations could not be virtuous and progressive unless they safeguarded the differences between men and women, the separation of politics from polite society, the segregation of public from private life. In the months just before Polly Jefferson and Sally Hemings arrived in Paris, Thomas Jefferson had been traveling in the south of France and in Italy. He had seen endless examples of women out in public, doing men's work. For him, such sexual disorder was both a cause and a symptom of social injustice. He observed that in the least prosperous parts of Europe, the natural order of things had been upended. He began his "Notes on a Tour through Southern France and Italy" with a description of the countryside, and a critique of social life:

I observe women and children carrying heavy burthens, and laboring with the hough [hoe]. This is an unequivocal indication of extreme poverty. Men, in a civilized country, never expose

196 🧏 THE WOMEN JEFFERSON LOVED

their wives and children to labour above their force or sex, as long as their own labour can protect them from it.

Jefferson glossed over his own hypocrisy in making such a pronouncement, he who sent women by the scores out to his Virginia fields to plow and hoe and cut tobacco on the frozen ground of late winter and in the blazing summer sun. Back at Monticello, Ursula presided over the slaughter of dozens of pigs and hung hundreds of pounds of ham in his smokehouse. He did not extend the privileges or responsibilities of free women to enslaved women, any more than he affirmed the liberties of enslaved men.

But he had, after all, been away from Virginia for three years. Far across the ocean, he was nurturing and polishing a nostalgic vision of his life at Monticello as an unbroken idyll of happiness, an arcadian counterexample to the artifice and corruption of Europe's most lush, decadent, and teeming capital. As he thought about how women lived, and where they belonged, he became more and more persuaded that the United States was more progressive, more civilized, more moral than Old Europe. In Languedoc, he saw women working as barge hands and lock keepers on the canals, jobs that he considered "much too laborious for them," though he did not suggest that those women were physically unable to do their work. Presumably they were laboring "above their sex" rather than "above their force." But doing such inappropriate work, Jefferson argued, not only taxed women's strength, but also imperiled their morals. "Can we wonder if such of them as have a little beauty prefer easier courses to get their livelihood, as long as that beauty lasts?" he asked. He blamed the elite women who hired male hairdressers and domestics for the corruption of working girls: "Ladies who employ men in the offices which should be reserved for their sex, are they not bawds in effect? For every man they thus employ, some girl, whose place he has taken, is driven to whoredom."

In March and April of 1788, nine months after Polly and Sally came to Paris, Jefferson set out on a seven-week tour of Holland and the Rhine valley. Once again he was alarmed that "the women here, as in Germany, do all sorts of work." In his journal, he proceeded to lay out his view of women's nature in greater detail than he ever had before:

While one considers them as useful and rational companions, one cannot forget that they are also objects of our pleasures. Nor can they ever forget it. While employed in dirt and drudgery, some tag of a ribbon, some ring or bit of bracelet, earbob or necklace, or something of that kind will show that the desire of pleasing is never suspended in them. How valuable is that state of society which allots to them internal employments only, and external to men. They are formed by nature for attentions and not for hard labour. A woman never forgets one of the numerous train of little offices which belong to her; a man forgets often.

Jefferson's attention to women's eagerness to please, their weakness and vulnerability to whoredom, verged on the obsessive. The arrival of his younger daughter and her maid strengthened his determination to see that the girls and women who lived under his protection were sequestered, not simply from hard labor, but from men's salacious gazes and thoughts. He prided himself on his ability to control his base impulses, but he knew that other men were not so virtuous. His daughters, and young Sally Hemings, the girl who, in fleeting moments, may have raised the ghost of his lost Martha, were members of his family, deserving of his care, his protection, his possession. Paris was a wicked and enticing place. He sent his daughters to a convent. He would certainly have done what he could to shield Sally Hemings from hungry eyes, even as he looked at her with eyes of his own.

Amazons versus Angels

16

OVER THE MONTHS that followed, Sally Hemings grew from a child into a woman, a coming of age that was, according to her son, bound inextricably with becoming the mistress—or, to use Madison Hemings's word, concubine—of Thomas Jefferson. Jefferson was a vigorous, charismatic, powerful man of forty-four living in a city renowned for its wickedness. He could have picked out sexual partners like a man at a morning market, inspecting a bin full of dewy ripe peaches. He knew any number of gorgeous, talented, well-born, and willing women. What in the world was going on in Thomas Jefferson's mind?

IN THE THREE years since he'd come to France, Thomas Jefferson had been amazed, amused, attracted, captivated, annoyed, and appalled by the women of Paris. While his gregarious predecessor, Benjamin Franklin, had reveled in his status as the ladies' favorite, Jefferson was more reserved and quite a bit more priggish than the celebrated Franklin, Paris's favorite bon vivant in a coonskin cap. But like Franklin, Jefferson presented himself as an American original, a sunny-tempered, democratic rustic. The Virginian was no stranger to politics, and Paris society was nothing if not political. He learned very quickly to sense the undertones, to watch out for intrigue in every gesture or glance.

Jefferson loved the concerts and theater and opera, so he found himself in places where women displayed themselves to the public. He was a popular figure at the salons and levees where women ruled. He learned to flirt and gossip, to clothe himself with elegance, to know fine food and wine. He spent time with flamboyant women and enjoyed socializing with them more than he ever had before, and a good deal more than he ever would again. The women of haute Paris were often pretty and sometimes witty, and a few were even learned. They dressed with elaborate care, cultivated the art of conversation, and in some cases excelled in the arts of music and painting. While he sought out a more conventional crowd than Franklin's circle of "atheists, deists and libertines," in John Adams's waspish phrase, Jefferson liked artists and musicians and writers and radicals who questioned the rules. He was well acquainted with women who dared to probe the edges of propriety. In one case, as we will see, he was simply bedazzled by an accomplished, mildly daring lady.

But even as Jefferson took his place in the social whirl, even as he insisted that he did "love this people," he remained a little aloof and considerably critical. He recoiled at the sight of peasant women and their city-dwelling sisters doing work he considered above their abilities and against their nature. Elegant ladies were also doing all kinds of things they should not have been doing. Their idleness and extravagance disgusted him; their forwardness took him aback. Some of them were especially aggressive, like the Dutch baroness he met when he attended a *lundi gras* masquerade with William Stephens Smith, John Adams's secretary, in 1786. Jefferson managed to slip out of her clutches, but "when Mr. Jefferson had made his escape," Smith said, the baroness "fastened her talons on me." The more Jefferson saw of Parisian women, the more his memory of Martha's many trials faded and sweetened, leaving behind a vision of familial peace and bliss. He began to imagine America as the land of manly men who lived up to their responsibilities, and modest, genuine females who created domestic tranquility.

Paris changed Thomas Jefferson in many ways, from the quality of the lace at his cuffs, to the vintage of the wine on his table, and not least, to the scope of his architectural and philosophical imagination. But while he enjoyed watching and escorting, flattering and flirting with lovely ladies, he hated hearing them challenge and disagree. The more they insisted and disputed, the more he convinced himself that for the good of society, women must be protected from politics, and public business in turn must be protected from the disruptive presence of meddlesome and seductive females.

It was not just that women were not made for such things (though they weren't, in his view). They had an innate desire to please men, and that made them dangerous indeed, potential, if not actual, agents of corruption. Jefferson chose his friends and allies carefully, with an eye to their discretion and their judgment. Years earlier, he had decided not to hire a man who "appears to have a good enough heart, an understanding somewhat better than common but too little guard on his lips. I have marked him particularly in the company of women where he loses all power over himself and becomes almost frenzied. His temperature would not be proof against their allurements were such to be employed as engines against him." In Paris, he grew ever warier of men who lacked control, of men who used women to get ahead, of designing females with agendas of their own.

One such alluring woman was the immensely wealthy and beautiful Philadelphian Anne Willing Bingham. She was the daughter of Thomas Willing, the richest banker in America, and the wife of the second richest, William Bingham. Anne Bingham enchanted Jefferson when he met her in Paris, in the winter before Polly Jefferson and Sally Hemings arrived. But he despised William Bingham, whom he regarded as an ambitious and unscrupulous arriviste. As the Binghams made their way back to America, he wrote to warn James Madison that William Bingham "will make you believe he was on the most intimate footing with the first characters in Europe and versed in the secrets of every cabinet. Not a word of this is true. He had a rage for being presented to great men and had no modesty in the methods by which he could effect it." Not only was Bingham obnoxious, but he was using his wife to gain influence. "If he obtained access," Jefferson commented, "... it was with such as who were susceptible of impression from the beauty of his wife."

Anne Bingham was not just beautiful. She was intelligent and broad-minded. She relished the freedom with which French women moved and talked and acted, and had told Jefferson as much. On the heels of his warning to Madison about her husband, Jefferson wrote Mrs. Bingham a long letter, asking her, "Tell me truly and honestly, whether you do not find the tranquil pleasures of America preferable to the empty bustle of Paris." Then he painted a picture of the Parisian grande dame, a passage that ranks as one of the funniest and most savage in Jefferson's entire correspondence:

At eleven o'clock it is day chez Madame. The curtains are drawn. Propped on bolsters and pillows, and her head scratched into a little order, the bulletins of the sick are read, and the billets of the well. She writes to some of her acquaintance and receives the visits of others. If the morning is not very thronged, she is able to get out and hobble round the cage of the Palais royal: but she must hobble quickly, for the Coeffeur's turn is to come, and a tremendous turn it is! Happy if he does not make her arrive when dinner is half over! The torpitude of digestion a little passed, she flutters half an hours thro' the streets by way of paying visits, and then to the Spectacles. These finished, another half hour is devoted to dodging in and out of the doors of her very sincere friends, and then away to supper. After supper cards; and after cards bed, to rise at noon the next day, and to tread, like a millhorse, the same trodden circle over again.

Jefferson figured that Anne Bingham would get a laugh out of his biting portrait, but he also attached a serious moral: "Thus the days of life are consumed, one by one, without an object beyond the present moment: ever flying from the ennui of that, yet crying it with us; eternally in pursuit of happiness which keeps eternally before us."

At that moment, he was, of course, insisting that his youngest daughter be taken from her home in Virginia and sent across the ocean to France. Still, he embraced a romantic image of home life in America, a vision of peace and harmony that he himself had known only fleetingly over the course of his own time-tossed, tragic marriage:

In America, on the other hand, the society of your husband, the fond cares for the children, the arrangements of the house, the improvements of the grounds fill every moment with a healthy and useful activity. Every exertion is encouraging, because to present amusement it joins the promise of some future good. The intervals of leisure are filled by the society of real friends, whose affections are not thinned to cob-web by being spread over a thousand objects.

Jefferson closed his letter by offering to send Mrs. Bingham news of the latest fashions, and perhaps even some items of couture, although he declined to pick them out himself. He ended with a poke at the political pretensions of some ladies. Mrs. Bingham should designate someone to choose any clothes he sent her, or perhaps "we will call an assembleé des Notables to help you out of the difficulty, as is now the fashion."

That winter, as he awaited word of Polly's voyage, it seemed to him that Paris women really were doing outrageous things, right out in public. The brawny market hawkers who hollered and quarreled could be forgiven their unladylike behavior, having to make a living, after all. But even fine ladies were forgetting themselves, intruding into business in which they had no place. Jefferson was willing enough to talk a little politics with women who did not push things too far. In letters to his learned female friends, he routinely mixed observations on events of the day with gossip, fashion news, and light flirtation. He told his friend the Comtesse de Noailles de Tessé that he had some ideas for a reorganization of the French government along more democratic, American lines, ending his proposal with a morsel of flattery: "This is my plan Madam; but I wish to know yours, which I am sure is better." He corresponded with Abigail Adams on matters great and small. Her outraged response to the "mobbish insurgents" who fomented the backcountry revolt in Massachusetts known as Shays' Rebellion had prompted Jefferson to observe, "I like a little rebellion now and then." But we should see these exchanges as news swapping, not policy making. Neither of these learned women advocated a real role for women in government, and neither proposed to the famous apostle of liberty that he ought to think about extending the Rights of Man to woman.

POLLY AND SALLY arrived in the summer of 1787, in the midst of international turmoil and rising civil unrest. That fall, with his daughters installed in the convent and Sally Hemings recovering from her inoculation at a house on the edge of the city, Thomas Jefferson wrote a staggering number of letters about everything from commerce to science. He handled myriad matters for American citizens with affairs in France, and French persons with business in America. He paid for wine and art and furnishings, dishes and phosphorescent matches, a bust of Lafayette for the state of Virginia and a consignment of American flora and fauna (including a moose skeleton!) for the Comte de Buffon.

But Jefferson also had women on his mind. The previous year, he had shaken off the worst of his grief over Martha. In July 1786, he learned that William Stephens Smith, the man with whom he had attended the menacing masquerade in Paris, had married the Adams's daughter, Abigail. In an exuberant letter studded with exclamation points, Jefferson offered his congratulations to the groom, adding a mildly bawdy suggestion: "May your days and nights be many and full of joy! May their fruits be such as to make you feel the sweet union of parent and lover, but not so many as that you may feel their weight! . . . I will wish you a good night. I beg your pardon, I had forgot that you would have it without my wishes."

This warm testament to the husband's joys bespoke Jefferson's memory of the passion he and Martha had shared. The dangers of pregnancy, those "private miseries" that had caused Martha's death and his own unspeakable pain, seemed to have vanished from Jefferson's mind. He concluded another letter to Smith with jocular greetings to "Mrs. Adams and Mrs. Smith. I hope the former is very well and that the latter is, or has been, very sick, otherwise I would observe to you that it is high time." How could he have forgotten so much? People in love are susceptible to amnesia, and by this time, Thomas Jefferson was wildly in love.

THE OBJECT OF Jefferson's passion was a beautiful artist and musician, Maria Hadfield Cosway. She had been born near Florence, Italy, in 1759, the daughter of English parents, her father a wealthy Manchester merchant who operated a fashionable hotel for English tourists. Educated at convent schools, Maria had been a child prodigy in music, painting, and languages. She had studied with celebrated artists in Rome, including Joseph Wright of Derby and Henry Fuseli. She painted mostly religious subjects, and by the age of nineteen was elected to the Academy of Fine Arts in Florence.

From her earliest days, Maria was torn between her desire for a religious vocation and her love of art and music. In 1778, when her father died intestate, she wanted to enter the novitiate, but her many friends and promoters convinced her to go to London and concentrate on painting and composing. Her mother was desperate to see her married, settled, and secure. At nineteen, Maria was charming, blond, blue-eyed, and lovely as well as talented and ambitious. She became a protégé of Angelica Kauffmann, the great Swiss-born painter who was among the founders of the British Royal Academy of Painting and Sculpture. Soon Maria was the toast of London society. She fended off numerous suitors before finally settling on-and settling for-the brilliant, rich, and famously eccentric painter Richard Cosway, the most successful miniaturist of his day, who was evidently as grotesque as Maria was beautiful. One historian described him as "a preposterous little Dresden china manikin with a face like a monkey," a dandy in the extreme who was determined to turn Maria into the chief ornament of his overadorned salon. She was ambivalent about the marriage from the first, to say the least. For all her education, Maria had the naïveté of a convent-bred girl, and her new husband ran in fast company. Richard Cosway was said to have had affairs with people of both sexes, and he painted pornographic snuffboxes for clients including the libertine Prince of Wales. While Richard attempted to mold her into a submissive English wife, Maria resisted his attempts to confine and control her. She painted, even exhibiting at the Royal Academy, and continued with her music, giving "Great Concerts" in the enormous parlor of their ostentatious mansion. Maria Cosway

also made friends by the dozens. She had plenty of artistic talent, but her gift for friendship was perhaps even greater.

THE AMERICAN PAINTER John Trumbull introduced Maria Cosway to Thomas Jefferson in the late summer of 1786, when the Cosways were visiting Paris. Jefferson and Maria likely met at the Halle au Bléds, the domed grain market that was as much an architectural wonder as it was a place of commerce. From that moment on through the autumn, Jefferson and Maria spent every possible moment together, sometimes all by themselves. Richard Cosway was busily drumming up commissions for himself, painting miniatures for the nobility of Europe, and pursuing his own amours. He had kept a close eye on his wife when they first married, but by this time, by mutual consent, the Cosways seem to have given one another considerable room to move. If Richard Cosway was jealous of the time Maria spent with the tall, charming American ambassador, no hint of his feelings has surfaced.

But we do know that Maria Cosway and Thomas Jefferson were smitten with each other. They took advantage of every moment together to nurture a romantic friendship that both found sweet and stimulating. Over the rest of Jefferson's life, he and Maria Cosway exchanged a series of warm, admiring letters unparalleled in his correspondence, letters that reflected the changes in their fates and fortunes as Jefferson rose to power, retired, and grew aged, and as Maria abandoned marriage and the madding crowd for a life less frivolous, as the founder of convent schools for girls. No one could imagine that the sweet and simpering coquette depicted in Richard Cosway's drawings of his wife would one day be the stooped, blocky, beatific old lady who was appointed a baroness of the Austrian empire for her work as an educator of women. Of course, Jefferson scholars have cared mostly about Maria's Paris interlude with Thomas Jefferson, and their speculations about the liaison between the two sometimes read like schoolgirl gossip. Arguing about whether they ever had sexual relations is a little like playing tennis with an invisible ball. Still, Maria Cosway was the first woman to capture Thomas Jefferson's attention after the death of his wife.

Maria and Richard Cosway left Paris for Antwerp, Belgium, in October 1786, leaving Jefferson suffering not only from the pain of her departure, but from the agony of a broken wrist, injured while "vaulting a stile" on some recent, unwise frolic. He rode part of the way out of town with the Cosways in their carriage, got out, and "walked, more dead than alive" to the other side of the street, where his own carriage waited to take him back to the Hôtel de Langeac. That night, he sat down to write to Maria Cosway, producing (painfully, with his left hand) the most celebrated letter in his voluminous correspondence, his extended "Dialogue between My Head and My Heart." In the form of a mock debate between restraining reason and unruly emotion, Jefferson rehearsed every memorable moment of their time together. For propriety's sake, he sang the praises of both Cosways, "these good people," but the letter was addressed to "My Dear Madam," and his thoughts clearly dwelled on the lady. He celebrated her "qualities and accomplishments belonging to her sex, which might form a chapter apart for her; such as music, modesty, beauty, and that softness of disposition, which is the ornament of her sex and charm of ours." He insisted on imagining that she might come to America-"I see things wonderfully contrived sometimes to make us happy"-tempting her with the chance to paint "the Cascade of Niagara, the passage of the Patwomac thro the Blue mountains, the Natural Bridge ... And our own dear Monticello." Maria, he said, wanted "only subjects worthy of immortality to render her pencil immortal." That summer, he traveled in northern Italy, missing her mightily: "I am born to lose everything I love. Why were you not with me?" But he did not seriously expect that when he returned home, as inevitably he must,

this woman both accustomed to the worldly pleasures of London and Paris, and devoted to the Church of Rome, would follow him back to faraway Virginia.

Maria Cosway returned to Paris without her husband in the fall of 1787. But by this time, Polly Jefferson had arrived. To Maria's annoyance, Jefferson was too busy to make time for her when she was available. Much to Jefferson's frustration, Maria was herself caught up in a social whirl that kept them from spending time alone. She may, moreover, have been nursing something of a grudge against him. The morning she left Paris, they were to have breakfast, but instead she fled at 5 A.M., without even telling Jefferson good-bye. "I leave you with very melancholy ideas," she wrote him. "You have given, my dear Sir, all your commissions to Mr. Trumbull, and I have the reflection that I cannot be useful to you." She may have been referring to the various errands Jefferson had asked Trumbull to do for him in London. But Jefferson was also devoting some of his precious time to posing for Trumbull, who was then working on his famous painting of the signing of the Declaration of Independence, as well as at least one miniature of Jefferson. A painter of portraits and miniatures herself, Cosway may have been jealous of Trumbull. When she returned to England in December, the romance had cooled considerably.

Such histrionic gestures did not impress Thomas Jefferson, who hated public displays of temper, particularly on the part of women. Maria Cosway had charmed and vexed him. But she never challenged his ideas of what a woman should be. Indeed, if anyone in Paris struck him as the embodiment of desirable femininity, of the yielding warmth and sweetness that he treasured and craved, it was Maria Cosway. In later years she would display the devotion to duty, seriousness of purpose, and regard for peace and harmony that made him rejoice when her letters arrived, remember their delightful time together, and value her friendship all the rest of his days. OTHER LADIES, HE believed, were going a little crazy. As winter turned to spring, the people were hungry, the French government was in financial crisis, and the fever for politics swept through the most exalted circles of Parisian society. Jefferson was appalled. The salons that had once delighted him with conversation about art and music, architecture and science, humor and coquetry, were now arenas of raging argument. "Society is spoilt by it," he wrote to his friend the Marquise de Bréhan, then traveling in America with her brother-inlaw (and lover), the Comte de Moustier. "Instead of the gaiety and insouciance which has distinguished it heretofore, all is filled with political debates into which both sexes enter with equal eagerness." That summer of 1788, as bread riots broke out and the danger of wider rebellion loomed, he complained to Maria Cosway that "the civil dissensions, tho' they have yet cost no blood and will I hope cost none, still render conversation serious, and society contentious. How gladly I would take refuge in your coterie. Your benevolence, embracing all parties, disarms the party-dispositions of your friends, and makes of yours an asylum for tranquility."

If only the soothing ministrations of ladies could calm, instead of inflame, the rising rage on the way to revolution. But to his alarm, the contagion threatened to cross the Atlantic and infect even his own countrywomen. Anne Willing Bingham had replied to his letter satirizing the women of Paris with a ringing defense of her French friends. "I agree with you that many of the fashionable pursuits of the Parisian Ladies are rather frivolous . . . but the Picture you have exhibited, is rather overcharged. You have thrown a strong light upon all that is ridiculous in their Characters, and you have buried their good Qualities in the Shade. It shall be my task to bring them forward, or at least to attempt it." She admitted that the ways of French women might not play so well in America, and owned that "the state of Society in different Countries requires corresponding Manners and Qualification." But Anne Bingham was not stepping back; quite the contrary. Imagine Thomas Jefferson's dismay as he read Bingham's letter making the case for female assertiveness in the boldest political language:

The women of France interfere in the politics of the Country, and often give a decided Turn to the Fate of Empires. Either by the gentle Arts of persuasion, or by the commanding force of superior Attractions and Address, they have obtained that Rank and Consideration in society, which the sex are intitled to, and which they in vain contend for in other Countries. We are therefore bound in Gratitude to admire and revere them, for asserting our Privileges, as much as the Friends of the Liberties of mankind reverence the successful Struggles of the American Patriots.

It took Jefferson nearly nine months to reply. When he did, he seemed to be responding as much to the tumult around him as to Anne Bingham's letter. She had requested fashion magazines as well as some theater pieces, and he sent both. "We have now need of something to make us laugh," he said, "for the topics of the times are sad and eventful. The gay and thoughtless Paris is now become a furnace of Politics. All the world is run politically mad. Men, women, children talk nothing else; and you know that naturally they talk much, loud and warm. Society is spoilt by it." He appealed to her vanity, even as he reminded her of her place:

You too have had your political fever. But our good ladies, I trust, have been too wise to wrinkle their foreheads with politics. They are contented to soothe and calm the minds of their husbands returning ruffled from political debate. They have the good sense to value domestic happiness above all other, and the art to cultivate it beyond all others. There is no part of the earth where so much of this is enjoyed as in America. You agree with me in this: but you think that the pleasures of Paris more than supply its want: in other words that a Parisian is happier than an American. You will change your opinion, my dear Madam, and come over to mine in the end. Recollect the women of this capital, some on foot, some on horses, and some in carriages hunting pleasure in the streets, in routs and assemblies, and forgetting that they have left it behind them in their nurseries; compare them with our own countrywomen occupied in the tender and tranquil amusements of domestic life, and confess that it is a comparison of Amazons and Angels.... As for political news of battles and sieges, Turks and Russians, I will not detail them to you, because you would be less handsome after reading them.

To Thomas Jefferson, there was nothing strange about telling a thoughtful and accomplished woman that her life's mission lay in devoting her every effort to creating a peaceful household for a man he considered a pompous and unscrupulous self-promoter. If anything, Anne Bingham's insistence on women's right to stand up for their beliefs had lessened his esteem for her. In his mind, she had joined the party of the unruly Amazons of Paris, betraying her sister Angels of America.

Jefferson was not in the habit of talking about angels. But when he did, he thought of Martha. He had referred to her as an angel in that first wrenching letter to Elizabeth Eppes after Martha's death; in this letter to one of the most cosmopolitan women in America, he drew on a memory of life at Monticello gone gauzy with nostalgia. In his imagination, no wells went dry, no slaves were whipped (let alone murdered), no babies agonizingly pushed out, only to die, and certainly no tramp of soldiers' boots disturbed domestic peace. All that remained was the vision of a cheerful, submissive, saintly female, serving without question or complaint the needs of her weary man. Doubtless Thomas Jefferson had enjoyed precious moments of love, ease, and acceptance, had basked in the warmth he shared with Martha. Doubtless she had waited for him, on so many nights when he had been away in Philadelphia or Williamsburg, and welcomed him joyously back to the home he had missed so much. But what man could edit life so ruthlessly, produce a vision so appealing, and not want to find a way back to that protected, tranquil, imagined home? What kind of woman would be able to—would be compelled to—play the part assigned to her in this domestic fantasy?

Martha herself was no angel. Angels do not generally extract deathbed promises. With one foot in the grave, Martha had half dragged him in with her, with a request that conveys a possessiveness that may seem to us the height of cruelty. She was, after all, a widow herself, who had found a second husband she evidently loved dearly. Why deny Thomas his own chance at happiness? In truth, this was a very particular type of promise. She had asked that he forgo marriage, saying nothing of sex, not even anything of love.

Let's not forget that Martha Jefferson made her husband swear his oath never to remarry in front of Elizabeth Hemings, the enslaved woman who had replaced her own mother and stepmothers in her father's bed, and Critta and Sally Hemings, two of the children of that union. During that last illness, when she needed to call a servant, she rang a small bronze bell she kept by her bedside. After she died, that bell, according to Hemings family tradition, was given to Sally Hemings.

Martha's death was both a devastating loss and a liberation for Thomas Jefferson. He had ventured as far as Philadelphia that summer of 1776 when Martha almost died, and he had resolved that he would never be so far from her again. Had she survived, it is unlikely that he would have taken the offer to go to Paris, or been able to throw himself into politics as he did after her death.

Jefferson cloaked his burning ambition with a modesty his political enemies saw as the cunning of a born liar. But ambitious as he was, he sincerely believed that he had a duty to serve the people, his state, and his nation, and to further the cause of democracy. Much as he would have loved to have an angel in his house, he could not have had a wife who made claims on his time and distracted him from the affairs of state as he charted his rise to the top. Maria Cosway delighted him and awakened his sexual desire. But captivating as she was, she was too European, too sophisticated, too formidable, too public a woman for Thomas Jefferson, and in any case, she was married (a fact that actually suited his needs). The Jefferson who conducted American business in Paris was a man in his prime and on his way up. He had no intention of retiring from politics. He had made his promise to remain unmarried, and he did not, it seems, want a wife at all. But he did long for the comfort and joy of a woman who would welcome him home, make no demands, be content with an entirely domestic life, and accept his authority and his affections without cavil or complaint.

Who could more perfectly fulfill his vision than the young, impressionable, beautiful, enslaved half-sister of the departed angel, now growing into womanhood before his very eyes?

17

Sally's Choice

When Mr. Jefferson went to France Martha was a young woman grown, my mother was about her age, and Maria was just budding into womanhood. Their stay (my mother's and Maria's) was about eighteen months. But during that time my mother became Mr. Jefferson's concubine, and when he was called back home she was enceinte by him. He desired to bring my mother back to Virginia with him but she demurred. She was just beginning to understand the French language well, and in France she was free, while if she returned to Virginia she would be reenslaved. So she refused to return with him. To induce her to do so he promised her extraordinary privileges, and made a solemn pledge that her children should be freed at the age of twenty-one years. In consequence of his promises, on which she implicitly relied, she returned with him to Virginia. Soon after their arrival, she gave birth to a child, of whom Thomas Jefferson was the father. It lived but a short time. She gave birth to four others, and Jefferson was the father of all of them. Their names were Beverly, Harriet, Madison (myself) and Eston—three sons and one daughter. We all became free agreeably to the treaty entered into by our parents before we were born.

> —Madison Hemings in an interview with a radical Republican newspaper editor in 1873

SALLY HEMINGS SPENT her first months in Paris adjusting to an alien culture, recuperating from inoculation, learning her way. She must have struggled to make herself understood to anyone except her brother James and the three Jeffersons. Patsy and Polly were in school, and Thomas Jefferson was busy with his work, his friends, and his frustrating not-quite-romance with Maria Cosway. In the spring of 1788 he traveled in France, Holland, and Germany and was gone for seven weeks. By the time he returned to Paris, the political crisis in France was approaching a crescendo.

Then came a killing winter, more horrible than anything Jefferson had ever known. "We are here experiencing a Siberian degree of cold," he wrote to Francis Eppes. "In November the thermometer was down at 8°. and twice this month at 6°. with every prospect of long continuance. A snow and cold North-Easter carry off houseless and ill-fed men here, as a cold Northwester carry off houseless and ill-fed cattle in Virginia." By December 1788, the temperature had dropped further, down to nearly ten degrees below zero, and Jefferson told Francis Eppes, "the cold still continues and occasions very general sickness." Still, it was Paris, where misery and magic dwelled side by side. The grandest Parisians drove their carriages on the ice of the Seine, which was "covered with thousands of people from morning to night, skaiting and sliding."

Sally Hemings may or may not have been among those who were ill, but Patsy and Polly, in close quarters at Panthémont, contracted typhus. They were stricken with fevers and chills and wracking coughs and thready pulses. "I have for two months past had a very sick family, and have not as yet a tranquil mind on that score," Jefferson wrote to Maria Cosway in January. Both girls were taken out of school and brought to the Hôtel de Langeac to recover. Jefferson had sent them to be educated and protected, but the convent had been the source of infection. Paris had become a more and more threatening place for his daughters.

Sally also knew some of the girls from Panthémont. Patsy's friend Marie Jacinthe de Botidoux wrote a letter to Patsy years later, asking her to "kiss Polly for me and give my best to Mlle. Sale [Sally]." Had Marie de Botidoux thought of Sally Hemings simply as her friend's slave, she might not have referred to her with the honorific title of "mademoiselle." But unless Patsy or Polly offered the information, the convent students may not have understood that the very lightskinned Sally was a slave or, for that matter, that she was of African as well as English descent. If the girls at Panthémont did know, they would not have had American ideas about race. Neither might they have been surprised at a family resemblance between Patsy or Polly and Sally. Convent schools often served as places of refuge for impoverished noblewomen and girls, some of whom played the role of servant/companion to their better-off relatives. Some, assuredly, were illegitimate daughters. Doubtless everyone gossiped about such mysterious relations.

Of course, this was an unprecedented time in French history, even at the Abbaye de Panthémont. The daughters of the French nobility were no more immune to political passions than their mothers and fathers. Some showed their radicalism by fraternizing with the lower orders. Patsy Jefferson had expressed the fervent wish that "the poor negroes were freed," and she may have treated Sally, who was only one year younger than Patsy, with affection. Friends like Marie de Botidoux also avowed a fervent devotion to democracy and the unfolding revolution; Marie boasted about gossiping with "the fishwives" about the queen.

When the Jefferson girls brought typhus home to the Hôtel de Langeac from Panthémont, Sally Hemings would have served as their nurse, if she was not herself too sick to help. During the darkest days of that dire, frigid winter, cooped up in a chilled and afflicted house, all the shivering Virginians must have ached for the heat of home. "Surely it was never so cold before," Jefferson wrote to Maria Cosway. "To me who am an animal of a warm climate, a mere Oran-ootan, it has been a severe trial. . . . The weather has cut off communication between friends and acquaintances here."

Thomas Jefferson was a frozen, worried, lonely man. Who would not have been susceptible to the comforting warmth of another body, a fellow sufferer from the care and the cold, a beautiful, kindhearted girl? Sally Hemings, whatever fear, doubt, and even anger she may have felt toward him, was a long way from home, in a frigid city. Surely she longed for comfort of her own.

Sally was probably near or past her sixteenth birthday when Thomas Jefferson claimed her as his sexual partner, his mistress, his concubine. Whatever passed between them was tinged with secrecy and shame. Perhaps for that reason, Sally was sent away, to spend five weeks with Jefferson's launderer, Dupré. Jefferson paid Dupré for her board and "washing" (or laundry) at the end of April 1789, a week after he paid the final bill for Patsy and Polly at Panthémont. Sally may have been learning how to clean and repair the fine clothing Jefferson was now buying for himself and his daughters. Or there may have been other reasons why Jefferson determined to send her off for a time at the very moment that his daughters were coming home. Still, Sally was back at the Hôtel de Langeac by the first week in May. In that spring of 1789, Jefferson laid out money for clothing for Sally, uncharacteristic expenses for a servant to whom he was paying wages and providing room and board. Wherever she was, she was in his accounts and in his thoughts.

THOMAS JEFFERSON WAS thirty years older than Sally Hemings. His conduct toward her was predatory and exploitative. This young woman without her own means or home, living in a foreign country far away from nearly all her family, depended upon Jefferson for her life and livelihood. As a slave, she possessed neither the right to consent to nor to refuse his attention, no matter how she felt about him. She was unspeakably vulnerable. When Thomas Jefferson took Sally Hemings to his bed, he made her his victim.

But in doing so, he was, as they used to say, no worse than he should have been. In Jefferson's universe, men and women never met as equals. Of course, as a slave, Sally could not hope to aspire to the title her half-sister had held, that of Mrs. Jefferson. But by the time Sally Hemings and Thomas Jefferson had sexual relations, she had already learned that in France she was not enslaved at all. The minute she set foot on French soil, she had become a free woman. Her brother James had been in Paris for three years when Sally arrived. If he decided to claim his freedom and remain in France, Jefferson could not make him go back to America. Given the agreement he and Jefferson made in 1793, James Hemings may well have seized hungrily on that freedom, with an energy that reflected the cries for liberty ringing through the streets of Paris, roiling the markets and threatening the merchants and terrifying and exhilarating peasants and bourgeois and nobles all. James did go back to Virginia, but he would make a deal with Thomas Jefferson: he agreed to train his replacement in Jefferson's kitchen, and Jefferson promised in turn to grant James his emancipation. The young man who bargained with no less a personage than the cool and commanding Ambassador Jefferson would

not have hesitated to let his little sister know that she too was free in France. Why would conversations in the scullery be any less ablaze with politics than they were in the salons? In the unlikely event that James had not told Sally she was free, surely someone else did.

According to Sally's son Madison, his mother used her knowledge of her freedom to cut her own deal with Thomas Jefferson. Sometime after that brutal winter of 1788-89, Sally Hemings had become pregnant with a child who was destined to live only a short time. Madison Hemings used the French word enceinte, perhaps his mother's way of both invoking her time in France and speaking in a genteel euphemism. Madison may have been in error about this pregnancy; there is no evidence of such a child in any written document, and the man who would later claim to have been that child, Thomas Woodson, was evidently not the son of Thomas Jefferson. Generations of Jefferson scholars have denied that the child existed. But Madison Hemings has proven a reliable source of information on his family's history in nearly all regards. We have two particularly strong reasons to assume that Sally was pregnant, and that Jefferson was the father of her child: the fact that Sally Hemings chose slavery in Virginia over freedom in France, and the fact that Thomas Jefferson freed her children.

Jefferson wanted to take Sally back to Virginia. He must have understood the overwhelming advantages he possessed in making his case. As a young, unwed pregnant woman "just beginning to understand the French language well," Sally's prospects for supporting herself in Paris were anything but bright. She had been dealt a very weak hand.

But she played her best card with skill. Whatever else she knew about Thomas Jefferson, she understood that they were doing something together that they should not have been doing. His conscience must have plagued him even as he worked to persuade her to come back to America with him. Jefferson would have been troubled by the idea of depriving a free person, even a free woman, of her liberty, even as her womanly weakness and dependence provoked in him a sense of obligation. As we have seen, Madison Hemings reported that his mother let Jefferson know that she meant to dispose of her freedom on her own terms.

As ambassador to France, Thomas Jefferson's job was to make treaties. Calling this agreement a treaty had the ring of Jefferson's joking with Anne Bingham about calling an Assembly of Notables to pick out her clothes. But the language, in this case, belonged to Sally Hemings. When she told her children that she had made a treaty with Thomas Jefferson, it carried the inflection of an inside joke between a woman who knew the position and the power of the man she was dealing with, and a man who was willing to be made fun of by a serving girl, a young female of mixed racial ancestry, a woman even then surrendering her freedom. There was something teasing and flirtatious and affectionate, and sardonic and ironic, in the tale Sally Hemings told, something that gives us a glimpse of a woman some called "Dashing Sally."

Treaties are also solemn, stately agreements with the force of international law. Treaty breaking is cause for war. Despite powerful incentives to violate his part of the agreement, Thomas Jefferson lived by the spirit and the letter of his treaty with Sally Hemings to the very end of his days.

THOMAS JEFFERSON HAD his pick of female companions in Paris, and surely could have selected one of any number of American angels in Virginia. He chose Sally Hemings. In the strange hall of mirrors that he inhabited, her insistence upon her freedom may have given him a rationale for wanting to possess her. She was already exceptional in his eyes, not simply a slave girl, but a Hemings, a Wayles, Martha's sister. She was, moreover, very light-skinned, and of mixed heritage. Jefferson had expressed his views on race mixing in his *Notes* on the State of Virginia, arguing that "blacks" were by nature inferior to "whites" in most regards. He argued, with confident circularity, that in order to prevent mixing, the races must keep separate. But like many southern slaveholders, Jefferson was fully capable of believing African Americans to be inferior to whites, of being, in short, a racist, while taking to his bed a woman who had African ancestors. Generation upon generation of white southern men did so, and no amount of social disapproval, of legal sanction, of shame or blame or personal peril ever stopped them.

Still, we are talking about Thomas Jefferson, a man to whom liberty was a cause worth pledging one's life, fortune, and sacred honor, who had fumed as the Continental Congress eviscerated the antislavery passages from his immortal Declaration. Why wouldn't Sally's insistence on her freedom make sense to him, help him see her as a woman and not simply a slave? Jefferson was, as Joseph Ellis has so eloquently explained, a brilliant rationalizer. Surely no one was in a better position to protect Sally Hemings than he was, and he owed her that much. Having brought her across the sea into a gathering revolution and then debauched her, he could not abandon her, even if he was leaving her a free woman. As he saw it, his honor lay not in letting her go, but rather in keeping her, in taking care of a woman to whom he had made a solemn vow. Recollecting the presence of Betty Hemings and her daughters alongside his own children at his wife's deathbed, he might even have told himself that Martha would have wanted it that way.

AND NOW WE come to the heart of the matter. Sally could not have known, as she stood her ground in Paris and made the fateful decision to return to America, whether Thomas Jefferson would keep his word. White men lied to slave women. Trusting Thomas Jefferson, and agreeing to go home with him, was not an entirely rational decision on her part. Why would she do so?

Sally Hemings had all kinds of reasons to want to go back to Virginia. It was her home, and most of her family was there. As a Hemings, she had been shielded from the worst burdens of slavery. But any slave could be sold, even—sometimes especially—those who were blood kin to the master. They could be torn from their homes, parted from loved ones, put into the hands of strangers against their will. Thomas Jefferson had never been a man to buy and sell people as if they were land or horses or harpsichords, but you never knew what might happen.

Of course, no reasonable person could rule out the possibility that money worries would force his hand. Jefferson was spending more than he was making, as his brother-in-law kept reminding him. Once he got back home, he would have to deal with his tangle of debts. But Sally Hemings may not have known his real financial situation. From all appearances, he was a very rich man. His house gleamed with elegant furniture and magnificent art, expensive books and paper, sumptuous food and fine wine. He attended the theater and the opera, rode in a fine carriage, traveled whenever and wherever he pleased. How could a sixteen-year-old girl not be impressed?

Sally was not the first woman of her family to enter into a liaison with a white man. She had an African grandmother and an English grandfather, Captain Hemings. When Sally Hemings put herself in Thomas Jefferson's hands and returned to America, she walked in the shadow of Elizabeth Hemings's long relationship with John Wayles, the parallel family that Martha Jefferson had honored in her own way. Sally's oldest sister, Mary, carried on the legacy. By the time Sally went to France, Mary Hemings had children by at least one white man, probably the Monticello carpenter William Fossett. During Sally's time in Paris, Mary was hired out to the white Charlottesville merchant Thomas Bell, with whom she had two more children. Bell would purchase Mary Hemings from his friend Thomas Jefferson and not only free their children, but bequeath his property to them.

Thomas Jefferson did not make Sally's sons and daughters his heirs, but he did promise to protect and provide for her, and to free their children. Sally also knew that he had promised Martha he would never remarry. If he kept that solemn vow, there would never be a new Mrs. Jefferson in charge at Monticello, bringing in a coterie of new servants to displace the Hemingses, or insisting that Sally herself be sent away or sold. Still, Thomas Jefferson might tire of her, or come to regret their affair. He must have been insistent and persuasive in making the case for going home with him, and against her remaining a free woman in Paris.

And yet there was as much to recommend against staying as there was to argue for going. Her prospects as an unwed mother in Paris were grim. Brother James might give her some support, and with his training and connections he may have been able to find them both places in another great household. But she had no secure employment options and only a tenuous command of the language. She was no muscular French fishwife, shouting her wares in the streets and gossiping with noblewomen about politics. Once the baby was born, if she stayed, she would have to find a way to both earn a living and care for her child.

And what of the world outside? Sally had to make her decision amid the surging upheavals of the French Revolution, with mobs of women breaking into bakeries and battling each other for bread, and crowds swelling to storm the Bastille and set the prisoners free. Thomas Jefferson might hope that the revolution would be achieved without bloodshed, but by the late summer of 1789 the people had taken to the streets. Even Jefferson admitted the possibility of violence to come.

224 🧏 THE WOMEN JEFFERSON LOVED

Sally Hemings had seen what revolution could do, had been formed by war from her earliest days. The rebellion that had catapulted Thomas Jefferson to political power and everlasting fame had been, for her and her family, traumatic. Jefferson and his fellow patriots had committed their treason in the name of freedom, but the Hemingses remained slaves. Would she have been eager to subject herself to an uncertain, even terrifying future? Jefferson doubtless reminded her of the dangers. Recalling his letter to Anne Bingham, we can easily imagine him comparing the perils of Paris to the peace of Monticello.

Thomas Jefferson could not force Sally Hemings to go home to Virginia. But even had he been able to do so, Jefferson, by temperament, preferred to get his way with what he would have called persuasion, but which we may see equally as manipulation. He never hesitated to use his daughters' desire to please him, to merit his love, in order to get them to do what he wanted. Why would he not have used similar tactics on Sally Hemings?

AND FINALLY, OF course, at that momentous instant in her life, Sally Hemings faced a lover and antagonist who was not just any American man, not just any Virginia slaveholder, but Thomas Jefferson. Arguably the most revered, vexing, contradictory, complicated figure in American history, a man just ascending to the peak of his power. She was thirty years younger than he was, a girl just becoming a woman, raised in slavery, though in relatively protected circumstances. She told her son that his father had beseeched her and made big promises. Jefferson was a person of rare charm, warm and kind, devoted to his children, with seemingly infinite prospects in the world. Few women in America or in France, slave or free, had a chance at such an offer. Maybe she should have been more skeptical of his intentions, less vulnerable to his pleas and promises. We may, in the way of our Puritan and Victorian forebears, disapprove of women who become mistresses without any hope of marriage, even as our society steeps itself in sex for sale, and even though most women of Sally's time had to treat marriage as a practical, rather than romantic, matter. But who could blame a woman like Sally Hemings, under the circumstances, for hoping to claim such a man's loyalty or protection, or perhaps his affection, or even his love?

Coming Home

18

IN THE SUMMER Of 1788, Thomas Jefferson was thinking about going home. He wanted Patsy, then sixteen, to find a suitable husband, an American, preferably a Virginian. His debts had festered and swelled since his departure. Virtually from the moment Jefferson left for France in the fall of 1784, his brother-in-law, Francis Eppes, had been sounding alarms, sending letters warning that crops were bad, and that "your creditors are very pressing for their respective balances." The practical Eppes told the cavalier Jefferson that he could not expect to make enough money selling tobacco or wheat to meet his obligations: "Whenever the time arrives for their being paid a sale must take place." When Francis Eppes spoke of selling, he meant slaves. He and Henry Skipwith had together auctioned off more than a hundred people to cover some of their share of John Wayles's debt, but Jefferson thought he could manage by selling off land, including Martha's Elk Hill.

As the time to return neared, money was not his only worry. What was he to do with Sally Hemings? He had no intention of acknowledging their relationship, but people would talk. He was planning to return to France, and would not even be around to protect her from gossip or worse. And what did he mean by protection? At the moment that he was promising Sally Hemings that he would provide security for her and freedom for their unborn child, Jefferson was pressing her to make an ocean voyage in the middle of a pregnancy. He would never have put Martha through such an ordeal.

Jefferson asked Congress for a leave of absence of five or six months, expecting to spend part of that time at Monticello. He told himself that he was taking his family home for their own good. Whether or not Sally Hemings was still thinking about staying in France, Jefferson made his arrangements fully expecting her to return. "Mine is a journey of duty and affection," he wrote to Maria Cosway in September 1788. "I must deposit my daughters in the bosom of their friends and country. This done, I shall return to my station. My absence [from Paris] may be as short as five months, and certainly not longer than nine. How long my subsequent stay here may be I cannot tell. It would certainly be longer had I a single friend here like yourself."

Meanwhile, he let the folks back home know that he was headed their way. Jefferson told the Eppeses that he and his daughters "look forward with impatience to the moment when we may be all re-united tho' but for a little time." He wanted to get his debts settled once and for all, and though his brief time in Virginia would be "filled with business and disagreeable things," he was still looking forward to renewing "my antient friendships."

Sally Hemings may have had doubts about going back to Virginia, and she and James both might have expected to return to France after visiting family. But in the end she had reason to conclude that she had as good a chance of a satisfying life in America as she did in Paris. Thomas Jefferson always tried to put the best face on things, and they may have shared that predisposition. She too had lived through a Paris winter so grim and gray and frozen and frightful that the sunny skies and green slopes of Virginia must have beckoned like a loving embrace. Lonesome and vulnerable and pregnant, she could remind herself that at Monticello, her mother, and her sisters and brothers, and her old friends would be there to help her, even if the master proved false.

And then there was all that baggage. Sally surely helped with the packing, and for a man who planned to return to France as soon as possible, he was not exactly traveling light. By the time he purchased and packed everything he wanted to take back with him—busts of his heroes and paintings of classical scenes, cases of wine and leather trunks and clocks and plants and a macaroni machine and a "chariot" (minus its driver's seat, unfortunately)—there were thirty-eight boxes, trunks, and crates to be shipped. True, he was leaving behind all the furnishings of the Hôtel de Langeac, the gilded mirrors and framed pictures and furniture and even his new cabriolet. But perhaps he would not go to the immense expense of sending a mountain of goods across an ocean, if he was only going for a short visit?

JEFFERSON HOPED TO embark in April 1789 so that he might be at Monticello in summertime. He expected that things would be pretty much as he'd left them, with George and Ursula and Betty Hemings "of course" to greet him there. Martin and Robert Hemings had hired themselves out for the years of his absence, but he wanted them back, too, at least for his visit.

To his frustration, he did not receive permission for his leave of absence, and so the winter wore on with no real prospect of leaving. The Jeffersons and Hemingses were still in Paris for the fateful summer of 1789, the dawn of a revolution that would truly turn the world upside down. Ambassador Jefferson kept close tabs on political developments, visiting Versailles daily and closeting himself with the high-minded aristocrats and ambitious politicians who pushed for enlightened reform. Jefferson was excited about the prospect of a new government dedicated to liberty and equality, and hopeful that the transition to a constitutional monarchy would be orderly and peaceful. He put his faith in leaders he found "cool, temperate and sagacious," and at the end of June he believed that the great crisis was over.

He was dead wrong, of course, and narrowly missed being embroiled in violence himself, as the revolution began. He rode in his carriage past the king's foreign mercenaries just before an angry crowd attacked the troops with rocks and forced them to retreat. He heard about the storming of the Bastille and watched as the king was brought to Paris by the deputies of the Assembly, surrounded by thousands of shouting citizens brandishing pikes and pruning hooks and pistols, swords, and scythes. In the days that followed, he would ride out to observe "the mobs with my own eyes" and visit the great scenes of Revolution in the days after the Bastille fell, "for nothing can be believed but what one sees, or has from an eye witness."

If Sally Hemings overheard the philosophical speculation and political maneuvering in Jefferson's parlor, in the kitchen the talk of revolution would have been hungrier and angrier, forged in muscle and blood and the faces of malnourished children. If she was permitted to venture out at all to see what was happening, she did not view the chaos of the streets from a high perch on the back of a fine horse.

THEY FINALLY LEFT Paris on September 26, bound for Le Havre, where they waited out the blustery weather for ten days before crossing the English Channel. John Trumbull had helped Jefferson book passage, staterooms for himself and his two daughters, convenient to unspecified quarters for his servant and theirs. But the party of five, three Jeffersons and two Hemings servants, James and Sally, were something more: a dual family, the kinship among them thrust into the shadows. Martha Jefferson's blood ran in the veins of four of them. Two of her half-siblings were saying good-bye to freedom. One of them carried the child of her widower back into slavery.

Jefferson bought a shepherd dog, "big with pup." Dumas Malone imagined the moment when "shortly after midnight the Jeffersons with slaves, bitch and baggage—left Havres on the packet *Anna*," bound for Cowes, on the Isle of Wight. Back in Paris, a political tempest blew up. On October 5, a crowd of some six thousand women, desperate for bread, gathered a horde of male allies as they marched to Versailles to confront the king and queen and force the royal family to return to the city. Though Thomas Jefferson had hoped that the revolution might be decorous, he understood the potential for shattering violence. The spectacle of women armed with pikes and guns, at the head of a mob that killed two palace guards, beheaded them, and paraded their heads on pikes, would have revolted him to the core.

John Trumbull had booked passage for the Jefferson party as the only passengers on the American ship Clermont, under the command of Captain Nathaniel Colley. They weighed anchor from England with a convoy of more than thirty ships, on October 23. Malone envisioned the voyage as a placid one for Jefferson, marked by little seasickness, fair winds, and good weather. The great biographer pictured his subject as a little wistful and a little bored. Thomas Jefferson had conducted his country's business at the highest levels for five years, had moved in glittering circles, had squired beautiful and accomplished women and reveled in the greatest art and most stirring music. He had seen and studied magnificent architecture and plunged into the headiest discussions of science and knowledge and progress. "More even than Maria Cosway," wrote Malone, "the music which had delighted him must have seemed like a lovely dream as he listened to the lapping of the waves." As he sailed homeward on this temporary errand, in Malone's view, he "could have had little adult conversation

except with Captain Colley.... Patsy and Polly occupied much of his time no doubt, and after a while he could observe his new shepherd pups but he probably spent a good many hours merely reminiscing."

Or perhaps he spent many hours burdened with weighty thoughts. Or he may have simply decided he would not see Sally Hemings as a problem; he would not have been the first or last man to decide that a mistress, even a pregnant one, was more or less on her own. It would have been like him to refuse to discuss the matter with any of his traveling companions, including Sally herself. Thomas Jefferson believed that families should not talk about some things, in the interest of domestic tranquility. Those unspeakable things were, of course, the very worries and dilemmas, the insecurities and injuries, that mattered most.

Patsy Jefferson knew that her father hoped to see her married soon. Only recently out of the convent, having even considered taking vows herself, she was feeling the pressure to find a husband quickly. Jefferson was headed back across the ocean, and if she was going to take such a momentous step, she wanted him there giving his blessing. She may have been aware of Sally's pregnancy and may even have suspected her father's part in the predicament. Could she help wondering, as they sailed home to Virginia, what had happened, what would happen, what people would think, what her mother would have thought? She had comforted and cajoled him since her mother's death. Did her father even care about what Patsy herself thought?

Polly doubtless looked forward to getting home. She assumed that she would be sent to Eppington, to be reunited with her beloved aunt and uncle. Once again her father would abandon her. The last time, Sally had gone to Eppington to be her servant. Now, as Polly approached womanhood, she would need a lady's maid. Sally was better qualified than anyone in Virginia to take that job, but this time Sally Hemings would remain at Monticello. Did Polly have any inkling what her father, her slave, and her sister might be thinking on that subject?

James Hemings was sailing back into slavery, though he, like Thomas Jefferson, anticipated that the voyage would be temporary. Much as he might have looked forward to seeing his home and family, he may have intended to leave Monticello as soon as he could. And what of Sally? She had Jefferson's word that he would take care of her, but he was planning to leave her at Monticello. She was pregnant for the first time. If she had seen some women grow big and give birth and raise babies without terrible trouble, she also remembered Martha Jefferson's agonies, and the dead children of Monticello and Eppington.

In the last days of the voyage of the *Clermont*, the coastline of Virginia was shrouded in fog so thick that they could not even see any pilot boats sent out from port. "After beating about three days," Patsy Jefferson recalled, "the captain, a bold as well as an experienced seaman, determined to run in at a venture." Even years later, Patsy would recall the moment in vivid detail, the mortal danger so close to the native land she had not seen in five years:

The ship came near running upon what was conjectured to be the Middle Ground, when anchor was cast at ten o'clock P.M. The wind rose, and the vessel drifted down, dragging her anchor, one or more miles. . . . We had to beat up against a strong head-wind, which carried away our topsails; and we were very near being run down by a brig coming out of port, which, having the wind in her favor, was almost upon us before we could get out of the way.

They managed to escape and landed at Norfolk, but before their baggage was unloaded, the *Clermont* caught fire. As nearly every sailor in the harbor jumped in to fight the blaze, it seemed that all might be lost. But the fire was successfully contained, and everything they had brought with them was saved.

IF THOMAS JEFFERSON had illusions about returning home for a brief domestic idyll, picking up his marching orders, and getting on the next boat across the Atlantic, his hopes were dashed when he arrived in Norfolk. The newspapers proclaimed that George Washington, newly elected president of the United States, had nominated Jefferson to be secretary of state. He longed to return to Paris, Sally Hemings or not, but he would not refuse the president. Sally could now be confident that he would not be abroad when her baby came. But neither would he be available to her. Jefferson was ascending another rung on the ladder of public service and personal ambition. For the next twenty years, despite busy and productive interludes at Monticello, Jefferson devoted himself to the politics he claimed to detest, in the name of principles he felt bound to defend.

The Jefferson party made its meandering way back to Monticello, along the way going to see Martha's (and Sally's) half-sisters, Elizabeth Eppes at Eppington and Anne Skipwith at Hors du Monde. While Patsy and Polly visited with their aunts, Thomas Jefferson met with his brothers-in-law to work out payment of their shared debt. They stopped at Spring Forest to see his sister Martha Carr, and at Tuckahoe, where Patsy found herself suddenly swept into courtship with Thomas Mann Randolph, Jr., son of her father's companion of his early days.

They arrived at Monticello on December 23, 1789, after a journey through bad winter weather along sodden, treacherous roads. The mud-caked horses were utterly exhausted. Slogging painfully up the deeply rutted, nearly impassable Three-Notched Road, they found a jubilant welcome. Word had spread that they were on the way, and the enslaved people on Jefferson's plantation asked to have the day off. They gathered near Shadwell, surrounded the carriage, and escorted the returning master with shouting and cheering all the way up the mountain.

Wormley Hughes, Sally Hemings's nephew, was just a little boy at the time, but he had a vivid memory of the return of the three Jeffersons and the two Hemingses. As an old man who had spent a lifetime running Jefferson's stable, Hughes told biographer Henry Randall in 1858 that the slaves had unhitched the horses, and pulled and pushed the carriage up the hill. Patsy Jefferson recalled that when they arrived at the house, the overjoyed slaves took her father out of the carriage and carried him, refusing to let his feet touch the muddy ground. The crowd parted for the Jefferson girls, who must have been impressive in their Paris couture.

Jefferson had been in France for five years. But for all intents and purposes he had not called Monticello home since Martha's death, more than seven years before. Many of those who cheered remembered him as a kind man, and those who had not known him had likely heard stories of his mildness and decency. They had reason to be happy that he was back. As Jefferson biographer James Parton noted, "A Virginia estate was a poor thing indeed in the absence of the master." The house was dilapidated, the crops had been poor, and the people eking out a living at Monticello had been subjected to the rule of overseers with no personal stake in their welfare. They were doubtless glad to see this man who was ultimately responsible for and to them.

Sally Hemings returned to the joy of reunion with her mother and brothers and sisters, and the pain of resuming her chains. Both she and James must have impressed their relatives with their French words and garments. But however she had changed, it was just a matter of time before the free woman of Paris took her place as just another slave at shabby Monticello.

JEFFERSON WAS QUICKLY consumed with the family business he had to do before leaving to join the new government in New York. He was knee-deep in matters involving his parents' affairs, a lawsuit against his brother Randolph, the estates of his long-dead sisters Jane and Elizabeth, and his late friend Dabney Carr. He wrote endless letters full of intricate calculations to resolve nagging problems. He attended to his neglected lands and ramshackle house, made plans for the spring planting, and worked over the design of his famous moldboard plow, as lingering diplomatic business and the press of his next set of duties closed in.

Before he knew it, he was also dealing with the betrothal of seventeen-year-old Patsy to Thomas Mann Randolph, Jr. Only a month after they returned to Monticello, Patsy was rushing into marriage with a young man her father found suitable and promising, but a man neither of them knew very well. Patsy and Tom Randolph were married on February 23.

If Sally Hemings was recently pregnant when they left Paris at the end of September, the fact must have been obvious by the time of Patsy's wedding. Jefferson had suffered through Martha's eight pregnancies, her hideous births, the miscarriages and the dead children. In April, he wrote to his friend Madame de Corny to thank her for her many kindnesses during his time in Paris. He was concerned about the volatile situation in France but ventured the "hope that a revolution so pregnant with the general happiness of the nation, will not in the end injure the interests of persons who are so friendly to the general good of mankind" as herself and her husband. Sally's pregnancy surely caused some dissension, if not full-fledged revolution, at Monticello, but everyone must have hoped that mother and child would not be injured by the experience. Such events often harmed people Jefferson loved. And if word got out that he was the father of Sally's child, his own interests would assuredly be injured, to say the least.

Still, he was glad to be home. He wrote from New York to a discontented friend in Virginia, saying that the path of his own life had "not been strowed with flowers. The happiest moments of my life have been the few which I have past at home in the bosom of my family. Emploiment any where else is a mere mouser of time; it is burning the candle of life in perfect waste for the individual himself. . . . Public employment contributes neither to advantage nor happiness."

Sally Hemings's mother had given birth to twelve children, and Betty Hemings lived to be more than seventy years old. Some of Sally's sisters did well with childbirth, and some, like Martha, did not survive the repeated traumas. Sally was surrounded by female kin who had vast experience in the matter. Madison Hemings never said whether his mother's first child was a boy or a girl; he probably did not know. The baby, he said, "lived but a short time." As far as we know, the child was never named.

Part IV

PATSY AND POLLY

Patsy and Polly

19

THOMAS JEFFERSON WAS a little nervous about running the Department of State. The United States of America was a frail, fledgling nation, facing a Europe in turmoil and rebellion in the American backcountry. He had only one previous experience with an executive position, as governor of Virginia during the Revolution. That time his public and private lives had crashed together with bloody fatality, bringing him disgrace and misery. He told George Washington that "when I contemplate the extent of that office, embracing as it does the principal mass of domestic administration, together with the foreign, I cannot be insensible of my inequality to it: and I should enter on it with gloomy forebodings from the criticism and censures of a public just indeed in their intentions, but sometimes misinformed and misled." In an ideal world, he would be free to enjoy the fruits of his farm, the labors of his field hands, and the attentions of his family in uninterrupted harmony. But Washington had nominated him. He could not refuse.

Before he went off to do his duty, he meant to settle his family according to his desires. He counted on Patsy and Polly to give him love and comfort, just as surely as he relied on the Hemingses to lay out his clothes, build his fires, clean his house, carry his messages, shell his peas, and fricassee his chickens. He wanted his daughters and their families close by.

He expected his domain to be a peaceful place, but by no means a democracy. At Monticello he ruled as a benevolent patriarch over people whose loyalty should be beyond question. He would be guided by his loving concern for their best interests, and they would understand that to obey him was to return that loving care. Much as he lamented the distance between his home and his political life, he believed that keeping the private separate from the public was the only way to ensure the safety and happiness of his women, his children, his family, his people.

The reality no more resembled Jefferson's ideal than an unripe persimmon resembles a perfect pear. He left behind a house at Monticello fallen into disrepair, a farm in general neglect, and a scattering of underproducing plantations in Albemarle, Bedford, Goochland, and Cumberland counties. Hundreds of people depended on him, from his daughters and his mistress to his house servants and his field workers. He in turn depended on them to look after his property, to pay his bills with their labor, or to support themselves by finding work elsewhere, until he summoned them back. One of those people was pregnant with his child, or perhaps had already given birth. His two daughters and new son-in-law, meanwhile, were trying to find their place in a world all three had left years before.

THOMAS MANN RANDOLPH, Jr., was an intellectual and an aspiring scientist who had seen something of the world. He had spent the years between 1784 and 1788 at the University of Edinburgh, a hothouse of the Enlightenment, studying languages and philosophy, mathematics and anatomy. Young Randolph had corresponded with Jefferson, who perceived "by his letters he has good genius, and every body bears witness to his application, which is almost too great." In short, Randolph seemed a little intense to his future father-in-law, but he had plenty of curiosity and talent, the right bloodlines, and excellent prospects in Virginia.

As wedding presents, the two fathers gave the couple land, livestock, and slaves. Jefferson tendered a thousand acres in Bedford County and twenty-seven slaves, inventoried in family groups, as was his careful habit. Thomas Mann Randolph, Sr., offered 950 acres of land at "Varina" in the lowlands of Henrico County, southeast of Richmond, along with forty unnamed slaves. The Varina land was a disappointment to the couple and to Thomas Jefferson, since Jefferson was urging his friend to offer a tract he owned at Edgehill, only three miles from Monticello. Randolph Sr.'s own father had done as much for Peter Jefferson, after all, trading the land at Shadwell for the famous bowl of arrack punch. But for the moment, Patsy and Tom Randolph resigned themselves to making the best of a situation they could not change.

After the wedding Polly left Monticello with the newlyweds, expecting to be taken to her aunt and uncle at Eppington. Jefferson, on his way to take his place in the government in New York, missed the girls terribly. "I am anxious to hear from you, your health, your occupations, where you are &cc.," he wrote Patsy. "Having had yourself and dear Poll to live with me so long, to exercise my affections and chear me in the intervals of business, I feel heavily the separation from you." But he fell back, as usual, on optimism. "It is a circumstance of consolation to know that you are happier; and to see a prospect of it's continuance in the prudence and even temper both of Mr. Randolph and yourself." Patsy Jefferson Randolph was indeed a young woman who turned a mild face to the world. But the same could not be said of Tom Randolph, a man who later stood on the floor of the Congress of the United States and announced, "Lead and even steel make very proper ingredients in serious quarrels." His own sympathetic biographer would call Randolph "thin skinned and sensitive to the point of violent contentiousness."

Adjusting to married life was no easy thing, Jefferson counseled his elder daughter. "Your new condition will call for abundance of little sacrifices, but they will be greatly overpaid by the measure of affection they will secure to you." And then he gave Patsy a piece of advice that sent a fierce double message, seeming to cast off the bond between the loving father and his fervently devoted daughter, while tightening the cinch: "The happiness of your life depends now on the continuing to please a single person. To this all other objects must be secondary; even your love to me, were it possible that that could ever be an obstacle."

Patsy Jefferson was a mature seventeen years old. She knew a lot about devotion to one person. From the moment of her mother's death, her father had relied on her to be his chief comfort and companion. She had embraced that role, riding with him through the woods and meadows of Monticello as he fled his wild grief, accompanying him on the restless rounds from Baltimore to Philadelphia and ultimately to Paris. By making herself indispensable, she earned the chance to go with him across the ocean, to dedicate herself to her studies at Panthémont, to be the girl who deserved his love. "The more you learn the more I love you," he had written to her, "and I rest the happiness of my life on seeing you beloved by all the world, which you will be sure to be if to a good heart you join those accomplishments so peculiarly pleasing in your sex."

Pleasing as those accomplishments might be, acquiring them was no stroll down the Champs-Elysées. Jefferson expected a lot from Patsy, more, he said, than he recommended for most girls, because "the chance that in marriage she will draw a blockhead I calculate at fifteen to one." Over the years he wrote dozens of letters reminding her that if she wanted him to love her, she must work hard and do her duty. In 1783, he'd left her behind in Philadelphia, while he followed the Congress to Annapolis. He'd written to remind her to obey the woman with whom she was boarding, and to lay out the schedule of work he expected her to follow:

from 8. to 10 o'clock practice music.
from 10. to 1. dance one day and draw another.
from 1. to 2. draw on the day you dance, and write a letter the next day.
from 3. to 4. read French.
from 4. to 5. exercise yourself in music.
from 5. till bedtime read English, write & c.

Jefferson was particularly exacting when it came to the matter of letter writing. "I expect you will write to me by every post. Inform me what books you read, what tunes you learn, and inclose me your best copy of every lesson in drawing. Write one letter every week either to your aunt Eppes, your aunt Skipwith, your aunt Carr . . . and always put the letter you so write under cover to me." Lest Patsy scribble off some careless lines, between dancing and drawing and music and reading in two languages, Jefferson let her know he expected polished productions. "Take care that you never spell a word wrong. Always before you write a word consider how it is spelt, and if you do not remember it, turn to a dictionary. It produces great praise to a lady to spell well." As if Patsy needed reminding of the devastating loss they had suffered, Jefferson took care to let her know how much he depended on her:

I have placed my happiness on seeing you good and accomplished, and no distress which this world can now bring on me can equal that of your disappointing my hopes. If you love me then, strive to be good under every situation and to all living creatures, and to acquire those accomplishments which I have put in your power, and which will go far towards ensuring you the warmest love of your affectionate father, Thomas Jefferson.

P.S. Keep my letters and read them at times that you may always have present in your mind those things which will endear you to me.

Patsy could not hope to escape his scrutiny on any matter, from the way she spent each minute of her day, to every stitch of her clothing. "Be you from the moment you rise till you go to bed as cleanly and properly dressed as at the hours of dinner or tea," he instructed her. "A lady who has been seen as a sloven or slut in the morning, will never efface the impression.... Nothing is so disgusting to our sex as a want of cleanliness and delicacy in yours.... The moment you rise from bed, your first work will be to dress yourself in such a stile that you may be seen by any gentleman without his being able to discover a pin amiss."

As much as he tried to control Patsy's outward behavior, Jefferson even hoped to be able to dictate the commands of her conscience. When, in 1783, religious zealots predicted that the world was about to end, Jefferson wrote to reassure his daughter that the prophecies were false. He could not help taking the opportunity to insist that she really ought to behave herself as if Judgment Day could come any time, and balanced his cheery prognostication with a ladleful of gloom: "never do or say a bad thing . . . you will always be prepared for the end of the world: or for a much more certain event which is death."

Patsy was smart and spunky, and she learned to fire back. She chided him when he failed to write to her, and she knew that guilt was the gift that kept on giving: "Being disappointed in my expectation of receiving a letter from my dear papa," she wrote him from Paris, when he was traveling in the south of France, "I have resolved to break so painful a silence by giving you an example that I hope you will follow, particularly as you know how much pleasure your letters give me."

Still, for the most part, she strove to live up to his expectations. At Panthémont, she practiced the pianoforte and harpsichord, struggled to read the classics, and grew so proficient in French that her English began to desert her. When he admonished her to be busy and avoid boredom as a poison to both body and spirit, she responded, "I am not so industrious as you or I would wish, but I hope that in taking pains I very soon shall be. I have already begun to study more." Jefferson let her know that a lot was riding on her diligence. "My expectations for you are high; yet not higher than you may attain. Industry and resolution are all that are wanting. No body in this world can make me so happy, or so miserable as you. . . . To your sister and yourself I look to render the evening of my life serene and contented. It's morning has been clouded by loss after loss till I have nothing left but you."

PATSY LOVED PANTHÉMONT. She made friends easily, but just as important, at Panthémont she had the attention of educated nuns who encouraged the efforts and soothed the longings of a talented, motherless girl. The papal nuncio in Paris, a close friend of Jefferson, had hopes that the nuns might even make a convert out of the daughter of the well-known Deist. He reported to a correspondent that sixteenyear-old Patsy "seems to have great tendencies toward the Catholic religion." According to Jefferson family tradition, Patsy so fully embraced the all-female religious community that she at one point even considered taking the veil. Her father quickly quashed the idea, and in some versions of the story, after receiving a letter from her declaring her intentions, got into his carriage, rode to the school, had his daughters brought to the door, and drove them away. Such a scene may never have happened, but if Patsy did raise the idea, she made her proposal to her father in the midst of his liaison with the devoutly Catholic Maria Cosway. Patsy knew how to get her father's attention.

She returned to America a polished and educated young woman of seventeen, tall and serene, bilingual, cultured, dressed in the latest Paris fashion. But she did not know the first thing about running a plantation household. Her father had hoped to settle her for a time at Eppington, to be trained by Elizabeth Eppes. He had written to his sister-in-law to say that Patsy would need "your finishing to render her useful in her own country. Of domestic economy she can learn nothing here; yet she must learn it somewhere, as being of more solid value than everything else."

There was no time. Patsy married Tom Randolph only two months after she arrived at Monticello. Biographer Fawn Brodie saw in this hasty marriage a flight from Jefferson's relationship with Sally Hemings. It may have been that, but Patsy had other reasons for the marriage. Her father was planning to leave her for the first time since she had been ten years old. If she remained single, she would have been sent to Eppington, a place that was a beloved home to her sister but that Patsy had only visited in the very stressful months after her mother's death. Tom Randolph was tall and dark and fit, a dashing horseman and deep thinker, who avowed his intention to make her happy and provide for her. Plus her father approved of the match.

Jefferson continued to hope that the young Randolphs would find a way to settle at Edgehill, though the elder Randolph seemed determined to fix them at Varina, the heavily mortgaged plantation far to the south and east of Monticello. They hated the place. Varina was fundamentally a "cropping" plantation, a place where gangs of enslaved people sweated to grow tobacco under the lash of a hired overseer. The place had no stately home for the owners, and only two small houses with two rooms each for overseers. It was, moreover, so hot there, even in May, that the athletic Tom was "prevented altogether from taking exercise by the excessive heat," and he developed a nasty rash that "kept me for several days in excessive torture." Patsy, who had reveled in the female world of Panthémont, had no companions, not even her sister Polly (who had gone to Eppington) or her maid. Sally Hemings, the obvious candidate for that job, had not accompanied either of the sisters, but instead had stayed behind at Monticello.

Until such time as Randolph Sr. could be persuaded to turn over Edgehill to Patsy and Tom, the obvious solution was to have them return to Monticello and run the place in Jefferson's absence. While they would not have the satisfaction of setting up an independent household, they needed a home. Jefferson's neighbor, Nicholas Lewis, had acted as his steward for the property while the Jeffersons were in Paris, but Lewis was getting old. Patsy and Tom wanted to go back to Albemarle County. Tom hoped to buy a small farm near Monticello, no more than one hundred acres, an operation he felt he could handle himself without hiring an overseer. The property at Varina had been run into the ground, he thought, because "ignorance of Agriculture is so evident in our common Virginia Overseers that it must decrease in value every day under the management of one of them."

Glad as the Randolphs were at the thought of leaving Varina for Monticello, Polly preferred to be at Eppington, being mothered by Elizabeth Eppes in familiar surroundings. Mrs. Eppes was delighted to have her there and was hoping that Patsy would remain at Varina, near enough to Eppington for regular visits. Convenient as it was for Jefferson to leave Polly with her doting aunt and uncle, it was also hard for him to realize that Polly had come to see the Eppeses as surrogate parents. "I am sensible of your goodness and attention to my dear Poll," he wrote Elizabeth Eppes from New York, "and really jealous of you; for I have always found that you disputed with me the first place in her affections. It would give me infinite pleasure to have her with me, but there is no good position here."

Just as he had with Patsy, Jefferson tried to control Polly from afar. He reignited the battle over letter writing that Polly had fought with him since she had first learned to read and write. At some point, in Paris, the family had begun to address her as Maria, and Jefferson used the name in an instructive voice. "I have written you, my dear Maria, four letters since I have been here, and I have received from you only two. . . . This is a kind of debt I will not give up." We can hear him rehearsing previous arguments with Polly as he went on. "You may ask how I will help myself?" he inquired, and provided a stern retort. "By petitioning your aunt, as soon as you receive a letter to make you go without your dinner till you have answered it." He could not help adding, "How goes on the Spanish? How many chickens have you raised this summer?"

Thomas Jefferson was a formidable opponent, but Polly Jefferson had some moves of her own. She was beguiling when she chose to be: "She is a Sweet Girl, reads and Sews prettily and dances gracefully," Martha Jefferson Carr had told her brother four years earlier. But she could also be as stubborn as a stump. She had used every weapon at a small child's command, from sweet pleading to quivering tears, from charm and clinging to all-out shrieking tantrums, to fight his plan to force her to go to Paris. Elizabeth Eppes had been Polly's rock and refuge and had enlisted Jefferson's own sisters in her attempts to keep him from hauling Polly across the ocean, "draged [*sic*] like a calf to the Slaughter."

Polly's aunt Eppes had, in the end, been unable to defy Thomas Jefferson, which taught the child a lesson in the limits of women's power. So she learned to resist passively. "Laziness" was her weapon of choice. Her letters to Jefferson and to Patsy were often affectionate, but they were never as frequent as they admonished. Both her father and her elder sister could be sarcastic in addressing Polly, as they never were with each other. "No letter from you yet, my dear Maria," Jefferson wrote, reminding her of her literary debt to him and adding that "I think you have quite as little to do as I have, so that I may expect letter for letter."

Polly returned the favor with a measure of sullenness. "You tell me in your last letter that you will see me in September," she chided her father, "but I have received a letter . . . that says you will not be here before February. . . . I am afraid you have changed your mind." She acknowledged herself as his "Affectionate daughter," but she signed the letter not "Polly" or "Maria," but with the name that Elizabeth Eppes would have used when she introduced her niece: "Mary Jefferson."

The sisters returned to Monticello, from Varina and Eppington, in the fall of 1790. Jefferson had work to do putting his household and his family in order. He continued to promote the Randolphs' plan to get a place in Albemarle County. "I have always believed it better to be settled on a small farm, just sufficient to furnish the table, and to leave one's principal plantations free to pursue the single object of cropping without interruption," he wrote to Thomas Mann Randolph, Sr., endorsing the idea of absentee slave owning while he outlined a potential deal for some of Randolph Sr.'s land at Edgehill. Patsy and Tom could use the land, slaves, and crops at Varina to pay Tom's father for Edgehill. Meanwhile, Jefferson would be delighted to have them live at Monticello until they could build a house of their own.

Young Tom Randolph wanted Edgehill rather than Varina partly because he had some hope that by living on a smaller place, he might find a way to farm without using slave labor. As they negotiated over the purchase of Edgehill, Randolph Sr. was determined that his son buy a larger tract of land than he wanted and take slaves along with land. The son insisted that he wanted a smaller parcel of land alone. Patsy had expressed her hatred of slavery in Paris. Both she and her husband hoped to find some way to avoid a lifetime of owning human beings. "My father continues to press the purchase of Edgehill on me," Tom Randolph wrote to Jefferson. But Tom felt he had to refuse his father, despite the fact that taking what was offered would be the easiest thing to do. "My aversion to increase the number of my negroes would be an insurmountable objection," he insisted. "My desire to gratify my Father would induce me to attempt it if there was a prospect of my making myself whole, without employing slaves in the cultivation of the lands. It will be better I believe to confine my views to a small tract, just sufficient to supply me with provisions. Patsy agrees with me," he told her father, "but we both wish to be guided by you."

Tom Randolph took a reasonable tone with Jefferson, but not with his own father. He threw the kind of temper tantrum that would cause him trouble all his life, and the two quarreled bitterly. Jefferson tried to forge a compromise, urging that his son-in-law take slaves in family groups rather than simply as undifferentiated chattel. But the Randolph father and son were so at odds that negotiations broke down. Jefferson was frustrated with Patsy's husband. He wanted his family in Albemarle County, and Tom Randolph seemed to him to be stubbornly standing in the way. Jefferson was sympathetic to Randolph Sr.'s annoyance with his son, and surprisingly indifferent to Tom and Patsy's attempt to renounce slavery. "Nature," he told the elder man, "knows no laws between parent and child, but the will of the parent."

In the end, indeed, he would have his way. Meanwhile, it suited him, and them, to have them at Monticello, "perhaps for some years," he told his sister, Mary Bolling.

Patsy proved to be as fertile a bride as her mother had been, and

was pregnant with her first child. She could hardly have forgotten Martha's travails, and even if she maintained outward calm, she was surely apprehensive. So Jefferson decided that twelve-year-old Polly would have to leave Eppington to be with her sister at Monticello. Patsy would hardly be all by herself on the mountain, but Jefferson insisted that "the solitude she will be in induces me to leave Polly with her this winter," he wrote to a disappointed Elizabeth Eppes. "In the spring I shall have her at Philadelphia if I can find a good situation for her there. I would not chuse to have her there after fourteen years of age." Perhaps he thought he had kept Patsy in Paris too long. But Jefferson was also making plans to bring Elizabeth's son, Jack Eppes, to live and study with him in Philadelphia, though he considered the city a dangerous place for young people. He cautioned Jack's mother that she had better warn him about city girls. "I know no such useless bauble in a house as a girl of mere city education," Jefferson sniffed. "She would finish by fixing him there and ruining him."

Eighteen-year-old Jack Eppes was, it seems, already a young man with an eye for the ladies. After he joined his uncle in Philadelphia, in the spring of 1791, Jefferson reported to his sister-in-law that her son was doing well with his studies. "If we can keep him out of love," said Jefferson, "he will be able to go strait forward."

THOMAS JEFFERSON WAS an exacting householder, and he expected his elder daughter to run his Monticello according to his standards. Preparing for his return to the capital, he left behind with his retiring steward, Nicholas Lewis, careful instructions regarding his household and family. He wanted two meat-houses (smokehouses) built, one for himself and one for the Randolphs, along with a dairy and a stable, and he asked that the fences around the house, garden, and orchard be repaired. As for the inhabitants, Jefferson meant to establish the Randolphs' control in his absence while also protecting the Hemingses. "Mr. Randolph and my daughters . . . are to be furnished with whatever the plantations will furnish, to wit, corn, fodder, wheat, what beeves there may be, shoats, milch cows, fire-wood to be cut by the plantation negroes. . . . They are to have also the use of the house servants, to wit, Ursula, Critta, Sally, Bet, Wormley and Joe. So also of Betty Hemings, should her services be necessary. To be always cloathed and fed by me." Thus he prepared to leave his household in a state of domestic tranquility. But powerful as he was, there were some things he could not control.

Trouble in the Neighborhood

THOMAS JEFFERSON ENJOYED playing intellectual guide to his male kin. Soon after he returned to America, a young cousin named John Garland Jefferson asked for his help in studying the law. Jefferson offered to let the young man share the law books he had loaned to his favorite nephew, Peter Carr. The two came to Charlottesville in the fall of 1790, while Jefferson was still at home. He expected them to buckle down and get to work, and did not imagine that they would be much trouble. But they disappointed their fastidiously discreet mentor. Garland Jefferson and Peter Carr made the mistake of getting involved with a hotheaded lawyer named James Rind.

The trouble began with gossip, but the matter was serious enough that Thomas Jefferson decided he had to get Garland Jefferson out of town. He described the uproar in a carefully oblique letter to his sister Martha, Peter Carr's mother:

That you may have no uneasiness from what you will hear from Peter, I will mention to you that a worthless fellow, named Rind, wrote a libel on the inhabitants of Charlottesville and neighborhood, which P. Carr and G. Jefferson were imprudent enough

20

to suffer him to communicate to them. Rind then pasted it up in Charlottesville, and from expressions of his, the suspicions were directed on all three. Peter has I believe satisfied every body that he was innocent, and has taken proper notice of the much more scurrilous peice [*sic*] written against the three. The matter is over as to him. But not as to G. Jefferson. He leaves the neighborhood therefore, and I wish him to be boarded in yours, that he may be convenient to the books he is to read.

Jefferson asked his sister to find Garland Jefferson a place to stay, somewhere in Goochland County, "at a reasonable rate, distant from public places, and rather distant from you . . . the less he is with your family the safer their reputations will be. . . . Do not let it be delayed. . . ."

Thomas Jefferson hated having people gossip about his family. But however vicious the talk, he would not have bothered to involve himself unless he had some personal stake in settling things down. In this instance, he not only got rid of his young relative, but also sent him into seclusion and paid his bills. Jefferson further wanted both Carr and the younger Jefferson to sever all relations with their new friend Rind. The two, accordingly, wrote a letter to Rind, cutting off this "acquaintance formed in one week." Garland Jefferson insisted to his mentor that he had taken no part in Rind's original libels. "I was not the author of a sentence," he told Jefferson, "yet by my intercourse with Rind, I laid myself open to the suspicions of the people, and incurred the imputation of having done that which in my though[t]ful moments I look upon with a degree of horror."

Jefferson hoped that the matter would be put to rest by hustling his cousin off to the country. But he had underestimated James Rind's sense of personal betrayal, and overestimated his own capacity to manipulate people and events. Rind was angry, relentless, and determined to have satisfaction. When John Garland Jefferson got to Goochland County, Rind was already there, waiting for him. He was furious that young Jefferson had tried to break off their friendship. Rind had a reputation as a duelist, and when he told Garland Jefferson "ironically" that "a man who wou'd not from selfish principles give up a friend, ought to be damned," he knew he was tossing out fighting words. Garland Jefferson responded that "that was a language he had no right to hold," courting the very challenge Thomas Jefferson had hoped to prevent. Fortunately, the matter did not come to blows, or worse, a dawn meeting with pistols.

But what was in the letter James Rind "pasted up" in the middle of town? What kind of gossip about "inhabitants of Charlottesville and neighborhood" could have bothered Thomas Jefferson personally, and caused so much trouble for the Jefferson family? What accusation could be so damaging when it was posted in a public place and then turned back on three young men, that it could provide grounds for a duel? Such altercations typically involved any or all of three things: honor, money, and sex.

The Rind and Jefferson families had a history, going back to Jefferson's father-in-law, John Wayles, and forward to the moment when Jefferson's presidency would be rocked by revelations about his private life. James Rind's father, William, was the publisher of the *Virginia Gazette*. He had printed the satirical doggerel and angry letters attacking John Wayles's breeding, reputation, and character in the 1766 Chiswell affair. People in the neighborhood knew that John Wayles had fathered six children with his slave, Elizabeth Hemings, surely a subject that raised the question of "breeding," and his reputation and character were undoubtedly open to gossip on that score.

Whatever particular charges were hurled back and forth in Charlottesville nearly a quarter of a century later, Thomas Jefferson too was among those men who were vulnerable to shaming accusations of sex across the color line. And he was not the only one. At the time of James Rind's altercation with Garland Jefferson and Peter Carr, Jefferson's friend Thomas Bell, the prominent Charlottesville merchant, was living openly in a sexual relationship with Sally Hemings's sister, Mary Hemings. Years later, Jefferson's grandson, Jeff Randolph, insisted that Peter Carr, one of the accused, was the father of Sally Hemings's children, while Jefferson's granddaughter Ellen Randolph Coolidge fingered Carr's younger brother, Samuel, for that deed.

As historian Joshua Rothman has pointed out, white Virginians of this era, and Albemarle County residents in particular, did not exactly approve of interracial liaisons, but they tended to look the other way unless they had reasons other than offended morals to cause trouble for mixed couples. But this 1790 episode was also only one moment in a long-running family feud. Ten years later, in 1800, James Rind's brother William, who had carried on the family newspaper business, was publishing the Jefferson-hating *Virginia Federalist* and claiming to have "damning proofs" of Jefferson's "depravity."

Jefferson's response to the Rind imbroglio of 1790 foreshadowed his actions ten years later, when tales of his domestic doings threatened to destroy his presidency. He would dispose of the matter as quietly as possible and do everything he could to preserve the wall between his private and public lives. "I hope that this affair will never more be thought of by any body, not even by yourself except so far as it may serve as an admonition never to speak or write amiss of any body, not even where it may be true, nor to countenance those who do so," Thomas Jefferson told Garland Jefferson. "The man who undertakes the Quixotism of reforming all his neighbors and acquaintances will do them no good and much harm to himself."

He continued to pay Garland Jefferson's bills at least until the summer of 1793, when Jefferson received a letter from the Charlottesville merchant with whom he had set up a credit account for his relative. Garland Jefferson evidently decided he preferred to deal with somebody more "convenient" who would loan him cash as well as give him goods. The young man had not bothered to let his benefactor in on his change of plans. Worse yet, he had left behind a larger debt in Charlottesville than Thomas Jefferson had expected, "which has Swelled you're a/c. Some thing more than you had a right to expect." The merchant promised they would work it out. No doubt they did; the creditor in question was Jefferson's good friend Thomas Bell, a member of the family.

THE GARLAND JEFFERSON–JAMES Rind quarrel, and the ensuing scandal, could not have helped Patsy Jefferson Randolph establish peace and harmony at Monticello. She was, in the winter of 1790–91, eighteen years old, very pregnant, and struggling to get control of a house full of enslaved kin who had been operating pretty much on their own while the Jeffersons were in Paris. When last she had lived at Monticello, Patsy had been a motherless ten-year-old child, sticking to the side of the widowed father who was by turns numb and inconsolable. She had lived those first ten years in the midst of revolution and had rarely known the ease and comfort of a healthy mother in a peaceful home—perhaps mostly at Elk Hill. Now she must be the lady of the house.

As she moved to take command of the servants whom her mother had brought to Monticello, Patsy Jefferson Randolph may have claimed some of their sympathy, but she had not yet earned their obedience. Her father and mother had always relied on Martin Hemings to run the household at Monticello, keeping everyone in line with fierce discipline. But "Martin has left us," Patsy reported, without elaboration. She was having trouble with nine-year-old Wormley Hughes, Betty Brown's son, and ten-year-old Joseph Fossett, Mary Hemings's son, who had a tendency to break things. "Not relying much in the carefullness of the boys particularly when left to them selves I took an account of the plate china and locked up all that was not in imediate use." She even counted and locked up the "spoons &c." that were in daily use, every night and after breakfast. "It was very troublesome in the begining," she wrote to her father, "tho now I have the boys in tolerable order every thing goes on pretty well."

The two boys were not the only targets of Patsy's domestic crackdown. "I have wrought an entire reformation on the rest of my household. Nothing comes in or goes out without my knowledge and I believe there is as little waste as possible. I visit the kitchen smoke house and fowls when the weather permits and according to your desire saw the meat cut out." Thus young Patsy Jefferson, lately out of the convent school in Paris, joined her mother and a long train of plantation women, locking up the cupboards and carrying around the big ring of keys. In the dead of a Virginia winter, she hauled her cumbersome body out to the smokehouse to monitor the seasonal hog slaughter. Like Martha Wayles Skelton Jefferson before her, Patsy stood close as the strong-armed Ursula wielded her bloody knife, watchful lest any hungry or greedy or unruly person pilfer her pork.

Polly too came under Patsy's eagle eye. Though Patsy complained that she herself could not find a moment to read, she did make Polly keep up with her studies. "She is remarkably docile where she can surmount her Laziness of which she has an astonishing degree and which makes her neglect what ever she thinks will not be imediately discovered," Patsy complained to her father. She ferreted out every task Polly failed to complete, from studying Spanish verb tenses to practicing the harpsichord. Being a surrogate mother was a chore, but one she seized with a vengeance; Patsy reported to her father with a touch of humor that Polly found her older sister "inexorable." The sheltered young woman, with no training at all, grew up fast. She had no time for romance before the wedding, and few months after to enjoy marriage without impending motherhood. Now she shouldered the heavy responsibility of presiding over her father's cherished, demanding refuge. There is something wistful in the way Patsy closed that first letter to her father, detailing her myriad housewifely efforts: "Believe me ever your affectionate child."

Patsy came through the birth of her first child, a daughter, in fine shape, attended by her neighbor Mary Walker Lewis. Polly was kept away from the proceedings, or maybe chose to absent herself: she complained to her father that Patsy "had been very sick all day without my knowing any thing of it as I stayed upstairs the whole day." The new parents asked Thomas Jefferson to choose a name for the infant, a process that took over a month due to the slow mails. The first-time grandfather was thrilled, congratulating his daughter on becoming both a "notable housewife" and a mother: "This last is undoubtedly the key-stone of the arch of matrimonial happiness. as the first is it's daily aliment." He named the baby Anne, after his own sister, his wife's sister, and Tom Randolph's mother. From this moment forward, Martha Jefferson Randolph, devoted daughter and housekeeper, would have a long, demanding second career in motherhood. She would bear twelve children, eleven of whom lived into adulthood.

WHILE THOMAS JEFFERSON felt keenly his distance from Monticello every moment he was away, slavery wove the warp and weft of his family and finances, his emotional life and his business obligations, even as it divided his house. The Hemings family had come to the mountain with his bride, and they had taken over his household. Betty Hemings and her daughter Betty Brown had lived at Monticello with various of their children during his absence in Paris. Patsy Randolph would keep his house, relying on the steadfast Ursula, and Betty Hemings and her descendants.

260 🏋 THE WOMEN JEFFERSON LOVED

But four of Sally's sisters and brothers—Mary, Thenia, Martin, and Robert—had been hired out in the years that Jefferson had been away, and they were all making plans to depart Monticello for good. In 1792, Jefferson sold Mary Hemings, "according to her wishes," to Thomas Bell, along with their two young children, Robert Washington Bell and Sally Jefferson Bell. Jefferson had given Mary's oldest son, Daniel, to his sister Anna Marks while he was in Paris, and in 1790 gave her oldest daughter to Patsy and Tom Randolph. Mary's son, Joseph Fossett, and daughter, Betsy Hemings, remained Jefferson's property, though there would be much visiting between the Bell and Jefferson households. Thenia Hemings was sold to James Monroe, along with her five daughters, in 1794, presumably according to her own preference.

Martin Hemings, who had served as majordomo at Monticello for nearly twenty years, had been on his own in Jefferson's absence. He was evidently not prepared to resume his position in a household dominated by Thomas Jefferson and run by Tom and Patsy Randolph, and there may have been other reasons for his discontent. Martin Hemings quarreled bitterly with Jefferson in 1791 and insisted that Jefferson sell him. Jefferson, who seldom permitted himself displays of temper, was as angry as Martin was, and by 1795 they had parted company by mutual agreement. No record of sale exists, and of course Jefferson would have been within his rights to do anything he pleased. But Jefferson may well have simply let Martin leave to make his own way in the world, freeing him by passive consent if not legal action, demonstrating some implicit respect for the man who had stared down Tarleton's raiders and now openly defied his own master.

Robert Hemings had been working in Fredericksburg when Jefferson returned. But while Jefferson was gone, Robert had found a wife, and he was arranging to purchase his freedom by paying off his debt to his employer in Fredericksburg, who would then pay Jefferson. On Christmas Eve, 1794, Robert Hemings became the first enslaved person Thomas Jefferson ever formally freed. But Jefferson complained that Robert's employer had "debauched" him of the slave who had been at his side at the height of the American Revolution. The man had paid only sixty pounds for this skilled, well-traveled, and trusted individual, and Jefferson felt he'd been cheated of a fair price. Perhaps there was also a hint of hurt feelings in Jefferson's reaction, a suggestion that he felt personally betrayed by Robert's desire to be his own master.

The wrenching separation between Thomas Jefferson and Robert Hemings, so entangled by kinship and shared experience, almost amounted to a divorce. On a visit to Richmond in the winter of 1795, Patsy Randolph "saw Bob frequently" and reported to her father that Robert "repeatedly declared that he would never have left you to live with any person but his wife." Patsy was genuinely sympathetic, knowing how deeply any hint of displeasure on Thomas Jefferson's part could wound those who wanted so badly to please him, "He appeared to be so much affected at having deserved your anger that I could not refuse my intercession when so warmly solicited towards obtaining your forgiveness." But much as she felt Robert Hemings's pain, she stood on the ground of racial superiority as she pled his case with her father. "The poor creature," she wrote, "seems so deeply impressed with a sense of his ingratitude as to be rendered quite unhappy by it but he could not prevail upon himself to give up his wife and child." Whether or not she intended her words to hurt her father, they may have had that effect. In pursuit of his own duty, after all, that was precisely what Thomas Jefferson had done.

IN 1793, JEFFERSON wrote up an agreement with James Hemings, stipulating that once James had taught someone at Monticello to master the art of French cooking, he would be granted his freedom. James took his brother Peter as his apprentice and by 1796 had fulfilled his part of the bargain, and left Monticello to find his own way.

But Sally Hemings made no plans for independence. She remained in Virginia, to bear and lose the first child she had conceived with Thomas Jefferson, to take her place as one of three housemaids, alongside her sisters Critta Hemings and Betty Brown, under the domain of the young, inexperienced, and determined Patsy Randolph. Jefferson had made it clear that Sally and her mother and sisters and brothers, and now her nephews Wormley and Joe, were "always to be fed and cloathed by me." He meant to avoid imposing on Tom Randolph's slim resources, but he also let his daughter know that the Hemingses were under his protection.

There was reason they needed protecting. Jefferson owed money to people who were growing tired of not getting paid. Ironically, his father-in-law, the debt collector, had left him an inheritance that brought men of the same loathed profession to Jefferson's door. Much as he might hope to clear his accounts by selling tobacco or land (he was still trying to unload the Elk Hill plantation), he could not raise enough quick money to satisfy his creditors.

Jefferson resigned himself to selling human beings. His brothersin-law, Francis Eppes and Henry Skipwith, were frantic about their shared debt, and both sold large numbers of slaves to pay it off. Jefferson approached the matter obliquely, obscuring even from himself what he was doing. "I do not (while in public life) like to have my name annexed in the public paper to the sale of property," he once wrote to the Poplar Forest overseer who was selling eleven people on Jefferson's behalf.

Even in private correspondence, he found roundabout ways to discuss the business of trafficking in people. "I heartily congratulate you on the success of your sale," he wrote Francis Eppes, in a typical letter. "It will determine me to make a decisive stroke in the same way next winter." He could only bring himself to speak bluntly about what he was doing when he was signaling desperation, and begging others to pay their IOUs to him. In a letter trying to collect a debt from John Bolling, his sister Mary's husband, he said, "I hope you will not think it unkind in me . . . I find myself obliged this winter to make a very considerable sale of negroes in addition to the sales of land I have already made and shall further make." When the sales finally occurred, Thomas Jefferson was far away in Philadelphia, and in the end he was badly disappointed with the proceeds, "miserable enough, the negroes having averaged only $\pounds 45$ a peice [*sic*]." His beloved Martha's eldest half-brother, Robert Hemings, had sold for quite a bit more than that.

WITH WHAT MIX of familiarity and strangeness did life go on at Monticello in those days, in that household cleft by the fierce fiction of race, where a daughter ruled over her aunt, who was also mistress to her father? Patsy Randolph could not have been ignorant of the fact that six of Betty Hemings's children were her aunts and uncles, or that another of Betty's daughters was living in Charlottesville, in a common-law relationship with a well-respected white man who came to dine at Monticello and assured his friend Jefferson that "the family are all well." Patsy may have convinced herself that her father was above sleeping with Sally Hemings, but she could not fail to notice that Sally never took a husband, though Thomas Jefferson strongly encouraged his slaves to form nuclear families, and did everything he could, when buying and selling people, to keep husbands and wives and children together. Sally's singleness spoke for itself.

Surely it occurred to Patsy over the years that the beautiful, traveled, and "mighty near white" young woman who served as her father's chambermaid never conceived a child except when the master

264 🎇 THE WOMEN JEFFERSON LOVED

was at home. Between the time Jefferson took the office of secretary of state and the time he retired from the presidency, Sally Hemings gave birth to at least six children, at least some of whom bore a stunning resemblance to Thomas Jefferson. Four of those children lived to adulthood. All of them were, one way or another, set free. For their entire adult lives, often thrust together at Monticello, Patsy Randolph and Sally Hemings lived with a lie that split them into dual, unequal families, doubled the rhythms of daily life, etched in words and gestures and rote routines, over and over and over again. In the course of her sixty-four years of life, Patsy Jefferson Randolph kept silent about the matter. Only late in life, at the urging of her son, did she break that silence and offer her children a denial of the connection between her father and her enslaved half-aunt.

Families are where lies, secrets, and silences go to live. All of us find ways to live with falsehood, to pretend that we can't see what we don't want to tolerate. Thomas Jefferson loved his daughter. He knew how much pain it must cost her to pretend not to notice what was plainly in front of her face. In his selfish, slaveholding, possessive, and patriarchal way, he also loved Sally Hemings. He understood, on some level, that he owed her a great deal for her willingness to endure the denigration and invisibility of the concubine, the silent submission of the servant/lover, and most of all, the unconscionable vulnerability of the enslaved.

Both his daughter Patsy and his slave Sally were, in turn, deeply devoted to him, although their feelings toward him must have been so convoluted that they stymie the modern imagination. So even as Jefferson remained solicitous of Patsy's desire to deny his relationship with Sally, and just as he worked to respect and reinforce his daughter's domestic authority, he continued in his efforts to take care of Sally and her family. He made the point, in a letter to Patsy, of inventorying "the following articles for your three house-maids": 36 yds. callimanco 13 ¼ yds. calico of different patterns 25 yds. linen 9 yds. muslin 9. pr. cotton stockings thread.

By the time he wrote this letter, Polly was with him in Philadelphia, boarding with a local woman who kept a school for girls. She may have helped him figure out precisely what the Hemings sisters needed, and how much of each item to buy. But more likely, Sally Hemings, by this time an accomplished seamstress, had given him a shopping list, and he was fulfilling her commission down to the last thread.

WHILE JEFFERSON TRIED to keep everyone happy, in his absence there had been some trouble at Monticello. He imagined his home as a place of enduring sweetness, sequestered from the nastiness and strife that beset public life. But the people in his household did not always play their parts dutifully, and sometimes they were furious with one another. When there was some kind of unspecified friction in his household in the winter of 1791-92, he did what he could to support Patsy long-distance by reminding her of "the love I bear you, and the delight with which I recall the various scenes thro which we have passed together, in our wanderings over the world." Patsy and Tom Randolph were by then looking to move into a home of their own, but Jefferson wanted to keep them in his house as long as possible. So he told Patsy that he hoped "I shall be able to make you both happier than you have been at Monticello, and relieve you from the desagremens to which I have been sensible you were exposed, without the power in myself to prevent it, but by my own presence." His

266 🏋 THE WOMEN JEFFERSON LOVED

use of the French word for "annoyances" may not have been casual. Sally Hemings used her knowledge of the language to emphasize her exceptional place in Thomas Jefferson's life, to put herself, in at least this regard, on equal footing with Patsy Jefferson Randolph.

Still, Patsy was the master's daughter, the free white mistress of the household. She had endless ways to maintain her superiority. Jefferson was her steadfast ally in that effort, reminding her often that he wanted every slave at Monticello to look first to the needs and desires of the Randolphs, and only then to the tasks he wanted them to do. "I wish every other object to be considered as secondary in my mind to your accomodation [*sic*]," he insisted.

Jefferson understood that he was asking Patsy and Sally, and evervone around them, to perform an emotional trapeze act, sometimes in the midst of family upheaval. In the fall of 1792, two of Tom Randolph's sisters, Judith and Nancy Randolph, were embroiled in a spectacular scandal. Judith was married to yet another cousin, Richard Randolph, master of the aptly named Bizarre plantation, on the Appomattox River. Her younger sister Nancy was living with the couple at the time. The three were on a visit to a neighboring plantation when the unmarried Nancy either gave birth or suffered a miscarriage. What happened next was never completely clear. Slaves reported finding the discarded body of an infant somewhere on the plantation grounds. The rumor soon spread throughout Virginia that Nancy Randolph had borne her brother-in-law's baby, and that the two had killed the child. Richard Randolph was charged with the murder. His beleaguered wife, Judith, was forced to testify at his trial, and so was Patsy Jefferson Randolph, who was called as a character witness. Richard Randolph was acquitted but the scandal lingered for years afterward.

The rumors spread all the way to Philadelphia, where Secretary of State Jefferson wrote to console his distraught daughter. He offered

advice that bespoke his sense of responsibility for all the women under his care, and revealed a hint of his own guilt at having debauched a slave girl. He hoped that neither Patsy nor Tom felt "any uneasiness but for the pitiable victim, whether it be of error or of slander. In either case I see guilt in but one person, and not in her." Nancy Randolph, he held, was not to blame for her predicament. The man who was supposed to be acting as her protector and provider had taken advantage of the young woman. Patsy's beleaguered sister-in-law needed her friends' support, "when their commiseration and comfort become balm to her wounds. I hope you will deal them out to her in full measure, regardless of what the trifling or malignant may think or say." Jefferson reminded Patsy of the importance of loyalty, and of long family connection, and the danger of casting stones: "Never throw off the best affections of nature in the moment when they become most precious to their object; nor fear to extend your hand to save another, lest you should sink yourself."

Patsy replied that she was standing by Nancy Randolph but having trouble being entirely sympathetic to the fallen woman. She was speaking of her sister-in-law, but her words could easily apply to her half-aunt, Sally Hemings. "I have continued to behave with affection to her which her errors have not been able to eradicate from my heart," she told her father, "and could I suppose her penitent, I would redouble my attentions." Patsy was also worried about the potential injury to her own reputation, and she implied that she knew a thing or two about loyalty to close relatives who courted scandal, and women who were not penitent. "It is painful to an excess to be obliged to blush for so near a connection," she explained to Jefferson. "I know it by fatal experience."

PATSY RANDOLPH WAS in charge at Monticello, but even her father had told her that her first duty was to her husband. From the early days of her marriage, she discovered that answering to Thomas Mann Randolph's needs and desires, his caprices and his injuries, could be a tough job. Randolph had first exhibited his volcanic temper in his quarrel with his father over the purchase of Edgehill. In that instance, he had good reasons for standing his ground, but over the years he proved so touchy and quick to anger that he made more enemies than friends. He was nearly involved in several duels, quarreled with many of his relatives and even his solicitous father-in-law, and at length wore out the patience of even his long-suffering wife.

But Tom Randolph was not simply hot-tempered. His tendency to "nervousness" and melancholy led to repeated mental breakdowns over the course of his life with Patsy. They had been married less than five years when he first decided that he needed to travel, as treatment for a mysterious illness. Randolph's prolonged bout of ill health coincided with Jefferson's resignation from Washington's cabinet at the end of 1793 and return home to "retirement" at Monticello. Randolph took a long trip north, to New York and Boston, by himself. But his torments continued. In the summer of 1795, he decided to visithot springs resorts in western Virginia. This time Patsy went along. They had three children by now, so leaving the older two, Anne and young Thomas Jefferson Randolph, at Monticello, they set out for the springs with baby Ellen in tow.

Thomas Jefferson was very worried about his son-in-law. No one seemed to know what was really wrong with Tom Randolph, and Jefferson was as concerned about the treatment as the disease. Various members of his family, from his wife to both of his daughters, had been subjected to "the potent doses of Dr. Currie," the favorite physician of the Eppes family and himself a friend of Jefferson's. Jefferson always held that letting nature take its course was far healthier than the heroic prescriptions of doctors, who believed in pushing diseases to crisis with bloodletting, purging, and the administration of toxic doses of lead and mercury, before deadening the pain with opiates. He hoped that a little respite from everyday care, along with the mildest treatments, would make Thomas Randolph feel much better.

That summer of 1795 brought devastation to Virginia. Torrential rains drowned the corn in the fields and washed away more topsoil than Jefferson had ever seen flow into the swollen Rivanna. Floods carried off dams and mills along all the rivers, sweeping the Appomattox nearly clean and raging all the way north into Pennsylvania. Everyone Jefferson knew was ill, and he described Monticello as "a mere hospital of sick friends." But the worst news of all came from the Randolphs, on their way to the Sweet Springs. On or about July 23, 1795, little Ellen Wayles Randolph, less than a year old, had died at Staunton, of unknown causes. Jefferson hastened to assure his son-inlaw that it was "impossible that the journey could have had any effect on the accident which happened," though he had often worried about the effects of hard travel on babies, and had himself lost young children who had been forced to endure arduous journeys across the Virginia countryside.

Jefferson sent James Hemings to bring "the body of our dear little Eleonor" back to Monticello to be buried. Mourners included Jefferson's three sisters, Mary Bolling, Martha Carr, and Anna Marks. Jefferson paid his sisters' old tutor, Benjamin Snead, two dollars to read a funeral service. But the parents did not return for the sad occasion. Though Tom Randolph soon reported that his health was recovered, his hopes proved false, and his continuing mental problems caused tension in the family. The Randolphs seemed to withdraw into themselves, spending most of the fall and winter at Varina, while their children remained at Monticello with Jefferson. It was months before Patsy wrote another letter to her father.

Domestic Tranquility, Revisited

21

THOMAS JEFFERSON HAD gone into his retirement from politics with depressed spirits of his own. But he was a resilient man. As the terrible summer of 1795 slipped into autumn, he told his friend Angelica Church that he was "now in that tranquil situation which is my delight, with all my family living with me, and forming a delicious society." He wrote Maria Cosway that he had "bidden an eternal Adieu to public life which I always hated." He was a happy farmer, living in the outdoors, "eating the peaches, grapes and figs of my own garden," and permitted "from the innocence of the scenes around me, to learn and to practice innocence towards all, hurt to none, help to as many as I am able." He told Eliza House Trist that he was so busy with his farm, he had given up philosophy and science. "I read but little. Take no newspapers . . . and I have it in contemplation next to banish pen, ink, and paper from my farm. ... The society of my family and friends is becoming more and more the sole object of my delight." His family had lost one tiny member. But they had gained another. On October 5, 1795, Sally Hemings gave birth to her second child, a daughter named Harriet.

Jefferson presented himself to those faraway friends as a contented

country patriarch. But the reality was more complicated, as he admitted to those closest to him. Now that he lived off the soil, the weather was no longer simply a subject of his questing curiosity; it was a lifeand-death matter. If too much or too little rain fell, or temperatures were too low or too high, crops failed. When that happened, he had to buy food to feed his field hands and his household. In times of dearth, prices rose sky-high for what little grain could be had. "There is vast alarm here about corn," he wrote Tom Randolph in the winter of 1796. "My situation on that subject is threatening beyond any thing I have ever experienced. We shall starve literally if I cannot buy 200 barrels."

Jefferson's household was also changing. In 1796, James Hemings made an inventory of his kitchen utensils and set out to seek his fortune, replaced as chef at Monticello by his younger brother, Peter. John Hemings, Elizabeth Hemings's youngest son, began to train as a carpenter and furniture maker, while Wormley Hughes and Joseph Fossett worked first in the nailery, and then took up trades of their own. Jefferson meanwhile appointed "Great George" Granger to be his first and only enslaved overseer, holding that job alongside a white overseer named William Page. The two were a curious pair. While Great George was solicitous of his fellow slaves, Page was, according to Tom Randolph, "anxious but peevish and too ready to strike."

The public business of buying and selling, like the private endeavor of tearing down and putting up his house, continually disrupted the peace of Jefferson's domain. To deal with his mounting debts, Jefferson mortgaged many of his slaves to "friendly" creditors, a strategy intended to stave off more hostile demands. Meanwhile, enslaved and free workers were tearing down walls at Monticello, and everyone had to step lively to keep bricks from falling on their heads.

Despite the heartbreak of losing a child, Patsy Randolph was a sturdy and determined woman. She went on bearing and rearing her passel of children, shuttling between her own household and Monticello, keeping house for her husband, her father, and myriad guests, making her own rounds of visits to an endless array of relatives. Her sister Polly was far more delicate and retiring. By now, the family addressed her more and more often as "Maria," the name they had given her during her cosmopolitan experience in Paris. But as she grew to womanhood, she was still the girl who had been christened "Mary" and mostly known as "Polly," a homebody who fully embraced her father's notion that "we love best those we loved first."

On October 12, 1797, Polly married John Wayles Eppes, her first cousin. She had known and loved Jack Eppes since her early childhood at Eppington. Thomas Jefferson was absolutely elated at the match. Just as he wished his slaves to "marry in," to build and create family ties that would not require trips away from home, his vision of his family, happily encamped in his neighborhood, was a lifelong idée fixe. "I now see our fireside formed into a groupe," he told Patsy, in a letter crowing over Polly's engagement to Jack Eppes. Now he would preside over a family "no one member of which has a fibre in their composition which can ever produce any jarring or jealousies among us. No irregular passions, no dangerous bias, which may render problematical the future fortunes and happiness of our descendants. We are quieted as to their condition for at least one generation more."

Jefferson expressed himself even more emphatically to Polly, when he wrote to congratulate her on her decision to marry Jack.

This event in compleating the circle of our family has composed for us such a group of good sense, good humor, liberality and prudent care of our affairs, and that without a single member of a contrary character, as families are rarely blessed with. It promises us long years of domestic concord and love, the best ingredient in human happiness, and I deem the composition of my family the most precious of all the kindnesses of fortune. I propose, as in the case of your sister, that we shall all live together.

As a wedding present, he gave Polly and Jack Eppes his plantation at Pantops, adjoining Monticello. He included in the bargain thirty-one enslaved people. As he had with Patsy, Jefferson took care to enumerate the people he was giving to Polly as members of families. Among them was Mary Hemings's fourteen-year-old daughter, Betsy.

But Thomas Jefferson's vision of domestic life as an unbroken idyll was naïve. The proposal to move Polly and Jack to Jefferson's neighborhood never came to pass. At the moment when Polly Jefferson and John Wayles Eppes married at Monticello, most of the house was unroofed and exposed to the elements. Polly's beloved aunt Elizabeth Eppes could not even attend the wedding. Tom Randolph too seems to have missed the festivities, due to a black mood that had him contemplating suicide. He was so depressed, in fact, that he was afraid to face his family, and remembering "the horrors of 94 and 95," he told Jefferson that "I should shun them by embracing death if it could be done no other way." Jefferson himself was headed back to Philadelphia, and Elizabeth Eppes was pressing hard for the young couple to spend at least half their time at Eppington. This time, Aunt Eppes proved victorious. Polly and Jack Eppes gravitated to Eppington, the home they both knew best, the place where Polly would spend most of the rest of her life.

JEFFERSON INSISTED THAT he had no appetite for public life, that "ambition is long since dead in my mind," and that "I have no wish to meddle again in public affairs, being happier at home than I can be anywhere else." In the meantime, in 1796, he let his friends nominate him for president of the United States. He greeted the news that he had come in second to John Adams, and was accordingly elected vice president, with apparent satisfaction, pronouncing the office a "tranquil and unoffending station." He insisted that he would go to Phila-. delphia for only a month, slipping quietly into town to avoid formal fanfare, and would return to Virginia as quickly as possible. In this instance, he was as good as his word. Later in that spring of 1797, he was back at Monticello, savoring the first tender asparagus from his garden amid the blooming peach and cherry trees.

Much as he might have wished to spend his entire term as vice president at home, Jefferson cared passionately about politics. He meant to shape America's destiny, to ensure that men like him would always be free to enjoy the control of their property, the love of their families, the fruits of their labor and that of the people they commanded. He was confident that his cause was just, and though he hated conflict and confrontation, he knew a thing or two about how to play the game. His pose of equanimity barely masked his fierce ambition. He tried to appear above the fray, but he was the leader of the opposition to Adams's Federalists and needed to be in Philadelphia to tend his political fires. Thus he was away from home when word arrived that he had once again lost a child. In the cold, wet winter of 1798, disease came once again to his family, free and enslaved. Tom Randolph reported the sad news of the "death of Sallies child." Patsy, then living in comfortless quarters at a rented Albemarle County plantation, offered more details. Her own household was experiencing "more sickness than I ever saw in a family in my life. pleurisie, rhumatism, and every disorder proceeding from cold have been so frequent that we have scarcely had at any one time well enough to tend the sick." She or Tom had managed to visit Monticello almost daily, where things were a little better, with one notable exception. "Poor little Harriot," she said, "died a few days after you left us."

Patsy Randolph knew the pain of losing a child, and here we sense a glimmer of sympathy for Sally Hemings's grief, and Thomas Jefferson's own, at the death of two-year-old Harriet. But if they held a funeral for Harriet Hemings, no record testifies to the occasion. It was Sally Hemings's lot to suffer loss without the comfort of a husband to share her sorrow. She was six months pregnant with the son she would name Beverly. Whatever Thomas Jefferson felt about baby Harriet's death was twisted with shame and secrecy. He responded to Randolph's letter with nearly pathological obliqueness: "Yours of the 13th. came to hand yesterday, and relieves my anxiety as to the health of the family." Sally Hemings may not have known what her lost daughter's father had written, but even as he kept to his practice of grieving through silence, his words carried the inescapable cruelty at the heart of their master/slave relationship.

We may wonder, too, about the extent of Patsy Randolph's compassion for her father's concubine, her mother's half-sister. At the very moment that Patsy delivered Sally's tragic news, she revealed her own jealousy and possessiveness toward her father. Patsy reminded her father of their unique bond, rooted in their shared, sad history. "I feel every day more strongly the impossibility of becoming habituated to your absence—sepparated in my infancy from every other friend, and accustomed to look up to you alone, every sentiment of tenderness my nature was susceptible of was for many years centered in you," Patsy wrote. No "connexion formed since that could weaken a sentiment interwoven with my very existence." She closed with a jab at Polly, reminding her father of her sister's lazy and sullen refusal to write letters: "I have heard from Maria through Mr Eppes she deals much in promises but very little in deeds that are to be performed with a pen she was in good health and better spirits than usual."

Three young women, bound together by kinship and dependency, vied to bask in the warmth of Thomas Jefferson's affections. We may never know what Sally Hemings expected from the man who owned her and fathered her children, what she said to him or he to her, how

276 🧏 THE WOMEN JEFFERSON LOVED

many things were simply impossible to say. But Patsy and Polly repeatedly told Jefferson how much they loved him and how hard they worked to please him. Polly was plagued by a sense of her own inadequacy compared to Patsy. "What an economist, what a manager she is become," she wrote to Jefferson, while on a visit to Varina. "The more I see of her, the more I am sensible how much more deserving she is of you than I am, but my dear Papa suffer me to tell you that the love, the gratitude she has for you can never surpass mine; it would not be possible." Even after she had married Jack Eppes, Polly told her father that "I feel more & more every day how much the happiness of my life depends on deserving your approbation." He, in turn, frequently reminded his daughters that they were his only reasons for living. "On my part, my love to your sister and yourself knows no bounds," he told Polly, "and as I scarcely see any other object in life, so would I quit it with desire whenever my continuance in it shall become useless to you."

JEFFERSON WAS GENUINELY sympathetic to his daughters' trials and sorrows, and he begged them to write and tell him every trivial thing. But he also believed that women should endure domestic difficulty in silence. Polly wrote him about a painful visit to his sister Mary and her estranged husband, John Bolling, the notorious alcoholic. "My uncle Bolling is much as usual, in a state of constant intemperance almost, he is happy only with his glass in his hand," Polly confided. As her father's daughter, she placed some of the blame for her uncle's drunkenness on her aunt Mary. "He behaves tho' much better to my aunt than he did, and appears to desire a reconciliation with her, and I think could she hide her resentment of his past behaviour to her, she might render her situation much more comfortable than it is."

Jefferson hated to hear the bad news. "Mr B.'s habitual intoxication will destroy himself, his fortune & family. of all calamities this is the greatest," he wrote to Polly. But "I wish my sister could bear his misconduct with more patience. it might lessen his attachment to the bottle, & at any rate would make her own time more tolerable." There was a lesson for Polly in the Bollings' misery. "The errors and misfortunes of others should be a school for our own instruction," Jefferson explained, warming to his "sermon" on wifely submission as the source of marital happiness. "Harmony in the marriage state is the very first object to be aimed at. nothing can preserve affections uninterrupted but a firm resolution never to differ in will, and a determination in each to consider the love of the other as of more value than any object whatever on which a wish has been fixed. how light in fact is the sacrifice of any other wish, when weighed against the affections of one with whom we are to pass our whole life."

Jefferson knew, of course, that sometimes a husband and wife would disagree. He counseled forbearance for both parties, but where disputes arose, wives should always yield, lest a husband find "his affections wearied out by a constant stream of little checks & obstacles." Jefferson warned Polly against questioning or criticizing her husband, especially in front of company. "Nothing is so goading," he explained. "Much better, therefore, if our companion views a thing in a light different from what we do, to leave him in quiet possession of his view. what is the use of rectifying him if the thing be unimportant; & if important let it pass for the present, & wait a softer moment, and more conciliatory occasion of revising the subject together."

Polly Jefferson Eppes had been only four years old at the time of her mother's death. She might not have remembered Martha's "tart" tongue, and indeed, in the traumatic wartime years of Polly's early childhood, Martha may have been so sick, weak, and harried that she could not muster the fire for which she had been known in her youth. But the wife Thomas Jefferson had loved so well was no mealymouthed miss. If Martha Jefferson learned, as Jefferson suggested, to speak softly in public, and make her sharper points in private, she had thoughts and desires and worries and wishes of her own. She had insisted that her second husband buy and maintain the home she had shared with her first. She had brought to her marriage a house full of enslaved half-siblings and installed them in positions of responsibility. She had made Jefferson promise never to replace her, never to endanger her daughters' safety or security by putting them at the mercy of a stepmother.

Polly's surrogate mother, Elizabeth Eppes, showed similar force of character. She disputed Jefferson's plan to haul Polly across the ocean and repeatedly resisted his pleas to visit Monticello. She managed to keep Jefferson's younger daughter close to her, in defiance of his wishes. The Wayles sisters were, in short, agreeable women, but they were capable of speaking their minds. They had been raised to command and "correct" legions of slaves, to brew beer and slaughter hogs. They were not pushovers.

If Thomas Jefferson had a mental image of some model of feminine deportment as he wrote his sermon on wifely submission, Martha could have filled that role only as a figment of nostalgia, not as a fleshand-blood person. She remained a force in his life through the vow he had made to her, a promise he implicitly invoked every time he assured his daughters that they had become his only attachments, his only reasons for living. But the traces of their life together were fading. In 1793 he had sold Elk Hill, the place where they had passed some of their happiest times before the terror of Cornwallis. The deed was finally executed in 1799; by that time the place had become to him just an extra piece of property. He received "fifteen hundred pounds current money of Virginia" for Elk Hill, and the bonds for the property had gone directly to Farell and Jones, toward the payment of his debt.

DOMESTIC TRANQUILITY, REVISITED 💥 279

There was another woman, very much alive, who had very little choice except to please Thomas Jefferson, and no standing whatever to quarrel or criticize. That woman could not even complain if he beat or starved her, or forced her to wear rags and plow frozen fields in the dead of winter. Jefferson counted himself humane, in that he evidently did not do any of those things, in return for Sally's silence and her obedience to his will. And while he pursued the public's business in Philadelphia, Sally Hemings, the woman who came closest to Jefferson's avowed ideal, was back at Monticello, quietly mourning their lost daughter as she anticipated the birth of the first son of Thomas Jefferson lucky enough to live to be an adult. Danger

22

AS VICE PRESIDENT of the United States in 1796, Thomas Jefferson threw himself into the heat of political battle, after his fashion. Always a man to avoid confrontation, he often acted through indirection and innuendo, employing others to do his dirty work. Unlike his more openly Machiavellian enemy, Alexander Hamilton, or his rigid and pompous onetime friend, John Adams, Jefferson took care to maintain the calm demeanor that gave him plausible deniability, while his allies and acolytes took care of the fulminating and eye gouging and throat punching.

Ever since he had been secretary of state, he had used journalists to advance his views. In those days, Philip Freneau's *National Gazette* had been Jefferson's mouthpiece, against John Fenno's Federalist *Gazette of the United States*. But by 1796, Jefferson had turned to a new partisan to spread the stories that undermined his enemies: a newspaperman and pamphleteer named James Thomson Callender.

Callender was a Scotsman who had fled his native land. Having libeled Samuel Johnson, attacked George III, and angered his own noble patron, he had moved to Philadelphia and joined a group of radical Republican journalists. He published pamphlets outlining a political philosophy to the left of Thomas Jefferson but was more notorious for his vicious, sarcastic attacks on Washington, Hamilton, and Adams. Callender first gained fame in the United States with his *History of 1796*, a pamphlet that exposed Alexander Hamilton's affair with a married woman, Maria Reynolds. He insisted that his concern was to expose Hamilton's political corruption and the plots and crimes of the Federalists, but he specialized in a combination of gossip and invective that smeared his targets even as it exposed him to prosecution. He had an unstable disposition, a hot temper, and a perpetual urge to lose himself in the bottle.

In 1798, the volatile Callender was in desperate straits. Now he was in trouble in Philadelphia, and hoping to escape his enemies and his debts and the law, he set up shop in Richmond, Virginia. He certainly expected Virginia to be friendlier to his brand of political advocacy than anywhere else. Thomas Jefferson had become the chief sponsor of his attacks on the Federalists in general and John Adams in particular. Callender kept Jefferson posted on the progress of his work, the popularity of his pamphlets, and the pressure of his obligations. Jefferson, for his part, kept up the pretense of despising the bare-knuckle political combat in the presses. He wrote to Patsy from the capital, lamenting that he could not be with her, quiet and happy at home: "You should know the rancorous passions which tear every breast here, even of the sex which should be a stranger to them. politics and party hatreds destroy the happiness of every being here. they seem, like salamanders, to consider fire as their element." At that very moment, he was paying the venomous Callender, stoking the flames.

By 1800, the Adams administration had thrown Callender in jail under the Alien and Sedition Acts. The Federalists had pushed these hated measures through Congress, claiming that the laws would protect the country from disruptive foreigners and punish Americans who undermined the government with criticism. But to the Democratic-Republicans, the Alien and Sedition Acts were a direct assault on the Bill of Rights and the liberties of all citizens. Callender was imprisoned for "publishing false, scandalous, and *malicious writings*," having called John Adams a "hideously hermaphroditical character which has neither the force and firmness of a man, nor the gentleness and sensibility of a woman," among other things. When Abigail Adams learned that Jefferson was giving Callender money, she never forgave him. Though Jefferson was alarmed at the increasingly vitriolic tone of Callender's attacks and told James Monroe, "As to myself, no man wished more to see his pen stopped," he still saw fit to defend Callender as a symbol of the suppression of the press, the violation of the First Amendment, the Adams administration's assault on Americans' liberty. One of his first actions as president was to issue a pardon for the scandalmonger who had served as his political instrument.

Twenty-first-century readers accustomed to a twenty-four-hour news cycle might well wonder: How could Jefferson have blithely used a man who had exposed his enemy's adultery, and imagine that he himself would remain free from scrutiny? The answer, of course, is that he did not expect his adversaries to let him off the hook. The Federalist press had attacked him with as much vigor and venom as Callender had unleashed on Jefferson's adversaries. Jefferson believed, however, that he had insulated his private life from public prying. "Take care that nothing from my letter gets into the newspapers," he admonished Thomas Bell, who replied reassuringly, "Any confidential line I may at any time have the pleasure of receiving from you Shall never by me or my means be made publick. I see the unwarrantable and Shamefull attacks at your Character from the moment you stepd into office. Such infernal Scoundrels ought to be consign.d to the Algerens."

Ever since the Revolution had come to his door, Thomas Jeffer-

son had worked long and hard to rebuild the wall of separation between the women and children who inhabited his domestic realm, and the potentially lethal conflicts of his political world. He had hated seeing Frenchwomen inject themselves into politics, and as he rose through the highest ranks of the new American government, he was just as determined to segregate public life from what he perceived as the corrupting influence of ambitious women. As president he dined mostly with men and only rarely entertained the ladies of the capital. In some instances, in fact, he violated his habitually scrupulous manners and was downright rude to women he believed had forgotten their proper place. His intentionally discourteous behavior toward Elizabeth Leathes Merry, the haughty wife of British ambassador Anthony Merry, nearly provoked an international incident.

Jefferson reasoned that he maintained his virtue by keeping away from women in public. What he did in the privacy of his faraway home was, he believed, absolutely his own affair. He did not spend thirty-seven years building and rebuilding a house on a remote mountaintop for nothing. If he could bring the people he loved under his long-in-the-making roof, or at least settle them on nearby plantations, he might keep them safe from harm, or at least from prying eyes. His closest neighbors, so many of them his friends and relations, understood. They shared his foibles-addiction to fine things in the face of crushing debt, propensity for sex across the color line. He had quelled local scandal in the John Garland Jefferson-Peter Carr-James Rind affair of 1790, and had every reason to believe that what happened in Charlottesville stayed in Charlottesville, at least where the most powerful man in town was concerned. He could maintain his privacy by buying off or ignoring any lesser being that had the poor judgment to cross him.

In some regards, Jefferson's relationship with Sally Hemings may have seemed to him the *least* problematic aspect of his personal life.

284 🧏 THE WOMEN JEFFERSON LOVED

He had far more trouble with his debts, his crops, and the seemingly endless vexations of trying to get his house built. Every absence from home compounded his problems. The overseers in his fields and his nail shop could not control their workers, or beat them too much. Construction supervisors pulled down in sections the columns that supported his portico, and then forgot to number the pieces. Putting the columns back up was like a muscle-straining Rubik's cube.

Jefferson's daughters, meanwhile, had married according to his wishes, but just as he demanded perpetual proof of their affections, they returned the favor. Patsy announced that she looked forward to his return "with raptures and palpitations not to be described." Her own family was growing rapidly, and she was perpetually busy, but she found moments to write him letters that reminded him of their unique relationship. "Dearest and adored Father the heart swellings with which I address you when absent and look forward to your return convince me of the folly or want of feeling of those who dare to Think that any *new* ties can weaken the first and best of nature—the first sensations of my life were affection and respect for you and none others in the course of it have weakened or surpassed them."

Sally Hemings did not require that kind of attention. In fact, she was obliged to accept a social invisibility that penetrated the very heart of her family, an anonymity and illegitimacy that her nieces, Patsy and Polly, never faced, no matter how much they confined themselves to private life. Even in family correspondence, Jefferson and his daughters almost never referred to Sally, and never by name. If he wrote to her, he made no record of the correspondence, and he or his daughters and descendants did all they could to see that no such letters survived.

Nonetheless, when Sally gave birth to her third child, a daughter, Thomas Jefferson could not help mentioning the event in a letter, addressed not to Patsy or Polly, but to John Wayles Eppes, who was then at Eppington awaiting the imminent birth of his and Polly's first child. "Maria's maid produced a daughter about a fortnight ago," Jefferson wrote, "& is doing well." While he often noted the births of slave children in his account books (in the form of payments to midwives), it was a measure of Sally's importance to him that he mentioned the event in a letter; no other birth of an enslaved child merited such notice on his part. But we can also read, in Jefferson's oblique phrasing, the pains he took to balance his attachment to Sally with his deference to his daughters, and to the proprieties of racism and slavery. When that daughter died not long after, no member of Jefferson's white family commented in writing on this latest loss.

Sally Hemings had borne four children and lost three. Only her son, Beverly, born in 1798, remained. Surely her children's father, and their half-sisters, Patsy Randolph and Polly Eppes, shared in Sally's grief. Surely there were moments of remembering Martha Jefferson's similar trials. But many things could not be written, and some could not be spoken aloud, and some could barely even enter the realm of thought, including the freshest, most searing memories.

Whatever Sally was thinking or feeling, by this time Jefferson and his daughters had begun to pretend in public that she did not exist. Sally had little choice in the matter. As far as we know, once she had agreed to relinquish her freedom and return from Paris with him, she did not press the matter, as her brothers Robert and James did. Instead, she held Thomas Jefferson to his promise to free their children, and made sure they knew their own family history, a story that included an African woman and a half-African grandmother, an English sea captain, the lawyer, John Wayles, and the president of the United States. That history survived, despite generations of denial, denigration, and disappearance, a legacy only recently penetrated by historians seeking to know Jefferson not simply as he and his daughters would have him known, but as he was. SALLY HEMINGS, PATSY Randolph, and Polly Eppes were all pregnant in 1799. Experience had taught Thomas Jefferson a great deal about the dangers of childbearing. As reticent as Jefferson was about Sally's situation, he was, by contrast, volubly interested in his daughters' pregnancies and births. Patsy Randolph followed in the footsteps of her Randolph grandmother and great-grandmother, and proved herself a sturdy breeder and bearer of children. By the time Jefferson was elected president, she had borne five children, only one of whom had died. She would birth seven more, all of whom lived to adulthood. Though we do not know how Sally Hemings experienced labor and childbirth, we do know that she survived at least six and probably seven such episodes, and lived into her sixties. She was reportedly "doing well" after the birth of her daughter, despite the fact that there was sickness throughout the region at the time.

It is not clear what sort of illness swept through Albemarle County in the winter of 1799, but the malady came to Monticello with force. Sally Hemings's baby might have been a victim of the epidemic that felled enslaved people who had formed the core of Jefferson's household for most of his life. Jupiter, who had served Jefferson since childhood, who tended his horses and served as watchman when Jefferson was gone; "Great George" Granger, the plantation's only enslaved overseer; and Ursula Granger, George's wife, who reigned in the washhouse and smokehouse; along with their son George, who had been ill since 1798, were all so desperate for a cure that they turned to a "Negro conjuror" from Buckingham County. Jupiter, and perhaps all four, died horribly—vomiting and convulsing for hours, gasping for breath and sometimes lingering in that state after taking a dose that the man had said would "kill or cure." Ursula, in fact, held on in suffering for months, long after the black doctor had fled following Jupiter's death. According to Tom Randolph, the man's "poisons" had been responsible for "numerous [deaths] in this part of the country." Patsy thought the culprit should be brought back and tried for multiple murders.

Under the circumstances, it may have been better that Polly Eppes did not heed her father's urgings and go to Monticello to have her baby. Childbirth, rarely a picnic, remained a life-threatening ordeal for any Virginia mother at the turn of the nineteenth century. There was little in the way of sanitation, but much practice of "heroic" medicine, a system of treatment that relied on near-toxic doses of purgatives and "physicks" intended to cure in the same way that the "Negroe conjuror" had recommended, by almost killing the patient. Martha Jefferson Randolph managed to survive her many pregnancies and deliveries mostly by having the good luck not to need too much doctoring. But for her fragile sister, childbirth and its aftermath proved torturous. While Monticello reeled under the loss of Jupiter and George Granger, Ursula lay prostrate, and Sally buried her daughter in an unknown grave, Polly was in Chesterfield County awaiting the birth of her first child.

Jefferson still hoped that he could induce Polly and Jack to settle at his Pantops quarter. The irritable and whip-happy William Page, now overseer for Jack Eppes at Pantops, had a crew clearing land for tobacco fields there. Polly insisted to her father that she hoped they could find a way to move to Pantops, "& we shall then always be one of the first to welcome your arrival." But the Eppeses now had a house of their own, "Mont Blanco," on the Eppes family's ancestral Bermuda Hundred plantation. Jefferson continued to push them to visit. "Promises must not be forgotten," he insisted. When the time came for Polly's confinement, they did go home: not to Monticello, but to Eppington.

288 🎽 THE WOMEN JEFFERSON LOVED

Maria Jefferson Eppes bore a daughter in January 1800. Her father was in Philadelphia, presiding over the Senate and getting ready to stand for the presidency. When Jack Eppes wrote to let Jefferson know that "Maria was become a mother & was well," her father received the letter with "purest joy, my anxiety on that subject having been as great as yours." But within days, the baby died. Patsy wrote the sad news in the same letter in which she informed him of the death of Jupiter and Ursula's terminal illness, both Georges having already succumbed. Polly, meanwhile, suffered a ghastly infection that caused such severe abscesses in her breasts that they "broke" in multiple places. "I have not heard from her since," Jefferson wrote to Patsy; "there is abundant cause of deep concern in this."

Thomas Jefferson, who was intimately familiar with the feeling of losing a child, and worrying about a seriously ill mother, wrote to express his sympathy and offer his advice on how to deal with the loss: "I know that time and silence are the only medecines." But far from remaining silent in the face of her affliction, he opened his heart in a frank, expressive, almost effusive effort to heal his frail younger daughter with words, to erase any past tension or conflict between them, and to deal with his own empathetic terror:

Mr. Eppes's last letter informed me how much you had suffered from your breasts: but that they had then suppurated, & the inflammation and consequent fever abated. I am anxious to hear again from you, and hope the next letter will announce your reestablishment. it is necessary for my tranquility that I should hear from you often: for I feel inexpressibly whatever affects either your health or your happiness. my attachments to the world and whatever it can offer are daily wearing off, but you are one of the links which hold to my existence, and can only break off with that. you have never by a word or deed given me one moment's uneasiness; on the contrary I have felt perpetual gratitude to heaven for having given me, in you, a source of so much pure and unmixed happiness.

At that moment, Thomas Jefferson was heading into the fight of his political life, the campaign for the presidency and the protracted contest for the electoral vote in the election of 1800. He was also telling Patsy that "politics are such a torment that I would advise every one I love not to mix with them." He likewise insisted that the only place he could find true peace and contentment was at home with his family, ironically in the very season when his household had been ripped to pieces by the deaths of Jupiter and the Grangers, Jupiter's passing in particular "leaving a void in my domestic arrangements which cannot be filled." He spoke of domestic tranquility in the wake of the death of his and Sally's daughter, in the awful aftermath of Polly's labor, when her baby lay dead and she herself was in excruciating pain and mortal danger. For all his acute sensitivity to the contentiousness of public life, he could hardly bring himself to face the perils and agonies of private life.

Patsy, however, knew that the only way to conquer private dangers was to confront them directly. The moment they learned of Polly's predicament, Tom and Patsy Randolph determined to go to her side. Leaving little Jeff behind, they packed up nine-year-old Anne, the two-year-old daughter they had named Ellen, after their lost child, and baby Cornelia, and set out for Eppington. In the wake of a blizzard that had left fifteen inches of snow on the ground at Edgehill, it took them three days of "fatigue & some danger & suffering" before they reached Eppington. There, Tom said, "We found Maria much worse than we expected; still confined to her bed, greatly reduced in flesh and strength and suffering extremely from inflammation and suppuration of her breasts." The Eppes family doctor, Jefferson's

290 🏋 THE WOMEN JEFFERSON LOVED

cousin Philip Turpin, had been with her for days, dosing her heavily with castor oil and other "little medicines," hoping to reduce her infection by inducing vomiting and diarrhea. Jefferson was skeptical of "the system of physicking," believing that "for every good effect it can produce, I am sure two bad ones will result." The Randolphs shared his view; they were appalled at what Polly had endured. When they tried to convince the Eppeses to dismiss the doctor and cease the treatment, they met fierce resistance.

But they had more success convincing Polly that she had to stop taking Turpin's purgatives and focus on recovering her strength. Polly's infection proved stubborn enough to keep her in bed and in pain for another month, and Jack Eppes worried that "the sores on her breast have proved most obstinate & will not I fear be easily healed without the aid of the knife to which she feels as is natural a great repugnance." But Patsy remained at her sister's side, and the Randolphs' intervention likely saved Polly's life.

Scandal

23

WHILE POLLY JEFFERSON Eppes lost her child and fought for her life, her father launched his run for the presidency. In that fierce campaign of 1800, he had more and more trouble maintaining the cherished wall of separation between his home and his politics. Virginia was a hotbed of partisan animosity. Some of his own relatives embraced the Federalist cause and turned against him for reasons sometimes real and sometimes spitefully imagined. Old hatreds festered. As early as June 1800, William Rind wrote in his *Virginia Federalist* that he had "damning proofs" of Jefferson's "depravity," though he did not go into details. A tavern conversation in Richmond, among men with a grudge, carried the added weight of touching on the leaders of the nation.

James Callender, broke again and in and out of jail, wrote frantic letters pressuring Jefferson for money. Callender had the notion that the president would reward the service he had so enthusiastically rendered by giving him a job as Richmond postmaster. But Jefferson was growing uncomfortable with the viciousness of Callender's tirades, and he dragged his feet. Callender gulped down whiskey, listened to gossip, and read the papers, increasingly aggrieved against his former patron. "There seemed to be some special necessity in him," wrote Fawn Brodie, "to destroy not only men of eminence, but also his own benefactors." Callender would soon make it his business to collect as much information as he could about Thomas Jefferson's private life.

He did not have much trouble doing so. When Jefferson was at home, the whole world tramped to his door. Patsy complained about the "strangers which continually crowded the house when you were with us." On one visit to Monticello, "I never had the pleasure of passing one sociable moment with you. Allways in a crowd, taken from every useful and pleasing duty to be worried with a multiplicity of disagreeable ones which the entertaining of such crowds of company subjects one to in the country."

Jefferson offered sympathy. "Nobody can ever have felt so severely as myself the prostration of family society from the circumstances you mention," he wrote Patsy from Washington, where he was "surrounded by enemies & spies catching & perverting every word which falls from my lips or flows from my pen, and inventing where facts fail them." He longed for the peace and harmony of home, "where we love & are beloved by every object we see, and to have that intercourse of soft affections hushed & suppressed by the eternal presence of strangers goes very hard indeed." But he urged Patsy to be patient with the need to entertain all comers. "The present manners & usages of our country are laws we cannot repeal. . . . Consider that these visits are evidences of the general esteem which we have been all our lives trying to merit. the character of those we recieve is very different from the loungers who infest the houses of the wealthy in general." Whatever the character of his multitudinous guests, they were assuredly capable of carrying tales.

THE ELECTION OF 1800 proved a political trial by ordeal for Thomas Jefferson. Though Jefferson won the popular vote by an overwhelming margin, the electoral college vote resulted in a tie between him and his own vice presidential candidate, Aaron Burr. The matter went to the Federalist-controlled House of Representatives, where Jefferson's enemy, Alexander Hamilton, found himself lobbying on Jefferson's behalf, against Burr, whom he detested even more. Jefferson waited out the protracted battle, and finally took office in Washington, D.C., on March 4, 1801. His inauguration marked a sea change in American politics, heralding the decline of the Federalist party and the ascension of his own Democrat-Republicans.

In the midst of such a volatile and heady political moment, Jefferson was still thinking of home. He entreated his daughters to come to live with him there, but he knew that their family affairs would keep them in Virginia. They may, indeed, have resented his political ambitions; as Fawn Brodie pointed out, Patsy never wrote to congratulate him on his election.

But they had plenty to keep them busy. Sally, Patsy, and Polly were again pregnant that year, with Sally giving birth to a second Harriet in May, named after the daughter she had lost. By that time, James Callender had been snooping around Charlottesville long enough to amass ammunition to blackmail the president. Jefferson at first tried to pay him off, using James Monroe and Meriwether Lewis as gobetweens. But Callender soon confronted him directly, threatening to publish what he knew about Sally Hemings if Jefferson did not give him the postmaster's job. Jefferson was indignant that his onetime instrument made such presumptuous demands; he was confident he could meet the threat with haughty denial. "Such a misconstruction of my charities [toward Callender]," he wrote to James Madison, "put an end to them forever. . . . He knows nothing of me which I am not willing to declare to the world myself."

While Jefferson tried to deal with Callender, he gathered his family together. He managed to convince Polly and Jack Eppes that they should come to Monticello for the birth of her child, and she and her sister had their babies, Polly's son Francis and Patsy's daughter Virginia, a month apart, at their father's home that September. Thomas Jefferson had been present for the birth of at least one of his Hemings children, but now, for the first time, he was at home for the arrival of two of his grandchildren. He gladly paid the midwife, as well as settling his debt to the woman who had attended Sally the previous spring, before he left his burgeoning family to return to the capital. He arrived in Washington only days after William Rind's *Washington Federalist* printed a report that a prominent officeholder, "Mr. J," had "a number of yellow children and that he is addicted to golden affections."

James Hemings was also at Monticello that September, visiting his family and cooking for the household. Jefferson had hoped that James would come to Washington to serve as presidential chef, but he never actually asked Hemings himself, instead relying on intermediaries to carry messages. Sally may have acquiesced as Thomas Jefferson took greater and greater pains to conceal his connection to the Hemingses, but James may have been hurt by Jefferson's game playing. James wanted to go to Washington, but if he agreed to cook for Jefferson, he would be "among strange servants" and other people who might have heard the rumors about his sister. He wanted Jefferson to "send him a few lines," specifying the "conditions and wages you would please to give him in your own hand wreiting." But Jefferson never wrote.

James Hemings returned to Baltimore, where he had been living and cooking. Jefferson made a point of telling his go-between that "I would wish James to understand that it was in aquiescence to what I supposed his own wish that I did not repeat my application, after having so long rested on the expectation of having him." The trust between Thomas Jefferson and his wife's half-brother, the man who had served him from childhood, had been broken. A month later, word came to Jefferson that the talented and volatile Hemings had gone on an alcoholic binge and committed suicide.

Jefferson mourned James's death as a "tragical end." The news was a terrible blow to the family at Monticello, then in the throes of a whooping cough epidemic that threatened the lives of the Hemings, Randolph, and Eppes children. Tiny Francis Eppes coughed so violently that he was "perfectly black with it in the face" and in "a very precarious state of being . . . the most delicate creature" Patsy Randolph had ever seen. "Ellen and Cornelia were particularly ill both delirious one singing and laughing the other (Ellen) gloomy and terrified equally unconscious of the objects around them. My God what a moment for a Parent," Patsy wrote her father. As if that were not enough, Tom Randolph was once again losing his grip. "The agonies of Mr. Randolph's mind seemed to call forth every energy of mine," Patsy told him. "I had to act in the double capacity of nurse to my children and comforter to their Father."

Those trials alone were enough to strain everyone's tempers, but some further mysterious incident touched off the flames of domestic discord in that hard winter of 1801. When Polly left Jefferson's crowded, contentious, and febrile house for Eppington, she took along Critta Hemings, Sally's sister, as a nurse for her fragile son. Something had happened that fall to make Critta want to get away from Monticello. "I hope you had no objection to her spending this winter with me," Polly wrote to her father. "She was willing to leave home for a time after the fracas which happened there and is now anxious to return."

But now that Jefferson had ascended to the presidency, Monticello was no longer a protected, private place, no longer a family sanctuary. "With how much regret have I look'd back on the last two months that I was with you," Polly wrote her father; "more as I fear it will always be the case now in your summer visits to have a crowd." Much as he wanted her to come to Washington in the spring, Polly demurred. "I have been so little accustom'd to be in as much company as I should be in there to recieve the civilitys and attentions which as your daughter I should meet with and return, that I am sensible it is best for me to remain where I am."

By the summer of 1802, Virginia gossip about Thomas Jefferson and Sally Hemings metastasized into a national scandal. The Federalist *Port Folio* published a satirical ballad hinting that Jefferson had a black wife. Callender, now on the staff of the Federalist *Richmond Recorder*, was telling people that his former patron has subsidized his defamations of Hamilton, Washington, and Adams, and Callender geared up his direct attacks on Jefferson. The Republican press, in turn, went after Callender for his "apostacy, ingratitude, cowardice, lies, venality and constitutional malignancy," which only infuriated Callender further.

On September 1, 1802, he went public with his charges: "It is well known that the man, *whom it delighteth the people to honor*, keeps and for many years has kept, as his concubine, one of his slaves. Her name is SALLY." Callender charged that Sally had a son named Tom, who was "said to bear a striking though sable resemblance" to the president. He held that "by this wench Sally, our president has had several children. There is not an individual in the neighbourhood of Charlottesville who does not believe the story, and not a few who know it." He further reported that Sally Hemings had gone "to France in the same vessel with Mr. Jefferson and his two daughters. The delicacy of this arrangement must strike every portion of common sensibility. What a sublime pattern for an American ambassador to place before the eyes of two young ladies!"

The Republican *Richmond Examiner* quickly moved to denounce Callender as a liar. "That this servant woman has a child is true," wrote editor Meriwether Jones, a close friend of Jefferson, but Jefferson was not the father of that child. "Is it strange, therefore, that a servant of Mr. Jefferson's at a house where so many strangers resort, who is daily engaged in the ordinary vocations of the family, like thousands of others, should have a mulatto child? Certainly not."

Once the imaginary wall between the private and the public was demolished, it would prove as difficult to put back together as the jumbled columns of Jefferson's portico. Now the glare of political debate flooded the complicated triangulations of the Monticello household. Jefferson's daughters and their descendants would take up his defense, insisting that someone else had fathered Sally Hemings's children. But despite Republican threats of tar and feathers and horsewhipping, Callender persisted, rubbing raw the points of friction between Jefferson's daughters and their half-aunt. He grew ever more vitriolic and insulting in his portrayal of a woman who had never done a thing to court attention, who had devoted her own life to serving Thomas Jefferson and to the hope of her children's freedom. "Jefferson before the eyes of his two daughters sent to his kitchen, or perhaps to his pigstye, for this Mahogany coloured charmer." Anyone who dared question his story, Callender said, could meet him in court. He had a dozen witnesses "as to the black wench and her mulatto litter."

The Federalist press ran gleefully with the story, though no one could compete with Callender in the category of sheer invective. Some labored for a tone of objectivity, partisan as their purposes were. Their information was off the mark in some cases (at that point, as far as we know, Sally did not have a son named Tom), but much of what Jefferson's enemies published squared with what historians have now come to accept as the truth. The *Frederick-Town Herald* assured readers that "Mr. Jefferson's Sally and their children are real persons, and that the woman herself has a room to herself at Monticello in character of a semstress to the family, if not as house-keeper, that she is an industrious and orderly creature in her behaviour, but that her intimacy with her master is well known, and that on this account she is treated by the rest of his house as one much above the level of his other servants."

No one knows if Sally Hemings was "treated by the rest of his house as one much above the level of his other servants," though the Hemingses, who were blood kin to Jefferson's late wife and daughters, considered themselves as special, and were treated as such at Monticello. But the editor of the Lynchburg *Virginia Gazette* touched on Jefferson's sorest spot when he deigned to sympathize with Martha Jefferson Randolph and Maria Jefferson Eppes, and asked a pointed question. "These daughters, who should have been the principal object of his domestic concern," wrote the editor, "had the mortification to see illegitimate mulatto sisters, and brothers, enjoying the same privileges of parental affection with themselves. Alas! Mr. Jefferson . . . Why have you not married some worthy woman of your own complexion?"

Thomas Jefferson did not treat his Hemings children with "the same privileges of parental affection" accorded to Patsy and Polly. As we have seen, he followed the joys and sorrows of his daughters' lives with the closest possible attention, given his many commitments and interests. He did what he could to inspire, reassure, console, and control them. By contrast, by virtue of his own views on race, by tacit agreement with his free daughters, and according to the custom of the country, he kept his enslaved sons and daughter at an emotional distance. If he ever wrote to any of the Hemingses, those letters have not been found. His son, Madison Hemings, told an Ohio newspaper editor in 1873 that his father's "general temperament was smooth and even; he was very undemonstrative. He was uniformly kind to all about him. He was not in the habit of showing partiality or fatherly affection to us children. We were the only children of his by a slave woman. He was affectionate toward his white grandchildren, of whom he had fourteen, twelve of whom lived to manhood and womanhood."

Callender continued his attacks over the months that followed. Thomas Jefferson stayed silent. Meanwhile, the scandalmonger had enraged so many people in Virginia that it seems almost inevitable that someone would be moved to violence. On December 20, 1802, a Virginia Republican named George Hay, a onetime ally of Callender, attacked him with a walking stick, bashing in his head and smashing his fingers. Callender took Hay to court to try to recover damages and hired two lawyers to plead his case. One was William Marshall, brother of the Federalist chief justice of the United States, an enemy of Jefferson. The other was a Republican, but likewise no friend to Thomas Jefferson: James Rind, featured player in the 1790 altercation with John Garland Jefferson and Peter Carr.

Callender was once more doomed to disappointment. The Republican-dominated jury would not convict Hay in even such a brazen assault. Jefferson's onetime mouthpiece continued to attack his former benefactor, this time publishing the story of the president's long-ago overture to the wife of a friend, a lapse Jefferson would ultimately admit. But though Callender had severely damaged Jefferson's reputation, he gained nothing by his efforts. Eight months later James Callender got drunk for the final time, fell into the James River, and drowned in three feet of water.

WHILE THE PRESS fulminated and Jefferson's allies scrambled to defend him from Callender's charges, Jefferson himself never uttered a word in public in his own defense. He did, however, attempt at once to protect his daughters, and to use them as human shields. With Callender privately pressuring him for money and the Federalist press hounding him for exposing such delicate ladies to their father's iniquities, Jefferson wanted Patsy and Polly at his side, providing proof of his virtue. He pushed them to make a visit to Washington in the spring of 1802. Failing that, he hoped they would both be with him at Monticello that summer, and then return with him to Washington in the fall. When Polly explained that she could not come to Washington, or even visit Monticello in the summer because her husband needed all his horses for plowing, Jefferson offered to send a coach from Washington to pick up both of his daughters.

Now that the wall was well and truly tumbling, he urged Patsy and Polly to take a greater public role. The man who had so long insisted that women could find happiness only by confining themselves to the pleasures of their households now needed his daughters' political support. Monticello itself was no longer the refuge he had desired and designed, but was instead besieged with visitors, including perfect strangers, whenever he was at home. And much as they wanted to be with their father, his daughters hated the constant and expensive company that diverted his attention and demanded to be greeted and seated and fed and flattered.

Jefferson tried to convince Polly that her annoyance at the Monticello crowds was a sign that she had grown too accustomed to shutting herself up at Eppington and Bermuda Hundred. "I think I discover in you a willingness to withdraw from society more than is prudent," he told her. "I am convinced our own happiness requires that we should mix with the world." He spoke, he said, from his own experience in the years between 1793 and 1797, when he had "remained closely at home, saw none but those who came there, and at length became very sensible of the ill effect it had upon my own mind . . . and irresistible tendency to render me unfit for society."

Of course, during those years at Monticello, Jefferson had hardly been all by himself. He had commanded a house full of enslaved servants, directed a consuming construction project, opened his nailmaking shop. Betty Hemings and her daughters, Sally, Critta, and Betty Brown, had been on the scene, and for most of that time, until she married Jack Eppes, Polly had been there with him. Polly could not have failed to remember that in those years, Sally Hemings had conceived two children.

Polly resisted his pleas. She reported that both she and little Francis had been so sick that she'd asked "my dear mother," Elizabeth Eppes, to come to Bermuda Hundred to take care of her, and had kept Critta Hemings from returning to Monticello for the same reason. Meanwhile, there had been an outbreak of measles in Albemarle County. Jefferson still hoped Polly could be persuaded to come to Monticello when he was home, so he told her to stay away from Edgehill, where he feared Patsy's children would have the disease. So determined was he to have Polly at his house that he wrote to Patsy, then presumed to be nursing her own children through the epidemic, to ask her to go to Monticello herself, to make sure that any children on the mountain who had the measles would be isolated. "Should any one on the mountain have it they must remove," he told Patsy, and suggested that Sally Hemings and Betty Brown must take their children to stay at Elizabeth Hemings's house, a small dwelling on the Third Roundabout, several hundred yards south of the mansion. He assured Polly repeatedly that he was taking measures to remove any Hemings children who might be infected (not to mention Sally herself), and expressed his happiness that she had kept Critta with her: "At Monticello there could be nothing for her to do; so that her being with you is exactly as desireable to me as she can be useful to you." His message was clear: Polly should use the Hemingses as she wished, and he would make it easy for her to avoid them as she chose.

BOTH DAUGHTERS EVENTUALLY made their way to Monticello in the late summer, to join their father on the mountaintop where the Hemings children had, at least for a time, been tucked out of sight at Betty Hemings's cabin. Jefferson still wanted Patsy and Polly to come to Washington as soon as possible, and tried to overcome every objection they raised. He would pay for the journey, send horses and coaches, even see that they had proper wigs, which Patsy asked him to order from a Philadelphia milliner. Dolley Madison had assured them that in Washington, fashionable wigs were "universally worn and will relieve us of the necessity of dressing our own hair, a business in which neither of us are adepts." Sally Hemings may have learned something of elegant hairdressing when she had served as their maid in Paris, but she was certainly not invited to accompany them to Washington for this show of family solidarity.

Still, as much as Jefferson hoped to erase any sign of Hemingses from his life in Washington, he counted on them for his private comforts. He made a point of asking Patsy to bring Peter Hemings's recipe for muffins. "My cook here cannot succeed at all in them," he told her, "and they are a great luxury to me."

TRAVELING THE RUGGED roads of Virginia was a trial even for men alone, and Thomas Jefferson complained often about the inconvenience and danger. How much more difficult it was for two young mothers to make the journey to Washington, especially under such emotionally charged circumstances. Delay piled upon delay, and as bad winter weather approached, the hazards of the journey mounted. Both husbands had business of their own to attend to in Virginia, so the women would have to go by themselves. Polly pronounced the visit "scarcely worth making for so short a time" and said she would rather wait until spring and travel with her father, but "my sister will not agree to put it off any longer."

The steely Patsy was, as Polly suggested, utterly determined to stand by her father at this moment of crisis in his public life. She made sure that Polly did not back out, though at twenty-four, Polly seemed again the fretful child who had resisted her father's order to leave Virginia and travel to France so long ago. It did not matter how short the visit would be, Patsy said, "as this is a flying visit only to shew that we are in earnest with regard to Washington." She left all four of her daughters at home and took along only her son Jefferson, reasoning that "it is better to part with them for a time than risk such a journey with a carriage full of small children." She planned to return to the capital with her father in the spring, taking all the children along. Patsy Randolph was only twenty-nine, but she had been her father's fiercest and steadiest support for nearly two decades, from the time that he had been left a widower and she a motherless child. However much he insisted that nature had fitted men to protect and provide for women, the weaker sex, in his own life, Thomas Jefferson had learned to depend on this rock-solid female.

Jefferson's daughters made their way to Washington in November, returning to Edgehill in January "after a most disastrous journey sufficiently distressing in itself," Polly wrote to Jefferson, "but more so at the time from the depression of spirits felt on leaving you." They had spent happy hours mostly in his private sitting room but had appeared enough in public to demonstrate their unfailing devotion to their father. Both sisters had, at Jefferson's insistence, shopped for nice things in Washington, and Polly worried about the "immense" cost to her father. Neither Polly nor Patsy had experience of such indulgent spending; life on isolated plantations did not require fancy gowns or fussy accessories. Indeed, Patsy's little daughter, Virginia, left behind for a few weeks, "would not recognize her [mother] till she changed her dress for one that she remember'd from its being a calico."

Both Martha Jefferson Randolph and Maria Jefferson Eppes knew what it was to live with debt. Both their husbands had financial problems, and both women worried perpetually about money. But Thomas Jefferson turned a blind eye to his own distresses when he felt like spending. He insisted to Polly, "You did not here indulge yourselves as much as I wished, and nothing prevented my supplying your backwardness but my total ignorance in articles which might suit you." He hoped that she would return to Washington with Patsy in the spring. In any event, "Mr. Eppes's election will I am in hopes secure me your company next winter."

Thomas Jefferson, who had only two years earlier declared politics "such a torment that I would advise every one I love not to mix with them," had now drawn the husband of his shy and delicate daughter into that pit of public misery. While he blithely urged Polly to join them in the whirlpool of intrigue and malice, she had fought his entreaties before and she had no desire to submit in this case. Neither did Patsy return in the spring of 1803. She was pregnant once again, and Polly would shortly follow suit.

Tom Randolph also went to Congress, in the fall of 1803, and both sons-in-law lived with Jefferson at the White House. Polly moved to Edgehill to spend the winter with her sister. Whatever sibling rivalry had existed between them, they shared the loss of their mother, the common experience of bearing and rearing children of their own, the odd predicament of growing up with blood relations who were also their slaves, and the unique experience of being Thomas Jefferson's daughters. Together they defended the reputation of their beloved father against charges of racial mixing, charges they both knew to be true, and moreover, to be a family tradition. They had grown closer over the years. On November 2, 1803, Patsy bore her seventh child, a daughter she named Mary Jefferson Randolph, after Polly.

Just as their relationship with each other changed over the years, their feelings about Sally Hemings doubtless altered; no doubt Sally's feelings changed, too. As the three grew from girls into women, the tangled private bonds of race and enslavement, affection and possession, turned into national scandal, bringing denial and deception. The public controversy surely strained whatever affections they bore for Sally, and she for them, after a lifetime together. All the fuss must have made life more difficult for all their kin, Eppeses and Randolphs and Carrs and Bollings and, of course, Hemingses.

Jefferson's closest friends, James Madison and James Monroe, were both intimately familiar with life at Monticello, and both had been involved in the efforts to hush up James Callender. Surely those pragmatic gentlemen must have considered the idea that it would be best for everyone if Sally Hemings were sent away. She could go to another of Jefferson's plantations, or be packed off to live with some relative, perhaps his brother Randolph or one of his Carr nephews, particularly if any of those men were, as some of Jefferson's descendants would claim, the father of Sally's children. Jefferson might even have sold Sally to some sympathetic friend. Monroe, after all, had bought her sister Thenia years earlier.

But Thomas Jefferson stood by the woman who had given up her freedom to follow him home. Sally was not sold. She was not even sent off the mountain. Even at the height of the controversy, Jefferson was unwilling to concede anything more to public opinion, or to his white daughters' embarrassment, than to ask Sally and her children to move temporarily into her mother's house, a short distance from his own, on the pretext that they might have the measles. Sally had lived at Monticello most of her life. He revealed his devotion to her when he refused to make her leave then. And he never did.

Motherhood and Mortality

24

MARY JEFFERSON EPPES had endured a long train of illnesses in her twenty-five years of life. Her third pregnancy was as troubled as her first, and she dreaded the birth. Jefferson hoped that Polly would take heart from seeing her sister come through delivery in fine shape. "Take care of yourself my dearest Maria," he wrote to her at Edgehill. "Have good spirits and know that courage is as essential to triumph in your case as in that of the souldier." But he had frightening memories of his own. He tried to make light of their fears, assuring Polly, "Some friend of your Mama's (I forget whom) used to say it was no more than a knock of the elbow." If she had a good doctor near at hand, "nothing is ever to be feared." Polly's mother had had doctors aplenty, and her widower and daughters knew from heartbreaking experience that almost anything having to do with childbirth was worth fearing.

The Randolph household at Edgehill was chaotic at the calmest of times, with six boisterous children and a husband whose intermittent presence was a mixed blessing. The addition of the anxious and grouchy Polly and her sickly son tested Patsy's temper. "I write amid the noises and confusion of six children interrupted every moment by their questions," she wrote her father in January. She was coping as best she could without help from either Tom Randolph or Jack Eppes, who remained in Washington for the congressional session. "We are *all* of us 'as well as can be expected,'" she told Jefferson. "Maria's spirits are bad, partly occasioned by her situation which precludes every thing like comfort or chearfulness, and partly from the prospect of congress not rising till April. . . . I hope we shall do as well as if Mr. Eppes was here but certainly her mind would be more at ease could he be with her." Little Francis Eppes was having "dreadful fits; I cannot help fearing them to be epileptic," Patsy wrote, although she hoped he would outgrow them. She had, however, kept her suspicions to herself, knowing that Polly would be upset if the idea that Francis was epileptic became a subject of hurtful rumor.

Thomas Jefferson was determined to cheer up his daughters, despite his own worries. He hoped Congress would adjourn in time for Jack Eppes to "be with Maria at the knock of an elbow," and hoped that she too would "keep up her spirits." As for Francis's fits, "there is little doubt but he will out-grow them; as I have scarcely ever known an instance to the contrary, at his age." In Washington, Jefferson was enjoying the celebration of the Louisiana Purchase and happy not to have to deal socially with the haughty English ambassador, Anthony Merry, and his snobbish wife. "As much as I wished to have yourself and your sister with me," he told Patsy, "I rejoice you were not here." He was afraid; they all were. Polly must find a way to be brave: "Pour into the bosom of my dear Maria all the comfort and courage which the affections of my heart can give her, and tell her to rise superior to all fear for all our sakes."

Polly desperately wanted her husband home for the birth, and wished that her father might even manage to come to Virginia in time. Jefferson, who had, after all, a country to run, was sympathetic but realistic. "Let us all see that you have within yourself the resources of a courage, not requiring the presence of any body," he urged his younger daughter. But Polly continued depressed and weak. In a letter to her father on February 10, 1804, she avowed that the only thing that could cheer her up was the hope "of soon seeing you and Mr. Eppes." Five days later, Polly went into labor. Her daughter, Maria Jefferson Eppes, was born at Edgehill. The birth left the mother weak and feverish, and infection set in.

Patsy's daughter Ellen remembered the days that followed. Ellen was at the time only eight years old, but brilliantly precocious for her age, and childhood memories are often more sharply engraved than recollections softened and shaded by age and experience. She recalled her "poor aunt's pale faded, and feeble look," and the way that her own mother had slept in her aunt Maria's room and tended to her every need. Jack Eppes hastened to Edgehill as soon as he could, and Thomas Jefferson finally arrived at the beginning of April to find his younger daughter in mortal decline. He insisted on taking her to Monticello, borne in a litter by enslaved men who carried her the four miles from Edgehill, up the mountain. Little Ellen Randolph joined a poignant, almost macabre procession, as her aunt was "carried around the lawn in a carriage, I think drawn by men, and I remember following the carriage over the smooth green turf."

Mary Jefferson Eppes drew her last hard breath on April 17, 1804. She was twenty-seven years old. "This morning between 8. & 9. aclock my dear daughter Maria Eppes died," wrote Jefferson in his memorandum book. The deathbed scene recalled Martha Jefferson's last moments. Thomas Jefferson was likely by Polly's side, along with her husband, John Wayles Eppes, her sister, Martha Jefferson Randolph, and the Hemings women. Elizabeth Wayles Eppes, Polly's beloved "mother," would be there soon, if not in time. The other children were close at hand.

Thomas Jefferson had now outlived his wife and all of their children, save one. He asked to be left alone for several hours. His sole surviving daughter by Martha said that when she went to look for him, she found him with his Bible in his hands. Meanwhile, someone—presumably Patsy Randolph, with likely assistance from one or more of the Hemings women—had prepared the body. By the time little Ellen was taken to the death chamber, Polly Eppes had been covered with a white cloth, strewn with "a profusion of flowers."

Ordinarily, by that time of the year, the jonquils and hyacinths would have already bloomed, and the tulips and irises might be opening. But the weather had been wet and bleak. "This has been a remarkeably backward spring," Thomas Jefferson wrote in his Garden Book. Monticello lay swamped, under a pall that chilled the bones and drenched the soul.

MARY JEFFERSON EPPES was buried at Monticello. Once again Elizabeth Wayles Eppes carried a motherless baby home to Eppington. She was accompanied this time by Francis Eppes and Patsy's oldest daughter, thirteen-year-old Anne Cary Randolph. Letters of condolence poured in. Even Abigail Adams, who admitted to Jefferson, "It has been some time since I conceived that any event in this life could call forth feelings of mutual sympathy," had found that "the powerful feelings of my heart burst through the restraint, and called upon me to shed the tear of sorrow over the departed remains of your beloved and deserving daughter-an event which I most sincerely mourn." Adams had waxed furious as Callender, Jefferson's hatchet man, had savaged her husband. Then she had watched as Callender lashed out at his patron with the story of Sally Hemings. She could not help reminding Jefferson of the "attachment which I formed for [Polly] when you committed her to my care upon her arrival in a foreign land, under circumstances peculiarly interesting." But she was not writing to taunt him about the peculiar circumstance of Sally Hemings. She had read an account of Polly's death in the newspaper and found herself remembering "the tender scene of her separation from me, when, with the strongest sensibility, she clung around my neck, and wet my bosom with her tears, saying, 'Oh now I have learned to love you, why will they take me from you?'"

Thomas Jefferson once more reeled with grief. It took him two months to reply to a letter from his old friend, John Page. When he did, he echoed the tortured words he had written to Elizabeth Eppes twenty-two years earlier. "Others may lose of their abundance," he wrote, "but I, of my want, have lost even the half of all I had. My evening prospects now hang on the slender thread of a single life. Perhaps I may be destined to see even this last cord of parental affection broken! The hope with which I had looked forward to the moment when, resigning public cares to younger hands, I was to retire to that domestic comfort from which the last great step is to be taken, is fearfully blighted."

Now his mind traveled back to the moment when he'd lost Martha, the casualty not only of his private desire, but of the revolution he had wanted and made, the war that had invaded her house and uprooted her family. A time when Martha Jefferson fled with her children, from Williamsburg to Richmond, from Monticello to Poplar Forest, when Cornwallis's men stomped through her house at Elk Hill, when they slashed the throats of the colts in the fields. "When you and I look back on the country over which we have passed," he wrote to Page, "what a field of slaughter does it exhibit! Where are all the friends who entered it with us, under all the inspiring energies of health and hope? As if pursued by the havoc of war, they are strewn by the way, some earlier, some later, and scarce a few stragglers remain to count the numbers fallen, and to mark yet, by their own fall, the last footsteps of their party." As he had after Martha's death, he contemplated, even longed for, his own. "We have, however, the traveller's consolation. Every step shortens the distance we have to go; the end of our

journey is in sight—the bed wherein we are to rest, and to rise in the midst of the friends we have lost!"

For all his pain, Thomas Jefferson was the president of the United States. Eventually he had to go back to work. He had spent the best years of his life in politics, and now, at sixty-one and feeling the ravages of age, the weight of his office seemed nearly insupportable. Jefferson was an ambitious politician, sometimes a ruthless partisan, capable of ferocious focus and Machiavellian manipulation in the service of his ideological and institutional goals. He did not profit from office—quite the contrary—and the time he spent in office kept him from the home life he idealized, the women and children he loved.

But he insisted throughout his life that he had not entered politics because of a desire for fame, but precisely in order to preserve the sanctity and liberty of his private world, the place where he really lived, where he found the source of all true happiness. In 1801, as he had sat in frustration, waiting for the electoral college to decide his election to the presidency, he had written to Polly to reassure her that she was as important to him as Patsy was, and to explain his motives for spending so much of his life away from them:

The scene passing here makes me pant to be away from it: to fly from the circle of cabal, intrigue and hatred, to one where all is love and peace. tho' I never doubted of your affections, my dear, yet the expressions of them in your letter give me ineffable pleasure. no, never imagine that there can be a difference with me between yourself & your sister. you have both such dispositions as engross my whole love, and each so entirely that there can be no greater degree of it than each possesses. whatever absences I may be led into for a while, I look for happiness to the moment when we can all be settled together, no more to separate. I feel no impulse from personal ambition to the office now proposed

312 🧏 THE WOMEN JEFFERSON LOVED

to me, but on account of yourself & your sister, and those dear to you. I feel a sincere wish indeed to see our government brought back to it's republican principles, to see that kind of government firmly fixed; to which my whole life has been devoted. I hope we shall now see it so established, as that when I retire, it may be under full security that we are to continue free and happy.

For Thomas Jefferson, private happiness was the source of all that was good, and good government was the instrument that could ensure private happiness. But the peaceful, harmonious, private sphere he envisioned was a chimera. Life at Monticello was not peaceful and not harmonious. It was not even private.

Part V

A HOUSE DIVIDED

Domestic Diversification

25

IN THAT COLD, wet, disastrous spring of 1804, Martha Jefferson Randolph returned home to Edgehill to cope with her sorrows as best she could. Patsy Randolph was a strong woman. She would do her duty, tend her husband and children. But her sister's death left her desperately clinging to her bond with her father, who was making his muddy and miserable way to Washington. "I do not hesitate to declare if my other duties could possibly interfere with my devotion to you I should not feel a scruple in sacrificing them," she wrote to Jefferson, "to a sentiment which has literally 'grown with my growth and strengthened with my strength. and which no subsequent attachment has in the smallest degree weakened. It is truly the happiness of my life to think that I can dedicate the remainder of it to promote yours.[']"

At the age of thirty-one, Patsy had spent her life trying to make Thomas Jefferson happy, striving to live up to his image of the ideal American girl, woman, wife, and mother. She had studied the classics and practiced the harpsichord, written endless letters and married a man her father approved. She had come of age in a convent school in a foreign country, had worked to master the disciplines and arts of plantation housekeeping, a job she never learned to love. Patsy earned her father's esteem by seeming to have no trouble with childbirth, raising and educating a burgeoning passel of children, and most of all, by being devoted to him.

She had also labored to master herself. From the age of ten, when her mother died, Patsy had put aside her own grief and supported her father when he faltered. In the wake of another grisly death, of the loss of her only sister and beloved rival for their father's affection, she steeled herself to hold him up once again. Whatever it cost her, she would be as cheerful and stalwart and competent as he had raised her to be.

But losing Polly shook Patsy to the core. "We are as usual well here," she assured her father, and then proceeded to demonstrate that she was anything but well. "I have myself had an attack of something like the cramp in the stomach," she admitted, offering appalling details. "The spasms were violent and came on with a desire to puke which however produced nothing more than an insuperable distension of the breast at the moment and a difficulty of breathing amounting allmost to suffocation." Her speech had been affected, and for hours she had been unable to sit or lie down. She insisted that she had merely made the mistake of "eating radishes and milk at the same meal," though Tom Randolph "affirmed it to have been hysterics."

Patsy had a history of digestive disorders, some episodes so disabling that she could not attend "even to my common domestic affairs." She met them by putting herself on a diet, giving up "meat milk coffee and a large proportion of the vegetable tribe." But this time she was sure that the severity of her symptoms "proves it to have been some thing more serious than mere hysterics," and she worried that another such attack "may not be as easily checked the second time." She acknowledged that "I was much alarmed my self."

Patsy might have been poisoned by bad radishes or spoiled milk, but she was also suffering from what we would now call post-traumatic stress disorder. These days we would treat her condition with the respect it deserves. But in Patsy's time, "mere hysterics" were a sign of feminine weakness, a luxury for delicate females like her sister, not formidable women like herself. She tried to keep her father from worrying, but having lost Polly, he was terrified that something would happen to Patsy. The more she tried to hide things from him, the more anxious he grew. "In endeavoring to spare my feelings on your real situation it gives me the pain of fearing every thing imaginable," he told her, "even that the statement of your recovery may not be exact." He implored, "Let me pray you always to give me the rigorous state of things that I may be sure I know the worst."

As he had before, Thomas Jefferson felt the agonizing tension between the claims of public duty and beloved family: "Had not Congress been sitting, I would have seen you as soon as my horses could have carried me." But even as he lavished her with tender concern and sympathy, he reminded her of her responsibilities. "Consider my dear Martha to what degree, and how many persons have the happiness of their lives depending on you, and consider it as a duty to take every care of yourself that you would think of for the dearest of those about you." He knew, of course, that she counted him first among that number.

As the months went by, Patsy suffered recurring bouts of disabling illness. She finally admitted that "having what I never in my life had before (an hysteric fit) thought my self dying whilst in it." She insisted, once again, that she was on the mend, and avowed that what she needed was exercise. Her father and her doctor heartily agreed, and she took to "riding out" on horseback in good weather, as often as she could find the time. Thomas Jefferson's daughter wanted to be like her father. She would learn to deal with emotional trauma by getting on a horse and riding away. SALLY HEMINGS, FOR her part, had spent much of her life with Polly Jefferson Eppes, the woman she had served and adventured with in girlhood: her niece, her mistress, her master's and lover's daughter. Whatever Sally felt or thought, Thomas Jefferson depended on her willingness to see to his needs. She had stood at Martha's deathbed, and now at Polly's. She had witnessed the ferocity and the helplessness of Jefferson's grief. Patsy had to go back to Edgehill soon after the tragedy, but Sally remained at Monticello to mourn with him. In his "Head and Heart" letter to Maria Cosway, Jefferson had described such a moment of affliction and had written, "When Heaven has taken from us some object of our love, how sweet is it to have a bosom whereon to recline our heads, and into which we may pour the torrent of our tears." Within a month of Polly's death, Sally conceived a child, her sixth, a son born in January 1805. She named him James Madison Hemings. He joined his older brother, Beverly, and sister, Harriet.

IN THE FALL of 1805, pregnant with her eighth child, Patsy took the unprecedented and never to be repeated step of going to Washington for her confinement. She insisted on going with her children to spend the winter with her father, even though she was leaving "at a time when it is so little convenient to Mr. Randolph." Having visited the capital once before, she knew that she would need expensive things to make herself presentable—a fashionable wig and combs, a "bonnet shawl and white lace veil, for paying morning visits"—not to mention paying the cost of travel and of boarding herself and her children. Tom Randolph, then serving in Congress and living at the White House himself, was having serious money troubles, and Patsy hated to saddle her father with her expenses.

Despite his mounting worries about his own financial difficulties, Jefferson pronounced himself glad to pay whatever was needed. Polly's ordeal had traumatized them both, and for the first time Patsy admitted that she was truly terrified of having her baby in Virginia. "My courage shrinks from the horrors of a trial so severe under the most favorable circumstances but rendered infinitely more so in this instance from the uncertainty of my accustomed medical aid and the want of a female friend," she told her father. Delivering a baby, she knew all too well, was no knock on the elbow. It was a matter of life and death.

Patsy gave birth to her child, a boy, in the White House. She gave her second son the same name Sally Hemings had given her child— Patsy's half-brother—a year before: James Madison. Her choice of name hinted at unspoken jealousy of Sally Hemings, but it also reflected Patsy's claim to her place as Thomas Jefferson's sole legitimate heir. She meant to bequeath her children a sense of their individual importance through their names.

The Randolph children's names testified to their parents' ambivalence about the burdens of their tangled family ties. Virginia families relentlessly named children after relatives, so much so that the only way to keep utter confusion at bay was to identify people either by nickname, or by place of residence. Patsy herself had been named after her mother and grandmother and Thomas Jefferson's sister, Martha Carr. Thomas Mann Randolph, Jr., not only bore the weight of sharing his father's name, but would also suffer the crushing indignity of seeing his father marry a second wife and bestow upon his much younger half-brother both his own name and most of his inheritance.

Patsy and Tom had asked Jefferson to name his first grandchild, and he had suggested "Anne" as a name often used on both sides of the family. They called their first son after Thomas Jefferson, and one daughter Mary, after Polly. All their other sons would be named in honor of Jefferson's distinguished friends: James Madison (born in 1805), Benjamin Franklin (1808), Meriwether Lewis (1810), and George Wythe (1818). But for their daughters, the Randolphs chose none of the family's usual names, Jane and Elizabeth and, of course, Martha. Instead, they made romantic choices: Ellen (born in 1796), Cornelia (1799), Virginia (1801). It seems they were so determined to avoid using a family name that when their seventh daughter was born, in 1814, they called her Septimia. Then again, Septimia, known as Tim, was the sixth of their living daughters, seventh only if one counted the first Ellen, the child who had died while Thomas Randolph shuttled restlessly from one water resort to another in search of a cure for his crippling depression. By the time Septimia was born, Martha Jefferson Randolph and Thomas Mann Randolph were living apart. The name Septimia was a reproachful reminder to the husband who blamed himself for the loss of the infant daughter whose tiny coffin had gone home to Monticello, borne in the arms of James Hemings.

MADISON HEMINGS WAS the first of Sally's children born after the Callender scandal. Jefferson had weathered that episode to be reelected handily. He had learned that whatever he did or said, in politics he could not avoid malice, slander, or the public's endless appetite for spicy secrets. His enemies had penetrated his personal life, but by gathering his family around him and refusing to acknowledge the rumors, he believed he had preserved his privacy. As Madison Hemings recalled, his father, Thomas Jefferson, "hardly ever allowed himself to be made unhappy any great length of time." He would do as he pleased, and meet attacks with silence, and when necessary, tolerant smiles.

Sally Hemings would bear Thomas Jefferson yet one more child. In May 1808, at the age of thirty-five, she gave birth to Thomas Eston Hemings, the son whose paternity has been genetically linked to a Jefferson male. Jefferson was sixty-five years old when Eston was born, but Sally was only thirty-five, assuredly still young enough to bear more children. She did not. In 1809, Patsy Randolph and her children moved to Monticello, a fact that would not have made any difference in Sally's childbearing had anyone but Thomas Jefferson been the father of her children. The permanent presence of his disapproving and possessive daughter may have put a damper on relations between Jefferson and his concubine. Or perhaps she had medical or emotional issues of her own.

Sally's life too was changing. In 1807, Elizabeth Hemings died. This founding mother had come to Jefferson's mountaintop with Martha Jefferson and six of John Wayles's other sons and daughters more than thirty years before. Betty Hemings raised her children and grandchildren to educate themselves as best they could, to learn skills, and to dream of freedom. That dream came true for at least four of her five sons, perhaps all of them, and many of her grandchildren. She also bequeathed her daughters the example of a woman making the best of her situation by seeking an alliance with a powerful man. Her oldest daughter, Mary, and her youngest, Sally, followed in her footsteps.

When she was gone, the Hemings family, and indeed, all of Monticello, had lost a matriarch. Even though Sally Hemings emulated her mother in her most important life choices, she was now nobody's daughter and left to set her own course. It was she who must set the example for the children; she who must teach them to dream free. If age had dulled Thomas Jefferson's sexual desire, Sally Hemings still enjoyed the protection of this possessive man. Once he had laid claim to Sally Hemings as his concubine, once she bore his children, he would expect and exact fidelity. We have no reason to believe that Sally Hemings disappointed him.

AMERICANS—FOR THAT matter, people around the world—have been fascinated by the strange relationship between Thomas Jefferson and Sally Hemings, by the allure of sex across the color and caste line. But if we are interested in complicated connections between women and men, we need look no further than Jefferson's daughter and son-inlaw. When Patsy and Tom Randolph married, they had every reason to expect happiness. They had been born to privilege, and they inhabited the same social world. There had been warmth and respect between the Randolphs in the early years of their marriage. But in every marriage, expectation collides with experience, like a runaway wheelbarrow full of fragile flower pots, jolting over a rock-strewn path. The Randolphs endured the death of a child, the demands of their immense and intense families, Tom's myriad financial and emotional problems, and the continual claims of Monticello. While Patsy took pains to pretend that motherhood was no trouble to her, the repeated assaults of pregnancy and childbirth took a toll on her body and mind. And by the time of Polly's death, Thomas Mann Randolph knew that he could never best his father-in-law in the contest for his wife's affections.

Randolph alternately raged and despaired at the burden of living in Thomas Jefferson's shadow. He was a touchy man in any case, but competing with Jefferson inflamed an already volatile temperament. When he quarreled with his brother-in-law, Jack Eppes, while the two lived at the White House during their time in Congress, Randolph moved into a boardinghouse without telling his father-in-law, who was appalled to learn that Patsy's husband believed Jefferson favored Eppes. The tension, heaped on top of the already heavy load of public business and political intrigue, gave Jefferson one of his prolonged migraine headaches. It had a worse effect on Randolph. He developed a fever in the boardinghouse, and despite his earlier reservations about bloodletting, allowed himself to be bled repeatedly. By the time Jefferson persuaded him to move back in, Tom Randolph was so weak and feverish that Jefferson feared his son-in-law would die.

After tender nursing by Jefferson and an attentive doctor, Randolph

slowly mended. Jefferson wrote to Patsy by every post, detailing the progress of Randolph's recovery. She was much relieved as Tom Randolph passed the point of danger, but more worried about her father's health than her husband's. "I make no exception when I say the first and most important object with me will be the dear and sacred duty of nursing and chearing your old age, by every endearment of filial tenderness," she assured Jefferson. "My fancy dwells with rapture upon your image seated by your own fire side surrounded by your grand children contending for the pleasure of waiting upon you."

Thomas Mann Randolph was conspicuously absent from his wife's rapturous fantasy. Even before Jefferson's retirement, before Patsy and the children moved to Monticello, Randolph often lived apart from his wife. When they were together, they had periods of amity, but he was prone to outbursts of temper and bouts of drinking. He was sensitive to a fault, manically impulsive, quick to take offense and to leap to unwise action. During his time in Congress, he quarreled with his vicious cousin, John Randolph of Roanoke, and was near to fighting a duel when Thomas Jefferson and others talked him down. He enlisted in the War of 1812, became an officer, and marched to Canada, but resigned in 1815 after disagreeing with his commanding general. After he returned, bitter and alienated, he spent much of his time away from his family.

No one can guess at the chemistry of passion and power, duty and despair, force, silence, acquiescence, affection, and anger that simmered between Jefferson's daughter and her tormented husband. Patsy bore Thomas Mann Randolph twelve children, nearly one every other year, despite their periods of friction and separation, exasperation and deep disappointment. In 1818, at the age of forty-six, she delivered her youngest son, George Wythe Randolph, named for her father's legal mentor. The Randolphs' marriage was many things. But it was not a haven of domestic tranquility. *

*

NO ONE WHO reads Jefferson's correspondence with his grandchildren could doubt that Thomas Jefferson was a doting grandfather. They adored him in return. Patsy raised her children to compete for Jefferson's attention and affection. She devoted "every moment that I could command" to their education, and fretted when they did not make the progress she thought they should. Patsy Jefferson Randolph was a woman of prodigious intellectual gifts, in her time one of the best-educated women in the United States. She was a disciplined and demanding teacher, and her children too often frustrated her expectations. "My 2 eldest are uncommonly backward in every thing much more so than many others, who have not had half the pains taken with them," she complained to her father in 1801. Anne and young Thomas Jefferson Randolph gave her "serious anxiety with regard to their intellect," and Anne in particular "appears to me to learn absolutely without profit." Patsy was relieved, however, that "Ellen is wonderfully apt. I shall have no trouble with her." Ellen, at that time only five years old, was already emerging as Jefferson's pet, his little "Elleanoroon," and already competing with Cornelia, age two, for her grandfather's favor. "Ellen counts the weeks and continues storing up complaints against Cornelia whom she is perpetually threatening with your displeasure," Patsy noted, wryly. "Long is the list of misdemeanors which is to be communicated to you, amongst which the stealing of 2 potatoes carefully preserved 2 whole days for you but at last stolen by Cornelia forms a weighty article."

Instead of measuring all the children by one standard, Thomas Jefferson valued each grandchild for her or his particular gifts. He eagerly encouraged them as they revealed their individual aptitudes and fascinations. He tried to reassure Patsy that her eldest children, if not as bright as precocious Ellen, had their virtues. He thought Anne "apt, intelligent, good humored and of soft and affectionate dispositions and that she will make a pleasant, amiable, and respectable woman." He believed his namesake grandson had a good disposition, but declined to fret about whether the boy had much intellect: "It is not every heavy-seeming boy which makes a man of judgment, but I never yet saw a man of judgment who had not been a heavy seeming boy, nor knew a boy of what are called sprightly parts become a man of judgment." He insisted that "I set much less store by talents than good dispositions; and shall be perfectly happy to see Jefferson a good man, industrious farmer, and kind and beloved among all his neighbors."

Heavy-seeming or otherwise, Jefferson Randolph and his brothers went off from their mother's parlor classroom to study with tutors, and if they desired, to go to college. The girls learned their lessons at home and continued to study as it suited them. Patsy instructed her daughters in reading and writing, classics and languages, and music and the arts.

Educated as they were, both their mother and grandfather expected the Randolph girls to take up housekeeping as their vocation. Thomas Jefferson sent his granddaughters chickens to raise and plants to nurture. By 1805, fourteen-year-old Anne began to take on some of the household management at Monticello, documenting her work in a particularly poignant way. On the family's annual summer visit to the mountain, Anne came across Martha Wayles Skelton Jefferson's household account book. Taking up this memento of the grandmother she had never known, Anne began to keep track of her own housekeeping, beginning with the entry "paid John Hemmings in full discharge of every thing due." Like Martha Jefferson, Anne traded with Monticello slaves for chickens and eggs, fruits and vegetables. The Hemings family appeared frequently in her transactions. Betty Hemings, Sally's sisters Nance and Critta, and her brothers Peter and John, sold Anne chickens and eggs. Eight-year-old Beverly Hemings picked and sold Anne Randolph three quarts of strawberries one June day in 1806. But

326 🎽 THE WOMEN JEFFERSON LOVED

Sally Hemings's name was absent from these accounts, which covered the years between the births of Madison and Eston Hemings, who were, like their brother Beverly, Anne Randolph's half-uncles.

Patsy was correct in thinking that her oldest daughter would never be a scholar. But Thomas Jefferson was equally right in believing that there was more to Anne than her mother credited. Anne Randolph was a gentle girl who shared her grandfather's passion for gardening. When she was only eleven, he wrote to her requesting a report on frost damage to his gardens and orchards, and asked her to ride over to Monticello from Edgehill to check on his peas and figs. By the summer of 1807, Jefferson was treating Anne as his Monticello gardening apprentice, asking her to report on "the state of our joint concerns there." He sent her seeds, plants, and roots. She in turn sent detailed accounts of which of his flowers and fruits and vegetables thrived and which died, and saved seeds. Anne developed a wide knowledge especially of flowers, enumerating the varied fates of his tuberoses and amaryllis, lilies and lobelia, anemonies and ranunculi, a flowering pea from the Arkansas River sent by Meriwether Lewis, and a plant commonly called twinleaf but known to Anne as Jeffersonia.

Of course, when Anne (or for that matter, her grandfather) spoke of gardening, they had no intention of wielding shovels themselves. "The tulips and Hyacinths," she told Jefferson, "I had planted before I left Monticello." The person who did the planting was almost surely Wormley Hughes, the Hemings cousin who served as Jefferson's master gardener, and also succeeded Jupiter in caring for and driving the master's horses. Wormley Hughes would one day dig Thomas Jefferson's grave.

JUST AS JEFFERSON imparted his love of gardening to his eldest grandchild, he shared his ardor for reading and writing with his second granddaughter, Ellen Wayles Randolph. By the time she had reached the age of five, Ellen had taught herself to read "by continually spelling out lines and putting them together and then reading them to who ever would listen to her." She clamored to learn to write as well, and Jefferson rewarded her enthusiasm by sending her a letter as soon as he knew she could read. He began by teasing her about her aversion to getting up early, telling her "I will catch you in bed on Sunday or Monday morning," a theme that soon became a comic refrain in their correspondence. Ellen would prove that anyone who wanted to get the better of her had best get up early in the morning, indeed. When Jefferson sent Ellen's ten-year-old brother, Jefferson Randolph, a French grammar, six-year-old Ellen demanded to learn French.

By that time, Patsy had reached the conclusion that even if others of her children were "blockheads," Ellen had inherited no small part of her grandfather's genius. Surviving childhood in the Randolph household was not easy. Ellen seemed to suffer even more than the others, catching everything from "eruptions" to whooping cough. But she endeared herself ever more to her mother with her zeal for reading. In the grip of a potentially lethal attack of dysentery, Patsy reported, Ellen "became thro the day delirious but employing every lucid interval in reading. Judge of my feelings My Dearest Father," wrote Patsy, "when hanging over her in agonies indescribable to have some question of natural history which she was reading at the time addressed to me by the little sufferer the activity of whose mind even the most acute bodily pain was never capable of subduing."

While he was president, Jefferson corresponded with his grandchildren, sending them books and bits of "newspaper poetry" for the literary scrapbooks he encouraged them to keep. Both Anne and Jefferson Randolph learned to read and translate Latin, and young Jefferson liked to read history and geography. They wrote to their grandfather with pride in their accomplishments. Ellen, though, soon outpaced her older siblings by writing to him frequently and at length. By the age of nine, Ellen was engaging Jefferson in intellectual discussions. When she asked him to name the "seventh fine art," since she and her mother could only recall six ("Painting, Sculpture, architecture, Music, Poetry, Oratory"), he responded with a disquisition on the history of the concept of the fine arts, and, citing Lord Kames, made the case for including gardening ("Not horticulture, but the art of embellishing grounds by fancy"). He sent her a pair of bantam chickens, proposing "a question of natural history for your enquiry: that is whether this is the Gallina Adrianica, or Adria, the Adsatick cock of Aristotle? For this you must examine Buffon, etc." Ten-yearold Ellen replied that she had begun reading Greek history, doing multiplication, reading in French, and copying "the historical part of Lord Chesterfield's letters for a lesson in writing." At night, she said, she sewed while her sister Anne read aloud to the family. But she had not forgotten the matter of the chickens. Relishing an intellectual joust with her famous grandfather, the little girl added a postscript: "Mama says Buffon cannot answer the question you propose to me."

Jefferson could not answer Ellen's letters as fast as she wrote them, and pleaded for her patience, since "the tide of business, like that of the ocean, will wait for nobody." She conceded that he surely had more to do than she did, and amused him with the kind of "small stuff" from home that he craved in Washington. Ellen Randolph surprised, impressed, and delighted Thomas Jefferson. But if she was Jefferson's intellectual heir, she must play the role not of the man of genius, but of the accomplished woman. Her grandfather reminded her that however learned she hoped to be, she was destined for housekeeping. Jefferson urged Ellen to turn from the contemplation of higher things to "descend to the more useful region and occupations of the good housewife, one of whom is worth more than the whole family of the muses."

At one point Jefferson suggested to Ellen that she use her natural

history books not to master a world of taxonomies and possibilities, but instead to learn about the four varieties of sheep he had recently acquired. For three of the varieties, he had only individuals of one sex, but thought he might interbreed them selectively and maintain pure strains, because "4. crossings are understood by naturalists to produce the true breed."

WITH THIS OFFHAND bit of interpretive animal husbandry, Jefferson raised with his small granddaughter the touchy subject of interbreeding. That likely did not resonate with Ellen Randolph at the time, but as it turned out, she would be preoccupied for the rest of her life with the problem of crossing and interbreeding. Ellen may only gradually have become aware of the tangled connections between her own family and Thomas Jefferson's shadow family, the Hemingses. But the fact that the young Randolphs and the four Hemings children, their uncles and aunt by blood, were all about the same age would suggest that they were very aware of each other. According to Virginia law, which Thomas Jefferson accepted as "our canon," the Hemingses, being less than one-quarter African, were already white people, just like Ellen Randolph herself.

Three of his four Hemings children claimed that white identity, two of them, evidently, with Thomas Jefferson's blessing. Ellen Randolph and her brother Jefferson, however, would vigorously deny the Jefferson connection to the Hemingses. They would carry on an elaborate family tradition of pretending that this shadow family virtually did not exist.

Thomas Jefferson showed them that this habit of denial was their duty, in the largest and smallest particulars. As he reminded Ellen of her responsibility to her chickens, he explained that "I rely on you for their care, as I do on Anne for the Algerine fowls, and on our arrangements at Monticello for the East Indians. These varieties are pleasant for the table and furnish an agreeable diversification in our domestic occupations." "Our arrangements at Monticello" was an oblique way to refer to enslaved people like the Hemingses, who raised chickens by the dozen, as we know from Anne Randolph's household accounts. Thomas Jefferson possessed two families who lived side by side, one enslaved and nominally black, the other entitled and putatively white. At a future date he would permit his slave children to go free, and to seek, if they chose, to cross over the racial divide, having already been "bred true." In the meantime, each in turn furnished "an agreeable diversification" in his domestic occupations.

The Pursuit of Happiness

26

FOR THOMAS JEFFERSON, the end to government service could not come soon enough. His second term as president was, in Dumas Malone's charitable estimation, "certainly not the most glorious of his public life." Others might call it something of a disaster, from Vice President Aaron Burr's alleged conspiracy to seize the lion's share of Louisiana Territory as a kingdom for himself, followed by Burr's trial for treason (he was acquitted), to the ill-conceived, ruinous embargo against Britain and France.

Nearly every letter Jefferson wrote to Patsy between 1805 and 1809 announced his weariness with public wrangling and his longing to get back home. Patsy had served as interim mistress of Monticello. Now both of them looked forward to her permanent move back to the place she had always considered her home. She would run her father's household and see to his comfort while her children diverted and revered him. He in turn would shower them all with love, inspire and instruct them, enjoy the luxury to read and think, refresh himself with wholesome country life, and generally pursue happiness. His grandchildren could hardly wait for his return. "How I long for the time that you are to come home to live and then we shall all go to Monticello to live with you," wrote Ellen, a sentiment Anne enthusiastically seconded. "It wont be long now thank God before you come home to live with us."

Even as they spoke of surrounding the returning patriarch with peace and love, they all knew that Monticello would not provide a tranquil refuge. They would have to guard jealously their moments of privacy and pleasure. The crowds had come before, but now, as they welcomed a president home, there would be hordes eager to see the Sage of Monticello, to get their morsel of the famous Jefferson hospitality, to gawk and talk and eat and drink, to trample his grounds and peer in his windows and demand his attention. No doubt some intruders hoped to get a glimpse of Sally Hemings and her children. His presidency had survived the scandal, and Thomas Jefferson might pretend that he had laid the Hemings scandal to rest, but the rumors continued to percolate. The Federalist-sympathizing Irish poet Thomas Moore had visited the White House in 1803, receiving a cool reception from the president. He took his anger and Federalist gossip about Jefferson's private life back to England, where he composed the verse that kept the story alive for decades:

> The weary statesman for repose hath fled From halls of council to his negro's shed, Where blest he woos some black Aspasia's grace, And dreams of freedom in his slave's embrace!

Monticello was no longer at the edge of civilization and far above the babble and the rabble. Every day, especially on Sunday, friends and relations, acquaintances and utter strangers would pour down the roads from every direction to pound up his roundabouts, on foot and horseback, in carts and carriages, by the dozens, by the scores.

Anticipating the problem, Jefferson once again sought agreeable

domestic diversification. Monticello had been a work in progress from the moment he had fled the smoking ruins of Shadwell to the time of his retirement from the presidency. In Europe, he had avidly studied every detail of great houses. When he returned, he had embarked on the great demolition and renovation that produced the white-columned brick Palladian masterpiece familiar to historians and tourists today. Monticello was a huge project, eventually encompassing eleven thousand square feet and forty-three rooms, including the workspaces under the house. Construction was not fully completed until 1809, when he finally returned home for good.

Toward the end of the renovation, Jefferson realized too late that in adding terraces on both sides of the house, he had made it possible for any curious person passing by to see right into his bedroom. Casting aside Palladio's insistence on symmetrical façades, Jefferson decided to add one more detail to protect his privacy. He ordered the construction of small louvered verandas, or "porticles," on either side of the greenhouse abutting his bedroom-cabinet-library suite. In these sheltered spaces he could sit outside without being seen. They also insulated his private apartments from prying eyes. If the porticles were intended to shield Sally Hemings's comings and goings from his bedroom, her family surely was not deceived; her brother John Hemings, the powerfully talented carpenter and furniture maker, built them. But at least the porticles hid Jefferson from the visiting multitudes.

Thomas Jefferson had taken a page from the noble apartments in the palaces of England and France and Italy in designing his spacious private quarters. He also followed the European pattern in turning the second floor of his house into a mezzanine, hidden from outside view, and in lighting the third floor with skylights. The majestic dome room, which gives the house its iconic profile, proved a bit of a puzzle to furnish and use. The porthole windows, designed for their pleasing aspect to outside viewers, were placed too high to see out of, and the space was too large to serve as a regular bedroom. Visitors sometimes lodged there, but most of the time it was used as a storeroom, full of extra furniture and bedding. Meanwhile, the Randolphs (and often other relatives) piled into the five second-floor and three third-floor bedrooms, along with surplus guests. Since there were often small children in residence (Patsy's children and, eventually, her grandchildren), enslaved nannies and nurses and child attendants would have been within calling, at least some of the time.

For all the grace and grandeur of the downstairs quarters, including the two elegant bedrooms that housed distinguished visitors, the upstairs bedrooms were dim, cramped, and stifling in hot weather. They were accessible only by two equally dark and narrow staircases, built to save both money and space. Anyone going up or down those stairs in skirts and petticoats would have had to squeeze through. Someone carrying a chamber pot or a child would have to step carefully, to say the least.

For Patsy's growing daughters, Monticello was a beloved place, but short on comfort and privacy. Few people of the time expected to have living space to themselves, but Thomas Jefferson insisted on his own grand and secluded quarters for reading, writing, and reflection. His learned daughter and her educated children envied his example. Ellen and Cornelia and their younger sisters Virginia and Mary all complained that between the demands of company and the lack of personal space, they could not study as they needed to do. They wrote letters in stolen moments, wherever they could find a place to perch, apologizing to the recipients for the hasty and disjointed "scrawls" and imploring the reader to "throw this scrap in the fire." Cornelia, who showed an early gift for drawing that blossomed into a talent for rendering architectural plans as well as domestic subjects, could never seem to find the time or place for her work.

Once the columns over the portico were completed, Jefferson had

a floor laid in a space above to serve as a storage area, a not-quiteaccessible drop down from the dome room. Virginia enlisted Cornelia's help in claiming the space. They piled up boxes to construct makeshift steps, hauled in an old cushionless sofa, and installed a couple of chairs and small tables to serve as writing desks. "I have taken possession with the dirt daubers, wasps and bumble beas," wrote Virginia, "and do not intend to give it up to any thing but the formidable *rats* which have not yet found out this *fairy palace*."

The Randolph children, of course, enjoyed luxurious accommodations at Monticello, compared to Jefferson's enslaved family. When Sally Hemings returned from France, she likely lived in a stone building on Mulberry Row, the slave "street" behind the main house, just above and at the edge of Jefferson's great vegetable garden. Later, Sally and her children may have moved into one of the twelve-by-fourteenfoot log cabins between the stone house and Jefferson's stable. If they lived with an earthen floor and a wooden chimney, Sally had to work at keeping things clean and managing her fires.

But just as likely, Sally may have had a room in the house. Jefferson's renovations called for stone "dependency wings" to be built under the terraces of the main house, as storerooms, kitchen, and housing for a few servants. Sally Hemings may have lived in one of the stone, brick, and wood rooms under the south terrace, close to the kitchen where her brother Peter served for a time as head cook. Those rooms may have been, as Jefferson's overseer Edmund Bacon described them, "very comfortable, warm in winter and cool in the summer," compared to the cabins on Mulberry Row. But any or all four of her children may have shared the space. Privacy was a luxury Sally Hemings had no right to demand, at least on her own behalf.

Though the Hemings children could not claim the privileges of Jefferson's free offspring, they saw themselves as a breed apart from most enslaved people. "We were free from the dread of having to be slaves all our lives long, and were measurably happy. We were always permitted to be with our mother, who was well used," Madison Hemings recalled. Up to the age of fourteen, the four Hemingses ran errands around the "great house," and after that they were taught a trade. Beverly, Eston, and Madison learned carpentry. Harriet worked in the "cotton factory," spinning and weaving. She had, of course, been expected to serve Jefferson and the Randolphs at their pleasure, though overseer Edmund Bacon insisted that Harriet "never did any hard work." But while Jefferson and Patsy relentlessly pressed the Randolph children to study their history and their Latin, to read great literature and write vivid, careful letters, no one looked to the education of the Hemingses. At the age of sixty-eight, Madison Hemings said he "learned to read by inducing the white children to teach me the letters and something more; what else I know of books I have picked up here and there till now I can read and write."

Monticello remained a musical place. Martha Wayles Skelton Jefferson had played guitar and harpsichord and pianoforte, and her daughters in turn played and owned beautiful instruments. The Randolph granddaughters were taught their music, and Virginia in particular developed a passion for the piano. Thomas Jefferson, of course, loved music, though the broken wrist he had suffered in Paris ended his violin playing for life. The Hemings children also inherited the love of music. Keyboard instruments were expensive and bulky, so Harriet may never have had her chance at a "feminine" mastery of music, but her brothers were well-known experts on the violin, who may have fiddled as they called the figures for country dances at Monticello and in the neighborhood. When Eston Hemings moved to Ohio, after his parents' deaths, his signature tune was a Scottish dance air, "Moneymusk," a song his father had copied out in manuscript years before. THOMAS JEFFERSON IDEALIZED the domestic tranquility of Monticello, which he had spared no expense to transform into a beautiful and unique place. There were exuberant spring days when the hyacinths bloomed in abundance, the peas fattened in their pods, the sounds of industry rang forth from weaving shop and kitchen and nailery, Mrs. Randolph hummed at her housework, and grandpapa set the young ones racing toward the house with a drop of his handkerchief.

There were other days when everyone was sick, when Cornelia or Virginia or whichever daughter had her month of housekeeping, that hated period of "carrying the keys" to the locked cellars and storage rooms. All the girls had to cope with quarreling children or angry servants, not to mention ten or twenty guests coming to dinner and staying overnight. Patsy worried at the toll so much company took on her aging father's health, not to mention the strain on his resources.

But Jefferson had his way of coping with the crush. He would, as he so often had, ride away. From the moment he ascended to the presidency, Thomas Jefferson had been planning his getaway. He began to make sketches for a noble villa, three days' travel southwest of his Albemarle residence, at Poplar Forest, the Bedford County property that Martha had inherited from John Wayles. The Jefferson family had stayed at an overseer's house there during their flight from Cornwallis in 1781; Jefferson had written his *Notes on the State of Virginia* there while recovering from a fall from his horse. In 1805 he traveled to Poplar Forest to meet with his master bricklayer, to discuss his plans for the octagonal brick house that would be his second architectural masterwork. The foundation would be laid in 1806.

By 1811, Jefferson began to make regular trips to Poplar Forest. He traveled to his sanctuary with his valet, Sally Hemings's nephew

*

338 🧏 THE WOMEN JEFFERSON LOVED

Burwell Colbert, or with John Hemings, Beverly, Madison, or Eston Hemings, and usually with one or more members of his white family. Patsy only rarely got to enjoy the indulgence of a vacation from Monticello, but on occasion she got to go to Poplar Forest. In September 1816 she left most of her children, including two-year-old Septimia, back in Albemarle, putting her husband and her daughter Ellen in charge of the household. "You may consider your journey to Bedford at this season as very fortunate," Ellen wrote her mother, "for it has saved you from many disagreable intrusions; we have had several large parties from the springs, and a coach & four is by no means an uncommon sight at the door." The uninvited guests included "impudent and ungenteel people who behaved as if they had been in a tavern" and "dashing but not genteel Carolinians, [who] made a great noise asked a great many silly questions and at last went away leaving papa and myself weary & disgusted." Ellen consoled herself with the fact that at least her mother and grandfather had been spared the annoyance of such company. "These intruders," she said, "have pretty generally expressed their regret at Grand Papa's absence and I have rejoiced at it-on his account-not on my own God knows."

Ellen, like her sisters, had to take her part in inventorying the hams and counting the silver and bossing the servants, jobs her grandfather regarded as labors of love. But she would often enjoy the privilege of escaping. By the time they reached their teens, Ellen and Cornelia were Jefferson's most frequent companions on his journeys to his Bedford County refuge. All three reveled in the chance to read and think without interruption, and the girls competed with one another for the title of most serious scholar. At Poplar Forest, she and her sister had the rare luxury of a room of their own. "Ellen and Cornelia are the severest students I have ever met with. They never leave their room but to come to meals," Jefferson noted. Of course, at that very moment, the inveterate puller-down-and-putter-up was supervising "an alteration in that part of the house" which "deprived them of their room longer than I expected."

Whatever inconvenience they encountered, the girls seized the opportunity for quiet study at Poplar Forest. As with all vacation houses, the place sometimes showed the effects of absence and neglect. On a visit in July 1819, they found the weeds growing up to the kitchen door, the planks of the terrace torn up by the wind, and every window on the front of the house shattered by a recent hailstorm. Rain had poured in, staining the floors and leaving behind mold and must. The central skylight was shattered, but the windows in their own room had been spared. Both girls quickly unpacked their books and Cornelia set out her drawings and tools. Ellen wandered from room to room, cheered at the thought of how much she got done at a place that seemed "more dismal than usual," wild and desolate. "Here, every day for six weeks at a time I have devoted from seven to eight hours to my latin . . . there hour after hour, I have poured [sic] over volumes of history, which I should in vain have attempted to read at Monticello."

What to do with such passionate students? Thomas Jefferson willingly added to his burden of debt the cost of educating his eldest grandsons, Jeff Randolph and Francis Eppes. He was determined that Jeff go to Philadelphia to attend lectures in science, anatomy, and surgery, though the boy had neither appetite nor aptitude for the work. Jefferson likewise patiently endured Francis's endless complaints about his schoolmasters and studies.

But even as Ellen roamed the wreckage at Poplar Forest in an intellectual reverie, she had no illusions about her future. "I have often thought that the life of a student must be the most innocent and happy in the world... the pursuit of knowledge unlike other pursuits is subject to no disappointments." She would have loved to learn for learning's sake, as her grandfather seemed to do. But as a woman she could

340 🧏 THE WOMEN JEFFERSON LOVED

not afford to do so. "If I had been a man with the advantages of early education, I would have been just such a one, I think, but being a woman and not a rich woman, I must be content with peeping every now and then into a region too blissfull for my inhabitance, and after having felt myself for a short interval as 'passionless and pure' as Byron's Spirit, return to the vanities, follies cares and pleasures of ordinary life."

OF COURSE, EVEN the most brilliantly idealistic men had to come to grips with the follies and cares of ordinary life. Thomas Jefferson himself was still in the White House when he began to acknowledge the reality that would eventually overwhelm all others: his burgeoning debt. Jefferson was hardly alone in owing far more than he could pay. By the beginning of the nineteenth century, the Virginia gentry was sinking fast, and none faster than the Randolph clan. Patsy wrote to her father in January 1808, detailing the fading fortunes of her husband, who had already been forced to sell land and slaves to pay his most obdurate creditors, but who was perpetually fighting off bankruptcy. Tom Randolph's siblings had similar difficulties. Two of his sisters had been abandoned by their bankrupt husbands, and one brother was homeless. Another carried a pistol to keep the sheriff from arresting him, and when the gun went off in his pocket, he was crippled for life. "The ruin of the family is still extending itself daily," Patsy wrote, and though she had persuaded her husband not to co-sign his brothers' IOUs, they remained "both in a state of great anxiety."

Jefferson replied that he wished he could help his son-in-law, but he had his own problems. "I have now the gloomy prospect of retiring from office loaded with serious debts, which will materially affect the tranquility of my retirement," he admitted. Still, he insisted on taking an optimistic view of his difficulties. "Not being apt to deject myself with evils before they happen," he told Patsy, "I nourish the hope of getting along."

Far from being reassured, Patsy was appalled at her father's impracticality. "Your last letter has cast a gloom over my spirits that I can not shake off," she told him. "The impossibility of paying serious debts by crops, and living at the same time, has been so often proved, that I am afraid you should trust to it." She urged Jefferson to think only of his own comfort, and "not to consider the children but secure your own tranquility and ours will follow of course." Solicitous as always of her father's happiness, Patsy Randolph was a realist. Even at his best moments, her unstable husband could not pay what he owed, could not avoid the entanglements of his demanding family, and he definitely could not make a living growing tobacco with slave labor. How Thomas Jefferson would manage his even greater obligations, she could not tell.

Despite her mounting dread, Patsy Randolph urged her father to pursue his pleasures as he saw fit. Jefferson, in turn, begged her not to deny herself or her children anything that his credit could purchase for them. Patsy fretted and scrimped and saved, while he continued to play the lofty Virginia planter, spending lavishly, gratifying his architectural passions and his epicurean tastes, pressing his plans for educating his grandsons, for launching his granddaughters into society and onto the marriage market. Poplar Forest satisfied his need for privacy and peace, but that refuge from the hectic din at Monticello was yet another drain on his dwindling pool of resources. In his mind he was still the provider and protector of his family, and in theirs he was the revered patriarch. But more and more, Thomas Jefferson had come to rely on his purported dependents, enslaved and free, for his physical, psychological, and financial comfort and security.

The Perils of Matrimony

27

AS HE SETTLED into retirement at home, Thomas Jefferson devoted his still formidable talents to one of his proudest achievements, the building of the University of Virginia. He was determined to create a first-rate institution of higher learning, amply supported, felicitously designed, fully equipped, and preferably in Charlottesville. He had been thinking about a state university for years, and by 1817 he had managed to convince the state to fund the enterprise and to locate the university in his hometown. The process of getting the university adequately financed, built, and into operation lasted nearly the rest of his days.

Jefferson hoped to live to see his grandsons at the university. But in 1825, when the first students began to attend classes, the eldest among them, Jefferson Randolph, had already finished his education and was busy managing his grandfather's farm while trying to establish his own growing family. Patsy's younger sons, James and Ben, would eventually join the student body. None of his grandsons were serious scholars, but then, in general, the young men fortunate enough to go to the university were more notable for their family connections than their intellectual curiosity. One of Thomas Mann Randolph's nephews was among those expelled after a drunken student riot the first year of operation.

Even though Patsy Randolph's daughters were as well educated as any women in the United States, and better schooled than most American men of their time, there was no question of college attendance for them. Anne, Ellen, Cornelia, Virginia, and Mary Randolph were formally instructed by Jefferson's closest disciple, his curious, disciplined, patient, brilliant daughter. Martha Jefferson Randolph complained that child care, health problems, her husband's misfortunes, and the endless company at Monticello made it impossible for her to attend to her own reading and writing, but she was utterly determined to educate all her children, female as well as male. Ellen and Cornelia were her most dedicated students, but even the least intellectual among them had the benefit of a teacher who knew far more about most things than most people, let alone most women, because her father had worried that she might marry a blockhead. In 1962, President John F. Kennedy would famously tell a White House dinner gathering of Nobel Prize winners that "I think this is the most extraordinary collection of talent, of human knowledge, that has ever been gathered together at the White House, with the possible exception of when Thomas Jefferson dined alone." At Monticello, the earlier gathering of genius was multiplied. There, unlike the White House, Thomas Jefferson had the good fortune to dine with Patsy Randolph.

But the Randolph girls were not at liberty to use their education, their talents, or their ambitions to make their way in the world as they would. Anne could not take to the road on botanical expeditions as the Quaker William Bartram did. Ellen could not study Latin and Greek and law and run for the legislature. Cornelia could not turn her architectural drawings into houses for the wealthy. Instead they had to find a man who might provide them with prosperity and security. They brought to the marriage market some distinct assets: distinguished family, fine manners, sensible and even scintillating conversation, the skills of plantation mistresses, and not least, their close connection to their revered grandfather. But as time passed, their fortunes declined along with those of Thomas Mann Randolph and Thomas Jefferson. Without dowries, they had trouble attracting suitable men.

Jefferson's eldest granddaughter was the first to find a husband. On September 19, 1808, seventeen-year-old Anne Cary Randolph, the gentle soul who delighted in flowers, married the handsome Charles Lewis Bankhead, at Monticello. Anne's mother had her hands full, as usual, having given birth only two months before to her ninth child. But Patsy had reason to hope that Anne had made a good match. The groom's father was a distinguished Virginia doctor and Charles Bankhead himself was planning to study the law. Jefferson anticipated that Anne and her husband would live for at least a time at Monticello, where Bankhead would avail himself of Jefferson's law books. Anne obviously hoped for the same. Two months after the wedding, when they finally left the mountain to visit his family, Patsy reported that the bride was "in a state of such extreme dejection at the separation from her family that it rendered the scene a very distressing one."

By 1812, the Bankheads were living at Carlton, an eight-hundredacre farm on the west slope of Monticello Mountain. It may have seemed to Thomas Jefferson that his long-standing dream of keeping his family close was coming true. But Anne's bridal anguish turned out to be prescient. Four years into his marriage, Charles Bankhead had proven himself a violent drunkard, already deep in debt and utterly unable to manage his affairs. Anne had taken refuge with her motherin-law, with Bankhead evidently out of the picture for the time being. Jefferson and Bankhead's father assumed his debts and took control of his house and land, for the support of Anne and her children. Her husband was to have absolutely no part in that management. Jefferson took the additional step of adding 130 acres to the property, exclusively for the benefit of his beleaguered granddaughter. He had to set aside his deep belief that women were fitted by nature to depend entirely on men, in order to provide for Anne. More than anything, Anne Bankhead needed protection *from* her husband, and only financial independence could give her any hope of security. "Hers," Patsy lamented, "has been a hard fate."

Patsy understated the matter. Anne Randolph Bankhead's marriage was a living hell. Charles Bankhead was locally famous for getting roaring drunk and beating up his wife and children. Virginia society tended to tolerate bad behavior in husbands (witness Jefferson's advice to his newly married daughter Polly, preaching the wife's duty to bow to her husband's wishes, and her obligation to conciliate even an alcoholic husband). But Bankhead was not gentleman enough to confine his brutality to his own household. Edmund Bacon, Jefferson's Monticello overseer, recalled that "I have seen his wife run from him when he was drunk and hide in a potato hole to get out of danger."

Thomas Jefferson prided himself on his peaceful household. Bankhead brought violence right into Jefferson's home. According to Edmund Bacon, one night Bankhead had attacked Burwell Colbert, the Monticello majordomo, in Jefferson's dining room, because Colbert refused to give him any more liquor. "Mrs. Randolph could not manage him," said Bacon, so she sent for the overseer rather than for her husband, who was too "excitable" to settle such matters reliably. But Thomas Mann Randolph heard the noise, rushed in, grabbed a fireplace poker, and knocked his son-in-law down "as quick as I ever saw a bullock fall," said Bacon. "The blow pealed the skin off one side of his forehead and face, and he bled terribly."

Anne's husband became so uncontrollable that he was at first consigned to his own father's medical care, and for a time, to an asylum. In 1816 he returned to visit Monticello, but Patsy reported to her father that Bankhead had "recommenced his habits of drunkenness." Patsy and Tom Randolph were ready to send him to jail, if necessary, declaring, "If his family are much disturbed or endangered will take at once the steps necessary for their protection, as circumstances may require." Patsy did not see any use in "sending him to the mad house," since Bankhead would only return "with renewed health to torment his family longer." Instead she thought they should hire "a keeper" to prevent him from harming others, "and let him finish him self at once."

Charles Bankhead did not drink himself to death, as his motherin-law wished he would. Anne, much to everyone's dismay, would not leave her husband and come permanently to live at Monticello. Thomas Jefferson admitted that he had "for some time taken for granted that she would fall by his hands." But he believed Anne was "too attached" to Bankhead to listen to her worried family and abandon her monster of a husband. Jefferson thought wives should love their husbands, but it seemed that love could turn to poison.

No one at the time understood the psychology of battered women, the demeaning and the isolation and the terror that decimate selfesteem and lead women who have been abused to imagine that they are the ones at fault. In Anne's time, neither the law nor the custom of the country gave a runaway wife much hope or support. Anne Bankhead, too ashamed to imagine herself worthy of her family's care, did what millions of women in her hideous situation did before and have done since. She stayed with her abuser.

Charles Bankhead, for his part, continued to embarrass and infuriate the Jefferson-Randolph clan. February 1, 1819, was court day in Charlottesville, a time when men came together from their scattered plantations to settle their legal disputes, to drink and socialize and politick, and to fight. Some incident—others later claimed that Bankhead had sent an abusive letter to Jeff Randolph's wife, but it may have been that Anne's brother had simply had enough of his brotherin-law's outrages against his sister—provoked the confrontation. Jeff Randolph was waiting for Bankhead at a Charlottesville store, armed with a horsewhip. Bankhead arrived carrying several knives. In the melee that followed, Bankhead stabbed Randolph in the hip and left arm, and Randolph, bleeding profusely, was carried into the store for treatment. Bankhead was taken to court and made to post bail. Thomas Jefferson had already come to rely heavily on his stalwart eldest grandson and heir apparent. Now news of the fight came to Monticello, with reports that Jeff had been seriously wounded. The old man had his horse saddled. He rode to town in the darkness, walked into the store where his cherished namesake lay suffering, and wept.

EVEN AFTER CHARLES Bankhead had stabbed her brother, Anne Randolph Bankhead remained with her husband, though a man was hired to live with them because, in Patsy's words, "They will always require a protector." Anne's younger sisters looked at her hideous life and dreaded the prospect of matrimony. "I am glad to hear sister Ann is going to be settled in a home of her own, particularly as she will have protection from that brute, for I am sure she must always be miserable," wrote twenty-year-old Cornelia to eighteen-year-old Virginia, wishing that Charles Bankhead would be sent away somewhere they would never see or hear of him again. But even had Anne's marriage not been a nightmare, their parents' long and difficult relationship provided them with plenty of reason to question whether getting married really provided any security. Husbands, it seemed, might not be worth the trouble they caused.

Patsy knew how they felt, and she shared their misgivings. "Ellen fulfills the promises of her childhood," she wrote to Elizabeth House Trist in 1815. "She is a nurse to me in sickness a friend and companion in health and to her grand Father 'the immediate jewel of his soul' I think sometimes she will never marry and indeed after her sister's fate I almost wish she never may." Patsy was not simply worried about her daughters' potential husbands. She was also perpetually on the lookout for any exhibition of touchiness, instability, or anger in her own children, any trace of what she and they referred to as "the Randolph" in their blood. Patsy thought Ellen had inherited a tendency to hypersensitivity from her father, which might get in the way of a happy marriage. Her daughter's feelings were "too acute for her own happiness she is very much like her Father but with out his temper, and such are not calculated for this selfish world."

Even when a seemingly perfect man presented himself, Patsy hesitated to part with her daughters. With every passing year, they in turn were more aware of how much their mother and grandfather needed them. When eighteen-year-old Nicholas Trist, grandson of Jefferson's old friend Eliza House Trist and already virtually a member of the Jefferson-Randolph family, wrote to Patsy in 1817 to ask for the hand of seventeen-year-old Virginia, Patsy put him off on the grounds that both he and Virginia were too young. Many warm letters passed between members of the Trist and Randolph families over the next years, while Virginia remained at Monticello and Nicholas went first to West Point, and then began to seek his fortune, eventually to use his nimble intelligence and family connections to pursue a career in diplomacy. By the time they finally married, in 1824, the Randolph sisters had long since learned to think of Nicholas as a brother, one who could sometimes be as annoyingly arrogant as any of their biological brothers.

Trist was particularly close to Ellen, who wrote to him far more frequently than he returned the favor, and who demonstrated that she had inherited the family gift for sarcasm. "Really, my dear Nicholas, you are quite too modest and humble; you will never make your way in the world with so poor an opinion of your own merits . . . how could you so far underrate your own communications, & overvalue my poor returns as to think *one* of your letters worth only *ten* of mine—what disinterestedness & humility. the days of chivalry are reviving," Ellen told him. She pronounced herself, "tempted to quote from Sir Anthony Absolute 'Why Jack, you d—d impudent dog!' only I am afraid you might be shocked at so flagrant an usurpation of the rights of your sex, which reserves as a peculiar privilege, the use of such energetic expressions."

But Ellen loved Nicholas Trist, and the chance to converse with a learned and lively male companion overcame her irritation. She wanted to talk about John Locke's *Essay on Human Understanding*, which she had just been reading, wishing that she had read it ten years earlier, so that she might have pursued her education in a more systematic way. Still, even when she was discoursing on philosophy, Ellen could not help ribbing her almost-brother one more time for his presumption of manly privilege—"Was I a man, could my studies have any object of sufficient importance to stimulate my exertions, I would now, even now, commence my education . . . as it is, I am nothing but a woman, and could promise myself no competent reward for so much trouble—and perhaps you will say if I had not been a woman I should not have thought myself & my concerns so entertaining a subject as I appear to have done, talking to you of nothing else."

It took Nicholas Trist more than six years to marry Virginia Randolph. His bride remained at Monticello long after they had married, even after they had children. If this most beloved and promising young man had to serve such a long probationary period to be accepted by a Jefferson granddaughter (and her protective mother), how much more difficult was the task for lesser mortals. Thomas Jefferson's grandchildren had grown up seeing their connection to him as proof of their special standing in the world. They were by no means all scholars, but they certainly were accustomed to highpowered conversation, and to being listened to in their own right. Ellen and Cornelia, launched into society at Monticello and Poplar Forest and Richmond, routinely contrasted the sophisticated talk at Monticello with the vapid babble they endured elsewhere, and they were savage critics of the young people they met. Cornelia mocked a pretty girl who had caught the eye of her cousin Francis Eppes, by quoting a piece of doggerel: "All the brains / That little squashy head contains, Wouldent fill a musqueto's eye sir."

Ellen and Cornelia amused each other by heaping scorn on the people they met. Ellen wrote to her mother from Richmond, mentioning "Mr Wilson, the member of legislature, whom [Cornelia] may remember always neatly dressed and powdered, and talking of Philadelphia 'till even I got weary of the subject—if she does not know him by these tokens, bid her remember him as one of the alligators, whose open mouths and furious gestures, gave me such reasonable alarm at the governer's party." The Randolph girls made an inside joke of referring to their beaux as "alligators," much to their mother's amusement. But smart girls who imagined potential friends and suitors in terms of mosquitos' eyes and alligators' mouths tend not to be very approachable. Thomas Jefferson's granddaughters must have scared the life out of potential aspirants.

Cornelia and her younger sister Mary never married. Mary may have been too shy, and in any case, by the time she had reached the age of marriage, her father was already ruined and her grandfather was facing disaster. Cornelia was another story. Though Ellen was clearly Thomas Jefferson's favorite granddaughter, Cornelia competed with her older sister for her grandfather's approval. She was serious about her studies, disciplined about her art, and stalwart about bearing her share of the housekeeping duties. But Cornelia could not bring herself to engage in the dead-serious frivolity of finding a husband. When she and Ellen were sent to Richmond to stay with their aunt Mary Randolph, Cornelia was "bashful" to a fault, telling Virginia that "as to being able to enter into conversation wi[th] any one, it is a thing I find more difficult than ever." She chafed at social rituals and hated having to make conversation with "stupid" young men who impressed her as "puppies."

On a visit to Richmond, Cornelia could barely endure the ordeals of grooming and socializing. She wrote home to complain to Virginia that "I have either been sick or in an ill humour, or stupefied or more truly all three together ever since I have been here." She had borrowed some architectural books from a male acquaintance, but had "scarcely look'd into them," since she had "no time to do any thing useful or agreeable." Instead convention dictated that she fritter away her days doing pretty much nothing. Cornelia's bitter description of her life in Richmond recalled her grandfather's satiric rendering of the preening and boredom of Parisiennes:

we get up evry morning just in time to dress for breakfast, & after that is over we come up & dress again to recieve company, we set in the drawin room from this time untill . . . it is time to adjust our dress for dinner, we cannot . . . work in the drawing room because . . . there is almost constantly some visitor there; after dinner it is too dark to do any thing & from that time untill ten oclock . . . we all set round the fire except the gentlemen who choose to play cards, & some talk nonsense, & some yawn & stretch, & pull out their watches & wonder at its being so early & would all fairly go to sleep at last if they did not seem to be afraid of this & do every thing in their power to keep themselves awake each exerts himself by turns to make a noise. Cornelia retired early and gratefully from the field, but Ellen remained in the hunt. From the time she was eighteen, Ellen made frequent visits to Richmond, staying in her aunt Mary Randolph's thriving boardinghouse for weeks at a time. She wrote long letters home, describing the interesting and indolent gentlemen she met, the elegant dresses other young women wore. She was at first appalled by the cost of fashion. She sent her mother a piece of fine fabric "to have made for me," guilty at the thought of the other women of Monticello clad in rude cotton while she wore expensive linen, but her aunt had insisted that she could not go about town in "coarse and slazy" clothing.

As time passed, Ellen grew accustomed to spending money on herself, to paying for clothes and shoes and shawls and bonnets, and sometimes even for dressmaking. Ellen had traveled some distance, if not in miles, in habit, from the home where enslaved women wove the homespun garments that Patsy insisted the family wear during Thomas Jefferson's embargo. But even as she began to visit in town and receive callers at Monticello, Ellen could not think of dressing appropriately without calling on the skills of slaves back home. Anticipating her return from Poplar Forest in the spring of 1818, Ellen issued minute and imperious instructions for dressmaking by her own servant, Sally Cottrell:

I left cambric for one pair of sleeves, which Sally can cut out by the paper pattern, taking care to make them longer & larger, and besides this to allow for eight narrow tucks, which she must put in them as they are for my tucked frock which I brought have with me—she knows how to frill them . . . I wish my cambric frock with the pointed flounce, to have a new plain flounce, and new sleeves with three puffings like Cornelia's stuff—the cambric dress with the striped flounce to have new plain sleeves with straps to them, and the flounce ripped off—when she has done this and it is not a week's work; she may begin the tail of my striped muslin—which she is to trim with three puffings, in the manner of Cornelia's sleeves, set on above the hem the width of which she will know by a pin stuck in it—I hope she will work steadily for otherwise when I get home I shall meet a great deal of company & have no [...] clothes to wear—

She could not help adding a postscript: "Sally must make the tucked sleeves of the coarsest piece of [c]ambric," she insisted, and closed, "Do throw this letter in the fire."

Years passed, and Ellen remained single. Some combination of hesitation and haughtiness no doubt contributed to her unmarried state, but the well-known wreckage of her father's finances made things even worse. As she approached her twenty-third birthday, she lamented to her mother that "I have already been held to the world as a fortune-hunter in petticoats." Still single three years later, the trash talk had followed her to Washington, where she was still a belle but had been "galled more than once by the malicious gossiping of people who have nothing to do but exercise their spite against their neighbours." She could not help shopping in order to appear fashionable, and she needed money to pay her bills, but feared to approach her father. "Perhaps I had better write to him myself," she told her mother, but "I am so much afraid of his strange temper that... I know not what to do."

As she passed her twenty-seventh birthday, Ellen Randolph was the real-life embodiment of that combination of female arrogance and desperation later immortalized in the figure of Lily Bart, the tragic heroine of Edith Wharton's *The House of Mirth*. She was still single and nearly ready to give up trying when Thomas Jefferson received a visit from a learned young Bostonian. Joseph Coolidge was a Harvard graduate who had traveled in Europe and read widely. He was instantly enthralled by Ellen, and she, for a wonder, welcomed his attentions. Thomas Jefferson approved of Coolidge and encouraged his suit, though he told Coolidge that neither he nor Ellen's father could provide a dowry. Fortunately, Coolidge's fortune was enough to provide for his own family (though not enough, sadly, to rescue the Jefferson-Randolph clan from ruin). They were married on May 27, 1825, in the drawing room at Monticello, and soon after left on their journey north, to start a new life in Boston, farther from home than Ellen Wayles Randolph Coolidge had ever been in her life.

The family missed Ellen terribly, especially the aged and ailing grandfather who had doted on her and who must have sensed that he would never see her again. But they were delighted at the match she had made. Joseph Coolidge was a sort of anti-Charles Bankhead, as kind and solicitous of his new bride as he was prudent in his financial affairs. Her mother and sisters rejoiced at her rescue from their ruin. "I am not selfish enough to mingle with the sorrow I cannot help feeling at the loss of your society, any regrets for the cause that has deprived us of it," her sister Mary wrote, the following autumn, "since it has called you to a situation of more comfort and happiness than we could ever have hoped to see you enjoy among our fallen fortunes." As the clouds of ruin darkened "round us so thick as sometimes to shut out even the hope of better days," said Mary, they were happy. to think that "you at least are exempt (except through the medium of sympathy with those you love) from a participation in whatever may befal our interests."

Even Thomas Jefferson, the congenital optimist, was succumbing to despair. His daughter and grandchildren watched disaster approaching, and each met the family's dire prospects in his or her own way. Patsy was nearly paralyzed with depression while her son, Jefferson, labored mightily to salvage what he could. While most of her daughters stood helplessly by, plucky Cornelia chafed at her feminine inability to change the family's fortunes. "I know I wish I could do something to support myself instead of this unprofitable drudgery of keeping house here," Cornelia wrote to Ellen, later that fall. "But I suppose not untill we sink entirely will it do for the grand daughters of Thomas Jefferson to take in work or keep a school, & we shall hold out for some time yet; ours is not a galloping consumption but one of those lingering deseases which drags on for years & years."

Cornelia was only partly right. In the months that followed, tragedy came to Monticello again and again, not as a lingering disease, but as a swift and vicious infection, not malingering at a frustrating shuffle, but bearing down upon them at a headlong gallop.

The Capriciousness of Fortune

28

THOMAS JEFFERSON'S FINE brick houses were built on mountains of shifty paper. He owed the merchants of Bristol and London and the book dealers of Paris, the Virginia storekeepers who sold him candles and coffee, the joiners and bricklayers and well diggers who waited to be paid, hat in hand, sometimes for years. Virginia gentlemen passed around IOUs like buckets at a house fire. At any moment, someone, or everyone, could get badly burned.

In 1819, the first great financial panic in United States history swept the nation, setting off a wave of bank failures and foreclosures that swamped the farms and plantations of Virginia. Jefferson, like other planters, was already in trouble. Over his long years of government service, his salary had never covered his living expenses. His crops had never paid his bills. He had inherited debt and borrowed heavily in his own right. From time to time, he sold land and people in the attempt to settle the larger claims against him, but his sales never brought what he expected or needed. He was generous to the point of pathology; while Patsy and her children fretted about expenses, he insisted that they buy whatever they need and treat themselves to extravagances, charging his accounts. As his debt mounted, he continued to spend freely on anything he wanted, from oil for his salads to art for his drawing room.

The Panic of 1819, that first great bust of a boomtime American economy, sealed his fate. He already owed nearly eighty thousand dollars, in today's terms a sum approaching \$1.5 million. But the bonds of friendship and kinship dragged him down deeper. He had co-signed a note for Jeff Randolph's father-in-law, Wilson Cary Nicholas, in the amount of twenty thousand dollars. Thomas Jefferson was at Poplar Forest with Ellen and Cornelia, suffering from a crippling bout of rheumatism in his hands and knees, when word came that Nicholas had gone bankrupt and would have to sell everything to pay his debts. Thomas Jefferson would now be on the hook for the additional twenty thousand. "God grant, *we* may be enabled to weather the storm," Ellen wrote her mother. "After struggling all our lives with debt & difficulty, we may be reserved as another proof of the capriciousness of fortune."

Jefferson had staked his political life on a vision of an ideal society in which free men, living close to the soil, reigned as kings of their own domains. He had written his *Summary View of the Rights of British America* and the Declaration of Independence from the viewpoint of the liberty-loving Virginia planter, had conjured the masterful grid survey plan for the Northwest Ordinances, had consummated the deal for the Louisiana Territory, so that men across America might enjoy the freedom of living happily on the land with their wives and their offspring. Thus he imagined his own life. It was a magnificent vision, but fatally flawed. Like Thomas Jefferson, farmers throughout American history have enjoyed the freedom of space, of land of their own. Like him they have ruled and relied on their women and children and survived on mortgages and revolving credit. And like him, by the tens of thousands, so many have failed. WHEN JOHN WAYLES Eppes married Polly Jefferson in 1797, Thomas Jefferson had been jubilant. He had predicted that his estimable sonsin-law would safeguard the family's fortunes for at least another generation. But by the beginning of the 1820s, both Jack Eppes and Tom Randolph were in serious financial trouble. Eppes had a health crisis that forced his resignation from the United States Senate in 1821. An "unskillful bleeder" tore a hole in his arm that left him "nearly a cripple." Between his infirmity, "bad crops and bad prices," and a warehouse fire that destroyed much of his tobacco, Eppes was not even able to pay his son Francis's school fees. Jack Eppes was only fifty when he died, in September 1823, at Millbrook, his Buckingham County plantation. He left behind his and Polly's son, Francis, a second wife, Martha Jones Eppes, and children ranging in age from three to thirteen.

*

But that was not all. Betsy Hemings, the niece of Sally Hemings who had been given to Polly Jefferson as a wedding present, also survived John Wayles Eppes. According to Betsy's descendants, Jack Eppes followed the family tradition established by the grandfather for whom he was named. After Polly's death, Jack Eppes had taken the enslaved Betsy Hemings as his concubine, and, like his father-in-law, Thomas Jefferson, started his own shadow family. Eppes's widow and her children moved to another plantation, but Betsy Hemings remained at Millbrook until her own death in 1857. Her descendants, like those of her aunt, kept alive the oral history of their interracial family. But while Sally Hemings's progeny relied on storytelling and memory to preserve their genealogy, Betsy Hemings's offspring possessed a powerful piece of material evidence to support their story. To this day, Betsy Hemings's impressive tombstone sits next to that of Jack Eppes in the remote Eppes family graveyard, and not, as might be expected, in the Millbrook slave cemetery.

THE CAPRICIOUSNESS OF FORTUNE 💥 359

Jefferson had long intended that Polly's son, Francis Eppes, should inherit the Pantops quarter of his Albemarle County lands, in keeping with his desire to hold his family close. But now his dream of populating his neighborhood with his descendants was as frail and tattered as his aging body. He salvaged what he could. Out of generosity to Polly's only surviving child as well as the hope of protecting his legacy from his creditors, he let Francis Eppes know that he intended to leave Poplar Forest to him. Meanwhile, he relied ever more heavily on the assistance and advice of his eldest grandson, the steady and conscientious Jeff Randolph, who would soon find himself in the position of having to rescue the family's fortunes.

Jeff had to begin by offering his own father what assistance he could. Thomas Mann Randolph was never able to escape either the financial or emotional burdens of slaveholding. Like Thomas Jefferson, Tom Randolph sold both land and slaves in the vain effort to pay what he owed. Randolph considered himself "a real practical farmer ... devoted to my fields as a sea captain is to his ship." He paid close attention to his land and embraced efficient new ideas like contour plowing. But for the life of him, he could make no better headway against the undertow of debt, slavery, and hard luck than so many Virginia planters did. From the beginning of his marriage to Patsy Jefferson, Randolph had hated slavery even as he owned many slaves. He never lost his loathing of the institution that underlay his livelihood, never developed that hardness of heart that enabled slaveholders to see the people they owned as something less than human. We can read his anguish in a poignant letter to his agent in Richmond in 1815, when he made the heartrending decision to sell people he knew well and respected:

The negroes, all of which I part from with very great regret, are as follows. One of the likeliest young mulatto women, about 19

360 🎽 THE WOMEN JEFFERSON LOVED

years of age, which can be seen any where. Her name is Betsy, and it may very properly be mentioned that she is the daughter of that valuable mechanic and faithfull servant of Dr. Brockenbrough called Charles, now at the Sweet Springs. Her character is certainly good. A man called George of whom I can produce certificates that he is a healthy able hand, an excellent driver or teamster in every way raised in the low country. His wife Jenny, as faithfull a servant as ever lived. Two girls her daughters of the age to make waiting maids, both likely and healthy. And a man of about eight or nine and forty, (Mason by name) for whom I cannot expect much because he has a rupture although otherwise very healthy and an excellent hostler. I ask the favor of you to sell this man to someone who will treat him well at a sacrifice in price, even if I get only 200\$ for him. I am attached to him and sell him from necessity.

Such necessities would become more urgent and more frequent, with every passing year. By the mid-1820s, Randolph had sold or mortgaged nearly everything he owned. Soon the auctioneer would come to cry the bidding at Edgehill.

WHILE THE BURDEN of debt pulled Jefferson and his kin ever deeper, the institution of slavery, the source of their livelihood and subject of their loathing, spread relentlessly westward. In 1820, Congress passed the Missouri Compromise, permitting slavery in the new state of Missouri, and in other parts of the Louisiana Territory south of 36°30' latitude. "This momentous question, like a fire bell in the night, awakened and filled me with terror," Jefferson famously told Maine congressman John Holmes. "I considered it at once as the knell of the Union. it is hushed indeed for the moment. but this is a reprieve only, not a final sentence." Perhaps, he thought, some scheme for gradual emancipation and expatriation might be concocted, but Jefferson had lost his optimism. "As it is," he said, "we have the wolf by the ear, and we can neither hold him, nor safely let him go. Justice is in one scale, and self-preservation in the other."

Jefferson's letter to Holmes was, as so many have noted, a comment on the evils of slavery and the generally desperate situation of Virginia slaveholders. But it was more than that. At this moment of peril to his own family, Jefferson vented a bitter and deeply personal rage against sons who squandered the freedom to which he had dedicated his life. "I regret that I am now to die in the belief that the useless sacrifice of themselves, by the generation of 76. to acquire self government and happiness to their country, is to be thrown away by the unwise and unworthy passions of their sons," he told Holmes, "and that my only consolation is to be that I live not to weep over it."

Looking to the insecurity of his descendants and dependents, the wreckage of his legacy, the desperate half-measures of his heirs, Thomas Jefferson knew that he had built a house divided, and that it could not stand. The deep and bloody fissure ran from the Tidewater, through Monticello and Poplar Forest, clear across his nation, wounding everything in its wake. He could not simply emancipate all his own slaves; they were too valuable, and his finances too dire, to do so without leaving Patsy utterly destitute. She hated slavery as much as he did, but he owed it to his beloved and increasingly desperate daughter and her children to hold others, including their own shadow family, in bondage.

He also owed something to Sally Hemings. She had given up her freedom in France to return to America with him. Jefferson had promised her that their children would be free. And so, as the vaunted Missouri Compromise spread the stain of slavery into Missouri and across the Southwest, he forged his own private compromise, his own personal moments of emancipation and expatriation. Beverly and Harriet Hemings, Sally's oldest son and daughter, had both passed the age of twenty-one. He had not drawn up formal papers of manumission for anyone since their uncle, James Hemings, in 1796. He would not go through the legal process of granting Beverly and Harriet their freedom. He would find another way to solve the problem of his children's enslavement.

According to Jefferson's beliefs, his Hemings children, being the product of three generations of interracial intimacy and less than onequarter African, were white. Though the enslavement of Sally Hemings made them slaves in the eyes of the law, Virginia statute also deemed them legally white. Beverly and Harriet Hemings wanted to be free, and to claim their father's racial privilege and pass into white society. Thomas Jefferson had learned that keeping people close did not mean keeping them safe. He had promised their mother that her children would be free. He would simply let them go.

BY THE TIME he was twelve years old, Beverly Hemings had achieved the status of "tradesman" on Thomas Jefferson's plantation, while his half-nephew, Jeff Randolph, went off to school. His sister Harriet learned the trade of weaving in the "cotton factory," at the same time that her Randolph half-nieces (Virginia was just Harriet's age) learned French and Latin, drawing and poetry, natural history and multiplication. The Hemings children were painfully aware of their clandestine genealogy, but as Madison Hemings insisted, they were also "markedly happy" in the knowledge of their eventual freedom. Their parents' Paris "treaty" gave the Hemings children hope and resilience.

By 1822, Thomas Jefferson's wealth had evaporated, and his lands, houses, treasures, and human property were in jeopardy. Whenever his creditors decided they had had enough, they would demand the auction of his property. It was time for Beverly and Harriet to fulfill

THE CAPRICIOUSNESS OF FORTUNE 💥 363

their mother's plan and their father's promise. At the respective ages of twenty-four and twenty-one, they left Monticello. When Jefferson inventoried his slaves two years later, he simply noted that Beverly had "run away 22" and that "Harriet. Sally's run. 22." Their brother Madison reported that Beverly went to Washington to live as a white man, marrying a white Maryland woman whose family members were "people in good circumstances." They had only one child, a daughter who "was not known by the white folks to have any colored blood coursing in her veins." Harriet too went to Washington and passed into white society, marrying and having children who "were never suspected of being tainted with African blood."

Beverly, as a man, would have found it easier to leave Monticello than his sister. No neighbor who knew him would have questioned his setting out alone, as his uncles Robert, James, and John had often done, riding one of Thomas Jefferson's horses. No stranger, farther along the road, would think anything odd about an apparently white man traveling on his own. But a woman of any race, traveling by herself to an unannounced destination, would attract unwanted attention. Jefferson made sure that his daughter got the assistance she needed, from his overseer, Edmund Bacon. Harriet Hemings made a lifelong impression upon Bacon. "She was nearly as white as anybody," he recalled, "and very beautiful." Bacon later insisted that Thomas Jefferson was not Harriet Hemings's father, even though the master treated Sally Hemings's daughter with particular care. "When she was nearly grown, by Mr. Jefferson's direction I paid her stage fare to Philadelphia and gave her fifty dollars. I have never seen her since, and don't know what became of her."

Thomas Jefferson had freed Harriet Hemings's uncles, Robert and James, and had permitted her brother Beverly to leave Monticello. In his will, Jefferson would emancipate Harriet's uncle John Hemings, her cousin, Joseph Fossett, and her brothers, Madison and Eston. But

364 🧏 THE WOMEN JEFFERSON LOVED

Harriet Hemings was the only woman Thomas Jefferson ever set free. He sent her away and likely never saw her again after Edmund Bacon put her on the stage. Jefferson may never have shown Harriet any sign of outward affection. He may well have told himself that he bore her no particular fondness. But he could not have given her a more precious testament of his love.

BY THE SUMMER of 1825, Patsy Randolph pronounced her family "irretrievably ruined." Tom Randolph had borrowed money at "usurious interest" and had gotten an injunction to put off the sale of his property. But Patsy knew that every day of delay simply added to their debts and postponed the inevitable. When the day of the auction came, four hours passed and nobody was bidding. People "got tired of waiting and were going off" when Jefferson Randolph, whose credit was still good enough that he could borrow money, stepped up and bought his father's Edgehill plantation and the people who were being auctioned with it. Patsy described the heartbreaking experience of seeing people she had known for so long put up for sale, "most of them old and . . . sold for little or nothing." Even Patsy's house servants went on the block: "Old Scylla Priscilla and Betsy with her children, Critty's 3 little orphan girls and an Orphan child of Molly Warren's making in all 3 women old and infirm and 8 little children all under Septimia's age, all girls but one." Despite her practical temperament and her long-standing anxieties, Patsy had never involved herself in the details of her husband's finances. She now found herself in the utterly new position of asserting her individual legal rights, at her son's insistence, to save the women and children who had worked in her household from being sold at a discount to strangers. Before the sale, Jeff Randolph had arranged for her to relinquish some of her dower rights-that is, her right to make a separate claim to as much as a third of her husband's property, for her own economic security.

He did so, paradoxically, as a means of protecting both Patsy and the people to whom she had a claim. "Under existing circumstances," Patsy insisted, "the word dower would never have been mentioned by Me, but My dear Jefferson who is the support of his family, had intended bidding for them for me to spare me the sorrow of seeing these my house servants and their children sold out of the family."

Thomas Mann Randolph was furious with his son. He thought Jeff had betrayed him and taken advantage of his impossible situation. He was also enraged at the wife who had stood by him so long, through so much. In the years since she had returned to Monticello, though they had been often apart, there was still affection and loyalty between them. But Tom Randolph could never get over the competition with his father-in-law for his wife's love, a contest Patsy simply refused to acknowledge. "My dear father wrote most kindly and pressingly to him to live with us altogether, for of late years he has spent most of his time at his plantations, but his independence of spirit will not permit him to stay where he could be doing nothing for himself or his family," she told Randolph's sister, Nancy. "His spirits are gone and he is completely overwhelmed."

BUT THERE WAS worse yet to come. Despite Charles Bankhead's periodic attempts to sober up, Anne Randolph Bankhead's marital miseries continued. The family was appalled, but helpless to do anything but disapprove. "Mama and myself were so peculiarly unfortunate the other day . . . as to have a encounter with Mr. Bankhead in one of his drunkest moods," Mary wrote to Ellen, in September 1825. "Fortunately for us, there was no one present but the family, and we were spared the shame and mortification of such a meeting (which I *know* was premeditated on his part) in the presence of entire strangers. Aunt Cary and Wilson succeeded at last in carrying him home but not until he had offered to shake hands with us. I *could not* have given him mine and acted from impulse in withdrawing it, though I still think I was right in doing so, whatever impression his cry of unrelenting malice and persecution on the part of our family towards him, may make on people who never can be fully acquainted with all the circumstances of the case."

At the time of that angry encounter, Anne Bankhead was pregnant with her fourth child. Then thirty-five years old, she had lived half her life in the loving embrace of her family, tending the flowers and trading for chickens at Edgehill and Monticello, and half as a terrified wife, surviving the assaults of her improvident, insane tormenter. Back when her marriage had only begun to go wrong, her grandfather had written her a letter offering a gloomy sort of comfort, in terms she understood. "Nothing new has happened in our neighborhood since you left us," he told her.

The houses and trees stand where they did. The flowers come forth like the belles of the day, have their short reign of beauty and splendor, and retire like them to the more interesting office of reproducing their like. The hyacinths and tulips are off the stage, the Irises are giving place to the Belladonnas, as this will to the Tuberoses &c. As your Mama has done to you, my dear Anne, as you will do . . . and as I shall soon and cheerfully do to you all in wishing you a long, long, goodnight.

Now that long good night was at hand. Sometime after the new year of 1826, Anne Bankhead gave birth prematurely, at Carlton. She lingered for weeks, as had her aunt and her grandmother, before giving up the fight on February 11, 1826. Medicine was hardly a science, but the family felt certain that medical malpractice had contributed to her death. "Much cause have we to think that the mismanagement of

THE CAPRICIOUSNESS OF FORTUNE 💥 367

our ignorant Drs . . . has murdered the poor babys mother," Cornelia wrote to Ellen.

Thomas Jefferson had been too ill to go to see Anne until the morning that she died. By the time he arrived, she had lapsed into unconsciousness. Crushed by the burden of his debts, his legendary health failing, he could hardly bear the loss, weeping uncontrollably. "Bad news, my dear Jefferson, as to your sister Anne," he wrote to the grandson who had journeyed across Virginia and north to New York and New England, hoping to raise funds to save his grandfather's legacy. "She expired about half an hour ago.... Heaven seems to be overwhelming us with every form of misfortune, and I expect your next will give me the *coup de grâce*."

The death of Anne Randolph Bankhead marked the third generation of Jefferson women to die from childbirth: Thomas Jefferson's wife, Martha Wayles Skelton Jefferson; his daughter, Mary Jefferson Eppes; and now his eldest granddaughter. Martha had died in her bedroom, in the first version of Jefferson's great house. Polly had given birth at Edgehill, to the east, and been carried up the mountain to die. Anne had died at Carlton, on the western flank of Jefferson's mountain, at the place her grandfather had taken from her husband and put aside for her security. The three women's deaths inscribed a fatal circle around the life of Monticello and the breaking heart of its master. Every twenty years, it seemed, the Jefferson family tree was watered with the blood of mothers.

When We Think How We Liv'd but to Love Them

29

A HEAVY PALL descended on Monticello. In the wake of Anne's death, a sober Charles Bankhead had come to seek reconciliation with the family, and to ask them to care for his and Anne's two youngest children, Ellen and the infant William. Patsy could not bear to look at the puny, ailing baby boy "with any feeling but sorrow." But her "beloved and sick father" had made the journey to Carlton, determined to reconcile with the man they called a monster, the man they believed had driven Anne into an early grave. Patsy resolved that she would find forbearance, in memory of "our lost saint, for so in truth I may call her." No one at Monticello could escape the feeling of responsibility for Anne Randolph Bankhead's tragedy. "To all that she has left behind her, and loved," Patsy told Ellen, "I pledge my self to shew that kindness which it was my misfortune not to have had it in my power to shew to herself."

Childbirth was always an occasion for dread in Virginia households. Patsy had lost a mother, a sister, and a daughter that way, and at the moment of Anne's demise, two more of her daughters were expecting. Virginia was wretchedly pregnant at Monticello, while Ellen was nearing her due date in Boston. The terrified Ellen begged to have Cornelia come to be with her. With four young children and the aging Thomas Jefferson to care for, Cornelia was desperately needed at home, and Patsy fretted about the expense of sending her north. But Cornelia needed the break from unrelenting gloom. She insisted that the trip wouldn't cost much. "Now that I am in black," she pointed out, her traveling wardrobe would be "very smal[l] & soon made." The Coolidges finally prevailed on Patsy to spend the money. Jeff was headed north again, in search of loans or gifts to help his grandfather, and he could escort his sister on the five-hundred-mile journey to Massachusetts.

Patsy and her daughters belittled the eccentricities that came with their Randolph heritage, but they relied on the Randolph propensity for producing strong women. When it came to childbearing, Ellen and Virginia were lucky to inherit the Randolph gift for breeding without dying. This was the most valuable legacy that their greatgreat-grandmother, Jane Rogers Randolph, and their great-grandmother, Jane Randolph Jefferson, handed down to their own mother, Patsy Jefferson Randolph. Given her sister Anne's fatal ordeal, however, Ellen was surprised, and not a little smug, at her easy labor and delivery. "I do not attempt to deceive you as to the pain," she wrote to Virginia, "but upon the whole you get through with it infinitely better than you could possibly conceive without having experienced the strength & support that is granted to a woman even in the hardest part of the operation." Virginia in turn came through the process in good shape. "The baby received the name of Martha Jefferson at her birth," Mary reported, "mama of course opposing it."

THOMAS JEFFERSON LIVED out the final months of his life in a house full of overburdened women and small, demanding children. That

370 🏋 THE WOMEN JEFFERSON LOVED

he remained at Monticello at all, given the rising clamor of his creditors, was a matter of immense relief to the family. Patsy poured her heart out to Ellen in a long and remarkable letter, detailing the ruin of Thomas Mann Randolph and the approaching disaster at Monticello. Jeff Randolph, now desperately trying to salvage any shred of his grandfather's legacy, understood that time had run out. They would have to sell Monticello "and as many negroes as would pay the debts," and move immediately to Poplar Forest. He could barely bring himself to propose the scheme to his grandfather, but if they delayed, they would lose everything. Patsy had never seen her son "so much agitated as he was, and the situation of the rest of the family even down to the little children was really as if a recent death had taken place."

One night as Thomas Jefferson lay awake in pain and worry, he had a brainstorm. He conceived the idea of a lottery to sell some of his property at fair value. Under the scheme, Jefferson would offer up particular parcels (for instance, the Shadwell mill), and winning-ticket holders would get their choice of his offerings. If the Virginia legislature would authorize such a scheme, Jefferson believed, he might not only pay his debts, educate the youngest Randolph sons, and provide a home for Patsy and the children, but most of all, he could remain at Monticello for the waning days of his life. Jeff Randolph agreed that a lottery might save the day and said he would take the plan to the legislature. Patsy hoped that her son's success would prolong the life of "my dearest dearest father who . . . would have had his heart broken by his difficulties and ourselves reduced to abject want."

After considerable arm-twisting, Jeff managed to convince the state legislature to authorize the lottery. To his great disappointment, and that of his grandfather, the legislators insisted that the house at Monticello be included in the list of property to be sold, though not immediately. Still, Thomas Jefferson found strength in hope, and in the

WHEN WE THINK HOW WE LIV'D ¥ 371

assurance that as long as he lived he would be able to stay in his home. He was in near-constant pain and had been taking ever-increasing doses of laudanum, tincture of opium, which doctors prescribed for everything from diarrhea to cardiac disease. After the lottery bill had passed, he seemed to be rallying: "He is diminishing his quantity of laudanum at night which he never ventures to do unless he thinks himself getting better," Mary wrote to Ellen. Unfortunately, once relieved of the immediate burden of worry, Jefferson went back to his old hospitable, profligate ways. "To our great annoyance," Mary told Ellen, "he has resumed the practice . . . of inviting students to dinner on sunday and we are to have to day a company of school boy guests who for any pleasure or profit we expect from their society are not worth the additional trouble their presence gives."

Even as the lottery provided Thomas Jefferson a reprieve, it sealed the ruin of his daughter and her dependents. Patsy contemplated the certainty of being turned out of the home she loved, once her father died. She had no idea where she would go or how she would survive.

Her father, meanwhile, put his affairs in order. On March 16 he made his will. He left Poplar Forest to Francis Eppes, preserving the line of male inheritance he had long held as a self-evident truth. But Jefferson had to face the fact that he could no longer safeguard the women he loved by sequestering them behind a sheltering wall of male provision and protection. If he failed to make special arrangements for Patsy, and simply left the remainder of his property to her, she would be at the mercy of the law. At the moment of his death, everything he left to his daughter would pass to her husband, the bankrupt Thomas Mann Randolph. Everything would be lost to Randolph's many insistent creditors. Patsy, her spinster daughters Cornelia and Mary, her younger children, and even her Bankhead grandchildren would be destitute.

All his life, Thomas Jefferson had insisted that women belonged

at home. Their happiness lay in confining themselves strictly to the tender and tranquil amusements of domestic life, and trusting to men to take care of business. Now he was forced to lay aside those articles of faith, in the interest of the women he loved. On March 17, he added a codicil to his will declaring his daughter's "independance." Martha Jefferson Randolph had borne and raised twelve children, run multiple plantations, cared for, supervised, and denied a shadow family of enslaved relations, held rock steady through fifty-four turbulent years. But she had never had the power to make a contract, control her own property, or even take custody of her children. Now, far too late, her dying father designated her as "a femme sole," a single woman whose lawful power to dispose of land and people and possessions, to control her own affairs, was the equivalent of that of a free man.

JEFFERSON ALSO MADE arrangements for another woman he loved. The codicil to his will bestowed freedom on five men, all of them members of the Hemings family, two of them his and Sally Hemings's sons. Madison and Eston Hemings were to serve as apprentices to their uncle John Hemings until they turned twenty-one, at which point they would be free. Since Virginia law at the time required freed slaves to leave the state, Jefferson asked the legislature to grant permission for all five men to remain "where their families and connections are, as an additional instance of the favor, of which I have received so many other manifestations, in the course of my life, and for which I now give them my last, solemn, and dutiful thanks." In such an oblique fashion did Jefferson acknowledge his love and gratitude not only to the men he freed, but to Sally Hemings, the woman who had stood by him nearly forty years, whose name he could not even now bring himself to write. He maintained the public silence with which he had met rumor and scandal, certainly to spare Patsy the embarrassment of further talk, but perhaps also to protect Sally

herself from malicious gossip. If it was his wish that she eventually go free, he left that choice in the hands of Martha Jefferson Randolph: Sally's niece, her children's half-sister, her master's daughter.

ON THE FIFTIETH anniversary of the Declaration of Independence, two of the greatest of the Founding Fathers lay dying. American schoolchildren know the story. At the end, John Adams found solace in believing that "Jefferson still lives." Jefferson, his mind on the history he and his old friend had made, asked "Is it the Fourth?" Their near-simultaneous passing and their famous last words have been enshrined as emblems of the moment when a nation lost its greatest leaders and lost its way, left to the inept devices of mediocrities stumbling toward discord, disunion, and the cataclysm of civil war.

Thomas Jefferson believed he had lived too long. From the time he had lost his beloved Martha, and again when Polly died, he had spoken of his death as a release. But now, during the last months of life, he had come to anticipate dying as a reality, as "a person going on a necessary journey," as Jefferson Randolph recalled. By the middle of June, said his grandson, "he gradually declined, but would only have his servants sleeping near him." One of those servants was undoubtedly Burwell Colbert, Monticello's longtime butler and Jefferson's personal servant. It is not clear who else Jefferson kept close by at the end, but the vagueness of the reference raises the likelihood that Sally Hemings was among those near at hand. Many friends and neighbors wanted to visit, but Jefferson would permit only the family, his doctor, and his slaves to visit him in his closing days.

Three men left eyewitness accounts of Thomas Jefferson's final hours: his doctor, Robley Dunglinson, his grandson-in-law, Nicholas Trist, and his grandson, Thomas Jefferson Randolph. They were with him the evening of July 3 when he inquired whether it was the Fourth, and they watched the clock as it neared midnight, hoping that the old man would live long enough to mark the anniversary, as he did. Thomas Jefferson's greatest biographer, Dumas Malone, has given us a version of these last weary hours that preserved the privacy Jefferson had so long cherished. There are no women, no children, no slaves in Malone's brief, moving rendition of the deathbed scene, no extra utterances to append an anticlimactic coda to the poetry of commemoration.

But there is, of course, more to the story. Jeff Randolph remembered that after his grandfather asked the date, the doctor offered his patient his usual dose of laudanum. The dying man refused: "No doctor, nothing more." Thomas Jefferson fell into a restless, delirious state, sitting up in his sleep and going "through all the forms of writing," calling out that the Committee of Safety must be warned. "At four a.m. he called the servants in attendance, with a strong and clear voice, perfectly conscious of his wants. He did not speak again." We do not know who among Thomas Jefferson's slaves were at his bedside, or what he told them at this last lucid moment. Surely Sally Hemings was there at some point to say good-bye. In the morning, Jefferson did communicate again, wordlessly. His longtime "attached servant," Burwell Colbert, knew him so intimately that when Jefferson silently expressed discomfort, it was Colbert who understood that Thomas Jefferson usually slept sitting up. The old man was slumped too far down in his bed. Colbert adjusted his pillows and raised his head, and Jeff Randolph recalled that Jefferson "seemed satisfied."

Martha Jefferson Randolph had sat with her father during the weeks of his decline. On this day of death, it seems she kept away. Here was the moment she had dreaded most in her life. Perhaps she could not bring herself to watch as he slipped into unconsciousness, as he fell in and out of delirium, as he saved his last words for the unnamed servants. So she kept her death vigil in another room, with her daughters, Mary and Virginia, close by her side. On the morning of the Fourth, Nicholas Trist sat by Jefferson's bed, writing a letter to Ellen's husband, who he hoped was on his way from Boston with Ellen and Cornelia. Trist knew they would be too late for Thomas Jefferson, but not for Patsy. "The presence of E______ and C______ is of *inexpressible* importance to mother," wrote Trist. "I need not say more, nor attempt to depict her situation. They (mother and the girls) are fully aware of his condition, and have been told to consider him as already gone." Thomas Jefferson survived until fifty minutes after noon. When the old man had breathed his last, his beloved grandson, Jeff Randolph, closed his eyes.

AT THE END, Thomas Jefferson was surrounded by people he loved: Jeff Randolph and Nicholas Trist, members of the Hemings family, Patsy and Mary and Virginia and the younger Randolph and Bankhead children. Though his body grew weaker by the hour, his mind was clear, nearly to the end. It was summer in Virginia, hot and humid. Other families treated illness by closing all the doors and windows, but the Jeffersons and Randolphs believed in fresh air. The sash windows of his bedroom and cabinet admitted cooling breezes to the alcove bed where he lay. To give him peace and quiet, Patsy might have sent her youngest children, twelve-year-old Septimia and eight-year-old George, along with young Ellen Bankhead, outside to play. If Thomas Jefferson heard their shouts, rolling a hoop on his lawn, it might have given him a small moment of joy.

In the hushed house, sounds would carry to his ears: the murmured reminders of the home he had created, slipping in and out as Patsy or the older daughters tried to maintain routine. From the upstairs a baby cried and was nursed into silent contentment by a slave woman. From Patsy's sitting room came the sounds of children, practicing their reading or their sums. In his own room, rustlings marked the hushed path of Sally Hemings, sweeping, dusting, tidying, smoothing

376 🎇 THE WOMEN JEFFERSON LOVED

his covers. A cooling hand was laid on his forehead, a damp sponge held to his lips. Strong arms raised him up on his pillows. Silent, loving eyes looked into his own.

Patsy Randolph left no written account of those days. Henry Randall, the man Jefferson's grandchildren trusted with the job of writing his biography, worried about violating Patsy's confidence by saying too much about the details of her grief. Patsy, he said, "shrunk from their exposure, except to the eye of the most intimate friendship. . . . It seemed to her a drawing aside of the veil from domestic scenes, from which delicacy should exclude the observation of all strangers."

Still, Randall was a biographer. He felt compelled to reveal, as far as his own "sense of propriety" permitted, some intimate moments. On July 2, Thomas Jefferson had given his daughter "a little casket" with a message inside. A lover of literature and drama to the end, Jefferson reenacted the scene from the deathbed of his beloved wife, in which Martha had tried to copy out those lines from Tristram Shandy, preserved on a scrap of paper he kept all his life. Now, he copied out, in Latin, some lines from a William Shenstone epitaph: Heu quanto minus est cum reliquis versari quam tui meminisse ("Ah, how much less all living loves to me / Than that one rapture of remembering thee"). He found the strength, too, to copy at least part of an "Irish Melody" by Thomas Moore, the very man who had written the verse about Thomas Jefferson dreaming of freedom in his slave's embrace. But Jefferson had laughed off that bit of satire. He developed a taste for Moore's poetry, in the form of ballads the family might have sung around the pianoforte, including "It Is Not the Tear at This Moment Shed."

> It is not the tear at this moment shed, When the cold turf has just been laid o'er him, That can tell how belov'd was the friend that's fled,

WHEN WE THINK HOW WE LIV'D 🧏

Or how deep in our hearts we deplore him. 'Tis the tear, thro' many a long day wept, 'Tis life's whole path o'ershaded; 'Tis the one remembrance, fondly kept, When all lighter griefs have faded. Thus his memory, like some holy light, Kept alive in our hearts, will improve them, For worth shall look fairer, and truth more bright, When we think how we liv'd but to love them! And, as fresher flowers the sod perfume, Where buried saints are lying, So our hearts shall borrow a sweet'ning bloom From the image he left there in dying!

Less poetical, perhaps, but just as heartfelt, Jefferson had also written a tribute to Patsy. He declared that as he went "to his fathers . . . the last pang of life" was in parting from her. He recalled her mother and sister. "Two seraphs," he said, "long shrouded in death," awaited him. He would "bear them her love."

MARTHA JEFFERSON RANDOLPH and Sally Hemings were no strangers to grief. Separated by only a year in age, they were now in their mid-fifties. Each had lived through two revolutions, had seen babies die, had lost adult children, one to death and two to exile. They had survived the deaths of loved ones, standing virtually side by side, separated by the yawning gulf of race and slavery. Thomas Jefferson had been the bright star, the gravitational force that bent the path of their lifetime orbits, day by day, year by year. Now they must live without him.

They were far luckier than most of the people whose lives depended on Jefferson's fortunes. Six months after his death, on five frigid days

377

378 🎇 THE WOMEN JEFFERSON LOVED

in January, the first lots of his possession went, as Patsy had once put it, under the hammer. The auctioneer got good prices for Jefferson's horses and cattle, his carriages and his plows. Jeff Randolph had also advertised 126 enslaved people as "the most valuable for their number ever offered at one time in the state of Virginia," and they too sold at above market value. Thomas Jefferson's grandson bought back as many of the slaves as he could afford, but many could not be saved and were sold away from their families and friends. Over the next five years, sale after sale was held, as nearly everything Jefferson had possessed was sold to pay his creditors. Finally, in 1831, his beloved Monticello went the way of everything else.

Thomas Jefferson had lived in luxury and left his family in penury, as his enemies quickly pointed out. But Ellen Randolph Coolidge leapt to defend her grandfather. Not long after his death, a New York publisher approached Ellen for an account of the true state of Jefferson's finances. She offered a description of Monticello as she had known it, or at least as she imagined might appeal to a northern public disdainful of the degradations of slavery. "Much has been said of the elegance of Mr. Jefferson's establishment at Monticello," she wrote, "but there is no person of candour who has ever visited there who could not testify to the contrary of all this. the house has been fifty six years building and is still unfinished. a great deal of the work has been done by Mr Jefferson's own slaves amongst whom there were many tradesmen. there was but little furniture in it & that of no value, and many of the articles made by the negro workmen."

To vindicate her grandfather, Ellen had no problem denigrating the elegant artistry of John Hemings, the master craftsman who had built everything from the "siesta chair" that so comforted Thomas Jefferson's aching bones, to the domed roof over his head at Poplar Forest. Hemings had made a particularly lovely writing desk as a wedding gift to Ellen herself, a treasure that had been lost at sea when the

WHEN WE THINK HOW WE LIV'D 💥 379

boat carrying all her belongings northward sank off the coast. When he learned of the fate of his special present, John Hemings wept. Thomas Jefferson compensated by sending to Boston the portable desk on which he had written the Declaration of Independence, not to Ellen, but to her husband.

Ellen Randolph Coolidge would make a career of promoting her grandfather's memory, partly by demeaning and erasing the shadow family with whom she had grown up. The Hemingses provided the daily services, small and large, that Ellen had relied on all her life in Virginia, the hot water and clean sheets, the fresh figs and steaming muffins, the knitted stockings and fancy sewing. She had known them from birth, and may even have been the Jefferson grandchild who taught Madison Hemings to read. She missed those things badly in the north, as she found endless occasions to complain about the incompetent, insubordinate, stubbornly free servants of Boston.

But nothing the Hemingses had ever been to her or done for her mattered when the time came to defend Thomas Jefferson against the charge that he had taken a slave concubine and fathered "yellow children." Patsy Randolph had endorsed the denial of Jefferson's paternity of the Hemingses in her father's fashion, pursuing a course of public silence. Ellen, however, took action to combat the rumors. She insisted that her grandfather would never in his life have done such a thing as take Sally Hemings to his bed, precisely because he had loved his white daughters and his grandchildren. "Some of the children currently reported to be Mr. Jefferson's were about the age of his own grandchildren," she wrote her husband while on a visit to Virginia in 1858.

Of course he must have been carrying on his intrigues in the midst of his daughters family and insulting the sanctity of home by his profligacy. But he had a large family of grandchildren of all ages, older & younger. Young men and young girls. He lived, whenever he was at Monticello, and entirely for the last seventeen years of his life, in the midst of these young people, surrounded by them—his intercourse with them of the freest and most affectionate kind. How comes it that his immoralities were never suspected by his own family—that his daughter and her children rejected with horror and contempt the charges brought against him? . . . I would put it to any fair mind to decide if a man so admirable in his domestic character as Mr. Jefferson, so devoted to his daughters and their children, so fond of their society, so tender, considerate, refined in his intercourse with them, so watchful over them in all respects, would be likely to rear a race of half-breeds under their eyes and carry on his low amours in the circle of his family.

Ellen granted that there were mixed-race children at Monticello but insisted that they must have been the offspring of "Irish workmen" or of "dissipated young men in the neighborhood who sought the society of the mulatresses." As for Sally Hemings, Ellen insisted that she was "pretty notoriously the mistress of a married man, a near relation of Mr. Jefferson's," though she admitted that Sally's children were "all fair and all set free at my grandfather's death, or had been suffered to absent themselves permanently before he died." Ellen identified Jefferson's nephew, Samuel Carr, as that near relation, and took pains not only to denigrate that relative, but to smear Sally Hemings in language reminiscent of James T. Callender. "There is a general impression that the four children of Sally Hemmings were all the children of Col. Carr, the most notorious good-natured Turk that ever was master of a black seraglio kept at other men's expence. His deeds are as well known as his name." Randolph descendants would stubbornly cling to that myth until DNA evidence proved it false, though some have not stopped looking for alternative explanations of the paternity of Sally Hemings's children.

For Ellen, the very presence of Jefferson's white daughters was proof enough of her case. Sally, she pointed out, "had accompanied Mr. Jefferson's younger daughter to Paris and was lady's maid to both sisters. Again I ask is it likely that so fond, so anxious a father, whose letters to his daughters are replete with tenderness and with good counsels for their conduct, should (when there were so many other objects upon whom to fix his illicit attentions) have selected the female attendant of his own pure children to become his paramour! The thing will not bear telling. There are such things, after all, as moral impossibilities."

Ellen Wayles Randolph Coolidge was either disingenuous or willfully ignorant. Certainly she did what she could to draw a proper Victorian veil over activities that earlier generations regarded in a far different light. Her grandmother, Martha Wayles Skelton Jefferson, had been the much-loved daughter of John Wayles, a man who had taken a slave concubine and fathered six enslaved children alongside his four free daughters. That slave woman, Elizabeth Hemings, had raised Martha and her sisters, and Martha had brought her father's concubine and her slave half-siblings to live with her at Monticello. She had installed Hemingses in positions of respect and authority in her household and relied on them through the chaos of war, in sickness and in health. Her daughters, Patsy and Polly, had stood at their mother's deathbed, side by side with the women of their shadow family. They had heard their father swear never to remarry, in the presence of a beloved wife who had preferred her father's slave mistress to her white stepmothers.

If Thomas Jefferson followed John Wayles's example and took a mistress who was both his daughters' half-aunt and his slave, there was little Patsy or Polly could do except learn to live with their father's

382 🧏 THE WOMEN JEFFERSON LOVED

choice. Polly's widowed husband, Jack Eppes, may have repeated the pattern for a third generation. In Jefferson's world, liaisons between white masters and slave women may not have been strictly moral, but they were anything but impossible. They were a family tradition.

PATSY RANDOLPH HAD been spared the sight of Jefferson's slaves up on the auctioneer's block. At the time she was far away from Monticello, visiting Ellen in Boston. But she was all too familiar with the sight of human beings sold like cattle. She had lived through the forced sale of her husband's human property. She did not have much sympathy for Ellen's nostalgia for the slaveholder's easy authority, the slave's compulsory obedience, and she had little patience for complaints about the insolence of Boston servants. "The discomfort of slavery I have borne all my life," she had written Ellen at the moment when Thomas Mann Randolph's slaves were sold, "but it's sorrows in all their bitterness I had never before conceived. . . . The country is over run with those trafickers in human blood the negro . . . buyers. . . . how much trouble and distress y[ou] have been spared My beloved Ellen by your removal, for nothing can prosper under such a system of injustice."

Patsy's family had not prospered. "My life of late years has been such a tissue of privations and disappointments that it is impossible for me to believe that any of my wishes will be gratified, or if they are, not to fear some hidden mischief flowing even from their success," Patsy wearily confessed. She would never recover from her father's death. Heartbroken and penniless, she shuttled among her children's homes in Boston and Philadelphia and Virginia. Her poverty was scandalous; she became something of a southern martyr. In 1827, the state legislature of South Carolina voted to give her a ten-thousanddollar pension, much to the relief of her indigent children. The state of Louisiana would shortly follow suit. Patsy at first insisted that the money be used to pay her father's debts rather than her own living expenses.

But in the end, Patsy Randolph was fortunate to have raised children who loved her, who could provide her comfort and support in those last hard years. As she drifted from place to place, she left behind in Virginia the last vestiges of her father's legacy: the few people she still nominally owned. Among those individuals was Sally Hemings. After Thomas Jefferson had gone to his final rest, next to his wife and younger daughter in the cemetery on the mountainside, Sally Hemings too was lucky enough to be able to depend on her children. She moved to Charlottesville, into a house owned by her sons, Madison and Eston Hemings. The three were listed in the 1833 parish censuses as "free people of color," though Sally had never formally been freed.

Sally Hemings died in Charlottesville in 1835, believing that she had been free, informally, since 1826. She was buried in an unknown grave. Martha Jefferson Randolph followed her half-aunt a year later. She would be buried with her father and mother and sister, at Monticello. Patsy had written a will in 1834, requesting that her heirs give Sally her "time," a way of recognizing Sally's freedom without forcing her to leave the state. In doing so, Patsy redeemed a promise she had made to her father, a last tacit bargain between survivors, a partial, poignant fulfillment between two women who could not begin to speak all the intimacy and experience, all the delight and grief, all the tension and anger, all the courage and cowardice that lay between them.

From the mother whose memory haunted his immortal Declaration, to the wife he tried to keep safe behind brick walls, to the enslaved woman and free daughters and granddaughters who gave him their lives, Thomas Jefferson had lived in a world of women. His love

384 🎽 THE WOMEN JEFFERSON LOVED

for them informed his greatest achievements and glowed at the heart of his vision of life, liberty, and the pursuit of happiness. He made them promises that he too often failed to keep: noble and self-serving, idealistic and self-deluding, generous and flawed promises. That he spent a lifetime trying to fulfill those promises, and that they returned the effort, testified to the presence of love among them, in all its protean, problematic, potent forms. The women Jefferson loved knew that love itself was no guarantee of prosperity or security, or even bodily safety. It was not the answer to anything. It was not one thing. It was contradictory, costly, complicated, and sometimes deadly. Love could heal, and it could and did hurt. But it was as necessary to him, and to them, as blood and bone, as omnipresent, and sometimes as invisible, as air.

Acknowledgments

THIS BOOK IS the product of a lifelong fascination with Thomas Jefferson, and a long-standing commitment to telling women's stories. I've been reading and thinking about this book, on and off, since I was a graduate student, but only recently have I been able to commit my time and mind to writing it. Over the past four years, I've had the luxury of research fellowships from multiple institutions; the invaluable professional assistance of librarians, archivists, museum curators, and fellow historians; and the amazing support of family and friends. It hardly seems enough to mention all of you by name.

The University of New Mexico gave me a sabbatical year to commence my research, a Research Allocations Grant to travel to Lodi, Italy, on the trail of Maria Cosway, and made it possible for me to spend a year on special assignment at Yale University. Thanks to Patricia Risso, Charlie Steen, Yolanda Martinez, Dana Ellison, Helen Ferguson, and Barbara Wafer in the Department of History, Dean Brenda Claiborne in the College of Arts and Sciences, and the UNM Research Allocations Committee. I want to thank the Women and Gender Study Group in the Department of History for allowing me to present an early version of the first section of this book, and for making absolutely critical suggestions that have shaped the whole project. Thanks, too, to Cathleen Cahill, Barbara Reyes, Elaine Nelson, Rebecca Vanucci, and especially the amazing Sarah Payne, for keeping the UNM Center for the Southwest going and growing over these years. Since coming to New Mexico, I have been privileged to watch a great group of scholars earn their Ph.D.s: Andy Kirk, Abbe Karmen, Pablo Mitchell, John Herron, Michael Anne Sullivan, Judy Morley, Catherine Kleiner, Jeff Sanders, Amy Scott, and Erik Loomis. I also owe a real debt of gratitude to the lively and thoughtful students in my graduate seminar "Sally Hemings, Thomas Jefferson, and the Cultural Politics of History": Heather Baures, Adam Blahut, Kent Blansett, Heather Dahl, Kate Meyers, Allison Paskett, and Rebecca Vanucci.

The Huntington Library awarded me a Mellon Fellowship, and I spent a remarkably productive four months using their rich collections and enjoying the incredible community of Huntington Fellows. Thanks to Roy Ritchie, W. M. Keck director of research, Laura Stalker and the library staff, and Susi Krasnoo, for all they did to assist me. For amazing conversations over lunches at the Rose Garden and food and beverages in other places, I thank Jared Farmer, Jonathan Earle, Leslie Tuttle, Karen Halttunen, Deborah Harkness, Mae Ngai, Terri Snyder, Hal Barron, Mac Rohrbaugh, Sarah Hanley, David Igler, Bill Deverell, Peter Mancall, and Lisa Bitel. I was also privileged to present a portion of this work at the Huntington's wonderful "Past Tense" seminar, and for that I thank conveners Thomas Andrews, Laura Mitchell, and Jenny Price, and everyone who contributed to a great discussion.

My time in Los Angeles was immeasurably enriched by my work as Women of the West chair at the Autry National Center of the American West. I am so grateful to my friends and great thinking partners there, foremost among them Carolyn Brucken, Stephen Aron, Amy Green, and John Gray. Steve and Amy, and their sons Daniel and Jack, have opened their home to me and made me a part of their family over the years I've been traveling to Los Angeles. I've had the enormous pleasure of collaborating with Carolyn, one of the most insightful, intellectually generous, funny, and warmhearted people I've ever known. John's visionary leadership has inspired me and helped me to grow into the job. And all of them made it possible for me to fulfill my commitments to the Autry while also moving to the East Coast for a year. Knowing them, and being part of the Autry, has been one of the great joys of my life.

I would not have been able to write this book without the unparalleled people and resources of the International Center for Jefferson Studies, at Monticello. And I cannot imagine a better place to spend a month in residence than the Roosevelt Cottage at the ICJS. Everyone made me welcome, answered endless queries, offered indispensable advice, assistance, and information, and opened every door for me. It was a privilege to present my Fellows' lecture to a standing-room-only gathering of people who know more about Thomas Jefferson than any group of humans anywhere else on the planet. Boundless thanks to Saunders director Andrew O'Shaughnessy, Joan Hairfield, Cinder Stanton, Gaye Wilson, Leni Sorensen, Derek Wheeler, Jack Robertson, Anna Berkes, Eric Johnson, Leah Stearns, Carrie Taylor, Wayne Mogielnicki, Lisa Francavilla, and Marjorie Webb, at the ICJS, and Susan Stein, Elizabeth Chew, and Diane Ehrenpreis at Monticello for so generously sharing your knowledge, time, help, and encouragement. At the Albert and Shirley Smalls Special Collections Library at the University of Virginia, I want to thank all the librarians and archivists who helped me, particularly Margaret Raby, and Kristy Haney and Jeanne Pardee for their assistance with digital images. Susan Kern and Carl Lounsbury gave me the gift of their vast knowledge of Virginia history, architecture, and culture, and Reuben and Sue Rainey made me welcome in Charlottesville. Brian Truzzie, history

388 💥 ACKNOWLEDGMENTS

specialist at the Chesterfield County Parks and Recreation Department, took me on an amazing visit to Eppington.

Virginia Woolf said that women must have money and a room of their own in order to write. Yale University gave me far more than that. During my year as Beinecke senior research fellow in the Lamar Center for Frontiers and Borders at Yale, I lived the scholar's and writer's dream. Friends have been telling me for years what a happy privilege it is to know Howard and Shirley Lamar, and now I know what they mean. Johnny Faragher and Michelle Hoffnung, George and Nancy Miles, and Jay Gitlin and Ginny Bales made me so very welcome at the Lamar Center and the Beinecke, and I thank them along with Edith Rotkopf and Priscilla Holmes. I can't overestimate the generosity of colleagues including David Blight, John Demos, Paul Sabin, Beverly Gage, Alyssa Mt. Pleasant, Taylor Spence, Honor Sachs, Catherine McNeur, Christine DeLucia, Paul Shin, Ryan Hall, and all the folks at the Wednesday Lamar Center lunches. I must also mention my Lamar Center lecture, accompanied by a never-tobe-forgotten Derby Party and the vocal stylings of, well, everyone. Thanks, too, to the Writing History Group, a source of so many great conversations and ideas. Jonathan Holloway invited me to become a Calhoun College Fellow for the year and gave me the opportunity to present a Fellows' lecture. Dr. Ruth Westheimer offered enthusiasm and excellent advice about Jefferson, women, and being the mother of the groom. And I really appreciate the pleasure of connecting with old friends who made me feel right at home on the East Coast: hosts par excellence Geof and Mary Ann Bonenberger, Craig Pinto, Chris Romney, Tom Jacobson, Nomi and John Stadler, Michael Davis, and Donna Fish.

I am grateful to Carrie Supple and Elaine Grublin, of the Massachusetts Historical Society, Joellen ElBashir, of the Moorland-Spingarn Research Center at Howard University, and Emily Howie and Julie Miller, at the Library of Congress, for assistance with their essential Jefferson collections, and to Andrea Ashby at Independence National Historical Park and Dan Barkley at Zimmerman Library at UNM for his help. Marco Sioli, distinguished historian of early America at the University of Milan, not only arranged for me to visit the Maria Cosway archive at the Fondazione Maria Cosway in Lodi, but also drove me there and translated for me. And have I mentioned that he is a terrific cook, too? In Lodi, thanks to Giovanni Sacchi, secretary of the Fondazione Maria Cosway, and Tino Gipponi, the Cosways' biographer.

In a sense, this book originated over lunch with my literary agent, Elaine Koster, who asked me the question few writers dare ask themselves: "Tell me what book you burn to write." I have been the beneficiary of more than ten years of Elaine's wisdom, encouragement, knowledge, and advocacy. Carolyn Marino acquired the project for HarperCollins and has believed in me and helped me become a better writer for a decade. I am lucky now to be in the hands of my gifted editor at HarperCollins, Gail Winston, who has nurtured and shaped this book. Jason Sack has patiently answered myriad questions. Thomas F. Pitoniak provided expert copyediting. I am genuinely thrilled that Nick Springer, of Springer Cartographics, created the elegant map of the territory these women knew, traveled, and inhabited, which serves as the endpapers of this volume.

Over the years, many friends have watched this project develop from a thought, to a dream, to a reality. Katherine Jensen, Audie Blevins, Jean Owens Schaefer, David Robson, Bob Righter, Sherry Smith, Karen and Kent Anderson, and William H. Sewell, Jr., encouraged me in the early stages. Bill DeBuys, Dan Flores, Patricia Limerick, Elliott West, and Richard White have challenged and cheered me for longer than any of us cares to remember. Beverly Seckinger, Harriet Moss, Ernesto Sanchez, Laura Timothy, Greg Nottage, Mim Aretsky, Skip Gladney, Katie Curtiss, Hal Corbett, Colin Keeney, Beth Bailey, and David Farber have been more than patient, and have given me unstinting support and helpful suggestions. Dora Wang, my fellow author and delightful friend, has provided unending good counsel. Sally Denton, historian and writer extraordinaire, insisted, reasonably enough, that every American historian should kick off her or his research at the Library of Congress. Sally put me up in Washington, D.C., drove me to Monticello, made me laugh until I fell over, and continues to inspire me with her passion for history and her zest for life. Jon George, Carolina Gómez, María González, and Shannon Vigil often kept the wheels from flying off. Wendy and John Schmidt, and their wonderful children, Tom, Mike, and Allie, are the most delightful, stimulating family I have ever known. Wendy has been one of my closest friends for more than thirty-five years, and during my year at Yale, they showed me more love, hospitality, and joy than I can measure.

I could not ask for better colleagues and friends than the ones I have in the Department of History at the University of New Mexico. Linda Hall first urged me to write a book about Jefferson and women in 1997, and I've been grateful ever since. Melissa Bokovoy, Andrew Sandoval-Strausz, Cathleen Cahill, Tim Moy, Rebecca Ullrich, and Paul Hutton have been dear friends and intellectual companions on this journey. For more than twenty years now, Jane Slaughter and I have had occasionally "energetic" and yes, enlightening discussions about women's history, in a variety of places on two continents. I thank her for the unifying concept of this book and look forward to more spirited conversation, as much of it as possible in Italy.

I am lucky to have a family that has supported me in every way. Vi, Henry, and Sue Levkoff have given me a home away from home in New York, and I treasure my time with them. My brothers and sisters, especially Patty and Steve Bort, have cheered this project on. Kate Swift has been a mentor and a model as a writer, a feminist, and a person. Peter Swift has been a wonderful father to our two children, Sam and Annie Swift, now well embarked on adventures of their own and making us incredibly proud. I am excited to welcome Jessica Trujillo, a remarkable young woman, to our family.

A number of stalwart souls read all or part of the book manuscript and offered comments as scholars, and as the kind of readers every writer hopes to reach. Susan Kern provided invaluable insight into Jefferson's early life. Joshua Rothman offered suggestions regarding public knowledge of interracial intimacy in Jefferson's Virginia. Alfred Bush, Jan Shipps, and Janet and Bruce Brodie shared their deep knowledge of Jefferson's life and their insights into the politics of recent Jefferson scholarship. Amy Green and John Gray served as discerning lay readers. Stephen Aron urged me to state my big arguments more strongly, and to have courage (something he also recommends at the racetrack). Rick Hills contributed invaluable ideas about the connections between Jefferson's private life and public writings. Peter Mancall helped me see the larger historical context of my stories. Annette Gordon-Reed has served as both inspiration and critic, and generously took time from her busy schedule to offer careful comments that have immeasurably improved this book. Likewise, I can hardly express my gratitude for the support of and very detailed, indispensable reading by the foremost Jefferson scholar of our time, Lucia Stanton, Shannon senior historian at the International Center for Jefferson Studies.

Catherine Kurland deserves a special thanks for her meticulous and thoughtful editing of an early draft of this book. She became a real partner in the enterprise, and even better, a good friend. I look forward to many good times with her and John Serkin.

Three people have stood by my side every step of this journey, and if I could buy them all tickets to Paris, I would. My dear friends Marni

Sandweiss and Maria Montoya read multiple drafts of this manuscript, were available for endless conversations by phone and e-mail and over dinner, hosted me and feasted me, lived and breathed this book with me, and talked me off more than one ledge. I could not have written it without them. Chris Wilson, my partner, not only provided love and support, but read the book with the close and incisive eye of a brilliant historian, worked with me on the map, genealogical table, and images in this book, traveled with me to Virginia, Paris, and London, took photographs, looked after Benny the schnauzer, and kept the home fires burning while I was away. I cannot begin to thank him for all he's done. But now I have time to make a start.

Dramatis Personae

Thomas Jefferson's Grandparents, Parents, Uncles and Aunts, Cousins, Siblings and Their Spouses

- CAPTAIN ISHAM RANDOLPH: Father of Jane Randolph Jefferson, maternal grandfather of Thomas Jefferson, sea captain, merchant, planter.
- JANE LILBURNE ROGERS RANDOLPH: Mother of Jane Randolph Jefferson, maternal grandmother of Thomas Jefferson, b. Shadwell, England, about 1697; d. Virginia, 1761.
- PETER JEFFERSON: Jane Randolph's husband, father of Thomas Jefferson, b. Virginia, 1708; d. 1757.
- JANE RANDOLPH JEFFERSON: Mother of Thomas Jefferson, b. 1721, Shadwell, England; d. 1776, Virginia.
- WILLIAM ISHAM and THOMAS ESTON RANDOLPH: Brothers of Jane Randolph Jefferson; William, a Loyalist, moved to England before the American Revolution.

MARY RANDOLPH LEWIS: Sister of Jane Randolph Jefferson.

WILLIAM RANDOLPH: Jane R. Jefferson's cousin, great friend of Peter Jefferson, who "sold" him Shadwell for a bowl of punch; master of Tuckahoe.

394 🧏 DRAMATIS PERSONAE

- THOMAS MANN RANDOLPH, SR.: Eldest son of William Randolph; father of Thomas Mann Randolph, Jr.; father-in-law of Patsy Jefferson Randolph.
- JANE JEFFERSON (JANE JR.): Eldest of Jane and Peter Jefferson's children; sister of Thomas Jefferson, b. 1740 at Shadwell; d. 1765.
- MARY JEFFERSON BOLLING: Second child of Jane and Peter Jefferson; b. 1741 at Shadwell, married John Bolling, alcoholic brother-in-law of Thomas Jefferson.
- THOMAS JEFFERSON: Son of Peter Jefferson and Jane Randolph, married Martha Wayles Skelton, 1772; third president of the United States; b. 1743, d. 1826.
- ELIZABETH JEFFERSON: Mentally retarded younger sister of Thomas Jefferson; d. 1771.
- MARTHA JEFFERSON CARR: Younger sister of Thomas Jefferson, wife of Dabney Carr, Thomas Jefferson's best friend; b. 1746 at Tuckahoe.
- DABNEY CARR: Husband of Martha Jefferson; brother-in-law and best friend of Thomas Jefferson; d. 1773.
- PETER, SAMUEL, and DABNEY CARR, JR.: Thomas Jefferson's nephews, sons of Martha Jefferson Carr and Dabney Carr. Thomas Jefferson's grandchildren identified Peter and/or Samuel Carr as the father(s) of Sally Hemings's children.
- LUCY JEFFERSON LEWIS: Thomas Jefferson's younger sister; mother of Isham and Lilburne Lewis, who in 1811 murdered a seventeenyear-old enslaved man; b. 1752 at Tuckahoe.
- CHARLES LILBURN LEWIS: Husband (and first cousin) of Lucy Jefferson, and son of Thomas Jefferson's aunt Mary Randolph and Charles Lewis.
- ANNA SCOTT JEFFERSON ("NANCY") MARKS: Thomas Jefferson's youngest sister, twin, wife of Hastings Marks, b. 1755, Shadwell.

- RANDOLPH JEFFERSON: Thomas Jefferson's youngest brother, twin, b. 1755, Shadwell.
- JOHN GARLAND JEFFERSON: Grandson of Thomas Jefferson's uncle, involved in 1790 altercation with James Rind and Peter Carr.

The Wayles and Eppes Families

- JOHN WAYLES: Planter and lawyer, master of the Forest plantation. Father of Martha Jefferson and three other Wayles daughters, and of Sally Hemings and five other Hemings sons and daughters; b. 1715, Lancaster, England; d. 1773.
- MARTHA EPPES WAYLES: Daughter of Francis Eppes IV and Sarah Eppes, mother of Martha Jefferson, died in childbirth. Inherited Elizabeth Hemings and her African mother.
- [?] COCKE WAYLES: Second wife of John Wayles; first name unknown; mother of Martha Jefferson's half-sisters, Elizabeth, Anne, and Tabitha.
- ELIZABETH LOMAX SKELTON: Third wife of John Wayles, widow of Reuben Skelton. Inherited from her first husband Elk Hill plantation, later residence of Martha Jefferson.
- MARTHA WAYLES SKELTON JEFFERSON ("PATTY"): Wife of Thomas Jefferson, daughter of John Wayles and Martha Eppes, widow of Bathurst Skelton, half-sister of Sally Hemings, mother of Patsy and Polly Jefferson; b. 1748, d. 1782.

BATHURST SKELTON: First husband of Martha Jefferson, d. 1768.

- JOHN SKELTON, son of Bathurst Skelton and Martha Wayles (Jefferson); b. 1767; d. 1771.
- ELIZABETH WAYLES EPPES ("BETSY"): Second daughter of John Wayles, half-sister of Martha Jefferson and Sally Hemings, wife

396 🎽 DRAMATIS PERSONAE

of Francis Eppes V, mother of John Wayles Eppes, and surrogate mother to Polly Jefferson.

- ANNE WAYLES SKIPWITH ("NANCY"): Third daughter of John Wayles, half-sister of Martha Jefferson and Sally Hemings, wife of Henry Skipwith.
- TABITHA WAYLES SKIPWITH ("TIBBY"): Fourth daughter of John Wayles, half-sister of Martha Jefferson and Sally Hemings, wife of Robert Skipwith; d. before 1773.
- FRANCIS EPPES V: Husband of Elizabeth Wayles Eppes, first cousin of Martha Jefferson, master of Eppington, close friend of Thomas Jefferson.
- RICHARD HENRY EPPES: Teenage half-brother of Francis Eppes V, murdered in 1766 by fourteen-year-old-slave girl, Sukey.

JOHN WAYLES EPPES ("JACK"): Eldest son of Elizabeth and Francis Eppes, nephew and protégé of Thomas Jefferson, husband of Polly Jefferson.

MARTHA JONES EPPES: Second wife of Jack Eppes.

Children and Grandchildren of Thomas Jefferson and Martha Wayles Skelton Jefferson, and Their Spouses

MARTHA JEFFERSON RANDOLPH ("PATSY"): Eldest daughter of Thomas Jefferson; married Thomas Mann Randolph, Jr.; mother of twelve; mistress of Edgehill and Monticello; b. 1772, d. 1836. JANE RANDOLPH JEFFERSON: Second daughter of Thomas Jefferson

and Martha Wayles Skelton Jefferson; died in infancy.

MARY JEFFERSON EPPES (MARIA, "POLLY"): Second daughter of Thomas Jefferson and Martha Wayles Skelton Jefferson to survive to adulthood; married John Wayles Eppes; mother of Francis Eppes and Maria Eppes; resident of Eppington; b. 1778, d. 1804.

- LUCY ELIZABETH JEFFERSON: Daughter of Thomas Jefferson and Martha Wayles Skelton Jefferson; died in infancy.
- LUCY ELIZABETH JEFFERSON II: Daughter of Thomas Jefferson and Martha Wayles Skelton Jefferson; d. 1784 at Eppington.
- THOMAS MANN RANDOLPH, JR. ("TOM"): Husband of Patsy Jefferson; legislator, congressman, and governor of Virginia; planter.
- ANNE CARY RANDOLPH BANKHEAD: Eldest grandchild of Thomas Jefferson; eldest daughter of Patsy and Tom Randolph.

CHARLES BANKHEAD: Husband of Anne Randolph Bankhead.

- THOMAS JEFFERSON RANDOLPH ("JEFF"): Eldest son of Patsy and Tom Randolph.
- ELLEN RANDOLPH: Daughter of Patsy and Tom Randolph; died in infancy.
- ELLEN WAYLES RANDOLPH COOLIDGE: Daughter of Patsy and Tom Randolph; married Joseph Coolidge.
- JOSEPH COOLIDGE: Boston merchant and husband of Ellen Randolph.
- CORNELIA JEFFERSON RANDOLPH: Daughter of Patsy and Tom Randolph; never married.
- VIRGINIA JEFFERSON RANDOLPH: Daughter of Patsy and Tom Randolph; married Nicholas Trist.
- NICHOLAS TRIST: Husband of Virginia Randolph, grandson of Thomas Jefferson's friend Eliza House Trist.
- MARY JEFFERSON RANDOLPH: Daughter of Patsy and Tom Randolph; never married.

JAMES MADISON RANDOLPH: Son of Patsy and Tom Randolph; born in the White House.

BENJAMIN FRANKLIN RANDOLPH: Son of Patsy and Tom Randolph. MERIWETHER LEWIS RANDOLPH: Son of Patsy and Tom Randolph. SEPTIMIA ANNE RANDOLPH MEIKLEHAM: Youngest daughter of Patsy and Tom Randolph; married Dr. David Scott Meikleham.

398 🧚 DRAMATIS PERSONAE

- GEORGE WYTHE RANDOLPH: Youngest son of Patsy and Tom Randolph.
- SARAH NICHOLAS RANDOLPH: Daughter of Thomas Jefferson Randolph, great-granddaughter of Thomas Jefferson, author of *The Domestic Life of Thomas Jefferson*.

JOHN RANDOLPH OF ROANOKE: Cousin of Thomas Mann Randolph.

Sally Hemings's Family

CAPTAIN HEMINGS: Grandfather of Sally Hemings, English whaling vessel captain.

"AFRICAN WOMAN": Grandmother of Sally Hemings.

JOHN WAYLES: Father of Sally Hemings; see above.

- ELIZABETH HEMINGS ("BETTY"): Mother of Sally Hemings, inherited by Martha Jefferson; housekeeper at the Forest, Elk Hill, Monticello.
- MARY HEMINGS: Eldest daughter of Betty Hemings and unknown father; common-law wife of Charlottesville merchant Thomas Bell; mother of four children, including Joseph Fossett (enslaved carpenter freed by Thomas Jefferson, probably son of English carpenter William Fossett) and Betsy Hemmings, who was concubine or close companion to John Wayles Eppes. Never freed.
- THOMAS BELL: Charlottesville merchant and friend of Thomas Jefferson; father of Mary Hemings's children, Robert Washington Bell and Sally Jefferson Bell, who were freed in Bell's will and heirs to his property.

MARTIN HEMINGS: Eldest son of Betty Hemings and unknown father. BETTY BROWN: Daughter of Betty Hemings and unknown father, maid to Martha Jefferson; mother of Wormley Hughes, master gardener at Monticello; mother of Burwell Colbert, Thomas Jefferson's butler and valet. Burwell Colbert was freed by Thomas Jefferson's will.

NANCE HEMINGS: Daughter of Betty Hemings and unknown father.

ROBERT HEMINGS: Son of Betty Hemings and John Wayles; freed by Thomas Jefferson.

- JAMES HEMINGS: Son of Betty Hemings and John Wayles; trained as French chef; freed by Thomas Jefferson.
- THENIA HEMINGS: Daughter of Betty Hemings and John Wayles; sold by Thomas Jefferson to James Monroe.
- CRITTA HEMINGS: Daughter of Betty Hemings and John Wayles; never freed.
- PETER HEMINGS: Son of Betty Hemings and John Wayles; trained in French cuisine by his brother James; listed as free at the end of his life.
- SALLY HEMINGS: Youngest daughter of Betty Hemings and John Wayles; concubine of Thomas Jefferson; mother of six children likely fathered by Thomas Jefferson; given "her time" by Patsy Randolph after Thomas Jefferson's death; b. 1773, d. 1835.
- JOHN HEMINGS: Also known as John Hemmings. Youngest son of Betty Hemings and unknown father, probably Thomas Jefferson's English carpenter Joseph Neilson.
- LUCY HEMINGS: Youngest child of Betty Hemings and unknown father, probably Joseph Neilson.
- HARRIET HEMINGS: Oldest child of Thomas Jefferson and Sally Hemings; died at the age of two.
- BEVERLY HEMINGS: Oldest son of Thomas Jefferson and Sally Hemings; "ran away" from Monticello in 1822.
- HARRIET HEMINGS II: Daughter of Thomas Jefferson and Sally Hemings; "ran away" from Monticello in 1822.
- JAMES MADISON HEMINGS: Son of Thomas Jefferson and Sally Hemings; freed in Thomas Jefferson's will.

400 🏋 DRAMATIS PERSONAE

THOMAS ESTON HEMINGS JEFFERSON: Son of Thomas Jefferson and Sally Hemings; freed in Thomas Jefferson's will.

Other Significant People

- JUPITER: Slave at Shadwell and Monticello, Thomas Jefferson's valet and stable master, husband of Suck.
- SALL: Enslaved woman at Shadwell; mother of Jupiter, Lucinda, "Little Sall," and Caesar.
- MYRTILLA: Enslaved woman at Shadwell, mother of Fanny.
- HANNAH: Enslaved woman at Shadwell; sent to Randolph Jefferson's Snowdon plantation; possibly beaten to death.
- ISAAC BATES: Overseer at Snowdon who beat a slave named Hannah to death.
- REVEREND CHARLES CLAY: Episcopal minister, lifelong friend of Thomas Jefferson.
- DR. GEORGE GILMER: Doctor at Shadwell.
- REVEREND JAMES MAURY: Thomas Jefferson's tutor.
- BENJAMIN SNEAD: Tutor for Jefferson daughters and Randolph Jefferson.
- DR. THOMAS WALKER and JOHN HARVIE: Executors of Peter Jefferson's estate.
- JOHN MURRAY, FOURTH EARL OF DUNMORE: Royal governor of Virginia who attempted to incite slaves to revolt against rebel masters at the onset of the Revolution.
- GEORGE GRANGER ("Great George"): Enslaved overseer at Monticello.
- URSULA GRANGER: Enslaved cook, nurse, and slaughterer at Monticello, taken captive by the British.

- ISAAC JEFFERSON: Son of Ursula and George Granger, brother of George and Bagwell Granger; taken captive by the British.
- BARON and BARONESS VON RIEDESEL: German prisoners of war, friends of Thomas Jefferson and Martha Wayles Skelton Jefferson during Revolution.
- JOHN CHISWELL: Indebted planter, client of John Wayles.
- ROBERT ROUTLEDGE: Virginia merchant said to have murdered Chiswell.
- WILLIAM RIND: Publisher of Virginia Gazette's attacks on John Wayles.
- JAMES RIND: Lawyer and duelist; son of William Rind and brother of William Rind; involved in altercation with Peter Carr and John Garland Jefferson; lawyer for James T. Callender.
- WILLIAM RIND, JR.: brother of James Rind; publisher of *Virginia Federalist*.
- JAMES THOMSON CALLENDER: Republican publisher and scandalmonger who exposed Thomas Jefferson's liaison with Sally Hemings.
- ANDREW RAMSAY: Captain of the *Robert*, the ship on which Polly Jefferson and Sally Hemings sailed to London in 1787.
- ABIGAIL ADAMS: Wife of John Adams and friend of Thomas Jefferson; hosted Polly Jefferson and Sally Hemings in London.
- ANNE WILLING BINGHAM: Daughter and wife of Philadelphia bankers and friend of Thomas Jefferson in Paris.
- MARIA HADFIELD COSWAY: Anglo-Italian artist and musician, great friend of Thomas Jefferson.

RICHARD COSWAY: Artist and husband of Maria Cosway.

EDMUND BACON: Thomas Jefferson's overseer at Monticello.

Notes

ABBREVIATIONS

Personal names, manuscript collections, and short titles for works frequently cited are identified by the following:

Bear James A. Bear, Jr., Jefferson at Monticello: Recollections of a Monticello Slave and of a Monticello Overseer (Charlottesville: University Press of Virginia, 1999)

Brodie Fawn Brodie, Thomas Jefferson: An Intimate History (New York: Norton, 1974)

Domestic Life Randolph, Sarah Nicholas. The Domestic Life of Thomas Jefferson (New York: Harper & Brothers, 1871)

- Family Letters Edwin Morris Betts and James Adam Bear, Jr., eds., The Family Letters of Thomas Jefferson (Charlottesville: University Press of Virginia, 1995)
- Farm Book Edwin Morris Betts, ed., Thomas Jefferson's Farm Book (Charlottesville, Va.: Thomas Jefferson Memorial Foundation, 1999)
- FLP Family Letters Project, Thomas Jefferson Foundation, The Papers of Thomas Jefferson: Retirement Series, at www.monticello.org/papers/index.html
- Free Some Day Lucia C. Stanton, Free Some Day: The African-American Families of Monticello (Charlottesville, Va.: Thomas Jefferson Foundation, 2000)
- Garden Book Edwin Morris Betts, ed., Thomas Jefferson's Garden Book (Philadelphia: American Philosophical Society, 1944)
- Hemingses Annette Gordon-Reed, The Hemingses of Monticello: An American Family (New York: Norton, 2008)

ICJS International Center for Jefferson Studies

Kern Susan Kern, "The Jeffersons at Shadwell: The Social and Material World of a Virginia Family" (Ph.D. diss., College of William and Mary, 2005)

Life Henry S. Randall, The Life of Thomas Jefferson, 3 vols. (New York: Derby & Jackson, 1858)

LOC Library of Congress

Malone Dumas Malone, Jefferson and His Time, 6 vols. (Boston: Little, Brown, 1948)

MB James A. Bear, Jr., and Lucia C. Stanton, eds., Jefferson's Memorandum Books: Accounts, with Legal Records and Miscellany, 1767–1826, 2 vols. (Princeton, N.J.: Princeton University Press, 1997)

MJE Mary Jefferson Eppes

MJR Martha Jefferson Randolph

- MWSJ Account Book Martha Wayles Skelton Jefferson Account Book, Library of Congress
- Papers Julian Boyd, ed., The Papers of Thomas Jefferson, 35 vols. to date (Princeton, N.J.: Princeton University Press, 1950-), vol. 1
- Parton James Parton, Life of Thomas Jefferson, Third President of the United States (Boston: James R. Osgood, 1874)

SH Sally Hemings

SSCL Albert and Shirley Small Special Collections Library, University of Virginia

TJ Thomas Jefferson

TJ and SH Annette Gordon-Reed, Thomas Jefferson and Sally Hemings: An American Controversy (Charlottesville: University Press of Virginia, 1997)

TMR Thomas Mann Randolph, Jr.

INTRODUCTION

- xiii "We are his children": Mary Jefferson Randolph to Ellen Randolph Coolidge, November 26, 1826; Cornelia Jefferson Randolph to Ellen Wayles Randolph Coolidge, December 11, 1826, Transcripts of Manuscript, Correspondence of Ellen Wayles Randolph Coolidge, SSCL, University of Virginia, FLP.
- xvi Writing about the heroic Jefferson: See Fawn M. Brodie, "Jefferson Biographers and the Psychology of Canonization," *Journal of Interdisciplinary History* 2 (1971), 155-71; Annette Gordon-Reed, *Thomas Jefferson and Sally Hemings: An American Controversy* (Charlottesville: University Press of Virginia, 1997).
- xvii They have shadowed one another: The interracial Wayles-Jefferson-Eppes-Hemings family was far from unusual in their place and time, as historian Joshua D. Rothman demonstrated in his masterful study, Notorious in the Neighborhood: Sex and Families across the Color Line in Virginia, 1787–1861 (Chapel Hill: University of North Carolina Press, 2003).
- xvii To this day, many who revere: Brodie; Virginia Scharff, "What's Love Got to Do with It? A New Turner Thesis," Western Historical Quarterly 40 (Spring 2009), 5-21.
- xvii Much has changed since Brodie's time: TJ and SH; Eugene A. Foster et al., "Jefferson Fathered Slave's Last Child," Nature 396 (November 1998), 27–28. In addition to the documentary and genetic evidence, see also the statistical argument in Fraser D.

Neiman, "Coincidence or Causal Connection? The Relationship between Thomas Jefferson's Visits to Monticello and Sally Hemings's Conceptions," Forum: Thomas Jefferson and Sally Hemings Redux, William and Mary Quarterly, 3d series, vol. 57, no. 1 (January 2000), 198–210; Hemingses. For a full listing of resources on the DNA controversy and the Hemings-Jefferson relationship, see http://www.monticello.org/plantation/hemingscontro/hemings_report.html.

xxi These sources make it possible to know: MB; Kern; Thomas Jefferson Papers, 1606-1827, http://memory.loc.gov/ammem/collections/jefferson_papers; FLP.

1: THE PLANTER'S DAUGHTER

- 3 The Randolph clan: Jonathan Daniels, *The Randolphs of Virginia* (Garden City, N.Y.: Doubleday, 1971); Arthur Pierce Middleton, *Tobacco Coast: A Maritime History of Chesapeake Bay in the Colonial Era* (Newport News, Va.: Mariners' Museum, 1953), 110.
- 3 One such guest: Daniels, The Randolphs of Virginia, 37.
- 4 The Randolph family sailed: "Jefferson Family Bible, 1752–1861," accession 4726, SSCL, University of Virginia. See Peter Jefferson's list of birth dates and birthplaces of Jane Randolph Jefferson and siblings.
- 4 In times of war: Middleton, Tobacco Coast.
- 5 Even on voyages where stores were abundant: Ibid.,1-15.
- 5 Captain Randolph's English wife: Kern, 30.
- 5 Isham's business interests: The British slave trade had opened to private merchants in 1712. Stephen A. Flanders, *The Atlas of American Migration* (New York: Facts on File, 1998), 52.
- 5 Scarcely sixty years earlier: Kathleen M. Brown, Good Wives, Nasty Wenches, and Anxious Patriarchs: Gender, Race, and Power in Colonial Virginia (Chapel Hill: University of North Carolina Press, 1996), 133-36.
- 6 Isham Randolph traded the ocean: Daniels, Randolphs of Virginia; Parton; Life.
- 7 A portrait of Isham: www.vahistorical.org/dynasties/IshamRandolph.htm.
- 7 His Dungeness estate: Kern, 20-21.
- 7 The household was stocked: Parton, 5.
- 7 When Collinson's friend: Daniels, Randolphs of Virginia, 7.
- 7 "One thing I must desire": Ibid.
- 8 Daughter Jane: Kern, 475, transcribes Peter Jefferson's list of "Births and Deaths of the Sons and Daughter[s] of Isham Randolph by Jane his Wife, with whom he intermarried in Byshopsgate chur[ch?] in London the 25th, July 1717," University of Virginia 4726.
- 9 According to family tradition: Ellen Randolph Coolidge, quoted in Brodie, 681, n. 29.
- 10 In 1724: Virginia Magazine of History and Biography 14, no. 3 (January 1907), 226–27; Middleton, Tobacco Coast, 48–49.

406 🧩 NOTES

- 10 The rigors of such a life: Jane Rogers Randolph evidently developed such a capacity for command that Isham Randolph took the extraordinary step of appointing his wife as executor of his estate; Kern, 169.
- 11 "approved the sometimes savage punishments": Daniels, Randolphs of Virginia, 53.
- 12 A 1722 plot: Mary Miley Theobald, "Slave Conspiracies in Colonial Virginia," Colonial Williamsburg Journal (Winter 2005-6).
- 12 Insurrection scares and real plots: Adele Hast, "Legal Status of the Negro in Virginia," Journal of Negro History 54 (July 1969).
- 13 In 1730, when Jane was ten: Theobald, "Slave Conspiracies."
- 13 Our glimpses of Isham: Virginia Magazine of History and Biography 14, no. 3, 225.
- 13 He was thirteen years older: Malone, 1:3, 10; Paul Leicester Ford, ed., "Autobiography of Thomas Jefferson," in *Writings of Thomas Jefferson*, 10 vols. (New York: Putnam's, 1892-99); Parton, 9.
- 13 As for her temperament: Domestic Life, 21-22.
- 14 "an agreeable, intelligent woman": Life, 1:16-17.
- 14 "Possibly the Dungeness family": H. J. Eckenrode, *The Randolphs: The Story of a Virginia Family* (Indianapolis and New York: Bobbs-Merrill, 1946), 145-46.
- 15 Her father promised her husband: Virginia Magazine of History and Biography, 14, no. 3, 226.
- 15 Whatever Isham Randolph's intentions: Malone, 1:17.

2: THE PLANTER'S WIFE

- 16 Peter did what he could: On plantation life and landscape, see Rhys Isaac, The Transformation of Virginia, 1740–1790 (Chapel Hill: University of North Carolina Press, 1999), especially pp. 32–3. On Peter Jefferson's plans, see Malone, 1:10, 17. Arrack was an East Indian liquor made from coconut juice. See MB 1:143 n93.
- 17 In eighteenth-century Virginia: On death in childbirth in eighteenth-century America, see http://www.digitalhistory.uh.edu/historyonline/childbirth.cfm. "Account Book of Peter Jefferson" records a payment on August 27, 1758, of two pounds to Mrs. Jane Jefferson "to pay midwives for 4 Negroe wenches," HM912:26, Huntington Library. Although identified in the Huntington collections as Peter Jefferson's book, this ledger was probably a copy made by executor John Harvie.
- 18 The Jeffersons would ultimately have: Kern brilliantly reconstructs the material culture, daily rhythms, and social structure of the Jeffersons' life on their plantation.
- 19 For one thing: Kern, 88.
- 19 His earliest recollection: Domestic Life, 6.
- 19 At Tuckahoe: Malone, 1:20.
- 20 This was also the time: Ibid., 22-25.
- 20 Back home at Shadwell: Kern, 467.

- 20 The Jeffersons' newly expanded story-and-a-half house: Kern, 36-44.
- 21 Shadwell was a busy: Garden Book, 4-5.
- 21 Jane had grown up in a family: "Inventory of the Estate of Peter Jefferson," HM 912, Huntington Library; Kern, 110; *Garden Book*, 4–5.
- 21 The people at Shadwell: Kern, 456.
- 21 There were sheep: MB 1:406
- 22 Jane's daughters: Kern, 108, 116, 457.
- 22 But Jane also paid: "Account Book of Peter Jefferson."
- 22 Generation after generation: See, for example, Ellen Wayles Randolph to MJR, September 27, 1816; Ellen Wayles Randolph to Nicholas Trist, March 30, 1824; Cornelia Jefferson Randolph to Ellen Wayles Randolph Coolidge, August 3, 1825, Transcripts of Manuscripts, Correspondence of Ellen Wayles Randolph Coolidge, SSCL, University of Virginia, FLP.
- 23 Much later, Jefferson recalled: Brodie, 54, citing Randall, Jefferson, 1:131.
- 23 Their literate mother: Malone, 1:22; "Account Book of Peter Jefferson," 29 facing, 36 facing; Jane and her daughter Jane Jr. were unusual women in that they counted books among their personal property; see Kern, 104.
- 23 Peter's "tastes approached to the elegant": Life, 1:14.
- 24 Peter was fifty years old: "Account Book of Peter Jefferson"; Kern, 133-34, 164-66, 194.
- 26 "How different is the stake": Brodie, 529, fn. 9, citing TJ to TMR, June 23, 1806, University of Virginia. Much to TJ's relief, the dual between Thomas Mann Randolph and John Randolph of Roanoke was averted.
- 27 Thus Jane was spared the fate: As would befall Dolley Madison. See Catherine Allgor, A Perfect Union: Dolley Madison and the Creation of the American Nation (New York: Henry Holt, 2006), 351–53.

27 There was money enough: "Account Book of Peter Jefferson."

3: THE WIDOW JEFFERSON

- 28 Jane owned a woman named Sall: Kern, 129, 293-94.
- 29 Thomas was then studying the law: Malone, 1:49-143.
- 29 Thomas Jefferson recorded his delight: Garden Book, 4-5. Regarding the gardening pursuits of Squire and Caesar, see *Twinleaf Journal*, http://www.twinleaf.org/ articles/aagardens.html.
- 30 Jane's children learned to look to marriage: Kern, 94, 366-67.
- 31 Mary Jefferson Bolling kept in close touch: Kern, 393, 397.
- 31 Henry Randall offered: Life, 1:82-83.
- 32 When Thomas Jefferson visited: Thomas Jefferson to John Page, February 21, 1770, *Papers*, 1:36.
- 32 This young woman: Life, 1:40-41.
- 33 Young Jane Jefferson: Kern, 457-58.

- 33 In December 1771: MB 1:246-47, n. 56.
- 33 A fourth Jefferson daughter: Ibid., 144.
- 34 Thomas Jefferson and his mother: Purdie and Dixon, Virginia Gazette, February 22, 1770, cited in Malone, 1:126; and TJ to John Page, February 21, 1770; Papers, 1:35.
- 34 Nobody suggested: MB 1:158-59, n. 43, citing George Tucker, The Life of Thomas Jefferson (Philadelphia, 1837), 1:47.
- 34 An enslaved man: MB 200.
- 35 One other longtime member: Ibid.; Jefferson's MB 81, records a 1768 entry "Gave Harry and Myrtilla order on R. Harvie for goods to 16/6." N. 27: eds. Note that "Harry was a farm laborer inherited from PJ [Peter Jefferson]. He joined the British in 1781." According to historian Steven Hochman, as late as 1774 Thomas Jefferson had only sold one enslaved person: Myrtilla. See Steven Hochman, "Thomas Jefferson: A Personal Financial Biography" (Ph.D. diss., University of Virginia, 1987), 72.
- 36 The fire also threatened the security: Kern, 228.
- 37 While the site of the Shadwell house: Ibid., 470.
- 37 Jane and Elizabeth and Anna: Life, 1:58-59.

4: THE REVOLUTIONARY'S MOTHER

- 38 On a September day in 1772: Jefferson Family Bible, 1752-1861. Kern, 459-85, provides a masterful analysis of the significance of Jane Jefferson's Bible.
- 38 On the page facing: Kern, 79-132, 459-91.
- 39 Perhaps it was the impending birth: MB 1:294 n. 82.
- 39 Only a month before: Malone, 1:170-71.
- 39 Martha had her baby: MB 1:341 n. 47. James Parton speculated that Carr had died from "a malignant type of typhoid fever"; Parton, 126–29.
- 39 In her later years: Domestic Life, 46; Randall, Life, 1:83-84.
- 40 The steamy heat of a Virginia summer: Garden Book, 40; MB 341 n. 47.
- 41 Jefferson distanced himself: Garden Book, 40.
- 41 Here lie the remains: Domestic Life, 47.
- 42 Perhaps the death of Dabney Carr: "Dr. George Gilmer's Feebook, 1767, 1771-1775," Gilmer-Skipwith Papers, University of Virginia, MSS 6145; Kern, 361; MB 1:147, 254, 335, 345, 351, 451 for medical bills, 346 for assumption of debts, 353 for Jane's accounts.
- 42 The Reverend Charles Clay: MB 1:370-71.
- 42 On February 21, 1774: Ibid., 369-70.
- 42 On March 1: Ibid., 370.
- 43 Her son eagerly joined: Malone, 1:170-71.
- 43 Lord Dunmore: Ibid., 180-81, MB 1:376 n. 29.
- 44 As he set out for Philadelphia: MB 1:396.
- 45 Certainly she could see the vast differences: Bernard Mayo, ed., Thomas Jefferson and His Unknown Brother, Randolph (Charlottesville: University Press of Virginia,

1942), reproduces all the known letters between these brothers in a slim volume. The birthing of twins was hazardous business in eighteenth-century Virginia. Some historians have speculated that both Randolph and Anna Scott Jefferson suffered brain damage in the birthing process and were forever after affected.

- 45 The wrath of the English authorities: Brodie, 131-32, 167-68.
- 45 Thomas Jefferson, then in Philadelphia: Robert Carter Nicholas to the Virginia Delegates in Congress, Williamsburg, November 25, 1775, *Papers*, 1:266.
- 46 The Jefferson family: On the lives of slaves at Shadwell, see Kern, 189-305.
- 46 Jane would not live: Brodie, 584. See Robert Penn Warren, Brother to Dragons: A Tale in Verse and Voices (Baton Rouge: Louisiana State University Press, 1996).
- 47 How loyal were the Jefferson family slaves: MB 81 records a 1768 entry "Gave Harry and Myrtilla order on R. Harvie for goods to 16/6." The editors note that "Harry was a farm laborer inherited from PJ [Peter Jefferson]. He joined the British in 1781."
- 47 Jane Jefferson lived out her last months: MB 1:415, TJ to Thomas Nelson, May 16, 1776; Papers, 1:292; TJ to William Randolph, ca. June 1776; Papers, 1:408-10.
- 50 As the historian Susan Kern has pointed out: Kern, 120-21.
- 50 Those who argue: Jack McLaughlin, Jefferson and Monticello: The Biography of a Builder (New York: Henry Holt, 1988), 46–47; Kenneth A. Lockridge, On the Sources of Patriarchal Rage: The Commonplace Books of William Byrd and Thomas Jefferson and the Gendering of Power in the Eighteenth Century (New York: New York University Press, 1992), 70.
- 50 They also point to the vicious misogyny: McLaughlin, Jefferson and Monticello; Lockridge, Patriarchal Rage, 70. See also Jon Kukla, Mr. Jefferson's Women (New York: Knopf, 2007).
- 50 We should recall: Brown, Good Wives, Nasty Wenches. See also Paige Raibmon, "Naturalizing Power: Land and Sexual Violence along William Byrd's Dividing Line," in Virginia J. Scharff, ed., Seeing Nature through Gender (Lawrence: University Press of Kansas, 2003), 20-39.
- 51 Those who have dismissed: Malone, 1:37; McLaughlin, Jefferson and Monticello, 46-47; Lockridge, Patriarchal Rage, 48, 70.
- 51 In the latter: Ford, ed., "Autobiography," 1:2.
- 51 He had also lived for more than six decades: See, for instance, Cynthia Kierner, Scandal at Bizarre: Rumor and Reputation in Jefferson's America (Charlottesville: University Press of Virginia, 2004); Boynton Merrill, Jefferson's Nephews: A Frontier Tragedy (Princeton, N.J.: Princeton University Press, 1976).
- 52 When Jane Jefferson wrote her family history: Kern, 470-75.
- 52 So what of the letter: Papers, 1:408.
- 53 Jefferson began his letter: Ibid., 1:408-10.
- 55 **"These facts have given":** "The Declarations of Jefferson and Congress" in Garry Wills, *Inventing America: Jefferson's Declaration of Independence* (New York: Vintage, 1978), 378.

- 55 Historian Joseph Ellis: Joseph Ellis, American Sphinx: The Character of Thomas Jefferson (New York: Vintage, 1998), 62.
- 56 On October 7, 1791: TJ to James Lyle, October 7, 1791, Jefferson Papers, Huntington Library, MSS HM5632; Papers, 22:201.
- 56 But here we also find the tenderness: Jefferson never did manage to pay off his mother's debts; see Papers, 28:417.
- 56 In this effort to finish paying off debts: TJ to John Bolling, Papers, 22:198.
- 56 And then, of course, there was her Bible: "Jefferson Bible," University of Virginia, Accession 4726.

5: THE DEBT COLLECTOR'S DAUGHTER

- 61 John Wayles of Virginia: The most thorough account of John Wayles's origins and life is in *Hemingses*, 57-76.
- 61 Yet he perpetually walked the line: On the emergence of the conflict between British merchants and Virginia planters, see Woody Holton, Forced Founders: Indians, Debtors, Slaves, and the Making of the American Revolution in Virginia (Chapel Hill: University of North Carolina Press, 1999), 39–73.
- 62 "a species of property": Quoted in Malone, 1:201.
- 62 When John Wayles came to visit: John M. Hemphill II, ed., "John Wayles Rates His Neighbours," Virginia Magazine of History and Biography 66, no. 3 (July 1958), 302–6.
- 62 Some offered bonds: Ibid., 303.
- 62 Others used their family connections: Ibid., 303.
- 62 A Mr. Syme: Ibid., 304.
- 62 He was, according to Thomas Jefferson: Ford, ed., "Autobiography," 1:6.
- 63 The first was the widow Martha Eppes Eppes: "Thomas Jefferson memorandum," Edgehill-Randolph Papers, University of Virginia, photocopy in "Martha Wayles Jefferson" information file, ICJS.
- 63 When she married John Wayles: Wills of Francis Eppes, Francis Eppes and Lewellin Eppes, Jr., transcribed by Diane Ehrenpreis, information file, "People—Martha Wayles Jefferson," ICJS.
- 63 She made a somewhat different arrangement: "Henrico Co. Will and Deed Book, C, 1744–1748," 132–34, transcribed by Diane Ehrenpreis in "Martha Wayles Jefferson File," ICJS. On the Eppeses, see *Hemingses*, 54. On the doctrine of coverture, see Marylynn Salmon, *Women and the Law of Property in Early America* (Chapel Hill: University of North Carolina Press, 1989); Brown, *Good Wives, Nasty Wenches, and Anxious Patriarchs: Gender, Race, and Power in Colonial Virginia* (Chapel Hill: University of North Carolina Press, 1996); Carole Shammas, *A History of Household Government in America* (Charlottesville: University Press of Virginia, 2002).
- 64 Seven and a half months after they married: TJ, Memorandum on births and

deaths of Eppes and Wayles family members, Edgehill-Randolph Papers, University of Virginia, copy in "Martha Wayles Jefferson" information file, ICJS.

- 64 She delivered a daughter: Ibid.
- 64 By January 1760: Ibid.
- 64 We know all these things about the Wayles family: Ibid.
- 65 John Wayles, thrice wifeless: On the concept of concubinage, see *Hemingses*, 106-7.
- 65 Elizabeth "Betty" Hemings: Brodie, 89. See Bear, 4; Gordon-Reed, Thomas Jefferson and Sally Hemings.
- 65 "grew rich himself": Hemingses, 61.
- 66 When Betty Hemings began her liaison: I follow Gordon-Reed in believing that Martha Wayles Skelton Jefferson must have known about her father's relationship with Elizabeth Hemings; ibid., 448. On John Wayles's bequest to Elizabeth Lomax Skelton Wayles, see "Jefferson Family," *Tyler's Quarterly Historical and Genealogical Magazine* 6, no. 3 (January 1925), 268–70, in information file, "People—John Wayles (Estate)," ICJS.
- 67 He observed in 1766: Hemphill, "John Wayles Rates His Neighbors," 305.
- 68 While her slaves performed the hardest and worst jobs: Martha Wayles Skelton Jefferson, 1772–82, Part B: Household Accounts, Thomas Jefferson Papers Series 7, Miscellaneous Bound Volumes, Library of Congress. On plantation mistresses' labor, see Catherine Clinton, *The Plantation Mistress* (New York: Pantheon, 1984); Brown, *Good Wives, Nasty Wenches;* Shammas, *Household Government.*
- 68 According to family tradition: Domestic Life, 43-44; Life, 1:63-64. Bear, 5.
- 69 She had, it seems, a sparkle: Robert Skipwith to TJ, September 20, 1771, Papers, 1:83-84.
- 69 Her granddaughter: Ellen Randolph Coolidge, cited in Domestic Life, 43-44.
- 69 This paragon of white southern womanhood: Ibid., 66.
- 69 In the summer of 1766: Holton, Forced Founders, 39-73.
- 69 John Wayles found himself to be: Hemingses, 74.
- 70 Wayles tried to refute: Ibid., 74-76.
- 70 In the same summer: Martha's first cousin: New-York Mercury, July 21, 1766, in America's Historical Newspapers, NewsBank and the American Antiquarian Society, 2004, http://infoweb.newsbank.com.
- 71 Local authorities wasted no time: John Frederick Dorman, Ancestors and Descendants of Francis Epes I of Virginia (Society of the Descendants of Francis Epes I of Virginia, 1992), 1:153, 2:397, ICJS.
- 72 The killing of Richard Henry Eppes: Ibid., 2:398.

6: BRIDE AND WIDOW

73 She married twenty-two-year-old Bathurst Skelton: TJ Memorandum, Edgehill-Randolph Papers. University of Virginia, ICJS; Inventory of Bathurst Skelton's estate, Charles City County Will Book, 1766–74, 525–27, copy in Monticello Women's Project files, "Martha Wayles Skelton Jefferson," ICJS; Marie Kimball, *Jefferson: The Road to Glory* 1743–1776 (New York: Coward-McCann, 1943), 169–70.

- 74 The Skeltons set up housekeeping at Elk Hill: Elie Weeks, "Thomas Jefferson's Elk-Hill," *Goochland County Historical Society Magazine* 3 (1971), 6-11; information file, "Places—Goochland County—Thomas Jefferson Land," ICJS.
- 74 They occupied a bluff-top brick house: Weeks, "Thomas Jefferson's Elk-Hill," 6-11; MB 1:329-32, 366; Malone, 1:162; Kimball, Road to Glory, 170.
- 74 Ten months later: "Jefferson Family," Tyler's Quarterly, 268.
- 75 Thus Martha, at the age of nineteen: Skelton left behind a young gentleman's accoutrements—in addition to his books, his horse and saddle, phaeton and harnesses, trunk and pocket instruments and razors—along with the basics of genteel housekeeping, silver flatware and cruets, copper plate warmers and chafing dishes, candlesticks, coffee pots, dishes and wash basins, along with four bottles of "mountain wine." But by far his most valuable inventoried assets were six enslaved adults and two children, valued together at £260, making up more than 80 percent of the value of his portable property. Inventory of Bathurst Skelton's estate, 525–27, ICJS.
- 75 Her father was a churchgoing man: See Rhys Isaac, The Transformation of Virginia, 1740–1790 (Chapel Hill: University of North Carolina Press, 1982).
- 75 He was an active member: *Hemingses*, 67. As Holton points out, William Byrd III, here identified as a friend of John Wayles, was another chronic debtor who was involved with John Chiswell in a failed mining scheme. Like Chiswell, Byrd took his own life. See Holton, *Forced Founders*, 43.
- 76 When Martha returned to the Forest: Farm Book, 26; Free Some Day, family tree inside back cover.
- 76 The law gave Martha Wayles Skelton a right to own property: The most thorough treatment of this subject is Brown, Good Wives, Nasty Wenches. See also Shammas, Household Government, and Jan Lewis, The Pursuit of Happiness: Family and Values in Jefferson's Virginia (New York: Cambridge University Press, 1983).
- 77 One such admirer: Jefferson paid the blacksmith at the Forest before heading back to Williamsburg: "Gave smith at Wayles's 1/3." MB 1:209.
- 77 Thomas Jefferson was a busy man: See Malone, 1:129-42.
- 77 And he was working frantically: Jefferson moved to his new home on the mountaintop on October 26, 1770, settled some business in Charlottesville, tended to his cases, and found his way back to the Forest by December 10. He was back again by December 20. MB 1:209, 212–13.
- 77 "Mr. Jefferson was generally": Life, 1:33-34.
- 78 Martha Skelton and Thomas Jefferson shared: Ibid., 65; Domestic Life, 44.
- 78 But they also had similar ideas: Parton, 101. On the cultures of sentiment and sensibility, see William Reddy, The Navigation of Feeling: A Framework for the History of Emotions (Cambridge, England: Cambridge University Press, 2001); Martha Tomhave Blauvelt, The Work of the Heart: Young Women and Emotion, 1780-1830

(Charlottesville: University Press of Virginia, 2007); Nicole Eustace, *Passion Is the Gale: Emotion, Power, and the Coming of the American Revolution* (Chapel Hill: University of North Carolina Press, 2008). On TJ and sentiment, see Wills, *Inventing America*.

- 79 By the beginning of 1771: TJ to James Ogilvie, February 20, 1771, Papers, 1:62-63.
- 80 A Quaker woman he knew from Williamsburg: Mrs. Drummond to TJ, March 12, 1771, ibid., 66.
- 80 And while Jefferson's letter: Hemphill, "John Wayles Rates His Neighbors," 306.
- 80 By the beginning of June: Life, 1:65.
- 82 As Jefferson looked forward to setting up housekeeping: TJ to Thomas Adams, June 1, 1771, Papers, 1:71–72.
- 82 Music, love, luxury, and indebtedness: Ibid.
- 83 Jefferson, for his part, prepared to take on a wife: TJ "Fee Book, 1764-74 [other accounts, 1764 to 1794]," HM 836, Huntington Library.
- 83 On May 26, a terrible flood: Garden Book, 27; MB 1:256; information file, "People– John Wayles," ICJS; Elizabeth Coleman, "The Great Fresh of 1771," Virginia Cavalcade 1 (1951), 20–22.
- 83 We don't know if little John Skelton was a sickly child: TJ memorandum, Edgehill-Randolph Papers, University of Virginia, ICJS; Malone, 1:158, 432.
- 84 "Come to the new Rowanty": TJ to Robert Skipwith, August 3, 1771, Papers, 1:78.
- 84 "Your invitation to the New Rowanty": Robert Skipwith to TJ, September 20, 1771, Papers, 1:83-84.
- 85 The pretty vision they shared: "Jefferson Family," Tyler's Quarterly, 269-70.

7: MR. AND MRS. JEFFERSON

- 86 Throughout the fall of 1771: MB 1:266, 284-85.
- 86 Finally, after all the delays: Papers, 1:86-87.
- 86 The guest list included: On Anne Wayles and Henry Skipwith, see MB 1:342. On Francis and Elizabeth Eppes and their home at Eppington, see "Places—Eppington," ICJS vertical file; Mary Miley Theobald, "Eppington," *Colonial Williamsburg* (Summer 1997), 54–60; Betty Woodson Weaver, "Mary Jefferson and Eppington," *Virginia Cavalcade* 19, no. 2 (Autumn 1969), 30–35. I am also grateful to Brian Truzzie, historic sites specialist for Chesterfield County, for materials on Eppington and for a tour of the house on June 20, 2008.
- 87 There was music and feasting: MB 1:285.
- 87 Martha Wayles Skelton and Thomas Jefferson made their vows: Church of England, Book of Common Prayer, and Administration of the Sacraments and Other Rites and Ceremonies of the Church: Together with the Psalter Or Psalms of David, Pointed as They are to be Sung Or Said in Churches (London: Joseph Bentham, 1765). Original from the New York Public Library, digitized August 2, 2006, 420 pages, books. google.com/books.

- 87 The ceremony began: Ibid.
- 88 By the time Martha and Thomas came together: Shammas, Household Government, 80.
- 88 "Gentle and sympathetic people": Malone, 1:158.
- 89 The historian Kathleen Brown: Brown, Good Wives, Nasty Wenches, 342.
- 89 The trip would become the stuff of family legend: Garden Book, 33; Life, 63–65; Parton, 102–3.
- 90 The place was dark, the hearth cold: Life, 1:64-65; Parton, 103.
- 90 Linger here a moment: TJ, Autobiography, The Thomas Jefferson Papers, Series 1. General Correspondence. 1606-51-1827, Thomas Jefferson, July 27, 1821, Autobiography Draft Fragment, January 6 through July 27, http://memory.loc.gov/ammem/ collections/jefferson_papers/.
- 90 Here is a picture of them: http://en.wikipedia.org/wiki/ossian.
- 91 a bed he had recently bought: MB 1:265.
- 91 Both she and Thomas generally traveled: Bear, 6; Hemingses, 114.
- 92 By February 2, they had relinquished: MB 1:286-301. MWSJ kept accounts that year, which TJ copied down. See MB 1:300.
- 93 She may have had some trouble: Ibid., 290.
- 93 Martha's book: MWSJ Account Book, Library of Congress.
- 94 As hard as they worked for their masters: On trade between masters and slaves, see Philip D. Morgan, Slave Counterpoint: Black Culture in the Eighteenth Century Chesapeake and Low Country (Chapel Hill: University of North Carolina Press, 1998), 358-61.
- 94 In the summer of 1772: MB 1:300-1.
- 94 The Monticello well was unreliable: Ibid., 291; McLaughlin, Jefferson and Monticello: 156–57.
- 94 For all the trouble Martha would later have: MWSJ Account Book.
- 95 John Wayles was worried: John Wayles to TJ, October 20, 1772, Papers, 1:95–96. On the voyage of the Prince of Wales, see the Transatlantic Slave Trade Database, http://www.slavevoyages.org/tast/database/search.faces. The clearest exposition of the Prince of Wales matter is in Hemingses, 68–69.
- 95 He went to a plantation called Maiden's Adventure: Bear, 3.
- 96 But the relationship between the mistress and her slave woman: MB 1:334; Free Some Day, 33-34. On the debt collection, see Hochman, "Thomas Jefferson," 72-73; Bear, 3. On Ursula's storytelling, see Rhys Isaac, "The First Monticello," in Peter Onuf, ed., Jeffersonian Legacies (Charlottesville: University Press of Virginia, 1993), 80.
- 96 Her sister Elizabeth Eppes: Dictionary of American Biography (New York: Scribner's, 1931); Dorman, Ancestors and Descendants of Francis Epes I, 1:399; "People— Jefferson Family—Eppes Family," vertical file, ICJS.
- 96 Martha had worries as well as joy: MWSJ Account Book.
- 96 Consequently, the Jeffersons were absent: MB 1:336-37.

- 97 Carr was feeling poorly: Elizabeth Dabney Coleman, "The Carrs of Albemarle County" (unpublished M.A. thesis: University of Virginia, 1944), cited in "People— General—Carr, Dabney," vertical file, ICJS.
- 97 Thomas Jefferson's terrible grief: TJ to the Reverend Charles Clay, May 21, 1773, Papers, 15:571.
- 97 **Carr's second grave:** Her housekeeping journal lapsed during that time, and we have other reason to think that she and Thomas were often apart during the spring of 1773. Martha Jefferson would prove to be a remarkably fertile woman. The patterns of her childbearing closely reflected the time she and Thomas were able to spend together during the course of their marriage. She did not become pregnant with their second child (her third) until late July or early August, when they were back at Monticello, MB 1:336–346; MWSJ Account Book; Malone, 1:434.
- 97 Historian Rhys Isaac: Isaac, "The First Monticello," 90-93.
- 98 He was still looking out for her: "Jefferson Family," Tyler's Quarterly, 269-70.
- 99 Wayles, however, made it clear: Ibid.
- 99 Martha chose not to intermingle: MB 1:329, fn. 13.

8: MARTHA'S PROPERTY

- 100 Thomas too was attending to his human property: MB 1:346, September 29, 1773: TJ takes "an appointmt. Of 11 slaves from my mother, revocable by her last will & paimt. Of all monies she shall owe me." These appear to be slaves from Peter Jefferson's estate and their children. According to footnote 64, "Although his mother's will devised four of the slaves to other children, TJ was never reimbursed for his disbursements of her behalf so that all of the slaves became his absolute property in 1777, one year after her death" (as per Fee Book: Jane Jefferson Account, Personal estate account, Misc. accts.: Jane Jefferson acct.) Huntington Library, HN 5572 FAC.
- 100 Now Martha had to make some decisions: MB 1:342-43; Free Some Day, p. 103.
- 101 The oldest Hemings sons: MB 1:342; *Farm Book*, 9. Mary Hemings, Elizabeth's oldest child and the mother of Daniel, was at Wingo's, or Poplar Forest, at this time. She later went to Monticello.
- 102 It was only three years since the murder: See chapter 3.
- 102 His brothers-in-law: MB 1:329, fn. 15.
- 102 Jefferson noted his intent: Ibid., 371.
- 103 In 1948, Dumas Malone would write blithely: Malone, 1:161-62.
- 105 Thomas Jefferson admonished Martha: Ellen Randolph Coolidge letterbook, University of Virginia Library, Accession 9090, 66–67.
- 106 She watched closely over the slaughtering: Jefferson noted his own suspicions of theft at his Bedford plantation: "Stanly [the overseer there] has killed by his own confession 12 hogs, but as Jupiter (one of his negroes who kept a tally of it) sais 16. Stanly told Garth some time ago he had about 50 or 60 lb. of butter to send me, but now he has but about 20 lb. The negroes say he has sold a great deal of corn." MB 1:380.

- 106 Jefferson hated violence: Marie Morgan and Edmund S. Morgan, "Jefferson's Concubine," New York Review of Books, October 9, 2008, 15.
- 106 The Hemingses did not go all at once: Farm Book, 15-18.
- 106 Even though she had not insisted: MB 1:329, fn. 15: "In the partition Martha received all the lands in Bedford and Amherst counties and the Willis Creek lands and part of the St. James' lands in Cumberland County. In addition to her share in the division of the estate, she came into possession of two properties which Wayles had held as tenant by courtesy: Elk Island, to which she had dower rights from her first husband, and Indian Camp, an entailed estate inherited through her mother....

"TJ and Martha soon sold over half this land in an attempt to pay off their share of the debts of the estate. Henry Skipwith bought the St. James' and Indian Camp lands, giving the Elk Hill plantation as part of the purchase price. The Willis Creek lands were sold in 1790 and in Bedford County TJ retained only the Poplar Forest property." See also MB 1:366, fn. 1. For the three Elk-hill deeds, see MSS 1162, Special Collections, University of Virginia.

107 Isaac Jefferson, Ursula's son: Bear, 15-16.

- 108 In the wake of John Wayles's death: MB 1:383; MWSJ Account Book.
- 108 February brought the frightening earthquake: See chapter 3.
- 108 As he recovered from that tragedy: Garden Book, 47-50; MB 1:372.

9: HIS WORLD AND HERS

- 110 She duly recorded: MWSJ Account Book; MB 1:374-75; Garden Book, 55.
- 110 Down in Williamsburg: Malone, 1:172.
- 110 As he looked back later: TJ to Thomas Cooper, February 10, 1814, cited in Malone, 1:174.
- 111 Martha, back at Monticello: MB 1:374-75; MWSJ Account Book; Malone, 1:179-86.
- 111 As historian Fawn Brodie pointed out: Brodie, 120.
- 111 He was on perilous political ground: A Summary View of the Rights of British America, http://books.google.com/books; Thomas Jefferson, John P. Foley, The Jeffersonian Cyclopedia (New York: Funk & Wagnalls, 1900), digitized February 23, 2007, 963, 966.
- 112 The free man depicted in the Summary View: Ibid., 966.
- 113 Jefferson had ordered fourteen: MB 1:405; Malone, 1:191-93; McLaughlin, Jefferson and Monticello, 163-64.
- 113 The want of those windows: MB 1:389-91; MWSJ Account Book.
- 113 As Thomas sallied forth: MB 1:399-403.
- 114 One of those terrors became a reality: Malone, 1:210, 434.
- 114 Both women: Dorman, Ancestors and Descendants of Francis Epes I, 1:399.
- 115 There was fighting along the coast: Brodie, 130; chapter 1 herein.

- 115 "I wrote to Patty on my arrival": TJ to Francis Eppes, October 10, 1775, Papers, 1:246.
- 115 Even in Philadelphia, family tragedy: TJ to Francis Eppes, October 24, 1775, Papers, 249.
- 116 "I have never received the scrip of a pen": TJ to Francis Eppes, November 7, 1775, Papers, 252.
- 116 "I have written to Patty a proposition": TJ to Francis Eppes, November 21, 1775, *Papers*, 264.
- 116 "The Person of no Man in the Colony is safe": Robert Carter Nicholas to the Virginia Delegates in Congress, Williamsburg, November 25, 1775, Papers, 1:266. For a fuller rendition of this message, see chapter 1.
- 116 Still, Jefferson could not go: MB 1:411.
- 116 For her part, Martha was back at Monticello: MWSJ Account Book.
- 117 She may have had her hands full: TJ to Thomas Nelson, Jr., May 16, 1776, Papers, 1:292.
- 118 "You must certainly bring Mrs. Jefferson": Thomas Nelson, Jr., to TJ, February 4, 1776, Papers, 1:286.
- 118 Whether or not Martha wanted to go: TJ to Thomas Nelson, Jr., May 16, 1776, Papers, 1:292: "I am here in the same uneasy anxious state in which I was the last fall without Mrs. Jefferson who could not come with me."
- 118 Fawn Brodie speculated: Brodie, 149-50.
- 118 Before he left, he gave her ten pounds: MB 1:417, 431.
- 119 "I have snatched a few Moments": John Page to Thomas Jefferson, April 26, 1776, Papers, 1:288.

10: DOMESTIC TRANQUILITY

- 121 But in a far less celebrated passage: Wills, *Inventing America*, p. 377. Thanks to Rick Hills for reminding me of this section of Jefferson's draft.
- 122 "I am sorry the situation": TJ to Edmund Pendleton, June 30, 1776, Papers, 1:408.
- 122 On July 4, 1776: MB 1:421.
- 122 "I have received no letter this week": TJ to Francis Eppes, July 23, 1776, Papers, 1:473.
- 122 "For god's sake, for your country's sake": TJ to Richard Henry Lee, July 29, 1776, Papers, 1:477; TJ to John Page, July 30, 1776, Papers, 1:483.
- 123 "We return'd last Sunday from Elk-Hill": Francis Eppes to TJ, July 3, 1776, Papers, 15:576.
- 123 By the end of that month: TJ to Francis Eppes, August 9, 1776, Papers 1:488; Edmund Pendleton to TJ, August 26, 1776; Papers, 1:508.
- 123 It took Jefferson only six days: MB 1:425; Malone, 1:245-46.
- 123 Despite the perils of war: MB 1:428-29.

- 124 Dunmore had sailed away: Edmund Pendleton to TJ, May 24, 1776, Papers, 1:296-97.
- 124 On the way home, he bought five bushels of salt: MB 1:430-31.
- 124 In January, she and Ursula killed sixty-eight hogs: MWSJ Account Book.
- 124 "Could we but get a good Regular Army": Thomas Nelson, Jr., to TJ, January 2, 1777, Papers, 2:3.
- 125 But at Monticello, peace reigned: MWSJ Account Book; MB 1:445-47.
- 125 In August, she determined to get control: MWSJ Account Book. On hog butchering in eighteenth-century Virginia, see http://faroutliers.wordpress.com/2007/10/17/ hogs-ham-and-us-history.
- 126 "It will not perhaps be disagreeable": Richard Henry Lee to TJ, August 25, 1777, Papers, 2:13.
- 126 So she kept busy in the house: MWSJ Account Book, March 1778.
- 126 He planted his vegetable garden: Garden Book, 76.
- 126 Their third daughter: Jefferson would pay Dr. Gilmer "in full £43-12." MB 1:468-69.
- 127 He went reluctantly." MB 1:472-75; Malone, 1:293.
- 127 The War for Independence came to Albemarle County: Malone, 1:293-96.
- 128 "Often our lives were in danger": Baroness von Riedesel, Baroness von Riedesel and the American Revolution: Journal and Correspondence of a Tour of Duty, 1776–1783, revised translation with introduction and notes by Marvin L. Brown, Jr., with the assistance of Marta Huth (Chapel Hill: Institute of Early American History and Culture, and University of North Carolina Press, 1965), 79.
- 129 The baroness prided herself: Ibid., 82-83.
- 129 "Many of them let the slaves walk about": Ibid., 86.
- 130 "There are, of course, good masters too": Ibid.
- 130 The families did spend time together: Baron Riedesel to TJ, December 4, 1779, Papers, 3:212.
- 130 They shared a love of music: Cited in Malone, 1:296.
- 130 The entire time the Jeffersons and Riedesels were together: Brodie, 171-72.
- 131 Thomas Jefferson sold the pianoforte: MB 1:478-80; John Page to TJ, June 2, 1779, Papers, 2:278; TJ to John Page, June 3, 1779, Papers 2:279.

11: THE WAR COMES HOME

- 132 She started out asking for small sums: MB 1:488-91.
- 133 He recalled much later the impressive procession: Bear, 4, 6.
- 133 "It was cold weather when they moved up": Ibid., 6.
- 133 General Riedesel, then in New York: General Riedesel to TJ, March 30, 1780, Papers, 3:338.
- 133 "I sincerely condole with Madame de Riedesel": TJ to General Riedesel, May 3, 1780, Papers, 3:368.

- 134 Her letter echoed her pride: MWSJ to Eleanor Madison, August 8, 1780, Papers, 3:532. Diane Ehrenpreis, curatorial art historian at Monticello, has located at least one additional letter sent by Martha Jefferson on behalf of this effort. Personal communication, Diane Ehrenpreis, June 5, 2008.
- 135 Martha could not "do more": Baron Riedesel's October 2 letter to Jefferson offered congratulations on "Mrs. Jeffersons health and recovery." Riedesel to TJ, October 2, 1780, Papers, 4:4.
- 135 On November 3, Martha gave birth to Lucy Elizabeth: MB 1:502; Kelly Neff Quattrin, "For the Life of Her: Martha Wayles Jefferson and Diabetes," draft article in information file, "People—Martha Wayles Jefferson," ICJS.
- 136 Things went from bad to worse: Malone, 1:337-39.
- 136 The day before Arnold's troops arrived: Bear, 8.
- 137 The British moved on: Ibid., 10.
- 138 The Jefferson slaves remained with the British: Ibid.
- 139 "The day is so very bad": TJ to David Jameson, April 16, 1781, Papers, 5:468.
- 139 Martha, Patsy, and Polly fled Richmond: MB 1:509.
- 139 "We receive every day vague reports": Bolling Stark to TJ, April 30, 1781, Papers, 5:579-80.
- 140 "Mrs. Jefferson and your little family were very well": Ibid.
- 140 Tarleton arrived on June 4: Hemingses, 119.
- 141 But Cornwallis, in Jefferson's words: TJ to Dr. William Gordon, July 16, 1788, *Papers*, 13:363-64.
- 142 Some thirty slaves left with Cornwallis: Farm Book, 29.
- 142 In his later recollection: Farm Book, 29, and TJ to William Gordon, Papers, 13:363– 64.
- 142 Jefferson scholars have, until recently, taken an oddly sanguine view: Malone, 1:391.

12: THE BUTCHER'S BILL

- 144 While Cornwallis raged at Elk Hill: MB 1:511; Papers, 4:261, 266, 268.
- 144 When they got back to Monticello: MWSJ Account Book.
- 145 Martha's body was scarred and weakened: MB 1:519.
- 146 "Because of this impenetrable silence": Malone, 1:397.
- 147 Jefferson's letter to Monroe: Thomas Jefferson to James Monroe, May 20, 1782, Pabers, 6:186.
- 148 Some of Jefferson's other friends: Brodie, 206.
- 148 But Monroe was deeply sympathetic: Monroe to Jefferson, June 28, 1782, Papers, 6:192.
- 148 Sometime near the end: Papers, 6:196.
- 149 "The House servants": Bear, 99–100. Brodie, 208–9, has speculated on the reasons for Bacon's error regarding the number of living Jefferson children.

- 150 "My dear wife died this day": MB 1:521.
- 150 "A moment before the closing scene": Mary Randolph and Anne Cary, "Reminiscences of Th.J. by MR," *Papers*, 6:199–200.
- 150 "He kept his room for three weeks": Ibid.
- 151 "Mrs. Jefferson has at last shaken off her tormenting pains": Edmund Randolph to James Madison, September 20, 1782, cited in *Papers*, 6:199.
- 151 "When at last he left his room": Randolph and Cary, "Reminiscences of Th.J. by MR," *Papers*, 6:199-200.
- 151 Martha Wayles Skelton Jefferson was buried at Monticello: http://wiki.monticello. org/mediawiki/index.php/Martha_Jefferson_Epitaph.
- 152 "This miserable kind of existence": Thomas Jefferson to Elizabeth Eppes, October 3(?), 1782, Papers, 6:198–99.
- 152 Even in this private letter: Ibid.
- 153 "Patsy rides with me": Ibid.
- 153 Some historians have seen: Brodie, 211; Hemingses, 147.
- 153 If Thomas Jefferson held any truth to be self-evident: On Jefferson's gender ideology, see Kukla, Mr. Jefferson's Women; and Brian Steele, "Thomas Jefferson's Gender Frontier," Journal of American History 95, no. 1 (June 2008).
- 154 In the shadow of her death: "I received yesterday your favor of the 9th. inst. And am happy that the sale of Elkhill is at length completed." Thomas Jefferson to Daniel Hylton, January 20, 1783, *Papers*, 6:220.
- 154 "Old Master had a small brick house": Bear, 17.
- 154 Jefferson scholar James A. Bear, Jr.: Ibid., 127, n. 62.
- 155 Yet he could describe the place with precision: "Jefferson's Advertisement for Sale of Elk Hill," October 5, 1790, *Papers*, 17:567–69; MSS 4009, Special Collections, University of Virginia.
- 155 Dumas Malone wrote: Malone, 1:397.

13: STORIES AND SHADOW FAMILIES

- 159 "I never knew of but one white man": "Life Among the Lowly, No. 1," Pike County (Ohio) Republican, March 13, 1873, reprinted as "Reminiscences of Madison Hemings," in Brodie, 637-38.
- 160 "Capt. Hemings happened to be": Ibid.; see also Bear, 4; and Life Among the Lowly, No. 3," Pike County (Ohio) Republican, December 25, 1873, reprinted as "Memoirs of Israel Jefferson" in Annette Gordon-Reed, Thomas Jefferson and Sally Hemings: An American Controversy (Charlottesville: University Press of Virginia, 1997), 252-53.
- 161 She was the property of Francis and Sarah Eppes: The marriage indenture made April 9, 1746, and recorded by Bowler Cocke in Henrico County established that John Wayles would get a life estate in Martha Eppes's inheritance, which included nine enslaved people including "Parthenia, Betty & Ben a Boy together with all their

offspring born and to be born," and that Martha would receive her dower rights as well as her own property in the event of John Wayles's death, "notwithstanding her Coverture." Information file, "People—John Wayles," ICJS, marriage indenture transcribed by Diane Ehrenpreis.

- 161 He was careful to note that his great-grandfather: See Marcus Rediker, The Slave Ship: A Human History (New York: Viking, 2007).
- 164 "Just as Elizabeth Hemings and her daughters had seen": Hemingses, 148.
- 164 In fact, he had to hire a guide: MB 1:523-54; Malone, 1:399.
- 165 And now came months of uncertainty: Malone, 1:419, 421. 12,
- 165 Jefferson left the management of his business affairs: TJ to Nicholas Lewis, July 11, 1788, Papers, 13:343.
- 165 Jefferson also made provision for Betty's older sons: Ibid.; Hemingses, 317.
- 166 And Sally Hemings, at nine or ten years old: Malone, 1:39-40.
- 166 Elizabeth Eppes was also half-sister: Bear, 15.
- 167 Elizabeth Eppes's life: John Frederick Dorman, Ancestors and Descendants of Francis Epes I, 2:398-99; Information file, "Places—Eppington," ICJS; Bettie Woodson Weaver, "Mary Jefferson and Eppington," Virginia Cavalcade 19, no. 2 (Autumn 1969), 30-35; Mary Miley Theobald, "Eppington," Colonial Williamsburg (Summer 1997), 54-60.
- 167 Francis Eppes, like Thomas Jefferson: See McLaughlin, Jefferson and Monticello; Information File, "Places-Eppington," ICJS.
- 167 Eppes had begun to build in about 1770: Dorman, Ancestors and Descendants of Francis Epes I, 2:398-99; Information file, "Places—Eppington," ICJS; Weaver, "Mary Jefferson and Eppington," 30-35; Theobald, "Eppington," 54-60. On the gendered architecture of Monticello, see Elizabeth V. Chew, "Inhabiting the Great Man's House: Women and Space at Monticello," in Joan E. Hartman and Adele Seeff, eds., Structures and Subjectivities: Attending to Early Modern Women (Newark: University of Delaware Press, 2007), 223-52.
- 168 But for Sally Hemings: Robert Hemings had also been sent to Eppington with a letter from Thomas Jefferson to Francis Eppes. Francis Eppes to TJ, September 16, 1784, Papers, 15:615.
- 168 People began to suffer the symptoms of pertussis: http://en.wikipedia.org/wiki/ Pertussis.
- 169 "I wish it was in my power": Francis Eppes to TJ, September 16, 1784, Papers, 15:616.
- 169 "It is impossible to paint the anguish": Elizabeth Wayles Eppes, to TJ, October 13, 1784, Papers, 7:441.
- 170 It took nearly seven months for this letter: Ibid.; Malone, , 2:xxv.
- 170 He had, however, found out about his daughter's death: James Currie to Thomas Jefferson, November 20, 1784, Papers, 6:538-39.
- 170 He wrote to Francis Eppes: TJ to Francis Eppes, May 11, 1785, Papers, 8:141.

14: SUMMONED AND SENT

- 173 "Dear Papa": Mary Jefferson to Thomas Jefferson, ca. September 13, 1785, Papers, 8:517.
- 173 Jefferson acknowledged the problems: TJ to Francis Eppes, August 30, 1785, Papers, 8:451.
- 174 "Their dispositions are . . . hostile": TJ to Eppes, December 11, 1785, Papers, 9:91-92.
- 174 Jefferson was so worried about pirates: TJ to Eppes, January 7, 1786, Papers, 9:159.
- 174 Jefferson had begun by proposing the idea: TJ to Eppes, May 11, 1785, Papers, 8:141.
- 174 "With respect to the person": TJ to Eppes, August 30, 1785, Papers, 8:451.
- 175 "She would be in the best hands possible": TJ to Eppes, December 11, 1785, Papers, 9:91-92.
- 175 "I know that Mrs. Eppes's goodness": TJ to Eppes, January 24, 1786, *Papers*, 9:211–12.
- 176 In the end, Francis Eppes decided: Eppes to TJ, April 14, 1787, Papers, 15:636.
- 177 Francis Eppes set about pursuing: Eppes to TJ, August 31, 1786, Papers, 15:631.
- 177 In the meantime, Isabel returned to Monticello: Free Some Day, 39.
- 177 The child was so distraught: Malone, 2:134-35.
- 179 She was, according to the few descriptions we have: Bear, 4; "Life Among the Lowly, No. 3," Pike County (Ohio) Republican, December 25, 1873, reprinted as "Memoirs of Israel Jefferson," in Annette Gordon-Reed, Thomas Jefferson and Sally Hemings: An American Controversy (Charlottesville: University Press of Virginia, 1997), 252-53.
- 179 He would eventually marry his first cousin: See http://wiki.monticello.org/ mediawiki/index.php/Betsy_Hemmings; http://www.monticello.org/gettingword/ betsyhemmingsfamily.html; http://www.buckinghamhemmings.com/.
- 181 She would cling to Andrew Ramsay: Andrew Ramsay to Thomas Jefferson, July 6, 1787, Papers, 11:556.
- 181 They even worried Patsy Jefferson: Martha Jefferson to TJ, May 3, 1787, Papers, 11:334.
- 182 "They returned to virginia": Ibid.
- 182 He had written in December: TJ to Abigail Adams, December 21, 1786, Papers, 10:621; TJ to Francis Eppes, July 2, 1787, Papers, 11:524.
- 182 Adams had a terrible time prying Polly loose: Abigail Adams to TJ, June 26, 1787, Papers, 11:502.
- 183 Adams, who had found Polly in such ragged condition: Abigail Adams to TJ, June 27, 1787, Papers, 11:503.
- 183 Abigail Adams had considerable knowledge: David McCullough, John Adams (New York: Simon & Schuster, 2001), 67; Abigail Adams to TJ, July 6, 1787, Papers, 11:551.

- 183 Instead of coming to get Polly himself: TJ to Abigail Adams, July 1, 1787, Papers, 11:514.
- 183 Polly, disappointed and betrayed once again: Abigail Adams to TJ, July 6, 1787, Papers, 11:551.
- 184 Dumas Malone took from Adams's remark: Malone, 2:135.
- 184 Malone, one of the people who most vehemently denied: Fawn M. Brodie, "Jefferson Biographers and the Psychology of Canonization," *Journal of Interdisciplinary History* 2 (1971), 157–58 and 160–61.
- 185 Polly Jefferson was educated: Francis Eppes to TJ, August 31, 1786, Papers, 15:631.
- 185 Polly was also a hearty eater: Elizabeth Eppes to TJ, July 30, 1786, Papers, 15:628.
- 185 If the two girls arrived in London: Abigail Adams to TJ, July 10, 1787, Papers, 11:572-74.
- 186 Andrew Ramsay may have offered: Andrew Ramsay to TJ, July 6, 1787, Papers, 11:556.
- 187 Gordon-Reed reminds us: Hemingses, 200.
- 187 In the end, Sally Hemings found her way to Paris: Free Some Day, 108.

15: PARIS

- 188 The fourteen-year-old girl: Hemingses, 166.
- 189 In addition to his mundane duties: TJ to André Limozin, September 9, 1787, Papers, 12:110; TJ to Zachariah Loreilhe, September 9, 1787, Papers, 12: 111.
- 189 Polly "had totally forgotten her sister": TJ to Abigail Adams, July 16, 1787, Papers, 11:592.
- 189 Her reaction was understandable: TJ to Elizabeth Eppes, July 28, 1787, Papers, 11:634.
- 189 Madison Hemings: "Reminiscences of Madison Hemings," in Brodie, 639-40.
- 189 Abigail Adams, on the other hand: Abigail Adams to TJ, June 27, 1787, Papers, 11:503.
- 190 As the hired coach turned off the Champs-Elysées: McLaughlin, Jefferson and Monticello, 169-71.
- 191 The Hôtel de Langeac: Ibid., 211-12.
- 191 Within a week of her arrival: TJ to Mary Jefferson Bolling, July 23, 1787, Papers, 11:612.
- 191 He was just finishing up his apprenticeship: MB 1:673, 681.
- 192 In addition to Petit: MB 1:603. William Howard Adams, *The Paris Years of Thomas Jefferson* (New Haven, Conn.: Yale University Press, 1997), 19-20.
- 192 As soon as he could, Jefferson sent her off: MB 1:685; Hemingses, 213-23.
- 192 For more than two years, Sally Hemings lived in Paris: "Reminiscences of Madison Hemings," in Brodie, 639-40.
- 192 Polly and Patsy were also studying and speaking French: Free Some Day, 110; Martha Jefferson to T.J., May 29, 1787, Papers, 11:381.

424 🧩 NOTES

- 193 Just as he made certain that Sally was secure: Hemingses, 224-27.
- 193 She ate what the other servants did: Papers of Trist and Burke Family Members, MSS 5385-f, Special Collections, University of Virginia.
- 193 Patsy began to go out more: MB 1:729, 734; Free Some Day, 110.
- 193 Just as he began to pay James Hemings: MB 1:690, 718, 721, 722, 725.
- 194 She learned to care for the fine fabrics: Hemingses, 236-39.
- 194 The working women of Paris: On women and the French Revolution, see Joan B. Landes, Women and the Public Sphere in the Age of the French Revolution (Ithaca, N.Y.: Cornell University Press, 1988); Dominique Godineau, The Women of Paris and Their French Revolution (Berkeley: University of California Press, 1998).
- 195 "I observe women and children carrying heavy burthens": TJ, "Notes on a Tour through Southern France and Italy," *Papers*, 11:415.
- 196 As he thought about how women lived: Steele, "Thomas Jefferson's Gender Frontier," 17-42.
- 196 "Can we wonder if such of them as have a little beauty": Papers, 11:446.
- 197 "While one considers them as useful and rational companions": TJ, "Notes of a Tour through Holland and the Rhine Valley, 1788," *Papers*, 13:27.

16: AMAZONS VERSUS ANGELS

- 199 He spent time with flamboyant women: On his later avoidance of female company, see Catherine Allgor, *Parlor Politics: In Which the Ladies of Washington Help Build a City and a Government* (Charlottesville: University Press of Virginia, 2000).
- 199 "atheists, deists and libertines": Adams, The Paris Years, 75.
- 199 Some of them were especially aggressive: William Stephens Smith to William Short, July 30, 1787, quoted in MB 1:611.
- 200 Years earlier, he had decided not to hire: TJ to James Madison, February 14, 1783, Papers, 6:241.
- 201 As the Binghams made their way back to America: TJ to Madison, January 20, 1787, *Papers*, 11:95.
- 201 "At eleven o'clock it is day chez Madame": TJ to Anne Willing Bingham, February 7, 1787, *Papers*, 11:122-24.
- 202 "Thus the days of life are consumed": Ibid.
- 202 "In America, on the other hand": Ibid.
- 202 Jefferson closed his letter: Ibid.
- 203 "This is my plan Madam": TJ to Madame de Tessé, March 20, 1787, Papers, 11:227.
- 203 Her outraged response: Abigail Adams to TJ, January 29, 1787, Papers, 11:86; TJ to Abigail Adams, February 22, 1787, Papers, 11:174.
- 204 He paid for wine and art: MB 1:680-85.
- 204 "May your days and nights be many": TJ to William Stephens Smith, July 9, 1786, Papers, 10:116–17.

- 204 He concluded another letter: TJ to Smith, October 22, 1786, Papers, 10:479.
- 204 The object of Jefferson's passion: On the life and career of Maria Cosway, see Gerald Barnet, Richard and Maria Cosway: A Biography (Cambridge, England: Lutterworth, 1995); Helen Duprey Bullock, My Head and My Heart: A Little History of Thomas Jefferson and Maria Cosway (New York: Putnam's, 1945); George C. Williamson, Richard Cosway, R.A. (London: George Bell, 1905); and Ellen C. Clayton, English Female Artists, 2 vols. (London: Tinsley Brothers, 1876), vol. 1.
- 207 That night, he sat down to write to Maria Cosway: TJ to Maria Cosway, October 12, 1786, Papers, 10:443-55.
- 207 That summer, he traveled in northern Italy: TJ to Maria Cosway, July 1, 1787, Papers, 11:519-20.
- 208 "I leave you with very melancholy ideas": Maria Cosway to TJ, December 7, 1787, Papers, 12:403.
- 209 "Society is spoilt by it": TJ to the Marquise de Bréhan, May 9, 1788, Papers, 13:150.
- 209 "the civil dissensions": TJ to Maria Cosway, July 27, 1788, Papers, 13:424.
- 209 Anne Willing Bingham had replied: Anne Willing Bingham to TJ, June 1, 1787, Papers, 11:392–94.
- 210 "The women of France interfere": Ibid.
- 210 "We have now need of something to make us laugh": TJ to Bingham, May 11, 1788, Papers 13:151-52.
- 210 "You too have had your political fever": Ibid.
- 212 After she died, that bell: Susan Stein, *The Worlds of Thomas Jefferson at Monticello* (New York: Harry N. Abrams, 1993), 16.
- 213 Who could more perfectly fulfill: For an extended discussion of the "amazons and angels" comparison with regard to Sally Hemings, see *Hemingses*, 275–80.

17: SALLY'S CHOICE

- 214 "When Mr. Jefferson went to France": "Reminiscences of Madison Hemings," in Brodie, 639-40.
- 215 "We are here experiencing a Siberian degree of cold": TJ to Francis Eppes, December 15, 1788, Papers, 14:357-59; TJ to the Marquise de Bréhan, March 14, 1789, Papers, 14:656.
- 216 "I have for two months past had a very sick family": TJ to Maria Cosway, January 14, 1789, *Papers*, 14:446.
- 216 **"kiss Polly for me":** Marie Jacinthe de Botidoux to Martha Jefferson, November 4, 1789, Special Collections, University of Virginia, MSS 5385-a.a.
- 216 The daughters of the French nobility: Ibid.
- 217 "Surely it was never so cold before": TJ to Maria Cosway, January 14, 1789, Papers, 14:446. Fawn Brodie interpreted this letter as significant evidence that Jefferson had begun his affair with Hemings. See Brodie, 299.

- 217 Jefferson paid Dupré: Hemingses, 244-46; MB 1:731; TJ to Francis Eppes, December 15, 1788, Papers, 14:357-59; MB 1:729, 730-31, 734.
- 218 Of course, as a slave: Annette Gordon-Reed offers a brilliant analysis of the differences between Sally Hemings's status and choices and that of her half-sister, Martha Jefferson, in *Hemingses*, 353-76.
- 219 Madison may have been in error about this pregnancy: Eugene A. Foster et al., "Jefferson Fathered Slave's Last Child," *Nature* 396 (November 1998), 27–28.
- 219 Generations of Jefferson scholars have denied: Ibid.; TJ and SH. In addition to the documentary and genetic evidence, see also the statistical argument in Fraser D. Neiman, "Coincidence or Causal Connection? The Relationship between Thomas Jefferson's Visits to Monticello and Sally Hemings's Conceptions," Forum: Thomas Jefferson and Sally Hemings Redux, William and Mary Quarterly, 3d series, vol. 57, no. 1 (January 2000), 198–210. For a full listing of resources on the DNA controversy and the Hemings-Jefferson relationship, see http://www.monticello.org/plantation/ hemingscontro/hemings_report.html.
- 221 Jefferson had expressed his views: Thomas Jefferson, Notes on the State of Virginia (New York: Harper Torchbooks, 1964), 132-39.
- 221 Jefferson was, as Joseph Ellis has so eloquently explained: Joseph Ellis, American Sphinx: The Character of Thomas Jefferson (New York: Vintage, 1998).
- 222 Sally was not the first woman of her family: Free Some Day; Hemingses.

18: COMING HOME

- 226 "your creditors are very pressing": Francis Eppes to TJ, September 16, 1784, Papers, 15:616; Francis Eppes to TJ, October 23, 1786, Papers, 10:483.
- 226 When Francis Eppes spoke of selling: TJ to Nicholas Lewis, July 11, 1788, Papers, 13:339-44; TJ to Alexander McCaul, July 12, 1788, Papers, 13:349.
- 227 "Mine is a journey of duty and affection": TJ to Maria Cosway, September 26, 1788, *Papers*, 13:639.
- 227 Meanwhile, he let the folks back home know: TJ to Elizabeth Eppes, December 15, 1788, Papers, 14:355–56; TJ to Francis Eppes, December 15, 1788, Papers, 14:357–59.
- 228 And then there was all that baggage: MB 1:744; "Jefferson's Instructions for Procuring Household Goods," *Papers*, 16:321-24.
- 228 Jefferson hoped to embark: TJ to Nicholas Lewis, December 16, 1788, Papers, 14:362; MB 1:716.
- 228 To his frustration: TJ to Angelica Schuyler Church, February 15, 1789, Papers, 228:554.
- 229 He rode in his carriage past the king's foreign mercenaries: See Malone, 2:215–27; MB 1:738.
- 230 Jefferson bought a shepherd dog: MB 1:745.
- 230 Dumas Malone imagined: Malone, 2:236.

- 230 On October 5, a crowd of some six thousand women: On the women's march to Versailles, see Darline Gay Levy, *Women in Revolutionary Paris*, 1789–1795 (Champaign: University of Illinois Press, 1981).
- 230 Malone envisioned the voyage as a placid one: Malone, 2:243, 241.
- 232 "After beating about three days": Domestic Life, 151.
- 234 Wormley Hughes, Sally Hemings's nephew: Life, 1:552–53. On the condition of the Three-Notched Road, see TJ to Henry Skipwith, December 26, 1789, Papers, 16:51– 52.
- 234 They had reason to be happy: Parton, 1:286.
- 235 Jefferson was quickly consumed: On the Peter Jefferson estate matters, see, for example, TJ to Thomas Walker, January 18, 1790, Papers, 16:112-14; Walker to TJ, January 19, 1790, Papers, 16:114-15; TJ to John Nicholas, Sr., January 20, 1790, Papers, 16:115-16; TJ to Walker, January 25, 1790, Papers, 16:127-29; TJ to John Bolling, March 6, 1790, Papers, 16:207-8. On the moldboard plow, see TMR to TJ, April 23, 1790, Papers, 16:370-71; On Martha Jefferson's betrothal, see Thomas Mann Randolph, Sr., to TJ, January 30, 1790, Papers, 16:135-36; and TJ to Thomas Mann Randolph, Sr., February 4, 1790, Papers, 16:154-55.
- 235 Patsy and Tom Randolph were married: "Marriage Settlement for Martha Jefferson," Papers, 16:189-91.
- 235 He was concerned about the volatile situation: TJ to Madame de Corny, April 2, 1790, Papers, 16:289-90.
- 236 Still, he was glad to be home: TJ to Francis Willis, Jr., April 18, 1790, Papers, 16:353.
- 236 Sally Hemings's mother: Family trees of the Jefferson and Hemings families, *Free* Some Day, insert inside back cover; see also chapter 3 herein.

19: PATSY AND POLLY

- 239 He told George Washington that: TJ to George Washington, December 15, 1789, Papers, 16:34.
- 240 Thomas Mann Randolph, Jr.: TMR to TJ, August 16, 1786, Papers, 9:260.
- 240 Young Randolph had corresponded: TJ to Thomas Mann Randolph, Sr., August 11, 1787, Papers, 12:22.
- 241 As wedding presents: "Marriage Settlement for Martha Jefferson," February 21, 1790, Papers, 16:189.
- 241 "Having had yourself and dear Poll": TJ to MJR, April 4, 1790, Papers, 16:300.
- 241 "Lead and even steel": William H. Gaines, Jr., Thomas Mann Randolph: Jefferson's Son-in-Law (Baton Rouge: Louisiana State University Press, 1966), vi.
- 242 "Your new condition will call for abundance of little sacrifices": TJ to MJR, April 4, 1790, *Papers*, 16:300.
- 242 "The more you learn the more I love you": TJ to MJR, March 6, 1786, Family Letters, 30.

- 242 Jefferson expected a lot from Patsy: TJ to Barbe de Marbois, December 5, 1783, Papers, 6:374.
- 243 "from 8. to 10 o'clock practice music": TJ to MJR, November 28, 1783, Family Letters, 19.
- 243 "I expect you will write to me by every post": Ibid.
- 244 "Be you from the moment you rise till you go to bed": TJ to MJR, December 22, 1783, Family Letters, 22.
- 244 "never do or say a bad thing": TJ to MJR, December 11, 1783, Family Letters, 21.
- 244 "Being disappointed in my expectation": MRJ to TJ, March 8, 1787, Family Letters, 32.
- 245 At Panthémont, she practiced the pianoforte: MJR to TJ, May 27, 1787, Family Letters, 42.
- 245 "I am not so industrious as you or I would wish": MJR to TJ, April 9, 1787, Family Letters, 37.
- 245 "My expectations for you are high": TJ to MJR, March 28, 1787, Family Letters, 35.
- 245 Patsy loved Panthémont: Papers, 14:356n. Biographer Fawn Brodie surmised that Patsy's religious zeal was an expression of her jealousy of Maria Cosway; see Brodie, 305.
- 246 But she did not know the first thing: TJ to Elizabeth Eppes, July 28, 1787, Papers, 11:634.
- 246 Biographer Fawn Brodie saw in this hasty marriage: Brodie, 325.
- 246 Jefferson continued to hope: Thomas Mann Randolph, Sr., to TJ, January 30, 1790, Papers, 16:135; TJ to Thomas Mann Randolph, Sr., February 4, 1790, Papers 16:154– 55; TMR to TJ, April 23, 1790, Papers 16:370; TJ to MJR, April 26, 1790, Papers, 16:386; TMR to TJ, May 25, 1790, Papers, 16:441–42.
- 247 It was, moreover, so hot there: TMR to TJ, May 25, 1790, Papers, 16:441-42; TJ to Elizabeth Wayles Eppes, July 25, 1790, Papers, 17:264.
- 247 Patsy, who had reveled in the female world: TJ to Elizabeth Wayles Eppes, July 25, 1790, Papers, 17:266.
- 247 The property at Varina had been run into the ground: TMR to TJ, May 25, 1790, Papers, 16:441.
- 247 **"I am sensible of your goodness":** TJ to Elizabeth Wayles Eppes, June 13, 1790, *Papers*, 17:489.
- 248 "I have written you, my dear Maria": TJ to MJE, July 4, 1790, Papers, 16:599.
- 248 "She is a Sweet Girl": Martha Jefferson Carr to TJ, May 22, 1786, Papers, 27:755– 56.
- 248 She had used every weapon: Martha Jefferson Carr to TJ, January 2, 1787, Papers, 15:633; Mary Jefferson Bolling to TJ, May 3, 1787, Papers, 27:758.
- 248 So she learned to resist passively: TJ to MJE, July 25, 1790, Papers, 17:271-72.
- 249 Polly returned the favor: MJE to TJ, July 20, 1790, Papers, 17:239.
- 249 He continued to promote the Randolphs' plan: TJ to Thomas Mann Randolph, Sr., July 25, 1790, Papers, 17:274-76.

- 250 Both she and her husband hoped to find: TMR to TJ, March 5, 1791, Papers, 18:420.
- 250 Jefferson was sympathetic to Randolph Sr.'s annoyance: TJ to Thomas Mann Randolph, Sr., October 22, 1790, *Papers*, 17:624.
- 250 Meanwhile, it suited him: TJ to Mary Jefferson Bolling, October 31, 1790, Papers, 17:655.
- 251 "the solitude she will be in": TJ to Elizabeth Wayles Eppes, October 31, 1790, Papers, 17:658.
- 251 Eighteen-year-old Jack Eppes: TJ to Elizabeth Wayles Eppes, Papers, 20:413.
- 252 "Mr. Randolph and my daughters": TJ to Nicholas Lewis, ca. November 7, 1790, Papers, 18:29.

20: TROUBLE IN THE NEIGHBORHOOD

- 253 Garland Jefferson and Peter Carr made the mistake: The elder Rind had criticized John Wayles's conduct in the Chiswell affair; see chapter 5.
- 253 "That you may have no uneasiness": TJ to Martha Jefferson Carr, November 7, 1790, Papers, 18:26.
- 254 Jefferson asked his sister: Ibid.
- 254 The two, accordingly, wrote a letter: John Garland Jefferson to TJ, November 12, 1790, Papers, 18:43-44.
- 255 When John Garland Jefferson got to Goochland County: Ibid.
- 256 At the time of James Rind's altercation: See T7 and SH.
- 256 As historian Joshua Rothman has pointed out: Joshua D. Rothman, Notorious in the Neighborhood: Sex and Families across the Color Line in Virginia, 1787-1861 (Chapel Hill: University of North Carolina Press, 2003), 30, 53-56.
- 256 But this 1790 episode was also only one: Ibid.
- 256 "I hope that this affair will never more be thought of": TJ to John Garland Jefferson, February 5, 1791, Papers, 19:252.
- 256. He continued to pay Garland Jefferson's bills: Thomas Bell to TJ, June 12, 1793, Papers, 26:258-59.
- 257 "Martin has left us": MJR to TJ, January 16, 1791, Papers, 18:499.
- 258 Polly too came under Patsy's eagle eye: Ibid.
- 259 Patsy came through the birth of her first child: Mary Walker Lewis to TJ, January 23, 1791, Papers, 18:594; TMR to TJ, February 2, 1791, Papers, 19:239-40; TMR to TJ, February 8, 1791, Papers, 19:259; MJE to TJ, February 13, 1791, Papers, 19:271.
- 259 The new parents asked Thomas Jefferson: TJ to MJR, February 9, 1791, Papers, 19:264; TJ to TMR, March 17, 1791, Papers, 19:582.
- 260 In 1792, Jefferson sold Mary Hemings: TJ to Nicholas Lewis, April 12, 1792, Papers, 23:408; Free Some Day, 132.
- 260 Thenia Hemings was sold: James Monroe to TJ, June 17, 1794, Papers, 28:100.
- 260 Martin Hemings, who had served as majordomo: Hemingses, 486.

430 🎇 NOTES

- 261 On Christmas Eve, 1794: "Deed of Manumission for Robert Hemings," December 24, 1794, *Papers*, 28:222; TJ toTMR, December 26, 1794, *Papers*, 28:225.
- 261 The wrenching separation between Thomas Jefferson and Robert Hemings: MJR to TJ, January 15, 1795, Papers, 28:246.
- 261 In 1793, Jefferson wrote up an agreement: "Agreement with James Hemings," Pahers, 27:119-20.
- 262 Jefferson resigned himself to selling human beings: TJ to Bowling Clark, September 21, 1792, Papers, 24:408.
- 262 "I heartily congratulate you": TJ to Francis Eppes, March 14, 1791, Papers, 19:554;
 TJ to Francis Eppes, January 20, 1791, Papers, 18:578; Francis Eppes to TJ, April 5, 1791, Papers, 20:151; Henry Skipwith to TJ, April 7, 1791, Papers, 20:166; Francis Eppes to TJ, April 27, 1791, Papers, 20:313; TJ to Henry Skipwith, May 6, 1791, Papers, 20:373-76.
- 263 He could only bring himself to speak bluntly: TJ to John Bolling, October 7, 1791, Papers, 22:198.
- 263 When the sales finally occurred: TJ to TMR, March 1, 1792, Papers, 23:253.
- 263 Patsy Randolph could not have been ignorant: Thomas Bell to TJ, June 12, 1797, Papers, 29:427.
- 263 Surely it occurred to Patsy: TJ and SH, 80-81.
- 264 He made the point, in a letter to Patsy: TJ to MJR, December 4, 1791, Papers, 22:376.
- 265 When there was some kind of unspecified friction: TJ to MJR, March 19, 1793, Papers, 25:353; TJ to MJR, March 18, 1793, Papers, 25:404.
- 266 In the fall of 1792: See Cynthia Kierner, Scandal at Bizarre: Rumor and Reputation in Jefferson's America (Charlottesville: University Press of Virginia, 2004).
- 266 The rumors spread all the way to Philadelphia: TJ to MJR, April 28, 1793, Papers, 25:621.
- 267 Patsy replied that she was standing by Nancy Randolph: MJR to TJ, May 16, 1793, Papers, 26:53.
- 268 Thomas Jefferson was very worried about his son-in-law: TJ to TMR, August 7, 1794, Papers, 28:111.
- 269 That summer of 1795: TJ to TMR, August 18, 1795, Papers, 28:438; TJ to TMR, August 20, 1795, Papers, 28:439; TJ to MJR, July 31, 1795, Papers, 28:429.
- 269 Jefferson sent James Hemings: TJ to TMR, July 26, 1795, Papers, 28:419; MB 2:930.
- 269 But the parents did not return: MJR to TJ, January 1, 1796, Papers, 28:569.

21: DOMESTIC TRANQUILITY, REVISITED

270 As the terrible summer of 1795 slipped into autumn: TJ to Angelica Schuyler Church, September 8, 1795, *Papers*, 28:454.

- 270 He wrote Maria Cosway: TJ to Maria Cosway, September 8, 1795, Papers, 28:455.
- 270 He told Eliza House Trist: TJ to Eliza House Trist, September 23, 1795, Papers, 28:455.
- 270 On October 5, 1795: Fraser D. Neiman, "Coincidence or Causal Connection? The Relationship between Thomas Jefferson's Visits to Monticello and Sally Hemings's Conceptions," William and Mary Quarterly, 3rd series, vol. 57, no. 1 (January 2000), 205.
- 271 "There is vast alarm here about corn": TJ to TMR, February 7, 1796, Papers, 28:608.
- 271 In 1796, James Hemings made an inventory: "Deed of Manumission for James Hemings," February 5, 1796, *Papers*, 28:605; "James Hemings's Inventory of Kitchen Utensils at Monticello," February 20, 1796, *Papers*, 28:610.
- 271 The public business of buying and selling: TJ to TMR, April 11, 1796, Papers, 29:63; TJ to James Lyle, May 12, 1796, Papers, 29:96; TMR to TJ, February 26, 1798, Papers, 30:145.
- 272 On October 12, 1797: TJ to MJR, June 8, 1797, Papers, 29:424.
- 272 "This event in compleating the circle": TJ to MJE, June 14, 1797, Papers, 29:430.
- 273 He was so depressed: TMR to TJ, November 6, 1797, Papers, 29:568.
- 273 Polly and Jack Eppes gravitated to Eppington: John Wayles Eppes to TJ, September 25, 1796, Papers, 29:186; TJ to MJR, June 8, 1797, Papers, 29:424; TJ to Francis Eppes, September 24, 1797, Papers, 29:532; Elizabeth Wayles Eppes to TJ, October 10, 1797, Papers, 29:546; "Marriage Settlement for John Wayles Eppes," October 12, 1797, Papers, 29:547–50.
- 273 Jefferson insisted that he had no appetite for public life: TJ to TMR, November 28, 1796, Papers, 29:211; TJ to TMR, January 9, 1797, Papers, 29:260; TJ to TMR, January 22, 1797, Papers, 29:273-74; TJ to Benjamin Rush, January 22, 1797, Papers, 29:275; TJ to TMR, March 23, 1797, Papers, 29:322.
- 274 In the cold, wet winter of 1798: TMR to TJ, January 13, 1798, *Papers*, 30:28; MJR to TJ, January 22, 1798, *Papers*, 30:43.
- 275 "Yours of the 13th": TJ to TMR, January 25, 1798, Papers, 30:55.
- 275 "I feel every day more strongly the impossibility": MJR to TJ, January 22, 1798, Papers, 30:44.
- 276 "What an economist, what a manager she is become": MJE to TJ, February 27, 1796, Papers, 29:308.
- 276 Even after she had married Jack Eppes: MJE to TJ, February 1, 1798, Papers, 30:69.
- 276 He, in turn, frequently reminded his daughters: TJ to MJE, March 11, 1797, Papers, 20:314.
- 276 "My uncle Bolling is much as usual": MJE to TJ, December 8, 1797, Papers, 29:579.
- 276 "Mr. B.'s habitual intoxication": TJ to MJE, January 7, 1798, Papers, 30:15.

22: DANGER

- 280 Callender was a Scotsman: See Brodie, 416-28; TJ and SH.
- 281 Callender kept Jefferson posted: James Thomson Callender to TJ, March 21, 1798, Papers, 30:188.
- 281 "You should know the rancorous passions": TJ to MJR, May 17, 1798, Papers, 30:355.
- 281 By 1800, the Adams administration: TJ to Callender, October 6, 1799, Papers, 31:200; Callender to TJ, February 15, 1800, Papers, 31:376; "Pardon for James Thomson Callender," March 16, 1801, Papers, 33:309–10; Brodie, 424.
- 282 Twenty-first-century readers: TJ to Martha Jefferson Carr, April 21, 1800, Papers, 31:525.
- 282 Jefferson believed, however, that he had insulated: TJ to Thomas Bell, May 18, 1797, Papers, 29:371; Thomas Bell to TJ, June 12, 1797, Papers, 29:427.
- 283 As president he dined mostly with men: See Allgor, Parlor Politics, 4-47.
- 284 He had far more trouble with his debts, his crops: TMR to TJ, February 26, 1798, Papers, 30:145.
- 284 Construction supervisors pulled down in sections: TMR to TJ, January 3, 1801, Papers, 32:390. On the failure to number the column pieces, see McLaughlin, Jefferson and Monticello, p. 287.
- 284 Patsy announced that she looked forward to his return: MJR to TJ, June 23, 1798, Papers, 30:424.
- 284 Nonetheless, when Sally gave birth to her third child: TJ to John Wayles Eppes, December 21, 1799, *Papers*, 31:274.
- 286 It is not clear what sort of illness: MJR to TJ, January 30, 1800, Papers, 31:347-48; TMR to TJ, ca. April 19, 1800, Papers, 31:523.
- 287 Jefferson still hoped that he could induce Polly and Jack: TJ to MJE, April 13, 1799, Papers, 31:90; MJE to TJ, June 26, 1799, Papers, 31:139.
- 287 "Promises must not be forgotten": TJ to John Wayles Eppes, July 4, 1799, Papers, 31:146.
- 288 Maria Jefferson Eppes bore a daughter: TJ to MJR, January 21, 1800, Papers, 31:331; MJR to TJ, January 31, 1800, Papers, 31:347; John Wayles Eppes to TJ, February 7, 1800, Papers, 31:362; TJ to MJR, February 11, 1800, Papers, 31:366.
- 288 "Mr. Eppes's last letter informed me": TJ to MJE, February 12, 1800, Papers, 31:368.
- 289 "politics are such a torment": TJ to MJR, February 11, 1800, Papers, 31:366.
- 289 The moment they learned of Polly's predicament: TMR to TJ, February 22, 1800, Papers, 31:389; TJ to TMR, March 4, 1800, Papers, 31:415; John Wayles Eppes to TJ, March 16, 1800, Papers, 31:440.

23: SCANDAL

291 Old hatreds festered: Brodie, 427.

292 "There seemed to be some special necessity in him": Ibid., 417.

- 292 When Jefferson was at home: MJR to TJ, January 31, 1801, Papers, 32:527.
- 292 Jefferson offered sympathy: TJ to MJR, February 5, 1801, Papers, 32:556.
- 293 They may, indeed, have resented: Brodie, 432-34.
- 293 Jefferson was indignant: Ibid., 458-60.
- 293 While Jefferson tried to deal with Callender: Malone, 4:xxvi; MB 2:1051, 1053; Farm Book, 130; TJ to MJE, October 26, 1801, in Family Letters, 211; Rothman, Notorious in the Neighborhood, 30.
- 294 James wanted to go to Washington: Free Some Day, 128-29; Hemingses, 544-51.
- 294 James Hemings returned to Baltimore: Ibid.
- 295 The news was a terrible blow: MJE to TJ, November 6, 1801, Family Letters, 211; MJR to TJ, November 18, 1801, Family Letters, 212–13.
- 295 Those trials alone were enough: MJE to TJ, November 6, 1801, Family Letters, 211; MJE to TJ, April 21, 1802, Family Letters, 224.
- 295 "With how much regret have I look'd back": MJE to TJ, January 24, 1802, Family Letters, 217.
- 296 On September 1, 1802, he went public: Richmond Recorder, September 1, 1802, cited in Brodie, 464.
- 296 The Republican Richmond Examiner quickly moved: Richmond Examiner, September 25, 1802, cited in Brodie, 465.
- 297 "Jefferson before the eyes of his two daughters": Richmond Recorder, September 22, 1802; September 29, 1802; December 1, 1802, cited in Brodie, 468-69.
- 297 Their information was off the mark in some cases: For a full listing of resources on the DNA controversy and the Hemings-Jefferson relationship, see http://www.monticello.org/plantation/hemingscontro/hemings_report.html.
- 297 The Frederick-Town Herald assured readers: Frederick-Town Herald, reprinted in the Richmond Recorder, December 8, 1802, cited in Brodie, 469.
- 298 "These daughters, who should have been the principal object": Lynchburg Virginia Gazette, reprinted in the Richmond Recorder, November 3, 1802, cited in Brodie, 470.
- 298 His son, Madison Hemings, told an Ohio newspaper editor: "Reminiscences of Madison Hemings," Brodie, Appendix I, 641–42.
- 299 Callender continued his attacks: See Michael Durey, With the Hammer of Truth: James Thomson Callender and America's Early National Heroes (Charlottesville: University Press of Virginia, 1990), 165.
- 299 Jefferson's onetime mouthpiece: On Jefferson's interest in Elizabeth Walker, see Kukla, Mr. Jefferson's Women, 41-62.
- 300 He pushed them to make a visit to Washington: TJ to MJE, March 3, 1802, Family Letters, 219; MJE to TJ, April 21, 1802, Family Letters, 224; TJ to MJR, May 1, 1802, Family Letters, 225; TJ to MJE, May 1, 1802, Family Letters, 225–26; TJ to MJR, June 3, 1802, Family Letters, 226–28.
- 300 "I think I discover in you a willingness to withdraw": TJ to MJE, March 3, 1802, Family Letters, 219.

434 💥 NOTES

- 301 Polly resisted his pleas: TJ to MJR, October 7, 1802, Family Letters, 236; TJ to MJE, October 7, 1802, Family Letters, 236-37; TJ to MJR, October 18, 1802, Family Letters, 237; TJ to MJE, October 18, 1802, Family Letters, 237; MJR to TJ, October 29, 1802, Family Letters, 238; TJ to MJR, November 2, 1802, Family Letters, 238-39.
- 302 Traveling the rugged roads: MJE to TJ, November 5, 1802, Family Letters, 239; MJR to TJ, November 9, 1802, Family Letters, 239.
- 303 Jefferson's daughters made their way to Washington: MJE to TJ, January 11, 1803, Family Letters, 240.
- 303 But Thomas Jefferson turned a blind eye to his own distresses: TJ to MJE, January 18, 1802, *Family Letters*, 241.

24: MOTHERHOOD AND MORTALITY

- 306 "Take care of yourself": TJ to MJE, November 27, 1803, Family Letters, 249.
- 306 "Some friend of your Mama's": TJ to MJE, December 26, 1803, Family Letters, 250.
- 306 "I write amid the noises and confusion": MJR to TJ, January 14, 1804, Family Letters, 252-53.
- 307 Thomas Jefferson was determined to cheer up his daughters: TJ to MJR, January 23, 1804, Family Letters, 254-55.
- 307 "Let us all see that you have within yourself": TJ to MJE, January 29, 1804, Family Letters, 256.
- 308 In a letter to her father: MJE to TJ, February 10, 1804, Family Letters, 256.
- 308 Patsy's daughter Ellen remembered: Domestic Life, 300.
- 308 "This morning between 8. & 9. aclock": MB 2:1125.
- 308 Thomas Jefferson had now outlived: Domestic Life, 300; Garden Book, Plate X, facing p. 94.
- 309 "It has been some time since I conceived that any event": Abigail Adams to TJ, quoted in *Domestic Life*, 304-5.
- 310 "Others may lose of their abundance": TJ to John Page, June 25, 1804, cited in Domestic Life, 302-3.
- 311 "The scene passing here": TJ to MJE, February 15, 1801, Papers, 32:593.

25: DOMESTIC DIVERSIFICATION

- 315 "I do not hesitate to declare": MJR to TJ, May 31, 1804, Family Letters, 260.
- 316 "We are as usual well here": Ibid., 261.
- 316 Patsy had a history of digestive disorders: Ibid.; for her history of complaints, see MJR to TJ, January 31, 1801, Family Letters, 192.
- 317 "In endeavoring to spare my feelings": TJ to MJR, January 21, 1805, Family Letters, 266.
- 317 "Had not Congress been sitting": Ibid.

- 317 She finally admitted: MJR to TJ, February 28, 1805, Family Letters, 268; Ellen Wayles Randolph to TJ, July 4, 1805, Family Letters, 275.
- 318 "When Heaven has taken from us": TJ to Maria Cosway, October 12, 1786, Papers, 10:443-55.
- 318 Within a month of Polly's death: Neiman, "Coincidence or Causal Connection?" 205: Hemingses, 590.
- 318 In the fall of 1805: MJR to TJ, October 26, 1805, Family Letters, 280.
- 320 As Madison Hemings recalled: "Reminiscences of Madison Hemings," in Brodie, 641.
- 320 Sally Hemings would bear Thomas Jefferson yet one more child: E. A. Foster et al., "Jefferson Fathered Slave's Last Child," *Nature* 396 (November 1998), 27–28; Neiman, "Coincidence or Causal Connection?"; "Report of the Research Committee on Thomas Jefferson and Sally Hemings," Thomas Jefferson Foundation, 2000, http://www.monticello.org/plantation/hemingscontro/hemings_report.html.
- 321 Once he had laid claim to Sally Hemings: Hemingses; TJ and SH; Neiman, "Coincidence or Causal Connection?": "Report of the Research Committee on Thomas Jefferson and Sally Hemings," Thomas Jefferson Foundation, 2000, http://www.monticello.org/plantation/hemingscontro/hemings_report.html.
- 322 Randolph alternately raged and despaired: Letters from TJ to MJR, March 1, 2, 6, 9, 11, 20, 23, 27, 30, 1807; MJR to TJ, March 20, 1807, Family Letters, 296–306.
- 324 Patsy raised her children to compete: MJR to TJ, January 31, 1801, Family Letters, 193. TJ referred to "Elleanoroon" in letter to MJR, December 27, 1798, Papers, 30:605.
- 324 He eagerly encouraged them: TJ to MJR, February 5, 1801, Family Letters, 195.
- 325 On the family's annual summer visit: Anne Cary Randolph, 1805-1808, House-
- hold Accounts, Thomas Jefferson Papers, Series 7, Miscellaneous Bound Volumes, Library of Congress; Malone, 5:611–12.
- 326 Anne Randolph was a gentle girl: TJ to Anne Cary Randolph, May 20, 1803, Family Letters, 245-46; Anne Cary Randolph to TJ, December 12, 1806, Family Letters, 292.
- 326 By the summer of 1807, Jefferson was treating Anne: Anne Cary Randolph to TJ, November 9, 1807, *Family Letters*, 314.
- 326 "The tulips and Hyacinths": Ibid.
- 326 The person who did the planting: Lucia C. Stanton, "Wormley Hughes (1781-1858)," http://www.monticello.org/plantation/lives/wormley.html.
- 326 By the time she had reached the age of five: MJR to TJ, April 16, 1802, Family Letters, 223.
- 327 Ellen would prove: Thomas Jefferson Randolph to TJ, February 24, 1803, Family Letters, 243.
- 327 By that time, Patsy had reached the conclusion: MJR to TJ, July 12, 1803, Family Letters, 246-47.
- 328 By the age of nine, Ellen was engaging Jefferson: Ellen Wayles Randolph to TJ,

July 4, 1805, Family Letters, 274; TJ to Ellen Wayles Randolph, July 10, 1805, Family Letters, 276; TJ to Ellen Wayles Randolph, November 30, 1806, Family Letters, 291; Ellen Wayles Randolph to TJ, December 12, 1806, Family Letters, 293.

- 328 Jefferson urged Ellen: TJ to Ellen Wayles Randolph, June 7, 1807, Family Letters, 309-10.
- 329 With this offhand bit of interpretive animal husbandry: TJ to Francis C. Gray, March 4, 1815, Thomas Jefferson Papers, Series 1, General Correspondence, 1651– 1827, Library of Congress. See Fawn Brodie's discussion of Jefferson's letter to Francis C. Gray on the mathematics of miscegenation, Brodie, 586–87.
- 329 As he reminded Ellen of her responsibility: Ibid.

26: THE PURSUIT OF HAPPINESS

- 331 For Thomas Jefferson, the end to government service: Malone, vol. 5, Jefferson the President: Second Term, 1805-1809 (Boston: Little, Brown, 1974), xi.
- 331 His grandchildren could hardly wait: Ellen Wayles Randolph to TJ, January 15, 1808, Family Letters, 321; Anne Cary Randolph to TJ, January 22, 1808, Family Letters, 324.
- 332 "The weary statesman": On Moore's verses, see Lucia C. Stanton, "Looking for Liberty: Thomas Jefferson and the British Lions," Eighteenth-Century Studies 26, no. 4 (Summer 1993), 651.
- 333 Toward the end of the renovation: McLaughlin, Jefferson and Monticello, 323-28.
- 333 Thomas Jefferson had taken a page: Chew, "Inhabiting the Great Man's House: Women and Space at Monticello," 223–52.
- 334 For Patsy's growing daughters: Ibid., 232.
- 335 Sally Hemings may have lived: Free Some Day, 112-13; Bear, 46.
- 335 "We were free from the dread": "Reminiscences of Madison Hemings," in Brodie, 641-43; Bear, 102.
- 336 Monticello remained a musical place: Free Some Day, 101.
- 337 But Jefferson had his way of coping: S. Allen Chambers, Poplar Forest and Thomas Jefferson (Forest, Va.: Corporation for Jefferson's Poplar Forest, 1993), 21-34.
- 338 "You may consider your journey to Bedford": Ellen Wayles Randolph to MJR, September 27, 1816, Transcript of Manuscript, Correspondence of Ellen Wayles Randolph Coolidge, SSCL, University of Virginia, FLP.
- 338 "Ellen and Cornelia are the severest students": TJ to MJR, August 31, 1817, Family Letters, 419.
- 339 On a visit in July 1819: Ellen Wayles Randolph to MJR, July 18, 1819, Correspondence of Ellen Wayles Randolph Coolidge, SSCL, FLP.
- 339 "I have often thought that the life of a student": Ibid.
- 340 "The ruin of the family is still extending itself": MJR to TJ, January 2, 1808, Family Letters, 318.
- 340 "I have now the gloomy prospect": TJ to MJR, January 5, 1808, Family Letters, 319.

341 "Your last letter has cast a gloom": MJR to TJ, January 16, 1808, Family Letters, 322-3.

27: THE PERILS OF MATRIMONY

- 342 As he settled into retirement at home: Malone, vol. 6, The Sage of Monticello (Boston: Little, Brown, 1981), 275-82.
- 342 None of his grandsons were serious scholars: Ibid., 389-90, 464-69.
- 343 "I think this is the most extraordinary collection of talent": American Presidency Project, http://www.presidency.ucsb.edu/ws/index.php?pid=8623.
- 344 Jefferson's eldest granddaughter was the first: Family Letters, 357n.
- 344 Two months after the wedding: MJR to TJ, November 18, 1808, Family Letters, 360.
- 344 But Anne's bridal anguish turned out to be prescient: MB 2:1270; Malone, 6:159. MJR to Elizabeth House Trist, May 31, 1815, Transcript of Manuscript, Elizabeth House Trist Papers, Virginia Historical Society, FLP.
- 345 Anne Randolph Bankhead's marriage was a living hell: TJ to MJE, January 7, 1798, Family Letters, 151-53; Bear, 94.
- 345 Anne's husband became so uncontrollable: MJR to TJ, November 20, 1816, Family Letters, 417.
- 346 Anne, much to everyone's dismay: Wilson Cary Nicholas to TJ, February 28, 1819, and TJ to Wilson Cary Nicholas, March 8, 1819, Thomas Jefferson Papers, Library of Congress, cited in Alan Pell Crawford, *Twilight at Monticello: The Final Years of Thomas Jefferson* (New York: Random House, 2008), 170–71.
- 346 Charles Bankhead, for his part: Malone, 6:299-30. On court day, see Rhys Isaac, The Transformation of Virginia, 1740-1790 (Chapel Hill: University of North Carolina Press, 1982), 88-90.
- 347 Even after Charles Bankhead had stabbed her brother: MJR to TJ, August 7, 1819, Family Letters, 430; Cornelia Jefferson Randolph to Virginia Randolph Trist, August 11, 1819, Transcript of Manuscript, Nicholas Philip Trist Papers, Southern Historical Collection, University of North Carolina, FLP.
- 347 "Ellen fulfills the promises": MJR to Elizabeth House Trist, May 31, 1815, Transcript of Manuscript, Elizabeth House Trist Papers, Virginia Historical Society, FLP.
- 348 "Really, my dear Nicholas": Ellen Wayles Randolph to Nicholas Philip Trist, March 30, 1824, Transcript of Manuscript, Nicholas Philip Trist Papers, Library of Congress; FLP.
- 350 **Cornelia mocked a pretty girl:** Cornelia Jefferson Randolph to Virginia Randolph Trist, August 11, 1819, Nicholas Philip Trist Papers, Southern Historical Collection, FLP.
- 350 Ellen and Cornelia amused each other: Ellen Wayles Randolph to MJR, April 14, 1818, Correspondence of Ellen Wayles Randolph Coolidge, SSCL, FLP.

438 💥 NOTES

- 350 The Randolph girls made an inside joke: MJR to Virginia Jefferson Randolph Trist, January 10, 1822, Nicholas Philip Trist Papers, Southern Historical Collection, FLP.
- 351 On a visit to Richmond, Cornelia could barely endure: Cornelia Jefferson Randolph to Virginia Jefferson Randolph Trist, December 14, 1817, Nicholas Philip Trist Papers, Southern Historical Collection, FLP.
- 352 She was at first appalled by the cost of fashion: Ellen Wayles Randolph to MJR, March 2, 1814, Correspondence of Ellen Wayles Randolph Coolidge, SSCL, FLP.
- 352 But even as she began to visit in town: Ellen Wayles Randolph to MJR, April 14, 1818, Correspondence of Ellen Wayles Randolph Coolidge, SSCL, University of Virginia, FLP.
- 353 "I have already been held to the world": Ellen Wayles Randolph to MJR, 21 December 1818, Correspondence of Ellen Wayles Randolph Coolidge, SSCL, FLP.
- 353 Still single three years later: Ellen Wayles Randolph to MJR, April 3, 1822, Correspondence of Ellen Wayles Randolph Coolidge, SSCL, FLP.
- 353 She was still single and nearly ready to give up trying: Malone, 6:456-59.
- 354 Her mother and sisters rejoiced at her rescue from their ruin: Mary Jefferson Randolph to Ellen Wayles Randolph Coolidge, October 23, 1825, Correspondence of Ellen Wayles Randolph Coolidge, SSCL, FLP.
- 355 **"I know I wish I could do something":** Cornelia Jefferson Randolph to Ellen Wayles Randolph Coolidge, November 24, 1825, Correspondence of Ellen Wayles Randolph Coolidge, SSCL, FLP.

28: THE CAPRICIOUSNESS OF FORTUNE

- 356 In 1819, the first great financial panic: Herbert E. Sloan, Principle and Interest: Thomas Jefferson and the Problem of Debt (New York: Oxford University Press, 1995). On salad oil, see TJ to TJR, April 16, 1810, Family Letters, 396. Even as late as 1822, TJ purchased marble busts of James Madison and James Monroe; see MB 2:1383.
- 357 But the bonds of friendship and kinship dragged him down: Ellen Wayles Randolph to MJR, August 11, 1819, Transcript of Manuscript, Correspondence of Ellen Wayles Randolph Coolidge, SSCL, FLP.
- 358 When John Wayles Eppes married Polly Jefferson: Francis Wayles Eppes to TJ, May 13, 1822, Family Letters, 445; Francis Wayles Eppes to TJ, April 23, 1824, Family Letters, 449.
- 358 Betsy Hemmings, the niece of Sally Hemings: Descendants of Betsy Hemmings (the Buckingham County spelling of the family name) offer their version of the doubled history of their branch of the Wayles-Hemings-Eppes family at http://www.buckinghamhemmings.com/.
- 359 Out of generosity to Polly's only surviving child: Malone, 6:287. Polly's baby daughter, Maria, lived only to the age of three. See *Free Some Day*, Jefferson Family genealogical chart.

- 359 Thomas Mann Randolph was never able to escape: TMR to Thomas Taylor, May 19, 1819, Robert Alonzo Brock Collection, Box 8, Folder 14, Huntington Library.
- 359 "The negroes, all of which I part from": TMR to Taylor, November 17, 1815, Robert Alonzo Brock Collection.
- 360 "This momentous question, like a fire bell in the night": TJ to John Holmes, April 22, 1820, Transcript of Manuscript, Thomas Jefferson Papers, Series 1, General Correspondence, 1651–1827, Library of Congress, http://www.loc.gov/exhibits/ jefferson/159.html.
- 361 "I regret that I am now to die in the belief": Ibid.
- 362 According to Jefferson's beliefs: Thomas Jefferson to Francis C. Gray, March 4, 1815, Thomas Jefferson Papers, Series 1, General Correspondence, 1651–1827, Library of Congress. TJ to Ellen Wayles Randolph, June 7, 1807, Family Letters, 309–10. See Fawn Brodie's discussion of Jefferson's letter to Francis C. Gray on the mathematics of miscegenation, Brodie, 586–87.
- 362 Though the enslavement of Sally Hemings: Gordon-Reed, in *Hemingses*, 596-98, offers the definitive discussion of the Hemings children's understanding of their racial and legal status.
- 362 By the time he was twelve years old: Farm Book, 128.
- 363 When Jefferson inventoried his slaves: Ibid.
- 363 Their brother Madison reported: Brodie, 640.
- 363 Harriet Hemings made a lifelong impression: Bear, 102.
- 364 By the summer of 1825: MJR to Anne Cary Randolph Morris, August 8, 1825(?), Houston-Morris-Ogden Family Papers, FLP; MJR to Anne Cary Randolph Morris, January 22, 1826, Smith-Houston-Morris-Ogden Family Papers, FLP.
- 365 "My dear father wrote most kindly": Ibid.
- 365 "Mama and myself were so peculiarly unfortunate": Mary J. Randolph and Virginia J. Randolph Trist to Ellen W. Randolph Coolidge, September 11, 1825, Correspondence of Ellen Wayles Randolph Coolidge, SSCL, FLP.
- 366 "Nothing new has happened": TJ to Anne Randolph Bankhead, May 26, 1811, Family Letters, 400.
- 366 Sometime after the new year of 1826: Cornelia Jefferson Randolph to Ellen Wayles Randolph Coolidge, February 23, 1826, Correspondence of Ellen Wayles Randolph Coolidge, SSCL, FLP.
- 367 Thomas Jefferson had been too ill: Eyewitness account by Dr. Robley Dunglinson, in *Life*, 3:549; TJ to Thomas Jefferson Randolph, February 11, 1826, *Family Letters*, 470.

29: WHEN WE THINK HOW WE LIV'D BUT TO LOVE THEM

- 368 A heavy pall descended on Monticello: MJR to Ellen Randolph Coolidge, March 1, 1826, Correspondence of Ellen Wayles Randolph Coolidge, SSCL, FLP.
- 368 Childbirth was always an occasion for dread: Joseph Coolidge and Ellen Randolph

440 💥 NOTES

Coolidge to MJR, February 8, 1826; Ellen Randolph Coolidge to MJR, March 23, 1826, Correspondence of Ellen Wayles Randolph Coolidge, SSCL, FLP.

- 369 Patsy and her daughters belittled the eccentricities: Cornelia Jefferson Randolph to Ellen Randolph Coolidge, February 23, 1826, Correspondence of Ellen Wayles Randolph Coolidge, SSCL, FLP; Ellen Randolph Coolidge to Virginia Randolph Trist, May 6, 1826, Mary Jefferson Randolph to Ellen Randolph Coolidge, April 16 and May 12, 1826, Transcripts of Manuscript, Correspondence of Ellen Wayles Randolph Coolidge, SSCL, FLP.
- 369 Thomas Jefferson lived out the final months of his life: MJR and Nicholas Trist to Ellen Randolph Coolidge, April 5, 1826, Transcript of Manuscript, Correspondence of Ellen Wayles Randolph Coolidge, SSCL, FLP.
- 370 One night as Thomas Jefferson lay awake in pain and worry: MJR and Nicholas Trist to Ellen Randolph Coolidge, April 5, 1826, Correspondence of Ellen Wayles Randolph Coolidge, SSCL, FLP.
- 370 After considerable arm-twisting: Mary Jefferson Randolph to Ellen Randolph Coolidge, April 16, 1826, Correspondence of Ellen Wayles Randolph Coolidge, SSCL, FLP.
- 371 Her father, meanwhile, put his affairs in order: Transcript, http://wiki.monticello. org/mediawiki/index.php/Jefferson%27s_Will; Albemarle County Will Book, 8:248-50.
- 373 On the fiftieth anniversary of the Declaration of Independence: Life, 3:543-44.
- 373 Three men left eyewitness accounts: http://wiki.monticello.org/mediawiki/ index.php/Jefferson%27s_Last_Words.
- 374 There are no women, no children, no slaves: Malone, 6:497.
- 374 Jeff Randolph remembered: Life, 3:544.
- 374 Martha Jefferson Randolph had sat with her father: Ibid., 3:547.
- 376 Henry Randall, the man Jefferson's grandchildren trusted: Ibid., 3:545; Stanton, "Looking for Liberty," 655-56; 666-68.
- 377 Less poetical, perhaps, but just as heartfelt: 3:545.
- 377 They were far luckier than most of the people: Free Some Day, 141-42.
- 378 Thomas Jefferson had lived in luxury and left his family in penury: Ellen Randolph Coolidge to Nicholas Trist, September 27, 1826; Ellen Randolph Coolidge, "Essay on Thomas Jefferson's Finances," 1826, Correspondence of Ellen Wayles Randolph Coolidge, SSCL, FLP.
- 378 To vindicate her grandfather: TJ to Ellen Randolph Coolidge, November 14, 1825, Family Letters, 461.
- 379 She missed those things badly in the north: As she commented in 1826, "The curse of domestic life in New England is the insolence & insubordination of the servants & the difficulty of getting any that do not give more trouble than they save." See Ellen Randolph Coolidge to Virginia Randolph Trist, May 29, 1826, Correspondence of Ellen Wayles Randolph Coolidge, SSCL, FLP.

- 379 Patsy Randolph had endorsed the denial: Patsy did tell Jeff Randolph to defend her father against the charges; TJ and SH, 80.
- 379 Ellen, however, took action to combat the rumors: Ellen Wayles Randolph Coolidge to Joseph Coolidge, October 24, 1858, Correspondence of Ellen Wayles Randolph Coolidge, SSCL, FLP.
- 380 Ellen granted that there were mixed-race children: Ibid. For the definitive discussion of Ellen Coolidge and Jefferson Randolph's promotion of the Carr brothers as Hemings progenitors, see *TJ and SH*. For the most recent attempt to pin the paternity of the Hemings children on anyone except Thomas Jefferson, particularly the Carr brothers and now Randolph Jefferson, see William G. Hyland, Jr., In Defense of Thomas Jefferson: The Sally Hemings Sex Scandal (New York: St. Martin's, 2009).
- 381 For Ellen, the very presence of Jefferson's white daughters: Ibid.
- 382 "The discomfort of slavery I have borne all my life": MJR to Ellen Randolph Coolidge, August 2, 1825, Correspondence of Ellen Wayles Randolph Coolidge, SSCL, FLP.
- 382 "My life of late years has been such a tissue of privations": MJR to Ann Cary (Nancy) Randolph Morris, January 22, 1826, Smith-Houston-Morris-Ogden Family Papers, FLP.
- 382 Her poverty was scandalous: Mary Jefferson Randolph to Ellen Randolph Coolidge, January 25, 1827, Correspondence of Ellen Wayles Randolph Coolidge, SSCL, FLP; MJR to Ann Cary (Nancy) Randolph Morris, March 22, 1827, Houston-Morris-Ogden Family Papers, FLP; MJR to Ann Cary (Nancy) Randolph Morris, January 22, 1826, Smith-Houston-Morris-Ogden Family Papers, FLP.

383 Sally Hemings died in Charlottesville: Free Some Day, 143.

Bibliography

BOOKS

- Adams, William Howard. *The Paris Years of Thomas Jefferson*. New Haven, Conn.: Yale University Press, 1997.
- Allgor, Catherine. Parlor Politics: In Which the Ladies of Washington Help Build a City and a Government. Charlottesville: University Press of Virginia, 2000.
 - ——. A Perfect Union: Dolley Madison and the Creation of the American Nation. New York: Henry Holt, 2006.
- Barnet, Gerald. Richard and Maria Cosway: A Biography. Cambridge, England: Lutterworth, 1995.
- Bear, James A., Jr. Jefferson at Monticello: Recollections of a Monticello Slave and of a Monticello Overseer. Charlottesville: University Press of Virginia, 1999.
- Bear, James A., Jr., and Lucia C. Stanton, eds. Jefferson's Memorandum Books: Accounts, with Legal Records and Miscellany, 1767–1826. 2 vols. Princeton, N.J.: Princeton University Press, 1997.
- Betts, Edwin Morris. *Thomas Jefferson's Farm Book*. Charlottesville: Thomas Jefferson Memorial Foundation, 1999.
- ------. Thomas Jefferson's Garden Book. Philadelphia: American Philosophical Society, 1944.
- Betts, Edwin Morris, and James Adam Bear, Jr. *The Family Letters of Thomas Jefferson*. Charlottesville: University Press of Virginia, 1966.
- Blauvelt, Martha Tomhave. The Work of the Heart: Young Women and Emotion, 1780–1830. Charlottesville: University Press of Virginia, 2007.
- Boyd, Julian, ed. The Papers of Thomas Jefferson. 35 vols. to date. Princeton: Princeton University Press, 1950-.
- Brodie, Fawn. Thomas Jefferson: An Intimate History. New York: Norton, 1974.

444 🧩 BIBLIOGRAPHY

- Brown, Kathleen M. Good Wives, Nasty Wenches, and Anxious Patriarchs: Gender, Race, and Power in Colonial Virginia. Chapel Hill: University of North Carolina Press, 1996.
- Bullock, Helen Duprey. My Head and My Heart: A Little History of Thomas Jefferson and Maria Cosway. New York: Putnam's, 1945.
- Chambers, S. Allen. *Poplar Forest and Thomas Jefferson*. Forest, Va.: Corporation for Jefferson's Poplar Forest, 1993.
- Church of England. Book of Common Prayer, and Administration of the Sacraments and Other Rites and Ceremonies of the Church: Together with the Psalter Or Psalms of David, Pointed as They are to be Sung Or Said in Churches. London: Joseph Bentham, 1765.

Clayton, Ellen C. English Female Artists. Vol. 1. London: Tinsley Brothers, 1876.

Clinton, Catherine. The Plantation Mistress. New York: Pantheon, 1984.

Crawford, Alan Pell. Twilight at Monticello: The Final Years of Thomas Jefferson. New York: Random House, 2008.

Daniels, Jonathan. The Randolphs of Virginia. Garden City, N.Y.: Doubleday, 1971.

Dictionary of American Biography. New York: Charles Scribner's, 1931.

- Dorman, John Frederick. Ancestors and Descendants of Francis Epes I of Virginia. 2 Vols. Society of the Descendants of Francis Epes I of Virginia, 1992.
- Durey, Michael. With the Hammer of Truth: James Thomson Callender and America's Early National Heroes. Charlottesville: University Press of Virginia, 1990.
- Eckenrode, H. J. *The Randolphs: The Story of a Virginia Family*. Indianapolis and New York: Bobbs-Merrill, 1946.
- Ellis, Joseph. American Sphinx: The Character of Thomas Jefferson. New York: Vintage, 1998.
- Eustace, Nicole. Passion Is the Gale: Emotion, Power, and the Coming of the American Revolution. Chapel Hill: University of North Carolina Press, 2008.
- Flanders, Stephen A. The Atlas of American Migration. New York: Facts on File, 1998.

Foley, John P., ed. The Jeffersonian Cyclopedia. New York: Funk & Wagnalls, 1900.

Ford, Paul Leicester, ed. "The Autobiography of Thomas Jefferson." In *The Writings of Thomas Jefferson.* 10 vols. New York: Putnam's, 1892-99.

- Gaines, William H. Jr. Thomas Mann Randolph: Jefferson's Son-in-Law. Baton Rouge: Louisiana State University Press, 1966.
- Godineau, Dominique. The Women of Paris and Their French Revolution. Berkeley: University of California Press, 1998.

Gordon-Reed, Annette. The Hemingses of Monticello: An American Family. New York: Norton, 2008.

——. Thomas Jefferson and Sally Hemings: An American Controversy. Charlottesville: University Press of Virginia, 1997.

Holton, Woody. Forced Founders: Indians, Debtors, Slaves, and the Making of the American Revolution in Virginia. Chapel Hill: University of North Carolina Press, 1999.

Hyland, William G. In Defense of Thomas Jefferson: The Sally Hemings Sex Scandal. New York: St. Martin's, 2009.

- Isaac, Rhys. The Transformation of Virginia, 1740–1790. Chapel Hill: University of North Carolina Press, 1982.
- Jefferson, Thomas. Notes on the State of Virginia. New York: Harper Torchbooks, 1964.
- Kierner, Cynthia. Scandal at Bizarre: Rumor and Reputation in Jefferson's America. Charlottesville: University of Virginia Press, 2004.
- Kimball, Marie. Jefferson: The Road to Glory, 1743-1776. New York: Coward-McCann, 1943.

Kukla, Jon. Mr. 7efferson's Women. New York: Knopf, 2007.

- Landes, Joan B. Women and the Public Sphere in the Age of the French Revolution. Ithaca, N.Y.: Cornell University Press, 1988.
- Levy, Darline Gay. Women in Revolutionary Paris, 1789-1795. Champaign: University of Illinois Press, 1981.
- Lewis, Jan. The Pursuit of Happiness: Family and Values in Jefferson's Virginia. New York: Cambridge University Press, 1983.
- Lockridge, Kenneth A. On the Sources of Patriarchal Rage: The Commonplace Books of William Byrd and Thomas Jefferson and the Gendering of Power in the Eighteenth Century. New York: New York University Press, 1992.
- Malone, Dumas. Jefferson and His Time. 6 vols. Boston: Little, Brown, 1948-81.
- Mayo, Bernard, ed. Thomas Jefferson and His Unknown Brother, Randolph. Charlottesville: University Press of Virginia, 1942.
- McCullough, David. John Adams. New York: Simon & Schuster, 2001.
- McLaughlin, Jack. Jefferson and Monticello: The Biography of a Builder. New York: Henry Holt, 1988.
- Merrill, Boynton. Jefferson's Nephews: A Frontier Tragedy. Princeton, N.J.: Princeton University Press, 1976.
- Middleton, Arthur Pierce. Tobacco Coast: A Maritime History of Chesapeake Bay in the Colonial Era. Newport News, Va.: Mariners' Museum, 1953.
- Morgan, Philip D. Slave Counterpoint: Black Culture in the Eighteenth Century Chesapeake and Low Country. Chapel Hill: University of North Carolina Press, 1998.
- Parton, James. Life of Thomas Jefferson, Third President of the United States. Boston: James R. Osgood, 1874.
- Randall, Henry S. The Life of Thomas Jefferson. 3 vols. New York: Derby & Jackson, 1858.
- Randolph, Sarah Nicholas. The Domestic Life of Thomas Jefferson, Compiled from Family Letters and Reminiscences by His Great Granddaughter. 1871. Rept. Scituate, Mass.: Digital Scanning and Publishing, 2001.
- Reddy, William. The Navigation of Feeling: A Framework for the History of Emotions. Cambridge, England: Cambridge University Press, 2001.

Rediker, Marcus. The Slave Ship: A Human History. New York: Viking, 2007.

Riedesel, Baroness von. Baroness von Riedesel and the American Revolution: Journal and Correspondence of a Tour of Duty, 1776–1783. A revised translation with Introduction and Notes by Marvin L.Brown, Jr., with the assistance of Marta Huth. Chapel Hill:

446 💥 BIBLIOGRAPHY

Institute of Early American History and Culture, and University of North Carolina Press, 1965.

- Rothman, Joshua D. Notorious in the Neighborhood: Sex and Families across the Color Line in Virginia, 1787–1861. Chapel Hill: University of North Carolina Press, 2003.
- Salmon, Marylynn. Women and the Law of Property in Early America. Chapel Hill: University of North Carolina Press, 1989.
- Shammas, Carole. A History of Household Government in America. Charlottesville: University Press of Virginia, 2002.
- Sloan, Herbert E. Principle and Interest: Thomas Jefferson and the Problem of Debt. New York: Oxford University Press, 1995.
- Stanton, Lucia C. Free Some Day: The African-American Families of Monticello. Charlottesville: Thomas Jefferson Foundation, 2000.
- Stein, Susan. The Worlds of Thomas Jefferson at Monticello. New York: Harry N. Abrams, 1993.

Williamson, George C. Richard Cosway, R.A. London: George Bell, 1905.

Wills, Garry. Inventing America: Jefferson's Declaration of Independence. New York: Vintage, 1978.

ARTICLES

Brodie, Fawn M. "Jefferson Biographers and the Psychology of Canonization." *Journal of Interdisciplinary History* 2 (1971), 157–58, 160–61.

Chew, Elizabeth V. "Inhabiting the Great Man's House: Women and Space at Monticello." In Joan E. Hartman, and Adele Seeff, eds., *Structures and Subjectivities: Attending to Early Modern Women*. Newark: University of Delaware Press, 2007.

Coleman, Elizabeth. "The Great Fresh of 1771." Virginia Cavalcade 1 (1951), 20-22.

Foster, E. A., et al. "Jefferson Fathered Slave's Last Child." Nature 396 (November 1998).

Hast, Adele. "Legal Status of the Negro in Virginia." *Journal of Negro History* 54 (July 1969).

Hemphill, John M. II, ed. "John Wayles Rates His Neighbours." Virginia Magazine of History and Biography 66, no. 3 (July 1958), 302-6.

- Isaac, Rhys. "The First Monticello." In Peter Onuf, ed., Jeffersonian Legacies. Charlottesville: University Press of Virginia, 1993.
- "Jefferson Family." Tyler's Quarterly Historical and Genealogical Magazine 6, no. 3 (January 1925).

Kern, Susan. "Material World of the Jeffersons at Shadwell." William and Mary Quarterly (April 2005).

- "Life Among the Lowly, No. 1." Pike County (Ohio) Republican, March 13, 1873. Reprinted as "Reminiscences of Madison Hemings," in Fawn M. Brodie, Thomas Jefferson: An Intimate History. New York: Norton, 1974.
- "Life Among the Lowly, No. 3." Pike County (Ohio) Republican, December 25, 1873. Reprinted as "Memoirs of Israel Jefferson," in Annette Gordon-Reed, Thomas Jefferson

and Sally Hemings: An American Controversy. Charlottesville: University Press of Virginia, 1997.

- Morgan, Marie, and Edmund S. Morgan. "Jefferson's Concubine." New York Review of Books, October 9, 2008.
- Neiman, Fraser D. "Coincidence or Causal Connection? The Relationship between Thomas Jefferson's Visits to Monticello and Sally Hemings's Conceptions." Forum: Thomas Jefferson and Sally Hemings Redux, William and Mary Quarterly, 3rd Series, vol. 57, no. 1 (January 2000), 198–210.
- Raibmon, Paige. "Naturalizing Power: Land and Sexual Violence along William Byrd's Dividing Line." In Virginia J. Scharff, ed., Seeing Nature through Gender. Lawrence: University Press of Kansas, 2003.
- Randolph, Mary, and Anne Cary. "Reminiscences of Th.J. by MR." Manuscript copy by University of Virginia Library. In Julian Boyd, ed., *The Papers of Thomas Jefferson*. Princeton: Princeton University Press, 1950, vol. 6.
- Stanton, Lucia C. "Looking for Liberty: Thomas Jefferson and the British Lions." Eighteenth-Century Studies 26, no. 1 (Summer 1993).
- Steele, Brian. "Thomas Jefferson's Gender Frontier." Journal of American History 95, no.1 (June 2008).

Theobald, Mary Miley. "Eppington." Colonial Williamsburg (Summer 1997).

——. "Slave Conspiracies in Colonial Virginia." Colonial Williamsburg Journal (Winter 2005–2006).

Virginia Magazine of Biography and History 14, no. 3 (January 1907), 226-27.

- Weaver, Betty Woodson. "Mary Jefferson and Eppington." Virginia Cavalcade 19, no. 2 (Autumn 1969).
- Weeks, Elie. "Thomas Jefferson's Elk-Hill." Goochland County Historical Society Magazine 3 (1971), 6-11.

MANUSCRIPTS, COLLECTIONS

"Account Book of Peter Jefferson," HM912. The Huntington Library.

"Inventory of the Estate of Peter Jefferson." Huntington Library. HM 912.

"Jefferson Family Bible, 1752-1861." University of Virginia Library. Accession 4726.

"Jefferson Papers," Huntington Library. HM5632.

- American Philosophical Society. Smith-Houston-Morris-Ogden Family Papers. Family Letters Project. Thomas Jefferson Foundation, at www.monticello.org/papers/index. html.
- Anne Cary Randolph, 1805–1808. Household Accounts. Thomas Jefferson Papers. Series 7. Miscellaneous Bound Volumes. Library of Congress.
- Coleman, Elizabeth Dabney. "The Carrs of Albemarle County." M.A. thesis, University of Virginia, 1944.
- Coolidge, Ellen Randolph. Letterbook, Special Collections. University of Virginia Library. Accession 9090.

448 💥 BIBLIOGRAPHY

Correspondence of Ellen Wayles Randolph Coolidge. Albert and Shirley Small Special Collections Library. University of Virginia. Family Letters Project. Thomas Jefferson Foundation.

Edgehill-Randolph Papers. University of Virginia. "Thomas Jefferson Memorandum."

- Elizabeth House Trist Papers. Virginia Historical Society. Family Letters Project. Thomas Jefferson Foundation.
- Gilmer-Skipwith Papers. University of Virginia Library. "Dr. George Gilmer's Feebook, 1767, 1771-1775." MSS 6145.
- Hochman, Steven. "Thomas Jefferson: A Personal Financial Biography." Ph.D. diss., University of Virginia, 1987.
- Kern, Susan. "The Jeffersons at Shadwell: The Social and Material World of a Virginia Family." Ph.D. diss., College of William and Mary, 2005.

Martha Wayles Jefferson. International Center for Jefferson Studies.

Martha Wayles Skelton Jefferson Account Book. Library of Congress.

Martha Wayles Skelton Jefferson, 1772-1782. Part B: Household Accounts.

- Nicholas Philip Trist Papers. Southern Historical Collection. University of North Carolina. Family Letters Project. Thomas Jefferson Foundation.
- Papers of Trist and Burke Family Members. Special Collections. University of Virginia Library. MSS 5385-f.

Robert Alonzo Brock Collection. Huntington Library.

Thomas Jefferson "Fee Book, 1764-74 [other accounts, 1764 to 1794]." Huntington Library. HM 836.

Thomas Jefferson Papers Series 7. Miscellaneous Bound Volumes. Library of Congress.

Thomas Jefferson Papers, 1606-1827, http://memory.loc.gov/ammem/collections/ jefferson_papers.

WEBSITES

American Presidency Project. http://www.presidency.ucsb.edu/ws/index.php?pid=8623. America's Historical Newspapers. NewsBank and the American Antiquarian Society, 2004.

http://infoweb.newsbank.com.

Family Letters Digital Archive. Papers of Thomas Jefferson, Retirement Series, at www.monticello.org/papers/index.html.

http://www.slavevoyages.org/tast/database/search.faces.

- "Report of the Research Committee on Thomas Jefferson and Sally Hemings." Thomas Jefferson Foundation, 2000. http://www.monticello.org/plantation/hemingscontro/ hemings_report.html.
- Stanton, Lucia C. "Wormley Hughes (1781–1858)." http://www.monticello.org/plantation/ lives/wormley.html.

Thomas Jefferson Monticello: Thomas Jefferson Encyclopedia. http://wiki.monticello.org/. Thomas Jefferson Papers, 1606–1827. http://memory.loc.gov/ammem/collections/ jefferson_papers. Twinleaf Journal. African-American Gardens at Monticello. Thomas Jefferson Center for Historic Plants. http://www.twinleaf.org/articles/aagardens.html.

Virginia Historical Society, Online Exhibitions: Virginia's Colonial Dynasties. www .vahistorical.org/dynasties/ishamrandolph.htm.

PERSONAL COMMUNICATION

Personal communication, Diane Ehrenpreis, curatorial art historian, Monticello, June 5, 2008.

Illustration Credits

Grateful acknowledgment is made for permission to reprint the images in the insert:

Page 1: Thomas Jefferson (1791) by Charles Willson Peale (Independence National Historical Park). Page from Martha Wayles Skelton Jefferson Household Accounts (1777) (Martha Wayles Skelton Jefferson, 1772-1782, Part B: Household Accounts. From the Library of Congress "The Thomas Jefferson Papers, 1606-1827, http://memory.loc.gov/ cgi-bin/ampage?collId=mtj7&fileName=mtj7page059.db&recNum=26&itemLink=/ ammem/collections/jefferson_papers/mtjser7.html&linkText=7&tempFile=./ temp/~ammem_OozC&filecode=mtj&next_filecode=mtj&itemnum=1&ndocs=19, accessed January 28, 2010). Page 2: Map of Elk Hill Property, drawn from memory by Thomas Jefferson (1793) (Courtesy of the Massachusetts Historical Society). The house at Eppington (Photograph by Chris Wilson). Page 3: Maria Cosway, Mezzotint by Valentine Green after Maria Cosway self-portrait (Monticello/photograph by H. Andrew Johnson). The Monticello mansion (Monticello/photograph by Robert Lautman). Page 4: Thomas Jefferson's Bedroom and Study (Monticello/photograph by Robert Lautman). Martha Jefferson Randolph, portrait by Thomas Sully (Monticello/photograph by Ed Owen). Page 5: Martha Jefferson Randolph's Sitting Room (South Square Room) at Monticello (Monticello/photograph by Robert Lautman). The Monticello staircase (Monticello/photograph by Robert Lautman). Page 6: Cook's Room in South Dependency, similar to room in which Sally Hemings may have lived for a time (Monticello/Thomas Jefferson Foundation, Inc.). Ann Cary Randolph Bankhead, portrait by James Ford (Monticello/Thomas Jefferson Foundation, Inc.). Page 7: Portrait of Ellen Wayles Randolph Coolidge (Courtesy Ellen Eddy Thorndike). Cornelia Jefferson Randolph, bust by William Coffee (Monticello/photograph by Ed Owen). Page 8: Floor plan of Monticello, with estate inventory, by Cornelia Jefferson Randolph (Special Collections, University of Virginia Library). Photograph of Virginia Randolph Trist and Ellen (Eleanora) Wayles Randolph Coolidge (ca. 1850s) (Monticello/Thomas Jefferson Foundation, Inc.). Bell used by Martha Jefferson, given to Sally Hemings (Monticello/Thomas Jefferson Foundation, Inc./Courtesy Moorland-Spingarn Research Center, Howard University).

Index

Abbaye de Panthémont, see Panthémont convent school Adams, Abigail, xx, 178, 189, 203, 282, 401 Polly Jefferson and, 182-86, 309-10 Adams, John, 165, 182, 199, 273, 274, 280, 281, 282, 296, 373 Adams, Thomas, 82 Addison, Joseph, 24, 74 Algerian pirate ships, 173-74, 181-82 Alien and Sedition Acts, 281-82 American Revolution, see War of Independence Amonit, John, 176, 177 Anna (packet), 230 Arnold, Benedict, 136, 138 arrack punch, 17, 406n Bacon, Edmund, 149-50, 335, 336, 345, 363, 364, 401 Bacon, Matthew, 31 Bankhead, Anne Cary Randolph, xiii, xix, 259, 268, 289, 309, 324, 325-26, 327, 330, 343, 368, 369, 397 marriage to Charles Bankhead, 344-47, 365-67

Bankhead, Charles Lewis, 344-47, 365-66, 368, 397 Bankhead, Ellen, 368, 375 Bankhead, William, 368 Barclay, Thomas, 175 Bartram, William, 7, 343 Bastille, 223, 229 Bates, Isaac, 36, 400 Bear, James A., Jr., 154 Bell, Robert Washington, 260 Bell, Sally Jefferson, 260 Bell, Thomas, 166, 223, 256, 257, 260, 282, 398 Bermuda Hundred plantation, 70, 72, 108, 167, 177, 287, 300, 301 Betsy (slave), 360 Bill of Rights, 282 Bingham, Anne Willing, 200-203, 209-11, 220, 224, 401 Bingham, William, 200-201 birth control, 135 Bolling, John, 30, 31, 56, 86, 139, 263, 276 Bolling, Mary Jefferson, 17, 22, 28, 30-31, 48, 86, 139, 250, 269, 276-77, 394 Book of Common Prayer, 87 Boston Massacre, 183 Boston Tea Party, 110 Botidoux, Marie Jacinthe de, 216-17 Boyd, Julian, xvii

454 💥 INDEX

Bracton, Henry de, 31 Bréhan, Marquise de, 209 Brodie, Fawn M., xvii, xviii, xix, 111, 118, 145, 148, 246, 292, 293 Brown, Betty, 76, 91, 100, 104, 106, 132, 136, 137, 149, 163, 259, 262, 301, 398–99 Brown, Kathleen, 89 Buffon, Comte de, 204, 328 Burgesses, House of, 6, 31, 39, 43–44, 77, 78, 80, 147 Burr, Aaron, 293, 331 Byrd, Maria, 75 Byrd, William, 11 Byrd, William, 111

Caesar (Sall's son), 28, 30 Callender, James Thomson, 280-82, 291-92, 293, 296-97, 299, 305, 309, 320, 380, 401 Caractacus (horse), 144 Carr, Dabney, 31-32, 39-40, 41-42, 43, 49-50, 87, 96-97, 98, 103, 235, 394 Carr, Dabney, Jr., 39, 394 Carr, Martha Jefferson, 19, 22, 31-32, 39-40, 48, 81, 87, 96, 97, 233, 248, 253-54, 269, 319, 394 Carr, Peter, 253-54, 256, 283, 299, 394 Carr, Samuel, 256, 380, 394 Carter, John, 3 Charles (slave), 360 Chesterfield, Lord, 328 childbearing, 8-9, 17, 18, 64, 118, 204, 232, 286, 287, 306, 318-19, 366-67, 368, 369,4091 childhood diseases, 168-70, 295, 301, 327 Chiswell, John, 69-70, 401, 412n Chiswell affair, 69-70, 101, 255 Church, Angelica, 270 Clay, Charles, 42, 47, 400 Clermont (ship), 230, 232-33 Coke, Edward, 31

Colbert, Burwell, 337-38, 345, 373, 374 Colley, Nathaniel, 230, 231 Collinson, Peter, 7-8 Committee of Correspondence, 39, 43, 97 Continental Army, 119, 132, 136, 138 Continental Congress, 44, 55, 111, 113, 115, 120, 150, 165, 221 Coolidge, Ellen Wayles Randolph, 48, 69, 105, 256, 309, 320, 338-40, 347-49, 350, 352-53, 369, 375, 378-81, 397 childhood of, 289, 295, 308, 327 intellectual precociousness of, 324, 326-29, 334, 343 marriage to Joseph Coolidge, 354 Coolidge, Joseph, 353-54, 397 Cornwallis, Charles, xxiii, 138-39, 140, 141-43, 144, 145, 154, 155, 278, 310, 337 Corny, Madame de, 235 Cosway, Maria Hadfield, xx, 204-8, 209, 213, 215, 216, 217, 227, 230, 246, 270, 318, 401 Cosway, Richard, 205-6, 207, 401 Cottrell, Sally, 352 Coutts, William, 87, 88 coverture, see property laws Currie, James, 170, 268

Daniels, Jonathan, 11 Davis, William, 87 Declaration of Independence, xxiii, 44, 51, 55, 121, 208, 357, 373, 379 "Dialogue between My Head and My Heart" (Jefferson), 207, 318 Dictionary of the English Language (Johnson), 74 "domestic tranquility," xxii–xxiv, 88–89, 92, 153, 200, 202, 211–12, 231, 240, 252, 270, 272–73, 289, 312, 337 dueling, 255 Dungeness plantation, 6, 8, 12, 13, 52 Dunglinson, Robley, 373 Dunmore, John Murray, Fourth Earl of, 43-44, 45-46, 97, 110, 115, 116, 117, 121, 124, 400 Dupré (launderer), 217

Eckenrode, H. J., 14

Edgehill property, 241, 246, 247, 249, 268, 289, 306, 360, 364

Edinburgh, University of, 240

electoral college, 293, 311

Elk Hill plantation, 74, 83, 92–93, 106–8, 113, 114, 123, 164, 167, 169, 226, 262 Jefferson family attachment to, 154–55,

278 in wartime, 139-40, 141-43, 144, 310

Ellis, Joseph, 55, 221

Embargo of 1807, 51

Eppes, Elizabeth Wayles "Betsy," 64, 65, 96, 99, 100–101, 114, 117, 123, 149, 151–53, 164, 166, 169–70, 211, 246, 309, 395–96 Hemings children related to, 166, 233 marriage to Francis Eppes, 72, 86, 167 Polly Jefferson and, 175–76, 178–79, 247–48, 251, 273, 278, 301, 308

Eppes, Francis (Elizabeth's husband), 71, 72, 86, 100–101, 102, 115, 116, 122, 123, 161, 164, 165, 166, 167, 169, 170, 192, 215, 226, 262–63, 396

as Polly Jefferson's guardian, 172, 173, 174-78, 180, 185

Eppes, Francis (Polly's son), 294, 295, 301, 307, 309, 339, 350, 358, 359, 371

Eppes, John Wayles "Jack," xvii, 96, 101, 166, 251, 284–85, 358, 382, 396

in Congress, 304, 307, 308, 322 marriage to Polly Jefferson, 179, 272–73, 276, 287–88, 290, 293–94, 301

Eppes, Lucy, 169

Eppes, Maria Jefferson, 308

Eppes, Martha "Bolling", 169-70

Eppes, Martha Eppes, *see* Wayles, Martha Eppes

Eppes, Martha Jones, 358, 396 Eppes, Mary Jefferson "Polly," xix, 126-27, 149, 179, 214, 231-32, 251, 258, 298, 311-12, 396 childhood of, 131, 134, 136, 139, 143, 151, 165, 166, 168, 169-71, 277 death in childbirth of, 306, 307-8, 309, 316, 317, 318, 367 at Eppington, 172-73, 241, 247, 295-96 finding a chaperone for, 174-75 marriage to Jack Eppes, 179, 272-73, 276, 301, 345, 358 motherhood and, 285, 286, 287, 288-90, 291, 293-94 in Panthémont convent school, 191, 192, 193, 203 in Paris, 189-90, 191, 192, 193, 195, 197, 203, 208 resistance to father by, 173, 174, 176, 177, 180, 182, 186, 248-49, 301, 302-3 Sally Hemings and, 176-78, 180, 184-85 vovage to Europe of, 172, 177, 180-82 Washington visit of, 302-3 Eppes, Richard Henry, 70-72, 179, 396 Eppes, Sarah, 161 Eppington plantation, 164, 165, 167-69, 170, 190, 233, 241, 273, 300 Essay on Human Understanding (Locke), 349

Fan (Hannah's daughter), 36, 37 Fanny (Myrtilla's daughter), 28, 31, 37 Farell and Jones, 62, 95, 98, 278 Federalists, 281–82, 291, 293, 297, 299 Fenno, John, 280 First Amendment, 282 Forest, The (Wayles estate), 63, 66, 68, 86, 97, 100–101, 108, 118, 131, 164, 167 Fossett, Joseph, 137, 252, 257–58, 260, 262, 271, 363 Fossett, William, 113, 117, 222 Foster, Eugene, xviii

456 💥 INDEX

Franklin, Benjamin, 165, 170, 198, 199 Frederick-Town Herald, 297–98 French Revolution, 223, 228–29, 230 Freneau, Philip, 280 Fuseli, Henry, 205

Gaines, Mrs., 126 Gazette of the United States, 280 George (slave), 360 George III, King of England, 121, 280 Gilmer, George, 39, 42, 97, 111, 400 Gooch, William, 13 Gordon-Reed, Annette, xvii-xviii, 65, 76, 103, 141, 164, 186-87, 192 Governor's Council, 139 Granger, Archy, 96 Granger, Bagwell, 96 Granger, George, Jr., 95-96, 286 Granger, George, Sr. "Great George," 96, 132, 137, 138, 141, 142, 228, 271, 286, 287,400 Granger, Ursula, 95-96, 100, 107, 112, 124, 132, 137, 142, 149, 166, 196, 228, 252, 258, 259, 286, 287, 288, 400 Halle au Bléds, Paris, 206 Hamilton, Alexander, 280, 281, 293, 296 Hannah (slave), 36, 37, 46, 102, 400 Harrison, Nathaniel, 62 Harry (slave laborer), 47, 408n Harvie, John, 25, 29, 400 Hay, George, 299

Hemings, Betsy, 179, 252, 260, 273, 358, 364

Hemings, Beverly, see Hemings, William Beverly

Hemings, Captain, 159-62, 222, 398

Hemings, Critta, 65, 76, 106, 150, 161, 163, 212, 252, 262, 295, 300, 301, 325, 399 Hemings, Daniel, 137, 260

Hemings, Elizabeth "Betty," 68, 72, 73, 75, 87, 91, 100, 101, 105, 106, 149, 166, 212, 221, 236, 252, 321, 398 John Wayles's liaison with, 65–66, 76–77, 102–4, 161, 179, 222, 255, 381 at Monticello, 143, 164, 165, 177, 228,

252, 259, 300, 301-2

Hemings, Eston, see Hemings, Thomas Eston

Hemings, Harriet (I), 270, 274–75, 289, 399

Hemings, Harriet (II), xix, 215, 293, 318, 336, 361-64, 399

Hemings, James, 65, 76, 106, 132, 133, 136, 137, 143, 161, 163, 164, 165, 227, 232, 234, 269, 320, 399 freedom granted to, 261–62, 271, 285,

294-95, 362, 363

in Paris, 165–66, 180, 187, 191, 192, 193, 194, 215, 218–19, 223

Hemings, James Madison, 159–61, 318, 399

Hemings, John, 162, 163, 271, 325, 333, 338, 363, 372, 378-79, 399

Hemings, Lucy, 163, 164, 188, 399

Hemings, Madison, 189, 192, 198, 214-15, 219-20, 236, 298-99, 320, 326, 336, 338, 362, 363, 372, 383

Hemings, Martin, 76, 87, 101, 102, 104, 106, 123, 130–31, 132, 133, 141, 143, 163, 164, 166, 180, 228, 257, 260, 398

Hemings, Mary, 76, 104, 106, 132, 133, 136, 137, 142, 162, 163, 166, 180, 194, 222– 23, 260, 321, 398

Hemings, Molly, 137

Hemings, Nancy, 76, 104, 106, 149, 163, 325, 399

Hemings, Peter, 65, 76, 106, 161, 163, 262, 271, 302, 325, 335, 399

Hemings, Robert, 65, 66, 76, 101, 106, 123, 132, 133, 136, 137, 143, 161, 163, 164, 165, 166, 168, 180, 228, 263, 399

freedom purchased by, 260-61, 285, 363

Hemings, Sally, xvi-xviii, xix, xxi, 65, 100, 101, 103, 106, 149, 161, 188, 212,

234-35, 247, 300, 332, 377, 380-81, 383, 399 Abigail Adams on, 182, 183, 184-85 childhood at Monticello, 162-64, 166 at Eppington, 166, 167-68, 169, 170, 178, 179, 180 family stories, 159-62 first pregnancy of, 219, 227, 231, 232, 233, 235-36 freedom vs. slavery and, 218-20, 221-25 Jefferson's last days and, 373, 374, 375-76 in London, 182-83, 184-86 motherhood and, 270, 274-75, 284-85, 286, 301, 318, 320-21 in Paris, 189-94, 195, 197, 198, 203, 215-18, 223, 227-29, 302 Patsy Jefferson and, 263-65, 267, 274, 275, 285, 319, 320-21, 372-73, 379 as Polly Jefferson's chaperone, 176-77, 179-81, 182-85 as "protected" slave, 226-27, 262, 263-65, 266, 275-76, 279, 298, 305, 321, 335, 361, 372 social invisibility of, 284, 285, 294 Thomas Jefferson liaison with, 214-15, 217, 218, 224-25, 246, 321 voyage to Europe of, 172, 177, 180-82 Hemings, Thenia, 65, 76, 106, 161, 163, 260, 305, 399 Hemings, Thomas Eston, xviii, 215, 320, 326, 336, 338, 363, 372, 383, 400 Hemings, William Beverly, 215, 275, 285, 318, 325-26, 336, 338, 361-63, 399 Hemingses of Monticello, The (Gordon-Reed), xviii Henrietta, HMS, 3 Henry, Patrick, 113 hereditary ownership of slaves, 5-6, 28, 36, 42, 65, 72, 75 Hern, Isabel, 175, 176-77 Holmes, John, 360-61

Hors du Monde plantation, 101, 108, 167, 233 Hôtel de Langeac, Paris, 190–91, 207, 216, 217, 228 House of Delegates, 127 *House of Mirth, The* (Wharton), 353 House of Representatives, U.S., 293 Hughes, Wormley, 234, 252, 257–58, 262, 271, 326

interracial kinship, 66, 76, 101, 102–3, 104, 162, 166, 178–79, 221, 263, 329–30, 358, 362, 380 "Irish Melody" (Moore), 376 Isaac, Rhys, 97–98 Isham, William, 393 "It Is Not the Tear at This Moment Shed" (Moore), 376–77

James River, 6, 10, 83, 140 Jefferson, Anna Scott, see Marks, Anna Scott Jefferson "Nancy" Jefferson, Elizabeth, 17, 22, 28, 34, 36, 37, 42-43, 86, 108, 235, 394 Iefferson, Isaac, 68-69, 96, 107, 132-33, 136-37, 138, 154, 166, 401 Jefferson, Jane, 22, 23, 32-33, 235, 394 Jefferson, Jane Randolph (TJ's daughter), 109, 110, 114, 396 Jefferson, Jane Randolph (TJ's mother), xix, xxi, 80, 86, 100, 108, 124, 393, 406n childhood of, 3, 4, 5, 6, 8-9, 10, 11-13 family history written by, 38-39, 52 final years of, 43-45, 46-48, 117 marriage to Peter Jefferson, 13-15 as planter's wife, 16-27 Thomas's relationship with, 48-57 widowhood of, 24-25, 26-27, 28-37, 40, 42-43 Jefferson, John Garland, 253-54, 256-57, 283, 299, 395

458 🎇 INDEX

Jefferson, Lucy, see Lewis, Lucy Jefferson Jefferson, Lucy Elizabeth (I), 135, 136, 139, 188. 307 Jefferson, Lucy Elizabeth (II), 145, 148, 151, 164, 168, 169-70, 172, 188, 397 Jefferson, Martha (TJ's sister), see Carr, Martha Jefferson Jefferson, Martha "Patsy," see Randolph, Martha Jefferson "Patsy" Jefferson, Martha Wayles Skelton "Patty," xvii, xix, xxi, 195, 229, 321, 395, 415n Baroness von Riedesel and, 128-30 death of, 130, 149-50, 164, 204, 212-13, 221, 308, 310, 367, 376, 381 early years of, 64, 65-69 as governor's wife, 131, 132-43 health concerns of, 111, 118, 121, 122-23, 124, 127, 131, 135, 145, 147, 285 honeymoon at Monticello, 89-92 household duties of, 68, 93-94, 105-6, 108, 116, 117, 125-26, 144-45, 258, 325 last illness of, 145, 147-50, 164 marriage to Bathurst Skelton, 73-75 marriage to Thomas Jefferson, 38-39, 49-50, 82-85, 86-88 motherhood and, 109, 125, 126-27, 134, personal qualities of, 89, 92, 105, 146-47, 211-12, 277-78 property of, 100-109, 416n, 421n Thomas Jefferson's courtship of, 77-81 Jefferson, Mary (TJ's sister), see Bolling, Mary Jefferson Jefferson, Mary "Polly," see Eppes, Mary Jefferson "Polly" Jefferson, Peter, 13-15, 28, 30-31, 35, 36, 38, 45, 50, 52, 57, 241, 393 as planter and surveyor, 16-21, 23-27 Jefferson, Peter Field, 19 Jefferson, Randolph, 22, 23, 34, 36, 37, 42, 45, 48, 86, 235, 395, 409n

Jefferson, Thomas, 394 on the abolition of slavery, 112, 121, 221 accusations of "depravity" and, 255-56, 291, 293, 294, 296-98, 299, 304-5, 309 advice to and expectations of Patsy, 242-45 bequests of, 359, 371-73 commonplace book of, 50-51 correspondence of, xiv-xv, xvi, 25-26, 49-50, 83-84, 115-16, 203, 206 daughters' usefulness to, 299-300, 302, 304 "domestic tranquility" and, xxii-xxiv, 88-89, 92, 153, 200, 202, 211-12, 231, 240, 252, 270, 272-73, 312, 337 early years of, 17, 19, 21, 22, 23, 30, 33 Farm Book of, 93, 142, 154 financial troubles of, 99, 104, 222, 226, 227, 262, 271, 278, 284, 318, 339, 340-41, 353, 354-55, 356-57, 360, 361, 362, 370, 378 Garden Book of, 29, 40, 83, 90, 110, 309 as governor of Virginia, 47, 131, 132-43, 163, 239 as grandfather, 324-30, 331-32 as grieving husband, 150-56, 204, 242, 310 honeymoon at Monticello, 89-92 last days at Monticello, 369-71, 373-77 Maria Cosway and, xx, 204-8, 209 marriage to Martha Wayles Skelton, 38-39, 49-50, 82-85, 86-88 Martha Wayles Skelton courted by, 77-81 migraine headaches and, 47, 322 as minister to France, 165, 170, 173, 189, 195-96, 203-4, 220, 228-29 mother's debts assumed by, 42, 56, 100 mother's relationship with, 48-57 music enjoyed by, 78, 82 Paris household of, 190-92, 193-94 Paris society and, 198-200, 201-3, 209

political controversy and, 43-44, 45, 77, 111 Polly summoned by, 172-87 as president, 282, 283, 292-93, 295, 307, 311. 331 presidential campaign of, 289, 291 private life vs. public duty of, xiv, 147, 155, 282-83, 297, 300, 311-12, 317, 320 properties for sale by, 370-71, 378 Randolph family scandal and, 266-67 as revolutionary, 111-20 Rind/Iefferson family dispute and, 253-57 Sally Hemings and, see Hemings, Sally as secretary of state, 233, 239 at Shadwell, 22, 23, 29-30, 32 as slave-owner, 29, 42, 95-96, 100, 101-2, 104, 112, 142, 259-63, 271, 360-64, 372-73, 415n as vice president, 273-74, 280 on women's duties, see women, Jefferson's views on "Jefferson Establishment" (Brodie), xvii Jenny (slave), 360 Johnson, Samuel, 74, 90-91, 280 Jones, Meriwether, 296-97 Jupiter (Sall's son), 28, 42, 44, 77, 91, 123, 132, 137, 139, 142, 143, 286-87, 289, 326, 400

Kames, Lord, 328 Kauffmann, Angelica, 205 Kennedy, John F., 343 Kern, Susan, 50

Lee, Richard Henry, 122, 126 Leslie, Alexander, 135 Lewis, Charles, 33 Lewis, Charles Lilburn, 33, 47, 394 Lewis, Isham, 47 Lewis, Lucy Jefferson, 19, 22, 33, 48, 394 Lewis, Mary Randolph, 17, 33, 393 Lewis, Meriwether, 293 Lewis, Nicholas, 165, 247, 251 Library of Congress, xiv, xvi "Little Salley" (Sall's daughter), 28, 42–43 Locke, John, 349 London, England, 172, 182, 186 Louisiana Purchase, xxii, 307 Louisiana Territory, 331, 357, 360 Lucinda (Sall's daughter), 28 Lyle, James, 56

Macpherson, James, 78 Madison, Dolley, 302 Madison, Eleanor, 134-35 Madison, James, 134, 150-51, 164, 201, 293, 305 Malone, Dumas, xvii, 51, 88-89, 103, 142, 146, 155, 184, 230, 331, 374 Marks, Anna Scott Jefferson "Nancy," 22, 23, 31, 34, 37, 42, 81, 86, 260, 269, 394, 409n marriage market, 343-44 Marshall, William, 299 Mason (slave), 360 Maury, James, 24, 400 medical treatment, 268-69, 287, 290, 358 Meikleham, Septimia Anne Randolph "Tim," xix, 57, 320, 338, 375, 397 Merry, Anthony, 283, 307 Merry, Elizabeth Leathes, 283 Milton, John, 74 Missouri Compromise, 360, 361 "Moneymusk" (song), 336 Monroe, James, 147-48, 260, 282, 305 Monticello, 21-22, 35, 38, 43, 124, 125, 165, 169, 190, 191, 284, 350, 378 building of, 83, 86, 100, 107, 113 cemetery at, 33, 41, 98, 114, 151 disease at, 286-87, 295 in disrepair, 234, 240, 273 gardens at, 108, 126, 135-36, 274, 326 honeymoon at, 89-92

Monticello (cont.) music at, 128, 130, 336 Patsy Jefferson Randolph in charge of, 257-59, 260, 265-66, 331 renovations at, 333-35 slave quarters at, 335 slaves at, 94, 102-3, 104-6, 140-41, 196, 234, 259-63, 335-36 visiting multitudes at, 292, 295, 300, 332, 333, 337, 338, 371 in wartime, 140-41, 142, 143 Moore, Benjamin, 35 Moore, Thomas, 332, 376-77 Morgan, Edmund, 106 Morgan, Marie, 106 Murray, John, see Dunmore, John Murray, Fourth Earl of Myrtilla (slave), 29, 31, 35, 36, 37, 47, 400, 408n

Nan (slave), 31 National Gazette, 280 Neilson, Joseph, 113, 117, 162 Neiman, Fraser D., xviii Nell (slave), 126-27 Nelson, Thomas, Jr., 118, 124-25 New-York Mercury, 70-71 Nicholas, Robert Carter, 46, 116 Nicholas, Wilson Cary, 357 Noailles de Tessé, Comtesse de, 203 Norfolk, bombardment of, 117 Northwest Ordinances, 357 "Notes on a Tour Through Southern France and Italy" (Jefferson), 195-96 Notes on the State of Virginia (Jefferson), 144, 221, 337

Ogilvie, James, 79, 80 Ossian, 78, 90-91

Page, John, 32, 119, 122, 124, 131, 310 Page, William, 271, 287 Panic of 1819, 356-57 Panthémont convent school, 181, 191, 215-18, 242, 245-46, 247 Pantops plantation, 273, 287, 359 Paradise Lost (Milton), 74 Paris, France, 189-90, 194, 215 civil unrest in, 203, 209, 215, 218, 223, 228-29, 230 Jefferson household in, 190-92, 193-94 social life in, 198-200, 201-3 Parliament, British, 112 Parton, James, xv, 79, 90, 234 Pendleton, Edmund, 122, 123 Peterson, Merrill, xvii Petit, Adrien, 183, 189, 192 Phillips, William, 127, 139 Pike County (Ohio) Republican, 159 Pope, Alexander, 24 Poplar Forest plantation, 106, 140, 144, 164, 169, 262, 350, 359 villa built at, 337-39, 341, 357, 370, 371, 378 Port Folio, 206 post-traumatic stress disorder, 316-17 Prince of Wales (slave ship), 95, 104 property laws, 63-64, 73, 76-77, 364-65, 371-72

Raleigh Tavern, 110 Ramsay, Andrew, 176, 177, 180–81, 182–83, 186–87, 401 Randall, Henry, 14, 24, 31, 32, 40, 77–78, 80–81, 90, 234, 376 Randolph, Anne Cary, *see* Bankhead, Anne Cary Randolph Randolph, Benjamin Franklin, 319, 342, 397 Randolph, Cornelia Jefferson, xiii–xiv, xix, 289, 295, 320, 324, 334–35, 337, 338, 339, 343, 347, 350–52, 355, 369, 375, 397 Randolph, Edmund, 150–51 Randolph, Edward, 4 Randolph, Ellen Wayles (I), 268-69, 320, 397 Randolph, Ellen Wayles (II), see Coolidge, Ellen Wayles Randolph Randolph, George Wythe, 319, 323, 375, 398 Randolph, Isham, 3-4, 5-7, 8, 9, 11, 13, 15, 17, 25, 45, 51, 393, 406n Randolph, James Madison, 319, 342, 397 Randolph, Jane Lilburne Rogers, 3, 4, 5, 7, 8, 9-10, 369, 393 Randolph, John (of Roanoke), 26, 52, 323, 398 Randolph, Judith, 266 Randolph, Martha Jefferson "Patsy," xiii, xix, 26, 39, 57, 89, 94, 226, 231, 234, 261, 289-90, 298, 306-7, 308-9, 372, 374, 376, 396 as adoring daughter, 284, 292, 315, 341 betrothal of, 233, 235 Catholicism and, 245-46 childhood of, 96, 105, 106, 119, 131, 134, 136, 139, 140, 143, 149, 151, 153, 154 daughters educated by, 324-25, 343 daughters' matrimonial prospects and, 347-48 death of, 383 father's advice to, 242-45, 266-67 financial concerns of, 303, 354-55, 356, 364-65, 370, 371, 377, 382-83 first pregnancy of, 250-51 marriage to Thomas Mann Randolph, Ir., 241-42, 246-47, 249-52, 320, 322 Monticello household duties of, 257-59, 260, 262, 265-66 motherhood and, 259, 271-72, 286, 287, 304, 318-19, 322, 323, 369 at Panthémont convent school, 181, 191, 192, 215-17, 242, 245-46, 247 in Paris, 181-82, 189, 191, 192, 193, 216 personal qualities of, 242, 244-45 Randolph family scandal and, 266-67

Sally Hemings and, 263-65, 267, 274, 275, 285, 319, 320-21, 372-73, 379 slavery abhorred by, 181-82, 216, 250, 361 Washington visits of, 302-3, 318-19 Randolph, Mary, 351, 352 Randolph, Mary Jefferson, xix, 304, 334, 343, 350, 354, 374, 375, 397 Randolph, Meriwether Lewis, 319, 397 Randolph, Nancy, 266-67 Randolph, Peyton, 115 Randolph, Richard (Judith's husband), 266 Randolph, Richard (slave agent), 94-95 Randolph, Sarah Nicholas, 48, 69, 398 Randolph, Septimia Anne "Tim," see Meikleham, Septimia Anne Randolph "Tim" Randolph, Thomas Eston, 393 Randolph, Thomas Jefferson (Jeff), xiii, xiv, 179, 268, 329, 339, 342, 347, 354, 357, 362, 373-74, 375, 397 childhood of, 289, 303, 324, 325, 327 as financial rescuer, 359, 364-65, 369, 370 Randolph, Thomas Mann, Jr., 26, 51, 233, 235, 240-41, 274, 287, 289-90, 316, 319, 322-23, 340, 345-46, 397 in Congress, 304, 307 financial troubles of, 318, 344, 358, 359-60, 364, 365, 370, 382 marriage to Patsy Jefferson of, 241-42, 246-47, 249-52, 265, 320, 322, 323 mental illness of, 268-69, 273, 295, 320, 322 slavery abhorred by, 359-60 Randolph, Thomas Mann, Sr., 20, 241, 247, 249-50, 394 Randolph, Virginia Jefferson, see Trist, Virginia Jefferson Randolph Randolph, William (Isham's brother), 11 Randolph, William (Isham's father), 6

462 🎇 INDEX

Randolph, William (Jane Jefferson's cousin), 17, 19, 393 Randolph, William (TJ's uncle), 47, 51, 52-55 Reynolds, Maria, 281 Richmond, Va., 133, 136-37, 138, 139, 163 Richmond Examiner, 296 Richmond Recorder, 296 Riedesel, Frederika Charlotte Louise von Massow von, 128-30, 133-34, 162-63, 401 Riedesel, Friedrich Adolf von, 127-28, 130, 131, 133-34, 401 Rind, James, 253-56, 283, 299, 401 Rind, William, 70, 255, 401 Rind, William, Jr., 256, 291, 294, 401 Rivanna River, 16, 42-43 Robert (ship), 176, 178, 182 Roderick Random (Smollett), 74 Rogers, Jane Lilburne, see Randolph, Jane Lilburne Rogers Rothman, Joshua, 256 Routledge, Robert, 69, 401 Royal Academy of Painting and Sculpture, 205

Sall (slave), 28, 400 Saratoga, Battle of, 126, 127, 128 Scilla (Nell's daughter), 127 Scylla Priscilla (slave), 364 "shadow families," see interracial kinship Shadwell plantation, 17-19, 20-22, 23, 39, 43, 83, 241 burning of, 34-37, 48, 77, 79 gardens of, 29-30 slaves at, 18-19, 20-21, 28-29, 31, 34-35, 36, 46-47 Shakespeare, William, 24 Shays' Rebellion, 203 Shenstone, William, 376 Skelton, Bathurst, 73-75, 77, 87, 93, 395, 412n

Skelton, Elizabeth Lomax, 64, 395 Skelton, John, 74, 75, 76, 82-83, 395 Skelton, Reuben, 64, 73 Skipwith, Anne Wayles "Nancy," 64, 65, 86, 99, 100, 101, 107, 233, 396 Skipwith, Henry, 86, 101, 102, 107, 169, 226, 262, 416n Skipwith, Robert, 69, 83-85, 86, 117 Skipwith, Tabitha Wayles "Tibby," 64, 65, 69, 83, 84-85, 86, 99, 396 slaves: auctioning of, 95-96, 102, 226, 382 Baroness von Riedesel on, 129-30 hereditary ownership and, 5-6, 28, 36, 42, 65, 72, 75 insurrection threatened by, 12-13, 34, 45, 46, 71, 115, 116, 121 Missouri Compromise and, 360-61 at Monticello, 94, 102-3, 104-6, 140-41, 196, 234, 259-63, 335-36 plantation duties of, 18-19, 20, 21 punishment of, 11-12, 46-47, 105, 106 at Shadwell plantation, 18-19, 20-21, 28-29, 31, 34-35, 36, 46-47 wartime abandonment of, 137-38, 140-41, 142, 163 slave ships, 94-95 Sloane, Hans, 7 smallpox, 124, 137, 142, 163 inoculation against, 118, 165, 180, 192 Smith, Abigail Adams, 204 Smith, Williams Stephens, 199, 204 Smollett, Tobias G., 74 Snead, Benjamin, 23, 269, 400 Spectator (Addison and Steele), 74 Stamp Act, 80 Stanton, Lucia, xvii, xviii State Department, U.S., 239 Steele, Richard, 74 Sterne, Laurence, 78, 148, 376 Steuben, Friedrich Wilhelm von, 137 Suck (slave), 132, 137, 142

Sukey (slave girl), 71–72, 101 Summary View of the Rights of British America (Jefferson), 44, 111, 112, 357 Sutton, Robert, 192 Swift, Jonathan, 24

Tarleton, Banastre, 140–41, 163, 260 tobacco plantations, 16, 20 Townshend Acts, 80 transatlantic voyages, 4–5, 173–74, 180–82, 229–30, 232 Trist, Elizabeth House, 279, 347–48 Trist, Martha Jefferson, 369 Trist, Nicholas, 348–49, 373, 375, 397 Trist, Virginia Jefferson Randolph, xix, 294, 303, 320, 334–35, 336, 337, 343, 348, 349, 369, 374, 375, 397 *Tristram Shandy* (Sterne), 148–49, 376 Trumbull, John, 206, 208, 229, 230 Tuckahoe plantation, 19–20, 23, 233 Turpin, Philip, 290

United States of America, 239

Varina plantation, 241, 246–47, 249 Virginia: childbearing in, 8–9, 17, 18, 64, 118, 204, 232, 286, 306, 318–19, 366–67, 368, 369, 409*n* House of Burgesses, 6, 31, 39, 43–44, 77, 78, 80, 147 invasion threat in, 114–15, 116, 119, 135 Virginia, University of, 342 Virginia Committee of Safety, 122, 374 Virginia Convention, 113, 114 Virginia Council of State, 119 Virginia Federalist, 256, 291 Virginia Gazette, 70, 255, 298

Wales, Prince of, 205 Walker, Thomas, 25, 400 War of 1812, 323 War of Independence, 117, 124-25, 127, 138-39, 147, 153-54, 162, 163, 195, 224, 239, 261 Cornwallis and, 138-39, 140, 141-43 Richmond and, 136-37 Warren, Molly, 364 Washington, George, 136, 138, 233, 239, 281. 296 Washington, Martha, 134 Washington Federalist, 294 Wayles, Anne "Nancy," see Skipwith, Anne Wayles "Nancy" Wayles, Elizabeth "Betsy," see Eppes, Elizabeth Wayles "Betsy" Wayles, John, xvi-xvii, 74, 75, 80, 83, 87, 97, 102, 103, 107, 108, 159, 160-61, 167, 285, 321, 395, 420n-21n Betty Hemings liaison with, 65-66, 76-77, 101, 222, 255, 381 Chiswell affair and, 69-70, 101, 255 as debt collector, 61-62, 67, 94-95 debts incurred by, 67, 106, 226, 262 legacy to Martha of, 73, 98-99, 337 marriages of, 63-64, 65-66, 72 as slave-owner, 104, 105 Thomas Jefferson on, 62-63 Wayles, Martha Eppes, 63-64, 65, 72, 161, 395 Wayles, Martha "Patty," see Jefferson, Martha Wayles Skelton Wayles, Mrs. John, 64, 395 Wetmore, S. F., 159, 160 Wharton, Edith, 353 white supremacy, 16, 102-3, 221 widowhood, 24-25, 26-27 Will (slave boy), 71 William and Mary, College of, 27, 29, 37, 45,73 Williamsburg, HMS, 5 Williamsburg, Va., 6, 123, 127

464 💥 INDEX

Willing, Thomas, 200 Wilson (slave), 365 women: abuse of, 346, 366 domestic training of, 9, 22–23, 68 in French society, 198–200, 201–2, 203, 209–10, 211, 283 "hysterics" and, 316–17 Jefferson's views on, 53, 89, 104, 194–97, 200, 208, 210-11, 242, 276-77, 278, 371-72 property rights and, 63-64, 73, 76-77, 364-65, 371-72 Woodson, Thomas, 219 Wright, Joseph, 205 Wythe, George, 123

Yorktown, siege of, 137

About the Author

VIRGINIA SCHARFF is a professor of history at the University of New Mexico. She was a Beinecke Research Fellow at Yale University, holds the Women of the West Chair at the Autry National Center in Los Angeles, is a Fellow of the Society of American Historians, and is the former president of the Western History Association. She is also the author of four mystery/ suspense novels penned under the name Virginia Swift.

RAF Waddington Learning Centre

ΥΑΛΟΟΨ ΒΑΒΥ

BY THE SAME AUTHOR

FICTION

Wothers' Boys The Battle for Christabel pivW s Kpv7 Have the Men Had Enough? Private Papers Narital Rites The Bride of Lowther Fell Mother Can You Hear Me? Kindelbash Pendition of Mrs Pendicular Mr Bone's Retreat Kenella Phizackerley smoH 1 is nowo-nowo ssiM The Park ffvisdi L sipnvW fo sisavi L sy L uvukaBog ay1 CEOLEN GIVI Dame's Delight

NOILDIA-NON

The Rise and Fall of Charles Edward Stuart The Rise and Fall of Charles Edward Stuart William Makepeace Thackeray Memoirs of a Victorian Gentleman Significant Sisters The Grassroots of Active Feminism 1838–1939 Elizabeth Barrett Browning Elizabeth Barrett Browning

POETRY

saar uappiH

Selected Poems Of Elizabeth Barrett Browning (Editor)

SHADOW BABY

(

Margaret Forster

Chatto & Windus

of terror. Let Henry meet her (as indeed he had done). would agree to a meeting ... but the idea threw her into paroxysms shadow and she had no doubt of her answer. Henry said if only she years, she had asked herself what she would want if she had been the him. He was a man, he did not understand. All the time, all these she had nothing to fear in that respect, but she had never believed never violent. Henry had always said she had the wrong idea, that open it. She imagined violence all the time but the shadow was that she smashed the glass and thrust her strong hand through to her visitor becoming so demented, so incensed with grief or anger more. Sometimes she had visions of the door being broken down, of to be seen now, except the door itself, wood and glass, harmless once her duty, part of her punishment. There. It was gone. Nothing at all and the curtains. But she never did, she had to bear witness: it was position. She could have gone into her bedroom and closed the door clutching the handrail, waiting. She never moved first, never left her she would go, the ritual complete. Leah went on standing there,

refreshed, restored by this sleep of relief. later, was pleasant. She felt calm and sensible. She was thoroughly and into the welcoming oblivion. Even waking, a long satisfying time happen, and she would feel herself smile as she went eagerly over unconcern, without struggle. She could always feel it about to akin to death, a sleep quite dreamless, slipped into with such of being altogether. Often, she wondered if this kind of sleep was would fall into such a deep sleep it was as if she entered another state now, as she lay aching inside and out, was to know that. Soon, she ever sleep after such visitations. Sleep would come later and the bliss not expect to sleep. Nobody as guilty as she knew herself to be could on to the slippery blue eiderdown, was almost beyond her. She did swinging her legs up afterwards but failing, having to lift each one bedroom, even the act of levering herself on to the bed, sitting first, other she had ever experienced. She could hardly get herself into the How tired she felt, an awful exhaustion quite different from any

She ordered herself to be still, to let time pass, to endure the fear and misery with fortitude. This was always how it was and how it would be until one of them died.

It would have been the perfect crime except no crime was committed. Hazel knew she had done wrong but she had learned to The pretence was that she was learning Norwegian. Norwegian?' her father had exclaimed. 'Good God, why on earth does the girl want to learn Norwegian, nobody wants to learn that language, why on earth would they?' Her mother had thought it all out, her thoughts so complicated and devious they had the peculiarity of apparent truth. Hazel had always been 'fascinated by the Vikings',

care of her had amounted to a job, a financial transaction. said nothing more but it had upset her, this late evidence that the Confused, as she often was by her mother's strange logic, Hazel had would they have done it, how else could they have been trusted? laughed in astonishment and said of course they were paid, why else were paid for looking after her those five months, her mother had help other women'. Once, when Hazel had asked if these two women They were part of what her mother called 'a network of women who a teacher. How her mother had found this couple Hazel never knew. dependable'. Two women, quite elderly. One had been a nurse, one people she did not know but who, she was told, were 'utterly to this bleak place and now she had gone, leaving her in the care of painful and distressing. Her mother had gone. She had brought her penetrated her consciousness, that what lay ahead was going to be realisation which came much later, the day when it had finally from that time was not the moment of confession but the moment of be proud rather than ashamed. What she remembered most vividly danger for a while of thinking she had done something of which to felt herself so soothed by her mother's efficiency that she was in

live with this awkward knowledge quite quickly. It always seemed to her when she looked back, though this was something she tried (rather successfully) not to do, that her mother had conspired to make her feel she had done no wrong except to herself. And yet she fault,' she had said, without weeping, though not entirely dry-eyed, it was my fault, not his, don't blame him, please.' But she had no didn't even want to know his name. From the very beginning, after vital: absolute secrecy. She and her mother would share this secret. Nobody else. Certainly not her father or her two brothers and never, never, the man in question. All would be well if this was kept absolutely secret. It could be managed, and, eventually, obliterated. Managed it was. Her mother excelled at such management. Hazel

didn't make sense. said, 'Think,' and she did, she thought and thought and still it whether the country she was hiding in was Catholic? Her mother not as though she were seeking an abortion, so why did it matter mother said, 'don't you see?' Hazel hadn't done, not really. It was her mother. Why not Spain? 'Catholic countries, darling,' her them she shared it. Why not France? Why not Italy? she had asked bewilderment, even sometimes their irritation, and could hardly tell believe it?' Mostly people couldn't. Hazel grew tired of their 'going to live in Norway to learn their ridiculous language, can you my daughter Hazel,' he said to people when he introduced her, father had been exasperated but he had been amused too. This is Norway and learn the language, or try to, for a few months? Her Norse languages, so what better than actually to go and live in extraordinary. And now she wanted to go to university and read the countries, did she, always begging to go to Scandinavia, so loved snow and ice. She never wanted to go to Mediterranean had she not? From a tiny child, loved tales about them. And she

Perhaps the whole success of her mother's plan had depended on its bizarre nature. Told that Hazel was going to Bergen in Norway for a few months to learn Norwegian, people had queried only the oddity of her choice. Nobody had thought there could be any other reason for a seventeen-year-old girl to spend half a year in Norway. Norwegian, or any other Norse language, but went to read law, nobody had been suspicious. 'Glad you came to your senses,' her father (a lawyer) had said. It only seemed to prove, somehow, how genuine the Norwegian episode had been. The two women in whose house she had stayed had died soon after she returned, one of a heart attack, the other five years later of Alzheimer's disease. Her mother had been quite triumphant: no one would now remember Hazel or had been quite triumphant: no one would now remember Hazel or her sojourn there. As if it mattered.

And yet somehow it did matter, especially to her mother. She wanted the whole 'episode', as she referred to it, to have been wiped out. The deaths of the two women were important. Only they had known Hazel's name, though even there Mrs Walmsley had covered her tracks. The women never saw Hazel's passport. They believed her tracks. The women never saw Hazel's passport. They believed her tracks. The women never saw Hazel's passport. They believed part tracks. The women never saw Hazel's passport. They believed game. But she was for ald the mode the whole 'episode' seem like a game. But she was not there when the playing got rough. She never

saw me, Hazel used to reflect, when it came to the end, how battered I was, how suddenly wretched and despairing and guilty. By the time her mother had come to collect her, she knew she had looked much as she usually looked only paler (that Norwegian winter) and fatter (that Norwegian food). 'All right, darling?' her mother had asked, admittedly anxious for once, and 'Fine,' she had said, 'fine, thank you, Mummy.'

and then the shadows had danced on the wall in front of her. eyes had opened involuntarily at the moments when she lost control them, she had wanted everyone to remain unrecognisable, but her shadows when she briefly opened her eyes. She had tried not to see everything white - were drawn and lights were on and she saw huge since it was dark outside, the blinds - they were white too, startlingly white, floor, ceiling, everywhere sterile and white, but afterwards. And of shadows. The room had been all white, something similar) in it, which she had been given to drink since that night, and the scent of a drink, a drink with cloves (or of smells - a particular disinfectant, a brand she had never smelled she would wonder if she knew herself at all. It was often a question Certain things could trigger off such total recall of pain and loss that indulged. This pragmatic outlook saved her, though not entirely. she given to the kind of flights of fancy in which her mother never took the same risk. She wasn't morbid or sentimental, nor was life after this aberration and never made the same mistake again, which her father so proudly told her she came. She got on with her Slight in appearance, in character she was as solid as the stock from Fine. She was fine. There was nothing melodramatic about Hazel.

That was what remained in her mind for ever. One shadow. That was what remained in her mind for ever. One shadow. Indistinct, an outline only, quickly whipped away. It swung in front of her appalled gaze and then was gone. Never put into her arms: that had been agreed. She heard the gurgling cry, knew the shadow not weep, not then, she felt too frozen, hypnotised by the enormity of what she had done. A feeling of outright panic mixed with a new fear in her, the fear of one day being called to account, and her mother not being there to manage everything.

nnoh2-sivI

\sim

РАRT **О**ИЕ

Mr Dobson was patient and understanding, or so he judged himself. He had at least enough imagination to be aware that to many householders he was also alarming. Nobody was ever cheeky; They were on the whole respectful but resentful and he had to cope with this. He was particularly kind to women, especially to the elderly widows who lived in this lane. He wanted the census form filled in correctly: that was of prime importance. When an old woman opened the door of No. 10, Mr Dobson immediately doffed his hat, smiled and identified himself at once, producing his badge of accreditation. The woman, a Miss Mary Messenger, looked feeble.

mighty, though fewer than twenty-four hours had gone by. another had to be produced and then the effort of memory would be lanes the job had rarely been done. Often, the form had been lost; not be any question of a form not having been received), but in these appropriate form, delivered by his own good self (therefore let there house? The householders were meant to have filled in the simple: on the night of 8 April, how many people resided in this They were vague or confused, or both, and yet his question was so this were not at all clear as to how many people lived with them. They made his work difficult. Invariably the inhabitants of lanes like proper street. Mr Dobson, taking the census, hated lanes like this. unusual for a lane, but otherwise it had no pretensions to being a was not really a street. It was paved in giant blocks of sandstone, and was much frequented. It was not at all a quiet street. Indeed, it cosy way. The lane ran between the cathedral and the town square Lsqueezed together, leaning on each other in what seemed such a T WAS a narrow little house in a narrow lane, one of many all

6

She was also, he quickly realised, more than slightly deaf. Instead of bawling at her, Mr Dobson flourished a census form, pointed to the date and then to what was required by law and hoped Miss Messenger was not also short-sighted. She stood so long staring at the form that Mr Dobson began to wonder if she were illiterate, not uncommon with these elderly women. Fortunately she was not. After her long perusal, Miss Messenger shuffled off down the passageway and re-emerged clutching the original form delivered days before.

faintly worried. form had been collected and that was that, but he went on his way policeman. It was not his duty to pry, only to collect. The census neither here nor there. He was not a landlord, thank heaven, nor a paying lodgers. One little girl living with an elderly woman was that rents would be raised if it were discovered they harboured lanes like this were forever hiding things from landlords, terrified There was no reason to conclude that she lived there. Residents in importance. She might be only a visitor, a relative there for the day. whether there was a child residing at No. 10 or not was of no great that? Mr Dobson walked slowly down the lane reflecting that concealed the fact that a child lived with her? But why would she do hair. He stood for a moment, thinking. Had the old woman a small white blob of a face framed by a good deal of untidy dark indistinct of glimpses but indisputably real, the face of a young girl, the door at the far end of the passage. Only the briefest and most before it closed, the face of a small girl appear round the corner of thanked her and backed away as she shut the door. But he saw, just night of 8 April had been Miss Messenger herself. Mr Dobson To his surprise, it was filled in. The only occupant of No. 10 on the She put it into his hand without a word. Mr Dobson looked at it.

Mary Messenger, aged eighty (as stated on the census form), was still standing behind her front door, listening. She had her good ear pressed to the wide crack in the door, only recently emptied of the rags which had filled it all winter. She heard the census man's footsteps go off down the lane and was satisfied. But when she you, eh, didn't I say stay in the kitchen, eh, what you playing at, you want taken away to the poorhouse, eh?' Evie withdrew and Mary muttered her way after her, into the small dark kitchen at the back of the house. 'Nothing but bother, you're nothing but bother, and what the house. 'Nothing but bother, you're nothing but bother, and what thanks do I get these days, eh?' Evie ignored her. She stood on a stool and kneaded the dough on the table, her little firsts barely making any indentation, though she was trying so hard to do what her grandma did. The sight of the child's ineffectual kneading recalled Mary to the task at hand. She picked up the dough and slapped it about, her hands no longer shaking, as they did when they were not busy, but suddenly strong and skilful. Evie watched and admired and, without needing to be told, smeared lard on the inside of the bread pan. There was silence until the dough was shaped and moulded into the pan and then Evie hopped on to another stool and, using an old dishcloth, carefully opened the door of the oven in the range. In went the bread and Mary sighed and sat down and said, 'You're a good girl when all's said and done. We'll have a cup of tea and you can sugar it.'

She watched Evie take the blackened kettle off the hook over the fire. Very careful, the child was, did everything she was told carefully and liked to do it. There was no sulking, no impudence, not yet, but then she was only five, only just turned five. Not pretty, never would be, Mary had seen that from the beginning, but she was healthy, that was the main thing, and strong, and she had a cheerful disposition, so far. The tea was made and they both sat in front of the steaming mugs with a measure of contentment which each could sense in the other. 'Well, Evie,' Mary said, watching the child blow the steam and warm her hands on the mug, 'I don't know what's to be done about you. I haven't said you're here, don't you worry, but it can't go on for ever, can it, eh? Not for ever. I won't live much longer, that's for sure, my time'll be up soon, then what, eh?' Evie said nothing at all in reply. She appeared quite unperturbed by her grandmother's ramblings and only looked up from her tea at the 'eh?' sounds, as though not understanding the rest. Any 'eh?' commanded her attention, as it was meant to. Sometimes Mary said 'eh?' in no context at all, a sudden, harsh querying of nothing.

Evie went on blowing the steam which rose from the tea and stirring the sugar she had been allowed to put in even though it had long since dissolved. She liked the faint tinkle of the spoon on the side of the mug, a sound too faint for her grandmother to catch and object to as she objected, inexplicably, to so many things. Each day, it seemed to Evie, was full of traps, of things she must not do or say. She must not get up until she was told, unless she needed to use the po and even then she was expected to hop back into bed sharpish until given the signal to rise. Her grandmother slept in a double bed which took up most of the room and Evie slept on a mattress at the foot of it. There was room for three of her size in the bed with her grandmother, but she was not allowed to share it. 'I might smother you,' Mary said, and Evie accepted this as she was bound to accept everything.

She knew this old woman was not in fact her grandmother because she had been told so, not long ago. 'Am I your grandmother, eh?' Mary had barked at her, sounding angry. She had nodded dumbly, though aware as ever of verbal traps. 'No, I'm not,' the old woman said. 'Good as, used as, but I'm not, now don't you forget, eh? You haven't got a real grandmother and what do you need one for when you've got me willing, eh? You've got me willing, I dare say I'll get my reward in heaven.' And then, later, equally unexpected and sudden, she had said: 'If anyone asks, mind, I am your grandmother, eh? You remember that, don't you forget, it could be more than your life is worth.' Evie's heart had thudded a little at those words. It wasn't the contradiction which frightened her – first she had a grandmother (all she had) and then she didn't and now she did again (only sometimes, only if asked) - but the mention of her life. What was a life? How could anything be worth more? But she merely nodded, as though she had understood, and said nothing.

Evie, just turned five, was an expert at knowing when to say nothing. They were the first words she remembered, the first instruction - 'Say nothing.' She remembered being bundled into shawls and taken by Mary to the market and being told, 'Say nothing, if anyone talks to you, say nothing, eh?' She had obeyed, though it had not been difficult since all that the other butter women said to her was 'Are you cold, pet?' and 'Are you hungry?' and in both cases a shake of the head was sufficient. She sat on a little stool behind the old wooden bench that served as her grandmother's stall and watched the people coming to buy. She was seated so low down, almost on the ground, that what she mostly saw were skirts and feet, an endless procession of long skirts and black boots. Seeking to see something more interesting and of greater variety she gave herself a crick in the neck, peering upwards so hard and earnestly at all the faces looming over her grandmother's eggs. At the end of the morning, when she was carried to the cart and they trundled all the

long way back to Wetheral, she fell asleep and never saw anything of the return journey to the village.

Those days, the days of going to market with her grandmother. were already a long way off in her young mind. She could only just recall the green in the village and the big houses round it and the plains above the river where they had lived. But she knew she had preferred it: that country life, and the presence of someone else, some other woman whose face she could not recall. All that had gone. Here, in the city, she stayed in the house almost all her time, with her grandmother. They went out to shop once a week to that same market where once they had sold flowers and eggs. On Sundays, the cathedral bells, so close by, vibrated through the house but she and her grandmother did not go to church. She had never, to her knowledge, in her short memory, been inside a church. She was sure she should go to church and did once suggest it but her grandmother told her there was plenty of time for her to be a churchgoer in the future if she wished. 'Any road,' Mary had said, 'you're baptised, you can rest easy, she saw to that at least, baptised, all proper, in Holy Trinity, does that satisfy you, eh?"

It almost did. Evie knew where Holy Trinity was. It was the big church at the junction of the two roads in Caldewgate, outside the west wall of the city. She felt proud to have been baptised there and could see herself being held over the font and almost feel the holy water on her baby forehead. She longed to go into Holy Trinity and she resolved that one day she would indeed get inside the church and see the font. She had pictures and that was all. Her grandmother had a bible, even if she never went to church, and inside was a little illustrated booklet about Holy Trinity. One picture, very grainy, showed the font and a woman holding a baby and the vicar about to baptise it. Maybe the baby was her; she could at least pretend it was. But who, then, was the pleasant young woman holding her? Not her grandmother. There was a man in the picture too, standing a little behind the woman, his hat in his hand. Who was the man? Impossible to know, as most things were.

'You've made a meal of that tea,' Mary said. 'Sup it up, there's work to be done and half the morning gone. Get the tub, get that kettle back on, get the soap.' Evie got everything. She had to drag the heavy tin tub along, it was too heavy to carry, but she managed successfully to position it under the tap in the yard. The yard was tiny, barely three feet wide and five feet long; and at this time on a bleak spring morning it was bitterly cold. The fronts of the houses in the lane were protected from the wind by the high buildings opposite but the backs were not. The east wind, scudding down on to the city direct from the Pennines, hopped and skipped over the walls of the yards and, once inside them, ricocheted from end to end forming a whirlpool of dust. Evie went back inside and found her shawl and fixed it over her head and across her chest, fastening it with a safety-pin. Then she was ready.

She got the washing and put it into the tub and ran cold water on to it, and Mary appeared carrying the big kettle and added its contents to the tub. The water coming out of the spout was boiling but all it did was reduce the freezing cold of the water already in the tub. Mary made it clear that donating this hot water was a matter of being kind and that when she was a girl like Evie she had had to do the washing without its benefit. She stood and watched as Evie took a bar of soap and began soaping the clothes and pummelling them about and she sighed, as she always did, and said, 'I miss my washhouse, I should never have left that wash-house, eh?'

She still had a mangle, though. There was nowhere inside to put it so it stood in the yard, and Mary worried about it constantly. When they were in the house and the rain and wind were lashing the windows she'd groan and say, 'Oh, my mangle, out in this. Oh, that lovely mangle.' It was kept covered with a bit of sacking but many a wind was strong enough to whip this off in the night, no matter how well it had been secured, and then the mangle would be soaked and little by little the soakings were rusting the iron. It took both of them, these days, to turn the handle and it tired Mary. 'Sooner you grow big and strong the better,' she would say. 'This mangle is beating me, it's a devil, I had it tamed once but it's breaking out, it's beating us.' One day, not so long ago, she had said something else while she struggled with the fearful mangle. She said the usual bit about how the mangle was beating her now and there followed the well-worn memory of how once she had mastered it easily, and then she said something new: 'Your mother always promised ...' And then she stopped, abruptly, and turned the handle of the mangle furiously, with a sudden extra vigour, for a while.

Evie had heard the words quite distinctly – 'Your mother.' Her mother. She had a mother, then. Was it a mother who, like Mary, like her so-called grandmother, wasn't a mother at all? She didn't ask, she only registered the crucial word 'mother'. She'd seen little girls with mothers, she heard them saying 'Mam, mam,' she'd seen them belonging together, girls like herself and women called mam. She'd never asked, not yet, why she didn't have a mother but that wasn't because she was not curious, or that she didn't want to know the answer. It was just that she didn't ask questions at all. Questions annoyed Mary, even simple ones. 'Why does the clock tick?' for example produced rage, and a sharp 'It's a *clock*, now stop bothering the life out of me, why do clocks tick indeed, the idea, I don't know what's to become of you, I don't!' Any question at all brought forth this cry – 'I don't know what's to become of you!' and Evie had grown to dread it. It worried her, that and her grandmother's constant refrain that soon she would no longer be around, that her time was nearly up, she had not long to go.

The day after the census man came, Mary was even more shorttempered than usual and muttered all day long in a state of extra agitation. The bread was made, the broth cooked, the washing done, everything went on as normal but Evie knew something was going to happen. Her grandmother was forever telling her to 'Be still, settle yourself,' but now it was she who flitted about, touching things, as though checking them, as though making sure the table and chairs and cupboards were there. She opened and shut drawers all day long and in the afternoon, when she often had forty winks on her bed while Evie was given some task to do quietly - cleaning the cruet, making a fresh paper doily for it, cleaning the six precious silver teaspoons, tidying the larder, polishing the sideboard - she could be heard moving about and dragging something from under the bed. Evie wasn't in the least surprised to be shouted for long before the regular half hour was up and she went willingly, eagerly, up the few narrow stairs into the one bedroom.

Her grandmother was sitting on the edge of the bed with a small suitcase open beside her. It appeared to be full of papers, bundles of what looked like letters and some longer documents tied up with string. Mary was undoing the string on one lot. 'I'm all thumbs,' she complained, 'damned knots. Here, with your little fingers, you do it, Evie, but take care, mind, don't tear anything, eh?' Evie took care. She enjoyed delicately plucking at the knots and gradually working them loose and managing to draw the string free time after time. The knots were knobbly things, hard with age; they had been meant to be as secure as they were proving to be. Mary watched her, breathing hard, but for once ceasing to rant on. When the last vicious knot was undone she pushed Evie's excited hand away and pulled the bundle towards her, protecting the papers with her hands as though Evie might snatch them and run off. 'Now,' she said, staring at the child, 'now, there's something I'd better be telling you before it's too late. I don't know what's going to happen to you when I'm gone but it isn't right you should be left wondering, I never thought it was, you can't blame me for that, eh? It wasn't my fault, not what I wanted, I never thought it right.' She stopped and stared at Evie, who returned the stare. Mary saw what she had always seen, a small pale face, not pretty, and a mass of unbrushed dark hair and eves that held no challenge, that were accepting of everything before them. She saw a calmness and stillness that pleased her. And Evie saw an old woman who had suddenly changed. All the crossness had momentarily gone, all the power. Mary's face was as creased and pinched, her skin as vellow and coarse as ever, but she looked helpless, all the fight Evie was used to had vanished. It made her nervous, this collapse of her grandmother, it worried her and she twisted her hands together not knowing what to do.

'You can't read,' Mary said, in dismay. 'You should be at school, you'd learn soon enough, eh? I should have seen to it, but there's been enough to do, keeping body and soul together.' She selected an envelope from the papers on her lap and waved it in front of Evie's eyes. 'Now,' she said again, 'see this here? This is yours and don't let anyone tell you otherwise. Look, see this mark?' - and she showed Evie the letter 'E' on the envelope - 'that's you, that's for Evie, I kept it for you and nobody knows. It's in the Holy Trinity register for those who'll bother to look if anyone does and I'll be surprised if they do, though there's no telling what will happen after I'm gone, no knowing the mischief that will be done and me not here to see fair play, but you've got this here and I'm giving it to you now and it's up to you to guard it and keep it and use it when you need to, eh? There'll be questions and you won't know the answers but this will give you something to hang on to, you'll always know who you are if people forget to tell you, eh? Something, it's something; there's only one person knows more and she's never told and there's nothing I can do about that, Evie, and nothing you can do either, no good upsetting yourself, my lass.'

But Evie was not upset. She was confused but too excited to feel real distress. Her attention was completely caught by the envelope with the mark on it that was her, the line down with three straight spokes coming out of it. Her grandmother held it out to her and she took it and loved the feel of the very paper with 'E' written on it so plainly. Whatever was inside the brown envelope was thin. If she didn't hold the envelope tightly it was so flimsy it would slip from her fingers. 'Do you remember that day we stood outside the church, Evie?' her grandmother said, in a whisper. 'When the trees were all orange, eh? We stood well back, nobody could see us, the trees hid us. And that lady and gentleman came out?' She took Evie's wrists and pulled the child, still clutching the envelope, to her and whispered even lower and more urgently, 'Do you remember, Evie, eh?' Slowly, Evie shook her head. She didn't remember standing outside any church with her grandmother nor any orange leaves nor a lady and gentleman coming out. Mary sighed. 'You were too young,' she said, 'too young. Well, it can't be helped, it wouldn't do any good anyway, it's maybe just as well. Now, where will you put that envelope? Where have we got for you to put it?"

'In my pocket?' Evie suggested, feeling inside her apron pocket to see if it was big enough. Instantly, Mary was back to being as irritable as she nearly always was. 'No, no, child, for heaven's sake, an envelope with that in it in an apron pocket, the idea, no, you'll need somewhere safer, but it'll have to go with you wherever you go, it'll have to be a box or a bag you never let out of your sight when you leave here, now what can I give you, what'll serve ...?' Mary looked about the bedroom and her eye fell on the mahogany chest of drawers on top of which there was a clutter of different kinds of boxes containing a variety of things, necklaces and brooches, pins and buttons. She pointed and said to Evie, 'Fetch that tin here, the one with the dog on.' Evie reached up - it was a chest a little taller than herself - and pulled the flat tin towards her and lifted it off. She knew what was in it. Nothing important, nothing of value, only some ribbons, all folded neatly and never used. Her grandmother said that when her hair was smooth and tangle-free she could have one of these old, long-preserved ribbons to tie it up with, but Evie had never succeeded in brushing her wild and springy hair into anything like the required state and had never earned a ribbon. 'Nobody will bother about a girl having this,' Mary said, 'a tin of ribbons, they'll think nothing of it when the time comes. Look, we'll lift the ribbons and the envelope will fit snug.' It did. 'Then we'll cover it with ribbons, see?' The coils of ribbon, lilac and yellow and a beautiful red Evie particularly coveted, were laid flat side down

together forming a concealing band over the envelope with 'E' on it. 'There, that'll fox them, eh?' said Mary, and seemed pleased. 'You take it now, keep it with you, put it under your mattress.' Evie hurried to do just that, putting the tin under the pillow end, and Mary sighed with satisfaction.

Evie slept on the flat tin of ribbons for almost another year. Every day when she made her bed she peeped inside the tin and gently lifted one of the ribbons to check the envelope was there. She never took it out and she never looked inside it. It was enough to know it was there. Every now and again her grandmother would ask to see it and she'd take it to her and it would be inspected and then returned to its hiding-place. Meanwhile, Evie learned to write not just an 'E' but her whole name and some other words besides the alphabet. A man came round and, though Evie was instructed as usual to hide, the man was persistent and, lurking in the kitchen, Evie could hear him raising his voice to her grandmother and saying, 'I have it on good authority there is a child in this house of school age, madam.' Next time he came her grandmother had prepared her. 'You're sickly, Evie,' she told her, 'remember that if asked, you're sickly and can't go out, you have to stay with me or you get took badly. It might work for a while and there's nothing else will.' It did work. The man stared at Evie, who must have looked as convincingly sickly as she tried to suggest because he said, 'I see,' to her grandmother and then, 'The child needs a doctor.' Mary said she had no money for doctors nor for the medicines they might prescribe. The man addressed Evie directly and asked her how often she went out, how well she ate, whether she slept well – but Evie had been well instructed by Mary and simply stared up at him in bewilderment with her mouth hanging open. He never came again.

Life went on in the same way until one day Mary did not get up. Evie took her tea and toast and got on with what she always did, the household tasks by which she measured time. It was only when it grew dark and her grandmother was still in bed that things began to feel strange. She drew the curtains and lit the lamp and built up the fire but then, sitting alone with the mending, she felt awkward, she missed Mary in her chair talking to herself. She went to bed early, carrying out all the going-to-bed rituals of locking doors and dampening the fire and putting the guard round it to catch stray sparks and checking the wick of the lamp was turned low and the oil extinguished. But even lying on her mattress at the foot of her grand-mother's bed didn't seem right. Twice in the night she was wakened by the rattling of Mary's breathing and twice she got up and went and peered at the old woman, but she was deeply asleep and did not respond to the timid touch on her cheek. The next morning Mary woke up but did not touch her tea and toast nor the soup offered later on, and Evie began to be frightened. She spent most of that day in the bedroom hovering by the bed, longing for some instructions and receiving none, not a word. She wanted somebody to come but nobody ever did. There were people next door, on both sides, and Evie knew their names but not their faces. Even the names seemed to change - 'New folk,' her grandmother occasionally said when somebody had come to their door and Evie had been told to keep herself hidden, 'new folk again next door, I knew that last lot would never stay, but they're nothing to do with us, Evie, eh? Potts they're called, but that's no concern of ours, we keep ourselves to ourselves and ask nothing of nobody, eh?"

There was a smell on the third day that told Evie she must call on the Potts, or someone. She knew the smell of urine but this was worse, it came from her grandmother's mouth and it was foul. Going downstairs, opening the curtains on to the grey dawn light, Evie found herself crying. She didn't want to cry, she hadn't intended to, but the tears rolled down her cheeks and would not stop. She stared out of the window but there was nothing to see, nobody going down the lane at that time of the morning. But she couldn't tear herself away from the window, it offered some sort of hope. She stood motionless for half an hour, an hour, and when the first footsteps sounded on the sandstone flags she pulled the net curtain aside and peered out and tapped hard on the window-pane. A man passed by without so much as a glance but shortly after two women carrying big baskets heard her tapping and stopped and stared at her. But then, stupidly, Evie just stared back and did nothing and the women frowned and looked annoved and went on their way. Still weeping, and trembling now, she at last left the window and stumbled to the door which she opened with difficulty, it was always so stiff, and then she stood in the doorway and waited, not knowing what she was going to say when someone asked her, as they surely would, what was the matter.

The woman who did ask her was young and she was carrying a baby. She hitched the baby on to her hip and looked at the little girl

weeping in the doorway, a pathetic figure, very small and pale and ill-kempt and thin, standing there shaking violently. 'What's the matter, pet?' she asked, and when Evie went on shaking and sobbing the woman peered into the passageway of the house and said, 'Is your mam there? Hello, missus?' The baby, affected by Evie's sobs, began to cry too, though half-heartedly, merely in imitation, and the young mother knew it and paid no attention. 'We can't have this,' she said, putting the baby down on the step, whereupon it began to bawl in earnest, feeling the cold even through its lavers of shawls. She drew Evie to her and stroked her hair and said, 'There, there,' over and over again. When Evie was quieter, though her thin body still shook, the woman said, 'Now what is it? What's wrong? What's vour name, pet? Can't vou talk? Can't vou tell me?' Choking, Evie managed to hiccup the words. 'My grandma's sick.' 'Are you on your own then?' asked the woman anxiously, already seeing herself dragged into a mess she'd rather keep out of. 'Isn't there anyone else in the house? Where's your mam? Where's your dad? When will they be coming home? Where are they? Where can they be sent for?"

But Evie was incapable of giving any information and the young woman knew she would have to go into the house and see where this sick grandmother was. Hesitantly, holding her baby with one arm, putting it back on her hip, she took hold of Evie's hand with the other and allowed herself to be led up the stairs. She knew before she saw the old woman that she was dead and she stopped in the doorway of the bedroom and turned round. 'You'll have to come with me,' she said, her tone now sharp and not as caressing as before. 'Have you a key? We can't leave the house open.' Evie did know where the key was, a big iron thing hanging behind the front door and rarely used because they so rarely went out. The woman put it in her pocket. She seemed bad-tempered now, but Evie herself was calmer knowing responsibility had passed from her hands. She followed the woman down the lane eagerly, in her relief hardly noticing the cold. The woman hurried, her skirt flapping and her head bowed against the wind. Furtively, Evie looked about her. It was strange to be moving so fast instead of patiently keeping pace with her grandmother's slow amble. It felt exciting, urgent, and she no longer felt terrified. She wondered where they were going but did not dare ask in case she was cast off.

They passed St Cuthbert's church and came out on to West Walls, hugging the crumbling old wall, keeping out of the narrow road itself. But then, past Dean Tait's cut, the woman veered right and stopped at a door and knocked on it. It opened quickly and another woman, also young, stood there and said. 'You've taken your time, you'll be late.' 'I know I'll be late,' Evie's rescuer snapped. 'It can't be helped, it's this kid, standing crving fit to burst in the lane and saying her grandma's sick.' Here she dropped her voice and whispered in the other woman's ear. 'What could I do?' she went on, 'I couldn't leave her. And now what can I do? Who'll I tell?' They were all still standing on the doorstep but now the two women went inside and Evie followed, though they paid no heed to her. She had never, to her knowledge, been in any other house but her grandma's, first in the village, that dim memory, and then in the lane. She peered about her nervously, feeling it was wrong to stare. The room wasn't much better than her grandma's, it was just as small, but there was a good fire burning, bigger than her grandma ever allowed, and a good smell of some kind of cake cooking. And there was a brightly coloured rag-rug on the stone floor with two small children sitting on it playing with pan lids and pegs, and making a great racket.

'What's your name, pet?' the woman who lived there asked, turning aside from a whispered consultation with her friend.

'Evie.'

'Oh, she has a tongue. Mine's Minnie, and this is Pearl. Now what are we to do with you? Where's your mam?'

Evie didn't know what to say. Did she have a mam? She wasn't sure, she had never been sure. If she did have one then she'd gone. 'Gone,' she said.

'Where?' asked Minnie.

'Don't know.'

'When? When did she go? Early this morning?'

Evie shook her head and twisted her skirt in her hands. Finally, she said, 'I've never seen her, if I have a mam,' and began to cry again. Both women told her to shush, but kindly. Minnie gave her a piece of bread and a small mug of tea, and told her to get them down, she'd feel better. Another whispering session followed and then Minnie, who seemed to be in charge, said, 'Pearl's got to go now, so you can help look after little George. You can help me this morning till we see what's what.'

Evie enjoyed the morning helping. She spent it on the rag-rug playing with George and the other two children. She put the

wooden pegs into a pan, a battered old tin thing, and put the lid on and shook it about and then emptied it with a flourish. The babies loved it. She did it again and again and they never seemed to tire of the rattling noise and the surprise, a surprise every time, of the pegs cascading out. 'You've a way with you,' Minnie said approvingly. Later, she fed all three children. Minnie gave her a bowl of porridge and she made a game of feeding it to them. When one of them crawled or rolled off the rug she had to persuade them back on to it and she loved the feeling of the warm, soft, wriggling bodies. She hugged them and they hugged her back, their hands catching in her untidy hair and pulling it but she didn't mind. 'Got little brothers and sisters, have you?' Minnie asked. Evie shook her head. 'Big ones, then?' Evie shook it again. 'Oh dear, you are an odd one,' Minnie said. She watched Evie carefully. It was as clear as crystal what would happen to her, what the situation was. The grandmother was dead, Pearl was sure, the stench in the bedroom alone had told her, and unless some relative stepped forward it would be the orphanage up above the river for poor Evie. It was a shame, she was a pathetic scrap of a thing, she deserved better, but better was unlikely to be available.

Pearl, on her way to work in Carr's factory, reported the situation she had found at 10 St Cuthbert's Lane that morning, and the temporary address of the little girl, Evie. The body of Mary Messenger was removed before noon. A policeman came round to Minnie's house in the afternoon and asked (in front of Evie) if she was willing to keep Evie. Minnie said she was willing but that she couldn't, she had no room. Evie would have to go somewhere else but she hoped the child wasn't to be sent off without her things. The policeman said he'd take Evie back to her grandmother's house first, before handing her over to 'them up above the river' (with a significant look at Minnie) and she could take some clothes and anything else of hers that was small enough to go in a bag. Minnie made each of the babies kiss Evie, then told her she'd see her one day and to try not to take on too much, she would only make it worse.

The policeman took Evie home and made a list of what the child took from the house. It was not a long list. Two dresses, two pinafores, two shawls, a pair of clogs, some woollen stockings and a tin box. These all went easily into a bag with a drawstring which Evie produced from behind the bedroom door. She found a coat, which she put on, a shabby article but thick and warm-looking, and a tam-o'-shanter which hid her hair completely. 'Ready for your travels?' the policeman asked her, but she neither responded nor nodded, she just stood there obediently, evidently quite composed. Knowing nothing of the weeping Evie had already done that day. he thought it odd she didn't shed a single tear. She seemed quite passive and he was glad: it made his job so much easier. She followed him, he thought quite happily, out of the house, never a backward look, and down the lane and across the Town Hall square and up Lowther Street and across the bridge. The noise of carts on the bridge was so loud and the crush of people so great that he took her hand for fear he would lose her. It was a steep hill to climb, up Stanwix Bank, but she managed it without faltering. They came to St Ann's House just as it began to rain and the policeman hurried her into the shelter of the doorway. He knocked on the door several times before it was opened by a stout woman wearing a dark blue apron.

'Here you are,' the policeman said, 'another for you. Her grandma's been found dead and there's nobody to have her, not yet anyway.'

'I haven't been told,' the woman said indignantly. 'There's been no notification.'

'Well, there should've been, it'll come,' the policeman said, and turned and left.

That was how Evie came to St Ann's House. She stayed there six months before she was claimed.

Chapter Two

 \sim

Shona's FATHER was a sea-captain. She was proud of him and Sboasted about him continually. Nearly every father in the village was a sailor but there was only one a captain and that was her daddy. She was like him in looks, not her mother. She had his red-gold hair, his very pale blue eyes and his full lips, though in his case these were hidden by a moustache and beard. All she had taken from her mother was a certain fragility which belied her true nature. Shona was as tough as her father, every bit as tough as Captain Archie McIndoe both in body and in mind. She only looked frail, 'a delicate wee girl' people said, but they were wrong.

The McIndoes had come to this remote part of north-east Scotland when Shona was a baby, only a month old to be precise. Her mother, Catriona, was still recovering from the birth which every woman in the village quickly learned had been a difficult one. Catriona was so weak afterwards she hadn't been able to breast-feed her baby and the other young mothers, all of whom had ample milk and to spare, had felt sorry for her. But Mrs McIndoe was not young, they noticed, she was surely only just the right side of forty and unlikely to have any more children. Shona, they predicted, would be an only child and they were proved right. She was an only child, greatly adored, who, everyone agreed, ruled the roost. It was an extraordinary sight to see her at the age of four dominating both her parents. Even in the kirk Shona exerted her authority, choosing where to sit and which kneeler to have.

Captain McIndoe was slow and quiet, the sort of man who could, and did, sit for hours over a pint of beer and a whisky without saying a word. Aboard ship he was said to be careful, cautious, a good man to sail with, never panicking in any emergency, always reliable: the women in the village liked their men to sail with him. And Mrs McIndoe was equally lacking in any spark, equally colourless though pleasant enough. She was in the Women's Guild and helped at bazaars but she was not sociable. she kept herself to herself and that self was thought of as a bit dull. So where, everyone given to such curiosity wondered, had Shona got her fire from? 'Is she like her grannie?' women sometimes asked Catriona after witnessing one of Shona's more extravagant displays of temperament and contrasting it with her mother's placidity. 'Is she after following in her grannie's footsteps?' Catriona would smile and say, 'A little, maybe,' but she never went so far as to say, as she was expected to say, that Shona was a throwback, the spitting image of one grannie or another. Another question was a common one put to the Captain himself when Shona's physical resemblance to him was commented on. 'Do you have any sisters. Captain?' But no, he didn't. No sisters whom Shona took after.

The McIndoes lived in a stone house above the harbour, bought outright when they arrived in 1956. The Captain was in the merchant navy by then but was known to have distinguished himself in the war when he had served with the Royal Navy working in Xcraft (midget submarines) off the coast of Norway. It was the nature of his job that he was away for long spells throughout Shona's childhood and that his daughter therefore lacked the strong fathering she could be seen to need. But then most fathers in the area were away at sea and it was the mothers who had to do the best they could with the help of the wider family. It was felt to be unfortunate that in the case of the McIndoes that wider family lived so far away.

Shona only became properly acquainted with her grannies when she was seven. She and her mother went to stay with Grannie McIndoe in Stranraer and Shona didn't enjoy the experience one bit (nor, in fact, did Catriona, but she never said so, being much too polite and discreet and much too aware of how dangerous it was to let Shona know). Grannie McIndoe found it hard to tolerate her young granddaughter's tantrums and wondered aloud why anyone else did, particularly her mother. 'Archie was never like this,' she proclaimed. 'His father would have thrashed it out of him. Where does she get it from?' Weakly, Catriona said she didn't know, but she was sure Shona would calm down as she grew older. Things were a little easier when they went on to Glasgow to Grannie McEndrick, Catriona's mother, but even in that household Shona's energy was a strain. 'Is she never still?' Grannie McEndrick asked. 'You were such a still child.' But though Shona was never still, at least this grannie found her amusing and was briefly entertained by her antics so long as they did not go on too long (though, alas, they often did).

It was at Grannie McEndrick's, however, that Shona disgraced herself and caused the greatest alarm. A neighbour's child, a boy called Gavin, the same age as Shona, had been invited in to play. The two children had seemed to get on tolerably well, once Shona's boasting about her father the Captain was capped by Gavin's pride in his father being Provost (which baffled but impressed Shona), and they had been sent into the garden to run around before tea. It was a big garden and the two children disappeared, not entirely to Catriona's pleasure. 'Och, you fuss too much, Catriona,' her mother said, 'it doesn't do to be fussing. You should be thanking the Lord wee Shona's not a clinger. You were a terrible clinger, so you were, wouldn't let me out of your sight, clung to my skirts all the time.' Catriona remembered, she needed no reminding, and flushed at the contempt in her mother's voice. 'She's a grand wee soul,' her mother said. 'Come and we'll take the chance to put our feet up and have a quiet cup of tea."

The tea was made, and drunk very quietly indeed. Catriona could never think of anything to say to her mother when they were alone together. She made inquiries about other family members and that was it. It never crossed her mind to share with her mother her true anxieties, knowing, as she did, that since these were all wrapped up with Shona's waywardness her mother would be scornful. There was no one Catriona could talk to about her fears except Archie, and he had little patience with them. She sometimes thought that if she had been able to find the right words to express her unease, then Archie would have listened to her, but as it was, even to her own ears, her sense of there being something not quite normal about Shona sounded silly. They sat and had tea and the weak, wavering shafts of sun came through the open window and warmed them.

The moment Skipper began to bark Catriona was on her feet. 'Whatever's the matter with you?' her mother said, exasperated. 'Look at you, the wee dog barking and you're all of a tremble. It's seen a cat, that's all, sit down, Catriona.' But Catriona could not sit down. She was out of the room and down the steps into the garden before her mother had finished chiding her. Skipper's barking was frantic. Quickly, only just preventing herself from running, she hurried across the lawn and into the rhododendron bushes from where the barking came. Skipper raced out of the undergrowth to meet her and then scurried back at once down a little path leading through the bushes to the wall which marked the boundary of the garden. She scratched her face on some strav gorse growing with the rhododendrons and had to part it to follow the dog, hurting her hands in her haste. Then she stopped abruptly. There was a dip in the ground near the wall, what her mother called a dell, though it was nothing more than a hole, grass-covered and shaded over by the low branches of a beech tree. Shona and Gavin both lay in it, both naked, their clothes in touchingly neat piles either side of them. Shona was examining Gavin's testicles with the greatest interest, first prodding and then holding his tiny scrotum, while Gavin, with his eves tight shut, held himself like a soldier, rigidly still, his arms straight by his side, his legs clamped together.

'Shona!' Catriona burst out before she could stop herself. 'What do you think you are doing? Leave Gavin alone, leave him!'

Shona looked up, not at all embarrassed, and said, 'We're playing doctors.'

'Put your clothes on, now, this minute, and Gavin, put yours on.'

'Why?' Shona said, but Gavin, red-faced, was already into his shorts. 'What's wrong with playing doctors?'

'Nothing,' her grannie said, appearing from the other side of the dell, arms akimbo and smiling. 'They're only this side of seven, Catriona, have some sense.'

That was how the incident ended, turned into something amusing by Grannie McEndrick, something so funny Shona was quite delighted with herself and Gavin half-hysterical with relief. There was nothing Catriona could say or do to stop the hilarity and she felt humiliated. There she was, a woman in her forties shown how to behave by a woman in her seventies, the older woman a model of commonsense. It was impossible for her to explain that her horror had had nothing to do with the children's nudity nor with what Shona was doing, but everything to do with the atmosphere of what she had seen. It was Shona's intensity, her concentration, her very lack of any sniggering or squealing which had frightened her and made her react so inappropriately and violently.

Putting Shona to bed that night Catriona felt awkward and

though she did all the usual fond things – kissed Shona, hugged her, tucked her up, said her prayers with her – she did it with half her normal enthusiasm, and after all the rituals were over could not quite bring herself to leave. She sat on the end of Shona's bed looking at her. Shona stared back, her big blue eyes not at all sleepy but instead challenging, accusing.

'Shona,' Catriona began, and stopped. What could she say? How could she redeem herself? 'Your Grannie is right,' she said finally, 'there's nothing wrong with playing doctors or with taking your clothes off.'

'You shouted,' Shona said.

'Yes, I did. I shouldn't have. I don't know why I did.'

'It was my turn,' Shona said. 'Gavin had looked at my wee-wee. I was just looking at his.'

'Yes, I know.'

'Did you see it?'

'What?'

'Gavin's wee-wee.'

'Yes.'

'Yuck. It's squidgy. Gavin says his brother says it grows and it makes babies.'

'Yes, it does, in a way. It's late, Shona, time to sleep.'

More cowardice. Catriona despaired. It was not that she was reluctant to describe to Shona how babies were made but that she feared the questions that would surely follow. She wasn't ready to lie so thoroughly yet, even though she had done so before. A new set of lies were needed and she had not got them ready. It was such a long time since she had held Shona, her baby, in her arms and had no doubts or qualms about a single thing - so confident she had been, once she was a mother, once she had been blessed. Archie could have accepted their lot, their destiny to be childless, but she never could have done so, never. She had had to have a baby, it had been vital to her sanity, not merely her happiness. Each time she was pregnant the glory of it transformed her. Each time she miscarried it was a tragedy of epic proportion. And the one stillbirth, the one baby she had carried to term, had made her want to die. She had tried to die. She wanted to be buried with her baby. And then there had been Shona.

One day she would tell Shona everything. When her daughter was of an age to understand, when she had perhaps had children herself, then would be the time to tell her. She would have no fears then, time and Shona's growing-up would have dispersed them and she would be able to speak freely.

They did not go again for a long time to stay with Grannie McEndrick. They were invited, in invitations that had an increasing edge to them, that were on the verge of becoming orders, but Catriona managed to be resistant to them. She pleaded her own poor health and there was nothing her mother could do about that except complain her daughter had never been really well since Shona's birth. 'It took it out of you,' Ailsa McEndrick said when, instead of her daughter and granddaughter coming to visit her, she went to visit them (complaining all the way about the difficulties of the journey). 'You were too weak after all those miscarriages, Archie should have had more consideration.' 'I wanted a baby,' Catriona replied. 'Oh. I know that,' her mother said, 'we all know that. But not at the cost of your own health. Look at you, stick-thin and no colour at all and think how you once were before.' Catriona smiled. She'd been quite plump, she'd had a good complexion and her mother couldn't forgive her for sacrificing both - as if weight and skin mattered beside the having of a baby. She would have offered up far more vital things to have one, her hair, her teeth, anything. But her mother couldn't be expected to understand that kind of desperation. She had had four children and had often enough in Catriona's childhood come near to implying this had been one, if not two, too many. Her first son had been born when she was only twenty and she had never experienced that craving for a child which had become her daughter's own.

Walking along the beach one rare still August day, Ailsa suddenly said, 'You should have come home, you should have been looked after properly. That's when it all started, when you were carrying Shona. You didn't eat, I know you didn't.'

'Oh, Mother, don't hark back, it was seven years ago for heaven's sake.' She didn't look at her mother at all. They were side by side, keeping an eye on Skipper and on Shona, racing ahead along the edge of the sea. They walked a bit further until, with that violence for which it was famous on this part of the coast, the tide started to rush in over the flat ground forming deep gullies round islands of sand, and they shouted at Shona and the dog and veered sharply inland, into the dunes. Ailsa was panting before she got over them and on to the track behind. 'I'm getting old,' she gasped, 'I must be, I'm puffed after that wee hillock.' But then she looked at Catriona and was so struck by her daughter's pallor she stopped dead. 'You're not well,' she said, her concern as ever coming out as an accusation. 'What is it? What's the matter with you?'

It was tedious, this endless emphasis on how she looked, and Catriona resented it. Every time they met there was this same interrogation, always leading back to the birth of Shona. Catriona had written from Bergen, where Archie was based at the time, and told her that she was pregnant again but said she wanted to keep the expected birth date secret because she was superstitious, after three miscarriages and a stillbirth, and believed that if she revealed it another tragedy would follow. Her mother rang her saying she would come at once. But Catriona had been adamant, no, her mother was not to come. The doctors had declared her perfectly fit and the maternity hospital in Bergen was excellent.

So her mother had been out of it, deprived of the whole experience. She had never seen Catriona pregnant with Shona nor was she anywhere near for Shona's birth. When Catriona rang her and said she had a beautiful, healthy new granddaughter, Ailsa had remained quite silent for a full minute before she had said. 'I can hardly believe it. not without seeing her.' When she did see her, a month later, there was a sharpness in her mother's eves which Catriona feared. 'Let me look at her properly,' she had said, almost snatching the baby from her cradle. But then the sharpness had disappeared as Shona was minutely inspected. 'She takes after Archie,' Ailsa pronounced. 'Look at the colouring of her. But she has your shape of face, Catriona, heart-shaped, just like your face, and see the way her right ear is a wee bit bigger than the left, that's the same as yours.' The birth weight, 7lb $3\frac{1}{2}$ oz, was exactly the same as Catriona's had been and so was Shona's length, eighteen and a half inches. Once these comparisons were made, Ailsa was happy. 'I never thought you'd do it,' she said. 'I thought it was going to be your cousin all over again, what with the miscarriages and stillbirth, just like her, and then nothing ever again. You've been lucky in the end, Catriona.' 'I know,' Catriona had said, 'I know I have.' 'But.' her mother had added, reverting as she did so to her usual more hectoring tone, 'let that be enough, will you? Don't tempt fate, don't try again, be grateful for what you've got, mind.' 'I'll be grateful.'

Catriona promised, though privately reflecting it was far too late, fate had already been tempted and she had tempted it knowingly.

Without Archie, of course, nothing would have been possible. Another husband might not have been able to bear his wife's obsession, he might have recoiled from the rawness, even the ugliness, of the hunger behind it. But Archie had not. He was patient and understanding and said only, 'If this is what you want' and 'If this will make you happy.' But he had been surprised. He had looked at her and his eyes had been shocked even though he said nothing. Then he had taken her hand - hot, feverish - and squeezed it and said she could have her way if she was quite sure she knew what she was doing. But she felt that she had caused him pain and was sorry for it. She knew that she had forced him into a position of surrender, though she was not entirely sure what she was compelling him to surrender. Control, she supposed. She had taken control away from him. He was not an overbearing man, for all that he commanded a ship, but he liked to do things his way. Now they were doing this thing her way, relegating him to a subservient role at this crucial point in their lives. Fortunately, once Shona was back in Scotland with them, the balance was restored, partly because it became apparent that neither of them controlled her. It amused them both, their little daughter's independent spirit; it helped that they could see nothing of themselves in her. 'She would make her way anywhere,' Archie said, admiringly. He was glad their only child was a girl. A boy would have been more complicated, he felt, he would have worried about Catriona left for such long periods with a son. Leaving mother and daughter felt comfortable and he did not mind at all that he was on the periphery of their relationship for so much of the time. Catriona had what she wanted and he wanted what she wanted, simple as that.

He watched them sometimes without their knowing. Especially at first, when they came to this carefully chosen village on the northeast coast, when they were settling down and he was still anxious about Catriona's mental well-being. He would stand outside the bedroom door, hidden in the shadows, and watch through the gap his wife nursing the baby. She couldn't breast-feed, but she wanted to pretend that she did and so she sat with her blouse undone and the baby nestled close against her empty breast, and the bottle of milk tipped so close to her own nipple that it grazed it and the baby fidgeted, fighting the natural nipple off to get at the satisfying rubber teat. It moved him to see this scene; but it disturbed him, though he was not quite sure why. Catriona carried things too far. She had her baby, why did she need to convince herself she was feeding it? Why was this subterfuge important to her? Was she doing it for the baby's sake or her own, and if for her own what did it mean? But Archie asked none of these questions; he only observed and left his wife to it.

Chapter Three

 \sim

EVIE WAS a hard worker. It was what everyone remarked on – such hard and willing worker, for a small child, with a real idea of how jobs should be done. Give her something to clean and she'd go at it as though her life depended on it, scouring dirty old pans as if expecting it to be possible that through her efforts they could be restored to their former shining selves. It was assumed by those who gave her the work to do in the Home that she had had a hard taskmaster, or mistress, that perhaps she had been bullied and beaten into such diligence. But no. When questioned as to her past, and Evie did not speak of it unless she was directly asked, she had only words of affection for her dead grandmother. She had wanted to please her, and hard work was what had given her most pleasure, both the doing of it herself, when she had been able, and seeing Evie being like her, her exact copy.

Except Evie never forgot she was not, could not be, such an exact copy. The woman who had been her grandmother was not her grandmother; nor was Mary the mother of the woman who had been Evie's mother. This was too complicated to explain so she never attempted any explanation. It hurt her even to remember this truth and to find it would not disappear. She had the tin safe, of course. It had gone first into the bag when the policeman stood over her, and when she came to the Home she had managed to hide it inside one of her thick woollen stockings. There was nowhere for her to put her few belongings, except the communal chest of drawers at the end of the dormitory she shared with eleven other girls, but it worried her so much, thinking of other hands finding and handling her precious tin box, that she could not bring herself to place it in any of those capacious drawers without hiding it first inside a stocking. She thought of keeping it under her pillow instead, as she had been used to doing, but that was not safe either. Girls stole things and hid what they had stolen in or under the pillows, and so these were regularly inspected. Nor could she keep it in her apron pocket – it made a bulge and would be remarked on. There was nothing for it but to ask Matron to keep it for her, a solution far from satisfactory and one she had to be driven to after several days of feverishly moving the tin around.

Matron was rarely seen by the girls in the Home, but she was always known to be there, a formidable presence in the background. built up into an ogre by the rest of the staff. It was a big Home, St Ann's, housing at any one time a minimum of sixty and a maximum of a hundred girls between the ages of five and fifteen. It was meant to be a place of safety for orphaned or abandoned girls, but in effect had become a house of correction too. There were girls there who had been convicted of stealing and other minor crimes (though to hear the thundering of the magistrates the theft of a penny bun sounded very major indeed), or of persistent vagrancy. Several were there for soliciting and these inmates took some managing. There was one attendant, referred to by the girls as the Handler, to each dormitory, women of low intelligence and sluttish habits who ruled their own little kingdoms with a mixture of brutality and favouritism. Evie was of no interest to Madge, her Handler, and so she was left mercifully alone except to be made extra use of when her capacity for hard work became noted. 'Proper little worker, are we?' Madge sneered, but soon she left her alone. Evie was first up in the mornings, no lying abed for her, and first to wash in the freezing cold water, without a word of complaint. She laid the tables and washed the dishes and swept the floors with an enthusiasm marvellous to see and was marked out very quickly for future promotion to Monitor when she should be old enough. Madge approved of her and Evie saw that she did, though no word of praise or admiration was forthcoming.

But she could not take her tin box to Madge. She did not trust her. Madge herself, she soon knew, stole, though she was so hard on those girls discovered to be thieves. She took from her charges any sweets or cakes that came their way, on the grounds that they were bad for growing girls, but what was worse was her filching of the small and treasured items they had managed to bring with them. So Evie could not and would not give her tin box to Madge. She would give it to Matron who, for all she knew, might be just as untrustworthy but had not yet proved herself so. The problem was how to gain access to Matron. She was virtually invisible in the Home. Evie had seen her once only, to be checked over (a matter of lice, rashes and sores) and officially registered. She had been taken to Matron's room but was not sure she could find it again.

For a young child the scheming necessary to visit Matron without anyone else knowing was impossible. Evie could not imagine how it could be done. But one morning she was seen hurriedly shifting her box from one stocking to another in the big bottom drawer of the chest and Ruby, the girl who saw her, gave her good advice. Ruby was older, nine to Evie's six, and she had already been in the Home nearly three years. She was quick and clever but, unlike Evie, she was lazy. Madge hated her for the cunning with which she could evade work as surely as Evie welcomed it, and for the intelligence with which she exposed half of Madge's own evasions. Ruby put her hand over Evie's as it struggled to transfer the box and said, 'What you got there?' Evie froze. 'Something you're hiding,' Ruby whispered. 'Show me, I won't tell.' Wordlessly, Evie was obliged to let the little box peep out of its hiding place. "S only a box," Ruby said, 'isn't it? What's inside, then? Not money? Sweets? What's inside? I won't tell.' Evie, hoping it would satisfy Ruby, murmured, 'Ribbons, just ribbons,' but Ruby was intrigued. 'Let's see, are they pretty, then? I've never had a ribbon, never.' She looked over her shoulder as she said this, to check that Madge was not bearing down upon them, which comforted Evie. Ruby was evidently disposed to keep her secret. Carefully, she lifted the lid and in a moment of inspiration offered Ruby one of the three ribbons. Ruby's face crinkled into a great smile and she lifted the red ribbon out of its nest. So eager was she to have and hide it that her sharp eyes missed the layer of paper under the ribbons, and Evie was able to put the lid back on before any more questions were asked.

Ruby was so happy with her ribbon. She would never be able to wear it, for fear of Madge, and her hair was shorn so close to her head (she had had nits) that there would have been nowhere to tie a ribbon, but this didn't matter. 'You can't keep on doing this,' she admonished Evie, 'you won't get away with it for ever. Madge'll find it. What you going to do?' Evie shook her head miserably. She didn't dare say she wanted to give her treasure to Matron. But Ruby thought of it herself. 'What you want to do is give it to Mrs Cox, that's what you want to do, give it over to Mrs Cox, Matron, that's her.' Evie confessed she didn't know how to arrange this and Ruby took charge at once.

They finished getting their stockings from the drawer and dressed rapidly. Beds had to be made and then it was breakfast in the huge kitchen and then washing-up, but after that there was a chance. Madge and the other attendants were always preoccupied after breakfast with sorting out the different chores for the day and there was a brief lull for the girls while tasks were disputed and assigned. Ruby took Evie's hand and led her out of the long corridor, where the washing-up was done at a row of stone sinks. She seemed to know exactly where to go, racing up stairs and down passages as though following a trail and bringing her in a minute to a door with MATRON clearly written on it. Ruby even knocked for Evie, who was much too frightened to do so, and when a surprised voice called 'Come in' she opened the door and pushed the terrified Evie in. 'What are you doing here, girl?' Matron said. She was drinking her tea and hated to be disturbed. The effrontery was so appalling she had not yet entirely taken it in. But she could sense already that she would have to react to it with a fine degree of rage so that it would never happen again. Meanwhile she had the most pathetic apparition standing before her, a child literally trembling, utterly ashen-faced and without, it seemed, a tongue in her head, a head Mrs Cox quite failed to recognise, which made this visitation even more outrageous.

Maud Cox was not an unkind woman. She had little of the Madge in her, but she lacked imagination and the feat of empathy was beyond her. 'Now there's no need to take on so, whatever it is,' she said, after she had watched with fascination how Evie trembled. 'What have you done? Who sent you to me?' Evie shook her head. 'Nobody sent you? Then you are very bold, coming to me like this, it is not your place. What is your name?' 'Evie, ma'am.' 'Well, Evie, speak up, or I shall have to look your name up in the register and call for your dormitory monitor to take you away.' Evie closed her eves and with a great effort thrust the tin box at Mrs Cox. 'What? A box? Is this about a tin box? Did you steal it? Let me look.' Surprised at her own curiosity, Mrs Cox took the box and examined it. It was quite unremarkable, a cheap thing with a gaudy picture of a dog of doubtful breed on the lid. She shook it. It made no sound. Without asking Evie's permission, she opened it. Unlike Ruby, she was aware immediately that there was something under the ribbons.

Watched by Evie, whose eyes were now wide open with apprehension, she went to the table near the window and took the remaining two ribbons out, laying them side by side. 'Now what have we here?' she murmured. 'What is all this fuss about?'

There was a long silence. Evie wanted to cry but she was experienced at withholding the noise of weeping. She saw Mrs Cox smooth out the flimsy piece of paper which had nestled in its envelope under the ribbons and study it. She studied it a long time. Her manner, when finally she put it on the table, also changed. 'Do you know what this is?' she asked, her tone peremptory. Evie shook her head. 'Who gave it to you?' 'My grandmother,' Evie whispered and then was in agony, knowing as ever that her grandmother was not her grandmother and therefore she was telling a lie and would be punished if this was discovered, which it was bound to be. She choked in her agitation, but Mrs Cox ignored this and started looking in a folder. 'Something will have to be done,' she said. 'You belong to a family after all.' Evie felt a little leap of hope. hope not for something grand but for all this to pass over quietly and her box to be protected. She had not vet spoken of why she was here, but now some courage came to her, she blurted out, 'Please, ma'am, will you keep it for me?' 'Keep it for you?' said Mrs Cox, irritated. 'Of course I'll keep it. I have to keep it, and attend to it. Now go away and don't come again until you are told to.'

It was such a long time until Evie was sent for that she was convinced she never would be. Ruby had pleaded to be told what had happened in Matron's room but some innate sense of caution had prevented Evie from telling her. All she had said to her new friend was that Matron had said she would keep the tin box safe and ves, she had been cross and told her not to come again. The two of them were back in the kitchen and were milling about with the other girls before Madge noticed their absence. Evie was grateful for Ruby's cunning and cleverness. She only worried that Ruby would want something in return - everything in the Home, every act of apparent kindness, had its price - but the ribbon seemed to suffice. All Ruby wanted, apart from that, was to be her best friend but Evie was sadly inexperienced in friendship. She did not know how to indulge in cosy, intimate chat, she had no confidences she wished to share, and Ruby was disappointed. There were no larks with the solemn Evie, no possibility of fun at Madge's expense. Evie was too much in awe of authority to become Ruby's true apprentice and was

soon abandoned in disgust. 'You've nothing to talk about, so talk to yourself,' Ruby announced one day and that was that.

Evie thought about Ruby's accusation carefully. It was not true, she did have things she wanted to say but she saw no point. She wanted most of all to speculate about what was going to happen to her but she could not bring herself to do so. When she had lived with her grandmother she had never considered the future, she didn't know what it was, but now it loomed frighteningly ahead all the time. She looked at the older girls and wondered if she would live at this place until she was like them, and the thought gave her a strange feeling in her stomach. She wanted also to ask about school, about whether she would get any schooling. Girls went to Lowther Street School from the Home every day but they were all older than she was and she wondered how old she would have to be before she. too, went with them. She and twenty or so others attended lessons in the schoolroom for two hours in the morning, but often the attendant who was supposed to teach them was needed for some other task, and they were set to copying letters on their own. They sat on benches and held bits of slate on their knees and copied the alphabet, which was tedious when you knew it already as Evie did. If only she could become one of the school party she felt she would not fret so much about what was in store for her.

Sometimes she was one of the girls taken into the city and she found this painful. At first it had been exciting to be told by Madge to put her coat on and pick up one of the baskets that hung from nails at the end of the washing-up corridor and wait on the doorstep, because they were going to market. Only the most biddable and docile girls were chosen to go to market and usually they were older than Evie, so she knew she was privileged. Eight of them walked, two by two, behind Madge and one of the other attendants down Stanwix Bank and across the Eden Bridge and up into the market; all the way Evie looked about her, recognising the cathedral and the castle, and her heart beat furiously with a disturbance she did not identify as nostalgia. In the market itself, seeing the butter women, or waiting for Madge to buy eggs and put them in her basket, she could hardly bear the memories. She wanted to leave not by the door they had entered but by the other door, the one at the top of the little cobbled hill in front of the butcher's stalls, the one that led out into Fisher Street and to the Town Hall and across the square to the lane where she had lived. She was pulled fiercely in this opposite

direction and was harshly reprimanded by Madge for lagging behind. 'If you're going to be a lagger you won't come again,' Madge admonished her. So Evie controlled herself, as she always did, and marched resolutely back to the Home. So many thoughts she could have spilled out to Ruby but they all stayed in her head, and at the end of each day, especially market days, she went to bed confused, her head aching and heavy with so much suppressed emotion. She fell asleep eventually, convinced she would never escape back into the lane, back into a real house and household, but that there was nothing she could do about it. Fatalism was what her grandmother had dinned into her most successfully of all.

She had been in the Home a few more months after the tin box had been given to Mrs Cox when Madge came into the dormitory one morning and, after yelling at everyone to jump to it and get up, she shouted, for everyone to hear, that Evie was to go to Matron's room straight after breakfast. Madge stood over her while she washed and dressed, and personally brushed her hair, complaining that it was no wonder Evie always looked as if she were pulled through a hedge backwards with hair like hers. It would be a blessing, swore Madge, if Evie got nits and had to have all her dreadful hair shaved off, that would cure it. Satisfied that no more could be done to make Evie fit for inspection, Madge let her go down with the others, but Evie noticed Madge watching her and then the other attendants staring and whispering. This attention was sufficient to alert all the girls to there being suddenly something special about scraggy little Evie, Miss Never-says-a-word. She felt a tension around her which, instead of alarming her as it normally would have done, somehow pleased her. She felt important and it was a rare experience. She ate her porridge slowly and drank her tea (more water than tea and not much of it) and then went to Madge and said she did not know how to find Matron's room. One of the big girls was sent to guide her and Evie trotted dutifully at her heels far more cheerful than on the occasion when she had gone with the breathless Ruby.

There were two people with Mrs Cox, a man and a woman. Neither of them looked comfortable. The man in particular shifted about from foot to foot and was forever turning his cap in his hands. Evie dropped her eyes. It was rude to stare and indeed she had no desire to. She saw only that this man was quite old and bald and had a very red face. The woman was younger but, again, Evie allowed herself only a quick glimpse, enough to take in that she was small and plump, and then looked at the floor.

'This is Evie,' Mrs Cox said. 'She's a good girl, everyone here speaks well of her I'm pleased to tell you. You'll have no trouble. And she's a hard worker for one so young, we'll be sorry to lose her and I can't say that for many of the girls here.'

'She's little,' the man said, 'and thin, desperate thin, not much on her bones. Is she healthy?'

'Perfectly healthy,' Mrs Cox said, sounding quite indignant. 'You can't go by appearances with young girls, let me tell you that.'

'Did she bring anything with her when she came?' the woman asked. 'Any trappings?'

'No, nothing,' Mrs Cox said. 'We took her in what she stood up in and a bag with a change of clothes.' And the tin box, Evie silently added, but Mrs Cox didn't mention it. 'Well then,' the woman said, 'it can't be helped. Will we take her now, is she ready? There won't be a carry-on, will there, there won't be a lot of bawling?'

There was no bawling. Evie was told, there and then, in front of the two strangers, that she was a very lucky girl and thanks to the prodigious efforts of Mrs Cox and the Authorities she would be going to live with her newly located family.

'Do you know what the piece of paper in your ribbon box was, Evie?' Mrs Cox asked. Evie thought it best to shake her head. 'It was your certificate of birth. It showed who your mother was, and where you were born. This, Evie, you will be thankful to know, is your mother's cousin and his wife, and they have kindly agreed to make a home for you. What do you say?'

Evie looked up. Three faces confronted her, all expectant, none wearing a smile. What *should* she say? 'Thank you, ma'am,' she said.

'You'll have to pull your weight, mind,' the man who was her mother's cousin said. 'It won't be a holiday.'

'Go and get your bag,' Mrs Cox said, 'and wait at the front door.' Evie didn't move. 'Evie, did you hear?'

'Yes, ma'am.' Still she stood there, not knowing how to ask for her box but seeing Matron frown she just said, 'My box, please, ma'am,' as a statement rather than the request it should have been.

Fortunately, Mrs Cox was amused and said to the cousin and his wife, 'It's a tin box she had, with ribbons and the certificate in it' – 'No money?' the man interrupted – 'No money. Someone had obviously impressed the child with its importance and she brought it

to me for safe-keeping.' The box was produced and handed to Evie, who then did a quick bob of a curtsey and backed towards the door.

The man and woman were waiting for her at the front door when she came down from the empty dormitory with her bag. There had been no one to say goodbye to and indeed she had no desire for farewells. She wanted just to slip away before anyone noticed and before her departure turned out to be a mistake. 'Come on, then,' the man said, 'we've wasted enough time.' She followed him and the woman to a cart outside. 'Get in,' the woman ordered, but however hard she struggled Evie was too small to reach the single step. Hands seized her from behind, strong impatient hands, and dumped her without a word on the wooden plank seat. The woman got in on the other side, with the man in the middle holding the reins of the horse standing patiently in the shafts. 'Settle yourself,' the woman said, 'it's a long ride, hang on to that bar on the corners and going down hills, and if you fall out don't expect us to stop, you'll have to run behind all the way, won't she Ernest, eh?' And they both laughed so heartily Evie wondered how she'd missed the joke. Ernest. Her mother's cousin was called Ernest. She wished she knew the woman's name, but not another word was spoken during the whole long, long journey.

Evie had no idea where she was. The cart turned the other way from the city and was soon in the country. At first it was thrilling to be bouncing along between green fields that stretched far away to the hills on the horizon, but when not a house had been in sight for what seemed hours Evie began to feel uneasy and even afraid. The fields were pretty, there was nothing alarming about them, and the outline of the hills blue and smudgy, not at all grim, but there was no life anywhere. She felt she was being carried away to oblivion and with every mile her sense of herself, never strong, diminished. The woman, who was Cousin Ernest's wife, paid no attention to her but there was at least some little comfort in her squat presence. And Evie was pressed hard by Ernest's flank and though it was uncomfortable it was also reassuring - while someone so solid was next to her she could not disappear. Once, she was handed a piece of cake wrapped in greaseproof paper. She was so surprised she almost dropped it and even when she had unwrapped it from the grubby paper, she still did not eat it for several minutes. She wanted to look at it, at all the raisins and currants embedded in its yellow flesh. There had never been this kind of cake in the Home, only very

occasionally a hard, dry kind of gingerbread which left a gritty taste in the mouth. This cake was beautiful. Evie ate it in tiny bites, savouring every last morsel. She would have licked the paper if she had been on her own, but the woman took it from her as soon as she saw the slice of cake was finished.

It was dark before they arrived on the outskirts of a long village. Evie was exhausted and had several times dozed off only to jerk herself awake in case she missed the arrival at wherever the cart was going. Twice she had thought that moment had come but the stops had been to water the horse and for the man. Ernest, to put a coat on. When they stopped for good, Evie was still not certain that they would not trundle off once more, and it needed the woman to lift her down to convince her this journey was over. She was lifted down and set on her feet and her bag was put into her arms, and then the woman opened the door of what Evie could dimly make out was a house of some strange kind. 'Mind the step,' the woman said. 'I only whitened it yesterday, I don't want mucky footprints on it.' Obediently Evie lifted each foot carefully over the white part of the step. She knew about whitening steps and about rudding them too. Her grandmother had whitened her own step once and Evie had loved to help. She thought about offering there and then to whiten this woman's step the next day but as usual the words would not come as spontaneously as she would have liked, and by the time she had thought them out they were in a living-room and the woman was saying, 'Straight to bed, there'll be plenty to do in the morning. Take your shoes off here and follow me, I'm dog-tired myself.'

Evie followed her up one flight of carpeted stairs, the rough carpet feeling scratchy under her thinly stockinged feet, and another, uncarpeted, into the smallest room she had ever seen. It was a slot of a room with a skylight in its sloping roof and the bed filled it so completely that the door had to open outwards. 'You'll be all right here, it's a good bed, too good for a child. You're not frightened of the dark, I hope? No silliness?' Evie shook her head. 'Good. I'll knock you up in the morning and I want no shilly-shallying when I do. There's a chamber-pot under the bed, be careful you aim properly. I'll show you tomorrow where you empty it. Go on then, into bed with you.' Evie hesitated. The only way to get into bed was to climb on to it from the doorway. She clambered up and turned herself round and hesitated again. The woman was still watching her, the lamp she was carrying held high so that Evie was in the shadows of its glow. 'You don't sleep with your clothes on, I hope,' said the woman. 'They haven't brought you that low in that place?' Evie shook her head again and began to unbutton her pinafore at the side and then the neck of her thick woollen frock at the back. The woman put the lamp down on the floor outside the open door and, surprisingly, said, 'Here, come to the end of the bed, I'll help you.' Evie had never been helped to dress or undress in all her life in so far as she was able to remember and was embarrassed, but she did as she was told and the woman unbuttoned her down to her liberty bodice. 'Do you keep this on?' she asked. Evie nodded. In the Home, liberty bodices were only removed once a month for a wash-down of the whole body.

She found her shift in her bag and put it on and got into the bed. The sheets were cold but they were proper sheets and not the bits of bleached sacking used in the Home. The blankets were heavy and she felt trapped, they were tucked in so tightly. 'Goodnight, then,' the woman said, and then, 'I notice you haven't said your prayers, Miss, unless you're being lazy and saying them lying down.' Evie remained still. In the Home, they had all knelt in rows at the foot of their beds, repeating their prayers aloud. But where could she kneel here? On the bed? She began to struggle to get out from between the covers but the woman stopped her. 'Say them in bed,' she said.

Evie slept at once. She slept soundly and deeply but was nevertheless awake before the woman came to knock her up as promised. The light coming through the tiny diamond-shaped skylight directly over her head woke her. She stared up at the dark grev sky, slowly becoming paler, and felt excited. There was no Madge shouting, nobody crying or coughing, none of that cloying smell that hung in the morning air of a dormitory where twelve girls slept with the windows tightly shut. She felt alert and fresh and eager. She got dressed and then with great difficulty made her bed and folded her shift and put it under her pillow – a soft pillow, not stuffed with horsehair as in the Home - and then she sat crosslegged on top of the bed and waited. The moment she heard feet coming up the stairs she was at the end of the bed and had opened the door and presented herself before the woman had got anywhere near knocking upon it. 'Goodness me,' the woman said, startled, 'all dressed without so much as a cat's lick unless you've found your way to a sink which I doubt.' Evie hung her head and stood still. She knew that was always the best way should she be accused of anything. 'I'll show you,' the woman said, 'and we'll say no more about it.' The sink was on the landing, built into a little alcove. 'You're lucky,' the woman said, 'running water on every floor in this house. I bet you haven't had that before, have you, eh?' Evie shook her head. 'And we've a fixed bath but you won't be using that, it's for Ernest.' Evie followed the woman on down the rest of the stairs, relieved that in spite of the evidence of the day before this person was clearly a talker. Life was always better, easier, if a talker was in charge of you. It was those like Madge, glowering and silent except for her sudden spells of shouting, who were dangerous. Madge could be provoked by a returning silence on the part of any of the girls, whereas those Handlers who had been talkers had only needed to be listened to and they were satisfied.

Ernest was having his breakfast already in the kitchen, a great plate of bacon and egg and sausage. He didn't speak to Evie, just went on dipping pieces of fried bread into the yolk of the egg and ramming it into his mouth. She was not invited to sit down and did not presume to do so. 'Here's your porridge,' the woman said, 'and the milk is on the table.' Carefully, Evie took the bowl and carried it nervously to the table, to pour some milk on the top, then stood clutching it, not knowing where to go to eat it. The woman indicated with a nod that she was to go through the door behind Ernest. Evie edged past him, eyes on the bowl she was carrying, and found herself in a small scullery where there was a stool in the corner upon which she perched. It was quite a dark hole of a room but this did not trouble her. She liked being on her own to eat, privately, she enjoyed her food more that way. The porridge was as good as the cake had been, smooth and not glutinous as it had been in the Home, and the milk was rich and creamy. As she ate, slowly and neatly, concentrating on the task, she heard Ernest say, 'Not a scrap like her mother, not a scrap. I'd never have believed she was hers, never.'

'But then you never knew him when he was little,' the woman said. 'She might look like him when he was young.'

'Not like her mother, any road.'

'You said.'

'And I'll say it again, I'd never have believed it.'

There was a pause and then the woman began talking again. 'She's only little, mind, she's time to change.' 'She'll have to change a damned sight more than she's ever likely to if she's going to turn out looking like Leah.'

'You don't know what Leah looked like at this age either, don't let on you do because you don't.'

'I didn't say as I did but I knew her at ten and ten's not that much more than Evie is now, I knew her then, when they brought her from Carlisle. I can see her still, pretty as a picture, the hair on her. Now look at this one's hair and tell me she's Leah's.'

'Her hair hasn't been looked after.'

'Wouldn't make that much difference, it isn't hair like Leah's that I can see.'

'You don't see much. When it's washed regular and brushed regular and braided up it'll improve a treat.'

'You're going to do it, are you, all this messing about with her hair? That's what this is about, is it? That's why you wanted her?'

'It wasn't a case of wanting. I don't know how you dare say it was, it was a case of duty, and *your* duty too, you know it was.'

'Duty? It was a case of training up an extra pair of hands to be useful in the pub, that's what it was, that's what it is, lass. Never mind her hair, there's a pub to run and never enough hands. She'll have to earn her keep pretty soon.'

'She'll have to go to school first, she'll have to learn to read and write and add up.'

'She won't be at school all the time, there's plenty she can be trained to do before school and after school, and on a weekend and in the holidays, or anyways I did when I was her age and so did you, and if you'd had bairns that's what we would have had them doing, so I don't want any soft talk, right?'

There was silence, broken only by the clattering of dishes and the noisy slurping as the man drank his tea. Evie heard a chair pulled back and Ernest saying, 'I'm off.' She had finished her porridge. She decided to wash the bowl in the stone scullery sink but the moment she turned the tap on the woman shouted through at her, 'Don't waste water! There's water standing here, bring it through, you can wash it with the other dishes, now jump to it.'

Evie jumped.

Chapter Four

 \sim

When shona was eight, the McIndoes moved to St Andrews, a move which pleased them all. Shona was much happier. She still had a beach to run on, a wider and longer beach, but now she went to a school which satisfied her more. There were twenty-five girls in a class, all her own age and many of them as lively and energetic as herself as well as equally clever. She had real friends, Kirsty and Iona, for the first time and though she tried to dominate them, as she tried to dominate everyone, she did not always succeed. Kirsty and Iona were equally bossy and the three of them had to learn to give way occasionally to each other. It relieved Catriona to see this happening and she encouraged the friendship. They all lived near enough for the girls to walk to and from school together and visit each other's houses without needing either transport or supervision. Shona gained a new kind of independence and thrived on it.

Of the two houses she preferred Iona's, though Kirsty's was bigger and grander. Iona lived in the Old Town in a narrow close near the ruins of the cathedral. It was quite a small town house, its door opening directly on to the street, and it had no garden, but it had a pretty cobbled yard at the back with an open staircase going up to the door and a pantiled roof and dormer windows, and Shone thought it looked like an illustration from a book of fairy tales she had. She liked Jean, Iona's mother, who was young and attractive and smiled all the time whatever anyone did. She looked exactly like Iona, or rather Iona looked like her, the mirror image as people said, both of them with fine, sleek dark brown hair and large hazel eyes and delicate features. 'Iona's mammy is beautiful,' she said to her own mother, 'and she's young. I wish you were young.'

Catriona for once had the good sense to laugh. 'Well, I was once.' 'When?'

'Don't be silly, Shona – when I was young, of course, when I was Iona's mother's age.'

'When was that though?'

'Oh, about twenty years ago, I suppose, I don't know how old Jean Macpherson is, twenty-eight or nine maybe.'

'Why didn't you have me young?'

'I tried, but you just came when you were ready and that wasn't for a long time.'

Shona frowned. She recognised the tone in her mother's voice without being able to label it and she didn't like it, it made her feel cross, though she couldn't understand why. She felt she wanted to attack Catriona in some way, so she did. 'Why haven't I got brothers or sisters? It's not fair.'

'No, it isn't.'

'It's your fault too.'

'Fault doesn't come into it, Shona. I've explained before, I lost my other babies.'

'Why didn't you find them then?'

'You're being silly now, you know what I mean when I say "lost". I told you all about what happened and how sad it makes me talking about it.'

'Where did you have me?' Shona suddenly asked, in that abrupt, intense the way she had, the way that always disturbed her mother because it seemed as if a much older child was speaking.

'Where?'

'Yes. Was it upstairs?'

'Upstairs? Good heavens, no, it was in hospital.'

'But where?'

'Abroad.'

'Where abroad?'

'In Norway.'

'Where in Norway?' Shona was almost shouting now.

'Really Shona, the name of the town would mean nothing to you.' 'I want to *knom*.'

'Bergen. There you are, you see, it means nothing to you.' 'Why did you have me there?'

Once more Catriona told the well-known story of Shona's birth and once more Shona hardly listened. Her mother never seemed to tell her what she really wanted to know, but then she didn't really know what that was. She craved detail, the kind of detail Kirsty boasted about - 'My mammy was making a cake and she'd just cracked an egg on the side of the bowl and she felt me drop inside her, and my daddy said she looked funny and he told her to lie down, but she said she had to finish baking the cake and she did and he phoned the doctor and she put the cake in the oven before she went upstairs to have me, and just as I was born two hours later the oven timer pinged and the cake was ready and ...' There was nothing about cakes or ovens pinging in Catriona's account of Shona's birth. Shona didn't want the hospital described, it didn't mean anything to her. The only part of the story of her birth that she liked was the bit at the end, when her father came rushing in to see her and said, 'She's the loveliest thing I ever saw.' She told that bit to Kirsty and Iona only to find it didn't go down at all well. 'Babies aren't lovely when they're born,' Kirsty announced. 'They're ugly wee things, all of them, I've seen them, I saw my sisters just when they were born and they were horrible, screwed up and red and yuck all over their heads."

'Well,' said Shona, 'I was lovely, that's all.'

To her fury, Kirsty and Iona mimicked her and laughed and she didn't know how to stop them.

Often, when she was walking home from Kirsty's or Iona's house she wished she were going somewhere else, especially when her father was away. She'd walk along the shore road and look out to sea and think first of her father and then of where she had been born. It was like a speck in her mind's eye, fixed far away on the horizon, and she wanted to travel towards it and see it open up into something recognisable, the way lumps of blackness became land the nearer you approached them in a boat. 'One day,' she told her mother, 'I'm going to go and see where I was born.'

'Where you're born isn't important,' Catriona said, 'it's just a place. It's where you're brought up that matters and you know all about that, you remember the village, of course you do, and now you're in St Andrews and you won't ever forget this. You're a wee Scottish girl through and through.'

'I didn't mean that,' Shona said.

'What did you mean, then? Sometimes, Shona, I think you talk nonsense, you don't think before you speak - '

'I do so.'

' - and it can be very upsetting.'

'What's upsetting? I don't know what you mean, you talk nonsense, you don't – '

'Shona!'

Shona was stopped, for the moment. Her ninth birthday came and went and was tolerably satisfactory, but she preferred the treats her father gave her. He took her all the way to London once, on the sleeper, and showed her Buckingham Palace and the Changing of the Guard and they stayed in a proper hotel and went to Madame Tussaud's, and Shona at last felt in tune with herself, the self that had always wanted to dash about, to be among noise and bustle. She wished, aloud, and passionately, too passionately for a young girl, that she lived in London. Watching her, listening to her, sitting on the train all the long journey home, Archie was touched. It struck him that this was the difference between his own attitude to Shona and his wife's: Catriona was never merely touched by their daughter's restlessness and fierceness. Every flash of defiance, every symptom of some deep-seated rebellious spirit, and Catriona was full of despair and apprehension. She didn't see a clever lively young girl questioning and querying everything and everyone around her, but instead a potential disaster happening when Shona got 'out of hand' as she put it. She thought of the good years being over already, those years when Shona could be treated like a doll, when she could be made to a great extent in her mother's own image, when the force of her own personality had not yet become a real factor in the treatment of her. It wasn't, Archie knew, that Catriona wished to dominate or subdue Shona but that she wanted her daughter to be in step with her. She wanted harmony and intimacy in their relationship and the prospect instead of a growing discord frightened her.

It was supposed to be Archie's job, on these trips he took with Shona, between the ages of nine and twelve, to run the restlessness out of her so that when she came back to her mother she would be a different creature – docile, pleasant, agreeable. But it did not work out like that. Archie saw very well how, on the contrary, being away from her mother and her stable, staid life in St Andrews only made Shona want more of the same. She never wanted to go home, not even after the less successful excursions. It sometimes seemed the girl would rather be anywhere but at home with her mother, and yet Catriona was such a good mother, kind and gentle and absolutely devoted. Remembering his own mother, who had been remote and austere and never once, in so far as he could remember, capable of demonstrating affection, Archie was dismayed at how easily Shona spurned all that was so readily offered to her. But he didn't think anything could be done about this state of affairs. It was natural. Perhaps when Shona was older she would appreciate her mother more, perhaps when she had children herself ... but it was best not to think along those lines. He had always told Catriona to live more in the present, and not to torture herself with anguished speculation about the future, but she was unable to follow his advice.

By the time Shona was nearing thirteen and already an adolescent, developing far more rapidly than her friends of the same age, Catriona was overwhelmed by her, helpless in the face of her wilfulness. Motherhood still fascinated and absorbed her but she was increasingly frightened of what it involved. She couldn't talk to Shona about the things that needed to be talked about and felt constantly that she was failing in her own idea of her duty. Her mother was impatient with her. 'For the Lord's sake, Catriona,' said Ailsa McEndrick, exasperated, 'what are you fussing about? The girl's got eves and ears, she's smart, there's nothing you can tell her she doesn't already know, and I suppose you mean it's sex that is worrying you, is it?' It was. Even hearing her mother refer so openly to sex, as was her defiant habit, made Catriona despair. She had always been so embarrassed by Ailsa's unusually frank attitude to sex. She had never been able to share it and now that there was Shona to instruct this worried her even more than it always had done.

She had not enjoyed sex since she had known she would no longer be able to have children. While she had been fertile, even if her fertility ended in disaster, there had been a feverish excitement to sexual intercourse. All the time Archie was thrusting away she was visualising those little sperm poised ready to swim into her womb and at the moment of climax – Archie's, not hers – she saw the egg pierced and conception happening in a shower of stars. She always lay very still afterwards, holding within herself the life-creating moisture, and as it began to seep out of her she would feel sad. Only the thought of that egg perhaps already fertilised stopped her from weeping. But after Shona arrived, when she was told her tubes were now so damaged that conception would be impossible and that her fertility, on the edge of forty years of age, would be low, she lost the only interest she had had. There was no longer any thrill. But she was a good wife and she loved Archie and so she said nothing. She never turned away from him, never repulsed his advances. It was not distasteful to be made love to, but nor was it pleasurable. It simply no longer had any meaning for her.

Now that Shona was thirteen Catriona was almost fifty-three. She was post-menopausal and glad of it - all those night sweats, all those embarrassing hot flushes, all those symptoms she seemed to have so severely while other women had virtually none. She hadn't spoken to Shona about any of them nor explained her listlessness and general poor health. She didn't want to disgust or depress her with talk of the menopause. But she was obliged to tell Archie, who was equally obliged to notice her general debility and her sudden marked aversion to sex. He was understanding, as he always was. It occurred to Catriona that he might have another woman and though she recognised such a thought as unworthy, since she knew Archie, she found she did not care. It seemed fair enough to her. If she couldn't bear any sexual congress during her menopause and Archie found the lack of it month after month intolerable - well, then. All that worried her was that she, a non-sexual being, was in charge of a nubile thirteen-year-old at exactly the wrong time.

Catriona was not jealous of her daughter but she was afraid of what seemed to her to be Shona's blatant sexuality. She was too young, surely, to give out these signals, to look so sultry and to be perfectly aware of the effect she had on boys and men. She was no longer slight and delicate in build. She had grown tall and developed large breasts and pronounced buttocks – her figure was unfashionably Edwardian, with its tiny waist and exaggerated curves. But there was no fat on her: her stomach was flat, her legs slim. She wore her hair, a deeper auburn now, pulled back from her face, but when she released the hair from the combs which held it, it fell forward in a great mass of waves and curls half obliterating the fine-boned face and lending her an allure Catriona found disturbing. 'Why not have your hair shaped, Shona?' she would say. 'It's so unruly, such a bother for you to wash and brush, why not have it cropped, it would suit you.' But Shona wouldn't. She wouldn't have her hair touched. She took great care of it, indulging in all kinds of shampoos and conditioners and brushing it until it crackled, until it sang with life and all over her head tiny, thread-like tendrils sprang up like a halo.

Shona knew she was attractive and suffered from none of Kirsty's and Iona's teenage angst over their looks. Out of school uniform she looked like an actress, a little like a red-headed Sophia Loren. To her mother's distress she wore clothes completely unsuitable for her. clothes bought not in St Andrews or Edinburgh shopping with her watchful mother but in Carnaby Street on yet another trip to London with Archie. 'Why did you let her buy that ridiculous skirt?' Catriona raged at her husband. 'And those boots, white boots, for heaven's sake. Archie, what were you thinking of, look at her. look at her.' Archie looked and saw that his wife was right. Shona looked disturbing. The skirt hardly existed and she was the wrong shape for it, and the boots merely drew attention to the barely covered bottom. 'They're all wearing them down there,' he said. lamely, knowing he would be told, as he was, that Shona was not down there, she was here, shocking the whole of North Street and South Street whenever she paraded down them.

Kirsty's and Iona's mothers were suddenly not so fond of Shona. They began to say she was too old 'in her ways' for their daughters to spend so much time with. In Iona's family in particular this new antipathy was marked, but then Iona had a fifteen-year-old brother who could not take his eyes off Shona McIndoe's skirt. Shona, Heather Grant agreed with Jean Macpherson, was even less like her mother than ever and now hardly like her father either. But at least her parents were strict even if they failed to control how she dressed. If Shona stayed the night her mother rang to thank Jean or Heather but they both knew she was ringing to check up that her daughter was really with them.

There was, in fact, no need for her to check up, not then. Shona held hands with the occasional boy but she had not yet been kissed; and though the bolder boys had put an arm round her in the back row of the Old Byre theatre, it was doubtful whether Shona was as interested in boys as they were in her. If there was any sexual response on Shona's part it was well concealed. Her mother suspected, and was relieved to suspect, that Shona was not as mature as she looked – her startling body did not yet know what it was about. And then, having been comforted by this thought, she was thrown into sudden confusion. Had she been like this? Had she been like this, the woman she had tried so hard not to imagine all these years? Had she been unaware of her own power and suffered for it? And would Shona do the same, for the same reasons, whatever they had been, in the same way?

Panic filled Catriona. It was time to speak, of course it was, she had been a fool to think that time would never, *need* never, come. It had come, far sooner than she could have anticipated. Yet she stayed silent, eternally vigilant but silent. She simply could not bring herself to destroy what she had come to believe was truth.

Chapter Five

A T THIRTEEN Evie left school but, since she had only managed to be there less than half the time she was supposed to be, it did not make much difference. The transition from schoolgirl to working girl was hardly noticed. Evie had grown very quickly used to being kept from school, never counting on walking the two miles to the schoolhouse until the very moment she was grudgingly told to go. At first, she had minded her poor rate of attendance greatly, but after the first year it had mattered less. School was not the paradise she had once imagined. There were only two rooms, both enormous and divided by partitions, and the noise made her head ache. The partitions were thin and the poetry Class I was reciting in unison fought with the recitation of multiplication tables by Class 2 until those sitting in Class 3, as Evie was, found it hard to concentrate on memorising the geographical facts they were required to do.

But Evie, though disillusioned, made the most of her time at Moorhouse Board School. She learned to add and subtract, to multiply and divide. Being a girl she was not expected to master equations, as the boys were, but she struggled with simple fractions and succeeded in understanding them. Ernest was pleased with her. He tested her regularly, sitting with a stick beside him on the table and rapping her knuckles if she got his questions, as to five times nine and the like, wrong. Evie's knuckles were rarely rapped by him; which was fortunate because they had already been rapped by her teacher and were often red raw. Other girls cried when they were taken behind the blackboard by Miss Stoddard and caned with her stick, which was pointed at one end and thick at the other, but Evie did not. Other girls sometimes screamed that they would tell their mams and their mams would come to the school and play war with Miss, but Evie, of course, never did. She wondered what it would be like to have a mam to tell. She told Ernest's wife Muriel nothing. There was no point. Her heart pounded when Miss called her out because she had got something wrong but she taught herself to endure the punishment which followed without flinching. Miss Stoddard promptly caned her twice as severely in an attempt to make her weaken. But soon there was no cause for caning. Not even Miss Stoddard could fault Evie for anything except her attendance record and since, when the school officer visited the Fox and Hound, Ernest and Muriel gave adequate excuses she could not be blamed for that.

She made no friends during her intermittent years at school. 'Who are you?' she was asked when first she arrived, and 'Where do you live?' When she said she was Evie and lived at the Fox and Hound on the Carlisle road she was asked another question, one she couldn't answer. The question was 'Why?' Evie was obliged to say she didn't know. 'Does your dad work there?' her tormentors persisted, and when she said she had no dad they moved on to inquire about her mam, and then they pronounced her an orphan and sneered. 'She's got no dad, no mam, and she doesn't know who she is,' they sang. Evie listened to this chorus and was puzzled but not upset. What puzzled her was why having no dad or mam made her the object of ridicule, in the first instance, and then indifference. But at least she was left alone and rarely bullied. There was neither fun nor satisfaction in bullving Evie. She was not frightened, she didn't weep or turn red, nor did she attempt retaliation. She slipped in and out of school all those years like a shadow and was hardly remarked on.

Except for her singing. Evie's pretty voice was discovered by accident. She hadn't even known she possessed one since she had never had anything to sing about and had never been invited to. One day, all three classes on the first floor were brought together to sing carols just before the Christmas holidays. The partitions were opened up and all ninety-six pupils were lined up and ordered first to recite the words of 'In the Bleak Mid-winter' which they had been set to learn. Outside, the winter that year was very bleak indeed. Everyone had struggled to school through the snow and more could be seen swirling round the high windows of the vast, cold schoolroom. There was an oil stove at one end, near the teacher and the pianist, but it was making a poor job of heating the further reaches of the room. The coughing was unremitting and the breath coming out of ninety-six mouths into the freezing air caused little clouds to develop all along the rows.

Evie, because she was small, was in the front row and therefore lucky, since she did not feel as cold as those at the back. She was as near to enjoying herself as she had ever been. The teacher, a Miss Hart, was the nicest teacher in the school, young and kind and pretty in her pink frock. Everyone adored her and consequently behaved well for the duration of the time they spent under her gentle instruction. Evie, her eyes fixed on the lovely Miss Hart, felt dreamy and relaxed and not her usual alert, tense, terrier-like self, always on the lookout for trouble, always anticipating persecution or at least disapproval. She swayed slightly in time to the music and hummed the tune of the carol as Miss Gray played it through. 'Now,' said Miss Hart, 'I want each row to sing the first verse, row by row, and then we'll try to sing it together. Ready, the front row?' The front row had ten children in it, eight girls (including Evie) and two boys. 'One, two, three,' said Miss Hart and then dropped her hand as the signal that the front row should begin. Only Evie did. She had closed her eyes as soon as the signal was given and therefore did not see Miss Hart cancel it, with another wave of her hand, because the pianist had dropped her music. Out it came, Evie's sweet, soaring soprano voice and everyone listened spellbound until, realising she sang alone, she faltered and opened her eyes and stopped.

But Miss Hart was charmed. She made Evie sing the whole carol and clapped at the end. In a sense, this appreciation was too much and Evie would rather it had not been given. She didn't like to be the focus of attention. Attention of any kind was dangerous. Yet she could not stop herself feeling a rush of pleasure which continued for days afterwards. She had a voice, she could sing, she wasn't useless. Miss Hart kept her behind and complimented her and asked who she got her voice from. Evie was flummoxed. 'From, Miss?' she managed to ask. 'Yes, who in your family can sing like you? Voices are usually inherited, you know, they tend to run in families. Does your mother sing?' Suddenly, everything was spoiled. She had to begin again on the doleful saga of having no dad, no mam and living at the Fox and Hound with two people whose relationship to her she had never had properly explained. She thought, that day, of asking Muriel if her mother had had a voice but she could not bring herself to the point. She knew by then that a woman referred to as Leah had been, or was, her mother and that she had lived at one time in the same house as Ernest, her cousin, though whether it was in the Fox and Hound or not had never emerged. Neither had any clue as to what had happened to this Leah. Evie listened carefully to every mention of her and sometimes concluded she was dead and sometimes alive.

The strangest things provoked a reference to Leah. Ernest measured Evie each New Year's Day, up against the kitchen doorpost. 'She's still small,' he grumbled, 'she'll never be as tall as Leah, never. She'll be lost behind a bar, she'll never have the strength to draw a pint like Leah could.' And then there was her shyness, still acute after four years at the Fox and Hound. 'Goddamn it, lass,' Ernest shouted at her, 'don't jump like a frightened rabbit just because a stranger speaks to you. What good is that, eh?' And later Evie heard him complain to Muriel that she would never have a way with her, not like Leah who could charm the birds off the trees. Interestingly, Evie then heard Muriel say, 'Maybe just as well, birds weren't all Leah charmed and look what happened to her.' There was a silence. Ernest grunted. 'She'll be safer,' Muriel went on, 'being shy.' 'She'll be useless,' Ernest said, 'no good to us at all at this rate, there's no future to her.' 'She works hard enough,' Muriel said, 'you can't deny that, she's worth her keep.' 'Aye,' Ernest said, 'but I thought she'd be worth more in the long run.'

The work Evie did while she was still of school age was mostly housework, the same kind of cleaning and preparing of food that she had such a dim but happy memory of doing with her grandmother, only altogether harder. Muriel was a stickler for cleanliness and though Evie's own nature approved of her high standards and responded to them, sometimes it would strike her that what she was set to do was after all absurd. Muriel liked pans scoured till you could see your face in the bottoms of them. It was very, very hard to get the bottom of a pan clean enough to act as a mirror, and as she scrubbed and scrubbed, and peered and peered at her own vaguely emerging shadow of a face, Evie ruminated on the lack of sense in this exercise. It was the same with the silver forks, they too had to have faces visible in the handles, but at least that job was easier. Evie quite enjoyed cleaning the silver, spreading it out on the felt cloth kept for the purpose, and applying the paste and then polishing with a soft cloth. It was a restful task and, since she often felt very tired, a welcome one. And so was the sewing Muriel gave her to do, though at first she found it difficult to stitch a seam straight enough to satisfy her teacher. Muriel had the highest standards when it came to plain sewing. She would accept no slipped stitches and they had to run in lines as straight as a ruler.

Muriel sometimes paused from her own labours to talk to her at such times. There was no real affection between the two of them but as Evie had grown older, and proved so obedient, Muriel had become more companionable. She was not exactly kind to her but on the other hand she was not harsh or unfeeling and upon occasion showed a measure of real concern for Evie's welfare which always surprised her and left her somehow nervous. 'It isn't much of a life for a young girl,' she suddenly said one morning as she watched Evie scrubbing the stone floor of the kitchen, 'but then we've all had to do it, all our kind anyway, work, work, work, eh, Evie?' Evie looked up. She wanted the job over, she didn't want interruptions of this sort. 'You've missed a bit of mud there,' said Muriel, pointing with her toe. Relieved, Evie set to and eradicated it. 'Not much of a life,' Muriel repeated. 'You'd be better off behind the bar, where Ernest wants you if only you'd grow.' There was another pause. 'How old are you now, Evie?' 'Eleven,' Evie said, 'next month.' 'Oh yes,' Muriel murmured, 'March, I remember it was in the autumn she left, that would be right, she would just be showing with you.' Evie scrubbed, rhythmically, but she willed Muriel to go on. Something was being said, something of importance if only she could get hold of it. 'But you're small for eleven, that's likely why you haven't come on yet.' Evie paused, only vaguely aware of what was being said. 'That was when the trouble started,' Muriel said, and added with a sigh, 'It usually does, if it's going to. It did for your mother once she was a woman, right from then the men fancied her, though I didn't know her, mind. I saw her often enough later but I didn't know her properly then, it's only rumour, what went on.'

Evie knew it was the perfect opportunity to ask Muriel about Leah, to try to sort out all the enigmatic statements made about her and inquire once and for all if this Leah was indeed her mother and alive or dead, but it was too hard to begin. How should she begin? 'Who is Leah? Was she, is she, my mother?' She realised that she was afraid of the answers and even of there being no answers – it was preferable to have this hazy, shadowy, somehow soothing *idea* of a mother than be perhaps cruelly disappointed. There was such yearning within her for a mother, she so loved her fantasies of having one, that to risk losing them and having to substitute some harsh truth was not to be endured.

But this very failure to ask the questions about her own background, which most girls would have found irresistible, worked in the end in Evie's favour. If she had been openly curious, Muriel was the sort of woman who would have withheld information simply because she loved the power of knowing it when Evie did not. Ernest had told her to say nothing about Leah to the girl. He was quite adamant - 'Best if she knows nothing,' he had said, 'it might give her ideas, it'd lead likely to trouble and there's been enough of that.' But by the time Evie was thirteen, and on the edge of womanhood whatever she still looked like. Muriel knew that she would never be any trouble. She was thoroughly docile, without a flash of temper in her. It was safe to tell Evie anything at all, knowing both that she would never repeat it, because she had no one to repeat it to, and that she would not be unduly shocked or distressed. So Muriel, from then onwards, began to let things slip, little facts about Leah dropped into her monologues ready for Evie to pick up should she so wish. Muriel was not sure whether the girl did wish or not. Her expression betrayed nothing. And yet she thought she detected an extra stillness about Evie at these moments of revelation that alerted her to the girl's deep interest. It became a kind of game, trying to get some reaction from her, and the more Muriel played it the more careless she grew.

Evie, when she arrived at the Fox and Hound, had not appeared to know her surname or indeed that she was bound to have one. It was only when her name was called at registration in school that she realised her other name was Messenger and that she shared it with Ernest and Muriel. This had surprised and pleased her at the time, it had been like receiving a present and made her feel a certain kinship which had been more meaningful than hearing Ernest referred to as a second cousin. When she was older, the shared surname misled people. They assumed she was Ernest and Muriel's daughter and she saw how this irritated Ernest but pleased Muriel. 'She's not ours,' she heard Ernest say, when inquiries were made occasionally, 'she's my cousin's bairn, I've taken her in.' Sometimes, because Messengers had been at the Fox and Hound a long time, the inquirer would ask which cousin and then Ernest would say first of all, 'Leah Messenger, from the Caldewgate lot, kept the Royal Oak, her mam died, came here when they'd had enough of her, but little pitchers have big ears and that's as far as I'll go.' But if the question was asked of Muriel the reply was more detailed and nothing was said about little pitchers. 'No, she's not ours, and she's not my side,' Muriel would say, 'she's Ernest's cousin's bairn, Leah Messenger's, from the Carlisle side. We've taken her in, not that we ever knew she existed till she was six and then we got a letter, they'd traced Leah back to here. She was in a Home, this one, she'd been with another Messenger, old Mary, she lived here once, before my time, and Mary died and this one was put in a Home.'

Suddenly, Evie had a history and, though it remained sparse, she clung on to it. Her grandmother might not really have been her grandmother but at least she had had the same name and there was some connection between her and Leah, the Leah who was her own mother. That thought was precious, that link between Mary, Leah and herself. Bit by bit, Muriel strengthened it. When, at fourteen, Evie finally began her monthlies Muriel told her that now she had come on she must be careful or she'd fall and if she fell she'd share her mother Leah's fate. 'Look what happened to her,' Muriel said, sorting out rags to give Evie and telling her first to wash them well and keep them private. 'Fell, at seventeen, and that was that, that was you, that was her out on her ear and nowhere to go, so you be careful, though you won't have her problem looking as you do.' Another time, when Evie was late back with the milk, it was, 'Where've you been, not dallying with any lad, I hope?' Evie, who knew no lads, shook her head and explained about the late arrival of the milk cart with the churns at the crossroads. 'You be careful,' Muriel said, 'walking that road, that's how your mother got caught, walking that road and him coming up on his horse day after day. Did anyone speak to you? No? Good. Keep yourself to yourself, that's best.'

Evie did now finally help in the bar but only at quiet times when the daytime regulars were in, those with the patience not to mind her hesitations and difficulties with the pumps. Some were kind to her and tried to engage her in banter, but this flustered her – she found it hard to draw beer and take money and talk at the same time. Ernest always had her out from behind the bar long before it filled up and would order her back to the kitchen. 'You're flushed,' Muriel would say, 'your face is right red, Evie, you're more like Leah now, she had a good colour. Of course, she stayed all night in that bar, she drew them like flies, she could have had anyone she wanted, her looks could have been her fortune if she'd played her cards right.' Evie began washing the supper dishes, slipping them very, very quietly through the sinkful of water so as not to disturb Muriel's train of thought. 'But he came along, on his horse, and took a fancy to her and after that nobody could tell her anything, she was daft for him, daft. I told her, I said, "Leah" - I'd just married Ernest then and we were at the Crown, but I saw her often enough - I said, "Leah, lass, give over, he'll make a fool of you, he'll have you and leave you and won't give a damn," and surely she could see it, she'd heard the tales, they were well enough known, but no, she wouldn't have it, she wouldn't listen, not her. If she'd had a mam it might have been different, but her mam was dead and her dad too, and she was brought up in Caldewgate, then sent here. Her mam was Ernest's dad's sister's child and they brought her up as their own like we're bringing up you.' Muriel sipped the brandy and lemon to which she was partial, and looked at Evie's back, bent over the sink. 'She was lovely to look at, your mam, Evie.' And then, what Evie had waited so long for, 'Maybe still is, for all anybody knows, she'll only be in her thirties, wherever she is.'

So. Evie went over and over every one of Muriel's slurred words many times. Her mother might be alive. She was certainly not known definitely to be dead. She had felt quite faint hearing what Muriel said that night, and was glad to be facing away from her or for once in spite of herself her expression might have betrayed her excitement. At first, thinking about what she now knew, it seemed wonderful news but then, after all the hours of mulling it over, it seemed dreadful also. Her mother was not dead. She had therefore given her away. She had not wanted her. She, Evie, had been the cause of betrayal, misery and ruin, if Muriel was to be believed. Her mother had banished her for ever, given her to old Mary Messenger and abandoned her. When Mary died she had not come forward to claim her. She had let her be taken into a Home. But then Evie remembered she had been baptised and had a birth certificate. Did that mean some measure of concern for her and her soul? The thought of that certificate, the piece of paper in the ribbon box which had led to Ernest and Muriel taking her, worried her. She didn't have it any more. She still had the tin box and the ribbons. she still treasured those, but the paper had gone when it had been given back to her by Mrs Cox. Ernest must have it. She wished she had it, now that she understood the full significance of it. Perhaps, if she had it, she could find her mother. But another thought occurred to her: if her mother could have been found why did the people who found Ernest and Muriel not find her first? It could only be because she had disappeared. Unless – and this chilled Evie – her mother had denied Evie belonged to her.

Evie could not remember afterwards when she had decided that her sole purpose in life was to find her mother. She thought probably there was no one time when she had made the decision and doubted if the making of it had been precipitated by any particular thing. It had just grown with her, this strong sense of knowing what she must do, and it had made her curiously happy. She would not remain at the Fox and Hound for ever, working so hard for Ernest and Muriel, her days utterly monotonous and without hope of change. She nurtured her conviction that there would indeed be change and that she would bring it about herself. She would use her brain. She might not be beautiful like her mother but she knew she had a brain and that it must be capable of helping her. Answers came from this admirable secret organ in her head to the questions she put to it and she marvelled at the ease of the process once she got started.

Where and how could she start to look for her mother? Carlisle, of course, where she had lived with Mary once upon a time. And how could she get to Carlisle? By coach. Who would pay? She would have to save the money herself. Very difficult. She had no money except the rare threepence strangers in the bar gave her and the even rarer sixpence Muriel graciously bestowed upon her on market days in a fit of sublime generosity. These miserable pennies would have to be saved and, once accumulated, used for her fare. But in Carlisle where and how would she live during her search? She would have to find work the moment she arrived there, she would have to show a boldness she had never felt she possessed. And if there was no work? If her smallness and slightness and plain features put employers off? What then, brain?

That was too far to go. She stopped her questions at that point and settled for the limited plan of action she had thought up. Meanwhile, as she saved, as she put the small coins into her tin box of ribbons and sighed at how slowly they filled it, she drew from Muriel every last detail she could about Leah merely by forcing herself to say a word of encouragement here and there. 'You'll need a new dress,' Muriel said when, at seventeen, Evie's growth reached its modest limit, resulting in a sudden bursting of the buttons on her bodice. 'We'll make it a different colour, you look bad in navy, we'll try a brown maybe, your mother looked lovely in brown with that hair of hers.' 'Hair?' echoed Evie, timidly. 'Her hair, all gold it was, and masses of it, waves and curls, the lot. You haven't got it, you must've got yours from him, gold hair and hazel eyes, that was Leah, not that it did her any good, she was just the sort he fancied.' 'He?' repeated Evie, only a murmur but enough. 'Mr High-falutin', Mr Smart-as-paint, Mr Here-today-and-gone-tomorrow. Hugo was his name, la-di-da as himself, Hugo Todhunter, but they're ashamed of him now, his family disowned him and not before time, and off he went, to Canada, they said.' Evie stored the name away. It was easy to remember, it thrilled her to say it to herself. But she had no desire to find him, her father, it seemed, no desire at all, he was nothing to her. All she hoped was that through knowing his name she might be aided in her search for her mother when it began.

There were Todhunters in the village but she didn't think they were anything to do with this man on the horse whom Muriel described. There was nothing la-di-da about them, they were blacksmiths. But on the Carlisle road there was a big house, set back from it with a curving driveway, and Muriel passing it once had made some remark to Ernest about the old Todhunters letting it go to waste. 'Look at it,' Muriel had said, 'needs painting, needs the roof mending,' and Ernest had squinted at it in the midday sun as their cart rattled along and pronounced the neglect of this once fine house both a shame and a disgrace. 'Heart went out of them after he left,' Muriel remarked. 'And that other son died. There was only the daughter, and she married and left, remember?' Ernest did, but he wasn't interested. It was Ernest, though, who provided Evie with another clue, one of more importance than much of Muriel's chat. He heard Evie singing to herself one day as she worked in the washhouse, singing a hymn. 'Well,' he said, surprised, 'you've got your mother's voice if nothing else. Proper lark, she was, and she was in the church choir, loved to go to church, did Leah, never mind the rain, never mind the snow, off she'd go to St Kentigern's, came back like a drowned rat many a time, but she didn't care, she loved to sing in church, no stopping her.'

Evie stopped singing at once, struck dumb with the surprise and thrill of it - she had her mother's voice, she had something of hers,

something to bring them together, then, to identify her after all as Leah Messenger's daughter. She knew St Kentigern's, though it wasn't the church Muriel had taken her to. Muriel was a Methodist and the Methodist chapel lay in quite the opposite direction to St Kentigern's, which was a dim little church with a broken spire now and cypress trees crowded so closely round it that it was almost obscured. Evie had never been inside it, she had only seen it from the road, but now she resolved to visit it and see where her mother had sung. She walked there, a distance of a mile or so, and all the time she was walking she was thinking about her mother doing the same, feeling as free perhaps as she suddenly felt herself, hurrying out of the village and striking out between the hills until the road curved downwards and a great vista of moorland opened up. It was a fine day, the sky was a watery pale blue with big puffy clouds sent chasing across it by the strong easterly wind. Evie had her head up and her hair blew out in front of her and her skirt billowed around her as the wind pushed her on. Going back would be hard, struggling against it, but for now it was helping her.

It was a Thursday, late afternoon in March, and there was no one near the now ruined St Kentigern's. How black it looked, with its dark trees scowling in front of it and its stone walls encrusted with moss so old the green of it was forgotten. There was an old wroughtiron gate at the entrance to the path leading up to the church itself, wide open, banging in the wind. Evie closed it carefully behind her, rust coming off on to her hand. She was afraid the church door would be locked but, though the handle was stiff to turn, she opened it without much trouble. The smell inside was the smell of all neglected old stone buildings – damp, mould and a whiff of lingering smoke. It was a very small church. Evie counted the rows, only six each side of the narrowest of aisles, room for sixty devout folk at the most. And where could a choir have sung? She was puzzled. There were no choir stalls, only a row of six chairs to the left of the altar with a wooden rail in front.

Her mother would have sat on one of those chairs and stood when it was time to sing. Voices would sound loud in this small space, it would not take much vocal power to fill it with sound. Evie did not dare put it to the test. Softly, she crept down the aisle, tripping once on a piece of the matting which had frayed, and hesitated in front of the one step leading up to the altar. She badly wanted to sit, or at least stand, where her mother had stood, but she lacked the courage to intrude any further. This was enough. Here her mother had come, every Sunday, rain or shine, and she had sung. It occurred to the motionless Evie that she, too, had of course already been here, in her mother's body, and this thought startled her. She was not a stranger here after all. This was where she had begun. Had her mother remembered that every time she stood in a church, after she had parted with her? Did singing hymns bring back the memory of this particular church and of her baby? Lightly, Evie ran her hand along the shelf of the front pew. It was covered in dust. She wrote 'Evie', then she wrote 'Leah', then she drew a heart round the two names, then she pulled her sleeve across and obliterated the names.

Her mother Leah had gone to church, rain or shine, every Sunday. Would that be something she would stop doing? Evie, buffeted by the wind all the way back, did not think so. She would surely find a church wherever she was and sing in it. Visions of Holy Trinity in Caldewgate rose in her head, the church where she had been baptised, a grand, noble church not at all like St Kentigern's. She would go to Holy Trinity when she arrived in Carlisle, when that day came, she would go on a Sunday, to a service, and study the choir. And she would go to St Cuthbert's at the end of the lane where she had been left by her mother, with the woman she'd thought of as her grandmother, and inspect their choir too, and she would not stop there, she would if need be attend services in every church in Carlisle that had a choir. It gave her something solid to cling on to and now that sense of purpose which had been growing within her became so strong she felt she would burst with the desire to start on her quest to find her mother. She had sleepless nights, exhausted though she was, and dark circles developed under her eves until Muriel was moved to ask, crossly, if she was ill. Evie said she wasn't. 'Then buck up, for heaven's sake,' said Muriel. 'The sight of your miserable face is enough to put men off their beer and then where will we be, eh?'

On 11 March 1905, when Evie became eighteen years of age, she had $\pounds 6$ 4s. 6d. in the old tin box which held the ribbons. It had taken more than three years to save, every penny of it screaming hard work and self-denial. She was as ready as she would ever be. Nobody marked her birthday, though Muriel had remarked on its imminence the week before – 'You'll only be a year older than your mother was when she fell for you, so you be careful.' But as she'd issued the entirely unnecessary warning, knowing quite well that no fine men on horses had even so much as stooped to pass the time of day with drab little Evie, Muriel had had the grace to finish with a lame-sounding but quite affectionate, 'But you're a good girl, nobody can say you're not, you've never given us a minute's bother, that's the truth.' There was no reward for this lack of being a bother, not the briefest expression of congratulation on her birthday and no recognition of it in the way of a present. Evie was glad that this was so. It made it easier to leave. Only two things troubled her. Should she or should she not write Muriel a note? She supposed it would be wise, since she did not want a search party sent after her. She made it short: 'Dear Muriel, I am gone off to find other work. I will send you my address when I am settled, Evie.' And where was that precious birth certificate which the matron of St Ann's had given to Ernest? She hated to leave without it but did not dare search further. It hurt to regard the paper as lost for ever but there was no alternative.

She had, after all, more to take with her than she had reckoned. In the twelve years she had been at the Fox and Hound she had been well if not fashionably clothed by Muriel, who did not want her she had always said - to disgrace the establishment by being in rags. She had had a new dress made every spring for the summer and every autumn for the winter, and always had good boots and shoes, though Ernest complained bitterly about the cost. Of the clothes made for her, four dresses still fitted and she took them all, as she did her new black boots and her Sunday shoes. Her coat had just been renewed and it was a good, heavy tweed and she had two bonnets, both perfectly serviceable. Gloves, stockings, petticoats and chemises, all well worn but not shabby, swelled the pile on her bed enough to panic her. She could not carry all this and yet, if she did not, she knew Muriel would not dispatch these clothes to her in due course. So they must be crammed into a bag somehow and carried to Carlisle. An old carpet bag which a lodger had left behind and which Muriel had told Evie to burn, because it had a hole in it and stank of tobacco, would suffice. Evie patched the hole and wrapped every article in old newspaper in an attempt (vain) to protect it from being impregnated with the smell of stale smoke. She managed to get everything in, though she could not get the clasp to meet so had to tie the two sides together with string.

The weight of her bundle shocked her. She was strong but, even so, the only way she could carry the bag was by wrapping both arms round it as though it were a baby. The problem of getting it out of the Fox and Hound and along to the crossroads where she planned to stop the coach to Carlisle – she'd seen it hailed there even though it was not an official stop – almost defeated her. It was a mile away and half of that journey was lined with cottages from which eyes would peer at her and notice and tell Muriel, or Ernest, perhaps in time to stop her. She had no idea if her mother's cousin and his wife had the right to stop her but in any case could not endure the possibility of any unpleasantness. She must get the bag to the crossroads at night and leave it there, risking its discovery and theft.

Once she'd thought of this plan its execution was not as difficult as she had feared. She did not work in the bar after eight at night, not even now, and it was easy for her to slip out while Ernest and Muriel were hard at it. She took a wheelbarrow from the shed, and taking care to keep in the shadows - which was simple since only one side of the village street had any lamps at all and these gave a feeble light - she trundled her precious bag the mile to the crossroads. The hardest part was seeing her way over the last half mile. Once the village was left behind, it was a pitch-black night, no stars, no moon, no way of distinguishing road from moorland. Again and again she found herself on muddy grass even though she had been sure she was going in a straight line along the road. Only the white signpost helped, when it loomed into view at last, and thankfully she moved more quickly. There was a ditch on the opposite side of the road from where the coach would stop. She'd marked it out the day before and lined a place, about ten yards from the crossroads, with a piece of sacking. She dropped her bag on to this and drew the sacking over it and for good measure dragged some wet leaves across the hiding-place. It was the best she could do.

Her last night in the Fox and Hound was like her first in that she slept deeply and woke very early. She knew off by heart Muriel and Ernest's routine and habits and exactly how to evade their attention. Evie was expected to rise at six, rake out the fire in the kitchen, get it going and boil a kettle ready for tea. This day she rose at five, dressed, made her bed neatly, and crept downstairs. She raked the fire and reset it, as a last service, but did not light it or take any food or drink for herself. She was at the crossroads before six, knowing there was only one early morning coach and that it passed without stopping at the Fox and Hound as it did at other times. She knew it might not stop for her at her crossroads either but had tried to shut such a potential catastrophe out of her mind. She planned to stand in the middle of the road, knowing that though this was dangerous, the coach driver had a long view as he came down the hill and could not possibly miss her. He must stop even if he would not take her and she was determined he would, though she had no idea what form her determination could conceivably take.

It was still not quite fully light as she rounded the last bend and saw the signpost. It hardly seemed possible, but there was someone already there, someone who would have to see her retrieve her bag, someone who would surely guess she was running away. But she had to go on; there was no alternative. It was a man, shivering in the early spring morning air in spite of his thick coat and muffler and cap. He was stamping his feet and blowing on his hands as Evie approached and he looked as startled as she was. Bending her head, Evie walked past and found her bag and began tugging it out of the ditch. The man could not help but see. 'What have you there?' he shouted, and then to her consternation she heard his feet on the road, hurrying to her side. 'Want a hand?' he said, and though Evie shook her head he bent down and swung the bag on to his shoulder. 'Well, well, you'll not want any questions asked, I'll bet, eh?' and he tapped his nose. 'Catching the Carlisle coach, is it?' Evie nodded. 'Then that makes two of us. He'll have to stop now.' They returned to the signpost and stood together, the man in high good humour, chuckling to himself. 'No questions asked,' he kept saving, staring at Evie, who volunteered not a word. 'And you'll ask me none either,' the man said. 'Fair's fair, eh?' Evie nodded. 'Just one thing ...' the man began, but Evie never heard what that one thing was, because the coach came, thundering down the long hill so fast she could not see how it could stop in time.

But it did. The man heaved her bag up and then helped her – she had money only for the outside – and went inside himself. She was all on her own, sitting in state on top of the Newcastle to Carlisle coach, with a fine view all the way.

Chapter Six

 \sim

THEY WERE going to have a holiday, the three of them, perhaps the last family holiday they would ever have. It was Catriona who thought like that, not Shona. 'Soon you will be gone,' Catriona had been saying for what seemed like years now. 'Soon you will be gone, off on your own.' It sounded such a birdlike plaintive cry, so sorrowful and yet needful, begging for some kind of contradiction. But Shona never did contradict. Yes, soon she would indeed be gone and glad to be gone. She had her own life out there and she meant to have it, and her mother could not tug her back. She was going to go to London, to university, and she was going to read law and then there would be no stopping her. She would have a worthwhile, fulfilling career and be everything her mother had never been.

Knowing she was on the very edge of doing this gave her the deepest satisfaction. All she needed to do was pass her exams, gain the grades requested, and that would be that. London was the only place for her, she had no doubts about this. She felt ready to meet the challenges of crowds and noise and even the violence said to lurk round every corner. Her impatience was great but she was ready to become more tolerant of her mother's distress the nearer she came to her goal. It was sad, after all, she could see that, sad to have your only daughter, your only child, leaving you and being not in the least regretful. She wanted to be kind and so she was gracious about the proposed family holiday to celebrate her eighteenth birthday. Certainly she would go with her mother and her father on holiday in the Easter break. It was only a question of where.

'Somewhere hot?' Catriona suggested. 'The south of France? Spain?' Shona raised her eyebrows. They had never gone abroad. Archie said he got quite enough of abroad and preferred Rothesay and the Isle of Arran. But Shona didn't want to go to the south of France or Spain. She liked snow not heat, skiing and not lolling on beaches. She'd been skiing with the school in the Austrian Alps – that's what she wanted to do for her eighteenth birthday, but she couldn't suggest it. It would not constitute a family holiday because her mother could not ski and hated the cold, and her father, though he had skied in Norway when he was a young man before the war, had arthritis in his knee and couldn't do it any more. Shona thought carefully. March was not an easy month for a family holiday. Perhaps a city would be best. Paris? But she thought longingly of one day being there by herself and not encumbered with parents. Meanwhile her mother's face was contorted with anxiety. Shona wanted so much to please. 'Wherever you like,' she said, trying to sound cheerful, 'you choose.' 'But it's your birthday,' Catriona said, 'you must choose.'

In the event circumstances dictated the choice, or so Shona thought. Her father came home from six weeks away in the middle of February. He was tired and talking of one last voyage then retirement. In fact, he had committed himself to that voyage and it was to start from Bergen a week after Shona's birthday. 'Oh, Archie!' said Catriona, 'Archie! You knew it was her birthday, you promised we'd have a family holiday, how could you, how can we go anywhere now?' Her father looked stricken. 'Mum!' Shona said in reproach. Often, lately, she had felt she had to protect her father and never more than now when her mother seemed angry out of all proportion. 'I know,' she said brightly, 'let's all go to Bergen, to Norway, and Dad can sail at the end of it and you and I can come home, Mum.'

'No!' Catriona said. Shona stared at her. The violence behind that small word was alarming and her mother's expression disturbing.

'Why ever not?' she said. 'I've always wanted to go to Norway, remember, remember how when I was little I used to want to go and see where I was born? We could go to Oslo and then ...'

'No!' Catriona shouted again.

'Mum!' But Catriona had got up from the table where they were all sitting and begun to clear away their plates, crashing them together in a most uncharacteristically clumsy way. Her hands, Shona saw, were shaking. 'What's wrong with Norway, for heaven's sake?' she asked. 'I mean, I don't care where we go and if it fits in with Dad's plans ...' Catriona had left the room. She turned to her father and said, 'What's wrong with her? What's going on?'

Archie lit his pipe and said nothing. Shona waited, a strange feeling of anticipation banishing the lethargy she usually felt during family meals. She felt curious in a way she so rarely did about anything to do with her mother. There were never any mysteries about Catriona. She was such an obvious person. Once, given 'My Mother' as a title for a school composition, Shona had found her normal fluency deserting her. What of interest could she write? How could she make her mother sound interesting? There were the facts and nothing else, the ordinary story of her birth in Cambuslang in 1016, the youngest of four children, and her perfectly straightforward schooling at Hamilton Academy, before going into the post office as a counter clerk and rising to the heady heights of postmistress of a city post office - it was all boring until she got married to her merchant sea captain. And even then nothing worth recording had happened, just years of being a good little housewife in various parts of Scotland and the occasional temporary few months abroad in places like Bergen where she just went on being a housewife. Nothing, in young Shona's opinion, to write about. Her mother had no hobbies or interests either, unless knitting and sewing counted. It had been embarrassing scratching around for material, whereas if the title had been 'My Father' there would have been an abundance. Her mother was an open and extremely blank book.

But now there was something on the page. Her father might have lit his pipe and appear relaxed but Shona could tell he was not. He was tense, his shoulders hunched, his free hand tapping the table. They both went on waiting for Catriona to reappear and neither spoke. When there had been no sign of her for a full five minutes Shona gathered together the rest of the dishes and went through to the kitchen. Her mother was standing looking out of the window, the kettle beside her steaming away but ignored. Shona heard it click itself off. Her parents always had tea after their evening meal. The teapot stood ready on a tray together with cups and saucers. 'Shall I make the tea?' Shona said, but her mother grabbed the kettle and filled the pot and marched back into the dining-room. Shona followed, feeling more and more like a little dog trotting at its owner's brisk heels, unsure whether it is out of favour or not.

'I thought you had homework?' her mother said.

'I do.'

'Then go and get it done.'

'But I want to know if we're going to Norway or ...'

'No!' her mother said again, just as her father said, 'Yes.' His voice was the quieter but the more commanding. 'I think it's a good idea,' he said. 'We should have gone long ago.'

There was a sudden absolute silence broken only by Archie's puffing of his pipe. Astonished, Shona looked from one to the other barely able to credit that two people could assert themselves in ways they had never done before. They were mild people, her parents. They did not shout or rage, ever. They were hardly even irritable or raised their voices for anything, and exuberance of expression was unknown to them. Living with them was like being steeped in a still pond with nothing to ruffle the surface. And now those waters were broken by an antagonism quite shockingly blatant.

'Look,' Shona said, 'what's going on with you two? This is weird, what's all the fuss about?'

'Go and do your homework,' Catriona said, each word enunciated carefully and distinctly, but her voice at least level once more.

'No,' said Shona. 'You're treating me as if I was eleven, like a child. I won't, I can't, not till you tell me what all this is about. I'm not a child, you can't just shove me off. It's my holiday too, my birthday, I'm entitled to know why you're in such a state just because I suggested Norway to fit in with where Dad has to be.'

'You'll know in good time,' Archie said, 'but not now. We'll go to Norway. We'll go to Oslo, you'll like that, and then maybe explore the Hardanger, stay at Ulvik or Voss, and end up at Bergen. That's what we will do. Now trot off, Shona, there's nothing more to say tonight.'

Shona looked from him, calm but solid and full of an authority she had never been aware of before, to her mother, bent over the teatray, hands gripping the table so that the knuckles showed white, face hidden by her hair which had escaped from its small combs and hung dishevelled all around. She had never felt compassion for her mother, only a dry, superior kind of pity for her feebleness, but now she did. Catriona seemed to have been beaten, though in what sort of game, or little private war, she could not fathom. Her good, kind, gentle father had somehow beaten her and she knew it. Uneasily, Shona made for the door, aware, curiously, that she was hoping her mother would revive and retaliate. She did not want to leave her beaten. But there was no retaliation. As she went upstairs to her room Shona heard only the clatter of teaspoons in cups of tea and a cough from her father and then silence.

The silence seemed to go on day after day for the next few weeks, right up to their departure for Norway. Not a literal silence, since all the usual pleasantries were exchanged, all the small talk of basic family communication, but Catriona did not indulge in any chatter and its absence was marked. Shona marvelled that she missed it so, when it had always annoyed her, the accounts of what had been in this shop and that, what someone in a queue had said to someone else, how this price or the other had gone up and that it was scandalous. But now it was not on offer, she missed the security of the monotonous, harmless recital. Meals were awkward in a way she would never have anticipated. There was an onus on her she shied away from. If there was to be any real talk it would have to come from her, in a monologue, and she did not feel equal to it.

It was a relief to be packing to go on the wretched holiday, even if she dreaded the week ahead. At least there was the comfort of knowing it would soon be over and that whatever was wrong between her parents would come to an end, or she supposed and hoped it would. But where was the pleasure in this family trip? Her mother prepared for it as though for a prison sentence, folding clothes and putting them into a suitcase as though she might never take them out again and sighing all the time. 'For God's sake, Mum,' Shona said, 'this is ridiculous, you're so miserable, it's not true.'

'You care, do you?' said Catriona.

'What? What the hell does that mean? Of course I care, it's awful, it's making me miserable too.'

'Oh well, we can't have that.'

'Mum! There you go again, what do you mean, sounding all sarcastic and bitter suddenly?'

'I can be sarcastic and bitter if I want. It isn't your prerogative.'

'Heh, look, I've had enough, you're getting at me and I haven't done a thing wrong.'

'No.'

'Well then. Why the treatment, why are you making me suffer?'

'I don't think you're suffering, Shona. I don't think you know what suffering is.'

'Jesus!'

'Don't blaspheme, it doesn't help.'

'It does actually, it helps a lot, it bloody well does ...'

'I won't listen. I hate swearing.'

'And I hate atmospheres. It's worse than swearing to go around with a long face all mournful and not telling anyone why. Why don't you just swear and get rid of it, whatever's bugging you?'

'It isn't how I am. I don't get rid of things. You, you're the one who never holds back. It's the modern way, tell everyone everything and never mind if it would be better not told.'

'Oh my God!'

Exasperated, Shona left her mother and went to pack her own things. At least there were no more rows about clothes or how she looked. Trousers, sweaters, an anorak and all in dark sensible colours, that was her style these days, and the hair, which had caused so much comment, was firmly twisted and plaited and out of the way. She was a serious student and looked it, a cause for parental self-congratulation. Her parents came to open evenings to hear her praises sung by every teacher and were gratified beyond belief. Shona knew she was said to have 'grown out of' her earlier defiance and wilfulness. She enraged her friends now by working so hard and never having fun any more. They did not know what had happened to her. But Shona knew. Ambition had happened and nothing was going to get in its way.

Her mother also knew this, of course. Shona saw she had sensed the reason for her diligence and obedience, for her single-minded application to school work and her entire lack of social life. She'd sensed it and was afraid. Sometimes, on Saturday nights in particular, her mother had taken to saving to her, 'Are you not going out, Shona? All work and no play makes Jill a dull dog, you know.' 'Then I'll be dull,' Shona replied, holding back from adding, 'just like you.' It was ironic. Now her mother had her at home she didn't like it any more than when, at thirteen and fourteen, she had contrived to be out all the time. What Catriona liked was convention, she liked her daughter to do what others did, to be normal and average. It was what she had always wanted - nothing odd, nothing out-of-step in her daughter's behaviour. Pushing her clothes into a bag, Shona wished she could push her mother in with them and then drop the lot in the sea. She couldn't bear all this mournfulness and angst and the thought of having to endure it unrelieved for a whole week was too much - some birthday treat, some happy last-family-holiday this was going to be, probably so awful she would never forget it.

They flew to Oslo and spent three days there visiting the Kon-Tiki museum and the Vigeland Park and the Akershus Fortress and all the other sights Archie thought Shona should see. She tried to be enthusiastic but boredom seeped out of every pore. She felt like a small child, following her parents round dutifully while they waited for her reactions. Bedtime was a relief. She went to bed earlier and earlier, pleading exhaustion. It was better on the fourth day when they set off for the Hardanger Fjord, a journey of four hours from Oslo. The snow had begun to melt early and all along the route torrents of water cascaded down the mountains in spectacular waterfalls. But higher up the dark of the fir trees were still heavily snow-covered. It was easy then to exclaim over the beauty of the wild and jagged scenery and even Catriona came out of her sullen silence enough to express awe at the sight of the first fjord.

So they arrived in Ulvik, on Hardanger, in good spirits and booked into the pensionat close to the fiord. The sun shone on the pretty painted houses and on the deep blue waters of the fjord, and Shona was happy merely to be out in the open air and not trapped in buildings looking at things. But the next morning when they drove on to Bergen, her parents had sunk once more into some kind of depression which was mysterious to her. She still could not fathom the atmosphere between them nor work out whether they had quarrelled again. Both had stony faces, Catriona's white and lined, Archie's dark behind his beard as though he were suppressing rage. No one, this time, commented on the beauties of the countryside through which they passed, though it was even more impressive than the day before. The sun was everywhere catching on the white birch twigs mixed with the darker shades of the still-winter landscape and gave a brilliance to the mountains below the snowline. It was impossible not to feel exhilarated by the brightness and clarity of everything, but when Shona said so neither parent said a word. All the way to Bergen, the whole hour, neither of them spoke and she began to feel more and more detached from them.

Bergen delighted her. She had not expected such colour but when they approached the city it was lit by an extraordinary midday sun and seemed all tawny and golden, the many red gabled roofs and ochre-painted houses melding into each other from the angle at which they approached. Shona felt immediately proud that it was here she had been born and even when they were in the middle of the modern part of the city, and she saw it was more ordinary than it had first appeared, she felt drawn to it and excited by it. The seven mountains surrounding it seemed to her so protective and she liked the feeling of being in an amphitheatre. They stayed not in a fourstar hotel, as they had done in Oslo, but in a small guesthouse near the fish market, in a hilly street with houses almost touching each other at roof level. Her mother, she noticed, did not seem happy about this, but her father merely said, 'This is where we stayed,' as though that settled the matter. 'It is noisy,' her mother said, 'it was always too noisy,' but he said nothing.

The next morning Archie knocked on her door at seven o'clock when she was still deeply asleep. 'Shona?' he called. 'Get up, please, we need to be off early, before there's too much traffic.' She groaned but got up, thinking at first they were travelling again, but then remembered that no, this was where they were to stay the last two days before she and her mother flew home. Today was the day for visiting where she had been born. Only another day in which to try to be the obedient, dutiful daughter. But she felt irritable when she joined her parents downstairs and even more so when she was told just to have some coffee because they were going at once and could eat later. The sun had not yet warmed the air and it was freezing when they stepped out to go and find their car. Shona shivered as they slipped and slithered across the icy cobbles to the car and she wrapped her scarf more tightly round her. Catriona was buried in scarves and her fur hat was pulled right down over her ears, but Archie showed a careless disregard for the cold and had not even bothered to fasten his coat properly.

It was a short drive and then there they were, outside a building which was obviously a hospital. Shona cleared her throat. She was hungry. All the cold air had made her ravenous. 'Dad?' she said, but Archie was staring straight ahead, his hands still on the wheel of the car, but the engine turned off. 'Dad? This is it, is it, I mean where I was born?' He stayed silent, only shifting in his seat a little. 'Mum? This is it, right?' Catriona nodded. 'Well,' Shona said, trying to laugh, 'groovy place, eh? I'm overcome with emotion but I'm starving, can we go now?' An ambulance turned in, its siren going. 'We can't stay here, Archie,' said Catriona in a hoarse voice, 'we're in the way, we'll have to move.' Archie restarted the engine. 'Do you want to go inside?' he asked Shona, who looked incredulous. 'Inside?' she echoed. 'Dad, please, a hospital is a hospital, why would I want to go inside?' So they drove back to where they had parked the car overnight and trooped once more into the guesthouse and had a late and, in Shona's case, large breakfast. 'Funny,' she said, mouth still half full, 'when I was little I used to think of where I was born as being all romantic. I used to see this sweet little log cabin sort of place, like Heidi lived in, nestling in the snow and smoke coming out of the chimney, and Dad ploughing through the snow to get to it, and you, Mum, in a big wooden bed with a fur cover, having me. Silly, eh?' And she grinned at them and took more butter for her toast.

'Very silly,' Catriona said, 'it wasn't like that at all.'

'No. I've just seen it wasn't, it was just an ordinary hospital, nothing romantic.'

'No,' Catriona said, her voice flat, 'nothing romantic.'

'Except,' Shona said, still munching away, 'all births must be romantic, well, in the thrilling way, I mean they must be exciting wherever they happen. You were thrilled, weren't you, Mum?'

'Yes,' Catriona said, and the tears began to slide down her impassive face. Shona stopped eating. These did not look like tears of remembered joy. Carefully she put down her piece of toast and looked round the room. It was still busy with people finishing breakfast. 'Mum,' she whispered, 'what's wrong?'

Catriona shook her head and to Shona's relief brought out a tissue and applied it to her streaming eyes. 'Archie will tell you,' she whispered back.

'Dad?' Shona said, her stomach suddenly lurching. 'What is it? What's wrong?'

'Not here,' hissed Archie, looking agonised. 'Later, later.'

After that, they left hastily, shuffling out of the room, all three with their heads down, as though apologising for some disgrace. In the street Archie stood for a moment, ahead of the women, as if making some momentous decision only he could make, then set off at a rapid pace without looking back to see if they were following. 'Honestly,' Shona muttered, aggrieved. Catriona clung on to her arm, afraid of falling on the slippery surface along which they were being forced, by Archie's speed, to hurry. He took them to where the cable car started up the mountain and before they had reached him he had paid for their tickets. There was hardly anyone in this early morning car and they all sat in separate seats by the window. At the top, Archie got out. 'Are we staying?' Shona asked. 'Where are we going? Where is there to go?'

'Nowhere,' said Archie, 'we'll just stay here until the next car comes back.'

They were soon alone, the three of them. The sun was out now, growing stronger by the minute, and it was pleasant enough leaning on the rail looking down on the city strung along the seaboard. Without looking either to his left, at Shona, or to his right, at Catriona, Archie began to speak. Shona was hardly listening at first, the words simply did not penetrate. She was expecting her father to launch into a travelogue, a little lecture on the history of Bergen or to begin to wax nostalgic about all the time he had once spent here, or near here. She intended to listen, to take an interest, but found her attention wandering to the ships sailing into the harbour, her mind full of curiosity as to where they had come from and what was in their holds. But then she realised she had heard something odd.

'What?' she said. 'Sorry, I wasn't really listening, sorry, what did you say?' Her father put his head in his hands, leaning his elbows on the rail. 'Dad, I'm sorry, what did you say? Say it again, something about how I was born it was, wasn't it?' She was sure it had been but equally certain there had been something unusual about the familiar story, some mention of the word 'secret'.

'I can't go through it again,' her father said, his voice muffled. Another car was coming up, this one much fuller. Shona waited. Other people, freshly arrived, joined them and began pointing and taking photographs. 'Let's go down,' her father said. He looked awful. 'Dad,' she said, 'what's wrong? What is it?' – but he shook his head and half-smiled, a weary smile that made him look so pathetic.

All day, Shona had intimations of disaster and yet could not think what this catastrophe was going to be. Again and again she scrutinised first the face of her mother and then of her father and tried to imagine the worst. But what was this worst? Their deaths, she supposed. The death of one of them. Was that what this tension was about, this sense of strain which had hung over them now for so long? Was that what her father had been trying to tell her, all mixed up with the well-known tale of her birth? One of them was mortally ill and she had been brought here, where she had been born, to be told the news. It did not make sense, there was no connection to be made and she discarded the notion, annoyed with herself. It must be a different kind of bad news, not so sinister, not so shattering, but serious enough to arouse such anxiety and more likely to be revealed on a last family holiday together. Suddenly, as the three of them wandered in a dazed fashion round Bergen, Shona thought she had it: divorce. That would make a kind of sense – last family holiday – end of *family* – back to the beginning of it to make the breaking of the news not so painful ... A sort of sense but not enough. How weird it would be, to think of her parents apart when they had been together for what seemed an eternity and all that time completely content. Who would it be worse for? Her mother, of course. Her apprehension grew. She would not be able to desert her mother. Her mother would be pitiful and cling. She felt sicker and sicker.

They ate in the evening in a restaurant her father said he knew well. He said it while staring hard at Catriona. 'We used to come here,' he said, 'and talk about you, Shona.'

'Not here,' said Catriona, 'please, Archie, not here, not now.'

Shona turned to her. 'Mum,' she said, 'all day it's been talk of not here, not now. I can't stand this a minute longer. You look terrible, Dad looks terrible, I *feel* terrible. I'm sorry I wasn't listening when you tried to tell me whatever it is I've got to be told, but I'm listening now. Tell me.'

Archie stirred the thick fish soup.

'Not in a public place,' Catriona said. 'It might be better in a public place,' Archie muttered. 'Force us to be sensible.'

'I agree,' Shona said, though wondering if she did. Would she cry? Would her mother cry? Was there going to be a scene? She could hardly sit still, fidgeted about, picked up her napkin and found herself screwing it viciously into a ball and longing to throw it. Sighing, his soup pushed aside, Archie looked straight at her and she saw in his eyes anger, not misery, and knew this was nothing to do with divorce.

'We were very stupid,' he said. 'I especially. Stupid and maybe you'll think wicked. We wanted you so badly, Shona, you cannot imagine how badly. Your mother ...' He stopped.

Shona felt a flash of impatience. 'Yes,' she urged, 'go on, I know Mum had always wanted a baby more than anything and she'd miscarried and there'd been the stillbirth and then I came along, I know all that.'

'No,' said Catriona. She had blushed. Her pale face was a bright

filled Shona as she thought about her and tears at last came. Poor, poor girl, all the rest of her life spent with this shadow over it. Or had the shadow long since lifted and all memory of that baby gone from her mind? No. Shona told herself she could not believe this. No. She could not have been banished in such a manner.

But in any case it did not matter. She had no choice, none at all. Her need to know her mother was urgent and compelling and she would never be able to deny it. She would find her in no spirit of revenge and not to visit upon her any past sin, but to make sense of herself only. Her mother was her, or rather she, in the literal sense, was made from her mother and she could not resist discovering her own inheritance. I will not harm her, Shona thought, but I must know her, and where is the harm in that?

PART TWO

 \sim

Leah – Hazel

Chapter Seven

 \sim

EAH RETURNED every stare with a stare of her own, a look not of defiance but of pride. There was no feeling at all in her mind of shame or embarrassment and this was borne out by her carriage. She had always walked with her head up and her shoulders back, she had never huddled into herself as so many girls did, but now she seemed to emphasise the excellence of her posture. Nor did she attempt to conceal her pregnancy. She let her coat fall open, there were to be no straining buttons, and the child she was carrying already thrust itself forward in the most pronounced way. She saw the stares directed at the bump and then at the ring on her finger and then at her face and she smiled, however accusing or hostile the expression in the eves. People knew she was not married, that it was impossible for them not to have known if a marriage between Leah Messenger of the Fox and Hound and Hugo Todhunter of Moorhouse Hall had taken place. They were outraged that she wore a ring on her wedding finger and vet no one had directly challenged her, as she half wanted them to.

The ring was a symbol, as all rings are. There was, Hugo had said, no law saying a woman must be lawfully married before she could wear a ring on what was held to be her wedding finger. She must not say she was married because that would be wrong – she was not married according to the laws of either the established church or the country – but there was nothing whatsoever to prevent her wearing a ring if she wished to. And she did wish to. She liked to see it there, a shining reminder of the time Hugo had pledged his undying love and devotion to her, at night, in the little church of St Kentigern lit by the candles he had brought with him. He had repeated all the vows from the wedding service in the prayer

book, taking the part of the priest as well as the bridegroom, and she had repeated her own vows, her voice shaking with nerves though there was no one to hear it. There was no music but as they extinguished the candles and walked down the aisle together, their footsteps scraping the stone through the thin torn matting, an owl had hooted outside and then, when it had ceased, a single nightjar sang under the midsummer moon. 'Perfect,' Hugo had sighed, 'perfect.'

Oh, he was such a romantic lover! She had difficulty taking him seriously. Her instant reaction, that first day when he stopped his horse on the road and dismounted, had been derision. She was not a romantic. Her life had been hard and she had faced up to it, never once trying to deny this hard reality by escaping into daydreams. She had not reached sixteen without being aware of how dangerous her own beauty could be, how likely it was to surround her with predators. She scorned flatterers, turned her head away from those who showered her with compliments. There was no barmaid ever as expert at making men feel despised, and yet she was not hated for her aloofness nor did her contempt provoke rage or a desire to see her humbled. She was respected and she knew she was and traded on that respect. Hugo respected her from the beginning. He made no attempt to paw her or to flirt in any way. That first encounter laid the pattern. He walked with her, holding his horse by the bridle, and not one word did he say all the way back to the Fox and Hound beyond 'Would you permit me to walk a little way with you?' to which she merely shrugged. He bowed when they reached the pub and that was all. Again and again he did this, day after day, meeting her on the road, dismounting, asking if he might walk with her, walking, not speaking, bowing, and then going away.

But Leah was not stupid. It was all a means to an end and the more subtle and original the means the more need to watch for the hidden end. She thought she saw his intention when he gave her lilies on Easter Day and hoped he might be allowed to express his unbounded admiration for her loveliness which had bewitched him. She knew she was meant to blush and simper and thank him, and then he would take this as a signal to proceed in what was, after all, likely to be only a common-or-garden seduction. But she did neither. She knew all about him by then. She had heard the tales of his wild living, of how he was back in this bleak part of the world only because he was being hounded for money and had come to get it from his parents who had saved him from prison many times before. He was a rogue and she knew he was and would not be caught. 'Thank you for your lilies,' she had said primly, 'they will look very well upon the altar table if the vicar will accept them, and as for my loveliness, before God we are all lovely.' She had said it quite stern-faced, with due solemnity, but afterwards she had laughed at the astonishment and consternation in his eyes. If he thought her deeply religious, so much the better.

They were observed all the time. A road which looked empty was never empty of eyes watching from somewhere. They looked down from a cottage on a hill or through a hedge where a lone plough was driven in a field. He might not know this but she did and she was glad of it. It governed her behaviour, this certain knowledge that she was being watched. She had a hidden audience and performed for it. They would say of her, those who slyly spied on her, that she never gave Hugo Todhunter an inch, never allowed him anything approaching a liberty, that she showed herself immune to his unwanted advances. But she was not immune and that became the hardest of all things to conceal. She was not immune to his very looks and it made her feel guilty. It was wrong, in her own opinion, to admire a man for his looks. It was foolish, just as foolish as thinking one's own looks of consequence. That was the kind of attraction she feared and of which she was wary. Yet Hugo Todhunter was not generally thought of as handsome. He was not tall enough or broad enough to qualify as a truly handsome man and he did not turn women's heads in the street. But it was his looks she liked, his rough, unkempt hair, the darkness of his hair and eyes, his litheness, his brown complexion, not ruddy but olive-toned, and his air of concentration. He seemed always to be listening as they walked the road silently together and it made her curious.

It became harder and harder to keep silent and it was she who broke the silence in the end, asking him, irritably, why he insisted on accompanying her along the road in such a way. 'Are you tired of it? Shall I leave you in peace?' he said, and she was weak enough to say she did not care, only wondered at the pointlessness of the ritual. He said that to him it was not pointless, that on the contrary it gave him great pleasure and satisfaction, but that each day he met her he was deeply afraid he would be turned off like a dog. 'How could I turn you off?' she exclaimed scornfully. 'It is a free country, this is an open road.' He said she only had to express indignation at his arrival by her side and he would never dare to come again. There and then she should have expressed this indignation but she kept silent, and by her silence betrayed her interest. It made him bolder. He began to talk, though not in the manner she had imagined. He told her things, little bits of history about the area, little anecdotes about when he was a boy. He never asked questions of her or seemed to need any but the most superficial response. And still when they reached the Fox and Hound he bowed and left her, never entering the pub.

Weeks went by, months, and nothing ever changed, except the weather. With the first fall of heavy snow she was not able to walk the road at all and was shocked at her own dismay. She would not see him and it grieved her out of all proportion. The snow lasted a week. She thought he might come in search of her if he missed her as she missed him, but there was no sign of him and she chided herself for expecting him. She dreamed of him every night and woke excited, though all they had done in her dream was walk together as they always did. The moment the snow melted she was out on the road hardly daring to look for him and relieved to the point of faintness when she heard him gallop up behind her. All winter it was the same – the snow, the impossibility of walking, the missing of him, the secret joy when she saw him again.

In the spring, he made a move. She knew it was that, a move: she recognised it as such, but by then she felt he had earned the right to make it. 'Do you only walk here,' he asked her, 'along this road?' She said that mostly, as he knew, she did, but that in the summer, when the evenings were light, she sometimes walked down by the river on Sunday, if it was pleasant weather, if she were not needed at the Fox and Hound. She was fond of the river, she was told she had been born in a house on the banks of a river. He took note and the following Sunday, as she had anticipated, he met her down by the river. It felt strange to see him there. She felt awkward, but he was more at ease. They walked, they parted, she went on to church. But during the week he said there was a river walk he was fond of some miles away and he wondered if he might drive her in his pony trap to it, and they could walk it together. She was quiet for a moment not through any doubt as to the answer she would give, nor out of any desire to tease, but because she knew how significant a moment this was. She had only to accept the first invitation he had issued in almost a year for her interest to be declared. So she accepted.

They were seen, of course they were seen. They did not try to hide, there was no subterfuge. He picked her up in the pony trap at the Fox and Hound. They drove some four miles and walked the river walk and they drove back again, whereupon an avalanche of warnings and advice fell upon her ears. She was not deaf to the dire threats of disaster. She took heed. Hugo Todhunter was said to have been forced by his angry parents to spend this past year at home while they settled his debts, but was now on the brink of being sent by them to a new life in Canada where they had connections. They would not permit him to stay in the country and once more ruin himself, but had made it a condition of their saving him from prison that he would go into business under his uncle in Vancouver. It was to be his last chance. There were even those who told Leah the date he was due to leave and they did not quite believe her when she said she had no interest in knowing it, it was nothing to her.

But Hugo had not mentioned any departure to her, though he had begun to talk about his past life. 'I was spoiled,' he confessed, 'I was overindulged by my parents. Oh, I had the happiest of childhoods and paid the penalty.' Leah, who had known no happiness either as a child or since and barely knew the meaning of the word indulgence. ventured to inquire how there could be any penalty. 'I took my luck for granted,' Hugo said. 'I expected my luck always to be there and so I tried at nothing.' Leah was careful. It struck her as suspicious that a man should so berate himself. What did he expect? That she should protest, that she should not believe such self-depreciation. that she should be charmed by it? She thought hard before she made any comment and then said only, 'How unfortunate.' Hugo nodded. He went on to confess he had caused his parents great pain and if he tried for a thousand years to make amends he could never succeed. Leah thought the 'thousand years' extravagant and coughed. 'You do not know the agony of being ashamed,' Hugo said. 'There is no worse feeling to know that I am to blame for my own misfortune.'

Again, Leah thought hard. Should she point out that he had only just, in fact, placed blame on his parents for spoiling him, from which he alleged all else had followed? Or would he resent this, would he judge her unsympathetic to what he evidently considered a noble confession? He looked so truly sorrowful, she wanted so badly to comfort him. 'You can make a new life,' she finally said, 'and please your parents.' He smiled and said it would take a great deal to please them and, as he had acknowledged, he could never make up for the worry he had already caused them but that he intended to try. He said it had been a hard year. He said he did not know how he would have survived it if it had not been for her. She had given him hope. She, who was so pure and beautiful and modest, who conducted herself with such grace and dignity ... She had stopped him then. She had told him he did not know her and should not speak such nonsense. She was merely a poor girl, an orphan, who worked to live and had no other life and few hopes or aspirations. She did her best and that was all. He said it was for that he admired her – she had nothing and did her best and he had had everything and had done his worst.

So they might have gone on if she had not tripped and fallen and cut her head open on a sharp stone and passed out for an instant with the loss of blood. When she came to, he was cradling her in his arms and kissing her and showering her with frantic endearments, and there was no more hope of keeping her distance. She loved him. It was simple, after all, defying all sense but true nevertheless. He asked her to marry him there and then and she accepted and that was the happiest moment. But it was only a moment. It did not last nor, really, had she expected it to. He said he had told his parents who had raged and stormed and would not hear of such a marriage; and she asked why he had ever thought they would. He had no money, none at all, and neither of course did she, and all prospect of marrying was hopeless. He said he would have to go to Canada and restore his fortunes and then return and claim her. She accepted this, it was inevitable, there was no other way. So they had their own ceremony, in the little church before he left, and she did not regret it for one minute nor pine for a real priest and a real service.

Nor did she regret the child, except for the first days of uncertainty when her mind filled unpleasantly with all the practicalities of her position. She had Hugo's address in Vancouver and she wrote to him at once, as he had instructed her to do should anything untoward occur. He had wished her to write weekly, as he would write to her, but with bowed head and hot cheeks she had been obliged to confess she was barely literate. He vowed that when he returned from Canada and they were married properly he would educate her himself. He painted a fetching picture of them both sitting side by side on the riverbank with open books on their knees and a slate and pencil at their side. She was intelligent, he said, he could tell she was and she would learn quickly. But he was relieved that she could, if with difficulty, write her name and some simple words and could copy his own name and address on to an envelope. It was fluency she lacked, the ability to pen a letter expressing her feelings and, similarly, though she could read simple sentences, a solid page of writing was a blur to her and took hours of laborious scrutinising before it made sense.

Her message, some six weeks after his departure, had been crude: 'I am well,' she wrote, 'I am with child. I am happy.' Afterwards, she wondered if she was wise to have proclaimed her happiness but she had not wanted him to think her distraught or that she was accusing him of ruining her. He had not ruined her. He had never forced her and had most conscientiously acknowledged the possible consequences of their love-making. She had told him she would take the risk if he would and that, in truth, as he could see, as he could feel, she could not hold back. How, later, could she ever convey to those who questioned her the urgency and power of that desire? It was impossible. She remembered only that it was so, that she was overwhelmed, without being able to call up the exact sensations. Where her sharp mind was at the time she did not know and did not trouble to search for the answer once it was over.

Money arrived immediately, even before his passionate, remorseful letter half of which she failed completely to decipher. Fifty guineas, in the form of a banker's order, payable on proof of identity at a bank in English Street, Carlisle. The part of his letter which she could understand, if with difficulty, said that the presentation of the ring he had given her would serve to identify her together with a sample of her signature. The ring had his initials and hers intertwined on the smooth inner surface, and he had already sent the signature on her letter to the bank for them to match it. He had thought of everything but was in an agony of apprehension on her behalf. Correctly, he envisaged she would have to leave the pub and urged her to find some lodging in the village where she would be safe and comfortable until the child was born. More money would follow, he said, and by the time she was brought to bed he would have booked his passage home and would come to claim her.

But she did not try to find lodgings in the village. She did not wish to stay there, among people who despised Hugo and who would sneer at her condition and see her as a victim of his villainy. It was her own choice to return to Carlisle, where she had been born, and she went there full of confidence, excited at the new life which was opening before her. She was very far from being a wronged woman, humble and penitent. She swept into the bank as though she was perfectly accustomed to doing so and met the eyes of the clerk to whom she presented Hugo's draft with some hauteur. She knew her signature revealed the uncertainty of her hand but she did not care. He gave her a pen and a fresh piece of paper and she saw him watch as, with immense concentration, she formed the letters of her name, making, as ever, a mess over the double 's' in Messenger try as she did, she could never stop those letters running into each other and looking ugly. Then she had to remove her ring, which she never liked to do. She watched anxiously as it was lifted up and looked at through a magnifying glass and then, to her consternation, taken out of her sight into some back room to be checked by an invisible person. It was only then that she felt vulnerable and that her position seemed precarious. Once the ring was back on her finger she was reassured - as she was by the money, fifty guineas counted in front of her into a cloth bag with a drawstring. She pulled the string tight.

It was a fortune to her, a sum so substantial it represented absolute security and she wished everyone she had left behind in the village could know the goodness of a man they thought had no good in him. She stood for a moment on the steps of the bank surveying the busy street and thought of what all the money in her possession could buy. There were shops lining the street to which she could give her substantial patronage - dresses she could have and a fur tippet and boots of the finest leather. She smiled, amused at this absurd thought, knowing she would never be tempted. The money was for her keep to give her shelter and food, to pay for a nurse when the baby was born and see her safe until Hugo returned. Her sole concern was to use it wisely. Her first task was to trace the only person in this city whom she knew to be a member, if a distant one, of the family to which she had once belonged. Her recollection of this woman, an aunt she thought, was vague in the extreme. Mary, she was called, Mary Messenger, and she had been kind. It was this Mary who had taken her to the coach so long ago and kissed her and wept over her and hoped she would be lucky in the place to which she was going. Mary had given her food for the journey and a shawl to wrap herself in and, if she was not mistaken, it was with Mary that she had lived up to then. Where exactly she did not know and could not fathom, however hard she tried. An impression of crowds came back to her but she could not grasp what this might signify.

Leah walked past the cathedral and turned the corner at the castle to walk over Caldew Bridge. A pub in Caldewgate, the Royal Oak, had been mentioned often by her relatives at the Fox and Hound. Messengers had that pub and it was from those Messengers she had always understood she came. Occasionally, one of these Carlisle Messengers visited, on their way to or from Newcastle, and she would be paraded before them and reminded she was 'Annie's lass, poor soul'. Caldewgate was a sorry sight, full of smoke pouring from the tall chimney of Dixon's factory and from the trains shrieking their way out of the railway yards below the old wall of the city.

The people at the Royal Oak had none of that interest in her which they had begun to show during recent visits to the Fox and Hound. They looked at her belly and looked at her ring and smirked, and were disposed to draw her into the kind of questioning to which she had no intention of submitting. But they gave her Mary Messenger's address readily enough. Mary now lived in Wetheral, a village on the river Eden some five miles to the south of the city. A washerwoman, she lived by herself and was never seen in Carlisle. Leah made her way to Wetheral at once, walking briskly, her spirits lifting as the river came into view, broad and fast-flowing with the winter rains. Mary lived on The Plains, a row of houses just outside the village, beyond the pretty triangular green. These houses looked too solid and imposing for a washerwoman, but there was a short row of terraced dwellings near the end and here she knew she would find Mary. It was not the most satisfactory of reunions. Mary was in her wash-house, mangling. She stood in her clogs turning and turning the handle and forcing folded sheets through the rollers with such energy that great streams of water shot into the tub below. All around were tin baths of washing in all its various stages and the air was full of steam and dampness.

'I am Leah Messenger,' Leah said. Mary did not stop mangling. Leah repeated her name but still the mangle was turned until at last a long sequence of bed sheets had passed through and were piled on top of others waiting to be dried. There was plenty of time for Leah to observe Mary. She saw that she was old, much older than she had expected. Her hair was white and she had no teeth and her body, though it gave every indication of a surprising strength, was bowed. Leah felt a little dismayed – this was not the kindly, motherly creature of her memory. In the silence that followed the mangle's screechings and strainings she said yet again that she was Leah Messenger. Mary stared at her, no hint of welcome or recognition in her fierce face.

'What are you wanting?' she asked eventually. 'I've nothing to thank any Messenger for, I'm sure, eh?'

'Neither have I,' said Leah. She had not meant this as a challenge or an attempt in any way to cap what Mary had said, but it stopped the old woman from fussing with the washing.

She came closer to Leah and peered into her face. 'You were just a child, eh? When they sent you away.' She shook her head. 'Bad days, bad days,' she sighed. She began to trudge out of the washhouse and in through the back door of the house. Leah followed. The back kitchen was dark and not much warmer than the washhouse, but there was a kettle spluttering above the fire where it hung on a big iron hook. Mary poked the dead-looking coals and flames leapt up and the kettle boiled in seconds. She made tea, measuring one level spoonful carefully into a brown teapot, and covered it with a tea-cosy. Then she sat rocking the teapot backwards and forwards, absently. Leah sat down too, without being asked.

'Annie's girl,' Mary said at last, speaking as if to herself, all in a mutter, 'poor lass. She died of fever when you were two and then what was to become of you, eh? The Grahams next door had you for a while, their lass had died and you were of an age with her and a comfort, and then he died and she went back to her folk and they wouldn't have you, that wasn't their own. What could she do, eh? Nothing for it. "You'll have to take her back," she said to the Messengers, and they wouldn't hear of it, you were about seven then, a long time till you'd be of real use. I tried, I tried. Nearly a twelve-month I tried, begged them to let you stop with us but they wanted more work out of me than I could give with you under my feet and they fixed for you to go to Annie's uncle but they lied, said you were ten and able to help in the pub, and I don't know how you weren't sent straight back, that's the truth.'

'I was tall,' Leah said, 'and I did work.'

'Oh, Messengers always get work out of folk, eh? That's one thing, always get work, worked me to death, then I saw my chance and got away, but not from work. Oh I work, work, no end to it, but not for them, not now. I manage, that's what, I manage.'

'Can I help you manage?' Leah asked.

'Eh?'

'Can I help you manage? I've got some money, I can pay my way and I can work hard too. I need a room. I can pay rent. Look,' and she took out the little cloth bag the bank had given her and tipped the coins out on to the table.

'Honest money, eh?' Mary asked.

'Honest money. I can pay rent.' And then, in case Mary had not noticed, since she had neither let her glance at any time rest on Leah's belly nor asked any question about her condition, Leah said, 'I'm expecting, in February, I need a place to lie in.'

There was no formal agreement. Mary looked at the money steadily, until Leah pushed two of the guineas towards her, and then she grunted and got up and said that since she must return to her mangle, Leah must sort herself out. There was very little to sort out. Mary's house, if it was indeed hers, which the more Leah thought about it seemed unlikely, was small. There appeared only to be the kitchen and next to it a room with a bed; up the rickety stairs was one other room only. It, too, had a bed in it but there were no covers on it and Leah deduced Mary slept downstairs. She sat on the edge of the doubtful-looking mattress and was relieved to find it was firm and did not smell. There was no rug on the floor, which had several holes in it where the planks had split. There was a trunk in one corner which she did not yet feel up to investigating and two other boxes under the window, both open, both containing blankets and covers. It would do. It would have to do. Some of the guineas could be spent, legitimately, on making this room more comfortable. She could scrub it and distemper the walls and make a curtain for the window. She could help Mary with the washing so long as she avoided lifting heavy weights. And it was temporary, only a way of getting through the next months until Hugo came and rescued her. She would be quite content here with old Mary, waiting for her baby to be born, waiting for Hugo to return, it would work out well.

And it did work out well, very well. Leah was content in Wetheral and Mary was more than content. The difference Leah made in the house was great and, though Mary never commented on this vast improvement in her way of life, she registered it within her. Leah was tidy and neat and a hard worker. She found ways of doing things that Mary had never thought of, ways of making the heaviest work lighter. She was ingenious and saved both of them strain and, though she was four months pregnant when she came to live with Mary, she did not let her condition hold her back from almost all the jobs to be done. There was not much communion between them at the end of each weary day but Mary grew to love Leah's very presence as she sat with her eyes closed in the rocking-chair she'd bought from a woman selling off her dead mother's furniture. She watched her rock and rock and was pleased by the sight of the young mother-to-be. She asked no questions and would not have had much interest if information had been volunteered – it was enough that Leah was with her, her arrival a piece of good fortune the like of which Mary had never known.

The baby was born in the middle of March when Leah was well past her time both by her own reckoning and that of the midwife whose services she had engaged. 'We can't leave it for ever,' this woman said after two weeks of high expectation that the birth would occur at any moment, 'I'll have to bring you on soon, my lass.' But Leah, though tired, did not want any interference. Every day she walked down the hill to the river Eden and up through the woods, lovely with all the new spring growth, and with every step over the rough ground she felt her child turn and kick and knew it would come when it was ready. Mary did not like her to walk alone in the woods in case she went into labour far from help, but Leah was sensible, she took no risks. The first strong pain came when she was indeed far from home, at the very top of the high woodland path, but she was not frightened. Slowly, slowly, she made her way down, even pausing to break off a branch full of dancing catkins, and at every subsequent pain she stopped until it was over. Her waters broke at the foot of the steep hill leading up to The Plains but she did not panic, only shifted her shawl from round her shoulders to round her waist to hide the stain and then she continued, a little faint it is true, but determined not to rush. Mary, looking out for her, as she always did now, knew from the way Leah walked that she was at last in labour and went for the midwife before ever she reached home. The birth was not as swift as this beginning had promised. All night Leah laboured and it was not until dawn that the baby was born after a great loss of blood which had alarmed the midwife. It was a girl and she was small, not the robust creature Leah was reckoned to be capable of bearing. There were many distraught tears because it was not the boy, the image of Hugo, that she had desired. But she requested pencil and paper - an envelope had been prepared long since - and wrote the news of the child's safe arrival upon it.

After that had been done, it was only a matter of waiting.

Chapter Eight

THE HABIT of obedience was so natural to Hazel that it took a mighty effort for her to query an order or instruction. This had always made her popular with teachers and much loved by her parents and relatives but, not surprisingly, except to Hazel herself, it caused problems with her siblings and contemporaries. 'Why do you always do what you're told?' they asked her angrily and were exasperated that she did not even understand the question. It was effortless for her to do what she was told since she automatically respected authority. Life to her was simple. It was governed by laws and rules which had been designed to protect her and she saw no reason to reject them. She enjoyed being obedient, and quick in her obedience, not because of the praise she earned, the frequent 'good girl', but because of the sense this gave her of everything being controlled.

This made her pregnancy at seventeen the most astonishing and unbelievable occurrence. Her mother could not stop herself in the first instance from saying, 'Hazel, are you sure?' and she did not mean was her daughter sure of her condition but rather was she sure she had had sexual intercourse at all. She had warned Hazel of its dangers, of the horror of an unwanted pregnancy, at an early age; her daughter being such an obedient girl, she had hardly thought it necessary to go on reinforcing this warning. Hazel was only a schoolgirl and a model one at that. Her A-level results had been better than expected and both her parents were eager for her to go to university. She had not yet gone out much into the world and so far as her mother was aware knew no boys beyond her brothers and their friends whom she only ever saw in their company. It was simply extraordinary to think of Hazel having sex, and Mrs Walmsley had to block from her mind the vision she suddenly had, of her daughter crushed under some oaf. Because, of course, it must have been some brutish oaf, whatever Hazel said to the contrary. She would have told her mother the name of her seducer but this was banned. No names were to be divulged. A university place could be deferred. And nobody, *nobody*, was to know, not even her best friends.

It was easy for Hazel to obey this order. She had no best friends, no girls with whom she had intimate conversations. She was a solitary girl, self-contained, who at her boarding school made no lasting alliances. Since she was pretty and gentle-natured she was perfectly attractive to others but she resisted all efforts to involve her in relationships. This was noted by her teachers, who would write pointed comments on her reports about her failure to mix. They concluded that Hazel's problem was twofold: she was considered a goody-goody by her peers, and she was a true loner, best left to get on with life as she wished, by herself. So far as could be judged, she was not unhappy, nor did she appear shy and reserved. She spoke to other girls quite freely and joined in games and other activities but preferred not to carry friendship any further.

By the time she was sixteen, Hazel was one of those girls frequently in demand to make up numbers. She was pretty and clever and quiet, and absolutely no threat. It was 1954 and the only way girls met boys at her school was when they were allowed, once a term, to go in an organised and supervised group to an equally illustrious boys' school with which they shared dances. There was no opportunity on these visits to pair off outside the hall where the dance took place, since hawk-eyed teachers guarded all exits. But it was impossible to prevent boys whispering invitations to girls while they danced and assignations were made accordingly. These were not dangerous on the surface. There was a small town half-way between the two schools to which sixth-formers were allowed to go on Saturdays between the hours of two o'clock and five o'clock. Here, in tea-shops, boys met girls and the thrill was tremendous. Both sexes felt that anything could happen after the obligatory tea and doughnut. Walks could be taken in the park, along the river ... Oh, there were opportunities for the bold.

Hazel was not in the least bold. She politely declined when invited to meet a boy in a tea-shop. But when she was asked by girls to please, please, go with them because they did not want to meet a particular swain alone, she could think of no objection. There were no rules about not meeting boys to have tea and, curiously for one not interested in close friendships, she liked to do favours. So she obliged. She went to the tea-shops and after ten minutes, given an agreed signal, she left. It was harmless and she derived some amusement from her role as chaperone. This was how she met George. He was always inviting girls to tea-shops and his invitations were met with alacrity. Hazel had accompanied four different girls over a year to meet George and all of them rapidly wanted to get rid of her once their first nervousness was over. 'Don't go, Hazel,' George urged, but she always went. He invited her to meet him at the schools' Easter dance but she refused, as usual, even though she thought George more interesting than anyone she had vet met. He was not good-looking - for one thing, he had red hair and the skin that went with it - but he was witty and sharp and fun to be with, far more fun than those handsome but dull boys with whom girls liked to be seen.

It turned out that George lived near Hazel in London, a few streets away in Notting Hill. She met him in a bookshop in the Christmas holidays and they stood for a while and talked about what they were buying. George suggested they go round the corner and have a cup of coffee in the new espresso bar that had just opened, but Hazel declined politely. She met him again, getting on a bus, and sat with him until Oxford Circus. He suggested she might like to go to an Ingmar Bergman film with him, in the afternoon, but she said no, thank you. 'Is it your middle name? "No thank you"?" George asked before she got off the bus. 'My middle name is Rose,' Hazel said, quite seriously and straight-faced. But she found herself wondering, as she walked down Oxford Street, why she did always say no to George when she found his company agreeable. She was a puzzle to herself as well as to him. It was somehow tiring to be with other people, she seemed always to be glad to be alone again however much she had enjoyed the conversation. But she knew she could not go through life with this attitude. She saw herself isolated by her own disinclination for friendship and it troubled her. She would have to make an effort of some sort, she thought.

So she made the effort with George. At the next dance, three months after the chance meeting on the bus, he made straight for her on the dance floor and the moment they were waltzing – waltzes and quicksteps were the preferred dances at these events – he said he

knew it was no good asking her but would she meet him the following Saturday not in a tea-shop but in an art gallery where he was going to see a painting by Dante Gabriel Rossetti. She agreed. George was triumphant, wrongly assuming it was the originality of his suggestion which had made Hazel capitulate. They met, as arranged, and stood in front of Rossetti's painting of his sister, and George talked a little glibly but quite knowledgeably about it, while Hazel listened attentively. Then they went for a walk to the other side of the town and George talked all the time. She was about to say no, thank you, when he suggested meeting again the following week, but stopped herself just in time.

George passed his driving test as soon as school broke up in June and was allowed to borrow his mother's car. This was a great event in his young life and he wanted Hazel to share in his luck. His invitations to go for a drive were pressing and he could not understand why she did not share his excitement.

'A drive?' Hazel said. 'Where to?'

'Oh, anywhere,' George said. 'Does it matter?' Hazel thought for a moment. Of course it mattered, surely it did. What was the point of driving if one was not driving to somewhere. 'You're so literal,' George complained. Hazel did not argue. She thought she probably was literal and did not see this as a criticism. 'To Oxford, then,' George said. Hazel thought carefully again. George was hoping to go to Oxford. There was a purpose to this drive. He wanted to look round several colleges and this attracted her. She had not entertained any ambitions of Oxford for herself but was nevertheless interested enough to look round. So she agreed. She even mentioned it to her mother, though not that she was to be driven to Oxford by a young man. Her mother was distracted at the time, organising a charity ball (she was heavily involved with a great many charities and on a great many committees) and when Hazel said she was going to look round Oxford with a friend she simply said, 'Very nice, dear,' and that was that.

Hazel had no sexual experience whatsoever. She had never held a boy's hand, not even George's, and certainly never been kissed or embraced. She had heard other girls talk of being fondled and petted and there were even hints of more breathtaking contact but it had meant nothing to her. It did not worry her that she alone seemed unimpatient to be made love to: she was, as in many departments of her life, content to wait. This patience was severely jolted in Oxford. George took her on a punt, very pleased with himself, because he had thought to bring a picnic and a rug. Dutifully, Hazel got into the punt and allowed herself to be punted as far up the river Isis as George could manage without collapsing. He moored the punt among some reeds and out of the picnic basket he produced a bottle of champagne. Hazel had had no more than a sip of champagne occasionally, at weddings, and still thought of it only as a pleasant fizzy drink. She drank half the bottle with George and was amazed at how it made her feel – she floated, she felt light-hearted and giggly. This encouraged George and for the first time he touched her. It was awkward in the punt, which rocked alarmingly, but he managed to wriggle himself down beside her and he put his arms round her and squeezed her. 'Do you mind, Hazel?' he asked anxiously. No, she said, no, she didn't mind in the least, she liked it.

George could not believe his luck but then he grew worried. He put his hand up Hazel's skirt, a very full affair with a stiff crackly petticoat underneath, and she had no objection. He slipped it inside the bodice of her dress and got it round her breast inside its wired bra, and she did not remove the hand. He kissed and kissed her and she lay there smiling and serene, while his excitement grew. 'Hazel, Hazel,' he said, 'you aren't drunk, are you? You do know what you're doing, I mean what I'm doing?' Hazel said she wasn't drunk and she knew what he was doing. So then it was up to George and he was in agony. He could tell he could go as far as he liked and it shocked him. A bit of resistance would have made him happier, the need for persuasion on his part would somehow sanction his advances. He didn't want to take advantage of Hazel but on the other hand he couldn't bear to pass up such a chance. He was too honourable and it wasn't fair. He groaned and sat up and put his head in his hands. He shouldn't have given her the champagne. She said she wasn't under the influence of the alcohol but she acted as if she were and he had a sudden image of Hazel's furious parents accusing him afterwards ...

There was no afterwards that day. Angrily, George pulled himself together, punted Hazel back, and drove home like a maniac. He lay on his bed hitting the pillow and cursing himself for his saintlike behaviour. Next time, he vowed, he would take Hazel Walmsley at her word: if she acted as if she wanted it then she'd get it. In preparation, he bought some Durex at the barber's.

He met Hazel now every day and they embraced – in Hyde Park,

in all the public places they frequented - and she was as soft and vielding as she had been in Oxford, without the help of alcohol. But she was going the following week, with her family, to France, and time was short. Then they were both invited to a party by a mutual friend and George knew this would be it. Hazel knew too and was quite composed. The whole idea of finding out about sex now intrigued her and she had replaced her former willingness to wait with a curiosity all the keener for being so sudden. Not, she reassured herself, that it was so sudden. She had known George now for well over a year. For the whole of the last week since the Oxford day, they had been kissing and cuddling and Hazel was beginning to wonder at George's self-restraint. She could see he was apprehensive and she couldn't think why. She wasn't. She knew that anyone looking at her, so demure and modest, would never know how she felt. This interest she had, to understand what sex was really about, was all the more powerful the longer the discovery was delayed. She didn't love George in the least nor was she sure that she was attracted to him in the way he seemed to be to her but she liked his company. Wasn't that enough, to begin with? Wasn't George the sort of boy suitable for a first sexual experience? She hoped so.

The party was in a large house near Campden Square. There were lights in the trees in the long narrow garden and very pretty it looked. But George and Hazel were not in the garden with the other eighty-odd young guests. They were in the house in a room at the top, with the door locked and barricaded (like all the other doors on that floor). They took all their clothes off at once and George fell upon her eagerly and that was the first time, quite unsatisfactory for both of them, what with George's struggle with the wretched Durex and Hazel's impatience. Second and third attempts were better but it was not until the early hours of the morning, when mine host was hammering on doors yelling that his parents would be back soon, that the two of them caught any rhythm. 'I love you,' George murmured during their last embrace. Hazel didn't say a word. They dressed slowly, with barely the energy needed, and left the accommodating house. 'When will I see you?' George asked. She shrugged. She was relieved that she was off to France in a few days and he was going to Scotland to relatives in St Andrews. She felt she wanted a long rest from George and plenty of time to absorb and analyse what had just happened.

She never saw him again. 'Tell no one,' her mother said, and she

obeyed. The moment she suspected she was pregnant she wanted George kept out of it, dreading any further involvement with him. She didn't want the baby, of course she didn't want it, but she didn't want George either. Her own foolishness maddened her. Why had she placed such faith in George's use of Durex, his confident assurance that she could not become pregnant? It seemed such an aberration, such a deformity of what she knew to be her true character. She wanted to be rid of the baby, rid, too, of all thought and memory of George. But her mother said abortion was both illegal and too dangerous and she herself had not the faintest idea how to obtain one. The idea that she would have to give birth to this consequence of her lust appalled her. Her quietness, when she was told by her mother that she would have to have the baby then give it up for adoption, was mistaken for her usual obedient reaction; but it was something else, a quietness born of shock and inner panic. She couldn't be going to have a baby, it was surely impossible. She had not a single maternal feeling nor any nurturing instinct. It filled her with disgust to think of what she was going to have to go through.

The absurdity of finding herself in Norway took some time to strike her. She could not claim to be either stunned or in a dream, but there was something automatic about everything that happened once her mother had made the arrangements. She packed her things, new things, strange garments her mother had selected for her from a maternity clothes shop, and she said goodbye to her father, who was still chortling at the idiocy of her destination, telephoned her brothers who told her not to do anything they would not do, then left London with her mother. During the journey to Bergen neither of them spoke much. Hazel closed her eyes and feigned sleep, reflecting upon what an odd person her mother was: on the surface so bright and cheerful and utterly conventional, yet secretly full of cunning, a woman whose thrill in life seemed to come from the excitement of subterfuge. She felt she was simply a plot to her mother, something complicated to be worked out as neatly as possible in the minimum time. She wasn't a girl at all.

The house she found herself in was tall and narrow, quite unlike the generously proportioned home from which she had come. She had a large attic room at the top. There was a window at either end but disappointing views from both – rooftops out of the east window, a vast wall out of the west and no greenery in sight. She smiled wanly, as she hung up her clothes, to think that her natural preference for being alone was now so completely gratified.

The two women with whom she lodged were polite and helpful but she could tell at once they were only interested in her situation and not in her. They made no attempt to mother her nor did they subject her to any kind of cross-examination. She gathered there had been other girls in her predicament staying with them before her. She feared, from the look of them, that they might be religious but if so they kept their beliefs to themselves. They took her round the house and showed her where everything was, gave her a map of the town and a timetable of meals, and then she was left to get on with her new life. She thought both women very strange but their detachment suited her. Each day she went to the library and there she followed a work plan that Miss Bøgeberg, the teacher of the two women, had made out for her. She learned the history of Norway in detail and studied its economy and of course its language, at which she became reasonably proficient after an initial struggle. She left the library shortly after three in the afternoon and walked round the town, taking care to be home before dark. She ate with Miss Bøgeberg and Miss Østervold and then retired to her room where she read or wrote to her mother. This was a laborious business because she had so little to say. She wrote a great deal about the weather every week and struggled after that to fill up the page. She wanted to ask her mother again how she knew these two odd Norwegian women, what her connection was with them, but she never did. Her mother would only be evasive.

It was autumn when she arrived but even so the first snow fell within three weeks and she was glad. Her mother had not exaggerated Hazel's passion for snow – she loved it, not for its prettiness but for the way it sealed off noise and dirt. She liked the muffled feeling that came with thick snow, that feeling of being cocooned, of time being suspended. She liked the clothes that had to be worn, the heavy coats and thick scarves and hats and gloves – beneath them she felt herself slipping away from exposure and was happy. It suited her particularly well to be garbed like this now that she was pregnant. Nobody, looking at her in her fur overcoat, could tell her condition. In the library it was so hot there was no question of keeping on her outdoor clothes, but she always waited until she was in the bay by the window, which she had made her own spot, before divesting herself of the heavier garments. Even then, she wore big sweaters and did not have to resort to the hideous maternity smocks until the last month.

The last month was hard. It was February and the snow lay thick on the ground and there was a bitter wind sweeping in from the sea which meant she could huddle inside her furs and not arouse any comment. But she did not go to the library any more. She did not go out much at all. The two women did not press her, only expressing the opinion that exercise was important and so was fresh air 'for the sake of the baby'. Hazel was unmoved. She was not interested in doing anything for the sake of this baby. Why should she be? She was not going to keep it. It was her fault that she was having it; she admitted readily to herself that it was her carelessness and greed and ignorance that had led to the baby being conceived at all, but that did not make her care what happened to it. It made her angry to think she had been denied an abortion. The baby was a mistake and should have been treated as a mistake. It should have been wiped out. She blamed her mother for not being able to procure an abortion and herself for not insisting. But she had not even tried to abort herself - no sitting in hot baths, drinking bottles of gin, no hurling herself down flights of stairs, no experimenting with knitting needles. Her obedience had been her undoing and she wished she had rebelled ferociously. The anger grew in her with the baby and every time it heaved and kicked in her stomach she punched it back.

She had been to the hospital where she was to have the baby on three occasions only and otherwise had been seen once a month by a doctor. All kinds of information was offered to her about the condition of the baby and about preparation for the birth, but she absorbed none of it. She listened and nodded but said nothing. The only thing that she wanted to know was when the child would be born, and no one could be precise about that. Her own birthday was on 1 March. Her mother must have told Miss Bøgeberg and Miss Østervold because they had made her a cake, a very nice cake with icing on it and the number 18 picked out in little pink sugar roses. Miss Bøgeberg gave her some writing paper and Miss Østervold some talcum powder, and she was suitably grateful. But she went to bed at four o'clock in the afternoon that day, suspecting her mother would telephone and not wanting to speak to her. She thought she might cry and, hearing her weep, her mother might come, which she did not want. She said she was tired and told the two women to tell her mother, if she should ring (which she did) that she would phone her the next day.

She lay in bed on this, her eighteenth birthday, and tried to imagine her mother having her. She knew the details of her own birth but they seemed sparse to her now she was poised to give birth herself. Her mother had always been matter-of-fact: she was born on a Tuesday at two in the afternoon, after a short and easy labour at home, a much welcomed girl after two boys. Her grandmother Rose had come down from the North to see her and pronounced her the image of her dead grandfather. For some reason this had not pleased her mother who, when relating this, always added, 'Nonsense, of course.' Never did her mother talk about any emotional feelings to do with motherhood, and Hazel had always been glad, but now it dismayed her to realise she didn't know how her mother had felt. Nothing had been passed on to her. Her mother had not acted as though she could recall any emotion. In a daze of misery and of apathy she spent her birthday going over what her mother had said when Hazel had confessed she was pregnant. Surely it was shocking, her mother's apparent lack of shock? Her first words had been, 'We must be sensible,' and her second, the instruction to tell nobody. The whole message had been delivered swiftly and coolly: this was a practical problem to be solved in a practical way. The unborn baby was never given any reality beyond being a problem to be solved. And how grateful she had been for such a mother, never once pausing to reflect until now how unlikely such a response was. 'Your life must not be ruined,' her mother had said, and she had agreed. Ruin. An illegitimate baby equalled ruin. Oh, she agreed. 'Times have changed,' her mother had gone on, 'even if not enough. Your life doesn't have to be ruined.' Quite.

She was given 16 March as the most likely date and at once made a calendar so that she could cross off the days, which she did viciously every night. The first vague pain during the night of 15 March she welcomed eagerly, and when her waters broke she was triumphant, not minding in the least the growing strength of the contractions. Getting rid of the baby was a process she so longed to have completed that she did not fight the pain but went with it, surprising the midwife and the doctor in the clinic. They told her she was very brave, for one so young, but they were mistaken, she was not brave. She wanted this *over* and was doing her best to help her body expel the intruder. The greater the pain, the nearer she felt to escape, and the problem for those attending her was to hold her back not urge her on.

She hadn't wanted to know whether it was a boy or a girl but they told her anyway, forgetting what she had requested. But they could not make her look at it. She saw the child's shadow on the wall but then closed her eyes and turned her head away. She didn't open them again until she was in a room on her own and had been assured that the baby had gone. She didn't ask where. Miss Bøgeberg and Miss Østervold took care of everything. She slept blissfully that night. It was all over, the mistake overcome, her body and life returned to her. When her mother came to take her home she was radiant with relief and the impatience to start where she had left off. People back home told her how well she looked, if pale. They asked about Norway and what on earth she had done there, but she recognised their lack of real curiosity. She had only to say a few sentences in Norwegian and they laughed and made dismissive movements with their hands. It was all too easy to return without suspicion just as her mother had known. No one inquired too closely as to what she had done in her year off.

In October, she went to University College to read law. She had always supposed she would go out of London to university, to Bristol or Exeter, or Durham, all places to which her school regularly sent people, but having left London for so long, she had developed an affection for it. Her parents were pleased. They gave her the granny flat, recently adapted out of the basement in readiness for her father's mother who was in poor health and thought unlikely to be able to manage on her own much longer. It had its own entrance and was entirely self-contained, and Hazel would be free to do whatever she liked there. There were no student parties or hordes of young people trooping in and out. There was no loud music and no crashing about. Hazel studied hard and took very little part in college activities. She was an exemplary student just as she had been a model pupil at school. Sometimes her mother looked at her and could not believe what had happened - Hazel was so unruffled, so undisturbed. A period in her young life which had been traumatic had, in fact, resulted in no trauma at all. She was the same Hazel.

But she was not. It took about a year for Hazel to appreciate that she was more unlike other young women than ever. Her original sense of being different had been to do with her desire to be selfcontained, but now she was different through the nature of the experience she had undergone and because it had to remain forever secret. In the company of her contemporaries she felt so used and old that she could hardly relate to them or to their concerns (unless they were to do with work). Sex, sex, sex was the ever-prevailing subject of conversation and pregnancy the ever-present terror; and she had no patience with either. She knew about sex, she knew about pregnancy, but she could confess to neither rich knowledge. She wanted to stay away from both for a very long time. But keeping herself apart no longer came effortlessly. She could feel herself gravitating towards a certain kind of human contact, the kind she had had initially with George, and then shying away, afraid of where it would lead.

George had written to her, several times, letters forwarded to Norway which she had read with such detachment they seemed not to make sense. Who was this man, full of his undergraduate days at Magdalen? He was nothing to her. He was an ex-, and brief, firsttime lover and the father of a child she had not wanted. It irritated her to be reminded of his existence, and she had no intention of acknowledging it. She worried, once she was back home, that he might turn up at her house, or attempt to contact her through their mutual school friends, but he did not. It was enough, apparently, for George to receive no response to his letters for him to decide he was rejected. He had doubtless found consolation elsewhere. He did not know, she couldn't help thinking, how very fortunate he was. In idle moments, she wondered if he would have married her. He couldn't have denied he was the father of her baby - she didn't think he would even have attempted to, not just because he was proud of being honourable but because it could be so easily proved. But he was only eighteen, with Oxford before him. How could they have married? There was part of George, she realised, which would have relished the agony of the moral dilemma to do or not to do the decent thing. Well, she had done it for him. She had borne and got rid of their mistake and saved him from any anguish at all. It made her proud of herself. Not many girls, she reckoned, would have been so unselfish. They would have wanted the boy to suffer. It was remarkable, too, that her own mother had not wanted George named and pilloried - most mothers, surely, would want the boy forced into facing up to his responsibilities and made to pay.

Gradually, though only in the vaguest way, Hazel realised her

mistake had not been entirely obliterated. With time, instead of growing weaker the memory of the baby grew stronger. It was only the memory of a shadow, after all, but that shadow crept around in her subconscious and she did not know how to get rid of it.

Chapter Nine

 \sim

IN JULY, Leah went back to the village, taking Evie with her. The journey, which had seemed adventurous the year before, now seemed tedious. It passed in a daze of discomfort, as she clutched the baby to her breast to cushion her fragile bones from the brutal joltings of the coach. On the way to Carlisle, all those months ago, she had not even noticed how rough the road was as it climbed over the moors. She had no interest now in her fellow passengers and they had none in her – she was just a poor young woman with a child. Choosing to get out at the crossroads and walk the mile to the Fox and Hound, she was overcome with nostalgia, seeing in her mind's eye her former braver self marching so confidently at Hugo's side. Now she trudged, dreading the mission she was on and yet knowing it had to be undertaken.

There was no other way. She had waited long enough. She had sent three other letters but none had been replied to nor had any more money been sent. Those fifty guineas, which had arrived with such speed in November, were long since finished and she had become what she had resolved never to be, a dependant on old Mary. Both of them lived on the washing they took in and though the income was regular it was pitifully small, enough for one person to live on but a struggle for three. Mary never objected. She was used to hardship and found it easy to be even more frugal than usual, but it pained and shamed Leah to witness the extent to which Mary's small comforts were gradually whittled down.

A month ago she had dressed herself as smartly as possible in the one new dress she had made after Evie's birth (believing more money was on its way), and she had gone to Carlisle and into the bank to inquire if a money order had come from Canada for her. But it had not. The clerk had stared at her insolently and smiled, and she had been unable to return his stare with a similar spirit to that which she had displayed on their first encounter. She had bowed her head and retreated hurriedly.

She knew there might be all kinds of reasons why Hugo had not replied and had not for one moment imagined herself finally deserted. He could be ill or dead. Who, after all, would have been able to inform her of this? No one knew where she had gone when she left the Fox and Hound and she had communicated with no one since she had taken refuge with Mary. The only way to find out what had happened to Hugo was to return to the village and ask. The people there would know. They always knew everything, especially if it were scandalous or tragic, about anyone whose family inhabited their village. She had only to appear with her baby, well known to be Hugo Todhunter's bastard (as Evie would be labelled), for information to be showered upon her from all sides. She was prepared for it. Whatever she learned, whatever she had to bear, no one would see her weep. She would return to Carlisle on the evening coach and so back to Wetheral and Mary and face up to whatever was to be her fate. But she had to know - it was unendurable to tolerate any further waiting.

She had never noticed before how the village blurred into the hillside. It was all grey houses, grey-green tiled roofs, grey-brown stone walls and the black road running through it. Even in summer, as now, the hardness of the stone was barely softened. There were few trees – the wind was too strong to allow all but the toughest to stand – and no flowers. It surprised her, but then she had grown used to Wetheral and its soft prettiness, the pink sandstone houses and white-washed cottages and the rich colours of the trees and flourishing shrubs. She thought, as she passed the church, now fallen into disrepair, where Hugo had 'married' her, that she was glad after all to have left this dour spot behind. It was no place to bring up a child, there was nothing here to lift the heart or bring joy and colour into a young life. She pulled Evie closer to her and quickened her step.

No one at the Fox and Hound was glad to see her. Her uncle Tom was changing the beer barrels and hardly looked up. 'Come back, have you?' he grunted. 'What for? Not hoping we'll take you in, are you?' She said no, she was not. Then she stood still and waited, knowing he would not be able to resist passing on whatever malicious gossip he had hold of. The silence was long and humiliating. Evie began to cry and her uncle said, 'Crying for her dad, is she? Then she'll cry a long time, she can bawl her head off all day and he'll not hear.' Leah's heart began to thud, fearing this announcement was the prelude to news of Hugo's death. 'He hasn't come home, has he?' her uncle went on. 'Disappeared, that's what, clean off the face of the earth, or Canada, any road. And in debt, as usual, owing his relatives a packet. You got yourself tied up with a rascal there, Leah, but you can't say you weren't warned.' Leah turned and began to walk out. 'Hey, where you off to without saying a word? Going to his parents? Well, they'll give you nothing, my lass, they're tired of him and his bastards, they've had enough of women knocking on their door with his babies in their arms ...'

She did not hear any more. The last jeer, she was certain, was made up and thrown at her only to hurt and worry; but she had perfect faith in Hugo. It was the kind of rumour about him there had always been and she took no heed. There was no point her staving in the village any longer, but it was some hours before the coach would return to the crossroads. There was nowhere for her to go. She had no friend to visit. She had worked, she had walked and she had gone to church to sing in the choir, but otherwise she had had no life in this bleak village. She would go to the church now, not St Kentigern's but St Mungo's, the new parish church, where she had gone every Sunday after they closed the other. She would sit quietly there and feed Evie and eat the bread she had brought with her. She might even sleep a little and the thought comforted her. There was so much to absorb. If Hugo had vanished, leaving debts again, what did it mean for her? No more money, for sure. He would be so wretched and ashamed and this would prevent him contacting her. He would imagine she would now wish to cast him off. How, then, could she reach him and tell him this was not so, that she wanted him on any terms and could forgive him sins far worse than running up debts or failing in business? Her head ached and she longed for the soothing interior of the church.

But on the way there she was bound to pass the Hall where the Todhunters lived. Her steps slowed. She stood at the gates, both standing open, and looked up the drive. It was not a long drive and the house could clearly be seen, squat and square, with its broad oak door. Hugo had told her he was afraid of his father, who was a bully, but that he loved his mother and his sister. His mother and his sister were called Evelyn, and Leah had taken that name for her baby, thinking to please him. She went on standing there, quite still. She imagined herself doing what her uncle had so untruthfully said many girls had done before her – walking up to that door, knocking, and presenting Hugo's child and claiming support from his family. She would never do such a thing, of course, not even for the sake of her baby. But it seemed hard that Evie's presence, her very existence, should remain a secret from her father's people, some of whom, the women, might be glad to know of it. She resolved that when she had Evie baptised she would send a card to Hugo's mother. A baptism card would surely not seem like a demand for help but a mere notification of fact.

She reached the church and sat inside for several hours and was bothered by no one. She did not sleep but nevertheless was refreshed and ready to face the long journey home. Mary was glad to see her, having feared she would not come back at all. Leah told her the truth, that Hugo could not be looked to any more and that she must provide for herself and her child as best she could. She believed that one day she would see him again but it was impossible to guess when that would be. Mary said nothing, only that Leah was a good worker and she was a good worker, and she was sure the child would in due course be a good worker; and they would manage. And manage they did.

Leah began to keep hens and grow flowers in their garden. She was given four hens and a cock by a farmer's wife whose washing they did and they were lucky, the hens under Leah's care were great layers. They sold the eggs and bought more hens and soon had a regular enough supply to make it worth going by cart to Carlisle market to sit at the butter women's stalls and sell their eggs there for a good price. They sold flowers, too, bunches of lavender and carnations and, in the spring, daffodils and tulips. They paid their rent on time and had food to eat, and Mary, at least, was happy. Leah was less so. It was not that her life was hard which depressed her - it had always been hard and in many ways was not actually as hard as it had once been - but thoughts of the future, hers and Evie's.

Hugo was becoming a dream from which she had woken up with feelings of bitterness she had never thought to have. She had been a fool, to trust him as she had done. She did not blame him nor did she think he had acted at the time of their loving with any deliberate deceit. She quite believed his love for her had been real and his intentions sincere, but what she ought to have seen was his inability to carry them out - that was where her faith had been misplaced. His own parents had had to learn the same lesson and though he had instructed her in how they had learned it, she had not heeded him. She had given way to her own strong desires and had believed in the power of love to solve all problems. And now she had to pay for her folly.

But what disturbed her most was how she seemed unable to stop herself blaming Evie. Leah had loved her unborn baby fiercely. and continued to love her while she was still sure of Hugo: but increasingly now she had come to see Evie as a constant reminder of her own stupidity and Hugo's weakness. By the time Evie was two, Leah had to force herself to hold her in her arms at all - Hugo's eves, in Evie's face, were an affliction and his hair, framing the child's face, made her want to cut it all off and burn it. Evie was all her father - the eves, the hair, the skin, the small ears, and it was agony to see this. It troubled Leah deeply to feel anything other than love for her child, and she hoped she never betraved her lack of it. but she could not control her sense of a shocking alienation. It was a relief, always, when Evie was not with her. Poor Evie, poor Evie, she said to herself, the saddest of refrains running constantly through her head, but her pity combined with guilt to intensify her bitterness towards the child. Mary, old Mary, was the one who gave Evie affection. It was a touching sight to see the child on her knee. being sung to, or holding her hand and staggering (both of them) round the garden. Evie called Mary 'Grandma' and Leah did nothing to correct her. It seemed natural that Mary should regard herself as grandmother to Evie. Once, Mary told her, she had had her own little girl, her own baby, but she would not tell what had happened to her.

From the little girl's own grandmother there had been no sign, though Leah had sent Mrs Todhunter a baptismal card. In some vague attempt at continuity she had taken Evie back to Caldewgate to be christened in the same church, Holy Trinity, where she knew herself to have been christened. But she had regretted this. She ought to have taken Evie to Wetheral church, which she now attended every Sunday and where she sang (though not in the choir). Wetheral was her home now and except for the weekly trips to Carlisle market she did not suppose she would ever leave it. She was only nineteen but her life seemed mapped out for her, at least until Evie was grown up, and probably for ever.

Others did not think so. Mary saw how the men ogled Leah and knew it was only a matter of time before she was made an offer it would be absurd to refuse. She dreaded the day when Leah would capitulate and kept an eve out constantly for threatening suitors. There were plenty. Even the curate was smitten, though fortunately he realised, as Mary did, that he had no hope. Leah had not a single good word for any of them. Men fell over themselves to please her and she took no notice. Mary knew Leah believed herself no longer attractive since the birth of Evie had thickened her waist and left her heavier, but she was wrong. Her figure was all the more pleasing since it had filled out, at least to the men it was. Marv knew Leah also thought the severity of her dress and the way she wore her hair made her ugly, but it did not. The lack of adornment, the blonde hair pulled tightly into the nape of the neck, the dark brown dress – all accentuated her beautiful complexion, the translucent quality of her skin. Even her reserved manner and her lack of conversation made her appealing, gave her a quality of mystery. In the market especially. Mary noted the looks. Among the ruddy-cheeked, weather-beaten faces of the butter women, Leah's stood out, a pale flower amid the florid colour. Her composure, as she sold her eggs, contrasted with the laughing, restless energy of the other women who twisted and turned to talk to each other all day long. It would have taken a blind man not to notice Leah Messenger in that setting. and the men in Carlisle market were not blind.

Henry Arnesen, though not blind, was severely short-sighted. He had struggled for years not to give in to the wearing of the eyeglasses he hated, but it was impossible for him to follow his trade as a tailor if he could not see clearly. Twice, at fairs, he had paid good money to people who claimed to be able to cure poor sight and twice he had been made a fool of. Now he wore his spectacles – two pairs, one for close work and one for distance – with resignation, goldrimmed ones, as light and invisible as they could be made. He was sure they made him look old and unattractive, but in this he was mistaken. The glasses did not detract from the pleasantness of Henry's features and they magnified his striking blue eyes – 'Too beautiful for a lad,' his mother had always said. He had thick brown hair and a splendid bushy moustache, and he was tall and well built – he was, without realising it, a handsome man.

But it was true, all the same, that, at the age of thirty, he was not only unmarried but had never gone courting seriously. His mother, anxious for grandchildren (Henry was her only child). complained about it. Henry's excuse was that he worked too hard to have the time for courting. This was partly true. He did work hard in his modest premises in Globe Lane. His father, also a tailor, had set him up there when he was twenty-one, and Henry had since repaid the investment many times over. When his father died Henry had taken on his regular clients too and had been supporting his mother ever since. Not only did he cut and sew clothes. made to measure, but on Saturdays he had a stall in the market selling material. Saturday was the busiest day at the market, when all the country people came in to sell their produce and, with any profit they made, might treat themselves to a length of fabric for a dress. Henry had a good eve for what these women liked and stocked his stall accordingly. Sometimes he made as good a profit on a Saturday as he had all the rest of the week. Besides. Henry liked his Saturdays. They were relaxing. He didn't have to wear his spectacles, because there was no need to see clearly. True, things were a bit hazy but he could manage perfectly with a little care.

He first saw Leah through a haze. He was standing behind his stall during a momentary lull and, staring across the sprigged cottons, he saw her pale, delicate face among the row of red ones. It seemed so still and pure among the tossing and turning of other heads, and he fumbled for the correct pair of spectacles and put them on. Leah's face sprang sharply into focus, a sad, quiet face with downcast eyes and a mouth closed and firm. But nothing could conceal the perfection of the skin, nor could the serious expression rob the face of grace and natural refinement. Henry kept his glasses on and watched Leah all the rest of the afternoon. He saw her leave with an old woman who was carrying a child. The child must be this younger woman's, which disappointed him. She was almost certainly married, then. He took his glasses off and sighed. It was always the way. Any woman who caught his attention was invariably married. Probably she was a farmer's wife, in from the country with her butter and eggs and about to be collected by the farmer in his cart. He thought he would just check to see, but his mother, who was usually on hand to look after the stall while he took a break, was indisposed that day and he was on his own.

But the following week his mother was there and so, he saw, was

the woman with the pale, delicate-boned face. He waited all day, observing her closely, and when the other, old, woman arrived with the child, as before, to collect her. Henry was ready, and he followed. He saw them go out of the back entrance and down towards the sands where they got into a large cart, already full of women, and off they went. It proved nothing. All farmer's wives, all going to the same village, likely. But the absence of a particular man and his individual cart gave Henry a small scrap of hope. The following week he left his stall half an hour before the general packing-up time and went down to the sands where all the carts were waiting. He recognised the cart he had seen the week before by its extra large, muddy, red-painted wheels and approached the driver. Henry was direct, seeing no point in subterfuge, 'Where are you going to?' he asked. The driver barely looked at him. 'Wetheral and parts,' he said, 'and no room for any more, like.' Satisfied, Henry went back to the market. Wetheral wasn't far. Five miles or so. He had occasionally taken his mother there and rowed her across the river Eden to Corby. Very occasionally. So occasionally he couldn't remember the last time. She would be delighted if he suggested such an outing now.

It was foolish, of course. Henry knew this perfectly well but nevertheless he drove his mother to Wetheral in his smart little pony trap – only recently acquired and a source of great pride – and once there the two of them walked round the village green and down to the river and sat watching the salmon leap. Henry had not expected to see the woman who intrigued him parading around Wetheral for his delight, so he was quite philosophical when she did not put in an appearance. But every Saturday thereafter when he saw that pale face on the far side of the market he derived some curious pleasure from knowing she came from Wetheral. It gave him an advantage, he felt, though it took him a long time to put this to any kind of use. He noted that the woman sold flowers as well as eggs and he began to buy them from her for his mother. Every week he bought two bunches of whatever the Wetheral woman had, taking care, Carlislefashion, to betray not the slightest interest in her. Only when this transaction had been going on for twenty-five weeks - he had counted - did he chance any attempt at conversation and even then he limited himself to pleasantries, all of which were responded to with similar ones. After almost a year, he was quite pleased with how things were going and was working himself up to bolder action, convinced that such was his subtlety that his true interest had not been guessed at.

Mary had guessed within a month of Henry's performance what he was about and so, really, had Leah. Henry was not alone. Many market men had suddenly begun buying flowers for astonished mothers, and Leah had reaped the benefit. But where Henry was different was in his patience and extreme caution. Mostly Leah's customers could not contain their ardour beyond a couple of weeks. Then, they would buy the flowers, thrust the money into her hand and ask her if they could bring her a cup of tea or, if they were very forward, meet her behind the market after it closed. These men were amazed, even shocked, by the straight rejection they met with and the look of anger which blazed from what they had misjudged as a calm, docile face. They were frightened off and never came back. Leah began to earn a reputation as one who belied her looks, a woman who was after all a spitfire, and Henry naturally heard what was said about her. The market looked vast but it was a small world and gossip circulated easily. He heard also that Leah Messenger - it was good to know her name at last - did indeed have a child, a girl, and that, though she wore a wedding-ring, there was neither sight nor sound of a husband.

Henry thought long and hard about the child. She would be a complication, were he to proceed. Undoubtedly, Leah would cling to the child and consider her future of more importance than her own, he was sure of it. Mothers, he had observed, were like that. So the question he pondered as he stitched away all week was, did he mind the child? She looked, so far as he could tell, a quiet little thing, never giving any trouble. During the hours she was with her mother and not taken off by the old woman she seemed to sit still and keep quiet. There was no running about shrieking, as many of the children did. But was the child a product of a marriage now over, for whatever reason, or of some unfortunate liaison? Was Leah Messenger, in short, what could only be called a fallen woman, and if she was, did he mind? Henry decided he did, a little. He had always thought that any woman in whom he took a serious interest would have to be above reproach. He was honest himself and highly moral, and expected the same standards in others. His own chastity, at thirty, was not something he could say he relished - far from it but on the other hand he was not ashamed of it. He knew what lust was and it had caused him some anguish, but he also knew how to

deal with it, or to control it without hurting anyone else. But he was tired of such control and yearned to have a wife. It was time.

It became irrelevant to Henry, after the first year, whether Leah had a child or not and what the existence of that child signified. He felt hypnotised by her. With or without his glasses, he found that her face swam before him all the time and he longed for Saturdays. At Easter, he bought all the flowers Leah had with her in a sudden uncharacteristic moment of recklessness. 'All?' said Leah, startled, since, because it was Easter, she had a great many flowers - tulips, narcissi, daffodils - arranged all round her in buckets. 'All,' said Henry firmly. 'But how will you carry them?' Leah asked. Henry made a gesture to indicate this was of no concern. 'I'll come for them when you pack up,' he said, grandly. When that time came, he took an Easter egg with him and asked permission to give it to the child. This was readily granted, and so was his polite request to wait while he ferried all the flowers across the market and up Lowther Street into Globe Lane (where he intended to leave all but one bunch in his workroom). It took him three trips and as he collected the last few bunches Leah became agitated, as he had known she would, and confessed she was afraid she would miss the cart home. Addressing old Mary and not Leah herself, Henry begged to be allowed to take them home to Wetheral himself since he was the cause of the delay.

Permission was very nearly not granted and Henry's flamboyant gesture of buying all the flowers was very nearly a grave mistake. Leah had respected his slow advances and had tolerated his addresses only because they were modest, even timid and presented no threat. She had hoped she would never have to put this niceseeming man down, but now she was not so sure. Her hesitation was marked but Henry had the sense not to try and persuade her and this swung the verdict in his favour. Elated, but struggling to seem matter-of-fact, he rushed off to deposit the last of the flowers and to get his trap and harness the pony, all of which took him far longer than he expected. When he finally came into view, down Market Street, Leah, Mary and the child looked a forlorn little group and he was touched by their evident anxiety as to whether he would turn up at all.

He tried to make the drive last as long as possible which was not difficult because although the trap was new the pony was old and rather tired. He had seated the child, Evie, beside him, between himself and her mother, and the old woman in the back. Gently, he put the reins in little Evie's hands and allowed her to hold them all by herself for a while on a straight and empty piece of road. If Evie had been older and talkative she might have given him the means to learn a great deal that he wanted to know about her mother, but since she was so very young and utterly silent she was no help. By the time Wetheral came into view Henry had gleaned no information about his passengers whatsoever. Leah volunteered nothing and he had asked nothing. She did not speak until they came to the turning off the green and then only to direct him to where she lived. The tiny terraced house did not look big enough to be home to more than the three people he delivered to its door, but he cautioned himself against optimism. He lifted Evie down and helped the old woman out and then, without hanging around, he doffed his cap and, brushing aside Leah's thanks, set off at once back to Carlisle.

Later in the same week, one evening after work, he went out to Wetheral and strolled around. He resisted the temptation to walk past Leah's house and instead passed the road end and walked along the river. From the river road, he climbed the steps which brought him out near the Crown Inn, and on a sudden impulse he went into the bar. It was fairly full and he almost walked out again but his thirst was great and he wanted a glass of beer before going home. Supping his beer at the bar he heard, as he was aware he had secretly hoped to, mention of the Messenger name. The two men standing just along the bar were talking about a rumour of some cottages being knocked down nearby and the tenants being put out into the street. A Mary Messenger was mentioned, with sad shakings of the head, and 'that young lass with the child who lives with her'.

Henry finished his beer and went up to the green to untie his pony. His mind was quite made up. He would ask Leah Messenger to marry him and he would say he was happy, of course, to accept Evie and love her as his own. His offer would surely be irresistible if it was true that Mary was to be evicted from her house. But would he take on old Mary too? He thought not. Surely that much would not be expected of a man. He would have to make it very clear that his offer did not include giving a home to old Mary. At least he could not be taken by surprise.

The surprise, when it came, had nothing to do with old Mary and was a much greater one than Henry had envisaged. It was more of a shock than a surprise. When he duly proposed to Leah, during a drive arranged with some difficulty, she said she had two conditions.

One was that he should never question her in any way about the father of her child. She would not reveal his identity, ever, nor did she wish to disclose the circumstances of how she had met him or what happened. She said so far as she knew he was in Canada and. since she had heard nothing from him in three years, she regarded him as dead. There had been no one before or since. The weddingring was real but did not signify a legal wedding. Henry listened carefully and said he would never, ever, mention anything to do with this episode in Leah's life. She need have no worries on that score he would accept her as she now was, with her child. But then came the shock. Leah's second condition was so extraordinary Henry thought he could not have heard aright. He asked her to repeat what she had said and bid her wait until he had stopped the pony so that the noise of its hooves and the rattling of the trap would not interfere with his listening. 'I can't have Evie living with us,' Leah said, calmly, 'she must go with Mary. We must pay Mary to keep her. I can't marry you if I have to bring Evie. I must start afresh. that is all'

For a long time Henry sat stock-still, wondering what kind of woman Leah was after all. It occurred to him that this might be in the nature of a test, a test perhaps of his decency. Eventually, starting to drive again, he said, 'But she is your child, she is barely more than an infant.'

'I know she is my child, but I cannot bear the pain of her. If I marry you it is to put all that pain behind me. I cannot love her as I should and would wish to. As I ought, as I have wanted to. Mary loves her. You may judge me harsh and cruel, but that is what I want, Evie to go with Mary if I am to go with you and be your wife.' This last was spoken in a whisper, with bowed head.

Henry took a quick look and saw the tears falling. 'Now then, now then,' he said, lamely and, clearing his throat, 'there's a lot to understand all of a sudden and I'm trying, but nothing alters my wanting you as my wife, I'm clear on that, if on nothing else.' They trotted a bit further until again Henry stopped the pony. 'You're the mother,' he said, 'it's for you to decide, not me. I only hope folk won't think I wouldn't stand for the child. It'd be natural for them to see it that way, whereas ...'

'Yes,' Leah said, 'you would take Evie, you made it plain.'

'To you, but it wouldn't be plain to others.'

'Would that matter?'

'I wouldn't like misunderstandings, to be thought ...' 'People forget,' Leah said. 'Hardly anyone knows me.' 'They see more than you think in the market.' 'Well, if you feel you can't ...'

'No. If that's what you want, then that's how it will be. Unless you change your mind, when it comes to the bit, and keep the child.'

'I won't,' said Leah. 'I will never change my mind. I would wish her a thousand miles away. Do you still want me as your wife?'

'Yes,' said Henry.

Chapter Ten

 \sim

I^T WAS a quiet but very pretty wedding, all planned for the gratification and pleasure of Hazel's mother. It was what she most wanted, and Hazel could not see how she could refuse to co-operate. Her mother had been so sad ever since the shockingly sudden death of her husband the year before – he had been only sixty-two and in good health. It was the unfairness of it which continued to grieve his widow. Hazel felt she could not add to that sense of grievance by marrying Malcolm in a register office, as she would have wished, and so she capitulated and left all the arrangements to her mother, who was quite restored to life for a while.

A pretty country wedding in Gloucestershire, where the Walmsleys had a cottage. Hazel walked from the cottage to the church, which was just down the hill and round the corner, a matter of eight hundred vards (Mrs Walmsley had the distance measured, the better to time the bride's entrance). Her eldest brother gave her away and very imposing he looked in traditional morning-dress. Hazel wore a deceptively simple-looking dress, white of course, white satin with a long, narrow skirt which made her look even more willowy than usual. She carried a spray of tiny yellow rosebuds, the colour of the bridesmaids' dresses. Four bridesmaids (her nieces) all under the age of ten and balanced in height to a most satisfying degree. Very sweet the little procession looked - 'like something out of Hardy', one of the more literary guests was heard to murmur. It was a windy day in April and the wind caught Hazel's veil and whirled it round her, though gently, and lifted up the dresses, adding an air of life and vitality to their slow progress. The church was beautifully and unusually decorated, with bowls of primroses and jugs of catkins.

Mrs Walmsley could not be completely content, since she longed

for her dead husband to be at her side to witness this happy event, but she came as near as possible to perfect contentment for the duration of the service. Hazel looked absolutely beautiful. She was quite unselfconscious, lacking entirely that nervous embarrassment which afflicts so many brides, and she moved with a rare grace and composure towards the altar. Who, reflected her mother, would ever guess Hazel's past? Or guess that hidden part of her past? Things could have been so different. Mrs Walmsley felt momentarily ill when she thought how different. If she had not acted, all those years ago, with such speed and efficiency, Hazel's life would have been wrecked at eighteen. She would never have gone to university, never qualified as a solicitor, never met Malcolm McAllister, who was so exactly right for her. Her whole life would have been ruined for the sake of one mistake. And not just her life, the life of the child, that child who had now been part of another family all these years and much better off. The burden on the child would have been intolerable. Mrs Walmslev had no doubts about this. She had doubts about very few things, in fact, though she had always tried hard not to think how her husband would have reacted if he had known why Hazel was really going to Norway. He had always let his wife manage domestic matters, but perhaps her secrecy on that momentous occasion would have appalled him. Perhaps. She didn't know.

But there before her was Hazel, a beautiful bride. Her mistake was never referred to. It had not been mentioned for years. Only when Malcolm had come on the scene had Mrs Walmsley been unable to resist the merest suggestion that Hazel should perhaps think about ... Hazel had been sharply offended. 'Mother,' she had said, more angrily than was surely necessary, 'Mother, surely you don't think I would let myself get anywhere near the point of marrying without being able to trust whoever I was involved with?' Mrs Walmsley had said no, of course not, but that it would be difficult and maybe, just possibly, there was no real need ... But Hazel had been even angrier. 'No *need*?' she had almost shouted. 'Mother, how could I not tell my future husband something so important?' 'Oh,' Mrs Walmsley had been unable to stop herself saying, 'Oh, is it important now, darling, when it was so long ago and over so quickly?'

The reception was in the house, spilling over into the garden. The wind dropped during the afternoon and the sun came out, and once the lunch was over everyone went outside. It was all very relaxed and Malcolm's people, who were rather under-represented (most of them seemed to have emigrated from Scotland to live in Canada), were particularly pleased with the informality. They were shy people, socially quite timid, Mrs Walmsley was surprised to discover, since there was nothing timid about Malcolm. His parents hardly said a word, though as the afternoon wore on they looked more at ease and loosened up sufficiently to express their appreciation of Hazel. She was the daughter-in-law they had always wanted. Malcolm was so fussy and they had begun to despair that he would ever consider any woman matched up to his high ideals. Hazel, they could see, did just that. She was flawless – beautiful, clever, diligent and without a divorce or some other entanglement in her past. They could not, they said, believe Malcolm's luck.

At five o'clock Hazel changed into jeans and a sweatshirt - she didn't think that indulging her mother with a traditional wedding meant she had to dress up conventionally to 'go away' - and left with Malcolm, similarly clad, for Heathrow airport where they boarded a plane for the Algarve. They reached the villa they had rented just before midnight and went straight to bed, to sleep. They had had their first night long ago, at Malcolm's flat. It was the first sex Hazel had had in eight years. There had been no one since George, not through lack of offers but because she would not allow such intimate contact. Something in her was damaged, though she was not sure what. Several times she had been tempted. But she had deliberately held back, forcing herself to consider the consequences of her desire. It was not that she was afraid of becoming pregnant again. Contraception was no longer a problem. The game had changed. She could take the Pill and, in common with her generation, she had no qualms about this. What she had qualms about was her self and her needs. She was afraid she would want to dispense with a lover the moment she had been satisfied. Then there might be a mess and she dreaded the complications of an unsatisfactory affair. She had never met any man who seemed worth the risk.

But Malcolm seemed worth it. He didn't want to own her mind as well as her body. What had first attracted him to her was that very air of detachment she so prized. He wouldn't, he said, want her to sacrifice this in order to accommodate him. He had proved, during the two years she had known him, as good as his word, and she loved him for it. Realising she loved Malcolm was such a relief, such a blessing. It freed her from the growing conviction that she was so self-contained she was incapable of loving another person, and selfish to such a frightening extent that she would never be able to put anyone else's needs before her own. The closer they became, the more she was liberated from self-obsession until, after six months, she was ready to move in with him. Malcolm said there were a few things she should know first. He told her he had been living with someone for four years before he met her. The flat he lived in had belonged, originally, to this woman. He took it over when they split up and she went to America. This, Hazel realised, explained the ruched blinds, the white lace bedspread and shaggy carpets so uncharacteristic of Malcolm, who had never had time to change them.

Malcolm offered to tell Hazel in detail about his 'previous' as he called her, but she declined to be enlightened. She said she didn't want to know about Malcolm's past, beyond simple facts such as where he was born (St Andrews) and if he had parents alive (ves) and brothers (no) or sisters (yes, one). She wanted to know him but not whom he had been with. 'Ah,' he had said, smiling, teasing her, 'but can you ever really know a person without knowing who they've been with? Aren't people their past?' It had been the perfect opportunity to tell him about George and the baby, but she wasn't ready for confessions. To her relief, he made no attempt to pry into her own immediate past, though he did express surprise that she had never lived with a man before him. Once they were sure of each other and had agreed to marry, Hazel knew she could keep silent no longer. He had to know about the baby she'd given birth to and abandoned, and she had to know what he thought about this. She intended to choose her time well, but in the end didn't choose it at all. Malcolm chose it, by asking her if she wanted children. They'd been to see his sister who had two boys of six and eight, both of whom Malcolm clearly adored. He'd played all day with them in a way Hazel found extraordinary - she hadn't suspected he would like fooling around with children so much, and she'd said so on the way home.

'Oh, I like children,' he'd said, 'don't you? Don't you want children? I mean, don't you want us to have a family eventually?' Her silence went on so long he became anxious and took his eyes off the busy road long enough to shoot her a quick look. 'What's the matter, Hazel?'

'I'll tell you when we get home,' she said. She wished she'd

blurted it out there and then, when he was driving, as though it was a casual bit of information she thought nothing of. Instead, by the time they did get home, this thing she had promised to tell him had built itself into something of huge significance and she was irritated by his clear expectation that she had some momentous disclosure to make. He opened a bottle of wine and she made sandwiches and they sat by the fire and, though he did not prompt her, she knew she could put it off no longer than she already had done.

'It's just,' she said abruptly, looking directly at him, 'that when I was eighteen I had a baby. It was adopted.'

He put down his glass and clasped his hands in front of him in that way he had, the way of seeming to brace himself, which she had noticed first about him. He'd been sitting in court exactly like that, hands clasped and pulled into his chest in that tense fashion. 'Adopted?' he asked, finally, and then, very carefully, much too carefully, 'Were you happy about that?'

'Yes. But I'd have preferred an abortion, if I could have found out how to get one.'

'So, obviously, you didn't want the baby.'

'Obviously,' she said, unable to keep the sarcasm out of her voice. 'Very, very obviously. I was only eighteen, seventeen, in fact, when I became so stupidly pregnant.'

'Stupid? I can't imagine you were ever stupid.'

'Well, I was. I was carried away.'

'I can't imagine that either.'

'No, you can't imagine any of it, I wouldn't expect you to. I can hardly imagine it myself now.'

There was a long silence. His face hadn't changed, the expression remained calm, but she saw a little muscle beating in his jaw. She wanted him to say something else though she couldn't think what. When he did speak, his question was exactly what she did not want from him.

'Do you know what happened to the baby?'

'No. I didn't want to. It was adopted.'

'It? Boy or girl?'

'Does it matter?'

'I'd like to know.'

'A girl.'

'Did you see her?'

'No. Only a shadow. I didn't want to see her, ever.'

'I suppose that's natural, if she was going to be adopted. They say women change their minds once they've seen the baby.'

'I wouldn't have changed my mind. I wanted to be rid of it so much.'

'No feelings for her?'

'None.'

'No guilt? No pity?'

'No. I was angry.'

'With the baby?'

'Yes, with the baby, even if it wasn't to blame.'

Malcolm nodded, and this annoyed her. He suddenly seemed complacent and smug. He was treating her professionally and she hated this.

'Well, then,' she said briskly, 'that's what I felt I should tell you.' 'I'm glad you did.'

'I'm not.'

'Oh, why not?'

'I've never told anyone, ever. Only my mother knew. My father never did and my brothers don't, and I liked it like that, secret. It isn't something I want to talk about even with you. It upsets me.'

'Pride,' Malcolm said. 'It all comes down to pride. It often does with you.'

'Does it indeed?'

'Yes. You're proud of being secretive, self-contained. It's a loss of face to have to reveal something so hidden.'

'Clever, aren't you?'

'Yes. So are you. Clever enough to know *I* know why you're upset, and it isn't anything to do with telling me about the baby. It's what I make of all this, isn't it? Whether I'll hold it against you? Whether I'll want to know who the boy was and all the other details? That's what's upsetting you, not the giving of the facts.' He refilled his glass and hers. She smiled. She liked it when he so neatly and accurately summarised her thoughts. 'Well, I do feel quite shocked,' he said. 'It *is* quite shocking, and sad, to me anyway, the thought of you, at a mere seventeen, eighteen, whatever, having to have a baby you didn't want. Awful.' He put his glass down and reached out and touched her hand, and to her own surprise she found tears welling up in her eyes, but she was determined not to let them fall. 'And I can't help thinking of that baby ... your child ...'

'I never think of it, the baby.'

'Is that really true?'

'Yes. I dream of its shadow sometimes, nightmares I suppose, but I never think of it growing, as a person. I don't want to, I won't allow myself to.'

'And what about having other babies, ours, and keeping them? That's how all this began, didn't it, when I said didn't you want children?'

'I don't know if I do.'

'I want them.'

'Well then.'

'Well what?'

'If you want them, I'll have them, I suppose.'

'Hazel, please, what do you think I see you as? A breeding machine? Why would I want to make you have children if you had no desire for them? It would be horrible.'

'I don't see why.'

'Then you should.'

Nothing more was said that evening, but Malcolm seemed preoccupied and distant for some days afterwards, and she felt sorry to have burdened him. She could see he was worried and struggling with the idea that he might be going to marry a woman who did not share his vision of family life. There was nothing she could do about it. He had to accept her lack of maternal instinct because it was so much a part of her that it could hardly be concealed.

Philip was a honeymoon baby. It was, of course, a failure of contraception, not an accident or mistake – she had not been stupid again – something to do with that tiny degree of unreliability which she knew should always be taken into account even with the Pill. But this time she could, she also knew, arrange to have an abortion if she wished – a speedy, painless operation if done at once, no more serious, they said, than having a tooth out and far less messy. Before ever she told Malcolm, she considered her options and decided she would have this baby. What she felt was not the excited satisfaction Malcolm would want her to share with him but more a sense of quiet pleasure, the pleasure of his delight. But was that enough? She remembered how she had loathed her body that first time, and how she had detested the whole process of pregnancy and birth. Was it worth going through it again on the grounds of giving Malcolm

what he wanted? This time the baby would not end up a shadow. It would be hers, to nurture and love, and she wasn't sure she could fulfil this curious role. Giving birth in itself, she had cause to know, did not automatically produce instinctive maternal feelings.

She said nothing at all for three months. Every day she asked herself if she felt any growing spark of love for what was developing inside her, but came up all the time against an inability to identify her own response. It was only by isolating what she did not feel that she could arrive at any kind of decision. She was relieved, for example, to realise that she did not feel any hatred or resentment. that she did not feel her body had been invaded or assaulted. She did not feel, either, that she was not in control. That was the most important thing: whatever happened this time she felt in control. She could have the baby, or not have the baby. There was no need to place herself in her mother's too capable hands. Then one weekend, when they were visiting Malcolm's sister again. Hazel noticed a newly framed photograph on the mantelpiece of his nephews as babies. One of them, the younger one, was, his sister pointed out, exactly like Malcolm as a baby. Hazel picked it up and studied it carefully. A chubby, smiling little Malcolm. Her stomach gave a flutter and a sudden thrill went through her - how very odd it would be to see Malcolm, whom she loved so much, as a baby.

She didn't know if that amounted to the beginnings of maternal love or not, but she took this unexpected emotional reaction as good enough evidence of something similar, and was relieved. Her decision seemed made for her. She told Malcolm that night and his jubilation was matched by his concern for her - did she want this baby, was she sure she wasn't going ahead just to please him? She convinced him that she did want it and he actually wept with happiness. (How, she wondered, could a man want a child so much?) Her whole pregnancy was a happy time and she enjoyed it. Occasionally she would remember Norway and the misery of those months and shiver at the memory, but there were no shadow dreams during the whole of that time to haunt her. She had to tell the hospital this was not her first baby but she did so without embarrassment and did not mind the few questions she was obliged to answer. When the date of the birth grew nearer she found herself praying she would have a boy. Philip was born after a short labour and the moment he was put into her arms and she looked at him, a great weight rolled off her mind - she did love him, she did feel what she was supposed to feel. But then, during the next few days, which should have been blissfully happy, a strange anxiety came over her. It felt precisely like that, something which came over her, a fog, a muzziness, and with it an unreasonable terror that she was not in control of herself. She did mention this briefly, hesitantly – it was so hard to describe – to a doctor, before she left the hospital, but was reassured that this dizziness (but she knew she had not said she felt dizzy, that it was his word) was a common post-natal symptom. It was all to do with re-adjusting to a different balance and to the shake-up of her hormones. She accepted this but the mental distress did not go away. It increased. She struggled to conceal her agitation but then she began hallucinating, seeing in front of her that other baby, the one she had given away without in fact ever seeing properly.

Malcolm, normally acutely sensitive to her mood, noticed nothing. He was so thrilled to be a father that he failed to detect, underneath her smiles, the tremors of real fear and, though she was an expert at suppressing emotion, she found it hard. Handling Philip, changing his nappy and seeing the fragility of his tiny body, watching his head loll if it was not supported, hearing his cries – all these things unnerved her. She felt so ill at the thought of once having wilfully abandoned such a dependent creature. It was brutal to remember, especially when she was feeding Philip, when his minute hands clawed at her full breast and her milk spilled from his mouth. None for that other baby. It had been denied everything, *she* had denied it her milk, her care, her tenderness and yet it had been hers, it had belonged to her, as Philip now did.

When she began to have nightmares it was almost a relief. She woke Malcolm with her screams, but could not tell him what had made her scream. She said she had dreamed that Philip was harmed and made a performance of getting up and checking him in his cradle. Since it was so easy to understand why she had this hideous dream, always beginning with that glimpse of the dangling shadow on the white wall, the shadow of her other baby, she tried hard to rationalise the content of the nightmare. Everything she had not let herself feel then she was feeling now. The nightmare was about acknowledging not just guilt but emotion. Though during the day she worked all this out satisfactorily, she still, however, woke up screaming at night. Malcolm held her close, soothed her, put the light on, made her a calming milky drink, did everything he could think of to reassure her. But he knew, after several weeks of these shattered nights, that this was not the natural anxiety of a mother for her newborn baby.

'Come on, Hazel,' he said, stroking her hair back from her damp forehead when at last her shivering had subsided, 'what's this about? What are you dreaming of? Tell me. I want to know.' She was silent, but began to move away, out of his arms. He resisted, holding her closer still. 'Come on,' he urged, 'tell me. This is no good. You're making yourself ill. Tell me.' She murmured there was nothing to tell, it was all 'silly', the way nightmares always are. 'You wouldn't scream like that if it was just silly,' he said firmly. 'You scream because you're terrified. What terrifies you, what do you see?' She said she couldn't bear to talk about it. Depressed, he realised there was no point in pressing her. They went back to sleep. But the next time the nightmare happened and her screams began he was ready. He didn't put the light on, nor did he hold her. He stayed quite still and let her scream and saw in the half dark how she sat up and seemed to push something away, shouting, 'No! No!' Then she collapsed back on to her pillow muttering almost incoherently about babies and weeping.

Next morning, he said to her, quite calmly, 'You had your nightmare last night.'

'Did I?' She looked embarrassed. 'I don't remember.'

'No. I didn't wake you up out of it. I thought I'd watch and listen.'

'And did you learn anything interesting?' she said, smiling, but alert, knowing he had.

'Yes. You talked.' He waited. Tricks like this were well known to them both. 'You talked about babies, in the plural. And you fought something off and shouted "No", repeatedly.'

'So?'

'So tell me. Don't make me guess.'

'I'm sure you've already guessed.'

'Stop it, Hazel. Why do I have to put into words what you can say much better? Is it some kind of test? Do I have to go through this when all I want to do is understand and help?'

'You can't, you couldn't understand. And no one can help.' 'Thanks.'

'It's true. I couldn't explain so you couldn't understand. It isn't an insult. I don't understand myself. I'm quite happy.' 'So happy you wake up screaming at least three nights a week.' 'I'm sorry.'

'That's exactly what you kept saying last night. "Sorry, sorry." You don't need to apologise, not to me. But of course you weren't saying sorry to me, you were saying it to her, that other baby, right?"

He thought she might hit him, so great was her anger. But she mastered herself and sat down on the bed, looking suddenly defeated. 'Yes,' she said, voice flat, 'I dream I see the shadow of her again, growing bigger and bigger and coming towards me. Pathetic, isn't it? Ten years too late and I discover I have a conscience.'

'It's all delayed guilt, brought on by Philip's birth.'

'I know that.'

'Of course you do. Right. So the only way to deal with it, if you can't persuade yourself that retrospective guilt is pointless, is to be practical. Your daughter ...'

'Don't call it that, don't! I hate those words.'

'Your baby, then ...'

'The baby, that will do, the baby, it.'

'It will be ten. It's been brought up by whoever adopted her -I can't go on unless I can at least use the personal pronoun, Hazel - and she's happy and settled and hasn't a clue about you nor does she care.'

'You don't know that. You don't know it's either happy or settled or that it doesn't think about me and wonder what kind of woman would give away her own baby, and never try to trace it and ...'

'Is that what you really want to do? Trace her?'

'No. I dread the thought, though, of being traced, hunted, and having to give an account of myself.'

'Not very likely.'

'You don't know that either.'

'All right then, for the sake of argument, *if* you could be told the baby was happy and settled and knew nothing about you and cared less, would that help?'

'Yes. It would let me off the hook, for the moment.'

'Then let's try and find out.'

Hazel didn't ask how. Malcolm was not a solicitor for nothing. He was expert at knowing whom to approach, how to get information. And he was discreet, there was no need for her to beg him to take care that her own name and address and circumstances should not be revealed. She had to provide him with some details, of course, or he had nothing to give a researcher or detective to go on. His expression, when she told him about the two women in Norway, was curious. Pained, she thought, it pained him to hear of all the subterfuge, or was the pain she thought she saw for her, for her young self in that predicament. But all he said was, 'Your mother. My God. Your mother ...' 'She did her best,' Hazel said, quite defensively. 'Her best? My God,' Malcolm said, and left it at that.

She had no nightmares while Malcolm, or someone on his behalf, several people, she imagined, though she didn't ask, pursued inquiries. He'd promised not to mention the subject again until he had definite news, and for her part she had promised to try to wait patiently – which she did. Just knowing that frightening shadow of her dreams was to be given substance helped to calm her, and she was able to devote herself to Philip without the very sight of his fragile baby body making her shake. And at last they bought a house and moved from the fussy flat, and all her time was taken up with choosing paint and wallpaper and furnishings. It wasn't the house they had envisaged, nor was Muswell Hill an area they knew and liked, but she found that the lack of familiarity was exciting.

Once installed in the house, Hazel felt a new person. She wasn't sure who that person was, or how she related to the old Hazel, but there was an exhilaration in feeling the boundaries of her life had changed dramatically. Being Malcolm's wife and Philip's mother in this friendly north London district was completely different from being her parent's daughter in smart Holland Park, or even Malcolm's mistress in chic Canonbury. She saw how, long ago, she ought to have found her own home, her own place, and not been content to depend on others. Surroundings did matter, after all; a break with the past, that break she had wanted, did follow on from a change of scene. Who you were depended more than she had ever guessed on where you were, or at least in her case it proved to be so. She felt so much better that she wished she had never let Malcolm try to trace her shadow-baby; she was on the point of telling him to cancel any investigation, when he came home one day with the result.

If he had asked her again, at that point, whether she was still sure she wanted to know, then Hazel would have shaken her head and told him to forget it. But he didn't ask. It made her think afterwards that he had guessed she would say no, and that he had decided to force the knowledge on her, believing it was for her own good. He didn't even wait until after supper but launched straight into a matter-of-fact account, as though relating one of his cases to her.

'She lives in Scotland,' he said, reading from a single sheet of paper he'd taken from his briefcase, 'name of Shona McIndoe, father's a captain in the merchant navy, mother doesn't work. She's healthy, an only child ...'

'Why did you have to tell me her name?' She watched him put the paper down.

'Shadows don't have names. This was all about turning a shadow you were afraid of into a person you don't need to fear, a little tenyear-old girl called Shona, living in Scotland beside the sea with a daddy who's a captain and a mummy who is devoted to her. Can you see her now? Not at all threatening, is she? Bears no comparison to that huge black heavy shadow.'

She didn't reply. He'd spoken very slowly, as though to someone of limited intelligence. There had been an edge to his normally even, quiet voice which she hadn't liked. He was angry, she deduced, but whether with her, and her reaction to his information, or with himself, for caring about this Shona, she was not sure. He did care, she knew that. She only cared because she was afraid of the longterm consequences this girl might bring about, but Malcolm cared about the girl herself, about Shona as Hazel's daughter, not as an instrument of possible vengeance. He wanted her for their own, that was what it was, she felt. They ate in silence. She didn't ask him how these details had been obtained. Slowly, she was absorbing them. Shona. A pretty name, wildly Scottish. Her father a seacaptain. An image came unbidden into her mind of a seashore and a girl running along it waving to a ship ... Romantic nonsense. She half smiled at that absurdity.

'So,' Malcolm said, watching her, 'a ghost, well, a shadow, laid to rest, I hope.'

'Thank you.'

'It was for my own sake too. I don't want my wife suffering nightmares for the rest of her life.' He paused, frowned, looked worried. 'Our children,' he said, 'will you ever tell them?'

'Of course not!' she cried, shocked. 'Why would I do that?'

'To stop being secretive,' Malcolm said, 'to be open about what happened.'

'I don't want to be open. It's my business.'

He shrugged. 'Maybe when they're grown-up, you'll change your mind, maybe if we have daughters.'

But there were no daughters. There were two more sons, at almost two-yearly intervals, and they had agreed three children were enough. When Anthony, the youngest, was two they almost weakened, but Hazel was ill, with an ovarian cyst which burst, and that was that. Three much-loved sons but no daughters. Hazel felt it was a kind of judgement but she was not unhappy to have three boys. It was Malcolm who had yearned for a daughter, who had the fantasy of a golden-haired girl to call his own. Sometimes Hazel thought how pleased he'd be if the unknown Shona emerged out of the shadows to confront her - Malcolm would welcome her and be eager to take her into his family. Hazel did not have nightmares about this any longer, but there were times when she would waken in the night and be unaccountably apprehensive and then a cold feeling would creep over her and make her shiver, and she would think 'Shona'. She tried to whisper the name aloud to get rid of it but it stuck in her throat. There was not even the smallest part of her that wanted to see this girl's name made flesh - no, she blocked the reality off completely. Instead, she concentrated on thinking of her as a happy, laughing creature without a care in the world. fortunate and content with her lot, and not even knowing she was adopted – not knowing that the woman who had so carelessly conceived her wished she did not exist. That is the worst thing, Hazel thought, I still wish, however happy she may be, that she had never existed. It doesn't matter to me what she has made of her life, or what life has made of her, I do not want her to exist. She is not nothing to me, not a bit of it. She is a strong, strong presence out there in the world, and I cannot stand up against her unless I deny her right to force retribution upon me.

But these were the exaggerated, melodramatic meanderings of night-time panics and were, thankfully, rare and soon over. She never spoke of them to Malcolm. As the months went on Hazel's thoughts were so full of her sons that there was no room for other speculations about her first-born. Gradually, she relaxed into a sense of security she had never had before. Her life, her happy and successful life resumed, with Malcolm and their children at the centre, and there was neither reason nor cause to feel threatened any more.

Chapter Eleven

 \sim

Leah MARRIED Henry Arnesen in St Mary's church on a wild Lautumn day with the wind howling through the trees in the cathedral close, sending the brilliant-coloured leaves swirling over the heads of the bridal pair as they emerged. Leah pulled her coat tightly around her (she had been married in an elegant pale grey coat and dress made by Henry himself) and shivered. Henry put his arm protectively round her and hurried her along to the Crown and Mitre where the wedding breakfast was to be held. Her head down against the wind, Leah nevertheless saw old Mary, and Evie with her, standing well back in the shadow of the wall, and first anger, then shame, heated her before ever she reached the fire in the inn. She had asked Mary to stay at home, and had thought she had been understood, but now that she had seen her and the child, the pathos of their position was unbearable. She had made them outcasts.

Mary had not after all been evicted, not yet, nor had the knocking-down of her cottage taken place, or been mentioned again by her landlord. She was still living in Wetheral, the sole custodian now of Evie. Henry paid a weekly allowance, enough to mean Mary need no longer take in washing. She couldn't manage the hens so they had been given away and the garden soon grew wild without Leah's care. The whole arrangement worried Henry more than it did Leah. She appeared to see Evie as perfectly well placed, whereas Henry fretted about Mary's age and infirmities and wondered if it was not irresponsible, unchristian even, to leave such a young child with her. He would feel happier, he said, if Mary and Evie were nearer, in Carlisle, but Leah would not hear of it. Henry had wondered also if it might not be kind to visit Evie at regular intervals to check on her welfare and reassure her that she was not forgotten by her mother. Leah was exasperated at his failure to grasp the depth of her desire to separate her child from herself completely. 'It is not natural,' Henry kept muttering. 'No,' agreed Leah, 'it is not.'

She had asked Henry not to tell his mother the true reason why Evie was to remain in Wetheral with Mary. It should be sufficient. argued Leah, to say the child was settled there and it would be wrong to uproot her. Mrs Arnesen accepted this quite happily. She wanted, in any case, to pretend her beloved son's bride was everything she had hoped for - a virgin, a modest, sensible good girl - and not a woman with a past containing a child and an unknown man. She was not at all sure she would be able to take to Leah. pleasing to look at though she was and by all accounts a hard worker. She saw her son Henry as already under Leah's thumb - he, who had been independent and nobody's fool for so long. And she saw clearly that Henry was far more in love with Leah than she with him. It was apparent the moment she saw them together. Leah, she correctly deduced, was making the best of things and in accepting Henry she was thinking of her future, allowing her head to rule her heart.

There were only six people at the wedding breakfast, all Arnesens. It was a subdued affair, though meat and drink were plentiful. It was over within an hour and the newly wed couple set off in Henry's trap for Silloth, bundled up in thick coats and with a blanket across their knees. Henry worried that it would be too cold – he had not reckoned on September weather turning so cold – but Leah enjoyed the ride and did not suffer at all. She had never been to the seaside and was excited at the thought of visiting Silloth, the little town on the Solway coast where Carlisle folk took their holidays. They came towards it along the sea wall, from the Skinburness end, and she felt exhilarated at the sight of the great waves crashing on the shingle. There were fishing boats far out in the firth and she marvelled at the courage of the men in them as she watched the boats all but disappear in the heaving water.

They stayed at the Queen's. Henry had spared no expense. They had a room overlooking the green with the sea just visible through gaps in the trees. There was a roaring fire and supper laid out in front of it – Solway shrimps, and hot buttered toast and Cumberland ham and roast potatoes, and apple pie to follow. They ate heartily and then it was time. The food was taken away, the maid came to turn down the bed, and finally they were left alone. Leah saw Henry put his glasses away and open his arms, and she knew she must respond and walk into his embrace, however much she dreaded it. This was what marriage was about, it was all part of the bargain. It was no good remembering Hugo, no good at all. She tried to act as though she had never known the lust that had overcome her with Hugo nor the exquisite pleasure which had followed, and indeed it was not too difficult. She *felt* like a shy, untutored bride, nervous and hesitant, a young woman who would need tenderness and care to be brought to respond to any caresses, let alone to a full consummation. And Henry treated her as this woman, touching her gently, pressing her to him gently, kissing her so gently at first that she hardly felt his lips and was tickled by his moustache. Yet his caution and respect were irritating to her - she would rather he had been passionate and quick and the whole thing over and done with. It was harder to hide her distaste the longer he tried to rouse her and it was she who broke away and, going over to the bed, swiftly took off her clothes and climbed between the sheets, as a signal that he should hurry and follow. She saw well enough that he was unhappy with this abruptness of hers but eager too and unable to stop himself following her lead. He came to bed and she turned towards him and he immediately clutched her to him and penetrated her, and it was over. She felt nothing at all.

Henry never grew any more skilled as a lover and Leah did not try to teach him, holding that it was not her business. She did not want to have to tell him where she liked to be touched or positioned - that was unnatural; it filled her with revulsion to think that the passion she had instinctively felt with Hugo was now something to re-create artificially. Sometimes Henry, after he had finished, asked her if she was either 'happy' or 'comfortable' but she never replied, only squeezed his hand, which seemed to suffice and reassure him. He was triumphant when she became pregnant immediately and, without any prompting on her part, left off sleeping with her for the sake of the baby. His grief when she miscarried in the fourth month was terrible to witness - if ever she loved Henry, she knew it was then, loved him for his distress and his compassion for her. He nursed her himself, doing all manner of intimate services which no man should have had to do, recoiling not at all from the mess and blood. She was weak afterwards for several months and he never once tried to resume normal relations. It was she who, seeing him plagued with longing as he bid her goodnight, held out her arms to

him and assured him she was restored enough to be his wife again. Once more she became pregnant and Henry's joy was tempered with such fear that she felt sorry for him.

They moved house before the baby was born. For a long time Henry had wanted to live somewhere a great deal more salubrious than Globe Lane. He would have liked, in fact, to live at Wetheral. but with Mary and Evie there it was impossible. He searched everywhere for a house near enough to the city for him to get to his place of work, but far enough out of it to be countrified; and eventually he hit on Rockcliffe, a village on the Eden estuary only four miles away. Leah liked the house and the village. It felt quite separate from the city, cut off from it, more so than Wetheral. It was smaller, far less prosperous, and she was not known there. They moved when she was in the sixth month of her pregnancy and she settled in well. It was a long drive for Henry each day but he swore he did not mind and was delighted at how Leah thrived in the bracing air of the estuary. His mother, whom they had been obliged to take with them, hated Rockcliffe and soon moved back to Carlisle. to her sister's home. Leah had the house to herself and was happy.

She experimented with saving this each day as she walked slowly on the marsh, watching the seagulls wheel off above the river-mouth to the open sea. 'I am happy,' she said aloud, and paused. It was, she thought, perhaps her state of pregnancy which made her feel so content and dreamy, and she did not know if it would continue once the child was born. She had an easy life suddenly after years of hardship and was constantly charmed by her luck. She had a husband who adored her and was kind and generous, and a little house all her own, a house it was a pleasure to clean and care for. She was a woman who was indulged and she never stopped marvelling at this unexpected upturn in her fortunes. Thoughts of Hugo were dim and distant and only occasionally troubled her. Sometimes, she fantasised his appearance on her doorstep and could not be sure she would greet him with rapture any longer. Perhaps, perhaps not. She would have a great deal to sacrifice now if Hugo arose and said follow me. The misery of not knowing where he was, the fever of wanting him, no longer burned within her and she supposed this meant that time had done what it was bound to do and healed her wounds.

But one still festered. Mary and Evie were in Carlisle now, in St Cuthbert's Lane. Henry paid the rent and an allowance. Leah had wanted Mary to be kept in Wetheral when at last the long-rumoured eviction (though not the demolition) took place, but Henry said Mary herself had insisted on coming into the city for the sake of the child. This struck Leah as nonsense - children were far safer and healthier out of the city and she did not know what Mary could be thinking of. 'Go and talk to her,' said Henry, but of course she refused. She knew how bitterly old Mary thought of her, and with justice, and was not brave enough. Nor did she wish to set eves on Evie. Henry had done so. For a long time he kept it secret but she always had suspicions, though she never confronted him with them. In the end he could stand his own deceit no longer and blurted out that he had felt he must see Mary and Evie settled in their new home, it was his duty. She never asked him about them and when she saw he was on the edge of volunteering information she turned away and put her hands over her ears. Once he tried to talk to her about Evie's future, about what would happen if Mary died, as she was bound to soon. She would not discuss this eventuality, but he warned her that he could not stand by and see his step-daughter sent to the workhouse, or a charity home.

Leah hoped that when Henry had his own children he would worry about Evie less. This time she carried the baby to full term, but when labour began she knew almost at once something was wrong. The pains stopped and started and were sluggish, and she began to bleed heavily and to feel the baby as a lead weight within her, without movement. The midwife sent for the doctor at once, saying the afterbirth was coming first and was causing the bleeding. Long before he had come out from Carlisle, Leah had lost consciousness and when she revived she hardly needed to be told her baby was stillborn and that she herself had been on the edge of death. More of Henry's tears, more weary months recovering, far less heart now for trying again, and when she did and a son was born it was only to end in another tragedy. At three months, he contracted whooping-cough and did not survive.

But Leah was still young and, even if a couple of years of unsuccessful child-bearing had sapped her former robust health, she still had every hope of raising a family. The doctor said so, she said so herself, but Henry was pessimistic and despondent. She knew, after they had buried their little son, what he was going to say, long before he managed to dare her fury by putting it into words. 'There's Evie,' he said, tears in his eyes, 'there's a daughter readymade and waiting.' 'No!' she said, and turned away from him.

They thought of moving to Newcastle. and Leah was all for it even though she loved Rockcliffe - the further away from Evie the better. There was a business opportunity for Henry which both attracted and vet alarmed him. He had expanded the Globe Lane premises and employed a workforce of five now. He saw that if he was to prosper further, as he knew he could, he needed a partner with capital. A partner presented himself, the friend of a customer. but he was a Newcastle man and wanted to stav there. Henry was tempted - the terms he was offered were good - and Leah was encouraging, but in the end his affection for Carlisle and his lack of any spirit of adventure led him to turn the proposition down. He would stay in his home-town and keep his business within his own grasp. A joint venture would not suit him, he said, he liked to be his own master. 'You're afraid,' Leah said, 'that's what it is.' Henry acknowledged perfectly cheerfully that this might indeed be so and he saw nothing wrong with it. He didn't like taking risks, he never had done, and he didn't like change. These folk who emigrated were beyond his comprehension, he added, to be reminded sarcastically by his wife that going to Newcastle, sixty miles away, was hardly the equivalent of emigrating. His last attempt at rationalising the decision was to say he couldn't desert his mother and that she was far too old and frail to move with them.

His mother died soon after the suggested move that had never taken place. Henry's mourning struck Leah as absurd and she upset him by coming as near as she could to saying so. 'She was old,' Leah pointed out, 'and ill, Henry. She had a long life, seventy-two is a fine age to have lived to. What did you expect?' 'She was my mother,' said Henry. Leah had no reply to this undoubted fact. True, Henry's mother had died. But why did her having been his mother make her death in old age so unbearable to him? He had not even liked his mother particularly. He had always been dutiful but had complained under his breath of how tedious she was, how she exasperated him with her fussiness. Now, suddenly, he was distraught. She found it embarrassing, at the funeral, to see her husband's face blotched with tears and see him sway as the coffin descended into its pit. It was ridiculous.

They cleared Mrs Arnesen's things out from her sister's home (this sister, Leah noticed, was gratified by Henry's distress) and once more Henry broke down. He handled his mother's few bits of tawdry jewellery with something like reverence and talked of passing them on to his daughters if he had any. It made Leah feel sick. But she had sufficient insight to realise that half her contempt might spring from the resentment and jealousy she felt because she had never known a mother. It was mysterious, this apparent bond between Henry and a woman to whom he had never been close, a woman sanctified by motherhood.

Soon after his mother's death, Henry came home one day feverish and was ill for nearly a month with pneumonia. Leah was terrified she would lose him, seeing her new-found easy life and contentment disappearing at a stroke, and seeing too that her affection for her husband had grown into something not so far from real love. She nursed him devotedly and when he was out of danger was so overcome with relief she could hardly leave him alone. A weak Henry, hardly able to move, kindled a strange desire in her. It shocked her, that she should find herself wanting to fondle and rouse a man lying on his bed with barely the energy to move his hand to lift a cup, but she could not conceal her agitation. She told him, for the first time, how she loved him and wanted him, and he, too, was more alarmed than captivated by the urgency of her embrace. He convalesced slowly, fretting all the time about his business, worried it would collapse without him. But he was pleasantly surprised. His assistants had managed well, the orders had been dealt with efficiently and had kept coming in. Financially he was still quite secure and the profit margin had barely dropped. The only thing that had been overlooked was the payment of the regular allowance to old Mary - and that was because nobody knew of it except himself and Leah.

He had always paid it in person, on the first of every month. But he had been taken ill on the 29 March and his illness had lasted until mid-May, which meant that Mary had been almost two months without any money. It worried him terribly to think of the consternation and indeed real hardship his failure to pay the allowance would have caused, and he hurried round to St Cuthbert's Lane as soon as he could. He still felt weak and light-headed and returning to work had tired him, but he could not return to Rockcliffe after that first day back in the city without taking money to Mary. He hoped to see Evie too, though Mary seemed to think, for some strange reason, that the child had to be kept hidden or she would be taken away from her. Sometimes, though rarely enough, Evie opened the door to him and then he did everything he could to prolong the interchange between them. His heart always went out to her - she was such an appealing elf of a child with her huge dark eyes and mass of unruly hair. There was nothing of Leah in her that he could see, but that did not detract from the fascination she had for him.

But a strange man opened the door, giving Henry a fright. He visibly started and was for a moment speechless.

'Were you wanting something?' the man said, belligerently, and made to close the door.

'Please,' said Henry, clearing his throat, 'please, where is Mary Messenger?'

'Who?' the man said. 'Mary who?'

'Messenger, Mary Messenger, who lives here with the child Evie.'

'That the old body found dead?'

'Dead?'

'Aye, a month back. Found dead.'

Henry stared at him, shocked and faint, and put out his hand to steady himself. He must have gone paler than he already was, because he heard the man say, 'Here, are you took badly?'

'No,' Henry managed to say, 'no, it was a shock, the news. Do you know what happened to the child?'

'No,' the man said, 'never heard of a child.'

All the way home Henry was rehearsing what he would do. The next day he would begin inquiries and find out where Evie was, then he would go and rescue her and bring her back with him. He would stand no nonsense from Leah. Had he not always said that when Mary died Evie must come to them? It had always been intolerable that she did not live with her mother, and this cruel and unnecessary separation must cease. But when he did reach home Leah greeted him with smiles and her own happy news, and he was not able to plunge immediately into telling her what he had decided.

She was once more expecting a child and that very day the doctor had pronounced her particularly healthy and well. She was to take things very easy, not allow anything to upset her and all would go well, he was sure. So was Leah. She said she felt confident in a way she had never done before and had only waited until he was better to tell him of this latest pregnancy. She was four months now, past the danger period, and the baby would be born close to Henry's own birthday, in September. Seeing her joy, Henry was trapped. Any mention of Evie would result in storms of argument and protest and endanger his wife's well-being. He could not tell her Mary had died nor could he find and claim Evie until after this baby was born. As it was, his quiet rather than rapturous acceptance of the news made Leah anxious once more about his health.

But he began making inquiries, secretly. He quickly discovered where Mary was buried and went to pay his respects and place a wreath on her grave. It was unmarked so he arranged for a stone cross to be made and erected with her name and dates carved upon it. Feeling furtive, he then visited the workhouse to see if Evie had been taken there but, to his relief, she had not. She must be in one of the city's homes for abandoned children, and he did not know where to start, nor was he sure if he should simply tour all the likely establishments in an effort to locate Evie. What was the point if he could not then take her back with him? And besides, a man coming to claim a little girl as his step-daughter would seem suspicious. He had no proof, no documents to brandish nor any explanation which sounded feasible as to how Evie had come to be in a Home. He needed Leah with him and he could not have her at his side until after the baby was born, if then.

Still determined to do the right thing, Henry bided his time uneasily, vowing to himself that he would make these miserable months up to Evie when finally she was with them. Leah never once asked about the welfare of either Mary or her daughter. She never mentioned them, which struck Henry as a sign that she had consigned both of them so successfully to a past she wished forgotten that in her own mind it had, in fact, been obliterated. Meanwhile, she flourished, growing happier and happier as the birth approached. This time, all went well. Leah was safely delivered of a baby girl on 14 September, Henry's own birthday. She would have preferred a son but the relief of giving birth to a fine, strong child was great enough to banish any feelings of disappointment. The baby, named Rose, thrived. She was like Leah from the beginning, with her mother's eves and mouth and, once it began to grow, her mother's lovely golden hair. Yet gazing adoringly at her or nursing her in his ever-willing arms Henry still thought of poor Evie. When Rose was six months old he decided that at last he could safely speak.

He waited until Rose was asleep and Leah was in a visibly tranquil

mood before he began and when he did he begged her first to listen to the end of what he had to say before she said a word herself. Quickly and unemotionally he told her of Mary's death and of Evie's disappearance, and then he said he would not stand for the child's abandonment. Firmly, he said it was their duty to locate and claim her as their own and that he was prepared to override any objections of hers. He understood them but they no longer carried any weight beside Evie's plight. She was only six or seven years old, a poor little thing, and would fit very neatly into their family as an elder sister for Rose. He finished by urging her to consider how there was room enough, surely, in their own happiness for a child who had done no wrong and would have been obliged to suffer much through no fault of her own.

Leah, as instructed, kept silent and did not interrupt. Even when he had stopped speaking she remained quiet. But her expression was mutinous. She turned away from him, walked to the window that overlooked the marsh and stared out of it, though it was already dark outside. He went over to her and put his hands on her shoulders, but she shook them off and moved away to poke the fire. Then she sat herself in front of it, hugging her knees and swaying slightly.

'We'll start visiting the Homes tomorrow,' Henry said. 'There aren't so many, we should be able to go round them all in a few hours. It's a simple question we'll be asking, only a yes or no needed.'

'It isn't simple,' Leah said, and smiled in a way he knew well, in that proud, sly way she could have when she was conscious of her own superiority.

'It is,' Henry said, but warily. 'All we do is ask if Evie Messenger has been brought to them.'

'Messenger isn't her name,' Leah said. 'You won't find her that way, not by giving that name.'

'But it's your name ...'

'True. But it isn't hers, not on the certificate, not in the baptism register.'

'What is her name then?'

'It is her father's.'

'But you weren't ... you weren't ...'

'Afraid to say it, Henry? We weren't married, is that what you're too kind to point out? That's true too, we weren't, but I gave her his name. I said we had been married and showed the ring, and no one queried it. I gave her his name because she was his and I thought it only a matter of time before she was entitled to it.'

'Well, then, we ask for a child of that name.'

'We? I'm doing no asking, Henry.'

'What was his name?'

'You promised never to ask.'

'I'm not asking to know about him, only so as to know the name Evie goes by.'

Leah rocked in front of the fire and said nothing.

'I can find out,' Henry said. 'I can search the baptism register for your name, Leah.'

'You won't find it. I told you. I gave his name.'

'I know her birth date, I can do it that way. I can search the records for that month, June, wasn't it?'

Leah smiled again and Henry realised he did not, in fact, know Evie's birthday. He did not know the day or month and was not even certain of the exact year, it could be 1888 or 1889, or even 1887. Nor, it now occurred to him, did he know where Evie had been baptised. Had it been in Wetheral parish church? Mary would know but Mary was dead.

'Damn it, Leah,' he said, 'you think you can make a fool of me.'

'No,' said Leah. 'You're not a fool. You're good and kind, Henry, I know that, and you want to do right by Evie, but I told you from the start how wicked I was. I cannot bear to have her near me. I wish I could. I know it is not her fault. I know I am unnatural and fail in my duty. You can damn me. But nothing has changed.'

'It has, it has,' broke in Henry excitedly, 'everything has changed. Mary is dead. Evie is suffering in a Home ...'

'You don't know she is suffering. It is a year now, or nearly. She may be settled, or she may have been given to a family. Let her have her own life.'

'Leah,' said Henry, despairingly, 'I don't know how you sleep at night with this on your conscience.'

'My conscience? What do you know about that, Henry Arnesen? My conscience is black and heavy, but I sleep. Whether *he* does I can't know and I don't want to.'

'You could make it light, you needn't have this on your mind.'

'It is not on my mind. I said my conscience was black and heavy, not my mind. My mind is as clear as it ever was. I can't bear to have that child with me and that is that. She's gone now, wherever she is. She's young, she will have no memories.'

'But you're her mother, Leah.'

'I am, and it means nothing beyond the word, not where Evie is concerned. To Rose, I am a mother and always will be. I cannot help it, Henry.'

'Evie will never know a mother now ...'

'She might. You cannot tell. She could be with a woman mothering her already. And I did not have a mother, you forget that, and I managed, as children do.'

'But your mother was dead.'

'As I am to Evie.'

There was nothing Henry could do, or nothing he felt able to do, but he bore great resentment against Leah. She had outwitted him and prevented him from following his own instincts. He felt how powerful his wife was in all matters emotional and it angered him. But because he was not the sort of man in whom rage could be sustained, this anger melted down into disapproval and this in turn trickled into feelings of detachment towards Leah. She was set apart somewhere within him because of Evie. Sometimes he found himself regarding her with such a sense of distance that it shocked him. He had to remind himself that this was his wife, the woman he loved greatly and to whom he had once felt joined in every respect. It worried and puzzled him, this strange awareness, but he found he had not the will to fight it. The birth of another daughter, Polly, two years after Rose made Leah into even more of a mother and, so it seemed to him, less of a wife. In a way it was a relief. He got on with his work and she got on with her mothering and he never again mentioned Evie.

The Arnesens stayed in Rockcliffe until Rose was of school-age and then Leah began to think they should move back into the city. She wished her daughters to be educated in a way she had not been and, though the village school would serve to begin with, she thought Rose and Polly ought to go on to the new Higher Grade School. Henry, whose own education, while far superior to Leah's, had not amounted to much (though he wrote a fine hand and kept excellent accounts), was in agreement. So when Rose was seven they moved back to Carlisle to a house in Stanwix with a fine view of the park and the river. It was a larger house than they had had in Rockcliffe but still a modest dwelling, though its location made it more expensive than Henry had expected. The girls went to Stanwix School, of which Leah greatly approved. The children were all from good homes and were clean and well-dressed, as of course were her own daughters, clad in the dresses and coats their father made so exquisitely. To be the wife and daughters of a tailor was a fine thing, though Henry himself did not do much of the actual tailoring any more. He was head of a regular little emporium, Arnesen & Co., with premises in Lowther Street, and supervised a staff of thirty. His own prosperity pleased him but he never took it for granted. Every year he salted away his profits in careful investments and, though he was generous to his family, he never got carried away. Leah took pride in Henry's carefulness. It was why she had married him, recognising as she had done his sound commonsense as well as his talent and willingness to work hard. Whenever Polly, who was inclined to impertinence, complained of her father's meanness Leah would admonish her sternly and declare Henry the most generous man in the world and tell Polly she did not realise how grateful she should be.

Leah was grateful. When she looked back to the horror of that period after the birth of Evie and remembered how Henry had provided the way out of the trap she had sprung on herself, she was overcome with gratitude. She thought she might have ended by murdering Evie. She had been mad inside herself while functioning perfectly on the surface – mad with grief and resentment and a terrible unjustified hatred. She'd seen her whole life wrecked by Evie, whom she would have to carry on her back for ever. At first the tiny child had been a symbol of that love she and Hugo had had for each other, and she had been precious, but gradually she had become significant in a different way, as a symbol, instead, of betrayal, of stupidity. She could no longer see Evie in her mind's eye, which was a comfort since that image had the power to torture her with its pathos, but she still felt her presence in a shadowy way from time to time, usually in occasional moments of low spirits.

She trained herself not to wonder, not ever, where Evie was, or what she was doing – that way real madness lay. Evie was gone, long since. Guilt had been kept at bay for so long that Leah considered it defeated, but never quite admitted this to herself. Five years, ten years, nearly twenty years, and now Evie would be a woman. No longer need fear of her lurk within that conscience she had once told Henry was black and heavy. Whatever had happened to Evie was now complete. The child had grown, the pathetic mite was no more and not even Henry could reproach her by trying to conjure up a vision of a poor weeping little soul searching for her mother. Evie would no longer need a mother.

But she did.

Chapter Twelve

 \sim

THE WOMAN was thick-set and tall with long untidy hair tied back with an elastic band. The weight of the hair, which Hazel felt would normally have hung free, a chaotic mess, seemed to pull the skin of her face tight, giving it an unpleasantly strained appearance. She wanted to tell the warder to let the woman wear her hair loose, but that was silly since it might be so fiercely yanked back at the woman's own request. Both her hands were heavily bandaged. Hazel could see a tiny spot of blood near the wrist on the left hand though the dressings looked absolutely clean, freshly done.

'Are you the lawyer?' the woman asked. Hazel said she was, tried to say it with a pleasant smile, showing sympathy. She was aware she was not good at sympathy, or rather not good at demonstrating it. Did this make her a bad or good solicitor? She was never sure. Malcolm always said detachment was important but she felt her failing was to appear to carry this too far and it troubled her. It was not that she was afraid of being involved with clients, particularly clients of this sort, but that she did not know how to project what she felt. More was expected of women in this situation and she could tell already that this client was disappointed in her.

'Well, then,' the woman said, 'tell them they can't take my baby away. Tell them. Tell them the law says she's mine. I had her. She's mine. They've no right. Tell them.'

Hazel sat down. The warder stood leaning against the wall, near the door, and the woman, Stella Grindley, sat opposite. They were quite close. Hazel could smell the soap used to wash Stella's clothes. She thought Stella must be able to smell her perfume, faint though the scent was, and wished she had not worn any. It might seem tantalising, a reminder of the outside world and the kind of lives lived in it which Stella could not share. She felt all her own senses heightened and this led to a tension in her which she struggled to dissipate before she began speaking. Everything she was obliged to say would be resented by Stella Grindley and though she was prepared for this, she was not prepared to deal with the rage and grief her information would surely release.

She spoke as quietly but as firmly as possible, choosing her words carefully, making them as clear and simple as she was able without being patronising. What she had to tell Stella was simple enough. after all. She could not keep her three-month-old baby, just as she had not been allowed to keep the last two. A place of safety order had been obtained and the baby was in the process of being adopted. Stella had been arrested outside King's Cross Station on charges of soliciting, stealing and common assault. She had been drunk, five months' pregnant and had a string of convictions behind her. At the age of forty her record was enough to make it out of the question that she should be allowed to keep this latest child, born while serving her sentence. She had already been told this, which was why she had cut her wrists with a piece of broken mirror glass she had managed to secrete. The cuts were not deep, her life had never been in danger, but her intention had been serious. This, she thought, was her last baby. She had had eight and kept none of them. The first four she had had with her for their first few years but then they had been taken into care. The fifth had died, apparently a cot death (though there had been some doubt at the time and suspicions of fatal neglect were raised). The last three were all taken away at birth or soon after.

When Hazel had finished the sad recital of what the law said, Stella Grindley was silent for a moment and then, with a speed which was shocking and took even the warder by surprise, she leaned forward and spat at Hazel a great gob of saliva which landed in the middle of her white blouse. 'You can fuck off,' Stella shouted, 'and so can the law. Go on, fuck off, you're useless.' The warder had already moved forward to restrain her but restraint was unnecessary. Content now, Stella sat still on her chair and folded her arms and smiled. 'Stupid little bitch you are,' she said. 'You know nothing.' She was reprimanded for language by the warder but ignored her. She was watching Hazel, who remained in her own chair, deliberately making no attempt either to inspect or mop up the patch on her blouse. She held Stella's stare and did not blink – she knew that of course she should get up and go without another word but she could not do it. She was held by Stella Grindley's contempt and wanted to challenge it. It was unwise, but she could not resist asking, 'Do *you* think you are fit to care for a baby?'

'She's mine,' Stella said. 'I had her.'

'Nobody denies that. But you can't care for her. You have no home, no money, no job, you're always drunk and you're in and out of prison. You are not fit, are you, to care for a baby? The law is only safeguarding the child.'

'She's mine. I had her. I'm her mother and I'm not giving her away and I'm not letting them take her away and you can go fuck yourself.'

'That's enough,' the warder said. 'Time's up.'

Hazel watched Stella Grindley being taken away and then followed. It was stupid of her to have hoped for any kind of rational discussion. Stella's only argument was one of possession: she had created and given birth to the child and therefore she was hers. In her mind, simple. There had been no point after all in Hazel's sanctimonious recital. The law was right to say what it did, but Hazel recalled most vividly the cut wrists and the yearning for the child - a yearning so powerful even if it seemed based not so much on overwhelming love as on fury at being cheated - and she was uneasy in her own mind. Efforts had been made, she knew, to help Stella cope with her children. She had been helped over and over again by the social services to reform so that she might keep her babies. Places in hostels had been found for her, grants of money procured, and even work found at one stage. But always she reverted to drinking and soliciting and stealing and, when in a temper, which was often, attempting to beat people up.

This latest baby would be adopted. Lucky baby, to escape Stella Grindley as a mother? But even while thinking this, Hazel was rejecting the underlying premise, that only good, decent, cleanliving sober women could be allowed to be mothers. She drove home knowing there was something wrong somewhere in this obvious truth. Stella had indeed given birth to her baby and it was *her*, as well as *hers*, an indisputable part of herself. That could not be contested, that fact could not be changed. It did not matter who adopted the baby, it was still Stella's and always would be. Caring for it was different. Stella had shown she could not care for it and any anguish she felt at having it taken away was as nothing compared to the anguish a child would suffer if left in her care. What, then, Hazel wondered, worries me so much? Stella's passion to keep her own baby, that's what. For whatever reason. A passion that made her cut her wrists. A passion I never felt, not once, for that baby whom I allowed to be taken away from me. Stella Grindley would think me a monster, not just a bitch, if she knew.

And then there was the evidence of Stella's suffering. She was suffering because her baby was being taken away, there was no doubt about that. There was always the mother's suffering, of one sort or another, in these cases. Stella was experiencing a terrible sense of loss. And I, Hazel wondered, did I suffer? And if I did, did I have any right to?

She became obsessed, in the days that followed, with this question, to the point of several sleepless nights when she disturbed Malcolm with her feverish tossing and turning. 'What's the matter?' he asked, but she said nothing. How could she tell him she was wondering if she had had any right to be regarded as having suffered at eighteen when she had that first unwanted baby? She did not want to return to any mention of the subject. What she had suffered from, she decided, was a failure of compassion. At eighteen, she had had no acquaintance with such a sophisticated emotion. She had thought only of herself, as young people do, of her own life being wrecked. There had never been any inclination to think beyond that.

But supposing she had thought about her baby as anything but an object to be disposed of - what then? Supposing she had had the imagination as well as the compassion to think of this baby as a person who would have feelings and dreams and desires, and to whom the deliberate denial of any attachment by his or her mother, would seem a terrible thing? She tried to think of having wanted to keep her baby, of being determined to do so at any cost to herself. It seemed to her extraordinary, all these years later, that she had never once thought of saying to her mother that she wanted to have and keep the baby. What would her mother have said? The temptation to ask began to plague her. Almost eighteen years had gone by and they had never, except for that brief moment when her mother had tentatively wondered if she had told Malcolm, talked about it. It made her realise what she supposed she had always really known, that she and her mother, by the tacit agreement of both of them, never discussed anything that was distressing or difficult. It was a habit she had grown up with and kept to without ever attempting to force a different kind of communication. But now she wanted some

kind of confrontation all these years too late – she wanted to know what her mother had really thought and felt, and most of all what she thought she would have done if her daughter had not fallen in so obediently with her plans.

Mrs Walmsley, at almost sixty, was busier than ever. Every day she had some charity work to do, of the organisational variety, and when she was not sitting on committees she was taking her work as a magistrate seriously - it was all action, just as she liked life to be. Then there was her role as grandmother which she relished and threw herself into. Seven grand-children, all living in or near London, so that she saw them often and had them to stay frequently. During the holidays she was much in demand, often taking her grandchildren to stay with her in her Gloucestershire cottage. She came to know the Science Museum, the Imperial War Museum, and the British Museum intimately, not to mention the Planetarium and the Zoo (though she refused to set foot in Madame Tussaud's, pronouncing it vulgar). Hazel, whenever she rang her mother, which was not as often as she felt she ought to, was treated to such a stream of approaching appointments that she felt she should get off the phone quickly. Delivering and collecting her own sons to and from their grandmother's she had only the most hurried of chats, since her mother was, if anything, busier than her busy self. It was impossible to contemplate any level of serious conversation in such circumstances. She knew she would have to wait until the next occasion when her mother came for supper and stayed the night, something she did no more than three or four times a year.

She was surprised, when the opportunity came, how hard it was to bring up the subject that troubled her. Of course, her mother never stopped talking, so it was always a strain trying to find a gap in her energetic résumé of her own activities, but when finally she paused long enough for Hazel to say anything at all, the words were slow in coming.

'Mother?' Hazel said.

'Yes, dear? But not next week, I am going to be *frantic* next week, not a spare hour ...'

'I wasn't going to ask you to do anything.'

'Oh, good, because I simply couldn't manage to take on another thing, not even for you, darling, so what was it, what was it you wanted to ask?' 'I'm not sure really,' Hazel said, faltering, before she had even begun. 'It's awkward, rather embarrassing actually ...'

'Embarrassing?' Mrs Walmsley said, astonished. 'Good heavens, Hazel, how can anything between us be embarrassing, how ridiculous. What is it? What's happened?'

Hazel heard the note of excitement in her mother's voice. Probably she thought she was going to be treated to some tale of adultery and even now was calculating who was having a fling, her daughter, or her son-in-law.

'It's about when I was young,' Hazel said.

'Oh.'

Smiling slightly at her mother's obvious disappointment, Hazel plunged into explanations but speaking in a staccato fashion quite foreign to her normal smooth speech patterns. 'When I was seventeen. Pregnant. That time. And I came to you. Told you. You took over. You organised everything. Well, what if ... I mean, what if I'd said I wanted to keep the baby ...'

'Absurd, you wouldn't have been so absurd,' burst in Mrs Walmsley. 'It never entered your head, thank God.'

'Why "thank God"?'

'Why? Really, Hazel. It would have ruined your life, of course it would, saddled with a *child* at seventeen, eighteen when you had it. What on earth would you have done with it? How could you have gone to university? An unmarried mother at eighteen – good heavens.'

'But if I had, Mother, if I'd refused to part with the baby once I'd had it, what would you have done?'

'Made you see sense.'

'So you wouldn't have helped?'

'No. What is this, Hazel? I don't understand.'

'What if I'd told Daddy ...'

'Told your father? He'd have been livid, he'd have wanted to find the boy and horsewhip him. There would have been the most fearful fuss, it makes me quite ill to imagine the scenes. No, you couldn't have told your father, impossible. It was essential the whole thing should be kept secret.' She paused, eyeing Hazel critically and with exasperation. 'You're a happily married woman, darling, with three lovely children and a good career, and here you are being silly, not like yourself at all. You're usually so sensible, you always have been except for that one bit of madness, and now you're plaguing yourself and me with all this speculation about what might have been said and done half a lifetime ago. It's so unnecessary.'

Hazel sat quietly for a few moments, watching her mother who was perched on the very edge of her chair, back rigid, head high, face flushed, a vision of righteous indignation. It was late. The boys had been in bed for ages, and Malcolm had retreated to his study a good hour ago.

'Let's stop talking about it anyway,' her mother said. 'It's bedtime, I've a long day tomorrow and so have you.'

'No.'

'What? Well, if you haven't, I have and ...'

'No, Mother, please, let's not stop. I want to understand and I don't. I've wanted to for ages.'

'Understand? What are you talking about? There is no mystery about what happened, it might have been kept secret but it wasn't mysterious, we behaved quite logically ...'

'That's it. All head, no heart, no thought for the baby, not from you or from me ... appalling ... I don't understand it.'

'It's perfectly easy to understand. You were a child yourself, you couldn't keep a baby, and it was thought about, it was thought about most carefully, I was most concerned it should go to good people, and I was assured it did.'

'But how could you or anyone else know? How could you know the people who adopted my baby were good?'

'Miss Østervold knew one of them. They had references, I expect, and ...'

'You didn't ask?'

'It wasn't my job, it was the responsibility of the organisation those ladies worked for.'

'No, it was ours, yours, since I just did what you said like an obedient little girl.'

'Hazel, are you accusing me of having failed in my duty?'

'No. I just want to understand how you could let me, encourage me, order me really to give my baby away.'

'You *wanted* to ...'

'Yes, yes, I did. I know, I certainly did. I wanted to get rid of it, true, quite true, but you were older and wiser, you were a mother yourself and knew what it meant ...'

'It meant doing the best for *you*, that's what it meant. It's what it always should mean, and that's all I thought about.'

'Didn't you ache for the baby, didn't it break your heart to think of the poor, motherless, rejected ...'

'Stop it!' Mrs Walmsley got up. 'I'm going to bed, I won't have this, it's unseemly and upsetting.'

'I'm sorry,' Hazel said, 'I don't want to upset you, but I'm upset myself. I thought I'd got over the guilt' – her mother clicked her tongue at this – 'a long time ago, but recently I've started thinking about what I did and it shocks me. I only wanted to know if it shocks you, when you think back.'

'I don't think back, there's no point.'

'Don't you wonder about your lost granddaughter sometimes?'

'Never. Lost granddaughter? I never think of there being such a thing. She isn't my granddaughter, wherever she is, she's the granddaughter of whichever family took her as their own.'

'And when they tell her?'

Mrs Walmsley, having gathered up her book and knitting and spectacles, and being ready now to go to bed as she had announced she would, began to leave the room, ignoring this last question. But Hazel followed her and stood in the doorway and repeated it. 'When they tell her, Mother? Tell her she was given away?'

'She may never be told. Lots of adopted children never are, and why should they be?'

'But if she were told?'

'Hazel, I'm tired, let me pass, I must go to bed.'

Hazel let her pass but went on following her, up the stairs to the spare room. She shut the door behind the two of them and stood with her back to it while her mother put her things down and picked up her nightdress and turned the bed covers down.

'What if she's the sort of girl who demanded to know everything?' 'Highly unlikely.'

'Not if she's my daughter, your granddaughter, us, not unlikely at all, she'll demand to know, and what then?'

'What do you mean, "What then?" I really don't see what you're getting at, Hazel, and I haven't since you started all this.'

'She has the right to make us suffer.'

'Hazel! I cannot stand this. Now let me go to the bathroom and when I come back I don't want to see you still here. Go to bed.'

Hazel went to bed. There was no point in trying to get her mother to help her nor any hope of comfort. Her mother had always been a woman of few doubts about her own behaviour. A blessing, really, to be like that, convinced that what one did was right. It made decisions simple – not the making of them so much as the bearing of the consequences. Once her baby had been 'dealt with' Hazel saw that her mother had obliterated all memory of her. Remorse was a word with which she had little acquaintance. The following morning, Hazel apologised. Her mother, smiling very brightly and at her most cheerful, stopped her and said she'd forgotten 'that little scene' already, and then she swept out to begin her deliciously hectic day.

Hazel never again assumed she might be able to form a new relationship with her mother, one based on an exchange of real feeling instead of superficial concern, which had always dictated a strange kind of wary politeness. But she knew that though seeming superficial, because it manifested itself in careful language, her mother's concern for her was not in the least shallow. She did care deeply, she did, as she had said, do everything, in her own opinion, for her daughter's good. What had angered her was that Hazel had challenged this. She had dared to suggest that what Mrs Walmsley had seen as the only course of action had not been the only course. Even more offensive had been the suggestion that she had had another duty, one she had failed to acknowledge, to the baby. Nothing hurt her mother more, as Hazel knew, than implying any dereliction of maternal duty. But she would not risk doing so again. The matter was closed.

In her own mind, it began to close again too. She did not do any more work connected with adoption. She went on dealing with Family Law, moving as time went on into Divorce Law, and specialising in cases where women had been beaten and abused. For months at a time she was untroubled by stray thoughts of that baby she had given away; and even when, for some reason, the memory was triggered, she was able to deal with it calmly. The older her sons grew and the more consuming family life became, the less she was bothered by her conscience. The little pricks of fear which had alarmed her disappeared, and she became serene and less wary.

That proved, eventually, to have been a mistake.

PART THREE

 \sim

Evie – Shona

Chapter Thirteen

 \sim

VIE HAD imagined Carlisle would be familiar to her but it was not. LAll the long way in the coach she had been remembering St Ann's, high on the hill above the river Eden, and in her mind's eye she had seen again the outline of the squat castle and the glint of the sun on the cathedral windows. She knew the bridge would be crowded as the coach left Stanwix and crossed the Eden into the city and that the streets round the market would be jammed with people and animals being driven home from the Sands. She expected to feel happy that she was back in her home town and was dismayed, when the coach stopped outside the Crown and Mitre, to discover that everything she saw looked different. The town hall market place was not the cheerful, friendly place she had remembered, full of women sitting beside makeshift stalls and with their children playing all around. It teemed with carriages and coaches and she was startled to see her first tram careering noisily along its iron rails. Her heart began to thud and she stood motionless, clasping her bag, not knowing what to do, and suddenly aware of the enormity of the decision she had made.

She had to go somewhere. She could not stand in front of the Crown and Mitre all day transfixed by the turmoil before her. But moving was difficult because of her heavy bag, which she could not carry more than a few yards without stopping. Her vague idea was to go back to the only place she knew, St Cuthbert's Lane, where she had lived with old Mary, but she knew this would be foolish. Somebody else would be living in the house where she had once lived and the sight of a girl carrying all her worldly goods in a shabby carpet bag would not appeal to them. But where could she go? She had no money for a lodging-house and the only people she knew of in Carlisle were the Messengers who ran the pub in Caldewgate and had occasionally called in at the Fox and Hound. She supposed she could claim truthfully to be of their family and therefore worthy of shelter, but she could not go to them. The would report her presence in due course to Ernest, who would come and get her. Even if he did not, and she was sure he would, she did not want Ernest and Muriel to know where she was.

She could go to the Home, to St Ann's, if she could get herself there, if she could beg a lift on a cart going in that direction. They might take her in, give her a bed in return for her labour. But that was another likely place Ernest might look, and besides she had only bad memories of the Home. Fleetingly, and she knew it was foolishly, she thought of the woman who had taken her to the house in West Walls on the day Mary had died.

Standing with her back to the wall of the hotel, her bag at her feet, Evie stared straight ahead as though having a vision. Nobody appeared to notice her. She was quite insignificant in her drab coat and the dark brown bonnet she wore had a wide rim which shaded her small face. She looked like a girl waiting to be collected, waiting with patience and resignation, and gave no hint of the inner terror she was experiencing. An hour she stood there, two hours, three hours. The crowds never seemed to diminish nor the clamour lessen. She heard the cathedral bells chime and watched the time on the Town Hall clock. It was already midday. She was lucky that the sun shone, though she was standing on the side of the main street which was now in shadow, and that there was none of that biting wind there had been earlier when she had left the Fox and Hound.

Opposite her she had been watching a scene she did not at first understand. There were a great many ladies milling about, all well dressed to Evie's untutored eye, and all pointing and talking to each other. They were pointing at girls, poor-looking girls, all of whom stood stock-still, many of them on wooden crates. The ladies walked round these crates and appeared to examine the girls, who looked downcast and mornful, then they would halt and some interchange would take place. Sometimes a girl would then step off the box and follow one of the women. Evie strained to see where they went, but could never quite make out their destination – woman and girl were both swallowed up in the crowds. It took her the whole morning to work out that what she was witnessing was the hiring of servants. There could be no other explanation. She had never known this could happen, there had been nothing like it in Moorhouse, but now it seemed blindingly obvious that this would be her salvation.

She was worried as she dragged her bag into the space in front of the Cross, where the girls were on view, that there was perhaps some system of which she was not aware. Was any girl allowed just to appear and offer herself for hire? She saw some older, rough-looking women standing a little way off, eyeing the girls, and when one of this group rushed forward and took a coin from a lady holding the arm of a girl she had selected Evie realised she was the mother. Maybe a girl had to be owned and brought for hire by her mother. Well, she had no mother and if this debarred her from trying to be hired she would soon find out. She did not have a crate to stand on either. Instead, she stood on her bag. There was nothing in it that could be damaged, it was full of soft goods. She knew she looked odd, perched on the carpet bag, and not like the other girls. There were few of them left now, the majority had been claimed, and those that remained looked pathetic specimens. They were thin and dirty with bare feet and sorry-looking clothes. Evie, in her tweed coat and felt bonnet and buttoned boots, knew she looked too grand but she could not help that. It was the one time in her life she had felt in any way superior and this only embarrassed her. She could not bear to look directly at any of the ladies inspecting her and dropped her eves, as indeed she had seen most of the girls do.

She did not have long to wait.

'What have we here?' she heard a voice say. Evie knew the question must be directed at her but kept quiet. 'Are you for hire, girl?'

She nodded her head.

'Look at me when you're spoken to,' the sharp voice instructed, and obedient as ever Evie looked up. She disliked what she saw. This lady was not like the others she had noticed. She was tall and heavy, dressed all in black, with a fierce, red face and a cane upon which she was leaning hard. She was much older than any of the other ladies who had hired girls and she was by herself. 'Age?' she snapped, staring at Evie.

'Eighteen, ma'am.'

The lady snorted. 'Eighteen indeed! And if you are, which I doubt, too old to be hired. Did you know that? So you see you should have told the truth. You are fifteen, am I right?'

Evie stayed silent and did not move.

'Hold out your hands.'

Evie held them out. The lady touched them, turned them over. Evie knew her hands were rough with all the time they had spent doing dirty work. They were covered in keens too, where she had cut herself and some of these cuts had festered and left little scars. But the lady seemed satisfied.

'Open your mouth,' was the next command. Evie opened it. She had had four teeth pulled last winter but otherwise she had all her teeth and they were sound, the travelling dentist had said so. 'Where are you from?' the lady asked next. Evie still stayed silent. 'Are you a runaway? Have you left a situation?' Evie shook her head. 'Then how do you come to be here, miss, coming from nowhere? Were you turned off?'

'No,' Evie managed to say.

'Where is your home?' the lady said, impatiently. 'You have to have had a home. I cannot take a girl with no home. You might be anybody, a thief, a little whore, how would I know? Where is your mother?'

'Haven't got a mother,' said Evie, worrying if that was strictly true.

'Father?'

She shook her head again.

'Have you come from the workhouse?'

More head-shaking.

'No, you do not look as if you have. You've been cared for. Out of the city?'

'Yes,' said Evie.

'A long way away?'

'Yes.'

'So you are a runaway. The police will be on to you, or whoever. Unless you are eighteen and small and had the right to leave, I don't know. Get off that bag. What's in it? No stolen silver or the like?'

'No,' said Evie.

'What then?'

'My clothes and shoes.'

The lady went on staring at her for a long time. Evie tried not to flinch. She knew this person would be trying to judge her character from her face and demeanour, and she tried to put into her expression her honesty and obedience and desire to work hard and not be any trouble. She knew she had succeeded when the lady said, 'Very well, I will take the risk, but I'll be watching you and one sign of impertinence or worse and you'll be out. Now pick up that bag and follow me.'

Luckily, the lady walked so slowly because of her age and needing her stick that Evie had no difficulty making her way behind her. There was a pony trap waiting on the corner of Bank Street and the lady got into it and gestured to Evie to do the same. An old, vacantlooking man was driving the trap and as soon as both women were settled, he flicked his whip and the pony set off at the slowest of paces. Nobody spoke. They went down Bank Street and round the corner into Lowther Street and round another corner into a square. Evie saw the houses here were all very tall and set close together in terraces. The trap stopped outside a house in the middle of the terrace on the far side of the square and the lady was helped out by the driver. He did not help Evie nor did he lift down her bag. She managed to heave it on to the pavement, though the effort strained her arms. Slowly the lady mounted the stone steps and the door was opened as she reached it.

'God knows what I've brought back with me, Harris,' she muttered, 'but in an emergency beggars cannot be choosers. We'll have to watch her like hawks.'

Evie saw a very tiny woman, surely even older than the lady who had hired her, standing holding the door.

'I don't like this at all, Mrs Bewley,' the tiny woman said. 'It isn't right, going to a hiring, it isn't proper, it isn't safe, it isn't for the likes of you, it isn't ...'

'Oh, hold your tongue!' snapped Mrs Bewley. 'I know all that, for heaven's sake. But we need a strong young girl, we can't go on without Hattie and Ella. The place is going to rack and ruin. You're too old, I'm too old, and the discomfort was becoming insupportable. It was time I used my eyes and my head to see if I couldn't find better staff myself. So be silent, woman. Take her up to the attic and then bring her down and get her started.'

Afterwards, Evie did not know how she had survived the first months in Mrs Bewley's household. She had thought she knew what hard work was, brought up as she had been in the Fox and Hound, but she quickly decided that working for Muriel and Ernest had been restful compared to slaving for Mrs Bewley and Harris. They had her up at five each morning and she was never allowed to crawl to bed before midnight, with only a few minutes here and there

throughout the day for her to eat and rest. She was, in the full meaning of the description, the maid of all work. And the work, too, was infinitely harder than it had been at the Fox and Hound. The Fox and Hound was a pub but it was not large. There were only six rooms besides the bar and all of them were small. But 10 Portland Square had twelve huge rooms on five floors and sixty-six stairs connecting them. Evie had to clean them all, take coal for fires to half of them and wait at table besides. She was drunk with exhaustion, visibly swaving on her feet by six in the evening, but if this was noticed it was never commented on. Often she thought that if the food she was given had been more substantial she would have had more strength, but she rarely had a good meal and existed mostly on bread and margarine and sometimes cheese or an egg. She had always been thin but now she saw there was hardly any flesh on her and her ribs showed through alarmingly. She could feel them with her hands as she dressed and undressed and she loathed that feeling, the evidence that she was becoming little more than a skeleton.

What sustained her was knowing she was in Carlisle, and therefore near her mother. Somewhere in this city Leah Messenger lived and, given time and opportunity, Evie would surely find her. She was allowed to go to church on Sunday, a request Mrs Bewley obviously felt bound to grant, though she was disbelieving that Evie really intended to go to church. 'A churchgoer?' she had queried, and had promptly subjected Evie to an interrogation. She had been challenged to recite the Lord's Prayer and, when this proved easy, the Creed. Only when, for good measure, she had thrown in a few Psalms, faultlessly recited (Mrs Bewley got her prayer book and checked), was Evie grudgingly believed. Mrs Bewley herself did not go to church, on account of her leg, she said, but she directed Evie to St Cuthbert's. St Paul's was nearer, but Mrs Bewley did not approve of the vicar for reasons she did not divulge.

Every Saturday night, no matter how exhausted she was, Evie felt uplifted by the approaching excitement of Sunday. She could hardly sleep for the anticipation of perhaps seeing her mother without knowing it – any one of the women in church could be her mother. She knew, after the first Sunday, that Leah was not going to be found in the choir of St Cuthbert's, since it was all male, and perhaps not in any choir, but she was sure she would be in some church on Sundays. The church she really longed to go to was Holy Trinity, but it was twice the distance from Portland Square as St Cuthbert's, and Mrs Bewley timed her return. If she came back a minute later than the ten minutes allowed for the distance there would be trouble, and trouble was not something Evie could afford to risk. Even after she had been in Mrs Bewley's household for a year she continued to be very careful to give total satisfaction and not to cause offence. But she saw that her goodness and her tolerance of harsh treatment in itself aroused suspicion. Mrs Bewley could not believe a young woman could be so docile and hardworking if she did not have some sinister ulterior motive. Sometimes she would look at Evie and say, 'So butter doesn't melt in your mouth, it seems,' which would be followed, after a significant pause, by, 'I don't believe it, you're too good to be true, you are, Miss. I'm watching you, mind.'

Watch Evie she did, closely, continously, and Evie was fully aware of her scrutiny. She knew Mrs Bewley hauled herself up all the narrow stairs to the attic on Sunday mornings and inspected it for stolen goods, though what there was to be stolen Evie could not imagine. She supposed jewels, since Mrs Bewley wore plenty of them. She had many glittering rings to decorate her gnarled fingers, and her throat was always circled with pearls. But if none of these was missing, why, Evie wondered, did Mrs Bewley go searching for them? At least her search would be quickly over. There were three truckle beds in the attic, but of course Evie used only one and was glad she did not have to share the miserable space with the two other maids there had once been in Mrs Bewley's employment. Otherwise there was only a chest of drawers and Evie's old bag to ferret around in and that could not take long. Yet Sunday after Sunday she could tell Mrs Bewley had vet again put herself through the pointless ordeal of climbing up to the attic and Evie marvelled at such persistence. The strain made her employer even more bad-tempered than usual and, if the thought of Sunday morning made Evie happy, the thought of Sunday evening depressed her. Nothing was ever right during the rest of the Sabbath. Every service she performed was criticised and it was on Sunday nights she invariably gave way and cried herself to sleep.

She was always ashamed of this weakness. She had hardly ever cried as a child, when she had felt desolate and despairing, but now she seemed to need to. It did no harm. No one knew she cried. She rose soon after dawn on Monday mornings with no visible evidence of having wept and neither Mrs Bewley nor Harris saw her at that hour. She had fires to rake out and reset, and the kitchen range to black-lead, and all manner of gruelling jobs they were not around to see. Nobody spoke to her until noon and then only to give her orders. In that vast house there were only the two old women, and most of the cleaning and polishing Evie did was to keep unused rooms in perfect condition. Only four rooms were regularly used – the kitchen, the dining-room, the breakfast room, and Mrs Bewley's bedroom – though the drawing-room fire was lit once a week when Mrs Bewley received visitors. These were few. The vicar of St Cuthbert's came every three weeks, took a cup of tea and departed within the half hour. The doctor came once a month, took a glass of sherry and made his escape even more quickly. Otherwise there was only a lady called Miss Mawson.

Evie did not know who Miss Mawson was, or why she visited Mrs Bewley every week, staying at least an hour. 'This is my new maid.' Mrs Bewlev said to Miss Mawson the first time Evie was in her presence (bringing in more coal for the fire) but she did not, of course, tell Evie who Miss Mawson was. Only Harris could have done that, but Harris never engaged in any kind of conversation with Evie. She was very deaf in any case and completely in her own world. She shuffled about the house doing little except issue orders to Evie, and when she was asked a question never replied. In the mornings Harris did the orders for the day, sitting at the kitchen table and laboriously writing lists. These lists were the same every day, but every day they were made on a fresh sheet of paper. Harris's real job was to cook, but she had told Evie she was the housekeeper and that Evie was to remember that. She had no interest in Evie at all (unlike Mrs Bewley, who was consumed with curiosity as to her background and real identity). It was easy to imagine how maids could have run rings round this old Harris without her noticing, until Mrs Bewley would have been mad with rage. In fact, she heard Miss Mawson say, 'Thank goodness you have got rid of those two wicked girls. I hope this one will be more satisfactory.' Evie longed to hear Mrs Bewley's reply, but it was not given while she was still in the room.

Miss Mawson always came at three o'clock in the afternoon and it became one of Evie's many jobs to let her in. Harris liked to receive people but her deafness meant she very often did not hear either the bell or the knocker, and Evie had been told to answer the door herself. She changed her clothes to do so, which is to say she took off the all-enveloping grey calico apron and cap she wore in the mornings to do dirty jobs, and put on an old white apron of Harris's. This was quite an attractive garment and Evie liked it. It only covered her front, exposing rather too much of her by now woefully worn once best dress, but it had frills round the shoulder straps and the bottom edge. It had been starched and kept pristine and dazzled Evie with its whiteness. Harris was no taller than she was herself, so this splendid apron fitted her and, while wearing it, she felt she had some self-respect after all. Miss Mawson was always particularly gracious to her, saying, 'Good afternoon, Evie' and 'Thank you, Evie' when her coat was taken, and 'Goodbye, Evie' as she left. Evie loved the sound of these simple pleasantries and murmured them to herself afterwards. Miss Mawson had a way of investing the unremarkable words with some real meaning and it was comforting to hear her. Also to see her. Evie did not know her age, but she thought Miss Mawson not more than forty or perhaps younger. She had lovely clothes in muted colours, dresses of lilac silk and pearl grey wool and blouses intricately embroidered round the cuffs and collars. She was, in fact, elegant in an understated way, and Evie responded to this elegance instinctively.

She wanted very much to discover where Miss Mawson lived and why such a kind lady visited the unkind Mrs Bewley so regularly and often, but she never came any nearer to doing so. But she saw Miss Mawson at church. Evie always sat near the back in an aisle seat behind a stone pillar. She crept in some five minutes before morning service began and took a prayer book and hymn book from the sidesman without looking at him. She liked to sit listening to the organ and preparing herself for the first hymn, but now and again she would look up and across the pew and watch the grander folk make their confident way down the main aisle to the family pews. They always held their heads so high, these people, and the mothers in particular were beautifully dressed in their Sunday best. There would be a good deal of subdued hissing at sulky children who were not being quiet enough and then the family group would settle down, a row of bent heads saying their prayers. Evie looked and drew her coat tighter around herself, feeling cold and tired.

Miss Mawson walked down the aisle on Sunday with such a group -a father, a mother, two young boys and an older girl -and Evie presumed she was with them. Immediately she saw her as an

aunt, the father's sister surely, since she did not resemble the mother, but when the family entered their pew Miss Mawson did not after all accompany them. Instead she slipped into one of the unmarked pews where anyone could sit, and it was clear when the service had begun and nobody had joined her that she was on her own. This somehow excited Evie. Miss Mawson, like her, was alone even if their circumstances were very different. Perhaps Miss Mawson lived entirely alone and had no family. Evie longed to follow her home, but of course there was no possibility of being able to do so. After the service, she hung back behind the departing crowd instead of darting out first to avoid the embarrassment of passing the vicar when he had taken up his station at the door. She followed Miss Mawson at a distance, separated by a dozen or so people, and was out of the church in time to see her walk down St Cuthbert's Lane. Evie usually went that way back to Portland Square in any case. But coming into English Street, Miss Mawson crossed in front of the town hall and turned left down Scotch Street. Evie's way turned right and down Bank Street. Standing for a precious few minutes on the corner (she could run the rest of the way home and still arrive on time) she strained her eyes to see where Miss Mawson was going. Towards Eden Bridge, it seemed. Then she must live somewhere in Stanwix. Gratified to have learned this, Evie hurried along wondering why, in that case, Miss Mawson attended St Cuthbert's and not a church in Stanwix. Was it out of some old loyalty? Or because she was in the habit of worshipping at different churches for variety? Or even that there was something special about that Sunday's service at St Cuthbert's?

Evie enjoyed pondering on this question. The little mystery gave an additional thrill to the following Sunday – would Miss Mawson be there or not? She was not. But two Sundays later she was, and Evie had a stroke of luck, such as rarely came her way. Mrs Bewley was unwell. The doctor had been on Saturday and pronounced her feverish and possibly about to go down with shingles. Mrs Bewley had instantly beseeched him to send a properly trained nurse to her since she vowed 'that chit of a girl' as well as 'that old fool, Harris' could not adequately nurse her and she would die of neglect. The nurse had been sent and Evie and Harris banished to their more mundane duties. When Evie had gone into Mrs Bewley's bedroom to do the fire, as she did every morning, she had been told by the nurse not to disturb the patient again unless she was specifically sent for. Nervously, Evie had bobbed a curtsey at the nurse, who was a figure every bit as formidable as Mrs Bewley, and asked if it was still all right for her to go to church as she did every Sunday morning with her mistress's permission. The nurse had said of course and that nothing would be required until one o'clock at the earliest.

Normally Evie had to be back in the house by a quarter past twelve, fifteen minutes after the end of morning service. Given this unexpected bonus of another forty-five minutes, she had been planning all the way to church what she would do with it, but when she saw Miss Mawson once more her other tentative plans were abandoned. She would follow Miss Mawson home and still be back in Portland Square by one o'clock unless her quarry lived a very long way away – which was not likely, or she would have come in a cab. Evie could hardly contain herself through the service, which she was used to wishing would go on for ever. This time, knowing the direction Miss Mawson would take, she shot ahead and fairly scurried down Scotch Street, pausing only at the corner of the market to withdraw into a deep doorway. There, breathing heavily from the exertion, she waited for Miss Mawson to pass, which she did, after a time that was long enough to restore Evie's energy. She passed quite near but looked straight ahead, walking gracefully and slowly and obviously enjoying the air and exercise. Evie followed at a distance of fifty yards, her head down in case Miss Mawson turned round. On the bridge, Miss Mawson hesitated briefly, but only to look down at the swollen river and possibly admire the daffodils growing wild along its banks. Then she proceeded up Stanwix Bank and turned eventually into Etterby Street. Evie did not follow her all along the street, which fell away down a hill then went up again. She could see perfectly well from her vantage point that Miss Mawson had entered the second last house on the right, using her own key. So far as Evie could tell, this house was guite small, guite modest, a terraced house, but not in the manner of the Portland Square terraces. There was no time to go down the hill and up again to examine its interior closely, not this Sunday. Turning back towards the city, Evie rushed home. To her immense satisfaction she was inside the house at ten minutes to one and not called upon by the nurse until half past.

Mrs Bewley did have shingles and was very ill. The nurse stayed three weeks and Evie had two more Sundays of extra free time as well as a much easier life during the week. There was no Mrs Bewley to stand over her and make her do again jobs she had already done faultlessly. She carried on methodically cleaning and polishing and performing all the tasks expected of her but, since she was not forced to do half of them twice over, she had, for the first time in over a year, hours to herself. These hours did not come all together but in separate stretches throughout the day. She still rose before six but by eleven she had done all the morning work and had two hours until dinner-time. It was the same in the afternoons, only the other way round - free until three and then busy until seven. She worried as to her rights in this situation. Might Mrs Bewley, when recovered, demand to know what had been going on? But Evie reckoned that if she had kept up her employer's standards and had always asked the nurse for permission to leave the house then she could not be accused of cheating. Doubtless Mrs Bewley would accuse her but then she was likely to do so however Evie had behaved.

So Evie went out regularly and experienced a feeling of freedom that was quite intoxicating. She roamed the market and convinced herself she remembered it well, though in truth she was disappointed to find she did not. There was something about the butter women's stalls that was vaguely familiar but that was all it was, the vaguest of recollections of sitting looking at people's feet. More daringly she ventured past the cathedral and over Caldew Bridge and into Caldewgate to Holy Trinity, passing on the way the Royal Oak, which she knew was run by Messengers. It was not a Sunday and Caldewgate was busy. Workers streamed out of Carr's biscuit factory and the place seemed as hectic as Portland Square was tranquil. Evie was apprehensive about entering the church on a weekday - she did not know if it was allowed - but her desire to see inside was so great that she went and tried the door. When it opened, she slipped inside, heart thudding and throat dry, rehearsing what she would say if challenged - 'Please sir, I was baptised here.' She went up to the font and stood touching the stone, her eyes shut. Here her mother, Leah Messenger, had stood holding her, a baby, in her arms and had given her a name. Mary had been with her, old Mary had been a witness, and it was all written down somewhere, there was proof. Evie trembled a little and wondered if this was the church, with its memories of her baptism, to which her mother still came. She could come one Sunday, while Mrs Bewley

remained ill, but what good would it do? She would not recognise her mother, her mother would not recognise her. It was pointless.

The whole search was pointless and not even a proper search. Evie, walking home through Caldewgate, despaired. She needed help. She needed someone to instruct her in how a search could be made and she had no one to advise her. While she had been at Moorhouse it had seemed so hopeful - knowing her mother's name. knowing where she herself had once lived with old Mary, knowing where she had been baptised - surely, knowing all this, she could find her mother. But now she saw how she had deluded herself and even been wilfully stupid. What she knew amounted to nothing. It was nineteen years now since she had been baptised, thirteen since Mary had died. She knew no one in Carlisle, a city of thousands and thousands of people. Her mother might not be here, and if she were, her name might be different, she might be married. Entering the Portland Square house, quietly, she thought she might as well leave. It was dark in the hallway, the heavy door shutting out the light except for a few feeble rays of sun struggling through the stained glass panels at the side. She should go up to the attic and pack her bag and leave. But where would she go? To the hirings again? She shuddered. How ever she had brought herself so low she could not now imagine. There must be other ways to find employment. She had often looked at Mrs Bewley's Cumberland News when making it into paper sticks for the fire, and she had seen advertisements for maids of every description, but they all asked for references, and she had none. Mrs Bewley would certainly not give her one and there was no one else in Carlisle for whom she had worked, or who knew her. Except Miss Mawson. Miss Mawson could be said to know her, in a manner of speaking. Miss Mawson might vouch for her obedience and reliability and politeness and trustworthiness, unless Mrs Bewley had told lies and poisoned her mind.

Throughout the following week, the third and last of Mrs Bewley's illness, Evie turned over and over in her mind the possibility of throwing herself on Miss Mawson's mercy and asking her help. But she was intelligent enough to realise that, as Mrs Bewley's friend, Miss Mawson could not reasonably be expected to give a reference to the maid who wished to leave her friend's employment while she was ill. It would not do, and Evie saw clearly that it would not. There was no point in embarrassing, perhaps even angering, Miss Mawson and humiliating herself. But the next time Miss Mawson visited and Evie opened the door to her she found herself trembling so violently that the visitor noticed.

'Why, Evie,' said Miss Mawson, all concern, 'you are shaking, dear, are you ill?'

Evie whispered, 'No, ma'am.'

'You are cold, then? Indeed, it is cold in this hallway, I have often thought so.' Evie nodded, relieved to be given this excuse. She stood aside to let Miss Mawson mount the stairs to Mrs Bewley's bedroom, but on the first step Miss Mawson lingered and looked over the banister at Evie. 'Are you worried, Evie? Are you afraid of what might happen to you if, God forbid, there is a tragedy?' Startled, Evie looked up. She did not know what Miss Mawson meant, but found herself nodding. 'Then do not fret, my dear, I would help you find a new situation.'

And, with that, Miss Mawson carried on up the stairs and Evie returned to the kitchen weak with gratitude. Hope had returned, stronger, promising more than ever and, though she had not yet quite worked out the implications of what Miss Mawson had said, she knew beyond any doubt that some positive reassurance had been given to her for the future. Miss Mawson had shown her a most motherly concern.

Chapter Fourteen

 \sim

THE TRAIN journey from London to St Andrews was always long and tedious, but Shona quite liked the numbness that regularly overcame her after the first hundred miles. She would try at first to read but the book would fall from her hands within half an hour no matter how good it was. Train journeys, long journeys like this one, were conducive only to day-dreaming and soon she would be in a stupor, no longer aware of the eating hordes around her. She watched the endless procession of travellers coming from the buffet carrying their absurd little paper carrier bags full of disgustingly smelly food and was surprised what little impact they made on her. People, nameless people about whom she would never know anything. She felt utterly remote from them.

The woman opposite her was clearly longing to engage her in conversation but Shona had resisted all overtures. No, she had not wanted to read this stout, dry-skinned, white-haired woman's magazine and no, neither had she accepted a share of her sandwiches. To the query 'Going far?' she had said she was and promptly shut her eyes. Fatal to be polite with five hundred miles ahead. She wanted to have established herself before Watford as unfriendly, uncommunicative and very, very tired. All true, especially the last. She felt exhausted and deeply, deeply tired, a drained, dizzy feeling not at all like ordinary fatigue. The thought of Catriona's fussing over her was for once something to look forward to. Good food would be cooked, a warm bed prepared and every comfort lavished upon her. She could wallow in all this spoiling and enjoy the sensation. For a few days, at least. Then she supposed the rot would set in as it always did. She would start to feel irritable again and that unbearable sensation of wanting to escape and never return would overwhelm her.

She kept her eves closed until Oxenholme and then she stared out of the window at the snow-covered hills of the Lake District. It was a dark afternoon. Though it was only midday, the December light was already fading fast. The white of the snow seemed fluorescent. beaming up towards the dark grey sullen sky. It felt like home though it was not. Shona was always puzzled by this strange sensation of familiarity whenever she was amid snow-covered mountains - she felt happy and comfortable vet there was no reason for this. Home was the sea, always had been. She closed her eves again after Carlisle. She was going to Glasgow instead of Edinburgh. where usually she changed trains for St Andrews, because she was visiting her Grannie McEndrick on the way home. It was not something she wanted to do, but the suggestion, her mother's of course, was not one she felt she could turn down. She hadn't seen her grandmother for over a year and she knew fine well how a glimpse of her was fervently desired. Grannie McEndrick had been ill since the summer and was full of sudden intimations of mortality. She'd let it be known she wanted to see Shona 'for one last time'.

She got off the train at Glasgow, dreading the trail out to Cambuslang and the big stone house where her grannie lived. She had no money for a taxi – what student had? – and the buses were so slow. Lumbered with a rucksack and another heavy bag she had difficulty getting on the bus at all, and nobody helped. She looked big and strong enough to manage on her own, she supposed. And she had made no effort to look attractive, why should she? She hated girls who traded on their looks to cadge help. Her beautiful hair was bundled up inside a woollen ski hat and she was wearing her customary black ski jacket zipped right up to her chin, with black trousers and heavy boots. Who would imagine such a formidable creature might have arms that were weak and ached with the weight of her load? She was so tired by now that she felt sick. She wished she had refused to stop off at Grannie McEndrick's for a night and day. There would be no luxury in her house. It was a house that had died in the last few years. Only two rooms were in use and all the others were shut up, the cold air seeping out from them through the ill-fitting doors. A house which had once seemed warm and hospitable was now bleak and repellent, everything about it neglected and dated in a shabby rather than quaint way. There

would be no delicious food. Grannie McEndrick existed on tinned soup and crackers and cheese these days.

Shona had to stop four times on the journey from the bus stop to her grandmother's squat house. She stood, bowed over, almost in tears. Tears of that kind of self-pity she found despicable but to which she had lately been succumbing more and more often. It was going to be such a strain undergoing her grannie's questioning. She knew what line this would follow: was she happy at university? Was she enjoying herself? Was the work interesting? Was it hard or easy? How was she managing in the big city? Had she been homesick? And, the most pressing question of all, 'Any romances, Shona?' She ought to be able to take it all in good part, or else lie cheerfully. No harm in joking, making up entertaining answers. But she had not the energy for it, nor for the truth. She wanted to get through the next twenty-four hours as painlessly as possible and then move on, duty done. Her one thought, as she reached her grandmother's door, was how quickly she could get to bed.

Not quickly at all. Ailsa McEndrick had had an afternoon sleep so as to be alert when Shona arrived. And she had stirred herself sufficiently out of the lethargy which seemed her new permanent condition to make a proper meal. No tinned soup. She had made a stew, the sort she used to make when all her family were at home, a stew with dumplings, and an apple pie. It had cost her a great deal of effort and she was looking forward to watching her granddaughter devour her offerings voraciously. Her first words were, 'Sit yourself down and tuck in, you'll be starving after that long journey.' Shona was indeed hungry but stared in dismay at the plate of stew plonked with triumphant speed in front of her, even before she had had time to take her jacket off.

'It's meat,' she said.

'Of course it's meat, best stewing steak, and the *price* now, it's scandalous, so you tuck in, there's plenty.'

'I don't eat meat,' Shona said. 'Grannie, I'm sorry, I really am. I should have told you. I just didn't think you made stew any more ...'

'Specially! For you, specially for you, you'll have to eat it.'

'I don't eat meat, I'm a vegetarian ...'

'There's plenty of vegetables in there, carrots and neeps and onion, they're all in with the meat, so you'll be all right, now eat up.'

Ailsa's face was red with exertion and fury. Such nonsense these

children talked, no meat indeed. Silly, silly ideas. How did they think they would grow? Though by the look of her there was no need for Shona to grow any more. She was a big enough lassie already, she'd be putting the men off if she got any bigger. She'd changed. Ailsa saw the changes and grieved. All that bonny hair in knots, she could see it was all full of knots. It needed a good brushing. That long, thick, wavy head of auburn hair scragged back and tied with an elastic band, not even a ribbon. And she was pale, dreadfully pale, no roses any more in her cheeks. She sat there, picking out the delicious, expensive pieces of meat and putting them on the side of her plate as though they were tainted, and not even the dumplings seemed to meet with madam's approval. But the apple pie was given the reception it deserved, which was something. Half of it eaten at one sitting, and with relish. Mollified, Ailsa settled into her armchair and said, 'Now, tell me all about it, I want to hear every word, mind, every word, just you start at the beginning and tell me all about what you've been doing down there in London.'

Carefully, Shona scraped her pudding bowl clean. It was a pretty bowl, blue and white, part of a set she knew her grannie's mother had given her as a wedding present. It was never used on normal occasions. Her grannie was treating her like royalty, making her special stew and apple-pie and using her best china. Now she wanted her reward. Shona swallowed the last morsel of the pie and took a drink of water. She could delay things by requesting a cup of tea. She disliked tea but all her grannie's meals were followed by tea, and she was surprised it had not yet been offered.

'Tea?' she suggested. 'Shall I make it?'

'I don't drink it any more at this time of night,' Ailsa said, 'it makes me have to get up to go to the bathroom. It'll happen to you too when you're my age. We McKenzie women have weak bladders and you're half McKenzie. But I'll make you some if you're wanting it, except I don't believe it, you've never cared for tea, just humouring me, were you?' Shona smiled. 'Now, what have I said that's funny, miss?'

'Nothing, just you're so sharp.'

'Sharp, am I? Sharp enough to know something's amiss with you. What is it? Have you got yourself into trouble?'

'No,' said Shona.

Trouble was not what she had got herself into. A mess wasn't exactly the same as trouble. She'd got herself into a mess and she

could see no way of getting out of it. From the moment she had arrived in London the search for her real mother had taken over her life to the exclusion of everything else. She went to lectures and wrote essays without any real understanding of what she was doing and was astonished that she got away with such minimum effort. She felt like a robot but nobody seemed to notice. Within a month she had moved out of the Hall of Residence and into a bed-sitter in Kilburn, a bleak little room in the basement of a dilapidated house which would appal her parents if they were ever to see it. But she preferred living there on her own to living with other girls. They all irritated her. They were so childish, so preoccupied with utterly pointless pursuits. They distracted her. Hearing them giggle, or yell, or sing enraged her. She felt the fog that seemed to surround her penetrated by a sudden harsh beam of light when she heard their noise and it disturbed her; she didn't want its illumination. She didn't want to be recalled to the life of an eighteen-year-old with an eighteen-year-old's desires. All she wanted to do was concentrate on finding her mother.

It was a point of honour not to have asked her parents a single question. They had finished the holiday in Norway in some style, the sense that something important had been achieved lifting all their spirits; and then there had only been a few months before she had gone off to London. She made phone calls and wrote dutiful regular letters, but never once did she bring up the subject of her adoption. She hugged the new knowledge to herself fiercely, telling no one, loving her secret, revelling in it. To ask questions would be to damage the constant pleasure of it. She wanted to find her real mother herself, without help, and particularly without the help of Catriona and Archie, though she knew that by excluding them she would be making her task much more difficult. But she wanted it to be difficult. She wanted to have to work hard and overcome all kinds of obstacles to discover this woman's whereabouts, this woman who had given her away immediately she had gone through the labour of giving birth to her. The searching was like a kind of labour itself to her - the pain, the struggle and then, she hoped, the joyful delivery.

She thought she would start by obtaining her birth certificate. Surely nothing could be simpler. St Catherine's House in Holborn was not far from University College and she found it without difficulty. She had imagined it as a grand building with an imposing, perhaps intimidating, entrance, but the doors, net-curtained, were like those to a block of council flats. The inside was equally unimpressive – low ceilings, grids to let light through, cheap lino strips down the middle of the shabbily carpeted floors. She wandered bewildered through the first room. Somehow she had thought the actual looking at records would be done by clerks, but no, she could handle the huge books herself – black for death, green for marriages, red for birth, yellow for adoptions.

The record books were wide and long, two inches thick, with heavy handles to pull them out of the racks where they were stored, four to each year, all arranged alphabetically. She loved the feel of these registers, the very difficulty of hauling the heavy volumes out of their nesting place and opening them, jostled on either side by other people doing the same. Such ordinary people, not scholarly as she had imagined, and all with the same intense air she had herself. There was no entry at all for Shona McIndoe's birth. The disappointment was sickening, but then she chided herself at once for her own stupidity – of course there was no entry in the records here, because she had been born in Norway. Would she have to go to Norway?

But she had been adopted in Scotland. Or had she? Had all the adoption proceedings taken place in Norway too? Was she adopted through a society? Or privately? Was that possible? She had to ask advice. She was assured by a clerk that the best way, in her case, to find out what she wanted was to consult the Norwegian records. Either that, or ask her adoptive parents for the papers they must have in their possession. Shona left the building disconsolate. No, she could not and would not ask Catriona and Archie for her birth certificate and adoption papers. If she did, they would know what she was doing and she did not want them to know – not because she feared hurting them but because she simply did not want anyone to spoil her secret quest. It *had* to remain secret. She would feel exposed and vulnerable, an object of pity, if the extent of her longing was known.

So she went to Norway. To explain her absence to her mother, who had expected her home earlier, she set up an elaborate pretence of going to stay with a girlfriend at her home in Sussex for a few days. Catriona sent her a \pounds_{10} note to buy some little present for her friend's mother – 'Never go empty-handed, Shona.' It came in useful because Shona had very little money left at the end of term and had already cut down her spending on food and fares to save the amount she needed for her boat and train tickets. Even with drastic economy and no other expenditure she only just managed to raise the money and knew she'd have to stay in a youth hostel once she got there.

The journey was terrible. How easy it had been to fly from Edinburgh with her parents in the spring, how horrible to go by boat across the bucking winter sea. It seemed to take for ever and once they had docked and she was in the train she still felt herself swaying for hours. The building where the Norwegian records were kept was not like St Catherine's House, and Shona could not get the hang of how to look things up. Speaking not a word of Norwegian didn't help, though it was true everyone she asked for advice spoke English. But again she came up against the problem of not knowing her real mother's name, only her own date of birth and the place. It was no good trying to find her birth registered here - she would have to go back to the hospital in Bergen and ask to see their records. Another train, another freezing walk through icy streets to a hostel. But then, in the morning, when she went to the appropriate office in the hospital, the woman in charge was not helpful. Shona had thought up a romantic-sounding story, but it did not impress the official.

'I only want to look at the entry made for my birth,' Shona pleaded. 'I'm a student and it's part of an assignment we've been set.'

'You are from England?'

'Yes.'

'You come from England on a student assignment to look at your name in our records?'

'Yes.'

'Why, please?'

'I've told you, it's an assignment.'

'To gain what?'

'Sorry?'

'What is the point of this assignment?'

'It's history, I mean using records to verify what we know as facts, to check facts.'

'And they send students to Norway?'

'Only because I was born here. It's just that I want to be thorough ...'

'Very thorough indeed.'

'Yes, very thorough. I want to impress my teacher.'

It took several more minutes of hostile staring and questioning before this woman went off to consult some superior. She returned with a form for Shona to fill in. It asked for the father's and the mother's names of the applicant. Shona hesitated. It would be no good putting McIndoe. The hospital records would surely have her real mother's name.

'I really would like to do this the other way,' she said, trying not to sound nervous. 'I'd like just to look at a list of all the babies born here on the day I was born, without using my parents' names. It would add to ... to ... it would be more original. Please, could I not simply look at the list? Isn't a record kept of every day?'

'Yes,' said the woman, 'but the files do not work on a daily basis. This is eighteen years ago. The list for that year is under names, not times. If you do not give me your name I cannot help you.'

There was nothing to do but cry, and how Shona cried. She collapsed on to the red plastic chair in the woman's narrow little office and wept and wept, her face buried in her arms resting on her knees. There was the scraping of another chair and the sound of the woman walking round from behind her desk. But then, instead of comfort, a constantly repeated, 'Stop, please. I ask you to stop, please, stop.' There was anger, not sympathy in the voice and Shona heard it. The whole thing was ridiculous and this woman knew it was and it made her furious.

'I'm sorry,' Shona said. There was nothing to be lost now. 'I don't know my mother's or my father's name,' she said, voice thick with tears still. 'I was adopted, I want to find my real mother, that's all.'

The woman frowned. 'There are rules,' she said. 'They must be followed in such circumstances. It is a very serious matter.'

'I know,' said Shona. 'What shall I do?'

The woman told her to go home and 'ascertain some facts'. Without them, no search could proceed.

And now Shona was sitting exhausted in her grannie's Glasgow kitchen, barely able to speak of what she had been doing down in London. 'Oh,' she said, covering her face with her hands, 'I'm tired, Grannie, can we wait until the morning?'

'But you're off in the morning, you're barely going to warm the bed. And you'll be off without so much as the time of day, I know you will. Your mother's told me you have to be on that eleven-thirty train, she can't do without you a minute longer. She's missed you something cruel. Have you given any thought to that?' Shona groaned. 'No good groaning, it's the truth. Dotes on you, always has, the light of her life. It isn't healthy, never was. I knew it would end like this.'

'Like what?'

'You wanting to be away, not wanting your mother.'

'I do want my mother,' Shona whispered, hoping her Grannie would not hear and read any significance into how the words had been said.

'What? Want your mother? Never, never, you've never wanted her, independent from the word go, that was you. You're like my mother, your great-grannie, dead before you were born, but you're the image of her.'

'How very odd,' said Shona sarcastically. It was so tempting to tell her grannie the truth and smash all these silly ideas of inherited genes. But it would be cruel. Grannie McEndrick would not be able to bear having been hoodwinked. She would be outraged, not at the deceit itself but at its wholly successful accomplishment.

'It isn't odd,' she was saying, 'it's obvious. You and your mother are chalk and cheese, but you and your great-grannie are as like as two peas in a pod, so you are.'

'I'm going to bed,' Shona said, abruptly.

'Aye, you go to your bed, and I'll go to mine because there's no sense in staying up when you're in this mood. Maybe a good sleep will freshen you and sweeten the sourness. There's a bottle in your bed. I'll wake you at nine o'clock and you'll at least have some porridge and a civil tongue in your head, I hope.'

'I'm sorry,' Shona said.

'I should think so too, disappointing your poor old grannie.'

Next morning, Shona made a huge effort. She took Grannie McEndrick her tea in bed and would not allow her to get up to make the blessed porridge. She made it herself and took two bowls of it into her grannie's bedroom, and they ate it together while Shona chattered away making up every word of her lively description of her life in London. No comment was made, but her grannie seemed prepared at least to pretend she was satisfied. They parted on good terms, with Shona promising to write. 'Be kind to your mother,' were the parting words. 'Remember now, mind you're kind to her.'

Kind. Shona contemplated the word all the way to St Andrews. How was one kind to one's mother? It suggested condescension somehow, a faintly patronising attitude. Kind, as to an animal, or child. Catriona, she knew, did not want kindness. She wanted intimacy, as she always had done. Kindness was surely an insult. But she tried, when she arrived, to be affectionate and happy to be home which was, she hoped, a version of the kindness her grannie had had in mind. Christmas passed off well and so did Hogmanay. There were no arguments, no sulks. The three of them managed a rapport which convinced Archie that telling Shona she was adopted had brought her closer to them. Catriona shook her head but could not come up with any specific reasons for doubting this.

'She's trying,' she said to her husband. 'She's trying so hard, and I'm thankful. But she isn't happy, she's changed.'

'Of course she's changed,' Archie said, exasperated. 'She's eighteen, she's just left home for college, it would be unnatural if she hadn't changed.'

'I meant in herself, her nature,' Catriona persisted. 'She used to be fearless and that's gone. She's anxious, tense, underneath.'

But Archie wouldn't discuss such nonsense.

Shona took the dog for long walks on the beach and gradually felt better. The weather was stormy but she welcomed the biting wind scudding off the black sea and even the rain suited her. She felt busy struggling along the empty sands and she wanted to feel busy. It helped her to think. She began to see quite clearly that she had been deliberately foolish over the last few months – it had been absurd to try to trace her real mother in the way she had done. She had to put a stop to this idiotic stubbornness and use the resources available. If she did not want her parents to know she was trying to find this woman who had abandoned her, then the only alternative was subterfuge. The vital documents would be in the house. Her birth certificate, the original one, and the adoption papers – there would have had to be some kind of document – would be in a drawer somewhere. All she had to do was find them and copy them. Simple.

She was not sure where to start, with her mother's belongings or her father's. Archie was away so much that it was Catriona who handled all the household affairs, all the bills and so forth, but then the papers she needed did not come into that category. Her father kept their passports in his desk and she'd heard him once refer to some insurance policies in a drawer there. So she began with his desk, not even waiting until both parents were out. She waited until they were both watching television, a favourite programme lasting an hour during which they always said they would not move even to answer the telephone, and then she went into Archie's den, leaving the door wide open. His desk was neat. Three drawers either side of the kneehole and one long one running above it. Each drawer was labelled. She looked into all of them in case the labels were misleading, but they were not; insurance policies were where they were said to be and so were personal documents. But no birth certificate, no adoption papers. She sat for a moment looking at her father's passport. It had never occurred to her, when he had given her her own, that to apply for a passport a birth certificate was necessary. Archie had dealt with it and merely handed her passport to her.

She could not bring herself to search her mother's drawers until the house was empty. Catriona had no den or desk. She had a bureau in the sitting-room, which was much too public to hold secret papers, stuffed full of bills and receipts. Shona knew it was pointless but looked through these quite openly on the pretext of searching for a guarantee for her camera which she vowed she had given her mother. The only other place in which her mother kept things was her bedroom. There were photographs there, some in a box and some in albums, and all kept on a shelf in her wardrobe. But Catriona rarely went out and if she did, wanted Shona to accompany her. With only three days of her vacation left, Shona was beginning to think she would have to risk a quick raid of the wardrobe shelf while her mother was busy in the kitchen. An appointment with the dentist came just in time.

'You should come with me,' Catriona said, 'you haven't had your teeth looked at for ages. I'm sure he'd fit an inspection into the hour he's booked me for, a whole hour, I can't imagine why he thinks he's going to take that long.'

'Make me an appointment for Easter,' Shona said. 'My teeth are fine just now.'

She locked the front door the moment her mother had left. It was better to risk her unexpected return and her discovery that she was locked out than have her walk in on her daughter's spying. That is what I am, Shona thought, a spy. There is no other word for it. Spying, I am spying. She even found her palms were sweaty and her heart beating rather faster than usual, fast enough to be aware of it, as she went up to her parents' room. Such a dismal room, all creams and beiges and with the kind of candlewick bedspread she loathed. from her with barely a backward look and certainly never with any embrace. 'Take care,' she said again, 'don't work too hard, and write. You'll write, won't you? And ring if you want, reverse the charges, or else I could ring you back, and ...'

'Mum,' said Shona, out of the train window, 'I'm not going to the North Pole, remember?'

'It always feels like it. You've got such a different life now, all those people I don't know.'

The train slid out of the station and Shona collapsed at the release of all the tension she'd felt for the last two days. She was not just going back to college, she was going to meet Hazel Walmsley. Tomorrow she would spend the whole day in St Catherine's House. She'd be there when it opened at 8.30. Already she fantasised the meeting with her real mother - she could see her, astonishment and joy on her face, and behind her shadowy figures, sisters and brothers (Oh, she hoped more sisters than brothers, at least one sister) who would gradually emerge and become distinct. There was another fantasy of course, but she dealt with it firmly: rejection. She did not believe for one moment that her real mother would not welcome her, and only entertained this possibility in an attempt to envisage every conceivable reaction. So, it was theoretically possible. Her mother might not want her illegitimate child to claim her. She might have a life in which the appearance of such a child would be an embarrassment. She might never have told her husband or her other children. She might recoil with horror at the appearance of her first daughter and deny her entry into her world.

Nonsense. Shona knew it was nonsense. Her real mother would be like her. She would have suffered and grieved for eighteen years and now all her sorrow would lift. She would need to be reassured that Shona bore her no ill will and had no desire to make her feel guilty. Once she realised that no retribution was sought, she would be relieved. I can tell her, Shona thought as the train sped into England, that I have had a happy life with wonderful parents and that will make her feel better. But then I can add the bit she will long to hear – I have had a happy life with a devoted and loving adoptive mother, but *she is not you and it is you I want*. Probably, this said, there would be lots of tears. Shona smiled at the prospect.

Chapter Fifteen

 \sim

MRS BEWLEY died in the early hours of 15 October, but of a Mstroke, not of shingles. Evie was spared the sight of her employer's dead body, though she was invited to pay her last respects if she so desired. She did not desire. She had had no respect for Mrs Bewley, though she did not of course give this as the reason for declining the invitation. She implied, without saying so, that she was afraid, and this was sufficient for the nurse and Harris to leave her alone and not press her.

A man who was said to be a nephew arrived later that day and took charge. Bit by bit scraps of information drifted Evie's way as she let people in and out of the house, took tea in and out of the drawing-room for the nephew and other unknown persons, and in general went about her normal business. She picked up that the house had been left to the nephew, and its contents divided between three cousins. Some provision had been made for Harris, and she was to have a calendar month to get out. 'Where will I go?' she kept asking Evie. Evie had no idea; she was naturally more concerned that she did not know where she would go herself, though she was perfectly aware no provision would have been made for her. It was more a question of how long she would still be allowed a roof over her head and of whether she would receive a pittance when she was turned out. This seemed unlikely, since she had never received a penny from Mrs Bewley, only her keep. The nephew - she had been told his name but it was such a complicated double-barrelled name she did not absorb it - did not leave her in suspense for long. He sent for her the day before the funeral and told her she could stay until Harris departed. It was, he informed her, generous of him, some might say foolishly generous, but he was prepared to grant her virtually a month's free board and lodging in return for the fulfilling of her usual household duties. He was putting the house up for sale and wished it to be kept clean and tidy and in good order. Evie curtseyed and thanked him.

She waited meanwhile for Miss Mawson to appear. There was a funeral tea and Miss Mawson would undoubtedly have been invited back to the house, she felt, to partake of the refreshments. Evie taking the mourners' coats, grew increasingly anxious when no Miss Mawson arrived. Had she after all not been included in the funeral party, or had she gone straight home after the burial? It was impossible to know. Evie contemplated going to her house and throwing herself on Miss Mawson's mercy, but she could not quite bring herself to do this, not yet. She had not reached such a pitch of desperation and still had shelter for three weeks. It was a strange period of time, almost enjoyable, since with Mrs Bewley dead and the nephew returned home to Manchester, and the cousins not having come to see to the furniture, for the moment she and Harris had the place to themselves. Harris surprised her. Old and deaf though she was, she knew how to take advantage. The nephew had given her money to feed herself and Evie while they maintained the house up to its usual standard. He had asked what her mistress usually allowed her and Harris had lied promptly and convincingly. The sum Mrs Bewley had actually given her each month was small enough to be in any case so unbelievable that no suspicions were aroused by her doubling of it. 'And then there will be extra for fires. sir, if you should be wanting Evie to light them to keep the terrible damp down. Mrs Bewley, sir, was very particular about fires ever since the paper came off the drawing-room wall with the damp, and pictures on the staircase were ruined by it, and ...' The nephew stopped her. Certainly, while the house was being viewed by prospective buyers he would want fires. Everywhere. He paid for coal accordingly.

Harris gave Evie only a quarter of the profit she had made, but even so it seemed a miracle to her to have this windfall. It was the first money she had had in over a year and the very sight of the coins thrilled her. When she had to leave this house she would not after all be penniless. If she had wished, she could also have increased the sum. Harris was very willing to lead the way. Every day she filched some small article and pawned or sold it. Nothing precious, nothing that had already been itemised in the inventory, made the moment the nephew arrived, but quite ordinary things which Harris knew would nevertheless raise a shilling or two. Pans disappeared and buckets, good cast-iron buckets, and an excellent carving knife and a marble slab for rolling pastry on – Harris had an eye for the right articles. Evie, invited to join in, declined. Harris told her to please herself but that the Lord helped those who helped themselves and there was not much time to do it in.

The two of them kept the house up, with Evie, as ever, doing the bulk of the work. She liked the silent house. Safe from Mrs Bewlev's shouting, she appreciated the peace and, though she worried incessantly about the future, this did not prevent her from appreciating the present. If only Miss Mawson would appear, she would be quite happy. She tried to ask Harris where Miss Mawson was, yelled and yelled the name at her, but if the old woman knew, she was not going to say. Twice Evie used her now empty afternoons to walk to Stanwix and wander down Etterby Street and up to the Scaur, but she did not catch sight of Miss Mawson. She saw a strikingly attractive-looking woman coming out of the next door house with two girls, and thought about stopping her and inquiring if she knew whether her neighbour was at home, but it would have been such a foolish question. Why did she not knock at the door if she wished to ascertain whether Miss Mawson was in residence? She left the street promising herself that if Miss Mawson had not appeared by the last but one night she would spend in Portland Square, she would indeed knock on her door.

But Evie was saved from this ordeal. A week before she was due to leave Mrs Bewley's house, Miss Mawson turned up. Evie gave a little cry of delight when she opened the door to her, but this quickly turned to a gasp of consternation when she saw how very pale and thin Miss Mawson was. 'I have been ill, Evie,' Miss Mawson said as she came into the hall and immediately sat down on the upright heavy wooden chair which stood near the dining-room door. 'I am still far from strong, but I must arrange to collect what dear Mrs Bewley left to me before Mr Banningham-Carteret sells the house. Will you help me, dear?' Alert and eager, Evie went with Miss Mawson up the stairs and into Mrs Bewley's bedroom. The curtains were still drawn and the fire was set, ready to be lit the moment anyone came to view the house, but certainly not kept burning every day as the nephew supposed. It took Evie only a moment to light it and to open the curtains a fraction, as instructed. Miss Mawson sighed. 'I have no heart for this, Evie,' she murmured, 'but it must be done.' Out of her bag she took a list and walked towards Mrs Bewley's huge double wardrobe. 'Open it, Evie, will you?' Evie opened it, opened both doors wide. There was an enormous number of clothes packed on to the rail, starting with coats at the left-hand side and working down through suits and dresses to skirts and blouses. Evie had not known her past employer had owned so many splendid clothes. In the last year she had worn virtually the same garments winter and summer, a black dress and shawl, and a black coat if she went out.

Miss Mawson consulted her list and took out first a satin evening dress with its own little cape. It was a beautiful garment of elegant design, the bodice encrusted with tiny seed pearls, each sewn on by hand. Carrying it to the bed and gently draping it there, Evie shivered at the cool, luxurious feel of the material. 'Made by Mr Arnesen,' Miss Mawson said, 'a long time ago, for Mrs Bewley's daughter who was my dearest friend.' Evie made no comment, though she was desperate to ask questions and demonstrate her avid interest. She hadn't known Mrs Bewley had a daughter. In fact, she was sure she had heard her bewail the fact that she had not and exclaim that if only she had had children she would not now be in the state she was in, dependent on an old deaf housekeeper and a chit of a maid. Next there came out of the wardrobe a riding habit, a dark red day dress with slashed sleeves, a cream-coloured woollen coat with brown velvet collar and cuffs, a short fur jacket and several white blouses, all with lace collars and very full sleeves. 'All Caroline's,' Miss Mawson said, 'and kept all these years. I do not know what is to be done with them. They are all out of fashion and I cannot wear them in any case, I am much smaller than Caroline was. Now, Evie, will you fold these garments most carefully and put them in the boxes I have arranged to be delivered? And finally, dear. will you carry them yourself into the carriage and accompany them to my house?'

Evie could not sleep for excitement. It had never occurred to her that there could ever be any circumstances in which she could actually be invited to Miss Mawson's house – it was a dream too wonderful for her ever to have had the nerve to dream. The boxes came, full of tissue paper, and the carriage waited. Evie packed the garments skilfully, folding the tissue paper between them, and carried the boxes into the carriage one by one. The driver hired by Miss Mawson knew where to go. Sitting in state, looking out of the window, Evie could not help smiling. Her sad little face beamed with pride even if there was no one to see it, and when she saw Miss Mawson come out of her house to greet her she was so overcome with pleasure she stumbled as she alighted and was distressed at her own awkwardness. But Miss Mawson did not seem to notice. She paid the driver and then showed Evie where to stack the boxes. Once this was done, Evie was at a loss. Should she speak up? Should she remind Miss Mawson directly of her previous promise? Though it had not been a promise exactly. But Miss Mawson was speaking to her and offering her a coin.

'For your trouble, Evie,' she said.

'Oh no, ma'am,' said Evie, 'I couldn't.'

Miss Mawson looked at her closely and seemed suddenly to realise something. 'Of course,' she said, as though to herself, 'you will be leaving Portland Square without anywhere to go, and I believe I ...' She stopped, apparently coming to some decision. 'Sit down, Evie, for I must, I am still so weak, and I cannot feel comfortable talking to you if you stand before me like this. Sit, sit.' Reluctantly, perching on the very edge of the chair indicated, Evie sat. 'Now, Evie, I cannot give you a reference because you have never worked for me and I cannot employ you because I am not rich and as you see this house is very small and I have a maid in any case, but I can give you a recommendation based on my knowledge of your work and character as I observed it during my visits to Mrs Bewley, and I can besides quote what Mrs Bewley said about you. Will that be of use, dear?' Evie nodded her head vigorously. 'Very well. Stay here and I will write something at once and give it to you.'

She disappeared up the stairs and Evie was left hardly daring to move, but wanting badly to examine the photographs she could see on the nearby mantelpiece. She could see Mrs Bewley in them, with a girl. Was that girl Miss Mawson? No. Nor did she look like Mrs Bewley. Evie was sure this must be the Caroline who had been mentioned, even though there was no physical resemblance. There was another photograph of this same girl and beside her was Miss Mawson. Younger, but definitely her. Both girls were laughing, their arms around each other's waists. Evie wondered why she had never seen these photographs among those which crowded the mantelpiece and piano top in the drawing-room of Portland Square.

Miss Mawson returned, holding out an envelope to Evie. 'I have

not addressed it, dear, so you can present it to whomever it may concern. And I have left it unsealed so that you may read what I have written. I wish you luck, Evie.'

Evie sprang up from her chair and took the proffered envelope eagerly. 'Thank you, Miss Mawson,' she said.

'Do you know the way back to Portland Square, dear?' Miss Mawson asked.

'Oh yes, ma'am,' said Evie, smiling to think how many times she had walked the distance.

'It must be lonely there now, in that big empty house with only poor Harris for company?'

'I like it, ma'am.'

'Do you?' Miss Mawson looked very surprised. 'What is there to like?'

'The quiet, ma'am, it is very peaceful and easier ...'

'Easier?'

Evie hesitated. She remembered that Mrs Bewley, who had destroyed all peace, was Miss Mawson's friend. She could hardly now describe how hard that woman had made her life. But Miss Mawson was not stupid.

'You never knew Mrs Bewley as she once was, Evie,' she said. 'The kindest lady imaginable. But you see she had a great shock years ago and never recovered. The pain of it made her bitter and I know she often seemed harsh, for she confessed as much to me. There is no harm, I think, now she has passed on, in telling you why she may not have been the most considerate of employers, as once you would have found her.' Miss Mawson stopped and went over to the mantelpiece where she picked up the framed photograph of Mrs Bewley and the girl. 'That was Caroline, Mrs Bewley's only daughter, her only child. She is dead now. But before she died she was greatly wronged by a man – do you understand me, Evie? – and died, in fact, in childbirth in the most miserable circumstances. I was her friend. I did all I could, but ... she ran away, you see, with this evil man and he deserted her. It was a most terrible thing.' Miss Mawson's eyes filled with tears and she turned away.

Evie did not know whether she ought to speak but her need to do so pressed hard and she could not hold back. 'And the baby, ma'am?' she asked.

'What, dear?'

'The baby, Miss Caroline's baby, I wondered ...'

'Oh, it died, fortunately, poor thing. A girl. She died, luckily, with her wretched mother, the very cause of her misery and then her death.'

Evie felt numb all the way back to Portland Square. Miss Mawson was gentle and good. She had had no doubts that it was lucky her friend's baby had died - 'the very cause of her misery'. She was so sure about the rightness of the baby's death. Evie had badly wanted to ask how anything could have been the baby's fault, but did not dare. She had to accept that in some curious way it was, as Miss Mawson had said, right that it should die. She stopped on Eden Bridge and looked down into the fast-flowing river. She had read, in Mrs Bewley's Cumberland News, of a woman throwing herself into this river because she was expecting a baby. She was a servant, this woman, and not married, and she did not want the baby. Slowly, Evie carried on her way. She had not died nor been murdered. Leah, her mother, had had her and looked after her, at least at first, and had seen she was baptised. Did that suggest Miss Mawson was always right in her assumption that illegitimate babies were better dead? Evie thought not and felt a little easier. Maybe she, too, had wrecked her mother Leah's life but it had not ended in death for either of them. She was motherless, but alive and in her case always with the prospect of finding her mother and making amends. But that struck Evie as strange even as she thought it - why had she thought in terms of making amends to her mother? It was as bad as Miss Mawson's kind of thinking. The amends, if they were to be made, were her mother's, for deserting her.

Muddled and tired, Evie arrived home to find Harris about to depart for good. She had found a place in the almshouses at Corby and must take the little house or lose it. The old woman was in a state of great agitation, and Evie had to help her into the trap she had hired and soothe her with repeated assurances that the Portland Square house would be properly looked after for this last week. The trap, she saw, was laden not only with Harris's belongings but with the faded curtains taken from her bedroom and a shabby counterpane from another little-used room and half the contents of what had remained in the kitchen cupboards. Alone in the big house, Evie locked and bolted all the doors and, instead of feeling lonely or afraid, found she felt exultant. A house, all to herself, if just for a week. She roamed from room to room, touching things she had never dared to touch, though respectfully and carefully, sat on every chair and looked in every mirror, and in her imagination grew and grew in stature and status.

It was a game she played all day long for the next six days. She still rose very early but now she lit a fire in the morning-room and had her meagre breakfast in comfort in front of it. She waited to see if the house was to be viewed - there was an arrangement whereby a boy came from the agency and said so before ten each day - and if not, she went out, enjoyed the town, entering shops she had never dared go into, and holding her head high. Robinson's, the new emporium in English Street, fascinated her, it was so beautiful with its plate-glass windows and carpeted floors and its mahogany counters behind which the sales assistants seemed veritable princesses they were so grand. Evie haunted that shop, happy to drift from department to department, admiring, but not of course ever spending. When she saw, in the Cumberland News, which was still unaccountably being delivered, that Robinson's were advertising for waitresses to serve in their Jacobean café on the first floor she knew at once this was the iob for her.

But would she be suitable? She was so small and slight and might be thought not strong enough to carry trays, and she knew she had no presence and would not inspire confidence in customers. All she had in her favour was Miss Mawson's reference which she had read over and over until she knew the words by heart - 'Evelyn Messenger has been known to me for more than a year as hardworking, honest and capable. I am sure she would give satisfaction to whoever employed her as indeed she did in the household of my friend, her employer, the late Mrs Elizabeth Bewley of 10 Portland Square.' Taking this precious document with her, Evie presented herself for interview at Robinson's. She went to the back door and was directed down into the basement and through another door into a corridor. This corridor was full of girls and women, all standing patiently in line, their backs against the bare brick wall. Evie took her place, heart sinking. All the other applicants seemed so confident. They talked loudly to each other and laughed and only she was quiet and cowed. One by one they went into the room at the end of the corridor and one by one came out, some flushed and triumphant, some downcast and in a hurry, and all, as they left, seeming to Evie powerful and desirable whereas she was feeble and unattractive.

In the tiny room there was an elderly woman who sat at a rickety

table with a list in front of her. She looked extremely severe with a heavy frown line etched between her eyes and she made no attempt at preliminary pleasantries. 'Name?' she snapped, and 'Age?', and 'Previous work?' and Evie replied as clearly and firmly as she could manage. When the woman looked up she said at once, 'Oh dear, you are small and thin, you'd never manage.' Evie felt her face turn red. She pushed Miss Mawson's reference towards the woman, saying, 'Please, ma'am, I'm a hard worker.' Something resembling a faint smile crossed the woman's fierce face, but she said nothing as she read, then replaced the reference. 'It isn't just a matter of hard work, it's a matter of strength, lass. Can't see you balancing a metal tray with a pot of tea for four and all the rest that goes with it on the tray. You'd be staggering. No, you won't do.' Evie's hand, as she took the reference back, shook. The woman noticed and looked at her again, properly this time. 'Want it that bad, do you?' she said, though without any discernible sympathy in her voice. 'Let's see. You're clean and tidy. Can you sew?"

'Yes,' said Evie, thankful that she had stitched things for Muriel, and had enjoyed the work.

'Well then. I know there's a vacancy for a junior in the cuttingroom at Arnesen's. Fancy that?'

'Yes.'

'Here, then,' the women said, scribbling on a scrap of paper. 'Take this to Arnesen's and say I sent you, you never know, they might take you on if they haven't got someone already. It's my daughter's just left, that's how I know they need someone.'

'Thank you,' said Evie.

'Tell the next to come in,' said the woman, 'and let's hope she isn't a waste of time too.'

Evie didn't know where Arnesen's was or indeed what exactly it was, apart from some place that employed girls to sew. She stood in English Street, outside Robinson's, and looked at the bit of paper the woman had given her. 'Henry Arnesen, Tailor' it said, and then an address in Lowther Street. Was it a shop, Evie wondered, as she hurried through Globe Lane to Lowther Street, and then as she repeated the name over and over to herself she recalled Miss Mawson saying Caroline Bewley's beautiful clothes had been made by Arnesen. It was not a shop, however, in the sense Evie understood it, the Robinson's sort of shop. The address led her to a stone house, part of a terrace, with steps leading down to a basement. On the front door she could see a brass plate with the name Henry Arnesen, Tailor, on it, but she thought she ought to try the basement first. Down she went and knocked on the door there only to hear a shout of 'Push! It's open.' Stepping inside Evie saw an extraordinary sight, three rows of women all working treadle machines with fabric of every colour flying underneath the needles. None of the machinists stopped when they saw her, but the one nearest the door shouted, 'What do you want, eh?'

Feebly, Evie waved her bit of paper and said, 'I was sent about a job.' 'What?' shrieked the machinist. 'A job,' Evie repeated, though still not loudly enough. When finally she had made herself heard, she was waved towards the door and a finger was pointed upstairs.

The front door led into a quite different atmosphere. Evie entered a large vestibule, with blue and green patterned tiles on the floor, and pushed open swing doors leading into a broad hall with a staircase rising from it. She stood there, intimidated by this grandeur, and jumped when there was a sudden slam of a shutter and a woman's head poked out of a cubby-hole. 'Can I help you?' a voice said and then, scanning Evie and her clothes, a more abrupt, 'What do you want?' Evie explained. The voice made a sound of irritation but told her to wait. The shutter was slammed shut again, but the voice and face emerged to form a woman who came out from her tiny office. 'Follow me,' she said, and set off down the hall, leading Evie into a long room where there was a trestle table set up and bales of material stacked along the walls. Without speaking to Evie, the woman went to the table and picked up two pieces of cloth. She held these out, indicating that Evie should take them, and then nodded towards a chair at the far end of the table. 'Sit,' she commanded. 'Sew.' Holding the two lengths of white cambric reverentially, Evie went to the chair, sat, and saw in front of her an array of needles arranged in order of size and a box of every coloured thread. She put the cambric on the table, selected the finest needle and threaded it at the first go. She did not know whether to sew the two pieces together in a plain seam or a French seam, or whether simply to hem the slightly frayed edges of both pieces. She resolved to do both. Head bent, she sewed a straight seam and then began to hem. 'Stop,' the woman said. 'You'll do. Report to the cutting-room Monday, eight o'clock sharp, clean hands, mind, and don't expect to be fed.

Outside again, standing in Lowther Street, Evie was dizzy with

success. She had a job, a job that paid. But how much? She had not thought to ask. A wage, though, however small. She scurried back to Portland Square, arriving just in time to hand over the keys to the estate agent's representative. He was only a boy but she had grown quite used to him and no longer felt embarrassed in his presence.

'You'll have to be off in the morning,' he said, cheekily.

'I know,' Evie replied, annoyed at this insolent air.

'Where will you go?'

'That's my business.'

'Got another situation, have you?'

She did not deign to reply, but stood waiting for him to leave which, in his own time and with a lot of alternate yawning and whistling, he did. Evie rushed up to the attic and packed her battered old bag. She had washed and ironed everything that needed mending. Her most respectable outfit she was now wearing and must continue to wear until she could afford a replacement. Her other clothes were rags, all clean but rags nonetheless and not suitable for viewing unless covered by an overall or apron.

She had no idea how to find somewhere to live by the following day, but securing the job at Arnesen's had given her a new confidence. She did not despair. First thing she would take her bag to the Citadel railway station and leave it in the left luggage, reckoning that she was more presentable without it. Tomorrow was Saturday, giving her two days to find lodgings before starting work. She slept well, as she always seemed to before days of great upheaval in her life, and was out of the house, for the last time, by seven o'clock, taking care to shut the door firmly. Her bag duly deposited - it cost two pennies but was worth it - she sat for a moment on a bench in Citadel gardens and went over the advertisements she had cut from the Cumberland News. She proposed to begin with Warwick Road, which seemed to be full of bed and breakfast establishments and which would be near Arnesen's premises in Lowther Street. The rents quoted were for rooms with running water, which she did not need, and for hearty breakfasts which were immaterial to her. What she was looking for was an attic with any kind of bed in it, and otherwise she required nothing but access to a tap, a sink and a water closet. The money Harris had given her would pay a week in advance at the rates quoted in the newspaper, but since she was not going to pay these rates, her wants being so

much more modest, she hoped to strike a bargain and manage to pay a whole month ahead.

Knocking on doors was hard to do. Evie forced herself on but cringed every time a householder appeared and stared at her. She had begun with the rehearsed little speech of 'Good morning, madam' (or sir - quite often a man answered the door) 'I am looking to rent an attic room and wondered if you would have one available?" What she had not been prepared for was incomprehension. No one seemed able to understand what she was saying. Over and over she was forced to repeat herself and then, quite often, and to her absolute consternation, the door would simply be shut in her face. Soon she had changed her approach. She discovered that if she held up the Cumberland News cutting and began, 'I saw your advertisement,' she was asked in. Once inside the front door it was easier to make herself understood and, though a look of irritation would cross the landlady's face, it was momentary, when Evie, after saying she did not want the actual room advertised, moved on to say she wanted only an attic and could pay in advance if the terms were reasonable. The question she was always asked was 'Are you in work, then?' and when she replied that she worked at Arnesen's the name acted like magic.

Midday Saturday found her the occupant of an attic bedroom in Warwick Road, her bag already collected and installed. The attic was small and dirty. It had no heating of any kind, no curtaining on the broken window, no carpeting on the floor and the bed was a campbed with a collapsed leg. She saw the landlady, a Mrs Brocklebank, watching her closely and knew that any sensible person would be expected to say no to this hovel. To say yes would signify either desperation or standards so low the dirt had not been noticed. Evie had said yes, but inquired where she might find a mop and bucket and water to prepare the room for herself. Quite amicably Mrs Brocklebank took her all the way down to the yard and showed her where she could find cleaning implements, so she could 'Please yourself if you're fussy'. She was fussy, very fussy. Not caring a bit that she was watched and, she was sure, laughed at, Evie laboured all the rest of Saturday to make the best of her miserable room. When she woke on Sunday she had never been happier. She had a place of her own, secured to her for at least a month. Nothing was required of her for an entire day and tomorrow she had a job. She lay on the uncomfortable and inadequately balanced bed and gloried in her new life. The tiny room smelled of the bleach she had been given to use, but she liked the smell and liked the look of the bare deal boards she had scrubbed so viciously. The window pane was patched over with brown paper and she had made a curtain out of her oldest and most useless skirt. All she had to do was get up and do whatever she wanted.

What she wanted most to do was eat, but food had not been included in the terms. She had a bun, one of two she had bought the day before, and she ate that and drank from the jug of water which had been standing all night. A smell of bacon began wafting through the whole house as Mrs Brocklebank prepared those hearty breakfasts she advertised and which her ten male boarders relished. Evie did not know what she was going to do about hot food. There were no cooking facilities here and she would never be able to afford to patronise even the cheapest café. She proposed to exist on cold food and water until she saw how much she was to be paid at Arnesen's. It was quite sufficient, after all; she would buy fresh bread rolls and cheese and a tomato or two in the market and an apple perhaps, and she would eke it all out carefully. Her mother, she suddenly felt sure, would be proud of her when she knew how resourceful she was being. Her happiness was overwhelming and made evident in her singing in church that morning - her lovely voice, which usually she took care to keep subdued, soared over everyone else's, and many a head turned to look at her and for once she did not mind attracting attention. She was only sorry that Miss Mawson was not in the congregation to witness her contentment.

This was diminished somewhat on Monday. She had expected to feel lost and nervous and to have to call forth her already tried and tested reserves of stamina, but nevertheless the end of her first day at Arnesen's found her exhausted and almost tearful. There had been no sitting and sewing straight seams in peaceful rooms, not a bit of it. She had never come near holding a needle in her hand. Instead, all day long she ran up and down the building, fetching and carrying and being shouted at. The place seemed to her chaotic behind its orderly façade, full of rooms where behind closed doors there was pandemonium. All orders were screamed, all instructions yelled. And, if they were not immediately understood, the language which erupted from faces red with rage was worse than any she had heard in the Fox and Hound. She trembled under this onslaught and her legs shook. Nobody was kind or gave a thought to her. She never left the building and had nothing whatsoever to eat all day. By the time she got back to her attic, without having had the opportunity to buy any of the food she planned, she was weak and sick with hunger. The remaining two-day-old bun she still had choked her with its dryness, but she forced it down and then wept and slept. She woke rigid with apprehension but determined above all else to procure fresh food. The market she knew would be open early, so she hurried straight there and bought what she needed, consuming half a hot new loaf and a huge slab of cheddar cheese cut freshly for her on the spot, and returning home with the rest. She felt better not just because of what she had eaten but for knowing she had fresh provisions waiting for her when she returned that night.

She was not quite as tired and desperate at the end of Tuesday. The racing around and being shouted at had been the same, but she had not felt quite so invisible and despised. One of the machinists had thought to offer her some tea and she had found the few mouthfuls made a huge difference. Her name was not yet known, nor had she expected it would be, but when she was greeted once in the cutting-room with, 'Oh, it's you again, look sharp with that pattern,' she felt comforted. The cutting room overawed her. Here she felt serious work was being done. It was quieter too, though roars did still split the air when something went wrong. Paper patterns were placed on beautiful-looking materials with great precision and she hardly dared to breathe in case she sent them fluttering. She heard Mr Arnesen's name mentioned frequently here - he was always being expected and his arrival half-dreaded, so much so that she built up an image of this man as some kind of ogre. When, on Thursday, he came to supervise everyone's current work, Evie was disbelieving as she heard him addressed and realised this was the great Henry Arnesen, tailor supreme, owner of this prestigious and profitable firm which he had built up, she had gleaned, entirely on his own, starting as a one-man business in Globe Lane.

He looked so gentle. Tall, though slightly stooped, and with a fine head of hair and broad shoulders, but mild-looking, his face smooth and virtually unlined and his eyes benign behind his spectacles. He did not shout. On the contrary, he spoke quietly and never raised his voice even when a disastrous mistake in the cutting of a highly expensive silk was discovered. Evie could see everyone admired him and that in spite of his apparent gentleness they thought of him as a tough taskmaster. She heard one of the machinists say, as he left the room after instructing one girl to unpick an entire garment, because her machining had very, very slightly puckered the material (a material so gauze-like it was almost impossible to work with), that she wouldn't like to be his wife. He was such a perfectionist, the girl had complained fretfully, life would be impossible married to such a man. But there was a chorus of disagreement - everyone else, it seemed, longed to be Mrs Henry Arnesen and thought her a lucky woman. 'He's been good to her,' someone said, 'everyone knows that, very good to her, worships her, and his daughters, he's a real family man, none better.' Heads had nodded. 'No philandering,' this voice of authority continued, 'not for Mr Arnesen. Content with his wife, he is, and always has been.' A current of envy seemed to pass through the room conducted silently from machine to machine. Evie, set to pick up scraps dropped all over the room, listened avidly. 'She's a looker, though, his wife,' said another voice, 'beautiful woman, with that lovely hair. Did you see her here last week? With her hair all plaited, the French way? Lovely. She's nearing forty, must be, but you'd never know it, she's kept herself well, kept her figure even if she's had two bairns and umpteen miscarriages, they say.' 'She's a good mother too, bringing those girls up well,' a voice chipped in, and another responded with, 'I'd be a good mother if I had her looks and her Henry.' The rest was lost in laughter and then Evie's job was done and she left the room and went where she was told she was needed, feeling heavy with a longing she thought she had grown out of, that wretched yearning for a mother who would never now be found. She wished she had never heard Mrs Henry Arnesen being talked of.

Chapter Sixteen

 \sim

THERE WAS a queue when Shona arrived outside the Public Search Room at 8.30 am. When the double doors were unlocked, everyone moved smartly, walking straight to the counters. She went first to collect some forms. She had discovered by now that when she found her mother's marriage entered in the ledgers she would need to fill out the appropriate form and present it to a clerk who would give her a copy of the certificate for $\pounds 5$. She took several birth certificate forms too. Her mother was likely to have children and she could surely trace them. Then, armed with her little sheaf of papers, she went through to the room which held the marriage ledgers. Slowly, she found the year books for 1957, the year after she was born, not because she thought her mother would have married then but because it was important to be thorough. Every year from 1957 up to the present one must be searched.

Her arms ached after the first hour, in which she had looked through five years of records for Hazel Walmsley's marriage. Twenty huge heavy ledgers taken down, spread open, looked through. Not many Walmsleys at all, which made the job easier, but still she was tired from all the lifting and from the tension. The room had filled up. By the time she got to 1964 there was no space on the counter to open the ledgers and she had to lug them to other counters where a gap briefly opened up. All around she could see people finding what they wanted and scribbling details down. She carried on through another year, dully now, sullenly turning pages, hypnotised by the very writing she was scrutinising.

Nine years and still her mother hadn't married. Shona broke off and went to wash her hands. The ledgers weren't dirty exactly but many of them were dusty. Little puffs of dust swirled around the room as the big books thumped on to the counters. She found herself looking in the mirror over the washbasin and not seeing her own reflection properly at all. She stared at her face and tried to see where it would age. Around the eyes, certainly. There were faint lines at the corners already and these would deepen and so would the line between her eyebrows. Maybe her whole face would become thinner and her full cheeks disappear and the bone structure emerge. Her hair would lose its shine and colour, it would go grey and she would at last cut it – she didn't want to be middle-aged with long grey hair. Tentatively, she leaned over the wash-basin and, scraping her abundant hair right back with both hands, she thought, yes, the greatest change of all would be to have her hair grey and short, severely short. That would age her.

Back she went to the search room, hardly able to get down the ledger for the spring of 1966. January to March for that year had few Walmsleys. None were entries for Hazel Walmsley. She put it back and reached for April to June. It was missing. She looked to the right and left of her to see who was using it. A man at the end of the crowded row had it. Shona waited for him to replace it and was annoyed when he put it back in the wrong order – how careless people were. She could have asked him to pass it straight over to her, but she wanted to go through the whole ritual.

Nearly ten years now and still her mother was unmarried. What did it mean? Maybe her birth had put her mother off men for life, maybe she had remained single, an embittered spinster. Shona hated to think so. She wanted to have been a mistake from which her mother had recovered quickly, and gone on to be happy, not an accident which had had long-lasting and dire consequences. It was beginning to occur to her that instead of tracking down a woman of a mere thirty-six years of age who had settled into marriage and motherhood with such ease that the memory of her illegitimate child was shadowy, she might be discovering a woman not far off forty who had spent all these intervening years full of remorse and regret and quite unable to build any new life. Disturbed, Shona hurried to open the summer ledger for 1966. Did she want to claim such a woman as her mother? No. She would feel so guilty, to have wrecked her life, and nothing she would be able to do would make up for the sentence she had served. Her mother would become her burden and she was not looking for a burden, she was looking for the setting down of her own.

There were twenty-seven women called Walmsley who married between April and June 1966. One was Hazel. Shona was so sunk in gloom that at first the entry meant nothing to her. Then she felt excitement course right through her as she snatched a pencil to copy the details on to the correct form. Only after she had done so, and had gone to queue at the counter where certificates had to be handed in, did she allow herself to relax and even then she could hardly bear to stand still. She wanted to shove all the people in front of her aside and bang on the glass partitions and demand instant attention. It took a full forty minutes before her turn came. She paid the fee and asked to collect the certificate at the end of the day instead of having it posted. It was agony to have to wait even those few hours ahead.

Outside, she hesitated. Covent Garden was near, she could go there and buy herself a cup of coffee and hunch over it as long as possible. She walked there and went into a café, propping the piece of paper upon which she had written the details of her mother's marriage against her coffee cup. Hazel Walmsley, aged twenty-eight, had married Malcolm McAllister in April 1966 in Gloucestershire. So little she yet knew, but so much more than she had ever done. She felt such relief that her mother had married after all and to a Scot, or a man with a Scottish name. They would have children by now, she was sure they would, but of course these brothers and sisters would be very young, it wouldn't be possible to become their friend. She felt a little disappointed at the realisation, but quickly consoled herself - it didn't matter, in fact it would be better, it would mean she could be accepted as a proper sister without question. The moment she had her mother's marriage certificate she would begin the search for her children.

Shona didn't open the envelope with the precious certificate in it until she was home. All the way to Kilburn she constantly touched it inside the pocket of her jacket, feeling the thin paper between her fingers, not ever letting it alone. Once in her room she flung herself on her bed and held the envelope high, as though offering it in some kind of sacrifice before opening it. She felt her face flush and a trembling set in as she saw that Hazel Walmsley was, or had been at the time of her marriage, a lawyer. It was so unexpected and thrilling that Shona could not get over it – coincidence, yes, but surely more significant than that, surely meaning that she and her mother shared like minds just as she had hoped. Catriona didn't have a like mind, that had always been the trouble. They did not think in the same way about anything and her own analytical, critical nature had endlessly come into conflict with her adoptive mother's gentle, rambling, discursive pattern of thought. Malcolm McAllister was a lawyer too. He was thirty-two to Hazel's twenty-eight. They had married in church on 11 April 1966. Shona was sure it had been a beautiful day – she could see it all in her mind's eye, her mother at last happy, and lovely in her dress and veil.

She didn't sleep at all that night. First she cried with excitement and then she cried with self-pity, for pity of the self shut out of her mother's happiness. Around three in the morning, giving up on all hope of sleep, she dressed and made tea and then sat hugging her cup, full of new doubts. What if Malcolm McAllister had been a case of better-than-nothing, a case of her mother waiting ten long years and marrying in desperation? No reason to think so but she thought it. What if he knew nothing of his wife's illegitimate baby? Shona pondered this long and deep. Clearly, there had been great secrecy. Everything she knew pointed to it. A baby born in Norway, well out of the way. The intention was surely to have kept the event secret and go on doing so. Why tell a new husband ten years later? But I would have to, thought Shona, I would want to, long before the actual marriage. Of course Hazel would have told Malcolm, of course. And what would he have said? About that she could not be so sure. Would it worry him, the thought of his wife's illegitimate child out there somewhere? Maybe. But Hazel would tell him there was no need to worry, the baby had been adopted and never heard of since. Shona smiled in the darkness of her room.

The births of her three half-brothers were quickly found the next day, Philip, born in 1967, Michael in 1969, and Anthony in late 1970, such plain names and not a Scottish one among them. No sisters, though. At first this made Shona sad but then she thought how much more special it made her to be her mother's only daughter. She fantasised the birth of her last half-brother and her mother's disappointment – still no girl to replace the daughter taken so cruelly from her. I have no rival, Shona thought, and was pleased. What pleased her even more was that she now had an address (taken from Anthony's birth certificate), which was only four years old, and it was a London address. She had never been to Muswell Hill but she knew it was in north London and not so very far east of Kilburn. The telephone directory listed an M. McAllister living at the same address as was on Anthony McAllister's birth certificate – it was easy, easy: it had all been there waiting to be found.

She couldn't afford the time to go to any lectures or write any essays - such things were trivial beside the need to lay siege to the house in which her mother lived. The nearest tube station to it was Bounds Green, which meant an irritating six stops on the Bakerloo Line, then two changes for another eight stops on the Piccadilly Line. It took forever, and yet as the crow flew the distance on the map was short. She had her A-Z of London in her hand as she came out of the tube and was mistaken for a foreigner by an eager-to-help middle-aged woman. 'Are-you-lost-dear?' the woman asked her, and it suddenly seemed a good idea to assume the persona of an au pair girl. She nodded, said in a ridiculously heavy French-English accent that she was and that she was looking for Victoria Grove. She didn't need the woman's help, the map was perfectly clear, but she let herself be guided across the street and directed down Durnsford Road towards the golf Course and Alexandra Park. If, as she stood guard outside her mother's house when she got there, anyone approached her, she would keep up her disguise. It added to the excitement, though she needed no boost to the tension she already felt.

The house was not as imposing as she had thought it might be. It was large enough to impress but ugly, with no redeeming architectural features and built of a particularly nasty-coloured brick. The door was painted green, but the paint looked in need of renewal. The front garden had been paved over and some tubs stood on the paving stones but they had nothing much in them, only some sad-looking wallflowers. Two dustbins, both overflowing, were perched near the wrought-iron gate and there was a broken-backed garden chair to the other side of it. Why would anyone want to sit on it and look at the unattractive front of the house? Shona couldn't understand it, but then decided that once this front garden had been a pretty place and that maybe the sun shone fully on the seat on summer mornings and it was a pleasant place to sit and watch the children play. Across the road was a church. Perfect. It had a wall round it and evergreen shrubs and a porch where notices were pinned. The whole patch where the small church stood - it was actually a Methodist chapel, she soon discovered - was in shadow on this winter morning and there was no better cover than its general murkiness, no lights on, no activity within its confines. She was

wearing her usual black trousers and black ski-jacket and nobody would notice her.

She took up a position behind the wall, in the corner where it met another wall dividing the chapel grounds from the next house. The shrubs were thickest here, so thick that she had to peer closely through them to see anything at all. It was cold and raining slightly, but she had thought to put several layers of clothes on and was warm enough to withstand a long vigil. In fact, she had hardly taken up her position, at seven o'clock, when the door of her mother's house opened and a man ran out. Her heart jumped a little as she watched him unlock his car, a modest Ford, and throw his bulky briefcase and thick file of papers into the back seat. He was quite a nicelooking man, this stepfather of hers, but as the very word stepfather popped into her mind she thought of Archie and recoiled from it. This man wasn't as handsome as Archie, her real father, but Archie was not her real father any more than this Malcolm. She shook her head from side to side, annoyed, not wanting any kind of father to get in the way of her real mother. For an hour nothing else happened except for a boy delivering a newspaper, she couldn't see what, and a postman unloading a hefty bundle of letters. She'd hoped, watching him approach the door, that he would ring the bell but he chose instead to shovel all the letters through the letter-box one by one. At eight the door opened again and she took a deep breath but it was only a girl coming out, a girl about her own age. This puzzled her. Who was the girl? A lodger? Would a couple like her mother and her stepfather have lodgers? Or a visitor? A relative? A babysitter who had stayed overnight? It disturbed her not to know and to have to indulge in such speculation.

At eight-thirty another girl came out, older this time and unmistakably some sort of nanny. She had the three boys with her, two in school uniform, dark blue blazers and trousers. They were all carrying bags and kicking each other and yelling, and the nanny was ignoring them as they followed her erratically to another car, a battered Volvo Estate. Shona saw one, the middle one, had her hair, short of course, but the same colour, surely their mother's colour? It made her feel strange, this sight of a half-brother with her hair, but otherwise watching the three boys walk in front of her hiding place was not the emotional experience she had imagined it would be. They were just boys, except for the hair of one of them. They were nothing to her and she felt rather ashamed of her lack of reaction. Half an hour went by and the nanny drove back. She went into the house but was out again within minutes wearing a long thick coat, carrying a satchel under her arm. She strode off towards the tube. An au pair, Shona thought, not a nanny, an au pair off to some course at a language school in Leicester Square or somewhere central. And that first girl would have been a friend staying the night. Maybe another day she would tail her. At ten o'clock a dowdy-looking, grey-haired woman was dropped off, by a man driving a plumber's van. She opened the front door with her own key. A dog, a labrador, rushed out barking and was called back in. The cleaner? Probably. She felt pleased her mother had a dog and wondered what its name was.

By midday, Shona was frozen and tired. It had begun to rain heavily now and the shelter she had thought so adequate wasn't any more. Where was her mother? Had she left her house even earlier than her husband, earlier than seven? Or was she away on business? Either that or she was working at home. That was more likely. If so, there was no point staying here, lurking in the bushes. Better to go home and come back another day. But it was hard to tear herself away when she still had such hope that her mother would be bound, at some point, to emerge. At one o'clock she forced herself to give up and retraced her steps to Bounds Green tube. At least she had seen the house and her half-brothers, at least the six hours of observation had not been entirely wasted. All spies - she reminded herself that she was a spy - had to be prepared to spend time reconnoitring their territory, getting to know the layout in case of in case of what? Escape? Hardly, she was getting carried away. Maybe she did need to know, all the same, where there was a café, or pub, or somewhere warm to spend half an hour or so not far from her mother's house; then she need not go home, but could thaw out on the spot and go back again. There was a lot she had to learn about detective work.

One thing that occurred to her when she reached the comfort of her bed-sitter in Kilburn was that she should take a camera with her. No one could possibly see that their picture was being taken if she shot from behind the shrubs. She wouldn't use a flash and even if the pictures came out murky they would be better than nothing. The boys had passed quite close to her and had been making such a racket, a little sound like the click of a shutter would have been completely drowned. She would take the house too and have something concrete to hold on to when she got home. Her camera was a Kodak, an eighteenth birthday present from her parents, quite a good one, she thought, certainly good enough to turn out reasonable snaps. It was tempting to put a film in and return to Victoria Grove at once, but she resisted the impulse. She must not become obsessive and spoil everything. She had resolved to be cool and objective, not get overwrought and do something silly. It was what she was most afraid of, that she would see her mother and be unable to resist running across the road and hurling herself into her arms. The very idea made her shudder.

Every day Shona made her way on the tube to Bounds Green and then to Victoria Grove, carrying her camera. No one ever came near the chapel or challenged her in any way. After three days, she was catching the first tube and still she had not seen her mother. But the inhabitants of her mother's house were by now familiar to her and their routine known. Her stepfather always left at seven, always in a hurry, but his return home was never regular. Sometimes it was around eight, sometimes nine, and on two days he had not come home by the time Shona observed her own deadline of ten o'clock. The children came home at four o'clock, though not with the nanny / au pair figure. They came home in different cars and were seen into the house by the drivers. The nanny / au pair had always returned by then from wherever she went and opened the door to them. Once an elderly woman drove them home and went in with them on a day when Shona had just begun to worry that the usual girl who looked after them was not back. It was only after this tall, elegant woman with a commanding voice - 'Philip! I shall not tell you again, get out of that puddle at once!' - had disappeared inside, using her own key, that Shona thought, of course, my real grandmother.

It shook her to realise this. Not Grannie McEndrick, not Grannie McIndoe, but her grandmother Walmsley. And this grandmother, the real one, must know about her; she must, no eighteen-year-old could have managed to go to Norway and have a baby all on her own. This grandmother, unlike her two Scottish grannies, had been involved. Suddenly, Shona felt afraid but could not think why. Why should she be afraid of this woman, her mother's real mother, her real grandmother, and yet not of her real mother? She didn't like the look of Grandmother Walmsley – too organised, too powerful, too immaculately dressed. She'd noticed the boys behaved well with her, that there was none of the shouting and kicking there always was

with the young woman who ferried them about. Was she a Tartar, an ogre? But the little one, Anthony, had held her hand very trustingly. Sitting in the nearest café that she'd been able to locate, Shona pondered this. She had not only new relatives to meet but a whole family history to inherit. It was daunting. She would never be able to absorb all the detail, it would take years. But then she had years, she was only eighteen, nearly nineteen.

It struck her, thinking this, that her birthday would be the perfect time to make herself known to her real mother. Melodramatic, perhaps, but then how could such a meeting ever be ordinary? It was always going to be dramatic whenever it took place and however it was handled. And it made sense, to approach her mother on the very day she would surely be thinking of her. She probably woke every morning of 16 March and felt a momentary distress, however happy she really was. It would be impossible for any woman not to have carved on her heart the date she had given birth to her first child. She would always see the date approaching, the fateful Ides of March, and remember and think about that baby and feel a whole mixture of emotions. It would be appropriate to emerge out of the shadows on such a day, to present herself as fully formed and ready to be loved and to love. But her birthday was two months away still and she did not know if she could wait. It needed patience, and her patience was running out.

Her reward came at the very end of the week. It had become like a job, going every day to Victoria Grove. She sat on the tube like a commuter, not needing to look up to know she had reached King's Cross and it was time to change lines again, and knowing her way in and out of Bounds Green so well that she could carry on reading until she was out on the pavement. She had become quite fond of her hiding-place among the shrubs in front of the chapel and had made it her own. She'd taken a collapsible wooden stool with her, and every afternoon she wrapped it in a black bin liner and left it flat under a bush. Taking it out each morning and setting it up and settling down upon it pleased her. She felt professional, less furtive, just for carrying out the ritual. She had hidden an old umbrella too, a man's brolly, which sheltered her when the rain grew too heavy. And she had her own hours, times when she went to the café near the tube, twice a day, and had a cup of coffee or bowl of soup before returning to her post.

Her mother's house was by now so familiar to her that she had

memorised every detail. She knew not just how many windows there were but how many window-panes and how many were curtained. how many had blinds. She had noted the Virginia creeper literally creeping from the next house, and seen where the drainpipe near the roof had a leak. At home in her bed-sitter she had rows of photographs now of the front of the house, some with Malcolm leaving, some of the boys coming hurtling through the door. They were all pinned up on a cork board along one wall, the first things she saw every morning. Best of all were four close-ups which she had had enlarged. These had been lucky shots, taken when her halfbrothers had passed so near to her that she could have reached through the bush and touched them. It had been a bright, sunny morning and the car had been parked in front of the chapel. Shona had snapped quickly and the snaps had come out beautifully, three of all three boys together and one of the middle one alone, the one with her hair.

She saw, once she had had this photograph enlarged, that he also had her features. They looked odd in a young boy's face. His big eyes swallowed his thin face whereas they were in proportion in her own, and his nose – her nose – straight and sharp-tipped, with the very full mouth beneath, just like her mouth, looked far too old for a young boy's face. But that was the point, he hadn't grown into these features yet – her features – and whereas her hair – his hair, their mother's hair? – was wonderful for a girl it looked less good on a boy. The thick auburn hair had been cut very short and its natural curliness, thwarted, had a bumpy, rough look. She was sure he must hate his hair. Her mother – their mother – would tell him it was lovely hair, just like her own, but he would still wish he had hair like his brothers', like his father's plain, straight brown hair.

That was the big surprise when at last Shona, perched on her stool, saw through the screen of foliage an unknown woman coming out of the house and realised it must be her mother Hazel: *she has not got my hair*. This woman had black hair, smooth and expertly twisted into a knot at the back. Was it dyed? Shona, peering hard, did not think so. It was quite uncurled and silky, not thick-looking hair like her own. The boy's hair must come from somewhere else in the family and so must hers. Distracted by the hair, she did not feel as emotional as she had expected and noted quite calmly her mother's other characteristics. She wasn't as tall as imagined but she was thinner, very fragile-looking indeed, a ballet dancer's figure. My eyes though, Shona thought, and felt a surge of pleasure, and my nose, and oh, how clearly my mouth. But not the skin. Her mother's complexion was olive-coloured. It gave her a slightly Spanish appearance – the black hair, the olive skin, the dark eyes. Her clothes were not exactly conventionally English either. Her suit was black but it had style. The jacket was tight-fitting with a velvet collar and unusually long, turned-back cuffs. She was obviously going to work, maybe to court, and she too carried a briefcase and thick files, just as her husband did. She was frowning as she got into her car and looked preoccupied.

The moment the car had driven away, Shona left. If only she, too, had a car, she could have followed her mother and found out where she worked and then there would be two places to watch. But why watch any longer? She had achieved her objective, she had seen her mother. There was no need to spy any more. Conscious that the next phase of this discovering operation was now upon her, Shona felt almost regretful. It had been so simple just to watch, to look, and not think of acting. Her role had been passive and she had enjoyed it. The long hours of cold and discomfort sitting among the bushes had made her feel virtuous. She was suffering for a purpose and it had appealed to her. But all that was over. Working out the next strategy was tougher and far, far more important. She'd read of people at this stage employing go-betweens, neutral people who went and saw the real mother and sounded out her reaction then reported back. It was unthinkable in this case. No one else knew. there was no one else at all who could fulfil such a delicate role.

But should she write or telephone first? Would that be the best way to announce her presence? Neither seemed right. If she telephoned and got her mother she felt she would dry up. There were no words adequate for a telephone conversation, they would be wasted. How could she say, 'I am your daughter, remember, you had me nineteen years ago and I was adopted?' No, too abrupt, too shocking. A letter would be better but it was too impersonal. She wanted to be *there* when the disclosure was made, to be able to hear and see her mother. She would just have to march up to the front door and ring the bell and do it. She would ask if she could come in – 'Excuse me, you don't know me, but could I come in for a moment?' Her mother would be amazed and ask why. 'Well, I have something to tell you, about myself and you.' Then surely her mother would guess and her face would change and ... Impossible to imagine the rest.

Shona went over and over this scenario, spotting snags all the time. Her half-brothers being there, making it embarrassing and difficult, or her mother being in a hurry and closing the door, or some stranger she didn't know about answering the door. She had to be sure her mother would be on her own, she had to have seen the husband, the nanny figure, and the boys all leave the house, and be as certain as it was possible to be that no one else, not even the cleaner, and certainly not the grandmother, was in. Then maybe she could invent some sort of initial cover, be a collector for some charity or other, just to ease the door-opening. She would need a tin or box but that was easily made. Save the Children, she'd be collecting for Save the Children, and this would lead her beautifully into 'Actually, I am your child' - oh, how ridiculous. Still, she liked the collecting disguise, it made her feel she'd have more confidence. If she lost her nerve she wouldn't feel so bad, she could just mumble and flee after saying she was collecting.

What should she wear? This was hard. Not her black outfit. She knew she looked quite threatening in that and not at her best. Vanity should not come into it but it did. She wanted to look attractive, a girl of whom her mother could immediately be proud. She would wash and brush her hair and wear it loose. Everyone, men and women, always raved about her hair. But she couldn't wear a dress, simply couldn't bring herself to be false. Anyway, unless it was an unusually mild day she would be wearing a coat and she had only one, as an alternative to her black ski-jacket, a green raincoat. But she liked this coat, though it was pretty useless, not at all efficient as a raincoat and never warm enough in cold weather. She knew she looked good in it. The colour looked well with her hair and the shape flattered her. So she'd wear the flowing green coat and her black trousers and white polo-neck sweater. There wasn't much else she could wear when she thought about it. Catriona was always offering to buy her more clothes, but she had never wanted any.

There, then, it was settled. On the morning of her birthday she would greet her real mother, trying to pick a time when she would be alone, just after everyone else had left, that hour in the morning Shona had learned was the best. Then by nightfall she would be with her real mother at last. The joy of it would be the best birthday present she had ever had.

Chapter Seventeen

 \sim

THEY HAD an odd way of training people in Arnesen's firm. Young men and women were taken on as Evie had been taken on, but they were not properly apprenticed until at least six months had passed. During that time they were watched closely and only when it was decided they had the right attitude were they offered a permanent position leading to a full-time career. What this right attitude was bewildered many a new worker. It seemed to have nothing to do with actual skill, because there was no opportunity to develop or demonstrate this at first. They were not let near any cutting or sewing but spent their time fetching and carrying and tidying up. Many a disgruntled youngster, turned away after the initial trial period, claimed to have been cheated. 'They didn't give me a chance to show what I could do,' was the complaint.

But Evie understood very quickly what constituted the right attitude and prospered accordingly. There was an art, in the first place, in moving about the different rooms in such a way as not to interrupt the harmony between tailor and material, or machinist and machine. You had to be able to appear at someone's elbow without jostling it and then wait for a pause in their activity to hand them what they had asked for. Making clothes, whether cutting material or stitching it, was very far from being an automatic business – it needed intense concentration at the level to which Arnesen's aspired and this concentration must not be broken. Evie was perfect. She slipped in and out of rooms quietly and carefully without ever calling attention to herself, and yet performing efficiently all the tasks she was given. Her intelligence was also noted. Tidying up at the end of each day needed an unsuspected amount of intelligence. The tools of the trade, the scissors (of many different sizes and types) and the needles and threads (of every strength and hue), all needed to be sorted and put in their respective places so that they would be ready to hand when needed. Evie had, from her very first day, loved arranging the scissors in order of size and had laid them in neat rows beginning with the shears and working down to the tiny pairs used for snipping wisps of thread after a garment had been sewed. She had a good eye, too, for colour. Matching colours was important. She'd be tossed a scrap of silk and given the command 'Thread, quick!' and have to rush to the huge open shelf where reels of every colour were stacked and choose the right shade immediately. It was astonishing how many people could not do this, could not see instantly which of fourteen pinks matched the rose silk.

It was this talent for colour-matching which brought Evie to Henry Arnesen's attention during the second half of the first year she worked in his firm. Her relief at being told she would be taken on and trained now, at the end of the initial six months, was equalled by a genuine delight in her work. She was happy at Arnesen's. She felt she fitted in, even though she had made no friends and hardly spoke a word throughout each long day. But she realised she had been accepted, she was part of what was going on and had no need any more to be nervous and worry about being thought stupid and useless. No one thought her stupid. Little compliments came her way all the time - merely a case of 'good girl' and 'that's right, that's what I wanted' but they were enough for someone who had never been praised in her life. The forewoman in the hand-sewn department took quite a fancy to her and used her most, claiming Evie had the surest eye for matching she had ever come across. Soon Evie was not only matching thread to material but having her opinion sought on the choice of colour for the material itself. She was taken by the forewoman, a Miss Minto, to the warehouse and asked to help match the colour of an artist's sketch to material. Miss Minto would hold the sketch up and say she couldn't tell whether the dress was meant to be sky blue or aquamarine and what did Evie think? Evie would timidly point to the bale she thought the best choice and Miss Minto would nod and say she was about to choose that one herself.

The customer, of course, had the last word. The fitting-room was on the first floor and Evie was overawed by its grandeur. It had a beautiful carpet and silk curtains and a fire always burning in the marble fireplace. Here Arnesen's most important customers came to consult over patterns and materials and then later to try on garments at various stages in the making of them. If the customer was very special, Henry Arnesen himself would handle the consultations, but usually Miss Minto did so. She wore different clothes on these fitting days and looked almost as grand as the customers. When she told Evie she was going to be granted the privilege of helping with the fittings she also told her she would have to smarten up before she was ever allowed in a customer's presence. 'You are shabby, I am afraid,' she said. 'You will need a decent dress, Evie.' Evie was overcome with embarrassment. She knew she was shabby, if clean and neat, but there was nothing she could do about it. Her wage was only just sufficient to support her in her Warwick Road attic and it had been a struggle to save up enough to buy something she needed (a pair of shoes) far more than a dress. But Miss Minto was not insensitive to the situation of young apprentices and went on to tell Evie to go and pick enough material to make a dress for herself. It had to be black and it had to be plain but beyond that she could please herself.

The dress was made within a day. Evie cut it out herself, given the use of the edge of a table and a standard pattern to guide her, and it was machined for her by Mabel, the kindest of the machinists. There were no fittings. Evie could not possibly have taken off her existing threadbare navy dress, because then Mabel and everyone would have seen the parlous state of the undergarments, so she pretended she had tried this new dress on when she had tacked the pieces together in another room, and that it was just right. Since she had measured herself very carefully, disaster was avoided. The dress fitted. It was plain enough even for Miss Minto who, in fact, complained it was too plain. 'You look like a mute at a funeral, Evie, for heaven's sake put some braid on the sleeves or something.' Then there was the problem of her hair, her poor, difficult, wild hair. Evie wore it in an attempt at a bun but, though she flattened it every morning with water, it would not stay flat all day long, and by the afternoon wisps were escaping all round her face. Miss Minto made her take her hairpins out so that she could look at the hair properly and ordered Evie to fetch a brush while she 'had a go' at it. Evie could have told her 'a go' would fail. 'For goodness' sake, girl, it's like a dog's hair, it must have driven your mother wild.' Evie blushed and kept silent. 'You will have to wear a cap,' Miss Minto

said finally, 'there are some quite pretty lace caps about. I will get you one, it is a justified expense.'

Clad in the new black cotton dress and the white lace mob cap covering her bothersome hair, Evie was duly initiated into the rites and mysteries of the fitting-room. It was her job to assist Miss Minto in all kinds of small ways - to hold lengths of material up, to hand over tape-measures and pins, to get down on her knees and do the pinning of the hem under the watchful eve of her superior. She was told not to say a word but that was an unnecessary instruction to give Evie. The customers usually had their own maid with them, or else a friend to help them dress and disrobe in the small room off the fitting-room, but occasionally Evie was called upon to assist in the removal of garments. She found this excruciatingly intimate and dreaded her scarlet face being commented on, but these women she helped disrobe were far too self-obsessed to notice Evie's agitation. She wondered whether, if she had had a mother, the sight of mature, unclothed female bodies would have seemed quite unremarkable, but as it was they seemed peculiar to her. Her own body was not something she had studied since her first days with Mrs Bewley, when she had thought herself so horribly like a skeleton, but even now, when she saw the breasts and stomachs and bare arms of these women trying on clothes, she felt like a different species herself. Her own body, though no longer so frighteningly thin, shrank within her black dress as she surveyed the well-rounded proportions of the customers. And these women liked their bodies, they were happy to preen in front of mirrors and conscious only of admiration. There was never anything wrong with their own shape if a dress did not look good - it was always the fault of the dress or dressmaker. Evie heard such lies being spoken by Miss Minto that she could hardly credit she was hearing aright, but then after the customer had gone she would hear the truth and understand the nature of the game being played.

Henry Arnesen himself only attended fittings for coats or suits. Day dresses and skirts and blouses were left to Miss Minto, though Mr Arnesen did occasionally supervise the choice of evening dresses, if not the fitting of them, simply because the materials for these were expensive, and it was important no mistakes should be made. Miss Minto was always there too, although merely in an advisory capacity. Evie, when she was first taken to one of these special fittings, was there in no capacity at all. She was there to be 'on hand' and to open the door. The customer on that first occasion was the Dowager Lady Lowther, a woman well past middle age who was small and exceedingly stout. To Evie's relief the dowager had brought her own maid and required no further assistance. Her maid stood behind the sofa upon which her mistress sat and stared through Evie as though she were not there, holding one end of a length of gorgeous blue satin while Miss Minto held the other and Mr Arnesen pointed out the depth of its sheen and beauty of its rich colour. The dowager was to be presented to Her Majesty the Queen at some grand function and wished to be dressed in appropriate splendour. There was a tension in the room which Evie felt most distinctly. Mr Arnesen had already spoken of the problems ahead to Miss Minto in Evie's hearing. The dowager was almost impossible to please, convinced as she was that she had grown merely a little plump when her size was gross. She would need flattering and the dress to be cut as cunningly as possible to minimise and disguise the serious imperfections of her figure. Choice of material and of colour, Mr Arnesen had stressed, were vital. The dowager must be steered away from her favourite colour, a bright fuchsia, and towards paler shades, preferably a grey-blue or dark blue-green.

The material now being displayed was neither grey-blue nor bluegreen, but Mr Arnesen was working his way towards the colour he wanted his client to pick. Evie listened to his quiet, authoritative voice explaining that this blue would not highlight the delicate tones of the dowager's complexion and was more the sort of thing for a florid person who did not care about the effect. He signalled to Miss Minto and Evie to roll that bale up and bring out another. 'This may look dull, your ladyship,' he said, 'but it is very sophisticated and subtle. You can see the way the light falls upon it, how soft the blue becomes, and this is a material which drapes beautifully, there is nothing stiff about it.' Evie saw the dowager was almost won over, but to convince her another bale was unrolled, of the very pink she so desired. Her lorgnette went up and a sigh escaped her. 'Lovely, don't you think?' she said, hopeful still. Mr Arnesen shrugged. 'A pretty enough young colour but brash, I always think, though if your ladyship insists I'm sure something can be made of it. Evie, hold it up and show her ladyship how it falls.' Blushing furiously, Evie did as she was told, knowing this was all to remind the dowager she was not young and also to make the colour look only suitable for the lower classes.

The grev-blue was chosen. Next, Evie had to bring in artists' sketches of proposed styles. The dowager pored over them, with Mr Arnesen pointing out various features in each dress and steering her away from plunging necklines and nipped-in waists towards more matronly designs. When the style was chosen and material agreed. Miss Minto disappeared into the dressing-room to take measurements, and Mr Arnesen wrote down everything that had been decided while Evie removed the bales of material one by one. She was rolling up a length of the pink from the last bale, when he stopped her. 'Don't take that back to the racks, Evie. I would like my wife to see it. It would look very striking on her. I will take it home with me tonight and see what she thinks. Leave it in the front office and tell them so.' But later, when Evie had done as she was instructed and returned to the machine-room where she was being allowed to machine straight seams at last, there came another message. Mr Arnesen wanted her to take the material to his home now, where his wife was waiting to look at it, and bring it back promptly after she had made her decision. Thankful that she was wearing her fitting-room dress, and therefore looked as well as she was able. Evie obeved orders.

The carriage stopped, to her surprise, outside the house next to the one she knew to be Miss Mawson's. Evie got out, carrying the material, wishing Miss Mawson would happen to look out and see her looking so prosperous and fine compared to that last occasion, but there was no sign of her. Instead she had been seen by Mrs Arnesen, who had sent the maid to open the door promptly and usher her in.

'You're Evie, I believe,' Mrs Arnesen said, smiling. 'A pretty name.' Evie wondered if there was something sad in Mrs Arnesen's smile as she said this or whether she had imagined it. 'It is Evie, is it?'

'Yes, ma'am.'

'And a very good worker, I'm told.'

'Thank you, ma'am.'

'This is a mad idea of Mr Arnesen's, don't you think, Evie, to suggest such a pink for a woman of my age?'

Evie said not a word. She couldn't agree that her employer was mad and she did not want to pass any comment on Mrs Arnesen's age, which in any case she did not know. But as she watched the material being held up under Mrs Arnesen's chin she saw her husband had been right. The pink did look striking.

'I've never worn pink, certainly not this shade of pink, perhaps a very pale pink once,' Mrs Arnesen was murmuring to herself, 'and I believe I am too old now and it is not suitable for a mother of two great girls. What do you think, Evie?'

If there was anything Evie dreaded most it was being asked directly what she thought, but there was no escape. 'The colour is right for you, ma'am,' she whispered.

Mrs Arnesen laughed. 'Right, you say? Why right, Evie?'

'Your skin, ma'am, it is pale but full of warm tones.'

Mrs Arnesen stared at Evie, astonished. 'Are you an artist, Evie?' 'No, ma'am.'

'Are you from an artistic family, dear?'

'I don't know, ma'am. I have no family, not that I know of.' Evie took a deep breath. Usually, this was all she ever managed to say on the subject of her origins, but Mrs Arnesen was so very nice, nicer even than Miss Mawson, that she felt emboldened. 'I was brought up by my mother's cousin,' she offered. 'I do not know, ma'am, if my mother is alive or not. She is lost to me and always has been.' Evie hung her head. She always felt flooded with shame whenever she was compelled to reveal her lack of knowledge about her mother. She did not see Mrs Arnesen's face change in expression but when. after there had been no response to her confession (for there usually was some response, if only a word of sympathy hastily uttered), she again looked up, she marked its stillness. Mrs Arnesen, from being animated and smiling, seemed to have gone into a trance. She was standing holding the pink material still but now she turned very. very slowly to look in the mirror above the mantelpiece and stared into it so intently and as though what she saw shocked her that Evie was alarmed. She did not know whether to ask Mrs Arnesen if she had been taken suddenly ill, or to keep quiet until what was surely some kind of fit was over. As ever, she chose to keep quiet. Mrs Arnesen did not, in any case, appear to notice she was there. She touched her own face, fearfully it seemed to the watching Evie, and the pink silk hung dejectedly now from her hands. 'No,' she at last said, 'no, I think not. But thank you for bringing it, dear.'

She looked so hurt and sad. Evie could not understand why. Was it because Mrs Arnesen had seen herself as old all of a sudden? Had the pink silk made her feel this? Was this a case of vanity? But Evie could not reconcile this judgement with the manner in which Mrs Arnesen had greeted her and her animation until the moment she had held up the silk. Or was it up to that particular moment? She felt confused. But as she struggled to understand, Mrs Arnesen said, very gently, and Evie could swear with tears in her eyes, 'Take the material back, dear. Tell my husband I don't care for it.' Distressed and still wondering what had happened to change Mrs Arnesen from a smiling happy woman to this downcast creature, Evie rolled up the material and wrapped it in a piece of calico. Mrs Arnesen had already left the room and was opening the front door, but before Evie could go through it and into the waiting carriage, two girls came in, making a great deal of noise, and her way was barred.

'Mother!' shouted the older of the two girls, 'Polly deliberately tripped me and look, my skirt is torn, it is *ruined*!'

'I did not trip you, Rose!' yelled the younger of the girls. 'Do not tell such fibs!'

'Girls, girls,' said Mrs Arnesen, closing her eyes and pressing herself against the wall of the hallway, 'my head aches as it is.' She put a hand to her forehead, but to Evie's amazement the two girls simply carried on as though she had never spoken. Evie, unable to get past the still furiously arguing sisters, crouched helplessly against the wall, clutching the material, and waited for them to stop. Neither of them seemed to notice her, so intent were they on claiming their mother's attention. Finally, Mrs Arnesen herself shouted, her hands over her ears. This seemed to bring her daughters to their senses and they both flung themselves upon her, kissing and hugging her. Still Evie stood there until at last Mrs Arnesen detached herself and said, 'Let Evie through, girls. You have made such an exhibition of yourselves.' Head down, Evie edged her way out of the house and into the carriage, further confused by what she had seen and heard in the last few minutes.

In her room that evening she lay on her bed and thought how little she knew about families. Those Arnesen girls mystified her – how could they shout so and cause their mother such pain? And all over a tear in a dress, a tear that Evie with her experienced eye had seen could be mended in a trice. Big girls too, not children. Neither of them was as pretty as their mother, though Rose, the older one, had the same hair, if already several shades darker and likely quite to lose its blondness later. But she struggled to be fair. It was not fair to judge Rose and Polly Arnesen on that scene. Perhaps they were usually as charming and content as they ought to be with such a mother and had merely been caught at a bad time. She imagined them apologising to their mother after she had gone, and making up for their selfish behaviour. Mrs Arnesen would forgive them of course. She looked the sort of person kind enough to forgive anything. She was kind enough to be interested in me, Evie thought, and marvelled at this. Her own mother, wherever she was, if she was still alive, would not be a fine lady in the same situation as Mrs Arnesen. It was not realistic to think so and Evie had cured herself of romanticism. Her mother would be working hard for her living somewhere. In her bones Evie knew this. Sometimes she had visions of a woman like herself but older scrubbing floors and cleaning grates, a woman looking worn and tired, and she shuddered. Finding her mother might have been a sad business after all.

She was no nearer finding her even though she had been in Carlisle nearly two years. She'd finally seen the baptismal register in Holy Trinity church and it had told her nothing more than she already knew. She'd even plucked up the courage to ask to see the marriage register but there had been no marriage recorded for Leah Messenger. As for choirs, no church Evie attended had middle-aged women in their choirs; and if her mother were singing away in the congregation, she could not be identified. Evie despaired of herself how could she ever have imagined that knowing her mother had a fine voice would lead her to her? She needed to know facts and they proved impossible to establish. She knew that she ought to go back to St Ann's and seek help from the matron, but surely the matron would have changed and would know nothing. Records must be kept, but for how long? And what sort of records? What was ever recorded about girls like her? It would be better to let go of the vision which had filled her mind for so many years and acknowledge that she was on her own and motherless. Why, after all, did it now matter? She was grown-up, not a child. She could be a mother herself if she so wished. It was too late for dreams of being mothered.

She thought about her life and her future differently, once her position at Arnesen's was confirmed. The panicky feeling that she would never belong anywhere had gone. She belonged at Arnesen's. She was known there. Every day a score of people greeted her and said her name, and she could feel recognition if not affection buoying her up. If she wanted, she could have friends – it was only her natural reticence which prevented her from exploiting the possibilities before her. She had even been asked to take a Sunday stroll by a young man, Jimmy Paterson, one of the apprentice tailors. She had said she could not and left it at that, and she could see he was hurt. Like her, Jimmy was shy and awkward. He had big, red hands which looked more suitable for butchering than tailoring, and a long narrow face to match his tall, thin body. Jimmy was nice enough but she didn't want to go walking with him or any boy. She was afraid of all men except Mr Arnesen. The best part of every week was when Mr Arnesen smiled at her as he went in and out. She felt she had made a little mark and was no longer quite so insignificant. If, after several more years, she had done well enough to be a proper seamstress, trusted by Mr Arnesen with skilled work, then she would be content.

It was harder to envisage contentment at home. Her Warwick Road attic could not be called a home, it was not at all what she needed to make her content. But it was cheap and it meant she very soon could save a little money, and that was important for any kind of happiness. Mrs Brocklebank had offered her another room, a much better one on the second floor at the back, a room with a wash-basin and running water in it, but she had declined. The rent was twice as much, even if reduced from the normal rate because Mrs Brocklebank liked her. She had made her mark in this house just as she had made it at Arnesen's and came and went quite comfortably. Her landlady was always trying to find out where she came from: she was very inquisitive, but Evie's evasions finally defeated her and she switched to inquiries about her work at Arnesen's.

It was from Mrs Brocklebank that Evie heard more about Mrs Arnesen, though she tried not to listen, knowing the teller loved gossip and was far from reliable. 'There are folk around who remember her before she married Henry Arnesen,' Mrs Brocklebank said. 'Folk in the market, they remember her. She used to come in from Wetheral on a cart, selling flowers and eggs.' Evie thought this very interesting but could not bring herself to ask questions. 'She wasn't always a fine lady,' Mrs Brocklebank went on, 'but she did well for herself, she chose the right man, though to do her justice she couldn't have known he'd prosper as he did. He only had a little place in Globe Lane and he kept a stall in the market too, at one time.'

Wandering in the market on Saturday afternoons Evie tried to imagine Mr and Mrs Arnesen there all those years ago. It was hard. She could not imagine Mrs Arnesen as one of the butter women. It was impossible to see that slim, lovely figure among all the bulky rough-looking matrons. Dreamily, Evie stood with her back against the far wall and looked through the crowds of Saturday shoppers at the benches crowded with the butter women. She screwed her eyes up, trying to create an image of Mrs Arnesen there, but all she could see was old Mary, who had looked after her. Mary had sat there once, she was sure. Mary had reminded her of it and urged her to remember Wetheral too, but she never could to any useful extent. Maybe they had come in on the same cart as Mrs Arnesen? She wished she had not been so very young and could remember more. Opening her eyes properly again, Evie began walking slowly around the stalls. Easier to imagine Mr Arnesen here. There were several stalls selling material. This market had been the place where the Arnesens met and it gave her a pleasant sensation to think of it. She thought about going to Wetheral to try to stimulate some recollection of her first three years, but didn't know how to get there. Maybe she could find a way to go there and walk about. It would be something to do on a summer evening.

Something to do, somewhere to go. She liked to try and think up treats for herself, cheap treats. Even though she was happy at work she needed to get out of her dismal attic in her free time at the weekend and it was always a problem. There was church on Sunday and market-wandering on Saturday afternoon (she worked in the morning) but otherwise her pastime was walking. She walked until her legs ached and her biggest expense was having her boots soled and heeled. Her walks often took her up Stanwix Bank and out along the Brampton Road nearly as far as St Ann's and very often she turned the other way at the top of the bank and went left and down Etterby Street and up the Scaur past the Arnesens' and Miss Mawson's houses and along the road to Rockcliffe, though she never went far enough to reach the village. She felt conspicuous walking along the country roads on her own, and preferred the streets of the city or at least its parks. Rickerby Park, Bitts Park, Linstock - she knew them all well. And the river, the river Eden, became so familiar to her she knew its every twist and turn as it meandered through the parks. No one ever spoke to her, but then why should they, since she did not know them. Once she saw Miss Minto in the

distance, descending the steps beside the bridge into Rickerby Park with her arm on a man's, and she hid until they had gone past. She dreaded encounters with people from work, who would see her exposed as lonely and without family on a Sunday.

All the time she was walking she was thinking about where she could live. She did not want to stay for ever in her attic and craved a better place, somewhere she could turn into a home. It was impossible ever to buy anywhere, she had no such delusions of grandeur, but she had heard of places that could be rented for reasonable rates and even of places where preferential treatment was given to single working women. These were not in Stanwix of course, they were nowhere near Etterby Scaur, which would have been her heart's desire. Stanwix was only for the well-off. It had huge, grand houses overlooking the river and then it had streets like Etterby Street for the not quite so affluent. The places she heard about were at the other side of the city near another river, the Caldew. She had walked there, over the Viaduct and down through the industrial suburb of Denton Holme. There was a factory near the waterfall and some little houses near it, and here some of the women at Arnesen's lived and liked it. Evie thought that with time and if she were lucky, and if there were a vacancy, she might aspire to one of the houses. They were built in closes and had only two very tiny rooms in each and no bathrooms, and a shared privy in a vard, but she didn't mind that. She would be able to settle there and be her own mistress.

She thought sometimes of Ernest and Muriel and wondered if they had searched for her and how long it had taken them to give up. Twice she thought she caught sight of Ernest in the market, and on the second occasion was almost certain it had been him. What would he have done if she had walked up to him and made herself known? But it never occurred to her to do so. She was much too frightened of what he might do, even though commonsense told her he could have no hold over her now. She had been frightened when she saw him – there was a little leap of fear in her stomach – but afterwards she had felt strangely pleased. None of her foolish dreams had come true – she hadn't found her mother – but her life now was better than it ever could have been if she had stayed with Ernest and Muriel. She had found work she was good at, she had a trade, whereas stuck in the Fox and Hound she would have remained a skivvy all her life. And she had a place of her own for which she herself paid and was not dependent on charity. She had been right to escape the loveless claims of her mother's cousin, even if her true objective had not been achieved. If Ernest had stopped her she ought to have been able, she reckoned, to act with dignity. He would be impressed that she was now an apprentice seamstress at a firm like Arnesen's, she might have had the pleasure of seeing him quite shaken by such a triumph. Probably he and Muriel would have envisaged her obliged to take to the streets or reduced to the workhouse, or working as a servant in circumstances far worse than she had endured while with them. Thinking all this through, Evie quite made up her mind that next time she thought she saw Ernest she would indeed challenge him.

But it was Muriel she saw, Muriel dressed all in black and getting out of a coach in front of the Town Hall as Evie passed it on an errand for Miss Minto one Wednesday afternoon. She stopped dead in her tracks and stared, and Muriel saw her too and recognised her. and said, 'Evie!' Evie blushed and smiled hesitantly, unsure how Muriel would treat her, and ready to fly if there was any unpleasantness. But Muriel was not disposed to be the least unpleasant. On the contrary, she hailed Evie as sent by the angels to help her find her way to a firm of solicitors in Abbey Street where she said she had business before going to her brother-in-law's public house in Caldewgate. 'It is so long since I was ever in Carlisle,' Muriel said, clutching Evie's arm, 'and I am bewildered, I don't know where I am any more. You can take me, Evie.' There was not, Evie noted, a single exclamation as to the great changes wrought in her own appearance and not a single question as to her health or status. Muriel treated her as though they had just parted the day before and nothing had changed. But everything had changed, and Evie knew she must make this clear. She explained that she was not at liberty to accompany Muriel. She was working at Arnesen's and was on an errand and must return within twenty minutes. Muriel looked startled. She ran her eves over Evie and seemed at last to notice the difference and be amazed. Across her face Evie saw the memory of what had happened more than two years ago begin to return. Muriel frowned and said, 'You ran away, you little hussy, after all we'd done for you. It was shameful, shameful. We should have set the police on you.' Firmly, Evie removed Muriel's hand from where it still rested on her sleeve and said she must go, but this changed Muriel's attitude yet again. 'Oh, Evie, don't go!' she said,

half moaning and her eyes filling with tears. 'You were like a daughter to me and it is a daughter I need now. Ernest is dead – yes, dead, last week. Come back with me to the Fox and Hound. We will let bygones be bygones and you shall share the house with me and everything.'

The idea was laughable. Evie shook her head and said she was sorry but she must go at once, whereupon Muriel became excited and came up close to her and said, 'I have something you will want, Evie, in my very bag here, something that is yours and I will give it to you if you will meet me.' Not believing her but desperate to get away. Evie agreed that after work she would return to this spot and meet Muriel, and then she left her and ran to Robinson's haberdashery where she had been going. Looking back as she entered the shop she saw Muriel still standing there, motionless, in danger of being knocked down by all the hurrying people if she did not move soon, and Evie felt suddenly sorry for her. Muriel without Ernest was harmless. There was no need to be either afraid of her or unfriendly. Even if there was nothing of interest in her bag she would still go to meet her and give her a little attention. All the rest of the afternoon Evie wondered all the same what it was that Muriel might have to give her. Money? It seemed unlikely. Muriel was a widow now and in control of whatever sum Ernest had left, but she would not be inclined to give any of it to a hussy who had run away. What, then? Something she had forgotten to take when she left the Fox and Hound?

Muriel was waiting, her bag at her feet. She looked more composed and greeted Evie calmly. 'Where can we go?' she asked. Evie shrugged. She had no idea and hoped Muriel did not expect to be taken to her attic. 'Robinson's is closed and so are all the cafés,' said Muriel, 'we will just have to sit on a seat somewhere until it is time for the coach back to Moorhouse.' They walked together to the cathedral and here they sat on one of the seats in the precinct. Fortunately it was a beautiful summer's evening and there was no danger of catching cold. 'I cannot go to them,' Muriel said as soon as they were seated. 'I could not live among them.' Evie presumed she meant the Caldewgate Messengers and murmured her sympathies. 'They are not even my own family. I never liked them. They were cruel to your mother and cruel to old Mary.' Evie held her breath, remembering vividly how she had done so every time Muriel started on one of these rambling trains of thought. 'Cruel people, and greedy. No, I couldn't live with them, but I can't live on my own and there's no one will come and run the pub, and I can't manage and so there's no help for it, I will have to go back to Newcastle and live with my sister and be useful, but I don't want to, I don't want to at all.' She took out a handkerchief and wiped her eyes. 'Oh dear, Evie, it is an awful thing to be widowed and no children to do all the managing and caring, no daughters to take me in.' Evie bowed her head respectfully but said nothing. 'But I have got something for you, Evie, and I must give it to you before I go for that coach. Oh, it is a long ride and no welcome at the other end, but I shan't come here again. I brought all Ernest's papers here, to the solicitors, and they are all in order and thank the Lord I am provided for and there is no trouble, but this was among them, and it is yours by rights, I suppose, Evie. It was given to us at the Home when we came and rescued you and took you away. Here, it might mean something to vou.'

Shuffling among all the belongings in her capacious bag, Muriel came up with an envelope and handed it to Evie with an air of someone bestowing great wealth. Evie recognised the envelope at once. 'Thank you,' she said, and put it into the pocket of her jacket immediately.

'Aren't you going to look inside it?' asked Muriel indignantly.

'No,' said Evie, 'I know what is inside it. I remember it. It was in my ribbon box and Mary gave it to me. Shall I carry your bag to the coach stop for you?'

Quite put out, Muriel nevertheless accepted the offer and the two of them walked to where the coach was already standing, and Evie helped Muriel board it. She did not look at Evie once she was seated. Evie felt relieved to be spared any false emotion and walked rapidly home. Only then did she take the certificate out and smooth it lovingly with her hands until the creased and worn piece of paper seemed real again and not the figment of her imagination she had almost come to believe it was. There was her mother's name and date of birth, and there was her own name and date of birth, and there were the official signatures and marks. And this time she knew what to do.

Next day she went straight to Mr Arnesen, bold as never before, and asked to speak to him. She chose her time well, knowing exactly when he would be there, in his own office, and not preoccupied. He smiled to see her. He was fond of her, she knew that and had always rejoiced at his approval.

'Well, Evie, and what can I do for you?' he asked.

'Please, sir, will you look at this and help me? I want to find my mother and don't know how, and I have this, sir, and believe it might be used to find her if only I knew how.' She placed the certificate on Mr Arnesen's desk with an unusual confidence which he noticed and was amused by.

'Well now, Evie,' he started to say, and then he looked at the certificate and stopped. Evie saw him go quite still. He put a hand either side of the piece of paper before him and went on staring at it for a long time. Then he looked up at Evie and she saw how intent his stare had become. 'Your name is Messenger?' he asked.

'Yes, sir.'

'Why did I not know that?'

'Sir?'

'You are Evelyn Messenger?'

'Yes, sir.'

'Good God. I knew you only as Evie. Good God. I never thought to ask ... I ought to know the names of all my staff ... I thought I did ... but I knew you only as "little Evie".'

Uncomfortable now, Evie went on standing there, pleased that Mr Arnesen seemed so unaccountably impressed, but confused as to why. He got up from his chair and came round to her and put his hands on her shoulders. 'Evie, look at me.' But it was he who needed, it seemed, to look at her. He searched and searched her face until she started to tremble and then he sighed and said he could recognise nothing, and then he went and sat down again, this time holding his head as though it hurt.

'Evie,' he said, 'you must give me time to think.'

PART FOUR

 \sim

Leah – Hazel

before her inner vision, a shadow engulfed her happiness. She struggled to be sensible but failed. She told herself that time would restore her normal buoyancy, as time had done before. Perhaps she was unwell without knowing it, she was not after all far off forty and things happened to women at forty. She forced herself to eat properly and to carry out all her daily tasks, and when she did not sleep at night she recited hymns in her head and did not allow her thoughts to meander down dangerous routes.

But when Henry came home, with his face tight and anxious, she knew. He tried to speak to her and she would not let him – she put a hand lightly over his mouth when he began to say he had discovered something incredible which he must tell her, and she told him she did not wish to know. He frowned and pushed her hand away and said, 'But I *must* tell you, Leah.'

'You must not.'

He stared at her and shook his head and said, 'I have no choice, it is too important, I must tell you that ...'

'No! You do have a choice. You will make me ill. I cannot bear it, Henry, you must *not* tell me.'

He sighed, walked about the room, poked the fire, and then suddenly wheeled round and said, 'There are other people to consider, there is what is due to them, to her ...'

She gave a little scream and tried to run from the room, but he stopped her. He put his arms round her struggling body and asked her what she was afraid of. 'There is nothing to be afraid of,' he assured her, 'she is only a girl, and a good girl.'

'No!' Leah shouted. 'No! No!'

'She is a good girl who will make no trouble, she will understand and ...'

'No!'

'Leah, I have to do something. She has asked for my help ...'

'I am asking for your help, I am begging for it, and I am your wife.'

'I have given it to you, all these years I have given it to you, have I not? I have kept silent when I should have spoken out, and I have given no thought to the help she needs and now she has come and asked me for it, knowing nothing, and I cannot refuse.'

'You can!'

'Listen. You have not even heard the circumstances, you have jumped to conclusions. Evie Messenger ...'

'No! Do not speak her name, for God's sake, I never, never want to hear it.'

'... came to me with her birth certificate which she has only lately been given, following the death of a cousin, and she asked me to help her use it to trace her mother ...'

'Henry! Please, Henry!'

'... whom she has never known, and I looked at this document and I saw well enough who she was, and I had never recognised her nor even known her name was Messenger, and I felt such *shame* ...'

'You felt shame?' Leah laughed in the middle of weeping and became hysterical, rocking backwards and forwards, repeating the word 'shame' over and over until Henry became angry.

'Is this what it is about?' he asked, releasing her so suddenly she stumbled as he moved to stand in front of her with his back to the door. 'Shame? You are too ashamed to recognise her as your daughter? Then that is as it should be, yes, as it should be. I wanted to take her ...'

'Oh, you are so good.'

'... and you would not hear of it and when I wanted to go in search of the child you would not help me, you said her name was not Messenger, you lied to me ...'

'Yes, I lied, and I am glad I lied, and I would lie again.'

'You thought only of yourself and this strange, unnatural aversion to your own child ...'

'Yes, I did, I had to.'

'And now, now when you have the chance to redeem yourself ...'

'I do not wish to redeem myself.'

'You said you were ashamed.'

'No! You said I must be ashamed. I am not ashamed, not then, not now. I did what I thought right and best ...'

'For whom? Best for whom? And right? How right?' 'Best for us.'

'Oh now, Leah, I was not party to this, I was not, you know I was not ...'

'We were to be married, then later when Mary died we were already married and our marriage could not have survived with her as part of it.'

'Such nonsense, wicked nonsense, how you can say these things ...'

'I say them because you force me and they are true. I am wicked.

Say it if you will, say it again, and I will agree, I am wicked and evil, an unnatural woman, a woman who did not and cannot love her own child and hated the sight of her and still does ...'

The rest was lost in sobbing so wild and loud Henry expected the girls to come running from their beds to see what terror had seized their mother, but they stayed mercifully asleep upstairs. Leah was on her knees, her face buried in her arms, which rested prettily on the seat of the yellow velvet-covered armchair. He did not want to touch her. Always, deeply hidden inside himself, he had known there was a part of Leah of which he was afraid and over which he had no control. He doubted if she had any control herself. This hatred, her terrifying rejection of what had been a frail vulnerable child and was now a poor, gentle good young woman, was uncontrollable. But it was time to control and tame it. His duty this time was clear. He must tell Evie Messenger who her mother was even if at the same time he had to tell her her mother did not want ever to see her and could not bear the mere mention of her name. He would have to attempt explaining the inexplicable as best he could and trust to Evie's goodness to understand and accept the unacceptable.

'You can cry, Leah,' he said after a while, when the ugly noise of violent sobs had quietened down, 'but it makes no difference. I must tell Evie Messenger the truth.'

Leah pulled away from the chair and lifted her blotched face up and said, 'If you do, I will leave you. I cannot stay here to be found and haunted by her. I will leave.'

'Don't say such things,' Henry said angrily. 'You are not yourself, talking like that, in that way.'

'I will leave,' Leah repeated. 'I will take the girls and leave.'

'You will not take my girls,' Henry said, as firmly as his alarm could allow him. 'I will not allow it and I will not allow this kind of talk. You are upset, I know that, of course you are, it is understandable, but this is *mad* talk and you are doing yourself no good. Stop. Stop it. Let us be sensible and reasonable for heaven's sake, Leah.'

But the crying began again and all he could think of to say was that he would send for the doctor if Leah did not control herself. It proved an effective threat. She slumped on the chair once more, her hands threaded through the mass of her hair which had come unpinned and cascaded over her shoulders, but she was quiet at last.

'Come, Leah,' he said, daring to touch her now, going down on his knees beside her and embracing her awkwardly, 'come to bed. Things will look different in the morning.' He had to half carry her upstairs and undress her and tuck her up like a child in their bed, where to his surprise and relief she slept immediately. But he himself did not. He lay awake most of the night, worrying. She couldn't leave him, of course. She had no money of her own and no family, no mother to run to, and nowhere to go, and she cared far too much about Rose and Polly to risk exposing them to the life of some kind of wandering exile. No, she could not and would not leave, but there were other dangers all too real. She could make herself ill. She could cry herself into a state day after day until she collapsed. She could make scenes, shout and scream and wear him down. She could decide not to speak to him, could decide to turn away from him in every sense, and such was her strength of will there was no guarantee that she could not keep it up. All these things Leah could do and make their life miserable; but he was resolved and that was that.

Leah, in the morning, sensed this. She woke to find a cup of tea steaming on the little table beside her, and Henry, fully dressed for work, standing looking down at her. 'You slept,' he said. She raised herself on her elbow and sipped the tea gratefully. Her head felt sore and her face ached. She felt her eyes had disappeared altogether and the skin seemed stretched too tight across her cheeks. 'The girls have gone to school,' Henry said. 'I would not let them disturb you.' She nodded. Henry was such a good husband and father, there was none better. It made her feel tearful to acknowledge this to herself, but there were no tears left, she had cried herself out. 'Stay in bed and rest,' Henry urged, 'I will come back later, in an hour or so.' She shook her head to indicate he did not need to but said nothing, afraid to speak for fear of what might come out. He kissed her lightly on her hot cheek and left. She lay back, listening to young Clara, their maid, who had just arrived and was clattering about downstairs, doing the fires. She had slept but she felt so tired, so weary. It was an effort to finish her tea and when she had done so she closed her eyes and lay back on her pillow. Tonight, when Henry came home, it would all have to be gone through again. She would have to force Henry somehow into weakening and holding his peace. It exhausted her to think of the arguments ahead, the hours of quarelling there would have to be. Then there was the threat she had

made. It ought to have been saved as the ultimate threat and she had made it already. She had to prepare herself to make it again and show this time that she would carry it out.

She was lying there, trying and failing to think out a plan of action, when Henry returned within the hour as promised. He brought her tea again and she assumed he had come to check she was well and about to get up. 'Thank you, Henry dear,' she murmured, 'but there is no need to disrupt your work. I am not ill. You do not need to treat me like an invalid. Go back and we will talk again after supper, and I will try to stay calm, though it is very hard.' Here a little sob escaped her but she stifled it with a cough and reached for a handkerchief. This was pressed to her mouth when Henry said, 'I have told her. It is done and over.' The scrap of lace in her hand, pressed still to her mouth, was all that prevented her from screaming. He had no need to explain. She understood at once. Her eyes widened as Henry walked over to the window and peered through the net curtains saying, 'She took it well. No tears or hysterics. I told her to sit down, but she would not. She was solemn when I told her you did not wish to have anything to do with her and that you could not help your feelings.' He turned and came to their bed and sat upon it and looked at her, his eyes meeting hers, but his gaze far from steady. 'So, Leah, it is done. She knows and that is that. I am going to provide for her. It is the least we can do. I am going to bank a sum of money for her and in return she has agreed that what has been a secret for so long will remain one. She will tell no one. She has been very good, Leah, very good.'

'And I have been very bad,' Leah whispered, 'and now I must suffer and pay for my badness.'

'There is no suffering except hers,' Henry said. 'She suffers.' He said this sternly enough to astonish himself, but was glad at the tone he had managed even if it would bring forth the full violence of his wife's anger and grief. But she gave vent to neither. She stayed perfectly still and quiet, shocked, he judged, into calm. 'I should have acted years ago,' he said, getting up again. 'Years ago, when she was little, when we married. Everything would have been different, it would not have been too late.'

'I can never come to Arnesen's again,' Leah said. 'I can never walk the streets of this city and feel secure again.'

'Secure?'

'I might come face to face with her now I have seen her and I would die.'

'This is fanciful talk, Leah. You exaggerate foolishly. She is a poor, sweet ...'

'Sweet?'

'She has worked for me for over a year and everyone is fond of her.'

'They will hate me.'

'No one will know. She has no desire to tell a soul.'

'You believe her?'

'Certainly I believe her. Why should I not? She has shown herself truthful in every way. She is to be trusted.'

'And I am not.'

'What are you saying now?'

'You do not trust me.'

'Of course I trust you. You are my wife. I do not understand why on earth ...'

'You do not understand.'

'No. I said I do not. How can you think I do not trust you, my own wife? It is absurd.'

'You do not understand, so you do not trust me.'

'Oh Leah! Talking in riddles helps no one.'

'It is no riddle to me. You do not understand my feelings and therefore you do not trust my instincts. You do not know what this – this *telling* you have done does to me, how afraid I am ...'

this terring you have done does to me, now arraid I am ...

'There is nothing to be afraid of, it is all over ...'

'... of myself, of what I have done, of what she knows I have done. She will come and claim me.'

'No, no, I have told you, she will not. I am settling a sum of money ...'

'Money? It has nothing to do with money, neither for her nor for me. She will not be able to resist coming now that she knows.'

'She will not come, though if she did it might prove the best thing that could happen. You would see for yourself what a ...'

'You forget. You sent her with the pink silk. I have already seen her.'

'There, then. What did I tell you? She is harmless, just a poor young working girl, an apprentice seamstress ...'

'In your employment. Sack her, Henry, give her money to leave Carlisle, find her a place elsewhere, *please*!'

Later, when he had at last returned to work, Leah felt some new hope. She had seen that Henry was at least turning over her suggestion in his mind and had not dismissed it out of hand. He would puzzle over the fairness of it all day, maybe even longer, and then it would be time to use more persuasion. Honour, his honour, was after all satisfied. He had owned up and told Evie Messenger the truth and now, to help further ease his conscience, he was going to tell her he would give her money. There was no moral problem about suggesting she should move to another establishment in another city. If he could find her a good situation, perhaps a better one - Henry had excellent contacts throughout the north of England - and somewhere pleasant to live, then he might convince himself he was doing the girl a favour. And the girl herself might see it this way too and be pleased and agree. But when Henry did come home at the end of that day he said nothing, and she curbed her impatience and held her tongue for another week before she could restrain herself no longer.

'Henry,' she said on Sunday night, after church, after the girls were in bed and Clara had left, 'Henry, have you thought of what I suggested, about the girl?' She could hardly say the word 'girl' and blushed nervously.

'Yes.'

'And?'

'It seems possible. I made inquiries. I could find a place for her in Halifax and see she was looked after.'

'So it is settled?' She knew, as she asked, it was not and she knew why, but he must say it.

'No. I spoke to Evie and she does not wish to leave this city, she is afraid of moving.'

'But she has hardly been here! Only a year ...'

'More than a year now, nearly two. She was in service a year.'

'Very well, two, only two. Why, it is nothing for a young woman, nothing at all, it is not as though she has lived here all her life ...'

'She says her only happy memories are here, of her early childhood, before she found Mary dead and was put into a Home ...'

'Henry, please.'

'It is what she said. She is going to rent a little house near Holme Head. It is a kind of settlement where ...'

'I do not wish to hear anything about settlements or houses.'

'You asked.'

'I asked only why she will not do the sensible thing and move.' 'And I was telling you, she is settled here and afraid to move, and attached to her childhood memories, though God knows it is pitiful enough what she has to remember.'

'She is cunning.'

'There is no cunning about Evie. She ...'

'How fond of her you have become.'

'Fond? I told you, everyone is fond of her, because ...'

'She is cunning.'

'Leah, you are being ridiculous.'

'She wormed her way into your employment knowing what she knew – that was cunning ... and now ...'

'Stop! She knew nothing when she came to work for me.' 'So she says.'

'Why would she say otherwise? How could she have known I had any connection with her? Tell me that. If she knew, which she could not have done, that my wife was her mother, why did she not come here, to confront you?'

'Because she is cunning.'

Henry left the house. It was dark, but he left the house and walked rapidly up the Scaur and out along the road to Rockcliffe, furious with his wife. He had hardly been able to look at her during the last few minutes - her beautiful face so contorted with malice, her eves glinting and cruel. Was she ill? Fear gripped him, as he walked and walked, that she was suffering from some mental condition he had occasionally suspected. It was not normal, it had never been normal, for her to feel this revulsion towards her first child. Perhaps she needed some kind of treatment, but he could not bear to contemplate such a thing - his head was full of frightening visions of Leah in a strait-jacket, and he moaned as he turned back at last. She must be made to see she was poisoning her own mind with absurd fantasies in which, it was clear to him, she expected some form of revenge. She thought of little Evie Messenger as an instrument of vengeance about to be let loose upon her for her rejection of the girl. She could not forgive herself for what she had done and did not expect Evie to do so. But was that right? Had he got it right? Or did he not understand, as Leah alleged, was he incapable of understanding the strangeness of her attitude to Evie? The fact was, he had never been able to believe Leah. It had not, and was not, a matter of understanding but of belief. He, a man, could not believe that any woman could not bear the sight of a child, and a daughter too, whom she had borne. It was unbelievable, especially when such a woman was the good and kind and intelligent Leah he had known now for eighteen years and seen as the perfect mother to his own two daughters.

He re-entered his own house quietly. The lamps were out in the parlour. Leah had gone to bed. Thankfully, he sank into the chair nearest to the fire and wondered if he dared to think about other reasons for his wife's detestation of Evie Messenger, her own flesh and blood. He had trained himself from the very beginning not to think about the man before him, the man she said she had loved yet whose name he had been forbidden to ask. There was no real cruelty in Leah's past, he was sure of it. She might have been cheated and tricked, though even that he could not be sure of since he knew no details and had accepted that he never would, but he was convinced there had been no violence. Evie, he was almost certain, had been a love child. Somewhere there was a man, her father, whom Leah at a most tender age had loved and been loved by. Since it upset him to think this and he had recognised his own envy, Henry had banished the awkward knowledge from his head, but now he regretted doing so. In his fear of losing Leah he had acquiesced too readily to her conditions and he ought not to have done so. If he knew now who Evie's father was and what had become of him then perhaps he would be nearer to that understanding which Leah accused him of lacking.

It had been an awful thing he had had to do. Sending for Evie first thing he had felt as faint as any woman with apprehension. She was such a frail, pathetic sort of girl, though he had already come to suspect that there was a strength of character about her which was not apparent. She was not an empty-headed, silly girl and, though she rarely looked him in the eye, he had seen enough to rate her intelligent beyond her education. When she appeared and stood obediently before him, a quiver of anxiety about her clasped hands, he could not at first find the heart to proceed. He cleared his throat then cleared it again and made a performance of finding a strong mint to suck. He could not speak with such a thing in his mouth and felt foolish when he was obliged to extract it and wrap it in a piece of paper and throw it away. All the time, during this fussing, Evie had stood patiently, declining to sit on the stool he had waved her towards. Her very patience distressed him. He was going to hurt her and it was like hurting a dumb and defenceless creature. But she had surprised him with the dignity she showed. 'Evie,' he had said, 'I have some news for you.' She said nothing, there was no start of expectation, no eager looking-up. 'It will come as a shock and not a pleasant one.' Still no response. 'It is complicated.' He hesitated. 'There is no easy way to tell you, but I believe, in fact I know, who your mother is.' Now, at last, there was a reaction. She smiled, a small tremulous smile, the first he ever recalled seeing on her wary little face. The smile made everything far worse. 'It is not necessarily happy news, Evie,' he had said, 'and I wonder if it might be better for you to remain in ignorance.' She looked alarmed and he hurried on. 'Oh, your mother is perfectly respectable, my dear, it is nothing like that, don't think the worst, it is only that your mother prefers not to open up wounds, which is to say, it is to say ...' He had floundered and stopped and sighed and started again. '... Which is to say, you will understand, she is married and has her own family now and she, well, she is reluctant to meet you.' He had been sweating by this time and felt red in the face. 'Would it not be better to know nothing, Evie?"

She had stared at him long and hard, her smile now quite faded. He waited, trying to encourage her by nodding his head. Her silence went on so long he was compelled to repeat his suggestion. 'Evie, would it not be better to remain in ignorance?' At this she shook her head. It was like dealing with a mute. He could not have this settled by a shake of the head. 'Evie,' he said, as solemnly as possible, giving her name as much gravitas as he was able and deepening his voice to do so. 'Evie, you must tell me properly. Are you prepared to take the consequences of knowing who your mother is? Do you understand those consequences?' She nodded. 'It is not enough to nod or shake your head, Evie. You must speak clearly, or I cannot be sure you do understand.'

'I understand,' she said.

'And what precisely do you understand?'

'My ... she, she does not want to know me.'

After that, what else could he have done? Climbing the stairs to bed, Henry could hardly bear to remember the painful dialogue that had ensued. Colour had flooded Evie's face when he had revealed the identity of her mother – he had been frightened by the sight of such pallor changing in a second to such a violent hue. She had looked about to faint and he had rushed to support her, but she had pushed him away and retreated to the door where she seemed to cower against it as though afraid of him. He had felt such disgust to have done this to her and had said over and over how sorry he was. Then there had been the ugly business of the money. He did not want to sound as though he were buying her silence and yet he could not let her go without offering her some token of his sincerity and sense of responsibility. He had wanted so badly to tell her how he had been willing and eager to bring her up as his own daughter, but he had thought it unwise to launch into what would sound like a defence of himself and an attack on his wife. He had wanted also to reminisce, to recall Evie as a baby, to tell her he remembered old Mary and the house in Wetheral and the place in St Cuthbert's Lane, and glimpses of herself as a child even if she did not remember him. But it was unseemly, in the circumstances. Instead he had tried to be business-like, though the atmosphere had been too emotional for a business transaction. When he told her the sum of money he was settling upon her he had been afraid she would reject the offer, but she made no sign of either rejection or acceptance. She had let him talk without interrupting, showing neither pleasure nor disgust. But when he had begged her not to speak of any of this to anyone, she had shown some spirit, and he had been glad of it. 'I only wanted to know,' she said, 'not to tell.'

There had been no cunning. Slipping into bed beside his wife, who if not asleep feigned it very well, Henry knew such an accusation was unfounded. In fact, he was agreeably surprised at how little cunning Evie Messenger had shown. She had been in a position of great advantage for a while in his office and yet she had not exploited it. She could have bargained and there had been no hint of her doing so. She could have threatened all manner of things. but instead had appeared to accept his proposal without opposition. There had been not one word of resentment against her mother, and Henry had prepared himself to endure the hate for Leah he felt Evie was entitled to express. If only Leah could be brought to see how well, how nobly Evie Messenger had behaved, she might be less afraid and soften towards her. Meanwhile, she would carry on her campaign to get rid of the girl and he would have to withstand her selfish efforts. He was the one who would see Evie virtually every day, see her and know her story. Leah had not thought of the

embarrassment he would have to endure. Tucked away at home she was protected, whereas he was not.

Henry slept badly and was glad to get up. Leah did not speak to him over breakfast and he did not speak to her, but the girls chattered enough to make their parents' silence unnoticeable. He ate his kipper and ran his eve over his daughters in a way he had never done before, searching their features for signs of their sister, Evie Messenger. There was none, no comparison to be made. Evie must be like her unknown father. He wondered how Rose and Polly would absorb the news that they had an older half-sister if he were to tell them. But he would not. He would not dare, and he found he had no desire to tell them after all. It was too shocking. They would think less of their irreproachable mother and that would be dreadful. But later in life, if they were to find out? Would they be kind? Kind to Evie? He was full of doubt on that score. Evie was a working girl, she belonged near the bottom of the social scale, whereas Rose and Polly were in the middle and quite likely to look down upon her without thinking this at all cruel. They would be embarrassed by a half-sister like Evie and there was little chance of their clasping her to their bosoms. No, on this he stood with Leah, though the matter had not been discussed. Rose and Polly were better left in the dark. The sad facts of their mother's early experience should not be thrown in their faces, ruining their happiness and endangering their sense of security. His duty to Evie, he decided, did not extend to spoiling his young daughters' happiness.

Leah, presiding over the breakfast table, seemed calm if quiet. She was wearing a dress he had made for her a long time ago and he wondered if there was some significance in this choice. It was a very pale green cotton day dress with a high collar and leg-of-mutton sleeves and he had edged all the seams with dark green piping. It was an old dress, fit only for mornings at home, but it was unusual and pretty, and he had always liked it. The cotton was very fine and creased easily, the one fault of the dress. He remembered giving it to Leah soon after Polly was born, and his dismay because it did not then fit her. 'I am a matron now, Henry,' she had laughed, 'the mother of two big babies and not the slim sylph you married. Childbirth changes women, Henry, have you not noticed?' She had teased him and he had loved her lack of vanity. When, after six months, her measurements had changed back again and the dress fitted he had been delighted. 'See,' he had said, 'childbirth did not change you for ever. You are still my slim and lovely sylph.' And now she was wearing it again and though the material across the bust looked a little strained to his expert eye and he suspected the waist was uncomfortably tight, the dress still looked very well on her. He thought he would risk stating the obvious and in doing so break their silence in a harmless way.

'You are wearing that old green dress, I see,' he said. 'It looks as pretty as ever.'

'It is not pretty and neither am I. It is old and worn out.'

'I like it, Mama,' Rose said.

'Thank you, dear.'

'And so do I,' said Henry. 'I am very fond of it, old or not.'

'You would be. You are always devoted to what you have made.'

There seemed no reply to that. Kissing the girls and then her – she did not avoid his kiss, but nor did she kiss in return as usual – Henry went to work.

The moment he and then the girls had gone, Leah locked and bolted both the front and back doors, explaining to Clara that there had been robbers about and that from now on the doors were to be made secure at all times even though people were in the house.

Chapter Nineteen

 \sim

MARCH, BUT more like January this year. The weather had played Mits usual trick. Glorious sun the first week, all the daffodils in bloom and the magnolia buds thickening and opening against the bluest of skies, but now there was sleet and stingingly cold rain and a general murk hanging over everything. Hazel hated March for its fickleness.

Everyone except her had left the house by nine o'clock, even Conchita, their Spanish au pair. Hazel was in her study, a little room on the first floor, working her way through the dreary details of a wife-beating case. She'd stayed up until after midnight and been back at her desk by 6 am, before either Malcolm or the boys were up. They knew not to disturb her though she could hear the howl of protest from Anthony when Conchita told him he could not, this morning, see his mother, because she was working very hard on a case that was coming to court next day. The boys were used to it, these occasions when she shut herself up late and early every now and again, but they never stopped resenting them. She often thought she might as well come out and see what Anthony or the others needed her for, because while they were yelling she could not concentrate anyway and simply sat staring out of the window until the commotion was over.

But it had been quiet now, the whole house, for nearly an hour. She liked the feeling, the bulk of the house behind her silent and somehow reassuring. In front of her she could see the road through the as yet bare branches of the big old pear tree which bore rotten fruit but magnificent white blossom. It was not exactly a striking or uplifting view but it was faintly rural in a satisfying way – the fruit tree, the shrubs, the chapel roof through them and the general air of peace. Few cars passed, fewer still pedestrians. She gathered up all her papers and began stuffing them into different files and was on her feet doing this when she saw a girl turn into the gate. She stopped and stared, curious to know who could be visiting at this time on a weekday morning. One of Conchita's many friends? No, they were all at their language school and this girl did not look Spanish with her auburn hair, quite lovely hair, long and curly. She was carrying a tin but Hazel couldn't make out what was written on the side. Collecting, though, she was collecting for something, and since she was a girl there was no need to be suspicious.

Hazel was not suspicious. She suspected nothing, there was no need to. On the way down the stairs she picked up some change from the hall shelf and had it in her hand as she opened the door. It was the girl who was startled, not she. She jumped and Hazel smiled and said, 'I saw you from my window upstairs. Here you are, will that do?' The girl didn't even hold out the tin. Hazel had to reach out for it and force her three coins through the slot. 'Save the Children - a good cause. I hope you're doing well,' she said and made to close the door again. 'Wait,' the girl said. Hazel paused, politely. She was a very attractive girl, what with the beautiful hair and very clear, light blue eyes, but she seemed to be in some kind of trance. She was staring so hard it was faintly alarming, even worrying. 'Was there something you wanted to say? To ask me?' Hazel said. A spiel, probably. Collectors were meant to convert you to their cause. Well, she had no time for that, she had to get to the office. 'I'm afraid I must go and get ready,' she said. 'Good morning to you, good luck with the collecting,' and once more she tried to close the front door.

'No!' the girl said, and blushed, and then said, 'Could I come in for a moment, please?'

'I'm afraid not,' Hazel said, and looked pointedly at her watch. 'I'm about to go to work. What is it you want?'

'You.'

'I beg your pardon?'

'I mean, to talk to you.'

'About?'

'Me. And you.'

There had been enough of them in her working experience, women who looked normal but were unhinged. Police stations were full of them and she'd dealt with her share in the past. The thing to do was to be polite and simply side-step them. 'Look,' Hazel said, 'I really must go,' and she began to push the heavy door shut. But the girl was leaning against it and she was strong. Irritated rather than afraid, Hazel told her to stop being so silly and said she would have to call the police if this nuisance went on.

'Please,' the girl said, 'I don't want to be a nuisance, I just want to tell you something and I can't do it on the doorstep, it's too personal. I'm not mad or anything, I promise. It's just, you know me. You don't know you do, but you do, and I want to explain and tell you who I am. I haven't come to make trouble, I promise.'

There was nothing to do but let the girl in. Hazel, walking stiffly, and not looking back, led the way not into the living-room but into the kitchen. She had to be occupied, do some small mechanical tasks. She prepared to make coffee, without asking the girl if she wanted any. She would grind beans, a good, loud noise. She filled the pot with water, another hearty sound as she turned the tap on. Clatter the cups, tinkle the teaspoons, fill the silence. She did not speak. Her back to the girl, she busied herself and tried to think. She had always said it was bound to happen. She could hear herself later on, when Malcolm came home, saying she had always known it would happen. But not like this, she hadn't thought it would happen like this, without warning. She'd imagined a letter or a phone call and could have dealt with those. Most of all, she hated being taken by surprise. It was an affront to all that was organised and efficient and prepared about her.

She had to turn eventually and put the steaming coffee pot on the table. 'Milk?' she asked, pleased at her steady, flat voice, 'Sugar?' The girl nodded. She seemed overcome now that she was actually inside the house. Hazel poured two cups, added milk to her own, pushed milk jug and sugar bowl across the table to the girl. She was not going to help her by telling her she knew now who she was. Let her do the telling since it was she who wanted to. She sipped the coffee and waited, imagining the girl as a client. Patience, that was the secret, and a relaxed atmosphere. But the girl across the table was far from relaxed. She was tense and nervous, biting her lip constantly, playing with the rings, little silver things, on her hands and not ever raising her eyes from the table. Nothing like me, Hazel thought, and felt unaccountably relieved.

'It's difficult,' the girl said. 'My name is Shona, Shona McIndoe. I'm a student, a law student at UCL.' Hazel noted how she did look up quickly at this point, checking to see if there was any reaction and, failing to see it, being disappointed. 'I don't know how to get to the point without maybe shocking you.' She paused, but Hazel kept silent, interested, in spite of the turmoil in her head, to see how this child of hers would go on. 'I've no wish to distress you, none at all.' Another pause and since no help was forthcoming the plunge had to be taken. 'I was born in Norway, in 1956,' she said. After that, it would have been stupid to pretend to be still unenlightened. 'So you are my daughter,' Hazel said, calmly, 'I see.' Not another word. Instead, she found she had to get up and do something. She walked to the telephone, back to Shona, and dialled her office number, her finger steady. She spoke to her secretary and said something important had come up and she would not be in for a while, she didn't know how long. Then she said, 'Let's move somewhere more comfortable.'

The living-room was messy, not yet cleaned up by Mrs Hedley. The boys had left Lego all over the floor and comics covered the battered sofa. Hazel swept them into a bundle and then opened the still drawn curtains. 'What a day,' she said, standing looking into the sodden, gale-buffeted garden.

'My birthday,' Shona said.

'Is it? 16 March, yes.'

'I thought maybe you always ...'

'No. I didn't, never. I promised myself I wouldn't and I didn't. It seemed – mawkish, somehow. I didn't want to do it for ever. I deliberately blanked out the date very successfully.'

'I suppose you were too unhappy, you just wanted to forget me and all about it.'

Hazel turned, unable any longer to avoid looking at the girl. There she stood, her hands in the pockets of her green cape-like raincoat, uneasy but also defiant, clearly bracing herself to face whatever was to come, bravely coming out with the theory she wanted to believe was true. Carefully, Hazel said, 'Unhappy? Yes, I was, of course. And I did want to forget but it took a long time. Forgetting the date you were born was nothing, but forgetting the rest, it was difficult. Impossible, really. But I tried very hard.'

'I'm sorry.'

Hazel allowed herself a little laugh. 'Shall we sit down?' she said, and sat herself, on the only straight-backed chair, leaving the girl with the choice of sofa or easy-chairs. She chose the sofa, but only perched on its arm. 'You have nothing to be sorry for. I'm the one who ought to be.'

'But you're not,' the girl said quickly, without a hint of a query in the words.

Hazel said nothing for a moment, studying her face. It was so hard to measure the degree of distress which might be under the controlled surface calm. 'It's complicated,' she said finally, 'as you might expect. I'm sorry, or I was sorry, about a lot of things. But nineteen years is a long time.' She wanted to say as little as possible. That was surely the right decision. She knew perfectly well that every word she said, every expression that crossed her features, would be analysed and reflected upon. It was cruel, perhaps, to make the girl take the lead, it would be kinder to help her by launching into a string of lively questions, but she did not intend to. And as for the gestures that would be even kinder, the warm embrace or tender kiss, she was incapable of them, which the girl would already have sensed.

'I shouldn't have come,' the girl said, and stood up again.

'Please,' Hazel said, surprised at herself as she stood too, and not knowing quite what she meant by this plea. The girl took it to mean that she had no need to apologise. 'No, really,' she said, 'I see now it was stupid. You've got your own life. It was just I couldn't resist it, I had silly ideas. But I'll go now and I won't trouble you again.' She was on the edge of tears, trying, Hazel could see, to contain them for a few more minutes until she was out of the house.

'Please,' Hazel repeated, 'you're upset. Sit down. I don't want you to leave like this. You'll go away with all the wrong conclusions. Give yourself time. And me, give me time. I'm more shocked than I perhaps look.'

'You don't look shocked at all. You don't even look surprised,' the girl said, and Hazel was relieved to hear at last the resentment.

'No,' she agreed, 'but then you don't know me, so you wouldn't be able to tell, would you?'

'I thought there would be some reaction. There's none. I could have been telling you what time it was for all the notice you took.'

'Oh, I took notice. I was thinking, but you can't see thinking, can you? I was thinking that I had always expected this, but I didn't know how it would happen.'

'Not like this,'

'Not like this, no.'

'But you dreaded it, you've always dreaded it.'

'No. What I've dreaded is not knowing what to do, or how you would be, whether you'd come full of hate or merely in a spirit of curiosity, and I suppose I hoped for curiosity.' She had said far more than she had meant to, but felt herself pleased with what had come out.

The girl was not pleased, though. She had flushed and was biting her lip quite savagely enough to draw blood if she continued. 'I don't hate you,' the girl said, 'and I don't blame you, but you aren't what I thought you'd be, I mean you aren't how I imagined my mother to be.' She stammered over the word 'mother'. Hazel knew she was expected to ask in what way she was different but was determined not to fall into that trap. 'I thought,' the girl was saying, 'I thought it would actually be a relief to you to find I'd been so well brought up and happy.'

'It is,' Hazel said quickly.

'It isn't. You just don't care. I'm nothing to you and the sooner I accept that the better.'

She picked up the shoulder bag she'd dropped and rushed to the door in a whirl of green coat, hair pushed angrily back but Hazel was as quick and reached the door at the same time. She would have to use the girl's name, but it was a struggle to do so. 'Shona,' she said, 'don't leave like this.' She couldn't let her go with so much unresolved and this feeling had nothing to do with concern for Shona. It was all to do with concern for herself and a sense of another solution being possible which would free both of them from each other. 'No, don't go,' she said again, 'not like this. You will only regret it and the disappointment will get worse.'

'It isn't disappointment. I knew that you'd probably ...'

'It is disappointment, only deeper. I'm letting you down, of course.'

'You can't help it, I told you, I know, I can see, I can feel. I mean nothing to you.'

'Oh, you mean something.' Hazel smiled, tried to look ironically at the girl and pull her into a shared sense of amusement. But the eyes were swimming and there was no possibility of irony being recognised. 'Sit down again,' she urged, 'at least let me satisfy your curiosity and wait until you're more in control.'

'I am in control. I'm not really crying. I'm not at all an emotional person, this isn't me.'

'No, I'm sure it isn't. And this isn't me either, but what could we expect? In the circumstances. As I said, we need time.'

'But you obviously don't want me here, I was wrong to think you might.'

'Yes, you were wrong, but you are here and that changes everything. I can't ever feel the same again and I don't know that I would want to. I'm going to go and take these clothes off and ring my office again and then maybe we could go for a walk, do you think? It's strange sitting like this. It would feel more natural, well, comfortable, to be outside and ...'

'Yes, it would to me too.'

All the time she was changing and telephoning Hazel found herself worrying about the imminent arrival of her mother, who was coming over to drop in what she referred to as 'real country eggs' brought back specially from her weekend in Gloucestershire. She had her own key and would just march in, expecting nobody at home, to put the eggs in the kitchen. It would be appalling to have her arrive while Shona was here. Hazel hurried, aware too that she was somehow hoping, even expecting, to hear the click of the front door, the sound of Shona running away, but it never came. She'd given the girl her opportunity to escape but she had not taken it, so that was that. Or maybe, thought Hazel, that wasn't what I was doing at all, maybe I was doing the running away and it hasn't worked, and now I must face up to the consequences and act appropriately. She came back downstairs, wearing trousers and a sweater, determined to do that. She would go through what had happened all those years ago and invite questions and then with a clearer conscience she would bid Shona goodbye. It was no good thinking she could, or ought to, pretend affection and gladness. She couldn't. She would have to be honest and get this over.

They walked down the road, Hazel relieved to have escaped her mother's arrival, their long strides matching and the dog straining at the leash in front of them, without talking. The flurries of sleet had stopped, but it was still a grey, ugly day, the sky heavy and murky.

'Are you warm enough?' she said to Shona as they entered the park. 'That coat looks quite thin for this weather.'

'This weather is nothing,' Shona said, 'I was brought up in Scotland, on the north-east coast.'

'Yes, I know.'

'You knew? How?'

Hazel was silent for a good stretch. She could sense Shona waiting. This, she thought, is going to please her, it will give her some satisfaction. 'Oh, some years ago, a long time ago, in fact, I can't remember exactly when, I had nightmares about you. They got worse and worse. You as a baby, though I never actually saw you, I didn't want to. And anyway, Malcolm, my husband, thought if he could find out that you were well and happy the nightmares might stop. They did, actually. I haven't had them since.'

'What happened in the nightmares?'

'Nothing in particular. Just a baby, you, or a baby I knew to be you, crying, howling.'

'How did he trace me, your husband?'

'I don't know. He's a lawyer too, he has access to various ways of finding things out. I didn't ask him.' There was a long silence. The dog bounded about and Hazel watched him, thinking what a hopeless park this was, not at all a substitute for real country as Hampstead Heath could be on such a weekday morning. She knew perfectly well that Shona would be working out the significance of what she had told her and she waited with interest rather than apprehension to see what she would say. But the girl said nothing at all. Stealing a sidelong look, to check if she was perhaps weeping again, she saw no sign of tears. 'Were there things, questions, you wanted to ask me?' she said.

'Yes.'

'Ask, then. I suppose you want to know who your father was and why I ...'

'No, I don't. I don't want to know about any father, he doesn't matter.'

'Well, if you say so, but his part is surely relevant. He was a schoolboy, no, between school and university ...'

'I don't want to know, I said.'

'Fine. But I want you to know he never knew, about you, I mean. Maybe one day you *will* want to know about him and that's what you should get clear.'

'It's the other bit.'

"Why I gave you up?"

'Yes. I mean, I know you were very young, younger than I am now, and I know abortion was illegal ...'

'I hardly even thought of abortion, it was something other girls had to do in back streets, that kind of thing, too dangerous and impossible. I would have been too frightened even if I'd known how.'

'Yes, I realise. And you were only eighteen, so how could you keep a baby?'

Hazel listened to the tone of sympathy. It was tempting to allow the girl to paint the attractively pathetic picture she was conjuring up. 'I didn't want to keep you,' she said, 'that's the truth.'

'You hated me?'

'No, not hate. I just wanted you cancelled out. I wanted to get home, back to my real life. Those months in Norway were, well ... they were ... I can't seem to think of a word to describe them.'

'Hell.'

'Near to hell, I thought. But that's too violent. It was the numbness, being suspended in time, it was more an in-limbo feeling, and that scared me.'

'But then you came home and you were happy ever after, so that was all right.'

The hint of sarcasm is my own, Hazel thought, it is precisely how I deal with hurt. Either I am sarcastic or contemptuous and she is only a girl and can't risk open contempt. But she suddenly felt less constrained, the girl's sarcasm helped. 'I wasn't happy for a very long time afterwards,' she said. 'I was lonely, though I'd always been quite a lonely sort of person, I mean a person who preferred to be on her own, not the same at all. And I just became more and more like that. Cynical, I was a little cynic too. I felt I'd learned my lesson. I was better on my own. I'd tried relationships, I'd tried one, that is, and it had messed up my life. I concentrated on working hard and keeping myself more and more to myself.'

'How sad.'

More sarcasm and now also that hint of contempt. Hazel smiled slightly. 'Yes, a little sad.'

'But you didn't think about me.'

'No. I was easily convinced you were happy somewhere and even if you weren't it wasn't my fault. I was told you'd go to a couple who desperately wanted a baby and I thought that would be a lucky thing, for you to be wanted so much. You can call it a hard attitude, if you want, but that's how it was.'

'Hard.'

'Yes, hard then.'

'But then you had nightmares.'

'My punishment, you mean? Later, I told you, a very long time afterwards.'

'When you really were happy, married to Malcolm, on 11 April, in a pretty Gloucestershire church.'

Hazel didn't bother asking how the girl knew such a detail. She could imagine the visit to St Catherine's House and the excitement of locating the entry in the ledger and getting the certificate. 'I remember now,' she said, 'it was after I'd had Philip, my first baby ...'

'Second.'

'Second. My first son.'

'You must have been so glad he was a boy.'

'I was.'

'And the third and fourth, both sons.'

'Not so glad with Anthony. Malcolm wanted a daughter.'

'But not your daughter.'

'That never arose. You were adopted and settled, and ...'

'And a secret.'

'Not from Malcolm.'

'You did the decent thing, of course, and confessed. So noble. How did he take it?'

She wants me to rise to this sarcasm, Hazel thought, but I will not. 'Well, he said the past was past.'

'Original. Not bygones will be bygones too?'

'Not quite.'

'And he didn't think any less of you for your disgraceful secret?' 'He didn't think it was disgraceful. He understood.'

'What did he understand?'

'That I hadn't intended to get pregnant, that I was very young, that adoption had been the only solution, that ...'

'Best.'

'What?'

'Best solution, not only. Adoption wasn't the only solution. You weren't a poor, penniless waif out of some nineteenth-century novel who'd been done wrong.'

'No, I wasn't. I didn't pretend I was.'

'But Malcolm, dear Malcolm, understood and forgave you and bore you not the slightest grudge.'

'Not a grudge, no. But something. It disturbed him to think of a

child of mine out in the world somewhere, however well looked after. He has always felt it wasn't right, which I haven't felt myself.'

'Except in nightmares.'

'Did they mean that? Not necessarily.'

Everything had changed. The girl walking beside her was no longer just an attractive but somehow neutral person – her very voice, young and light though it was, had become charged with menace, but even though Hazel found her stomach tightening with nerves, she also found the real emerging Shona exhilarating. She liked being challenged, she wanted to be. Defence was a way of life to her and she excelled at it. Others might feel that having their backs against a wall was an uncomfortable position to be in, but she didn't. If this girl had one unassailable right it was to attack, so she must be encouraged.

'You're imagining, of course, what you would do,' Hazel said, 'in the position I was in.'

'I'd have an abortion.'

'So would I, if I were eighteen and pregnant now.'

'But if I'd been you and couldn't because it was illegal or too difficult to arrange, then I would have to keep it.'

'Easier said than done.'

'No, not easy, but for me there wouldn't be any choice, I couldn't give away my own baby.'

'Not even for the sake of the baby?'

'That's just trickery, that sort of 'tis-a-far-far-better-thing-I-do sort of argument, it's despicable.'

'There's no point in discussing it ...'

'I don't want discussions.'

'What do you want, then? Remind me.'

'I wanted you, that's what I wanted. My mother. It's natural, isn't it?'

'Yes.'

They turned and began to walk back. This had gone on long enough. Hazel longed to get home and go through the awkward business of saying goodbye. It wouldn't be over, of course. She realised that. This girl might part with her believing she would never return, but she undoubtedly would. She'd go home, in a state of fury and misery and crushing disappointment, and then the resentment would build up inside her and she'd be unable to prevent herself returning. She would have to feed on that sense of being cheated which she was so transparently suffering from now. Hazel saw how it would be and was resigned to her own prognosis.

'Have you always known you were adopted?' she suddenly asked.

'No. I only found out last year, on my eighteenth birthday, well, almost on it.'

'That's interesting. Why tell you at all if it had been kept so secret, I wonder?'

'Dad thought it was time. He hadn't thought it should be secret, but Mum was ill when she had me, I mean *got* me, and she made him promise. They pretended to everyone, even my grandmothers.'

'True deception, then. And you grew up perfectly happy and without suspicions. No harm done, after all.'

'So, applause for you, you mean, with your far-far-better-thing stuff.'

'No applause for me, but relief.'

'But the point is you couldn't have *known*. You gave me away without being able to know I'd have good parents. Anyway, I don't care about that even if it sounds as if I do. I really don't, whatever I've said. What gets me is that you didn't *think* of me at all. I didn't haunt you except for those nightmares, which didn't last long. That's what's so awful. To have a child growing in your body and going through giving birth and knowing it is yours, your flesh and blood, and then *just giving it away*. It's obscene, that's what it is. And even now, I turn up, and you're not fussed, not really, just a little thrown but you can't wait to get rid of me when you think you've been *reasonable* and *civilised* enough. It isn't right, it isn't – oh, I can't think what ...'

'Understandable?'

'Yes. It isn't possible to understand the mentality of women who give their babies away when they don't have to and then when they've done it they don't *suffer*.'

'You want me to have suffered the tortures of the damned, to be still suffering them.'

'Don't mock. I didn't say anything about tortures. I just - I just want to have meant something to you and then I could forgive.'

'This is getting a little heated, you're shouting ...'

'Certainly I'm heated, I'm shouting, why shouldn't I? We're in a bloody empty park ...'

'It doesn't matter where we are, I don't respond to shouting.'

'You don't respond to anything, you're cold and unfeeling.'

'Maybe. You see what you escaped. You could have been brought up by a cold and unfeeling woman instead of your mother. I'm sure she is neither.'

'She isn't. She's warm and kind ...'

'There you are, then.'

'No, I am not, I'm not anywhere, you miss the point again. I thought you were a lawyer, but any lawyer would see the point. It doesn't matter about Catriona being warm and kind and all that, or about your being cold and unfeeling, or whatever. The point is, *you* are my real mother and that makes the difference. I'm looking for myself and I never could find me in Catriona.'

'Lots of girls are totally unlike their mothers. I'm unlike my own. We have nothing in common.'

'I've seen her.'

'When?'

'Bringing your sons home. I watched, I've been watching your house, just to see. Spying, I've been spying. Shocking, isn't it? And pathetic.'

It was both, but Hazel knew she must not agree with the girl. She was touched in the strangest way by this confession – hiding somewhere, watching, spying, and all to see her own mother. She thought of all the scheming and planning that must have been involved, and then she recalled how bitterly cold and wet it had been recently and imagined this girl shivering as she stood concealed behind some tree, or building. She couldn't just say goodbye to her. It was becoming more and more inevitable that she would have to invite her to meet Malcolm, but she couldn't bear the idea. Malcolm would love the girl. He would be fascinated by her and be eager to get to know her. And the boys, what would the boys think? They would take their lead from their father and, besides, they were too young to have the desire to make judgements of their own, they would not understand all the implications implicit in the sudden introduction into their lives of a fully grown half-sister.

They came out of the park and back on to the road. Hazel put the dog back on to his lead and caught up with the girl, who had not waited while she did so. She disliked the feeling of running after her, even if only for a few yards. Neither of them spoke all the way back to the house and as they neared it the girl said she was going straight to the tube. 'I'll drive you wherever you want to go,' Hazel said, 'I'll be driving to work anyway.'

'No need. The tube's only a few minutes away.'

'Where are you going?'

'I don't know, I can't think. Home, I suppose. You don't care, anyway, so why pretend you do?'

'I do care. I don't want you to be so upset ...'

'It's a bit late to worry about upsetting me.'

'It wasn't my intention to upset you.'

'Listen to yourself – "it wasn't my intention" – and you're talking to your own daughter. But I forgot, I'm a stranger and you like it that way.'

'Neither of us has any choice about that. We are strangers. The question is whether we're going to remain so.'

'Well, of course we are – you've made it quite plain that that's what you want.'

'I don't think I have. I might not be able to give you what you want, but I don't think I've said anything to indicate ...'

"To indicate"! Listen!"

'... that I want to remain a stranger.'

'But you do. You don't want to be disturbed. You don't want your lovely life disrupted.'

'Would you disrupt it?'

'What do you mean?'

'You were the one who used the word disrupted.'

'I meant messed up. If I came into your life properly, it would mess everything up.'

'Not necessarily. You, your life, might be the one messed up. You'd find me wanting. You'd be quite likely to find everything about me and my family and my life wanting. And what about Catriona, it was Catriona, wasn't it? That's her name, what about her?'

'She doesn't know. She doesn't need to.'

'But she would if we became close.'

'Close? Who said anything about close? With you? I can't imagine that, there would be no danger of that.'

Hazel found she had walked right past her own house even though the dog had tried to turn in the gate. They were at the end of her own quiet road and near the noisy main road, standing now on the corner of it. 'I'm off,' the girl said, 'I won't be back, don't worry.'

'Give me your address,' Hazel found herself asking without crediting that she could be doing so. 'I ought at least to have your address.'

'Why?'

'I don't want you just to vanish.'

'Worried about nightmares coming back?'

'No. That was unnecessary.'

'Yes, it was. I've said a lot of unnecessary stuff. Well, goodbye.' A car was turning from the main road into Victoria Grove. Its horn tooted and it came to a halt beside the two women before Shona had had time to set off.

'Hazel!' a voice shouted, and, turning, Hazel saw her mother leaning out of the window. She ought to have seen it was her car.

'Who's that?' Shona said.

There was a single moment to make the choice. Hazel knew her mother could not hear her. She was in the car and just out of range of any interchange. And the girl had obviously not recognised her, she hadn't associated her with the elderly woman bringing the boys home whom she'd identified as their grandmother. She could lie or easily practise evasion. But she did neither. 'It's my mother, your grandmother,' she said. 'Come back with me and meet her.'

Chapter Twenty

HENRY WANTED no more secrets. He wished all his dealings with Evie Messenger to be above board and to be known to his wife. However resistant she was to this knowledge and to any kind of involvement, even at second-hand, he was determined to force it upon her. But it was difficult. The moment he started to speak to Leah about anything to do with Evie she left the room or put her hands over her ears in a thoroughly childish way which angered him. If he tried to talk about the girl without using her name it made little difference – Leah still tried not to hear. He managed, nevertheless, to make it clear that he visited his step-daughter.

She was living now near Holme Head in a little house above the river Caldew. The money he had given her was banked and she had used it to rent this property and furnish it modestly. He had advised her to buy a house, which made far more sense than renting, but she would not hear of it. Money in the bank, and a substantial sum at that, pleased her more. She said she did not like spending and was averse to all extravagance. But as well as equipping her two rooms and kitchen with basic items she did have some clothes made for herself out of his money and this gratified him. He would have liked to have made them for her himself, as an additional contribution to her welfare, but she would not allow this, saying she did not want to give people any reason to talk. The idea of being the subject of gossip worried her continually, and he was surprised at the great care she took not to seem in any way familiar to him. At work, she was deferential in precisely the way she had always been, and outside work she was most reluctant to be in contact with him if an obvious reason was not readily available.

These reasons were hard to find. He, after all, was the head of a

prosperous tailoring establishment and she was a mere apprentice. Out of the Arnesen building what possible reason had they to meet? Only Evie's widely acknowledged usefulness provided Henry with excuses to take her out with him and, at her insistence, he used them sparingly. When he travelled to markets or to factories to buy cloth she went with him. There was nothing unusual in this. He had always been in the habit of taking an apprentice partly as a treat, partly to involve them in the business, and partly to run errands for him, to fetch and carry and procure all kinds of haberdashery as well as the material he had come for. When they returned from these trips – to Newcastle, to Halifax, to Rochdale – it was only natural that Henry should see Evie into her house since it was invariably dark by the time they reached Carlisle.

These expeditions were exciting. Every apprentice he had ever taken had been excited by the long journey and the experience of visiting a new and much bigger town. But Evie's excitement was well contained. There was no bouncing about on the seat beside him and no high-pitched stream of talk. She always sat, grave and composed, and said nothing unless directly questioned. He decided she was merely nervous and made allowances for this, but then, after their third trip in six months, he knew she was not nervous at all. This reticence was simply her. He saw in it, and in her unnerving steadiness, how life had treated her. She had had only herself to rely on and had never known the love of a mother. Henry reasoned that Evie could not open up to affection because she had never received any, and trust was quite unknown to her. It saddened and depressed him to discover how she was moulded and he spent many an hour on these trips. Evie utterly still and silent beside him, speculating on how different she would have been if Leah had kept her. She would surely have been like Rose and Polly, noisily secure and confident. But there was no way of being sure. Evie had been motherless and whether or not this unfortunate state had made her as inscrutable as she was could never be known.

She was unhappy about allowing him to enter her house when he duly delivered her home, but he insisted it was his duty to see her safely inside and said so loudly enough for anyone listening to hear. He left the door open, pointedly, and merely stood just inside while she lit her lamps. The room was very small but she had it nicely arranged. She had a round table with a fringed cloth, two old armchairs for which she had embroidered antimacassars, and a hook rag rug of many colours she had worked herself. 'Very cosy, Evie,' he said, 'you are quite the housewife.' He had to stop himself adding, 'Just like your mother.' She never said anything in reply, never showed pleasure in his admiration. Reluctant to go, he was always obliged to say goodnight very quickly and leave her. His own house, when he entered it a quarter of an hour later, always seemed overfurnished and lavishly decorated and overwhelmed him with its evidence of prosperity. He reminded himself that Evie had been here and seen all this and it made him uncomfortable to know she had witnessed the thriving and comfortable home-life she had been denied.

On one trip to Newcastle they passed through the very village, Moorhouse, where Evie, though reluctant to answer questions, had recently told him she had been raised. He wondered how she would react to passing through it and was watching her closely as the coach breasted the hill above Moorhouse and began its descent. She looked straight ahead, not a flicker of recognition on her face, and made no comment. He was the one who could not keep silent. As they came level with the public house she had named, the Fox and Hound, he said, 'Would you like to stop, Evie, and step inside for a moment?' She shook her head, but violently, not in her usual unresponsive way. 'I thought you might like to show people how well you are looking in your fine clothes.' She kept quiet until the pub was behind them and said, 'I know no one there now. My mother's cousin's wife has left. She has gone to Newcastle.'

'Ah,' Henry said, seizing eagerly on the slender prospect of any kind of conversation and not wanting to let it go. 'Of course, I forgot. Your uncle, if I can call him that, died recently. Were you fond of him?'

'No.'

'Was he unkind?'

'No.'

'Were you fonder, perhaps, of your aunt?'

'No.'

'Was she unkind?'

'No. She was kind sometimes, I think.'

'You think?'

'She did not beat me or starve me. She fed me well and bought me clothes, but I worked hard for it.'

'You are a hard worker, I know.'

Then they passed the school and the two churches, one ruined, and finally he saw Evie was not untouched by the sight of them. 'You went to church?' he asked.

'Yes. If I was allowed to. It was somewhere to go and I knew my mother used to go to church, in that ruined place.'

Henry tensed and sharpened his concentration upon her. Were her hands trembling ever so slightly? It was the first time she had ever referred to her mother. 'How did you know?' he said, gently.

'I was told. By my mother's cousin. He was not my uncle. She sang, my mother, in that church, when there was a choir there. I have her voice.'

Astonished, Henry let the coach rattle several miles while he absorbed this detail – so Evie had her mother's voice, Leah's singing voice, which neither Rose nor Polly had. She had told him this so proudly, the words 'my mother' coming out of her mouth so full and rounded this time and the statement 'I have her voice' so authoritative.

It was extraordinary, he reflected, that Evie made so little comment about her mother's outright and total rejection of her. He wished she would protest, that she would beg him to explain this cruelty to her, beg him to intercede. But she never did. She seemed quite fatalistic, accepting what was surely the most severe blow she had ever received with equanimity. It was not normal. He could hardly bear her acceptance and longed for it to fade away and for resentment, with which he could cope more easily, to take its place. All the time there grew within him the desire to break this deadlock. this intransigence of Leah's and this acquiescence of Evie's. He wanted the two women to come together even if only to clash resoundingly, and yet with neither of them could he make any progress. What he could not be sure of was how real, how sincere, was this attitude of Evie's? He could not claim to know her, or to be able to fathom her mind, whereas, though Leah's feelings were a mystery to him, he was certain enough of their genuine passion. Was Evie pretending? Did she dissemble for some purpose he could not guess at?

It made him uneasy to think so, but then he chided himself for becoming as fanciful as Leah, who was still afraid of Evie. It at first puzzled and then exasperated him that his wife insisted now on locking the doors when he was out at work and called out to know who was there before she would open them. The girls could not understand it – they came home from school and were locked out, and explanations of robbers being about frightened them.

'This is absurd, Leah,' he was finally moved to say. 'What is it you are locking our doors against in the daytime?'

Her reply was, 'You know.'

'But I do not know.' He must, he felt, force her to give voice to her ridiculous idea.

'You do. She will come, one day, and I do not want to be taken unawares.'

'She will never come. What makes you think she will? Nearly a whole year has passed since she was told the truth and she has come nowhere near you, nor made the slightest attempt to contact you. Admit it, Leah, you have no grounds for fearing her.'

'I have grounds.'

'You do not.'

'She is biding her time. I would do the same, bide my time then strike.'

'Strike? Are you mad? What is it you imagine? She is only a young woman without an ounce of hatred in her and ...'

'You do not know what is in her.'

'I know enough. I have got to know her as much as anyone does, whereas you know her not at all, and yet can make these senseless allegations.'

'I made no allegations. I merely said you do not know what is in her.'

'And you do?'

'She has me in her, whether I like it or not.'

'And so, because of that, you imagine her capable of coming here and striking you?'

'I did not mean actually strike ...'

'Thank God for that.'

"... so much as arrive and accuse me and claim ..."

'Claim what?'

'I do not know, how can I? What she thinks is due to her.'

'And all this, this imagined rigmarole in her head, is because you would do this and you see her as like you?'

'Of me, she is of me.'

'She is nothing like you, nothing. I can see nothing of you in her whatsoever, even if she does have your voice.'

'My voice?'

'Your singing voice, apparently. She told me as we passed a ruined church on the Moorhouse road where, she was told by your cousin at the Fox and Hound, you used to sing in the choir.'

Henry carried on, describing the trip to Newcastle, but Leah heard no more. She was back in that little church and singing her heart out, and Hugo was coming home soon to claim her and the baby she had just written to say she was carrying. So many years since that happy time - then she caught herself, astonished. A happy time? It was now that she was happy, surely, and that other time belonged to dark days, when she was lost and abandoned and a fool. Singing in that church she had been foolish and only in that sense 'happy', meaning vacant, stupid. It made her feel hot just to remember her trust and faith in Hugo Todhunter who, compared to Henry, her Henry, was weak and faithless, and had not known the meaning of the word love. She hated him. It had taken years for the hatred to build up - Oh, how forgiving she had been, it made her sick to think of it now: such excuses she had made for him, such blind understanding of his position she had shown. And he had left her with evidence of his betraval, that crying scrap of a baby - and she could not bear it.

So the child had grown up to have her voice. It surprised her. She had not the build to have a good voice. She was too thin, with hardly any chest, and looked as if she could have no power. It was a useless gift in any case. Singing had never helped her get on in life and it had not helped this girl, this daughter of Hugo's.

Henry had finished his recital. 'We came back the same road,' he was saying, 'but the village was all in darkness.'

'It would be,' she said, 'nights start early in Moorhouse. I dreaded the winter, dark by three in the afternoon on bad days.' She paused. Henry was giving her such a strange, pitying look. She turned away from him and said, 'She passed her father's house too, on that road, but you know nothing of him.' Henry cleared his throat. 'Do you wish to, Henry? Do you wish to?'

'Not if it distresses you. I haven't known, or asked, all these years, and I can manage.'

'But do you wish to know?'

'If you wish to tell me, at last.'

Leah went and stood by the fire and, leaning on the mantelpiece and staring into the flames, she said, speaking rapidly and in an irritated tone, 'His name was Hugo Todhunter. I vowed I'd never say it again. He was well-to-do. His family had the only big house in the village, on the edge, outside it. He went off and got into trouble and came home only when it was made a condition of his debts being paid. He met me on the road, he on his horse. You know the rest.' She turned round so suddenly that her dress was in danger of catching alight and Henry cried a warning. 'She is his daughter,' Leah said, 'she should go in search of him.'

'She has no interest in him. She does not even wish to know who he was and made that plain.'

'But she ought to know, it is her right. It is he who is responsible for her lack of a mother.'

'That does not make sense, Leah.'

'It does to me. It ought to make sense to her. Let her go to Moorhouse, to the Todhunters. I wrote to them, to the mother and the sister, and told them I had baptized their son's daughter and given her their name, Evelyn. Does she know that? Tell her that, tell her to go to Moorhouse and present herself.'

Henry did tell her. He told Evie the very next day, but he could see at once that she still had no interest. 'Of course,' Henry said, carefully, 'my wife does not know what happened to him after he went to Canada and left her. He may have returned, or he may be dead. There is no way of knowing. But if you were to visit the Todhunters and explain ...' Evie shook her head and stood still with an air of waiting to be dismissed. She was looking prettier lately, though that was not so very pretty. Her better clothes helped. She was wearing a deep royal blue dress with darker blue trimmings and it gave a brightness to her pale face. She had a more confident posture too. She stood with her thin shoulders back and her head lifted whereas formerly she had seemed hunched and her eyes were always on the ground. It was pleasing to see this improvement and he was sure others would have noticed it. He wondered, as he sent her back to work, if Evie might now attract a suitor, but it was not something he could ask her. He wished some young man would come along and take an interest in her and make her happy, but then while wishing this he had to remind himself that nothing would apparently make Evie happy except acknowledgement by her mother, or so she believed.

Since nothing could be done about this, Henry learned to put it out of his mind for longer and longer stretches of time. Evie seemed settled. She had her house, she was doing well at work. And Leah, though still bolting the door when she was alone, had settled down too. She was not quite her old self, not quite as carefree and cheerful, but there were no more tearful outbursts nor any overt signs of irrational behaviour. He hoped that she had come to believe that what he had told her was true – Evie Messenger would not make any trouble. If she could not have her mother's love she was now apparently prepared to forget about it and resign herself to being motherless. Perhaps she had decided it did not matter so much after all. What was a mother? An accident of nature, no more than that, and a father even more so. Only when one was young was a mother important and he reasoned that Evie had worked this out and accepted her loss. She might have found her mother, but she could not put the clock back and therefore rejection by her was all simply part of a tragedy that was over. It had become a fuss about nothing.

Henry was all the more surprised, having rationalised the situation to his satisfaction, when one afternoon two years later he returned to his house to find Leah refusing at first to unlock the door for him. He had to bang and shout before he saw her face pressed up against the stained glass, peering through it to check that it was indeed him. Then when the bolt was drawn and he gained entry it was only to see his wife run up the stairs and into their bedroom without a word of explanation. He called after her but she would not answer and he was obliged to follow her, highly irritated at the disruption to his usually soothing homecoming.

'Well, Leah?' he said, rather more sharply than he had intended. 'This nonsense again, after all this time?' She lay on the bed looking, he suddenly saw, so truly ill that for the first time he was concerned. 'Leah? What has happened? Are the girls ...?'

'The girls are out, at Maisie Hawthorne's, they are fine.' 'Well, then?'

'She came. I always knew she would.'

'Who? Evie Messenger?'

'Yes. Her.'

He was stunned, and sat down on the edge of the bed. 'Good God. When?'

'This afternoon.'

'But she would be at work.'

'It is Thursday. She works Saturday and has Thursday afternoon free now. You told me yourself of this change for your staff.' 'What did she say?'

'Nothing. I closed the door.'

'In her face?'

'Yes.'

'Was that necessary, Leah? After all this time ...'

'Time? What has time to do with it? She is allowed to do anything simply because two years or so have gone by in which she has done nothing? I knew she was biding her time, I knew she would come one day.'

Henry sighed and held his head in his hands. 'I am tired and hungry,' he said.

'There is food prepared for you. I cannot eat.'

Henry went slowly downstairs and into the dining-room where there were several plates laid out with covers over them. He went first to the cupboard and poured himself a whisky, which he had taken to drinking recently. Then he ate his way through the cold meats and the potato salad and the cheese, and afterwards got up and defiantly had another whisky which left him feeling sick. There had been no sound meanwhile from upstairs. He wished his daughters would come back to liven the place up and distract him. If Leah did not come down he would have to go up again to her. It was more tempting to go to Evie and find out from her why on earth she had come here, but his pony and trap were put away and, though trams ran into town now, it would mean walking to the top of the bank to catch one and then changing at the Town Hall. He would have to wait until tomorrow to see Evie and straighten this out. There was no point in talking to Leah before he had seen Evie. If she had shut the door in the face of her unexpected and dreaded visitor without allowing her to speak, then she could not possibly know anything.

It was an uncomfortable night. Leah wept, though quietly, and Henry slept only fitfully. Any sympathy he had previously had for his wife had disappeared. Her behaviour was inexcusable now and his main feeling was one of profound annoyance. They had been through all this and it was exceedingly tiresome to be faced with the prospect of having to go through it all again. He rose early and saw to his own breakfast and left without taking Leah any tea – she could make of that what she liked. The moment he arrived at work, he sent for Evie only to be told she was in attendance at a fitting, helping Miss Minto. Since he could hardly drag her out of it without arousing intense curiosity, he had to wait a whole hour, by which time he could hardly conceal his very real impatience. It was not a sensible state of mind to be in and he tried hard to seem calm when Evie at last appeared.

He asked first about the fitting at which she had just been present, nodding his way through her report without taking in a word. Only when he was sure his tone of voice would emerge as quite even, did he say, 'I believe you called at my house yesterday afternoon, Evie.'

'Yes, sir.' She did not add that the door had been shut in her face. Evie, he well knew, never added anything unnecessary.

'I am sorry my wife was indisposed,' Henry said, 'and had to close the door without hearing you – she was taken ill with such suddenness – but might I ask the reason for your visit?'

'I am getting married, sir, Mr Arnesen.'

Henry was so startled he dropped the pair of scissors with which he had been fiddling, and had to cover his confusion by making a performance of picking them up again. 'Married, Evie?' he finally said.

'Yes, sir. Next month.'

'May I ask to whom?'

'James Paterson, sir.'

'Jimmy? Good heavens, I did not know he was courting you. Has it been a long engagement?'

'There has been no engagement, sir. James has no money for an engagement ring and since we know our own minds there is no sense in an engagement.'

'I am very happy for you, Evie.'

'Thank you, sir.'

'So you came to my home to tell me?' Henry put into his voice his surprise that she should do this, since she must have known perfectly well he was at work, but Evie was not perturbed.

'No, sir. I came to tell my mother and to ask her to be at my wedding and sign as witness to it. She is my mother, after all. It would not cause comment. James does not know, nobody does. It would be a favour, and your being my employer and my mother your wife, and you have been very good, and at other people's weddings, sir, you have graced other occasions and are known for it, for the kindness and compliment. Otherwise, I have no one. It will be very quiet and simple and quick. Half an hour, sir, and that is all, and no breakfast or formalities.'

It was a veritable speech, and Henry recognised the effort it had

cost Evie to make it. She had rehearsed the words over and over, he was sure, and thought about them long and carefully. But what she could not have calculated was the effect. Henry felt moved to tears and at the same time disturbed. There was in Evie's voice an element he could not quite identify and it worried him – there seemed a note of warning in it, but of what was she warning him? And yet she had now gone back to looking as harmless and demure as usual, the sort of person who would not have the strength of character to issue warnings to her employer.

'Well, Evie,' Henry said, eventually, 'I must discuss this with Mrs Arnesen, but I fear she will not be well enough to attend any wedding.' Evie hung her head, but whether in disbelief or disappointment he could not tell. 'When are you to marry, exactly?'

'Saturday week, sir.'

'At which church?'

'Holy Trinity, sir, in Caldewgate, where my mother had me baptised.'

Again, Henry heard the same subtle message: take note, this is significant. 'Ah yes,' he said, pointlessly. 'And will you carry on living at Holme Head?'

'No, sir. Those houses are for single women. We have bought a house.'

Henry raised his eyebrows. There could be no 'we' about it. Jimmy Paterson could not possibly have any money. His money, the money he had settled on Evie which up to now she had refused to invest in a house, was the only identifiable source of the revenue needed for purchasing property. 'I am pleased,' he said, 'it is a wise move. Where is the house, might I ask?'

'Etterby Terrace, sir.'

Henry looked up sharply. Etterby Terrace was a tiny row of terraced houses running off to the left of Etterby Street, at the top of which, on Etterby Scaur, the Arnesens lived. Evie's expression was free of anything remotely resembling triumph, but he was quite sure she had understood the impact of this news. 'I did not know those Etterby Terrace houses could be got so cheap,' he said.

'It is in bad condition, sir, very bad.'

'Is it wise then, to take on such a burden when neither of you are yet earning anything substantial?'

'James's brothers are builders, sir, and his father a carpenter, and

they will see us all right. And we mean the house to work for us, to be a lodging house.'

'You are full of plans, then.'

'Yes, sir.'

'I wish you luck.'

'Thank you, sir. So you will come to my wedding, sir?' There was the faintest emphasis on the word 'you' and once more the hint of threat.

'I will let you know, Evie,' Henry said, 'but with my wife ill I cannot promise.'

He did no work for the rest of that day. His concentration had entirely gone and he could not settle to anything nor bear to be in the same building as Evie. But neither could he bear to go home where Leah languished so dispiritedly and would go into hysterics when informed of the reason for Evie's visit and when told where Evie and her husband were to live. In Etterby Terrace, Evie would be their neighbour. She would walk down the same street as her mother, stand at the same tram stops, use the same shops. Her presence would be insupportable to Leah, who would wish to move house at once. Well, this was not an impossibility. Henry had quite often contemplated buying a better house, a house more in keeping with the affluence that had come his way, and it was Leah who had demurred and asserted herself very fond of her present house. They could move. Stanwix was not the only place in Carlisle to live, even if still reckoned by everyone to be the choicest area. They could have a new house, a house built to their specifications, in some other pleasant part of town. There were building plots for sale on the other side of the river where there would be attractive views of Rickerby Park. It would distract Leah wonderfully to have meetings with an architect and then to have rooms to decorate.

But to leave Etterby Street for those reasons would be folly. Henry knew he would be foolish and cowardly to suggest such a solution. If Evie was set on making herself visible to her mother, then nothing would stop her. It grieved him to have to admit to himself that Leah had perhaps been right, or that at least she had had some correct inkling of how, given time, Evie would respond. Leah was a very determined, odd woman; Evie, it seemed, was equally determined and strange. They were after all, in spite of the external evidence against it, two of a kind. And neither would yield. Leah would not accept Evie as her daughter, and Evie had resolved to force her to do so. And he was caught between them, seeing the rights and wrongs on both sides and obliged to arbitrate.

Without being aware of where he was heading, Henry had walked down Lowther Street and down to the river, and now he was striding distractedly along the bank presenting the false picture of a man who had an urgent appointment. His mind was full of wild schemes to each of which he gave only a moment's consideration before rejecting them all as absurd. Most of these wild ideas hinged in one way or another upon engineering a meeting between Leah and Evie, locking them in a room together and making it impossible for them to escape until some kind of compromise had been hammered out. Evie would be all in favour of such confrontation, he was sure, but it would drive Leah mad and he was afraid of that madness.

Concern as to how to tell his wife about Evie's approaching marriage made him far more weary than all the walking he had done. His footsteps slowed as he neared home and he wondered if he would ever again enter it quite as eagerly and happily as he had once done. Leah was still in her bedroom, the girls once more out, and Clara nowhere to be seen. He felt brutal but could not abide the thought of a long drawn-out performance and so marched upstairs and announced straight away what Evie had told him - all of it without pause. There was silence from the prostrate figure on the bed. No screams or sobs. Relieved, he went and sat beside Leah and took her hand. It lay in his own, limp and unresisting. Her eyes were closed but no tears coursed down her pale cheeks. She seemed more composed than he had thought could reasonably be expected. He was pleased with her and bent over her and kissed her lightly. 'She can do nothing to us, love,' he said, 'remember that. She is a troubled soul who wants what she cannot have, because you cannot give it and she will come to realise this. When she has children of her own all this need of hers will fade, you will see. Be brave, no more shrinking from the sight of her, it will not serve.'

Leah, listening, knew he thought his words very fine but to her they were entirely empty. She let him pontificate and by her silence think she agreed with him. There was nothing else she could do. But next day, when he had gone to work, she bolted the door, once Clara had come, and again when she had gone. Clara left at five, since it was Saturday. Rose and Polly were at dancing class. She had hardly locked and bolted the door before there was a knock upon it. She went into the hall and saw the shadow and was not in the least surprised. She stood still until it had gone. Every Saturday after Arnesen's had closed, it would be like this - the knock, the shadow, the disappearance. They would have to move. It was intolerable to live like this, equally intolerable the thought of facing Evie Messenger out and telling her to go away and never return. She had thought of one of those speeches Henry delighted in - she had framed words of explanation in which she asked this woman for forgiveness, but begged an end to this haunting. It would never be made. Her punishment was to endure these visitations and the woman who was punishing her knew it. Nor was Henry right to imagine that, once children had been born to her, she would understand and desist. On the contrary, once she had given birth it would become more inexplicable, more monstrous that her own mother had first abandoned and now denied her. The anger would grow, not subside, and the hate intensify. And all the time Leah asked herself: in her position, would I have haunted my mother as she haunts me? She struggled to think not, but all the time Evie's right to persecute her seemed stronger and more frightening than ever.

Chapter Twenty-One

 \sim

THERE HAD been malice in her sudden decision, but Hazel was unsure at whom she had directed it, at the girl or at her mother, nor could she fathom the reason for it. But standing on the corner of Victoria Grove, with the girl about to depart, and hearing her mother call from her car, she had felt a sudden and violent urge to do harm – inexcusable and horrifying. She saw in the girl's eyes a sort of hope, quite naked and somehow touching and, as she guided her towards where her mother was now parking her car, she realised it was the first time she had actually made any physical contact with her. Only a hand on an arm, but it made the girl seem vulnerable and needy, to feel the skin on the wrist where it pulled free of the sleeve of her coat.

They walked together back to the house not quite arm in arm -Hazel's hand rested on Shona's rather than linked it - to where Mrs Walmsley stood holding a box she had taken out of her car. 'Hello, darling,' she said. 'I've brought you the eggs I promised. I didn't expect to find you at home - I was just going to use my key and pop them in.' All the time she was speaking Hazel and Shona were coming towards her and she had a bright, inquiring expression already on her face. 'Mother,' said Hazel, 'this is Shona McIndoe. Shall we go in and have some lunch? It's nearly lunchtime. We can make an omelette out of your eggs.' The three of them went inside, Mrs Walmsley talking all the time, very loudly, about her drive back from Gloucestershire and the horror of the traffic and there being no such thing these days as a quiet time on the roads unless one was prepared to drive in the early hours of the morning which, at her age, she certainly was not . . . Neither Hazel nor Shona spoke. Hazel was busy breaking and whisking the eggs and heating the pan, and Shona stood uncomfortably to one side while Mrs Walmsley laid the table.

'I don't think I've met you, my dear?' she finally said to Shona, her smile wide and forced. She wasn't sure she ought to say even that, but Hazel, rather rudely, had made no more than a sketchy attempt at introductions. It was impossible to know if this stranger was a friend or a new au pair, or a friend of the au pair's, or even a client, though that seemed unlikely, and she wished very much to be given some guidance before she tried to engage her in any kind of conversation.

'No, mother,' Hazel said quickly, 'you haven't met Shona. Sit down, this omelette is nearly ready. There's some wine open over on the dresser ...'

'Good heavens, dear, you know I don't drink in the middle of the day and never when I'm driving.'

'Water, then, put a jug of water on the table. Do you want salad with it, or bread?'

'Just the omelette will be very nice, though I had no intention of eating my own eggs.'

They sat down, Shona first removing her coat. Hazel noted how shapely her figure was now that she could see it undisguised by the loose coat. Not my figure either, she thought. More my mother's, that small waist and full bosom, more hers when she was young.

'Mother,' she said, as Mrs Walmsley took a mouthful of omelette and daintily dabbed at her lips with a napkin, 'Mother, this is Shona's birthday.'

'Oh, how nice. How old are you, dear?'

'She's nineteen,' Hazel said, before the girl could reply. 'She was born in Norway nineteen years ago today and adopted by a Scottish couple.'

There was an absolute silence. Mrs Walmsley put down her fork with extreme care, so extreme that the metal prongs touched the wooden table with no whisper of a sound. Her face delighted Hazel. It was so rare ever to see her mother confounded, and now she was. It took several seconds before signs of life returned to the frozen features and when it did the mouth tightened, a frown contorted the forehead and a flush slowly spread across the cheeks. Shona, Hazel saw, was smiling, a bitter smile acknowledging that here, too, there had been no exclamations of joy, no rush to embrace her. She was on her feet again, omelette untouched, struggling back into her coat. 'Don't go,' Hazel said.

'What a way to tell me,' Mrs Walmsley croaked, 'the shock, Oh dear.'

'I'm sorry to be a shock,' Shona said, grabbing her bag, 'it's all I ever seem to be to your family. But I'm off. I won't bother you again.'

Hazel pushed her chair back and followed her to the front door, but she was not quick enough, Shona was out of it and off. When she returned to the kitchen her mother was still sitting there transfixed. 'What a way to tell me,' she repeated, this time with the beginnings of anger in her tone. 'And how embarrassing. Did you not think of that?'

'Embarrassment? No.'

'Well, you should have done. You embarrassed me and embarrassed that poor girl. There was no need for it.'

'So what should I have said?'

'You shouldn't have said it at all, not in these circumstances. You should have told me quietly, when we were alone.'

'Secretively.'

'What?'

'Secretively. You want me to have kept it all secret still, as we did from the beginning.'

'To confront me with that girl, to put her in such a position ...' 'She put herself in it by coming here.'

'When did she come?'

'An hour or so ago.'

'She just turned up and announced herself?'

'Yes.'

'I can't believe it.' Mrs Walmsley pushed the half-eaten omelette away and got up. 'After all this time, who would have thought it ...'

'Anyone with any imagination.'

'She seemed a nice girl too. Is she a nice girl?'

'I've no idea.'

'What did she want exactly? What was her idea?'

'To satisfy her curiosity, but more than that really.'

'More?'

'I think so.'

'What kind of more? Will she make trouble?'

Hazel smiled. She could see how worried her mother now was – she craved reassurance, wanted to be told that Shona was a nice girl

who would do the decent thing and, having made herself known, would also realise she was as unwanted as she had ever been and disappear. She might fleetingly have referred to Shona as 'poor', but there was no genuine sympathy there, nor any desire to know what had been the fate of the girl. A smooth, orderly life, that was what her mother wanted, as she had always wanted and invariably succeeded in getting.

'What kind of trouble did you envisage?' she asked her mother, taking pleasure in how cool she must appear.

'Well, I don't know, be unpleasant, want some sort of recompense

'Compensation for being given away? What would that be, do you think? What form could such a thing take?'

'I don't know. You're the lawyer. Money, I suppose.'

'Money? Hardly, Mother. The law doesn't say adoption is a crime, the law sanctions it. Everything you did was perfectly legal and above board. You couldn't be sued for a penny.'

'Me? Why would I be sued? I didn't mean that, that's silly. I meant – oh, you know perfectly well what I meant. Is this girl going to hang around you, has she some axe to grind?'

'Would you call your mother giving you away an axe to grind?' 'But presumably she knows what the situation was, surely she understands ...'

'No, that is precisely the point. She finds it impossible to understand. It hurts even to try to understand when she feels, as she does, that nothing and no one would ever be able to force her to give up any child she ever had.'

'Oh, that's just romantic.'

'Maybe. At nineteen, you're entitled to be idealistic or romantic. I just wish I had been.'

Round and round the kitchen Mrs Walmsley went, putting straight objects that were perfectly straight, fussing with the kettle, first putting it on and then off, and displaying without seeming to realise it her agitation. Hazel watched her, never moving from her seat, and thought that if she had believed all this pacing about was evidence of emotional distress she might have felt sorry for her mother. But what she was seeing here, she was convinced, was resentment alone. Her mother resented Shona having had the impertinence to turn up, she resented Hazel for confronting her with Shona, and now, most of all, she was resenting what she would be labelling her daughter's obtuseness. She wanted Hazel to agree with her that something quite unacceptable had happened and that it must be dealt with firmly. And I am giving no sign of that, Hazel reflected, I am not showing either willingness to be organised by my mother or any eagerness to defer to her judgement and conspire with her to deal with 'trouble'.

But Hazel was wrong. Mrs Walmsley's thoughts were not at all along these predictable lines, and the loss of composure was indeed caused by her being far more distressed than Hazel could possibly appreciate. She was remembering and in remembering she evoked a deep-felt shame which had been her own. She was unable to turn to her only daughter and explain why she was as she was – it was too difficult, too much in the nature of confessional, and she was not in the habit of making confessions. All her life she'd striven to rise above the temptation to unload her fears and worries on to others and this had been at some considerable cost. She was labelled hard and unfeeling, was thought to care only about being efficient and respectable and keeping a masculine stiff upper lip. Her lip now felt very weak and quavering, but Hazel was so unsympathetic, it was impossible to break down in front of her and expect comfort. They did not, as mother and daughter, behave in that way. They were cerebral women who prided themselves on putting heads before hearts. Everything had to be talked about, reasoned. It was how their relationship operated.

And now it was not operating at all. Hazel was sitting there looking aloof and detached, whether because she had taught herself to be so – or been taught (and if so, by whom?) – or because this was her. There was no reaching her.

'I'd better go,' Mrs Walmsley said. 'I didn't intend to stay in any case.' She picked up her car keys and without looking at Hazel, and struggling to seem more like her usual self, said, 'I expect you'll tell Malcolm.'

'Of course.'

'Very wise, in case she turns up again. Will you get in touch with her, do you think?'

'I haven't her address or telephone number.'

'Poor girl. If I hadn't been so terribly shocked ...' 'Yes?'

'I should have said something. It wasn't kind.' 'No. Neither of us was kind.' 'Hazel, do you feel anything for her, for the girl?'

'Meaning?'

'Oh, are you upset? It's impossible to tell, and I feel so upset myself, it must be the shock, there's really nothing to be upset about.'

The rest of the day seemed very long. Hazel went to work and was busy, but still the hours dragged. She realised she both dreaded telling, and yet was eager to tell, Malcolm about the extraordinary visit she had been paid. His reaction was easy to predict. He would be desperate to meet the girl and would not be able to credit that she had been allowed to leave without revealing her address or phone number. But that would present no problems to Malcolm – he could track the girl down in no time given her name and age and the single fact that she was a law student at UCL. Then what? Would he go and see her? Would he persuade her to come again, to meet the family? And what of the family, their boys? Malcolm would insist upon telling them. He would enjoy it, the explaining, and because they were so young what he had to tell them about their mother would simply seem a story having nothing to do with pain or distress. It might even be salutary for her to be present while Malcolm did the explaining - it would make everything seem comfortingly ordinary after all.

Yet it was not as simple and straightforward as she had imagined, to acquaint Malcolm with the facts about her daughter's reappearance. There seemed no way into the subject. Evenings were so chaotic and exhausting in their house, with all three boys demanding and noisy, food to be made, and the next day's work hanging over both her and Malcolm. It was usually eleven o'clock before they had time to exchange any but the most perfunctory news. At midnight she made some cocoa and took it up to his study where he was still poring over documents, head in hands, looking grey and tired. He barely murmured his thanks before turning another page and did not even glance at her. Only the fact that she went on standing there caught his attention after a while and finally he looked up and said, 'Mm?'

'Come down to the sitting-room,' she said.

'I can't. I'm in court tomorrow, have to be, on this one.'

'Come down for a break.'

'I'd never get back to it, I'm nearly asleep anyway.'

'How much longer will you be?'

'An hour, I don't know, you go to bed.'

She stood, sipping her own cocoa, watching him. Whisky would have been better, she didn't know why she'd made this sickly milk drink. He was drinking his quite greedily though, in great gulps. But she was annoying him by hanging about.

'What is it?' he said, irritated. 'What's wrong?'

'Nothing.'

'Good. Go to bed then.'

She did. She went downstairs and washed her mug out and put all the lights off, but didn't tidy up, that could be done in the morning, it was what Mrs Hedley was paid for. She quite liked the look of the house at the end of the evening, the evidence there of living going on. Her mother's house had always seemed dead, with none of the debris of family life littering the place. Then she went upstairs and looked in on each of the boys, more mess, more things strewn everywhere on the floors, so that she had to take care not to trip in the half dark. She put her bedside lamp on and propped herself up to read, but she hardly took in a word. She liked her bedroom. Everything in it was her choice. Malcolm had views about the rest of the house, but not about their bedroom. It was mainly a green room - pale green carpet, dark green linen blinds, a white and green cover on the bed. It always soothed her. In spite of her tiredness she felt a little refreshed after she'd lain there a while. Malcolm would be too exhausted when he came to bed; it wasn't fair to tell him anything important, but if she waited he would be angry with her later and vow that he was always ready to be told vital things whatever his state, whatever the hour. It was no good thinking she would tell him in the morning, the mornings were hopeless, as disorderly as the evenings with the added pressure of everyone needing to depart on time. She would have to tell him now, here, peacefully.

He didn't come to bed until two o'clock and was startled to see her still sitting up with the light on. 'Why on earth are you awake?' he said. She put her book aside and watched him as he undressed. He was putting on weight. In his suit this was hardly noticeable but naked she could see the flab beginning. His whole life was stressful and unhealthy, but he loved his work and could not be persuaded to take time off for leisure. 'I hope you're not going to keep that light on when I get into bed,' he said, 'I can't sleep with the light on, you know that, and I'm dead-tired.' It crossed her mind that he was imagining she might have been staying awake to make love and that he was warning her of disappointment. That made her laugh – she had so little interest in sex these days – and so it was with a smile of amusement and a little derision that she said, as soon as he had got into bed, 'I'm sorry, it won't take a minute, there hasn't been a good time all evening, but even if you're shattered, I can't let you go to sleep without telling you what happened this morning.'

She told him as quickly as possible, managing to reduce the whole trauma of these hours to a few succinct sentences. Malcolm became alert immediately. He jumped out of bed and came round to her side to face her and put back on the light which she had just switched off. Then he scrutinised her face for what seemed ages before saying: 'So you're not upset?'

'Not really, no. Disturbed but, no, not upset in the way you mean.'

'You haven't said what she looks like.'

'Not like me. She has beautiful auburn hair, she's tall, and her figure is like my mother's used to be.'

'Attractive, then.'

'Yes. Oh, she's attractive.'

'But what is she like?'

'I don't know. It was impossible to tell. She was very strung up and nervous and then she became quite defiant and sarcastic ...'

'Hardly surprising.'

'No.'

Malcolm put the light off and got back into bed and lay with his hands behind his head, as she was doing, both of them staring into the dark. 'Well,' he said, 'let's get some sleep. I can't think straight, I can't think what we should do.'

'We don't have to do anything. It's been done. It's still up to her.' Malcolm groaned and repeated that they must get some sleep and promptly turned over and began breathing deeply.

They were both very quiet and polite in the morning, holding themselves clear of all the confusion. It was a day when both of them left the house together, an unusual occurrence. Hazel found herself automatically scanning the bushes in front of the chapel, remembering the girl's reference to herself lurking there. Abruptly, she told Malcolm this as they got into his car and he was horrified, and she wished she had never mentioned it. 'Pathetic,' he said, over and over again. Pathetic. All day, fully occupied though she was, she heard that word thumping in her brain, its rhythm insistent and strong. She fought it, not wanting to associate pathos with the girl, wanting to admit that it was only the spying and not the person who spied to whom the description pathetic could be applied. She told herself the girl wasn't a waif, she was an intelligent, able law student with a good home and loving parents who on her own admission could not have been more fortunate in life. That was not pathetic. That was lucky. It all came down to whether being mothered by your actual mother mattered – no, it all came down to whether being disposed of by her mattered – no, it all came down to whether being rejected by her when you had found her at last mattered.

Yes. By the time Hazel went home her analysis was complete. It mattered. This was what was crucial, how the girl was treated now, by her mother. She had not behaved well when the girl - oh, this must stop, when Shona - came to claim her. A great deal of her treatment yesterday was excusable but not all of it. It was perfectly excusable not to have pretended delight where she had felt none. It might be sad that she had not been able to fling her arms round her daughter's neck and embrace her passionately, but it was excusable. She had merely been true to her normal self and could not be blamed by Shona or anyone else for that. But she had not tried to empathise with this newly discovered daughter of hers. She had been wary and distant and from the first, she knew, had given off strong messages that she did not want any involvement. She had not really given Shona a chance to explore her own feelings, but had more or less dictated terms to her. And that was not excusable. She owed her some kind of welcome even if it could not be effusive. It was cowardly to freeze her out. The result could be that she would go through the rest of her life far more damaged by her mother's disinterest than she had ever been by her original rejection. It was not the adoption which hurt but the discovery of it, the sickening realisation that she, Shona, was valued even less as a fully grown person than she had been as a characterless baby. A baby was nobody, Shona was somebody. A mother who, face to face with her own creation as a person, turned away could not be excused.

Before Malcolm came home, Hazel had done her own detective work. Shona's name made looking for her easy – one phone call and it was located on the student list and her address and phone number given more freely than Hazel thought right, even if her voice, as a middle-aged, middle-class woman, could be said to arouse no suspicions. She thought that if she telephoned she might do more harm than good and if she wrote she would be ignored. The only thing to do was what Shona had done to her, turn up, unannounced, and plead. The moment she had decided this, she could not bear to wait. She asked Conchita to wait until Malcolm came home before going out to meet her friend. Then she dashed out to her car. Shona's street in Kilburn wasn't far away, but the traffic was heavy and it took her forty-five minutes. Then, when she had parked in the street and found the house she suddenly felt she should not be empty-handed. Did Shona drink? All students drank, surely. She found an off-licence and bought a bottle of the best champagne they had.

It was good for her, she conceded, to have to wait on Shona's doorstep as Shona had waited on hers the day before. Humbling, that is what it was. She was the supplicant now, unsure and uncertain of her reception, afraid of having doors slammed in her face, nervous as to how she should proceed, what she should say. Yet still, compared to Shona, she had the advantage. She was secure and had nothing to resolve, whereas she had seen how Shona felt: she could not know herself without knowing her true mother. She was wrong, Hazel was convinced, but was it up to her to demonstrate that? She was still debating this with herself. What she must do was give Shona reassurance, the sort of reassurance which would come only from being made to feel valued if not loved.

It was a mighty mission and Hazel half smiled at herself as she stood on the doorstep. She was no crusader. Neither in her personal life nor in her work – where it would have been welcomed – had she ever shown any sense of mission about anything. She had never felt inspired, she had always followed rather than led, or else stood quite apart. Now she felt that she was engaged on a conversion of great importance and that only she could manage it. It was crucial to get Shona to see I do not, after all, matter, thought Hazel, and neither does my lack of love for her.

The door was opened by an elderly man, which surprised her. She told him she was here to visit Shona McIndoe and he directed her down the stairs to the second door on the left in the basement. She realised she should have gone down the outside steps to Shona's own door and apologised. 'Happens all the time,' the man said, 'not that she has any visitors, she's no trouble, it's the other one, hordes of them coming to see her.' The window beside the basement door had wooden shutters barring it. Probably wise, given the area, but how dark it must make the room. Hazel knocked on the door but there was no sound from within, though she waited and repeated her knock several times. Maybe Shona was not back from college yet, maybe she had gone out. Leaving the champagne on the doorstep was not a good idea and yet she wanted to do that. In her bag she had a pen and paper and now she leaned against the door and scribbled a note – 'I came to drink this with you. *Please* get in touch – Hazel.' She thought about signing it 'Your mother' but that would have been outrageous. Then she laid the champagne sideways on the doorstep with the three empty milk bottles that were there in front of it. It was dark, nobody would see it unless they came and looked. She felt curiously elated after she had done this, as though something had been achieved, though it had not.

Malcolm was home early, for him. He was sharp with the boys, ordering them to bed before nine o'clock and allowing no television programmes. And he did not go to his study. He was in one of his rare clearing-up moods and rushed around tidying like a demented housewife, saying, as he always did in this mood, that his mother would have a fit if she saw this place. Hazel let him carry on. This was all too obviously a prelude to the kind of serious-talk sessions Malcolm loved to set up. Sometimes she was amused when he started his staging, sometimes so deeply irritated, she withdrew. Tonight she was neither. Malcolm's fussing was part of him, the lesser known part. It had to be endured just as her own detachment had to be when it was carried to similar extremes and used as a weapon. She watched him plump up cushions and straighten chairs and let him make and bring coffee.

'There,' he said, 'that's better.'

'Everything ready?' she asked, brightly.

He didn't ask her what she meant. He settled himself in his chair and drank some coffee and cleared his throat. 'I've been thinking of nothing else all day,' he said.

'Of course.'

'Same as you?'

'Of course.'

'And what conclusion did you come to?'

'Oh, Malcolm, for heaven's sake, conclusions?'

'Decisions, then.'

'None.'

'So you're not going to try to find her and do something about her?' His face grew red with indignation. It made her despair. How could he be such a good lawyer when he took so little care to establish facts, and assumed those that had never been stated?

'I've found her,' she said, with the deepest satisfaction, only with difficulty holding back from open gloating.

'Good,' he said, and nodded. 'Good, I'm glad.'

'Aren't you going to ask how?'

'No. It's easy enough. I'm not interested in how. Have you rung her, spoken to her?'

'No.'

'Why not?'

'I've been to her house, to the bed-sitter she has in a house in Kilburn.' Now she had him truly surprised. 'She wasn't in. I've left a note.' But she said nothing about the champagne.

'That's good,' he said, nodding again in that infuriating way. 'I didn't think you would act so quickly.'

'You didn't think I would act at all.'

'True. I thought ...'

'That you would do it. You were looking forward to all the persuasion, weren't you, Malcolm? To marshalling the arguments and guiding me towards my duty as a decent human being. I've spoiled your fun.'

'It wasn't going to be fun. I was dreading it.'

'Liar.'

'I was, I was absolutely dreading it. You can be so ...'

'Difficult?'

'Difficult, stubborn, and ...'

'Cold?'

'No, not cold, that's what you always think people, even me, see you as. Not cold. Remote. *Apparently* unmoved even when you are moved. And anyway, I know it isn't really my business.'

'But you're pleased with me for seeing the light all on my own.' 'Yes. Don't be so mocking. What now, though?'

'She might ring.'

'You don't sound too sure.'

'Of course I don't, how can I be? She might, she might not.'

'What if she doesn't, how long will we give her?'

'It's "we" now, is it?"

'I hope so. I'm in this too, come on, and so are the boys. It's our family she'll be coming into. We'll all have to welcome her.'

'What a horrible thought.'

'But I thought you ...'

Hazel got up and went through to the kitchen. There was nothing to wash in the sink, but she turned the cold tap on until the basin was full. If Malcolm came through she would scream but he didn't, he knew her well enough. Calmer, she filled a glass of water and went back to him. 'It isn't going to be a party,' she said, 'that is when, if, she comes.'

'I know it isn't.'

'You talk as though it would be a jolly little celebration – here is our long-lost daughter and sister, let's all dance.'

'I didn't say that, I said ...'

'I know what you said, it was how you made it sound.'

'No, it was how *you* made it sound. All I meant was that this is something we all have to cope with and it will take some doing, knowing how to act, what to say, striking the right tone ...'

'Acting.'

'What?'

'Acting, that's what it will be. We will all be acting parts.'

'The boys won't. When shall I tell them? What would you like me to say? How shall I explain things?'

'I don't want anything explained yet. If she comes, I'd rather she came just as a new friend and then later the boys can be told, when they know her a bit.'

'I'm not sure that's wise.'

'I'm not trying to be wise. I'm thinking of what she can handle and what I can handle. You've too much of a taste for drama, Malcolm. I don't want any drama. I want, I need everything to be as quiet and ordinary – well it can't be ordinary or natural – but as quiet and unemphasised as possible. It's too tense, the whole thing. I don't know her, I don't know what she's capable of, what could happen.'

'You mean you don't know what she wants, what she's after?'

'I don't think she knows herself. She thinks she's just satisfying some deep urge to find me, but I don't know. We'll see.'

'You haven't told me enough about her adoptive parents and how she was brought up.'

'She seems to love them, she thinks they were good parents, and she's been happy.'

'Well, that's significant, surely. She isn't looking for a happiness denied her, or anything like that. She can't be motivated by resentment.'

'Can't she?'

'Doesn't sound like it. Why should she want to make you suffer, or want to barge her way into your family, if she hasn't suffered herself and has had her own perfectly happy family? Why should she think you owe her, given this background of hers?'

'Oh, she'll think I owe her.'

'Why?'

'Because ...'

And then the telephone rang and even before Hazel picked it up she knew who it would be. 'Shona?' she said.

Chapter Twenty-two

 \sim

H^{ENRY} WENT to Evie Messenger's wedding. It was not an occasion that could in truth be called a wedding, in his opinion. It was a marriage ceremony and that was different. Evie, however, to his surprise, did wear white and she had a veil and a bouquet. She looked quite transformed. The word that came unbidden into his mind was 'proud': she looked proud, and he saw that all the members of the small party present were aware of this even if unable to give a name to the change in her. Henry told himself that long white dresses and veils were renowed for making the most humble and unlikely girls seem queens for a day, but he did not think it was only, as in Evie's case, a matter of disguise. She was proud, proud to be having a wedding, such a proper wedding, all decent and above board and public. It was only a pity her bridegroom had not similarly risen above himself. Jimmy was in a new suit, very smart, as befitted a tailor, but he looked uncomfortable in it.

It had crossed Henry's mind that Evie might ask him to give her away, but to his great relief she had asked nothing more of him than that he should sign the register as witness afterwards. Jimmy's uncle gave her away, though Henry was extremely doubtful about his right to do this. Presumably Evie had let it be known to the vicar what the circumstances were and he had sanctioned the bridegroom's uncle playing this role. Henry himself had consulted the vicar about his own proposed signing of the register and had been assured this was permissible. He had been rather startled, however, to hear from the vicar that Evie had told him she regarded Mr Arnesen as (the vicar's phrase, this, naturally) in *loco parentis*, because he had been like a father to her at work, although she had not wished to presume by asking him to give her away.

Miss Minto was present too. Henry was glad of this. He could not decide whether Evie had invited Miss Minto in order to make his own presence less obvious or because she truly wanted her. But Miss Minto was delighted to have been asked and sat with Henry on the bride's side of the church with obvious pleasure. There were only the two of them and not many more either on the bridegroom's side. Jimmy's mother was dead and the male members of his family were not church folk. His father and one of his three brothers had turned up and there was a male friend of his from Arnesen's and another young man Henry did not recognise, and one solitary elderly woman who might be a grandmother, Henry supposed, or an aged aunt. The church felt vast with only nine people and the vicar within it, and Henry could not help thinking how Leah and Rose and Polly would not only have swelled this pitifully small congregation but would also have given it the grace and charm and colour so conspicuously lacking.

'Doesn't she look lovely, bless her,' Miss Minto murmured to Henry, as Evie came down the aisle. 'I feel like a mother to her, I do, Mr Arnesen, God love her.' Henry could not think of what to say and was glad the organ had ceased and the vicar had begun to speak the familiar words, so that conversation was no longer permissible. He was glad to leave Miss Minto behind when it was time to go, as he had promised, into the vestry to sign the register. 'You are good to indulge her,' she whispered, apparently already apprised of what he was about to do. 'After all, you have been like a father to her and taken her under your wing, Mr Arnesen.' This irritated Henry profoundly and he entered the vestry looking unlike his usual calm self. He had not acted as a father. This was not true. He was good to all his employees, he hoped, especially the young apprentices, and there was nothing fatherly or even avuncular in his attitude, surely. It was merely good business practice to be fair and concerned and provide the best working conditions he could within the limits dictated by economic factors. And here he was, branded as acting like a father to a young woman to whom he should have been a real father.

He left as soon as he had witnessed the marriage, having made it plain he could not go to the married couple's new home – where there was no wedding-breakfast but a drink had been promised – because he must hasten back to his sick wife. He wondered, as he made his way home, if he should have kissed the bride. All the other men had done so and it would have been quite acceptable – indeed, not to have done so was perhaps too marked a departure from normal custom – but he could not bring himself to touch Evie. Instead he had shaken Jimmy's hand and told him he was a lucky man, and then he had smiled and nodded at Evie and wished her luck and he had gone. He was still feeling rather shamefaced about this as he entered his house and it made him less than understanding when Rose greeted him with the news that her mother had taken to her bed and had the blinds and curtains drawn and she did not know what to do. 'Shall you go for the doctor, father?' she asked.

'Doctor?' said Henry, curtly. 'It isn't a doctor she wants, Rose. At least, not in the ordinary way.'

Rose looked mystified and Henry sighed. 'Leave her be,' he said, 'she will recover herself presently.' He had wanted to go and remove his best suit, but now he decided only to take off the jacket and loosen his collar, so great was his reluctance to enter his own bedroom.

'You look very smart, father,' Rose said. 'Where have you been?'

It was such an innocent question, innocently asked, but it caused Henry such consternation he had to pretend to have a coughing fit, and Rose rushed to get a glass of water and thumped him on the back. He was such a poor liar. The simplest lie would do in this case: he had only to say he had been dining with a business client and Rose would be satisfied, but he could not bring himself to say this. If she repeated her query he did not know what he would do but fortunately she did not. She began asking instead if she could safely go and collect Polly from her friend's house and whether they might then go as usual on a Saturday to their dancing class, or should she stay here since her mother was unwell? Relieved, Henry sent her off, glad that she was neither as sharp-witted nor as sensitive as her mother, who would certainly have divined there was something amiss with him.

Leah knew where he had been. She knew today was the day Evie was to be married. He had told her that, since she herself refused to contemplate attending the ceremony in any capacity whatsoever, he felt he must do as her daughter had asked. His conscience, he had told her, would not let him rest if he denied Evie this mark of respect when she had been denied so much else. Leah had said nothing. He had dreaded some form of blackmail, threats that if he went to Evie's wedding she would never speak to him again, but no, none was forthcoming. But he knew she would neither ask him about the ceremony nor want to hear any spontaneous description of it which he might offer. Silence, that is what Leah wanted. And, as he had anticipated, to move house, to the other side of the river, or, better still, to one of the outlying villages, preferably to Dalston, on quite the other side of the city. He had not entirely dismissed this idea, in spite of his feeling that it would be a mistake to run away so obviously, but had prevaricated, pointing out that Rose still had a year to go at the Higher Grade School and Polly had just begun there. There was no other school of its kind in Carlisle, and Dalston was far too far away for it to be practical that the girls should go on attending it. Leah had conceded that for the next three years they must stay in the city but had pleaded to move, then, within its boundaries but out of Stanwix and the proximity of Evie.

That was how matters stood, Leah determined and Henry letting himself seem open to persuasion but, as ever, hoping matters would resolve themselves. One matter he had already resolved to act upon, however. On Monday he was giving Jimmy notice. He hated the thought of this, loathed the image of himself as hard and unjust which might be the interpretation put upon his behaviour. His employees would be shocked. Miss Minto would be most shocked of all - how could he have attended this young couple's wedding and done them the honour of signing the register knowing that he intended to dismiss the bridegroom the next week? It was not what Henry Arnesen was famous for and would be taken badly by everyone. But Henry had decided it must be done. He had to disassociate himself from Evie and this was the only way he knew to do it. This dreadful situation between his wife and her unwanted daughter must be ended and a stand taken. It might not be the kind of stand he would have chosen, but it was the only one he could think of. Evie, by coming to live cheek-by-jowl, had forced upon him this decision. Or that was how it felt. She, as a married woman, could not keep her job as an apprentice, but her husband, too, must go and the separation be complete.

He took the precaution, before he did anything at all, of checking to see if there were vacancies at Studholmes and in Bulloughs and was pleased to hear that skilled workers were needed in both establishments. Bulloughs even paid a slightly higher rate than he did himself, which surprised him, though their firm was smaller. There only remained the problem of how to put it to Jimmy and he pondered this long and hard. The thing to do was to present the case to him as one in which he had his best interests at heart. He would say how talented he was and he would tell him that these talents deserved more scope than he could give them and that he had heard Bulloughs were looking for people like him and that they paid a better wage. Then he would flourish the references he had already written and give him a month's pay. All very well, so far, but the smoothness of the operation in Henry's head stopped when he envisaged Evie's one-word reaction: why? There would inevitably be a 'why'. Even Jimmy, not half as bright as Evie, would think himself entitled to a 'why'. Henry felt ill thinking of this moment. Good God, he felt like swearing, do you not think I ask myself that and never know the answer? 'Because', that is the answer to your 'why', and I wish it were not. Or he could answer their one word with one word of his own: Leah. Leah is your answer. Leah, the woman I love, my wife, that is your answer, and if I understood her I would be a genius.

When Rose and Polly came home, late that afternoon, Leah was still in her bedroom with the blinds drawn and their father still sitting in his armchair as though in a trance. Polly was desperate to show off how she had mastered the latest dance steps and by her very enthusiasm roused Henry from his torpor. Rose, standing by the window so as deliberately to turn her back on her boisterous sister's showing off, said, 'Father, such an odd thing. Look, come and look do, there is a bride in our street.' Polly stopped dancing immediately and rushed to join her sister at the window where the two of them began an unseemly jostling for position and the lace curtain was almost dragged apart.

'Stop it!' snapped Henry. 'Come away from the window. It is rude to stare, come away at once.'

'But father,' Polly squeaked, 'she is coming here, she is!'

'I'm sure I've seen her before,' Rose was saying. 'I'm sure I have, I'm sure, but I can't think ...'

Henry had seized both of them by the arm and wrenched them away from the window with such violence that they both cried out at the same time as there was a knock on the door. 'Quiet!' he hissed, and went on holding their arms with both of them whimpering at the hurt of it. Another, louder knock came, but Henry shook his head and made them keep quite still. Their terror by this time was so great that both were near to tears and neither had any inclination to disobey a father who had suddenly changed character entirely. There was a third knock and then a different sound, a muffled, soft sound, and then footsteps retreating, and silence.

Henry let go of the girls and went to the window himself. where he stood behind the thick side curtain and peered out. He saw Evie, retreating down the street, alone. She was still in her wedding-dress, as Rose had reported. As he watched her, his eve was caught by something bright in the very corner of his line of vision. A ribbon, a vellow ribbon, trailing from his doorstep. Something had been left on his doorstep, left by Evie. 'Stay here,' he ordered the girls, both now huddled in a chair rubbing their arms where he had gripped them. Quietly, dreading that Leah would choose this moment of all moments to come down, he opened the door. Evie's bouquet lav on the doorstep. A bunch of vellow roses tied with a rather faded and shabby-looking length of yellow ribbon. He bent to pick it up and heard as he did so the girls tip-toeing into the hall. 'I told vou to stav still?' he shouted at them, but not before both had seen the bouquet. Rose burst into tears and Polly promptly ran upstairs screaming for her mother.

It was the end of their happy life, but then Leah had plenty of time to reflect that their happiness had ended some time ago, though they had both been reluctant to acknowledge this. Henry had been the more reluctant but now he, rather than she, was the more unhappy. She was fatalistic. She had always expected to pay and now she was paying, whereas Henry, who had done nothing wrong except in his own opinion, had always thought what he called commonsense would prevail. Evie had them both caught. Every day she walked down their street at least twice, every day she stood and looked at their house from the other side of the street. Only for a few moments, and never at the same time, but it was enough. Leah kept her blinds drawn at the front as well as her door locked. Clara had given notice, alarmed by the change in the household and not willing to clean in half-darkness, and no one else had been taken on. Leah said she would manage on her own, without a maid, and that she preferred the work to having to provide explanations for her odd habits.

Henry had talked of consulting the police and getting them to give Evie some kind of warning, but Leah had begged him not to. What could the police do? Evie was within her rights as a citizen, there was no reason on earth why she should not walk along their street whenever she chose, nor was there anything wrong in looking at their house. She offered no threat except in their own minds and even knocking at their door did not constitute a crime. She always went away when her knocks were unanswered, and who knew what she would say if asked by some policeman why she knocked at all? 'I am come to call upon my mother,' she would say, and what was wrong with that? No, it was no case for the police, surely Henry could see that. And he could. He saw it too clearly. Not only was Evie doing no harm, not only was she not disturbing any peace except theirs, but she had behaved well upon Jimmy's dismissal and Henry felt, yet again, in her debt. There had been no scenes, no complaints, not even a 'why?' Jimmy had taken his money and gone, not to Bulloughs, but to a new firm just setting up, a branch of a Newcastle firm that Henry could tell would soon rival his own.

All that was left for them to do was to give in or run away. Leah would not give in. Henry had exhausted that option and now no longer considered it. Leah was as obdurate as ever and he had wasted enough time and energy trying to change her. So they would run away. There was no time to wait for a house to be built, which is what he would have liked. Instead, they looked all round the city, everywhere except Stanwix. Finally they lit upon a house on the Dalston Road, but still within the city boundary. It was a doublefronted affair, built of local stone, and had some pleasant features - a conservatory, a spacious hall and a south-facing walled garden. The countryside was very near - once past the nearby cemetery open fields began and stretched all the way to Dalston itself - but the city centre was only a twenty-minute brisk walk away. The area was not smart, however, and that was a drawback. Coming from Stanwix, so high above the river Eden and therefore salubrious as well as green, Dalston Road was low-lying and too near the industrial suburb of Denton Holme with its many factories.

Rose and Polly were appalled when told that they would be moving house. They wept at the stigma of living near to Bucks factory and within sight of Dixon's chimney belching out its filthy smoke. It was useless to point out how much larger and prettier the garden was compared to the tiny one they would be leaving, or to list the merits of the conservatory about which they cared not one jot. They asked again and again the reason for leaving the home they loved and were told it was not their business to inquire into their parents' decision. But they could see for themselves that neither parent seemed any happier about moving than they did. Their father was more irritable than he had ever been and their mother quiet and withdrawn. It was all a mystery and an unpleasant one.

But Rose and Polly knew it was something to do with that bride who had placed her bouquet on their doorstep and thrown their father into such an uncharacteristic rage by doing so. No explanations as to why the flowers had to be thrown into the dustbin (though they were perfectly fresh) was ever forthcoming. The girls vied with each other in imagining who the bride had been and. though their interpretations of her gesture differed wildly, they both agreed it was all something to do with Father and that was why Mother was so upset. Neither of them knew about Evie walking down the street or standing outside the house or knocking on the door, and Henry privately thanked God for it. He could not face dragging his daughters into this mess and dreaded more than anything the possibility of Evie switching her unwanted attentions to them. But Leah said she only came when the girls were sure to be at school and as for them meeting her walking down their street, this would mean nothing to them since they were unlikely to identify her. One glimpse, so long ago, in the hall of their house and another as she retreated from their doorstep, her face partially concealed by her veil, was not sufficient for them to recognise her again.

In any case, Evie had changed. She was no longer so very thin. She had filled out to such an extent Henry thought she might be expecting, but as the months went by and she grew no fatter and no baby appeared in her arms, he had deduced he was mistaken. It was married life that had changed Evie's shape. It must suit her. Not only was she pleasantly rounded after six months but her complexion was quite rosy (unless she was using rouge). She walked with a bounce in her step which had been entirely lacking before and she was always well dressed. Henry heard that Jimmy flourished, as did the new firm for which he had risked working when he could so easily have played safe and gone to an established rival. Henry never had occasion to go down Etterby Terrace, which led nowhere, but, drawn to the street, he saw how the young couple's house was coming on by leaps and bounds and would soon, once painted, be as good as any in the humble little row.

It was this, Evie's prosperity, which made it so much harder to work out why the battle to win her mother over still mattered to her. 'I cannot think why she persists,' Henry said, when just before the move to Dalston Road Evie came and did one of her knocking turns, leaving Leah as usual depressed and nervous. 'She has a husband now and her own home and every reason to be content.'

'It has nothing to do with contentment,' Leah sighed. 'It is stronger than that. She cannot help herself.'

'Well, Leah, if you think that, then you should pity her and want to aid her.'

'Pity her? Oh, I pity her, I always have, but I hate her more. And as for coming to her aid, I could only do that by harming myself, it would be my undoing.'

'We are not far from being undone in any case,' said Henry, 'moving from a home where we are happy all on account of your unreasonableness.'

'Her unreasonableness.'

'No, you are equally unreasoning, you are in no healthier frame of mind than she is, frankly. When will it stop is the point? Moving may solve very little. Have you thought ...'

'Of course I have thought.'

'You realise she may ...'

'Yes, I realise. I expect it.'

'You expect it? Then why in God's name are we moving if you expect it?' exploded Henry.

'She will not be able to come so often,' Leah said, 'and I will not meet her in the street. Dalston Road is too far away for her to wander there every day. And she will not have been in the new house as she has been in this one. It is not tainted by her.' Henry made a small sound of disgust. 'Little things to you, Henry, but not to me. Even the distance of the front door from the street will help. Here, I am so vulnerable, opening as we do on to the street. In Dalston Road we will be set back comfortably and we have a porch and she cannot stand and look at that house as she can at this one. And there is a fence and a gate at the front and the gate can be locked, and it will be impossible for her to get near.'

'A fortress,' Henry said. 'You wish us to live in a fortress.'

'I wish to be safe.'

'And will the girls tolerate this? Is it not hard enough for them to be moved without locking them up?'

'They will not be locked up. I will not lock the gate when you and they are at home. She will not come then, she never does. You may shake your head, Henry, but I know her movements. She will only come when she can be certain I am alone.'

'Then one day, however careful you are with your locking of gates and however much you cower within this new house, she will catch you. You will be forced to speak with her and it may achieve in a few minutes more than all these years of hiding have done, and if I had had my way ...'

'Yes, Henry, I know.'

Those were their last words on the subject before the move to Dalston Road, which proved every bit as painful as had been anticipated. The new house seemed vast and cold, and their furniture lost in it, and in spite of the many new attractive wallpapers and carpets it was not cheerful. Left alone there all day while Henry was at work and the girls at school, Leah felt thoroughly displaced, though she forced herself to be active and set herself daily tasks in an effort to settle in quickly. She was always busy arranging and organising the house and had taken on two girls. Amy and Dora, who came in the morning to help her. While they were with her she made a supreme effort and left both gate and doors unlocked, though closed, but the moment they departed she made herself secure. It puzzled her neighbours, some of whom came to call and were astonished to find their way barred by locks. The vicar of St James, the nearby parish church, was perturbed enough to send a note by post expressing his concern and asking if perhaps he had merely been unfortunate enough to call on a day when for some particular reason the front gate had a padlock on it. Leah replied, saying that the gate had to be secured for a short time in the afternoons without offering any explanation as to why. She knew this would fuel local gossip but she did not care.

In arranging the rooms in the new house she took pains to make sure her life was lived at the back. Her bedroom overlooked the garden now, whereas in Stanwix their best bedroom had overlooked the street, and she chose two rooms at the back to be both the morning-room and the drawing-room. The rooms at the front became the dining-room, rarely used and almost never during the day, and a smoking-room which was also Henry's workroom where sometimes he did some cutting. It was delightful the way she never needed to look out of any of the windows facing the road and even more delightful that she had discovered a side entry into an adjacent unmade-up new road which she could use when she went out. She thought it most unlikely that Evie would ever realise this other door existed. It was covered in ivy and looked unused. Leah saw that it was kept in this state, resisting all suggestions from the gardener whom she had hired that it should be cleared and made accessible.

It took Evie a long time to come at all, so long that Henry wondered if the move had been more successful than he had ever hoped. She came late morning, as the maids were leaving, which made Leah suspect she had called before in the afternoon and found the gate locked. To come in the morning was perhaps more difficult and had taken time to arrange. The girls let her in and when one of them came to tell Mrs Arnesen she had a visitor Leah knew at once. 'Give me the key, Amy,' she said, 'and go, leave the gate today.' Then Leah backed inside and shut and bolted the front door, to the astonishment of Amy, who knew Mrs Arnesen must have seen the young woman who had come to call, already walking up the path. But she obeyed her orders, dodging past Evie in an embarrassed way, and catching up with Dora who had gone ahead.

Leah hardly heard Evie knock. She was in her bedroom at the back and instead of the sound of the knocker vibrating through the house as it had done in Etterby Street it barely travelled this far. But the next time she was not so fortunate. Once more Evie chose late morning, having clearly learned by now when Amy and Dora left, and she persuaded them to let her through the gate before they locked it. They were not happy about doing this, since they recognised this woman as the one who had made Mrs Arnesen act so strangely, but Evie seemed so gentle and harmless that they let her through. Then they carried out the instructions they had been given to the letter: once Evie was through, they locked the gate, as they had been told to do, and went round to the side entry to slip the key under the old door, as they did daily. Why they did this they had no idea, but ignorance did not bother them.

Leah, coming out into the walled garden, as she did every day when her maids left, saw the front gate key lying in its usual place, pushed through by Amy, and collected it. She stayed in the garden a moment, cutting some roses, and then she walked back into her house and went looking for a favourite jug into which she liked to put these pink roses. The knock caught her entirely unawares.

She stood still, half-way across the broad hall to the dining-room door. She could see the shadow as she had not seen it for months now, the distinct shape looming through the stained glass. Head bowed, roses falling from her hands and scattering petals at her feet, she waited, eyes now closed. Three knocks of course. Then the pause, then the retreat, somehow, past or over the locked gate. Leah did not move for several minutes and when she did it was to climb the stairs, slowly, and go into the spare room at the front to look out. Evie was there, but so far away she did not seem as threatening as she had done formerly. Leah did not wait to see her leave. She went into her own bedroom to lie down.

Henry, coming home before his daughters that day, had no inkling of the visitation. Since the weather was fine he had thought to take Leah for a drive to Dalston and Bridge End and for a walk by the river. But, as soon as he entered the house, he sensed a change of atmosphere and, calling for his wife and hearing her faint response from their bedroom, he suspected the truth. He found Leah lying down on her bed.

'But how did she get back through the gate?' he asked when she had told him the story. Leah said she supposed Evie had climbed over it, which presented to Henry's imagination such a distressing picture that he was shocked – the gate was solid and high, and a woman, with her long skirts, was not equipped to do such an unseemly and ungainly thing as climb over it. What would anyone witnessing this have thought? 'You must not lock the gate again,' he said, 'it is pointless now. She has found you and she is determined and no locked gate will keep her out. You must be satisfied with your locked door, Leah.' He took the lack of reply as unspoken assent.

The gate became an unlocked gate, as it had always used to be. Henry removed the padlock. Leah took back the key from Amy. Nothing was said. More months went by and Evie did not reappear. Henry wondered if finally she was expecting. He had such faith that a child of her own would reconcile Evie to being rejected by her mother that he looked to this event as a complete solution in spite of Leah's warnings. What Leah envisaged, as the weeks and weeks went by, was that Evie had indeed become pregnant, but that she was ill. Perhaps she was following her own mother's tendency to miscarry.

Then, one day, there was a knock at the door. Leah was alone in the house. When she heard it, she knew it was Evie, returned at last. But louder knocks, impatient, several taps one after the other, told her it could not be. Evie's pattern of knocking never varied. Going hesitantly to the front door, Leah saw through the glass panels a shadow far removed from that of Evie, saw the outline of a woman wearing a magnificent hat, and was reassured. She opened the door with something close to pleasure, ready with apologies for having no maid in the afternoons, and without the faintest idea as to the identity of her visitor.

Chapter Twenty-three

 \sim

EVERYTHING HAPPENED so very gradually. After the drama of that first shock, it was extraordinary how slowly and calmly events unfolded (except that, since nothing so solid as actual events took place, it was more a matter of a kind of emotional progress). Hazel marvelled at the apparent ease with which Shona made her way into their family. She had never, the day of that first meeting, thought her capable of such control and nor had she guessed how astute she could be. All the time, all the remaining time, that Shona was at UCL studying for her degree, Hazel felt she was the one suddenly marginalised. Shona was the centre, the one around whom Malcolm and the boys revolved and she had managed all this with the greatest of charm.

Malcolm had been the easiest to charm. His capitulation was no surprise to Hazel - that, at least, she had anticipated. Malcolm, after all, was a man of forty, and men of forty fall easily at the feet of beautiful nineteen-vear-old girls. Since Shona was his step-daughter he had no need to hide his adoration of her, but what amused Hazel was his assumption that in praising her daughter he praised her. 'She's so lovely,' he said, and 'She's so clever' and 'She has such personality,' and then he seemed to wait, Hazel thought, for her to look pleased and show she felt personally complimented to be this girl's mother. But she did not feel complimented in the least. She felt wary, suspicious, and never more so than when Malcolm was at his most effusive. He wanted to introduce Shona as his stepdaughter right away and in doing so already thought nothing of telling the tale of the adoption as though it was a mere anecdote, quickly, hardly pausing before relegating it to an unimportant part in their family history. It escaped him entirely that people's

astonishment – 'what, Hazel had an illegitimate baby at eighteen, Hazel?' – might offend his wife.

She saw it on everyone's face, this incredulity. People could not believe it of her. She saw them looking at her as though they had never seen her before, as though she was another and quite strange person. They were trying to imagine her reckless and daring, trying to place her in the past as having been the very opposite of what she had grown into, a serious, quiet, dependable woman to whom acts of carefree abandon were, in their experience of her, quite unknown. She felt angered by this and wanted to proclaim her own steadiness, wanted to tell them she had always been as she was now and that no essential element in her had changed. But it was impossible to launch into such a defence; instead, she smiled and by her silence – though she hoped it was noted there was nothing apologetic or defensive about it – tried to show she was above the sort of idle speculation in which they were indulging.

Shona, she saw, went along with Malcolm's delight in introducing her as his newly discovered step-daughter. She was proud of her status in his eyes. She knew she had filled a place which had been waiting to be filled for a long time – she was Malcolm's longed-for daughter. But she was faithful to her adoptive father all the same, never referring to Malcolm as Dad, even when nudged in that direction. Archie McIndoe was her father and no other. Once, when they were alone, soon after Shona had moved in with them – it was Malcolm, of course, who had insisisted she should give up that horrid little bed-sitter and come and live on their top floor without any question of rent or contribution to bills – Hazel had been stung, by something carelessly said, into asking Shona why she did not want to know who her real father had been.

'It isn't the same,' Shona said.

'But it takes two to make a baby. I didn't create you on my own.' 'No, but you gave me away on your own.'

Hazel smiled. She liked Shona's sharpness. 'True, but you could argue it was your father's fault I had you at all and needed to give you away. It's just strange that all the blame ...'

'Blame? I never mentioned blame. I don't blame you, not for the accident of having me, only for what you did afterwards and he had nothing to do with that. You said yourself you never even told him you were pregnant.'

'I would still have thought you'd want to know who he is.'

'Well, I don't, even if you're determined to tell me.'

Little spitting scenes, that is what these interchanges always were. Nothing very terrible was said but the tension was there, unrelieved at the end. They would part, each leave whatever room they were in and take care to come together again only when others were present. Hazel wondered for a while whether she was suffering from nothing more complicated than jealousy, but dismissed this as ridiculous. She was not jealous of Shona, neither of her youth nor her looks. nor, more to the point, her success as a step-daughter and half-sister. It made life easier that her daughter got on so well with everyone and that her presence, far from arousing resentment, or feelings of awkwardness, seemed on the contrary to breed a greater harmony. The boys were fascinated by her and saw her as some kind of fairytale princess who had come at last to claim her kingdom. She was like a present given to them and their attitude was their father's. When Shona left them to go back to Scotland for holidavs they were furious with her and moped until she returned.

Hazel spoke to Catriona McIndoe once on the telephone. She had asked Shona what her adoptive parents had said when she had told them, as she was bound to do, of what had happened, and how she was now living with her real mother. Shona had shrugged and turned red before admitting the great distress this had caused Catriona. 'I'm not surprised,' Hazel had said. 'Poor woman, all that love and devotion thrown in her face.'

'I haven't thrown it in her face,' Shona protested. 'It hasn't altered anything. I still love both of them.'

'I shouldn't think it feels like it to them, especially her,' Hazel said carefully.

'You haven't a clue about her so don't think you have. You're not a bit like her, you can't possibly understand her. She'd *never* have given her baby away, never, she'd rather have died first.'

So when Catriona did ring Hazel was prepared. The voice was soft, hesitant. 'Mrs McAllister?' it said, and Hazel guessed, the Scottish accent and the worry in the voice identifying Catriona at once.

'Mrs McIndoe?' she said, trying to change her own tone of voice from the customary clipped one she always found herself using. 'How nice to talk to you.'

This seemed to take the caller back. 'Oh,' she said. 'Oh yes, and

nice to talk to you too. I would not be bothering you, but I was wondering about the train Shona is catching ...'

·'Hasn't she let you know?'

'No. Well, it's been a wee while since she wrote and the last letter just said the seventeenth and as it's the sixteenth today I ... well ... I don't want to bother you, but I'd like to meet her train and ...'

'I'll get her to ring you when she comes home.' The moment she'd said the emotive word 'home', Hazel knew she should not have done so, but to apologise for it would double the hurt. 'Mrs McIndoe?' she said quickly. 'I *am* glad to talk to you. I've often thought about it but I imagined you wouldn't want to hear from me.'

'Och no, not at all. We can't carry on like that, now can we? It wouldn't do Shona any good. What's done is done and we must all just adapt.' The words were sensible but the voice shook.

Hazel knew the phone would be put down with a polite goodbye any moment. 'Mrs McIndoe?' she said again.

'Catriona, please.'

'Catriona, perhaps we could keep in touch now we've talked?'

'Yes, of course, for Shona's sake.'

Not at all for Shona's sake, Hazel thought, as she replaced the receiver. Not for her sake, for our own, for my sake in particular, and then she could not think why she was so sure of this.

'How nice Catriona sounds,' she said to Shona that evening and was somehow indecently gratified when she saw the effect of her innocent-sounding comment. 'She rang, to find out which train you're going to catch.'

'She'd no need to do that, she knew I'd ring tonight,' said Shona angrily.

'Well, maybe she wanted to speak to me.'

'What? Why on earth would she want to do that? She hates you.'

'She didn't sound as if she did.' Hazel knew beyond any doubt that Catriona McIndoe had never passed any opinion about her whatsoever. It was a foolish lie of Shona's and she followed it up with another.

'Well, she does. She told me she never wanted to speak to you, ever, or know anything about you.'

'Odd, then, that she should telephone my house.'

'She'd think you'd be out during the day.'

'She'd think you would be out too, surely. Who would she be hoping to get, do you think?'

'Some servant, to leave a message with for me.'

'But we don't have servants. Have you said we do?'

'Conchita and Mrs Hedley are servants.'

'Hardly.'

'To my mother they are.'

'I'm your mother.'

Hazel said it quite deliberately. She wanted to claim to be Shona's mother precisely at the moment her identity was confused. It was a crude but effective way of reminding Shona that motherhood had nothing to do with blood and everything to do with nurturing. Catriona was her mother and all Hazel's efforts were towards forcing her to acknowledge this at last. But Shona wouldn't, not then. She corrected herself and refused to receive the message. She rang Catriona there and then with Hazel still in hearing and in giving her the necessary information about the train was so curt it sounded offensive.

'Is that how you always talk to your mother?' Hazel asked.

'No, it's how I talk to Catriona,' snapped Shona.

'Why do you do it? Why do you hurt her?'

'You wouldn't understand.'

'I've just admitted that. I don't understand but I'd like to.'

'I don't think you're capable.'

'God, you're insolent, Shona,' but Hazel laughed even as she objected. 'Very, very insolent, and childish, for one so clever. You've been spoiled, grossly overindulged. You think Catriona loving you so completely gives you some sort of licence to insult.'

'No, I don't. I think she understands, whatever I say or do, so I don't have to watch my step. That's different.'

'I can't think why you ever wanted to leave this saint and claim me as your mother.'

'I haven't left her ...'

'Home to her once, in months, for forty-eight hours? A scrappy letter once every six weeks? And if you telephone, which I doubt, it hasn't been from here since you moved in. I think she thinks you've left her. You've deserted her, abandoned this mother who loves you so much, for me.'

There hadn't been any reply to that. Hazel realised she was always pushing Shona towards a quarrel so violent she would feel

compelled to leave, hurling words of hate as she went. But the moment never came and it was in Shona's abrupt departures, her lack of retaliation at the crucial time, that Hazel saw herself. Cutting off, in the midst of what seemed unstoppable fury, was their technique. It could never be mistaken for defeat or associated with giving in - it was too strong, too deliberate, this absenting of oneself, this ostentatious rising above taunts. So Shona had left the room in which they had been sitting and had gone off into the garden where Malcolm was making a half-hearted stab at weeding. She went and helped him and Hazel saw how Malcolm became instantly alert, how his previously languid movements changed to a vigorous bending and digging with his trowel. They weeded together for half an hour and then Malcolm went to collect the boys from the swimming baths and Shona went with him, though there was no need to and it would mean Conchita squashing up with the children in the back seat. Clever, Hazel reflected, she's clever, she is making herself indispensable in the most subtle way, vital to this family's, my family's, sense of well-being.

When Shona was away in Scotland Hazel felt liberated. She had her home to herself again. Her mother appreciated this. She had refused to be drawn into the admiring McAllister throng round Shona, and once the girl had moved in (which had naturally horrified Mrs Walmsley) she had taken care always to check she was not expected to be there before she herself came round. Hazel had told her how foolish this was.

'Shona can't be ignored any more, Mother,' she had said, very early on, just as Mrs Walmsley's attitude was becoming marked.

'I am not ignoring her,' her mother had said, 'I'm simply keeping out of it.'

'That's the same.'

'No, it isn't.'

'Well, whatever your interpretation, it's still silly, cutting yourself off from us because of Shona. You're hardly seeing the boys at all, you're cheating yourself and they miss you.'

'They don't miss me. They've got her.'

'Oh, Mother, really. She's just a novelty, they're excited. They're so young none of the implications occur to them. They can't work out why you don't want to be with Shona too, when she's so lively and such fun.'

'I know all that, but I can't help it. She alarms me.'

'Shona? Oh, and what is alarming about her?'

'You know.'

'Do I?'

'Yes, you do. I'm sure she alarms you too, she must.'

'Must? In what way "must"?"

'The way she's taken over your family.'

'It's hers, her family, that's what you're missing. She doesn't see herself taking over, she thinks she's fitting in, she's just slipping into a gap she sees as always having been there.'

'Well, it wasn't there. That's her mistake. There wasn't any gap. You know that, I know that. You should tell her so.'

'I'm not going to tell her anything. It would be fatal. Let her work it out eventually.'

'But she won't, she's determined. You've got her for life now.'

She'd told her mother not to be so melodramatic, but Hazel privately thought those words prophetic. Inviting Shona to move in to their house had been the first step along the for-life road. Malcolm, in suggesting it, had, she knew, expected resistance from her and she had been very careful not to offer it. Instead, she had gone to great lengths to make their tiny attic flat as attractive as possible. They had had tenants there before, students who baby-sat and did some cleaning in return for a very low rent, but once au pairs had come into their household, the attic rooms had been kept empty, for visitors only. Now Hazel had them decorated and graciously asked Shona to choose the colours for paint and a new carpet. Malcolm was pleased. It felt right to him that Hazel should prepare a nest for her daughter and make her feel truly wanted. It was a significant gesture, recognised as such by all parties. Then there was the matter of holidays. The McAllisters had good holidays. They both worked very hard indeed and holidays were not just for pleasure but for recouping lost energies and preparing them for the rigours always ahead.

'I was wondering,' Malcolm had said, that first year, as the time for booking flights and villas approached, 'about Shona. She'll want to come, won't she, as one of the family? So we won't need Conchita. She can go home for that month.' Hazel had raised her eyebrows. 'What? You don't think Conchita will like that? Surely she will.'

'Oh, I'm sure Conchita will, but what about Shona? Will she see herself as an au pair for a month?'

'She won't be an au pair, don't be silly.'

'If we haven't got Conchita, she'll have to be. How else will we cope? What about all that time to ourselves we get, with Conchita looking after the boys?'

'I didn't mean Shona won't want to be with the boys, but that won't make her an au pair, she's their sister, it's different.'

'Very different, different enough for her not to feel the least obliged to spend all day on a beach with three young boys if she doesn't want to.'

'But she *will* want to, she loves them, she plays with them for hours as it is.'

'That's her choice, her whim. Once she's expected to, she'll think differently. The point is, Malcolm, you won't be able to depend on her doing it, and if she doesn't, you have no way of making her.'

'So you don't want her to come?'

'I don't care either way. All I care about is you and me having free time really to relax.'

'I'll discuss it with her.'

'You do that.'

Shona came on their summer holiday with them, but so did Conchita. Malcolm paid for Shona of course, though with a good deal of secret swearing about the ruinous extravagance. It was not a success. Even Malcolm acknowledged this. The boys were normally quite happy with Conchita, but not if Shona was there. They wanted their half-sister all the time and when she grew tired of them, which she did quite quickly, within a week, they took their disappointment out on poor Conchita, who began to say she wanted to go home for good and thought she had been with the McAllister family long enough. Then Malcolm thought it not fair to treat Shona like Conchita and so in the evenings Shona came with them when they went out to restaurants. They were suddenly a threesome at the only time they could count on being just a couple. Hazel grew quieter and quieter, Shona more and more animated. She loved Italian night life - they had rented a villa near Sorrento - and her enthusiasm was so touching to Malcolm that he reacted by making sure they went out far more than usual. Shona was dictating the pace.

It had, some time soon, to come to an end, Hazel reasoned. Shona was a student. At the end of her three-year course she would have decisions to make, and by the end of her second year was already doubting whether she would carry on with law. Malcolm wanted her to. He told her she'd make an excellent defence lawyer and urged her to come and work as a legal clerk in his firm in her vacation. This would give her an idea of what legal aid work was about and he was sure would inspire her to try for articles. But Shona demurred. She said she felt she had made a mistake and should have done something with languages. She wanted to travel first, whatever she decided to do after her degree; and at the word 'travel' Hazel felt hopeful. But there was no sign of any travelling meanwhile. It struck Hazel as odd how much Shona stayed at home. She was twenty, twenty-one nearly, but she behaved like a middle-aged person, seeming uninterested in any of the social pursuits common to her age group. And where were her friends? There were none to be seen. No one came home with her or visited. Even Malcolm, so happy that Shona liked to be with them at weekends, thought this unusual. 'She's so attractive,' he said, 'I can't understand it. The men in her college must be blind.'

No, they were not blind, Hazel could sense that. They were not so much blind, these unknown men, as struck dumb by Shona's singlemindedness which would manifest itself in all kinds of off-putting ways. Shona had her studies – she seemed a serious student whatever her doubts about law as a career – and she had her new family and nothing and no one else was allowed to interfere. She would not be able, Hazel reckoned, to take on any relationship even if one were offered, not while she had this sense of mission to become one of the McAllisters. It was like a job to her and one at which she worked hard. Hours and hours had to be devoted to becoming part of the very fabric of this family of her mother's, and only when belonging had become effortless would she have room for anything else. It must exhaust her: watching Shona, observing her ever more closely, Hazel was sure of this. And all for what? What was she getting out of the struggle that made it worthwhile?

Sometimes Hazel envisaged how things would have been if she had kept Shona. Never, during all the lost years before Shona appeared on her doorstep, had Hazel ever fantasised about being a single parent, but then that dignified term had not existed. In the fifties there had been only 'unmarried mothers'. It had never occurred to her to wonder how she would have made out alone with a child. But now she grew fascinated by the possibilities and saw herself in retrospect exercising great ingenuity in doing what she had done while being a single mother. It was possible, she told herself, that her father, had he been told the truth, would have supported her; possible she could still have taken a degree and worked; possible that when she met Malcolm she would have had an eight-year-old daughter. This would not have put Malcolm off. He would have accepted and loved Shona. She would have been his ready-made daughter, they would have been a family from the beginning. And that was when her fantasy became interesting to Hazel – imagining Shona not desperate to become part of a family from which she had been excluded, but on the contrary desperate, in the normal adolescent and young adult way, to *escape* family ties. Especially maternal ones. Running from them, Hazel envisaged, running away, not towards, doing the rejecting herself.

She wished, often, that she could have proper discussions of this sort with Shona, but there was no chance of those. By the time Shona had lived with them for almost two years, Hazel knew her well enough to realise there never would be such an opportunity. But what was somehow comforting was the far deeper realisation that there never would have been either - even if Shona had been with her from birth, there would have been this reluctance on her part to engage in emotional encounters in which the unsavable might be said. Shona was her grandmother all over again. There never would have been any true connection. Hazel saw herself as stranded between the two of them, her mother unable to give and Shona to receive. The link, the link motherhood was supposed to give, was believed by Shona to give, was not there. She could not love Shona and Shona could not love her, but this lack of love had, in Hazel's opinion, little to do with what had happened in the past. Brought together now, as two adults, it was clear that with the exception of certain traits of mind and personality they were not alike and shared no common interests or attitudes. They would always have been destined to grow apart if, through the circumstances of intimate family life, they had been forced for many years to be close. Shona might have been denied her true mother but that mother would not have been true in any meaningful sense at all.

Hazel felt better. The more convinced she became that Shona and she would never have fused together, just as she herself and her own mother had never done so, the less guilty and anguished she felt about having given her daughter away. The shadow lifted and with it her resentment at Shona's very existence. She felt quite tender towards Shona and was able to demonstrate this in new ways. From being always on the alert and watchful, she felt she could afford to turn away and let the new family mixture settle down. It was settling in any case. The boys were growing up. Philip was mature for his age and in the two years he had known his half-sister he had naturally changed dramatically. At first he had admired and been fascinated by her, but gradually he began challenging her, competing with her, and in his arguments with her Hazel heard a determination not to let Shona dominate either him or his family. He got to a position where he had very nearly moved on to the attack, and it gave Hazel the opportunity to defend Shona and demonstrate sympathy. Philip was furious with her.

'I don't know why you stick up for her,' he would say. 'She can look after herself, she always does, she's so *selfish*.'

'She was an only child,' Hazel said, mildly.

'What's that supposed to mean?'

'Well, when you're an only child you do have everything your own way and it's hard to learn how to share properly.'

'But she's grown up, she's not a child, Mum.'

'Doesn't make any difference, she goes on learning, she still feels an outsider in groups.'

'She is.'

'Just because you've had a quarrel, Philip ...'

'It isn't just because of any row. She is an outsider. She doesn't fit in.'

'She's fitted in very well these last two years, amazingly well, considering she had to take on three brothers.'

'Half-brothers.'

'That's mean.'

'What is?'

'Stressing the half bit. You didn't used to be so mean. You used to hate it when Shona first came if anyone called her less than your sister.'

'I hardly knew what it meant.'

'Oh, Philip, you did, of course you did.'

'I knew the facts, but I was too young, I didn't really think about what they meant.'

'And now, that you're so grown up, you do.'

'Yeah, I do. I do. I've thought about it a lot and it's weird, her

turning up, coming here like that and then just latching herself on to us.'

'Not weird at all, quite understandable really.'

'I wouldn't do it. If you'd given me away and I'd been adopted, I wouldn't have done it. If I'd only found out when I was eighteen, like she did, and if I'd had lovely parents, like she says she has, I wouldn't have done it. I wouldn't have wanted anything to do with you, ever.'

'You can't know what you would have done, and anyway, you are you, Shona is Shona, and you can't judge other people by yourself.'

'Shona does. She wants us so we are supposed to want her.'

'You *have* wanted her, up to now, and you still do really, you're only fighting with her the way I fought with my brothers, it's all to do with age, it'll pass.'

'You're always saying that, about everything. Dad loves her anyway, she's his favourite. He always wanted a daughter, didn't he?'

'Yes, but ...'

'So we were all disappointments.'

'No, don't be silly, you weren't anything of the sort. And I only wanted boys, every time.'

'That's because you'd had a girl already.'

'No, it isn't. I hadn't "had" her in any real way, I'd given her away. I just didn't want daughters.'

'Why?'

'They're too difficult for a woman.'

'Mum, that doesn't make sense.'

He laughed and that was how that particular session ended. Philip called them that, 'sessions', and it amused her. More and more he wanted sessions in which he was looking for an argument or trying out some theory, and he would follow her round the house, whatever she was doing, haranguing her and pleading for a response. Witnessing this, Shona's envy was obvious and yet Hazel was not quite sure what exactly was being envied – Philip's confidence that his mother would want to hear him, or her own clearly happy involvement with him. Once, when he had had her pinned against the airing cupboard door, with her arms full of clean towels, while he ranted on for all of twenty minutes about the injustice of his not being allowed to go to the cinema on his own and had only been stopped by Shona yelling that there was a phone call for him, Hazel had tried to draw Shona into mocking him.

'My God,' Hazel had said, 'if he is like this before he's actually a teenager, what are we in for?'

'You like it,' Shona said, her face dark, brows furrowed. 'You love him like that.'

'Well, yes, I do,' said Hazel, carefully, towels at last deposited, but the bathroom door now blocked by Shona leaning against the frame. 'But I can still see he's going to be a pain.'

'I was a pain.'

'Were you? Yes, I can see you might have been like Philip at his age.'

'I wasn't like Philip. He's got you. He's a pain and you know he is and you don't care. I was a pain and my mother was terrified of me.'

'I expect she did her best and who ...'

'Of course she did her best. God, sometimes ...' And she went off, downstairs, to Hazel's relief. She knew she mustn't let this go and yet if Shona had chosen to go upstairs, to her rooms, it would have been so much more difficult to follow her.

As it was, she ran downstairs too and into the kitchen where Shona was taking something from the fridge. 'Shona,' she said, and went to her and, greatly daring, touched her on the shoulder, a light touch she hoped would be interpreted as affectionate. 'Shona, I take your point, I do see what you mean, about your mother being afraid because she didn't know who was in you, that's it, isn't it, that's what you meant? That she was always afraid because of your being adopted and so she couldn't ever know what you were made of?'

'Something like that,' Shona said, offhand now, but grudgingly willing to continue.

'And you, without knowing why, felt alien to her, and then when you found you were adopted you thought that was why, didn't you? That you'd been a cuckoo in a nest and if you could find the right nest – Oh my God, nests and cuckoos ...' and she began to laugh. For an awful moment she thought Shona was going to do the opposite, to cry, but she smiled too, and then began to giggle and they both collapsed. 'Not that funny,' Hazel said weakly after a while. 'I was just trying so hard.'

'You do try hard.' 'Is it that obvious?' 'Yes.' 'Oh dear.'

'No, it was a compliment, I meant it as a compliment. I know you try. I try too. It's stupid, really.'

'What, two people trying hard to understand and love each other?'

'Well, not the understanding, that's not stupid, but to try to love is, isn't it? It should be natural, it isn't worth anything, it doesn't work otherwise.'

'I do love you,' Hazel lied. 'I don't have to try any more.'

'But I don't love you,' Shona said, 'that's the point. I always wanted to and expected to, but I don't. I admire you, but that's no good, and I envy you, and that's terrible, to envy your own mother for what she's got.'

'I've got nothing you can't also have one day.'

'I doubt it,' said Shona, 'but it won't be your fault, I won't blame you.'

'That's good. I've done a lot of blaming myself and it isn't good, it isn't a good idea at all. I blamed my mother and it was wrong.'

'I don't know her. She doesn't want anything to do with me, does she? That's why she never comes if she knows I'll be around, and she gets all embarrassed if I catch her here. She hates me, she thinks I'm a threat to you.'

'She doesn't hate you, she just goes on wanting to pretend what happened all those years ago never happened, that's all.' Hazel paused. It felt odd to want to defend her mother. 'She's getting old now and she's stubborn, it's hard to change her. But she'll come round eventually, she'll have to. Everyone is so used to you now, you're so accepted, the shock value has worn off. Well, for everyone else. There's only her left and she doesn't really matter, her attitude needn't hurt you.'

'But it does. I've done nothing wrong, but she acts as if I had. I suppose she thinks it wrong to have come here at all. Does she call it "raking up the past"? I bet she does.'

'I expect she does too, but to herself, not to me. She knows how I feel.' Hazel hesitated. It seemed a terrible betrayal to want to go on to tell Shona how much she had always disliked her mother. It was not something it seemed right to do. 'She's quite an interesting person really, your grandmother,' she finally said. 'She had a hard life when she was a child, but she hardly ever talks about it. Her father was killed in the war, the First World War, and her mother was widowed before she was born. It wasn't really till she met my

father, your grandfather, that she had any life of her own. Her mother clung to her, she was the centre of her universe, literally, and it made her want me to feel free of that kind of thing. But I wasn't free, of course.' Hazel paused again, trying to gauge Shona's reaction. Was she bored with this potted maternal history? Did she think it superfluous to the circumstances now? Did she see it as an attempt to make her grandmother a more sympathetic character? It was so hard to know. 'Anyway,' she finished, lamely, 'she's not such a bad woman. She still thinks what she did was for the best.'

'For you.'

'Yes, I suppose so, but then I was real, I existed, I was her daughter. You were unreal, at the time.'

'And now I'm real. Definitely.'

'And she's afraid of you.'

'Well, she doesn't need to be. I'm not staying. The moment I've graduated, I'm off. I've decided. And I might never come back, so she needn't worry.'

'You're free to do what you like,' Hazel said. 'You can leave, you can come back.'

Neither of them could think what to say after that.

Chapter Twenty-four

 \sim

They were sitting in the drawing-room. Leah had offered tea, her offer prefaced with further apologies for the absence of the maid. Tea had been declined, but Leah wished it had been accepted. Making tea, even if it meant leaving her visitor alone for a few minutes, would have helped ease the awkwardness she felt. Her visitor was in some way distressed. The distress was controlled, but since she had often been in such a state herself Leah spotted the signs. She could not think how this woman's nervousness might relate to herself but waited with growing curiosity for the reason to emerge. The woman was in mourning so someone had died, which could account for her unhappiness but not for her visit.

Leah was glad her drawing-room was looking attractive. She had chosen what she thought a daring colour for the new carpet, a strangely green blue which had made Henry raise his eyebrows at the impossibility of matching anything else with it. But Leah had not tried to match it. The carpet had a cream diagonal stripe in it and it was this cream she had matched, in curtains and chair covers, except for cushions which were turquoise. The whole effect was fresh and cool, quite unlike the overheated tones of the parlour they had left behind in Etterby Street. The room had hardly been used. It was a room in which to receive company and they had received none. Everything was pristine and Leah was proud of it. She saw that her visitor was impressed and was evaluating her accordingly, before she spoke.

'You do not know me,' she said. Leah inclined her head, apologetically. 'My name is Evelyn Fletcher, but that will mean nothing to you either. Fletcher is my married name.' She paused, but there was no reaction from Leah. 'It is all a long time ago,' she sighed, 'and I have no wish to upset you. I could have written, once I discovered your whereabouts – that has taken time and it felt wrong to delay further.' She stopped and a small sob escaped her.

'Please,' said Leah, 'please, do not upset yourself on my behalf. I had much rather have a visitor than a letter.' It was graciously said, and the woman, Mrs Fletcher, managed to smile slightly.

'You are very kind, very understanding, but then we should have known that.' Another sigh, and then the straightening of her back. 'My maiden name was Todhunter. I am Evelyn Todhunter.' She observed Leah carefully. 'Now you begin to see?'

Leah said nothing. Her lips felt dry and she delicately ran her tongue round them. She could only nod. Her sudden lack of composure was not equal to any other response.

'It is a sad tale,' Mrs Fletcher said, 'and it has been sad for vou. too, for many years, I know.' She looked round the room and gestured at the framed photographs of the family and added. 'But you found happiness after the sorrow.' Leah flushed, a little spark of resentment starting to ignite inside her. 'I am not excusing my brother,' Mrs Fletcher said, 'never think that. What he did, how he behaved to you, to us, was inexcusable, and he knew it. At the end he begged forgiveness and that is why I am here.' A great rush of relief overwhelmed Leah. but Mrs Fletcher mistook her cry for anguish and rose out of her chair and came towards her, holding out her arms, and saving in a curiously affected and high-pitched singsong voice which grated on Leah's nerves. 'My dear. I am sorry. I am sorry, it is a dreadful shock, shocking, I know, and after so long, when you did not expect it. I will stop if you cannot bear to hear more, only say the word and I will go and never bother you again, you have every right to tell me to go!'

It took a while for both of them to regain their equilibrium. Leah recovered first, but needed badly to escape from this woman's suddenly cloying presence. 'You must excuse me, Mrs Fletcher,' she said, abruptly. 'I need some tea.' She went into her kitchen and set a tray with two of her best cups and saucers, and the silver teapot and water jug and sugar bowl and milk jug, and a plate of shortbread biscuits, but at the last moment before carrying the tray through, she removed the biscuits. Without asking Mrs Fletcher if she would not after all now change her mind, she poured two cups. Her own she drank in a moment, not caring how this might seem, and refilled her cup immediately. Mrs Fletcher sipped from hers hesitantly and eyed Leah anxiously from over the rim of the cup. 'Do you want to hear?' she asked.

'Yes,' Leah said, 'if you can bear to tell me.' She wanted to add 'and tell me quietly and sensibly', but did not.

'I do not know where to begin. He, Hugo, I can hardly say his name, it was banned for so long in our house, it is unfamiliar on my tongue, he died six weeks ago. He came home and died within a month. He knew he was dying, you see, and he came back, to Moorhouse, not knowing our father had died long ago and only my mother was left, ill herself. My father had forbidden her to reply when Hugo at last wrote, years after he had disappeared in Canada, he had said he would not even acknowledge Hugo as his son and she was to cut him out of her heart. But my father was dead and he came back and, of course, my mother took him in, though in no fit state to nurse anyone and needing a nurse herself. And I was sent for. I could not go immediately and nor did I wish to. I had suffered. I was at home during that dreadful time, dreadful, and I saw my mother weep and heard my father curse, and I suffered too. But I could not leave my poor mother to manage him on her own, so eventually I went. I wish I had not.' Here, there was a break in Mrs Fletcher's account, all of which had been delivered in a new low and monotonous voice, much preferable to the previous tone, but Leah had difficulty catching every word. She gave her no direct encouragement to continue beyond showing she was concentrating. 'Oh, he was a terrible sight, quite wasted away with disease, thin beyond belief and lined beyond his years and altogether a wreck of a man. Everything he touched went wrong, all his life. I cannot accurately recall the sequence of evils which befell him, and to tell the truth I do not want to. He was feverish with pain much of the time and rambling, and many things he came out with made no sense. But he spoke of you quite sensibly. He wept for shame at how he had treated you and begged me over and over to find you and beg you to forgive him, or he could never rest in peace. And he spoke of his child whom

'More tea?' Leah said.

Interrupted, Mrs Fletcher was thrown. She had warmed to the drama of her description and her voice had become louder and excited, and now that she was stopped she could not quite pitch it correctly. 'The child,' she repeated, 'he thought of his child at the end ...'

'But not at the beginning,' Leah said, curtly.

'I beg your pardon?'

'He did not think of his child at the beginning. And neither did you nor your mother.' Mrs Fletcher's mouth opened and her expression was one of such consternation it was horribly comic. Impatiently, Leah said, 'You cannot believe, Mrs Fletcher, that I am not touched and moved to tears at hearing of your brother's affecting deathbed speech, but I have no feeling for him, dead or alive, beyond contempt. And contempt for your mother too.'

'What did my mother ever do to you?'

'How did you find me?'

'We employed a detective. Forgive me if that seems sordid. He began with an old address. There was an address, you wrote to Hugo, and ...'

'I wrote to your mother, after Hugo's child was born. I told her Hugo had a daughter and I had named her after her, Evelyn, after her and after you, Mrs Fletcher. I asked for nothing, but I hoped, and my hopes were not answered. Your mother had my address as well as Hugo, if it ever reached him.'

'It would be my father ...'

'I did not write to your father. I wrote to your mother, woman to woman.'

'My father would have found out and ...'

'She could have found a way, but she did not want to extend help to her son's whore and his bastard child.' Leah was sorry to have come out with such ugly words. They defiled her and she felt besmirched and ugly herself, because of having uttered them.

Mrs Fletcher sank back in her chair and wept for real, and, though at first the sight left Leah unmoved, she said at last how sorry she was and that she regretted her vulgar outburst. They were both silent for some considerable time before Mrs Fletcher pulled herself together and said, 'My mother is still alive. She is old and ill and has not long to live. You make me afraid to tell you this but she wishes to give Hugo's child some money, a gift, if she will accept, though if she is of like mind with yourself ...'

'I have nothing to do with her,' Leah said.

'Your daughter?'

'Hugo's daughter. I have nothing to do with her. It pained me too much even to look at her and she was given into someone else's care from an early age.' Leah saw Mrs Fletcher's eyes stray to the photographs of Rose and Polly. 'They are my own daughters, my husband's and my girls.' She put a certain emphasis on 'husband' which was not missed by Mrs Fletcher.

'So you do not know where my brother's child is now?'

'Oh, I know,' Leah said. She got up and went to the bureau Henry had recently bought, and opened the lid and sat down and wrote, not caring about her poor penmanship, Evie's name and address on a piece of the pretty blue writing-paper she had taken such pleasure in choosing, though there was no one to whom she wrote regular letters. 'There,' she said, 'I am sure his daughter will be glad to hear of her father and this late gift.' She wished Mrss Fletcher would leave. Her mission was accomplished. She should leave, quickly. But still she sat on, seemingly rooted to the spot.

'I did not know of your letter to my mother,' she said. 'I would not like you to think I did and that I, too ...'

'I do not think that,' Leah said, as carelessly as possible. 'I have little interest, frankly, in what you did or did not know. But you lived in that house, your parents' house, your family home, with him, your brother, at the time. You lived in Moorhouse. I think you were well acquainted, as everyone was bound to be, in such a place, with my condition. I think you knew of me.'

Mrs Fletcher bowed her head and took refuge behind her handkerchief with which she patted her eyes over and over again. 'What could I do?' she whispered. 'It was such a ... it was spoken of in such ... when I did hear of it ...'

'It was a scandal,' Leah said. 'I will say it for you. And I was blamed for it, not he. I believed in him, I trusted him, and the result ... well, the result we know.'

'The poor child,' Mrs Fletcher said, 'when I think of it, that poor child. It breaks my heart.'

Leah laughed, a dry, short, hard sound with little mirth in it. 'It broke mine too,' she said.

'But you ... I thought I heard you to say ...'

'I said I could not bear to see his child and never have been able to. I did not mention my own heart. But it is mended. It has been mended a long time and now you will seal the last crack for me, the crack which threatens to open up now and again, under certain circumstances, when a certain person tries to prise it open. You will do more than you know to mend my heart if I am fortunate at last.'

Mrs Fletcher was mystified, but Leah let her remain so. She had no desire to confide in the woman. Let her make her way as soon as possible to Evie's home and acquaint her with the tidings she had brought. Leah could imagine the scene easily. Evie might always have vowed she had no interest in her unknown father, but presented with the glory of his deathbed cry for forgiveness and to have this capped by recognition from a grandmother who was now making her a substantial gift - it would thrill her. Leah was sure of it. Mrs Fletcher, in spite of her weeping, was an imposing figure and she was family, she represented a family now claiming Evie as its own. Evie would return to Moorhouse with Mrs Fletcher to see this grandmother. Leah was convinced of it. And what might come from that meeting? Satisfaction, she hoped, Evie's satisfaction to have at last a mother of sorts. And something more practical even: a move. Evie might be persuaded to return to Moorhouse to be with her grandmother and she might inherit the house and ... Leah stopped herself. There was Jimmy. There would be no work for Jimmy in Moorhouse. He would not wish to move. It was absurd to imagine such a solution. Nothing would change. Evie would still persist in haunting her.

For reasons she did not want to work out, Leah did not tell Henry of Mrs Fletcher's visit. She thought of it often in the following weeks, but she never spoke of it. It was a secret she hugged to herself and she relished the sensation. When Evie had failed to appear outside the house for some months she longed to know if she had gone to see her grandmother, but there was no way she could find out. It was tempting to inquire at Jimmy's place of work if he was still employed by them, but she was too embarrassed to ask and neither did she want to make such a direct inquiry. She wanted to find out naturally, having some superstitious belief that this would bring her luck. She began to go into the city centre with unusual frequency, merely so that she could search faces, looking for Evie or Jimmy – or rather, search in the hope of noting their absence. She was convinced that if she went often enough at the most popular times to the most popular places she would be bound to see Evie if she were still in Carlisle. The market seemed to her the most obvious meeting-place - every Carlisle housewife sooner or later went into the market, and Evie had always been fond of it if Henry was to be believed - so Leah haunted the market. She drifted from stall to stall with a half-full basket, scanning face after face, searching

and searching for Evie, at ten in the morning, at two in the afternoon, at closing time on Saturdays, at every time of day. Then she grew bolder. She took a tram to Stanwix and with pounding heart walked down the little terrace where Evie lived, back and forth, briskly, then loitering, watching the houses and trying to decide if the Patersons lived there still.

It was foolish behaviour and she knew it, but she could not stop herself. She walked the city centre streets, she prowled round the shops, she visited Stanwix and now she was out of the house as much as once she had hidden herself within it. Henry complained she was never there when he popped home unexpectedly, as he often did, and could not understand this new mania for shopping. Leah said there were still so many things she must buy for the house and was careful always to return with some trifling purchase. It had become an urgent necessity to find out where Evie was, and after six months of this searching she yearned for some final confirmation. It came by chance, just as she had wanted it to. Turning out of Etterby Terrace, Evie's road, which she had walked for the hundredth time, she proceeded up Etterby Street, her own old street, towards the Scaur, and met Miss Mawson leaving her house.

'Why, Mrs Arnesen!' cried Miss Mawson.

'Miss Mawson,' Leah murmured faintly, highly embarrassed.

'I am so glad to see you, my dear,' said Miss Mawson, her eyes positively shining with pleasure. 'I miss you all so much, I cannot tell you.'

'I miss you too.'

'It was a black day for me when you moved and I have never felt comfortable since without my dear neighbours. Now tell me, are you settled and happy in your splendid new home? Thank you for your card. Did I thank you at the time? I do hope so. I intended to call but I have not been well ... now, why don't you step inside and let me give you some refreshment?'

'Oh no,' Leah protested, 'you are on your way out, I can see that, I would not on any account ...'

'Where I was going can wait. Come, I insist. For old times' sake. This is too good an opportunity to miss. Come, I will not take no for an answer.' And before Leah could think of an excuse Miss Mawson had opened her door and was ushering her in.

It dismayed her to find herself in this position. She had lived next door to Miss Mawson for more than a decade and yet she knew her so little. They were pleasant to each other but there was no exchange of hospitality, and Leah had always felt Miss Mawson had in some way looked down upon her, because she was able to tell she was not a natural born lady, nor Henry a gentleman. This, Henry had always said, was her imagination and gradually she had conceded it might well be. After her cat had been run over and Henry had had the unhappy task of telling Miss Mawson (for it was he who saw the accident and arranged for the burial), the relationship between the two households had perceptibly changed. Miss Mawson became quite effusively neighbourly and invitations to take tea had been exchanged.

But with the arrival of Evie nearby, the friendship which had blossomed began to wither. Leah knew that Miss Mawson was acquainted with Evie. She was, if not Evie's friend, to some extent her patron and Leah always feared might be brought into the troubled situation between them. She was sure she had hurt gentle Miss Mawson by declining, under plea of headaches and general debility, all her offers of hospitality from then on. And there was always the worry that Miss Mawson had noticed Evie in the street peering at the Arnesens' house and might have inquired the reason for this of her.

But now, sitting in Miss Mawson's pretty little parlour, Leah realised she had been presented with the perfect opportunity to establish Evie's whereabouts. If Evie had moved, Miss Mawson would surely know, taking as she did an interest in the young woman. So eager was Leah to question Miss Mawson on this point that she grew bold. She no longer cared whether Evie had taken Miss Mawson into her confidence, but only that she should find out the truth. 'Has much changed in our old area here, Miss Mawson?' she queried. 'Or are we the only family to have moved lately?'

'Oh, indeed no,' said Miss Mawson, 'there has been quite an upheaval locally, all kinds of people taking it into their heads, for their own very good reasons, I am sure, to leave Etterby and find other accommodation. Those who are young seem to be the very people moving. Take the Patersons. You remember Evie? Who worked for your husband and married James Paterson? She came to live nearby in Etterby Terrace, you know, but has left already.'

'Really?' Leah murmured, hoping she masked her dreadful desire to know by seeming not unduly interested.

Miss Mawson was animated, delighting in such gossip. 'She has

been fortunate at last, the most extraordinary thing. She has found her family. It seems they are a good family of some means and a son has died who turns out to have been Evie's father ... And now the grandmother has sent an aunt to find her and Evie and James have gone off to some grand house near Newcastle to be made much of. It quite took my breath away on hearing of it.'

Omitting to comment that it took hers away too, Leah asked, 'And did you hear this from Mrs Paterson herself?'

'Oh no, from her husband who was making a costume for me and ...' Miss Mawson stopped and blushed deeply. Henry had always made her costumes. To leave him for Jimmy Paterson, working in a rival establishment, was a betraval of the first order and she gazed at Leah in horror. Leah made a little gesture of dismissal with her hands to indicate she thought nothing of this inadvertent confession and pressed Miss Mawson to continue with her enthralling tale. 'Well,' said Miss Mawson, taking courage, though unable quite to recapture her former zest in the telling, 'Mr Paterson said he would finish my costume before they left, but that would be that in Carlisle for him. I asked where exactly this grand house was and he said in a village, in fact quite some distance from Newcastle, but that there were plans already to move there. The grandmother is old and ill and there is another house owned in Newcastle itself and the plan is for the three of them to move there and for Mr Paterson to set up on his own account as a tailor there. I am so glad for Evie, all this, after her troubles lately, some fortune and happiness at last.'

'Troubles?' echoed Leah, suddenly alarmed, thinking that after all Miss Mawson was not as innocent as she seemed.

Miss Mawson dropped her voice, though there was no one else in the room but the two of them. 'She miscarried, twice. Poor Evie. She so wishes to be a mother. I had it from Mrs Batey who lives next door.'

Leah's eyes filled with tears. Seeing this, Miss Mawson, she knew, would assume she was affected in the way any tender-hearted woman would be, and would not expect her to explain the sudden tears. She wanted to leave Miss Mawson quickly, to get right away from her so that these foolish tears could be shed and she could then rejoice in safety, but it was impossible to extricate herself for another quarter of an hour. When she did depart, she was weak with suppressed euphoria and reached Stanwix Bank and the tram station in a daze. Evie had gone. She was to live a long way away. She had separated herself from the mother who would not acknowledge her. She had given up, at last.

Later, Leah was able to assess the chances of this being true in a more sober fashion. She saw that it was only safe to assume that Evie had left for the time being. Nothing could be certain about the future. If the Patersons did not make a go of it in Newcastle, they could well return to Carlisle, and Evie could start again where she had left off. But distance would work as much of a change in her as time might. Leah realised that once Evie had found her it was her proximity which had proved so tantalising - to have her mother round the corner and accessible was too tempting for her craving to be denied. Now that she was many miles away the constant pull to visit her mother would be weakened and lose its magnetic strength. Evie would be likely to be absorbed in building a new and better life around herself, and her old life and old obsessions would have the chance to fade. The abrupt nature of her departure from Carlisle also seemed to Leah to augur well - there had been no final visit to her mother's house. From the moment Mrs Fletcher had called, Evie had never reappeared.

It took a full year for Leah to feel that Evie must be settled in Newcastle and was not going to return, and another before she felt that the shadow cast by her had truly lifted. Miss Mawson told her, when she came to tea, that she had had a Christmas card. The Patersons were doing well. The grandmother had died and left them the house, and business was also good. 'But no mention,' Miss Mawson said, face composed into a suitably concerned expression, 'no mention of little ones, too sad. Time is running out for her, I fear.' Leah wondered. She calculated Evie's age now as - surely she was still only in her twenties, not too old at all. Miss Mawson must think her older. 'Her husband,' Miss Mawson was saving, 'has fears that if war breaks out he will be conscripted before long and is training Evie to be in charge while he is away.' Leah nodded. Henry was talking in a similar fashion, though he was too old to be in any danger, and in his careful way was also making preparations. Leah had no interest in rumours of war.

It was of more concern to her that Rose, very strong-willed these days, was not at all the amenable child she had once been. She had declined to stay a lady of leisure at home for ever and had insisted on having a career. Now she was threatening to marry. She was twenty years old and thought it time in spite of her excellent job in the Town Hall. Neither Leah nor Henry approved of her intended, one Joseph Butler, a butcher whose family owned three stalls in the market. Joseph had been courting Rose for a year, long enough for her parents to have marked him down as unsteady and far too interested in pleasure. Rose, when she was with him, became giddy and quite unlike herself. Henry had begun to mutter that marriage might be the best option, considering the way things were going, by which Leah knew he feared Rose would give way to Joseph and land herself in trouble. Leah, who could not bear the mere mention, however obliquely, of such a disaster, found herself hoping war might actually break out and carry Joseph out of the way for long enough for Rose to forget him.

The opposite happened. War was declared in August 1914, and Joseph joined up immediately. Rose burst into tears and announced she would marry him at once. She loved him and could wait no longer. No amount of pleading would make her change her mind, but since, in spite of her determination to marry with all speed, she wanted a proper wedding, she agreed to wait six weeks until Joseph had completed his basic training. The marriage would take place before, as was anticipated, he was sent abroad. Leah was thrown into a frenzy of preparations for the white wedding, and Henry too, of course, since naturally he was making Rose's dress and those of the four bridesmaids. But two days before the great day Joseph's regiment was ordered to France. The wedding had to be postponed since Joseph was not allowed home at all and Rose was unable to bid him a proper farewell. She dissolved into hysterical weeping and was inconsolable. The wedding dress was carefully wrapped up and put away and a new date fixed for Joseph's first leave.

Afterwards, Rose blamed Leah, quite openly and bitterly, for preventing her marriage. She said everyone knew she had wanted to marry Joseph Butler for months and that if it had not been for the opposition of her mother the wedding would have taken place in the summer. Leah did not try to counter this. However true, Rose would also have to admit, if reminded, that it was she who had delayed those fatal few weeks in order to have a splendid wedding instead of a hole-in-corner affair. But Leah was not going to remind her. Rose was too broken. No tears now, when real tragedy had struck. Once she had been told of Joseph's death in his first week of action she seemed to seize up. She sat pale and motionless hour after hour and it was Leah who did the weeping. When Rose fainted on the way downstairs one morning no one was surprised – she had hardly eaten a thing in the last month, since Joseph was killed. But Leah sent for the doctor, hoping he would give orders to eat which Rose would heed. He issued the orders, but for a reason Leah had never suspected.

Rose had known perfectly well that she was pregnant. The child was conceived the day Joseph joined up, when Rose could resist him no longer and believed herself certain to be married so soon that a little anticipation did not matter. If the marriage had taken place, Leah was aware, Rose's plight now would have been miserable and serious enough - a widow, at twenty-one - but without that seal of respectability Rose was ruined. Ruined more disastrously than she herself had been ruined, since Rose had far more to lose. Henry raged and damned the dead Joseph but Leah wasted no time on pointless ranting. Her mind was full of schemes, schemes to whisk Rose away in a manner no one would suspect and have her looked after until the baby was born and could be adopted. It was essential to act quickly, to put the word about that the doctor had pronounced Rose ill with a wasting disease which necessitated a move to a sanatorium at once. Lies must be honed until perfect and then the telling of them practised until they were all word- and expression-perfect.

But Rose proved intractable. She would not co-operate in any secrecy. She said if her parents cast her out she would not be surprised. She had brought, or was about to bring, shame and disgrace upon them and her punishment would be to take herself off to a Home for Fallen Girls – what else did she deserve? But she would not give up her child. Never. The child was all she had left of Joseph. Never, never could she part with that child and if keeping the child branded her as a whore, then so be it. Leah wept, Henry wept, Polly (who had to know) wept, but Rose did not. Her mind was quite made up. And, of course, they loved her and could not turn her out and so she stayed at home and was looked after; and the tongues wagged as viciously as Leah had dreaded. Rose insisted on calling herself Mrs Butler which worried Henry greatly, so much so that he paid to have her surname changed by deed poll, thereby ensuring she had a legal entitlement to the 'Butler' if not the 'Mrs'.

The baby was a girl. Rose called her Josephine and was from the first devoted to her. Leah watched her carefully, remembering her own initial devotion to Evie, and how frighteningly this had been replaced with revulsion. But Rose's passionate love for her daughter grew rather than abated. She told Leah she had a reason to live now and that Josephine was a constant comfort to her, a living reminder of Joseph whom she had loved so much. She carried her proudly in her arms with no hint of shame, though there were plenty who tried to make her feel ashamed. Joseph's own family, from whom she had hoped much, would not acknowledge her as their dead son's wife-inall-but-name. They were angry that she called herself Mrs Butler and wanted nothing to do with their grandchild. Rose endured this hostility with fortitude, merely commenting that Joseph would have despised their attitude.

It was one of the Butlers, a daughter of Joseph's sister, who, when Josephine was eight, taunted her at school with the word 'bastard'. She sang it under her breath whenever Josephine was near her, neither of them knowing what it meant. Rose, when asked by her daughter what it did mean, went white and compressed her lips tightly, saying only, 'Nothing. It is not a word for young girls.' But she went straight away to see Joseph's sister and warned her to put a civil tongue in her daughter's head, or there would be trouble. She did not know what she meant by her threat, but the violence and conviction with which she uttered it were effective. The Butler child desisted from then onwards.

Until, that is, Josephine was fourteen and long past complaining to her mother about taunts or teasing. Her one desire by then was to distance herself from a mother who enveloped her in such a squeeze of love that she felt she would suffocate. She longed for a father and for brothers and sisters, and for a normal family life instead of this claustrophobic existence, just herself and her mother, living now in a little house Henry had bought for Rose. She was so used to telling friends that her father had been killed in the war soon after marrying her mother that it came as a shock to her when first this version of events was challenged. It was the same Butler girl, grown insolent and daring enough to flout her own mother's order. 'They were never married,' the Butler girl said, hearing Josephine's patter to a new girl in the class. 'She's a bastard.' Josephine stared at her. She had an inkling now what a bastard was and, though not entirely sure, was more sure than she had been at eight that to be called a bastard was a terrible thing. She was afraid to speak and the Butler girl saw that she was. 'She's a bastard,' she repeated. 'Her mother was a slut who led my uncle on and maybe she led others on too and isn't even

his bastard, whatever name she has.' 'Liar,' Josephine managed to whisper, but quick as a flash the Butler girl said, 'Prove it, then,' and all there was left for her to do was turn away and leave the classroom.

She ought to have confronted her mother then but the thought horrified her. So she kept silent. Half the class had heard, of course, and gave her strange looks for a while. She held her head high and retreated further into herself and eventually the other girls lost interest. She worked hard and did well in examinations and decided she wanted to be a teacher. Her grandparents were delighted, but her mother worried aloud that it would mean her going away to training college and that such a separation would be torture. She did not want Josephine to leave her as Joseph had done and said so. Out came the story of her romantic but brief marriage and the retelling of it, in this context, snapped Josephine's patience. 'I'm leaving, Mother,' she said, 'I want my own life.' She longed to add that she knew this love-story was a sham, or at least the wedding part, but she held her peace.

Her own former restraint made it all the harder to endure her mother's decision to tell her the truth on her eighteenth birthday, before she left for teacher training college.

'I have something to tell you, Josephine dear,' Rose said, smiling tremulously, her eyes yearning for sympathy.

Josephine knew at once what it was. 'No,' she said, sharply, 'there is no need to tell me anything. I know.'

'What do you know?' whispered Rose, looking frightened.

'I know you were never married. That's all. And I don't want to hear about it. It doesn't matter.'

'Oh, but it does!' wailed Rose, and then there was no stopping her. Out came a catalogue of excuses and justifications, and Josephine could hardly keep still from agitation as her mother went on and on. 'I have never regretted what I did for a single hour,' Rose declared at the end of her recital, 'except for a moment or two when I saw the pain it caused your grandmother.' Leah was still alive, in her mid-sixties, and Josephine looked up to her and regarded her with the greatest respect. She could imagine easily her grandmother's horror. 'Your grandmother,' said Rose, 'wanted me to have you adopted but the thought never even crossed my mind. She tried to persuade me, she said I would have no life of my own, with a baby at my age and unmarried. She said you would be far happier adopted by a respectable couple. She said I was sacrificing my whole life for a baby who would never know the difference.' Then Rose sat back and looked hopefully to Josephine for gratitude.

But Josephine felt far from grateful. What she felt most strongly was embarrassment and resentment. Her mother need never have told her this story. It had been kept secret for eighteen years and it was monstrous of her to foist such a painful truth on her daughter. Josephine hated to think of Rose behaving so improperly and saw no romance in her parents' hurried passion. She resolved to tell no one, ever. Her mother had pretended and she would pretend. It was such a little lie in any case. But the knowledge that she was in fact illegitimate changed her attitude to her mother significantly and her attitude to sex was formed by it. She had always been made uncomfortable by her mother's intensity, her total devotion and had longed to be free of it. Now, she started to free herself, absolving herself from guilt. In spite of Rose's tears, once she had qualified as a teacher she promptly moved into a room of her own near the school where she taught and then, when she had taken up a situation in a London school, she never returned to live in Carlisle after she met and married Gerald Walmsley.

She never told Gerald she was illegitimate. Why should she? Gerald's family was socially superior to hers and she was afraid of them. Gerald himself had not the least interest in her background. She had to take him home, of course, to meet Rose and the rest of her family, but once that was done he had no contact with them except when they came to stay for the rare, very rare, visit. Rose was quite overawed by Gerald's profession and hardly spoke in his presence. She once tried to ask Josephine, after she had been Gerald's fiancée for a year, if she and Gerald had ... well ... if they had ... which she would, of all people, understand if – but Josephine silenced her, saying furiously that she and Gerald were only engaged, and he respected her and there was time for 'that sort of thing' when they were married.

Josephine wrote her father's name boldly in the church register and her mother kept the secret of her illegitimacy because she did not dare do anything else. She had used Joseph's surname for so long now it did not seem to matter (but she had a miserable feeling that it did, to Josephine at least). Josephine was glad to settle in London and begin her new, her very new, life. Her first son was born ten months after his parents' marriage, to Josephine's great satisfaction. Nothing could have been more respectable, and even though times were changing and morals with them, this mattered to her. Sex did not. It appalled her to remember that it was for *this* that her mother had risked her good name. It was absurd. Why could she not have waited? Why could she not have made *him* wait? Gerald had waited. There had been no question of his not doing so. He had not even pressed her too hard and once they were married his demands were modest, to her great relief. Gerald loved her and she loved him and sex was something quite different. When, after two sons, she gave birth to her daughter Hazel, she hoped to be able to bring her up to understand this.

Then mistakes would not be made.

Epilogue

I^T WAS a strange, lost feeling to have her dead. All hope gone. Hope ought to have left her long, long ago, but it never quite had. It should have departed with her when she left Carlisle but always, at the back of her mind, there had been the image of herself, carrying her baby, approaching her mother's door once more and finding it open, and seeing all the hostility on her mother's face fade, replaced by joy as she opened her arms to welcome her grandchild as she had not been able to welcome her child. Such a pretty picture it was. It kept Evie happy. All she needed was to give birth and she could give life to this fantasy, the transformation could take place.

Only twice was a doctor called for. They could afford doctors, it was not the expense which prevented her. It was the pointlessness and then the humiliation. They were impatient, these men, with her expectations. What did she expect them to be able to do? They told her to be glad she was miscarrying for there must have been something malformed about the foetus to cause its rejection. She lay and thought about this, in the dark, with the blood seeping steadily out of her. Malformed or not, she wanted to become its mother. Her tenderness, her loving care, would compensate. But no amount of lying still could keep any of her babies inside her. They left her, as her own mother had left her, and she was helpless with grief.

Once, the child was far enough along for its sex to be plainly seen. A girl, five months in gestation. She wished to keep her, in her bed, wrapped in the shawl she had crocheted, the shawl she would be buried in, but the midwife would not allow this. Her daughter was taken away and Evie screamed and screamed and was threatened with the madhouse if she did not stop. It would be the right place for her. She felt mad. But then there was Jimmy, patient and devoted, proving himself time after time, poor Jimmy forced to bear the brunt of her brutal distress. He gave up hope long before she did but pretended he had not. He indulged her fantasies and she was grateful to him. Seven miscarriages she suffered and all except two were dealt with by Jimmy, who took away the liver-like scraps which came from her and burned them. Blood became her familiar. The sight of it haunted her even when she was not bleeding and her aversion to all things red grew. She felt many a time that she was floating on oceans of blood and there was not a sheet in the house unmarked by the stains however long the linen had been soaked and scrubbed, soaked and scrubbed.

She wondered, as she lay in the midst of this blood when she was miscarrying, what her mother would think if she saw her now. Would her heart melt at last? When she saw the pain and misery and then the futility of it all? Evie talked to her, when the pain was at its worst, and was considered delirious. 'Is her mother at hand?' the doctor asked Jimmy and was told Evie had no mother, which was what he believed. The Arnesens' secret was safe with Evie and if he had suspicions (for where could his wife ever have found the money for them to buy a house?) they were of a different nature and all to do with Henry, but not Leah, Arnesen. Evie told him, when first she agreed to walk out with him, that she had no mother and that was that. Jimmy was an innocent in every way, a man who accepted and never questioned. His own mother was long since dead and he thought nothing of mothers. His wife's passion to become a mother completely baffled him.

Jimmy brought the Cumberland News home from Carlisle especially for Evie to see the announcement – Leah Arnesen, devoted wife of Henry and much loved mother of Rose and Polly, and grandmother of Charles and Josephine, on 11 April, at home, suddenly. Jimmy, who went on business to Carlisle often, had connections still with friends who continued to work at Arnesen's and was told it had been a heart attack. The funeral was in three days' time. At once, Evie determined to go. She had not been out of the house since her last miscarriage some two months since (a miscarriage which at her age of forty was indeed likely to be her last) and was still weak, but she never hesitated. Jimmy was aghast. He could not believe she truly intended to make the tiring journey and saw no alternative, when he realised she was in earnest, but to take her himself, though there was no reason for him to go again so soon to Carlisle. Evie dressed in heavy mourning, as though a principal mourner, and Jimmy privately wondered what the Arnesen family would think of such presumption. The church was almost full, because Henry Arnesen was a respected figure who had been mayor the year before. Entering the church, Jimmy saw Evie was taken aback at the size of the congregation. He indicated a row at the back still virtually unoccupied, but to his consternation she began marching down the centre aisle. He followed, because there was nothing else he could do but be loyal. She went right to the front, to the first row where Henry Arnesen and his two daughters and one son-in-law and two small grandchildren were all seated. Evie stood, waiting. Jimmy clutched her sleeve, but she shook him off, and at the same time Henry Arnesen stood up and motioned his family to do likewise and they all moved along, to make room for Evie and Jimmy.

The coffin was smothered with flowers, most of them camellias, white camellias, Leah's favourite flower. Everyone wept, except Evie. She looked through her veil at the coffin and the beautiful flowers and could not weep for the mother who had never loved her. She wanted to weep for herself, but the tears would not come. Instead, a sense of rage began to grow in her and her face behind its veil burned and she wondered the veil was not set alight by this heat. She hardly heard the words of the service and did not sing the hymn. When the coffin was taken out she was first to follow it, brushing Jimmy aside as he hesitated and cowered before the Arnesens. She knew everyone was staring at her, appalled by her impertinence and doubtless expecting Henry Arnesen to deal with her appropriately. But he handed her into the first car and got in beside her, with the two daughters whose expressions could not be seen but could easily be guessed at. No one spoke in the car. At the cemetery, Evie stood with Henry, and when the coffin had been lowered into its trench he turned to her and in everyone's hearing said, 'Will you come to the house?' She nodded. Jimmy was nowhere to be seen.

She found herself to be perfectly composed once inside the house she had never been allowed to enter. There was quite a spread laid out in the dining-room with glasses of whisky for the men and sherry for the women. Evie neither ate nor drank. She stood to one side, near the window and, looking out, thought of herself once always looking in. She was aware that Rose and Polly were engaged in whispered debate with their father and knew it was about her. He would tell them. He must tell them. It was why she had come. If he did not tell them she would have to do so herself and quite looked forward to this. But now, though she had, unlike all the other women, not lifted her veil, Miss Mawson had recognised her. 'Why, Evie, it is Evie, is it not? My dear, how good of you to come.' Evie inclined her head but said not a word. She saw that Miss Mawson positively vibrated with curiosity and the sense that something dramatic was about to happen if, with Evie's behaviour in the church, it had not already done so. 'So sad,' Miss Mawson was saving, 'so sudden, a heart attack, you know, though she had never had anything wrong with her heart.' Miss Mawson lowered her voice even further. 'It may have been weakened by the shock, of course. Years ago now but still a dreadful, dreadful blow at the time.' Evie had no idea what she was talking about. 'Rose, you know, and her intended killed in action, and then ... She is a pretty little thing, Josephine.'

Henry Arnesen came between them. He bowed to Miss Mawson and accepted her sincere condolences. Then he asked Evie to come with him a moment and, watched by the entire room, the two of them went out and into the study across the hall. Henry shut the door. 'Why did you come to the funeral?' he asked.

'I am her daughter,' Evie said, proudly. She knew what he was going to say.

'She has passed on,' Henry said. 'All that is finished. Do you wish to distress Rose and Polly more than they are already distressed? Do you wish to ruin their mother in their eyes now she is gone from them?'

Evie put up her veil. She looked long and steadily at Henry and smiled. 'Yes,' she said, 'I wish to tell my sisters I am their mother's daughter too and then I will go and never bother them again.'

'It is cruel,' Henry said.

'It is she who was cruel,' Evie said, 'and made me suffer all my life. And your girls are mothers themselves, they should understand, one of them especially, I am told.'

Rose and Polly slipped into the study nervously and stood either side of their father with Evie facing all three of them. They had changed greatly since she had last seen them. Rose in particular she would not have recognised. The pretty girl had given way to a sombre matron, pale of face and dull-looking, where once she had sparkled. Polly had merely lost weight and grown tall. They looked frightened, and their father did nothing to reassure them. 'This is Mrs Paterson,' he said. 'She has something she wishes you to know.' Rose gave a little moan. All three stared at Evie and waited. 'I am her daughter too,' she said. There was no reaction, so she repeated the words and for good measure added. 'I am your mother's daughter too, her first-born, before ever she married your father.' The two women both looked up at Henry. 'Father,' whispered Rose, 'can this be true?' He nodded, unable to speak. Nobody moved. Evie waited and waited, and then she said, 'I must go home now.' They parted and she went out into the hall and the front door was opened for her and outside limmy was waiting. She made him take her back to the cemetery and there she looked again at the mound under which her mother rested, and she felt it was over at last. 'I have no mother,' she said. 'I never had a mother, and I never shall be one.' limmy, standing at a little distance away, on her instructions, heard only an indistinct murmur and thought a praver was being said. He was in a hurry to get Evie home. She did not look well and whatever this attendance at Leah Arnesen's funeral was about he wanted it over

Evie went with him docilely enough. She had no more miscarriages. At forty-five she had an abrupt menopause and this was said to account for her unbalanced behaviour afterwards. She took to wandering the streets, knocking on doors and asking for her mother. And in the end Jimmy was forced to agree she needed treatment. Before it could begin, she died in a state mental institution, of a heart attack, quite unexpectedly.

It was in the middle of Australia that Shona suddenly felt homesick. Predictable, it was so predictable it made her smile in the midst of her melancholic turn of mind – the intense heat, the dust, the reds and browns, all so different from the Scottish coast. She sent a postcard to Catriona and Archie, saying she was missing St Andrews and would give anything for a blow along the beach in the rain and mist. At the bottom she wrote 'and missing you both too'. It was true. All the time she'd been at university in London she hadn't been back to St Andrews more than half a dozen times, for ever shorter periods, and yet now she was so far away she craved the place. She sat with her eyes shut on a bench outside the post office, her T-shirt and shorts damp with the perspiration which drenched her by midday every day and only seemed to leave her when she was actually standing under a cold water shower. She felt not just hot but sick. She had neither the skin nor the colouring, nor indeed, she thought, the metabolism to survive this kind of climate. The two girls she had teamed up with did far better. They were dark-haired Mediterranean types who soaked up the sun and came to life in its heat.

She wanted to go home. There was no reason why not. She could begin the long journey back any time she wanted. There was nothing to hold her here. Sixteen months she'd been away and it was enough - it was time, definitely time, to halt this roaming and think what she wanted to do with her life. But she felt sick and weak and lacked the energy to leave her companions and about-turn on her own. Maybe she was ill, maybe the bug she had picked up in India hadn't really left her stomach. She wished her mother was near, a babyish thing to wish, and she wouldn't say it aloud or the other two would laugh. She wanted to be looked after, fussed over and, still with her eyes shut, soothed herself with a vision of Catriona applying a cold compress to her burning forehead and ushering her into a cool and darkened room. It made her feel cheap, to think of her mother only as someone useful who would care for her. Perturbed, she opened her eves and tried to pull herself together. Some effort was needed. They'd left their rucksacks in the hostel, but now she said she was going to go back and collect hers and get a bus to Darwin and fly to Sydney and then home. 'I'm not up to this,' she said, and the other two accepted her verdict cheerfully. They'd only been together three weeks.

In Sydney she debated whether to telephone her mother but decided not to, a surprise would be best. Catriona would be saved the worry of knowing she was flying and fearing she might crash, the kind of worry to which she had always been irritatingly prone. It was harder to decide whether to let Hazel know she was to pass through London. She'd sent postcards to the boys from every country she'd visited and kept in touch that easy way. They'd given her a great send-off when she left, all of them coming to Heathrow and waving her through into the departure lounge, with little Anthony crying. She had felt quite tearful herself and had been proud to know she had such feelings. Hazel, unexpectedly, had embraced her warmly, but she had wondered if that warmth was because she was leaving. Now, if she returned, maybe it would not be evident and she was surprised to realise she did not much care. She admired Hazel but she had never been sure that she had learned to understand her. She could not decide, either, whether she actually liked her. What was there to like? Her composure? Her cleverness? Her ability to distance herself from emotion? Her organisational skills? The harder she tried to list in her mind why she might like Hazel the less convinced she was that she did. And she did not love her. There was at least no doubt about that. But when she thought of Catriona, reasons for liking her tumbled into her head. She was so kind, so unselfish, so gentle, so anxious to help in every way possible - and in any case reasons were irrelevant because she saw now that the feelings she had for this mother of hers amounted to love. Catriona and she had virtually nothing in common but they were nevertheless part of each other. All her life she had been exasperated by Catriona and she probably always would feel some measure of irritation. But there was a connection between them which she now had no pressing need to deny. She'd stopped looking for a mirror image of herself in the woman who had conceived and given birth to her. She was glad to have got something straight, at whatever cost.

Going home was not as traumatic as she had feared. The welcome was just as she had anticipated and she basked in it and thought how lucky she was to be assured of it whenever she returned. And she felt well again for the first time in months, really well, not a trace of nausea. She shed the inertia which had weighed her down and became her old energetic self – a lesson learned, she told herself, and never to be forgotten. But she didn't stay in St Andrews. She went to Edinburgh and took a job in the university's administrative department. She'd feared it would be deadly dull and had only taken it to make a start somewhere while she sorted out in which direction she really wished to go, but she found she liked it and was rapidly promoted. She had enough money to rent a flat and buy a secondhand car, and every other weekend she went home to St Andrews, to the delight of her parents. They were ageing and she was anxious about them and liked to make regular visits to see that all was well.

They wanted to see her married, naturally. They were conventional and had no time for any other kind of liaison. She took all the inquiries about 'romances' in good part, and made jokes about their expectations, but when she did have her first affair she kept it secret. She was old, she thought, at twenty-four, to be having a first loveaffair, but then she had had other things on her mind and had shut herself off from men. His name was Lachlan, and she was very happy with him for six months until she discovered he was married. The disappointment was worse than the shock, and the sense of rage at being hoodwinked greater than the humiliation.

She was more careful after that. She checked men out. From the beginning, she knew Gregory Bates was divorced and had a child of three. His honesty was heartening and so was his concern for his child. She met the child, saddled with the ridiculous name of China, very early in her relationship with Gregory. It might even, she considered later, have been a kind of test – if she didn't get on with China then there was no hope of any future with Gregory. After a year, he asked her to marry him and was most upset when she turned him down. 'I'd like to be your wife, Greg,' she said, 'but I don't want to be China's second mother.' So that was that, another relationship over.

She never intended to become involved with Jeremy Atkinson – by this time she felt liberated enough to think only in terms of an affair and nothing else – which was why, perhaps, she had such fun. Jeremy believed in having a good time. He was not her type and yet she was more attracted to him than she had ever been to any man. He made her feel lighthearted and irresponsible when she knew herself to be serious and conscientious, and she liked the strangeness of this. Jeremy was an accountant but gave the lie to the image of accountants as stuffy and dreary. He made a lot of money and spent it on holidays and entertainment and meals out. She hardly knew herself as she jetted off to the Caribbean with Jeremy and went out with him night after night to theatres and concerts. But when she found she was pregnant she had no hesitation.

She almost didn't tell Jeremy – there was no need for him to know – but in the end she did. He was vastly relieved at her attitude, her 'healthy' attitude as he called it, and insisted on paying for the abortion. It was simple enough to arrange, if costly (so she was glad of Jeremy's money) and she felt no after-effects, physical or psychological. But, naturally, during her one day in the private clinic she thought again about Hazel pregnant with her all those years ago, in the dark ages. She had always made it clear to Hazel – well, she hoped she had – that if an abortion had been possible in 1956 she would never have blamed any woman for having one. An abortion was far preferable to giving a child away after bearing it with resentment. She felt moved to write to Hazel afterwards, though not to Catriona – she would never tell her mother – and received in reply the kind of compassionate response she had hoped for. The abortion at least served the useful purpose of drawing her closer to Hazel.

She married Jeremy, but not for another three years, by which time she had decided she didn't want children, ever. She thought Jeremy might mind but he didn't: he said he had no desire whatsoever to be a father and was only surprised Shona had none to be a mother, because he assumed all women did, it being their biological destiny. The decision made, she had herself sterilised, an operation far more difficult to organise than an abortion, which amazed her. She had it before the wedding but told nobody, except Jeremy, that is. Doubtless their respective mothers would drive them crazy in the years ahead waiting for grandchildren, but that could not be helped. She would make it clear, as time went on, that she simply didn't want to be a mother without hurting them by revealing she no longer could be in any case.

She was a very beautiful bride, but what everyone remarked on was not Shona's beauty but her serenity. She seemed so happy with herself in a way she had never been, and Archie could not resist saying to Catriona, 'Everything turned out all right in the end. You were a perfect mother to her, that's why.' Catriona did not reply. She knew there was no such thing. Archie was only trying to reassure her with his compliment but she no longer needed such reassurance. Shona had come back to them. She had stayed close. That was what mattered, that was what every mother wanted.